Uncle Tom's Cabins

Uncle Tom's Cabins

The Transnational History of America's Most Mutable Book

Edited by Tracy C. Davis and Stefka Mihaylova

University of Michigan Press ANN ARBOR

First paperback edition 2020
Copyright © 2018 by Tracy C. Davis and Stefka Mihaylova
All rights reserved

For questions or permissions, please contact um.press.perms@umich.edu

Published in the United States of America by the
University of Michigan Press
Manufactured in the United States of America
Printed on acid-free paper

First published March 2018
First published in paperback April 2020

A CIP catalog record for this book is available from the British Library.

Library of Congress Cataloging-in-Publication Data

Names: Davis, Tracy C., 1960– editor. | Mihaylova, Stefka, editor.
Title: Uncle Tom's cabins : the transnational history of America's most
 mutable book / edited by Tracy C. Davis and Stefka Mihaylova.
Description: Ann Arbor : University of Michigan Press, [2018] | Includes
 bibliographical references and index. |
Identifiers: LCCN 2017052940 (print) | LCCN 2017061153 (ebook) |
 ISBN 9780472123568 (e-book) | ISBN 9780472037087 (hardback)
Subjects: LCSH: Stowe, Harriet Beecher, 1811–1896. Uncle Tom's cabin. | Stowe,
 Harriet Beecher, 1811–1896—Influence. | Slavery in literature. | African
 Americans in literature. | Race in literature. | BISAC: PERFORMING ARTS /
 General. | LITERARY CRITICISM / American / African American. | SOCIAL
 SCIENCE / Ethnic Studies / African American Studies. | ART / Performance.
Classification: LCC PS2954.U6 (ebook) | LCC PS2954.U6 U53 2018 (print) |
 DDC 813/.3—dc23
LC record available at https://lccn.loc.gov/2017052940

ISBN 978-0-472-03776-6 (pbk.)

Cover credit: *Uncle Tom's Cabin*, adapted and directed by Behrooz Gharibpour,
Bahman Cultural Arts Center, Tehran, Iran (2008); *Onkel Toms Hütte Reloaded*,
written by Gerold Theobalt, Kempf Theater, Grünwald, Germany (2015).

Contents

Acknowledgments vii

Introduction 1
 Tracy C. Davis and Stefka Mihaylova

I. Destination Points

Oh, Canaan! Following the North Star to Canada 33
 Tracy C. Davis

"I Go to *Liberia*": Following *Uncle Tom's Cabin* to Africa 59
 Marcy J. Dinius

II. Freedom's Pathways

Eliza's French Fathers: Race, Gender, and
Transatlantic Paternalism in French Stage Adaptations
of *Uncle Tom's Cabin*, 1853 81
 Emily Sahakian

Representing the Slave Trader: *Haley* and the Slave Ship;
or, Spain's *Uncle Tom's Cabin* 116
 Lisa Surwillo

The Bonds of Translation: A Cuban Encounter
with *Uncle Tom's Cabin* 139
 Kahlil Chaar-Pérez

"Black and White Are One": Anti-Amalgamation Laws,
Roma Slaves, and the Romanian Nation on the
Mid-nineteenth-century Moldavian Stage 165
 Ioana Szeman

"Schwarze Sklaven, Weiße Sklaven": The German Reception
of Harriet Beecher Stowe's *Uncle Tom's Cabin* 192
 Heike Paul

III. Recirculating Currents

From Abolitionism to Blackface: The Vicissitudes of
Uncle Tom in Brazil 225
 César Braga-Pinto

Medializing Race: *Uncle Tom's Cabin* in Colonial Southeast Asia 258
 meLê yamomo

The Divided Poland: Religion, Race, and the Cold War Politics
in the Rozmaitości Theater's Production of *Uncle Tom's Cabin*
in Kraków in 1961 282
 Katarzyna Jakubiak

Raising Proper Citizens: *Uncle Tom's Cabin* and the
Sentimental Education of Bulgarian Children during
the Soviet Era 314
 Stefka Mihaylova

Harriet Beecher, from Beirut to Tehran: Raising the *Cabin*
in the Middle East 343
 Jeffrey Einboden

Staging *Uncle Tom's Cabin* in Tehran 366
 Debra J. Rosenthal

List of Contributors 389

Index 393

Digital materials related to this title can be found on
the Fulcrum platform via the following citable URL:
https://doi.org/10.3998/mpub.8057139

Acknowledgments

In many families there is a book—traditionally a Bible—that is handed down from generation to generation. The book Tracy owns that fits this pattern is *Uncle Tom's Cabin*. Her undated Rand McNally edition, printed in Chicago, is signed on the inside boards by the juvenile hands of a great-aunt, two of her nephews, and a niece. The original owner of the book grew up on the Canadian frontier, on land that first felt a plough guided by her father's and brothers' arms. In such a place, books were neither plentiful nor disposable. This one, possibly given as a prize at Sunday school or at the one-room country school she attended, was clearly treasured. For this pioneering family who came from Iowa to Alberta just after the turn of the twentieth century, the book might have been regarded as their heritage. For the next generation—Tracy's aunt, uncles, and father, who were Canadians of Norwegian and American parents growing up during the Great Depression—the book took on the mantle of world literature.

Another edition of *Uncle Tom's Cabin*, this one in Bulgarian translation, was passed down across the generations to Stefka. Published in 1931, more than a decade before Bulgaria became part of the Soviet sphere, this translation was markedly different from the edition Stefka read as a middle-school student in the 1980s. Targeted to schoolchildren within a Soviet satellite nation, this later edition was, in effect, weaponized literature aimed at discrediting an ideological rival during the Cold War. Under these circumstances, it was not so much a novel of and about the middle of the nineteenth century as a testament to a fundamental flaw in American culture;

this crack in the foundation was responsible for ongoing and intensifying social inequality that was based on race and practiced as racism. The critique drew power from the fact that its author was someone whose credibility within American culture was sacrosanct. Across regime changes in the Soviet Union and even after the dissolution of the empire, the book remained lodged in school curricula, the only novel composed in English and having this status.

This endurance highlights a phenomenon central to our project: whereas the book history of *Uncle Tom's Cabin* in English can be seen as a matter of editions with fairly stable contents, both editions and texts in other languages were radically altered to reflect their times and circumstances. In both paradigms, transnationalism changes Stowe's legacy. Our families' copies of *Uncle Tom's Cabin* represent only two varieties of the transnational history of this text. The varieties multiply exponentially around the globe. Like other New World exports—the potato, tobacco, self-loading firearms, rock 'n roll, and hip-hop, to name a few—*Uncle Tom's Cabin* remains recognizable despite radically different seasonings, social settings, ideological applications, rearrangements, and users. Like so many other transplants that find new soil and climates conducive, *Uncle Tom's Cabin* has often gone native and developed a unique place in each host's culture. This mutability is indicated across the essays in this volume but is by no means limited to these landing points. Without a doubt, the permutations are not yet finite, as *Uncle Tom's Cabin* will continue to be a litmus test, flash point, and palimpsest for generations to come.

Presenting this perspective would be impossible without the expertise and curiosity of our authors. No one person or pair of collaborators could command enough knowledge of all the necessary languages and locales to reveal this history. We are deeply grateful to all the contributors—including several whom we have never met in person—for sharing their knowledge to help build this book.

We are also grateful to LeAnn Fields for expressing enthusiasm for this book from the start, to all the staff at the University of Michigan Press who have brought the book into readers' hands, and to Ira Murfin and Max Shapey for working with such care to perfect each author's prose and illustrations in the book's later stages.

Lisa Surwillo's essay is revised from its first printing in *PMLA* 120.3 (May 2005): 768–82. Heike Paul's essay is revised from its first printing in *Ameri-*

kanische Populärkultur in Deutschland, edited by Heike Paul and Katja Kanzler (Leipzig: Leipziger Universitätsverlag, 2002), 21–39. Both essays are used with permission.

English language quotations from *Uncle Tom's Cabin* utilize the Oxford World's Classics edition, edited by Jean Fagan Yellin (Oxford: Oxford University Press, 1998). Page numbers that appear in parentheses refer to that edition.

Uncle Tom's Cabins

Tracy C. Davis and Stefka Mihaylova

Introduction

LOCAL READINGS

From its earliest origins as a serialized story in the *National Era* and then a two-volume novel,[1] *Uncle Tom's Cabin* has been subject to localized readings. The first edition sold ten thousand copies in two weeks, prompting the editor of the *National Era* to proclaim it "THE STORY OF THE AGE!" By early 1853, the book had sold one million copies in U.S. and English editions.[2] Initial press reviews were polarized in accordance with the geography of American slavery. In Boston, the *Congregationalist and Christian Times* enthused that it "has done more to diffuse real knowledge of the facts and workings of American Slavery, and to arouse the sluggish nation to shake off the curse, and abate the wrong, than has been accomplished by all the orations, and anniversaries, and arguments, and documents, which the last ten years have been the witness of."[3] But as the subsequent printings made their way to the Southern states, these claims to persuasiveness and truth were vehemently refuted. A reviewer in Richmond admitted confusion as to "how Southern men and women can reconcile it with their notions of self-respect to purchase, or to read with any other emotion than disgust, a volume reeking with the vilest misrepresentation of themselves and their social institutions."[4] In Charleston, the book was referred to as mischief that, "like mushrooms from dunghills," will make "converts to the abolition cause" and lead "to the amalgamation of the white and black races on this continent"—an allusion to the profound fear of miscegenation, one manifestation of racism.[5]

As *Uncle Tom's Cabin* draws to its conclusion, Stowe sets aside the omniscient third-person narrator used in the rest of the book and addresses readers in an authorial voice. She invokes the "Men and women of America," "Farmers of Massachusetts, of New Hampshire, of Vermont, of Connecticut," "strong-hearted generous sailors and ship-owners of Maine," "Brave and generous men of New York, farmers of rich and joyous Ohio, and ye of the wide prairie states," and the "mothers of America," to break silence on the slave trade, cease their collaboration with the South, recognize the evil in their own actions, and do what is right (451).[6] Collectivizing readers as men and women of the North, she beseeches them to act on their Christian morality and give refuge to those seeking "education, knowledge, Christianity," so African Americans can avail themselves of the "advantages of Christian republican society and schools" (453). In the novel's example of George and Eliza Harris, however, these advantages are put to service in equipping ex-slaves to lead a foreign nation. This objective, rather than the passivity of Uncle Tom or the racialized "wicked drollery" of Topsy (246), caused abolitionists to divide over the novel. The American anti-slavery movement factionalized over ideological and tactical differences in the 1830s and 1840s, never to reunify. The serialized novel harmonized with the politics of the *National Era*: its editor Gamaliel Bailey was associated with the Free-Soil Movement (opposing extension of slavery to newly accessioned states), and its associate editor John Greenleaf Whittier, a founder of the Liberty Party, advocated a gradualist approach to abolition, combining a political solution with moral principles. William Lloyd Garrison's newspaper praised Stowe's book in general terms, yet his followers never embraced it, for they advocated immediate and total abolition.[7] Frederick Douglass regarded the movement to resettle freed blacks in Africa as a conspiracy to remove from the United States those most able to advocate for change, so the Harris family's ultimate move to Liberia in *Uncle Tom's Cabin* was profoundly misaligned with Douglass's principles. Though the American and Foreign Anti-Slavery Society endorsed how the novel promoted readers to weep and pray first and then work for the cause of abolition, even these gradualists could not universally endorse the flight to Canada, let alone resettlement in Africa, arguing, "We will ever discountenance and oppose all schemes, whether devised by State or National Governments or Colonization societies, of coercive expatriation, and all efforts to place the people of color in such positions that, as a choice of evils, they will consent to leave the land of their birth and their chosen residence."[8] So, even if the

novel's sympathetic devices and emplotments reflected abolitionists' observations of slavery, abhorrence of the Fugitive Slave Act, and personal actions to assist and abate the pernicious effects of bondage, abolitionists did not necessarily agree with or endorse the book's total or final directions.[9]

Thus, not only did opinion in the United States divide on the book's veracity; among pro- and anti-slavery advocates alike, its politics were challenged. Unsurprisingly, in other places in the world, different things about the novel mattered, were allied to local concerns, and became emphasized in adaptations and codified as resonant meanings. The text prompted readers to contemplate their subject positions and alignments. For example, when Simon Legree turns from Tom for the last time, an inner voice arises, saying, "What have we to do with thee, thou Jesus of Nazareth?—art thou come to torment us before the time?" (402). This was Stowe's attempt to give even the most dissolute Louisiana slave master a chance at Christian redemption. But what would a foreign slave owner, an ex-slave, or a Communist have made of that? Likewise, in his moment of death and salvation, Tom's countenance bears the expression of a conqueror, and he says, "Who,—who,—who shall separate us from the love of Christ?'" As George Shelby looks over him "fixed with solemn awe," he closes Tom's eyes, rises, and expresses his old friend's words "What a thing it is to be a Christian!" (427). What would a Muslim, a Buddhist, or an atheist have made of that? In George Harris's letter expressing his intention to go to Liberia, he describes his desire to "form part of a nation, which shall have a voice in the councils of nations," because "a nation has a right to argue, remonstrate, implore, and present the cause of its race,—which an individual has not" (441). What would a veteran of France's 1848 revolution, a supporter of Hungarian independence fighter Louis Kossuth, or (later) a Zionist or Palestinian have made of that? George Harris explains that America's blight will be removed not through its own actions but by example of an African nation (Liberia) to Europe, "if, there, serfdom, and all unjust and oppressive social inequalities, are done away with" (441). This is the internationalism of civil rights, as well as socialist nation building, that resonated in the nineteenth century, found full expression in postcolonial nations in the twentieth century, and continues to resonate from nations of the global south in the twenty-first century. Yet even when ideological influences are held in common, local exigencies result in unique understanding and challenges to liberation, reconciliation, and equalization.

Regional and religious identities are integral to *Uncle Tom's Cabin*, and

Stowe took pains to demonstrate historical authenticity and biographical antecedents.[10] In a reception history, however, facts may be interesting but nonbinding to interpreters; characters may have cultural specificity yet are subject to remodeling to serve local legibility; the text is a "thing" but also an interweaving of stories that can be selectively emphasized, rerouted, and interpolated across time in "a chain of constant impression, evaluation, and imitation [. . .] establishing new foundations."[11] *Uncle Tom's Cabin* therefore refracts a plethora of ideological positions, historical circumstances, and emplotments beyond those known in the United States of the 1850s. Within the novel, St. Clare puts the case well, in debate with his cousin Miss Ophelia: though the English laborer cannot be "sold, traded, parted from his family, whipped," he nevertheless "is as much at the will of his employer as if he were sold to him. The slave-owner can whip his refractory slave to death,—the capitalist can starve him to death. As to family security, it is hard to say which is the worst,—to have one's children sold, or see them starve to death at home" (237). Augustine St. Clare probes for comparison: which is the better or more heinous despot, the one who owns other human beings or the one who keeps them in thrall as wage slaves? What sets the plantation owner apart from the British capitalist is that the master in the United States lives among those whom he degrades. St. Clare sounds like Karl Marx when he forecasts, "One thing is certain,—that there is a mustering among the masses, the world over; and there is a *dies irae* coming on, sooner or later. The same thing is working in Europe, in England, and in this country" (240). While St. Clare links the unrest with the day of God's reckoning, the specificity of class and racial upheaval is significant. Nations might voluntarily manumit, as St. Clare points out to Ophelia, "The Hungarian nobles set free millions of serfs, at an immense pecuniary loss; and, perhaps, among us may be found generous spirits, who do not estimate honor and justice by dollars and cents" (322). Yet the process of making people free does not end with manumission. Whereas race continues to attach to social inequity in the United States, minoritarian ethnicities elsewhere (from Eastern Europe to West Africa, Australia to Guatemala, and Armenia to Cambodia) continue to demarcate cultural difference, social schism, and the fault lines that can erupt in exodus, human trafficking, or genocide.

Uncle Tom's Cabin was a runaway hit in the United States and Great Britain: those nations not only share a dominant language but also hosted each other's abolitionists to lecture, perform, and otherwise sway public opinion. There is extensive scholarship about this circulation and reception history. However, the book (and stage adaptations) quickly gained circula-

tion beyond the British-American vector, achieving near-global exposure, and it has continued to be read, seen, and reinterpreted around the world ever since the mid-nineteenth century. In some cases, ideology or faith enables *Uncle Tom's Cabin* to take on different referential contexts. Often, local concerns lead to excision, revision, or substitution of referential elements (with or without imposition of censorship). Sometimes, the exigencies of genre—as in the adaptation of the novel for cinematic presentation— necessitate concision, facilitate selective emphasis, and direct attention to particular facets (e.g., spectacle or music) to enhance effects. Even when the genre is consistent and the book is perceived as translation rather than adaptation, the translation can significantly alter meaning, invite different intertextual combinations, and cause referential substitutions.[12]

According to Lawrence Venuti, translation or adaptation are inevitably a process of domestication, reflecting the translator's or adaptor's task of making a text legible to a community of readers for whom it was not originally written. Any ethical considerations that arise in the process of translation are typically resolved in favor of the translator's, rather than the original author's, target audience.[13] By building a bridge between an original text and a translation's targeted local readerships, the translator also envisions a utopian transcultural community of readers who can communicate across differences.[14] As with translation, so goes adaptation, as a more explicitly intentional set of changes, including the transposition to other media. These processes are made especially obvious in the circulation history of *Uncle Tom's Cabin*. When a reception community is not American or Christian or capitalist, experiences the story as theater or film or television or dance, and is presented with linguistic and cultural approximations, substitutions, and incompatibilities, the permutations of understanding become exponential across remakes, "willful 'misreadings,'" "interracial witnessing," or "fantasy scenes of national feeling."[15] At the same time, the transnational audiences who accessed and sympathized with the story in various formats remained unified around a utopian vision of social equality that defied cultural differences even as it manifested in culturally specific variants. This is precisely the history that the present study seeks to uncover.

RACE AND ITS AFFECTIVE RESONANCES

For an American reading and viewing public, race is the underlying logic of *Uncle Tom's Cabin*. The terms *mulatto* and *quadroon*—which describe George and Eliza Harris; St. Clare's servants Adolph and Mammy; his

nephew's servant Dodo; Susan and Emmeline, who are sold in New Orleans along with Tom; Lucy, who is bought along with Tom by Simon Legree; and Cassy, Legree's housekeeper and Eliza's mother—represented not only the history of racial intermixing in the American South but also the sexual violence perpetrated on enslaved women and the ongoing moral crime of rending apart genetically related families. Stowe writes of George, "We remark, *en passant*, that George was, by his father's side, of white descent. His mother was one of those unfortunates of her race, marked out by personal beauty to be the slave of the passions of her possessor, and the mother of children who may never know a father" (114). This produced what Stowe describes as physical beauty (as well as spiritual grace) in the characters she marks in this way. In addition, there is a political facet to this identity and signification. Alfred St. Clare references Haitian slaves' slaughter of whites in San Domingo during the revolution of 1804 as justification for subjugating all mixed-race persons. His brother Augustine replies,

> Well, there is a pretty fair infusion of Anglo Saxon blood among our slaves, now. [. . .] There are plenty among them who have only enough of the African to give a sort of tropical warmth and fervor to our calculating firmness and foresight. If ever the San Domingo hour comes [i.e., an event like the Haitian Revolution of 1791–1803], Anglo Saxon blood will lead on the day. Sons of white fathers, with all our haughty feelings burning in their veins, will not always be bought and sold and traded. They will rise, and raise with them their mother's race. (277)

In other words, the current social order will not persist indefinitely, and by this racial logic, the *mulattos* and *quadroons* will feel the righteous fervor that has brought Europe to foment since the French Revolution of 1789 and will lead all black people to liberty.

As David C. Wall stipulates, *Uncle Tom's Cabin* may be "intended to revolve centripetally around the gravitational center of whiteness," offering readers in the United States and Great Britain "a narrative that constructed and validated a white identity predicated on the authority both to control and to represent the black body."[16] This patterning of "negative others,"[17] however, was not consistently applied in all cultures' reading of the novel. As a socially defined construction, race is neither a universal label nor a stable legible delimiter. We asked the contributors to this book how the American terms for race were translated for other reading publics. French

adaptations utilize three categories—*blanc*, *nègre*, and *mulâtre*—preserving the connotations of the English terms *white*, *black*, and *mulatto*. One French text circulated in Brazil, where the terms were also legible. But in Cuba, where *quadroon* and *mulatto* were translated as *cuarterón* and *mulato*, *nigger* was translated as *negro*, which loses the vicious and demeaning English connotations. In Romanian translations of 1853, both based on French versions, *quadroon* is translated as *carteron*; Theodor Codrescu's translation glosses it as "someone born from a mulatto [man] and a European woman, or from a European man and a mulatta,"[18] whereas Dimitrie Pop's translation defines it as "the child born from a Negro woman and a European man, or from a European woman and a Negro man."[19] Considering the complex significance of parental lineage and the history of gendered trafficking in the Ottoman principalities along the Black Sea, these permutations could be extremely important to the sense of the text. Another fascinating instance of the translator's creolization in a Cuban edition is the rendering of "boy or gal"—in "Well, haven't you a boy or gal that you could throw in with Tom?" (8)—as *criollito o criollita*, which means Cuban-born. Mid-twentieth-century Polish translations render *mulatto* and *quadroon* as *mulat* and *kwarteron*, remote enough from everyday parlance that all three translators glossed the terms for young readers. Polish counterparts to *Jim Crow* and *nigger* are replaced by equivalents: *czarnuszek* (little blacky) and *smoluch* (tar-stained). The specific choices each translator makes reveal how race is constructed and naturalized in the translator's culture.

How the American logic of race was conveyed in all these different contexts depended on local racial and ethnic distinctions and also on the medium through which the story of *Uncle Tom's Cabin* reached specific readers and/or spectators. Reading novels has not always been considered morally safe or elevating.[20] Nonetheless, the printed text enjoyed prestige unrivaled by performance (the other major medium of the century) in the West and beyond. In locales where literacy was not widespread and/or where printed texts, including novels, were expensive, the prestige of print endorsed the political standing of the social strata capable of buying and reading books. According to our authors Marcy Dinius and mêLe yamomo, this was the case in nineteenth-century Liberia and Southeast Asia, where the educated minorities used the novel to formulate or perpetuate existing racial policies and class distinctions, reinforcing their political domination. In both contexts, the novel's racial logic was understood in terms of local perceptions of class and race. At the same time, for readers who had had limited encoun-

ters with people of African descent and whose first significant introduction to blackness was the novel itself, print could deemphasize the significance of race, foregrounding gender and religion instead. In her essay herein, Stefka Mihaylova writes that this seems to have been the case with nineteenth-century Bulgarian readers of *Uncle Tom's Cabin*. In contrast, according to Bettina Hofmann's examination of translations for juvenile German readers, a pro-imperialist translation from 1911 emphasizes the importance of freedom, even renaming chapter 9, where George meets Mr. Wilson in the tavern, from "In Which Property Gets into an Improper State of Mind" to "Ein Kapitel über Menschenrechte" (A chapter on human rights). Like other German editions, that one reduces the incidence of references to God and the Bible, and the importance of literacy is limited in the scene of Eva's death, to being able to keep in contact with family members.[21]

For those first exposed to Stowe's story through one of many stage adaptations—as well as for readers of the novel whose racial taxonomies may have been shaped by watching performances—the minstrelized grotesquerie of blackface could overwrite race as overdetermined racism. The visual, musical, and gestural vocabulary of blackface minstrelsy emanated from the United States, and during the decades preceding and following the publication of *Uncle Tom's Cabin*, it was a highly successful and pervasive American export, with American companies (and spin-offs) touring not only Britain and continental Europe but as far afield as South Africa, Australia, East Asia, and South America. It is impossible to count the variants: traveling companies' versions do not attribute authorship, and local versions are largely untraceable. What matters is the mutability of tropes amid legible conventions. By the later nineteenth century, minstrelsy was ubiquitous wherever there was popular music; after 1929, *The Jazz Singer*, featuring Al Jolson, took the minstrel aesthetic to an even wider public. Cinematic adaptations of *Uncle Tom's Cabin* perpetuated minstrel stereotypes through Topsy, even the otherwise sensitive interpretation in the 1914 American film with Sam Lucas (circulating in Latin America as *La cabaña del tío Tom*). As demonstrated by Catherine Cole,[22] the formalism of minstrelsy could be adopted elsewhere without its significations, yet the essays collected here renew the idea that in texts about subjugation, racialization, and self-determination, skin color (whether natural, artificial, or exaggerated) was a significant aspect of casting (unless, of course, it was ignored entirely, with the story transposed to a mono-ethnic context).

As world literature, *Uncle Tom's Cabin* epitomizes the complexity of in-

ternational exchange, patterns of critical paradigms, and other "transnational features of literary history" that go along with globalized circulation since the nineteenth century.[23] Yet the wide circulation of *Uncle Tom's Cabin* is illegible without understanding how, at particular landing points, it assumed singularities within what Kevin Riordan calls the "intricate mechanics of [...] circulation."[24] For Una Chaudhuri, the distinctions "between here and there" convey the felt experience of pathos.[25] For this reason, Senator Bird is an intriguing figure to trace in the transnational history of *Uncle Tom's Cabin*: in him, Stowe condenses the paradigmatic stages of persuasion experienced by converts to the abolitionist cause. Whether or not this is taken up can help reveal how Stowe's emplotments matter.

In chapter 9 of *Uncle Tom's Cabin*, John Bird (senator for Ohio) hospitably receives the ragged and half-frozen Eliza and Harry, who have just crossed an icy river to escape slave catchers. Hitherto, Senator Bird's idea of a fugitive was abstract, merely advertisements in newspapers, but in the presence of a distressed mother and child—especially ones just reequipped in the clothes of his wife and deceased son—his heart is awakened (94). Bird's servants warm Eliza and Henry, then Bird conveys them seven miles along a muddy road in the dead of night, into the safe hands of John Van Trompe. Bird begins the chapter as a politician and husband, is altered by contact with vulnerable runaways, abets Eliza and Harry's delivery to their first stop on the Underground Railroad, and is not mentioned again in the novel. It is clear, however, that readers are to envision that he will return to Washington as an abolitionist. In all three French stage adaptations, Bird's adherence to the law of property creates an acute dilemma. In the Dumanoir and Dennery adaptation, Bird (renamed Kentucki) even authored the Fugitive Slave Act, prior to his encounter with Eliza (renamed Elisa). Instead of being a contented man with a doting wife, he lusts after Elisa, and the possibility of a sexual liaison hangs over the play. To save the life of Henry (renamed Henri) and Elisa's honor, Kentucki challenges her master (renamed Harris) to a duel. At the crucial moment, Elisa's husband steps in and fights the duel, and Bird closes the play by explaining that he shall amend his law. On a metalevel, Kentucki is allegorical for the United States, a less evolved version of France (which abolished slavery in 1848).

As Gay Gibson Cima reveals, the paradigmatic stages of conversion to abolitionism were recognizable by the 1830s: they involved imagining the pains of separation from family and home, the violence inflicted on slaves and the terrors of auction, slaves' unceasing toil while exposed to the ele-

ments, then the ultimate challenge to faith when slaves found themselves homeless and friendless. This pattern repeats across abolitionist fiction as well as slave narratives and is a mainstay in Stowe's story. For evangelicals, the kinesthetic effects of empathy awoke powerful conviction.[26] For nineteenth-century readers and theatergoers in general, there was a growing ability to feel the horrors of slavery not only psychically but also through physical manifestations of empathy.[27]

The abolitionist strategies of persuasion were integral to eighteenth- and nineteenth-century sentimental discourse. In addition to U.S. abolitionism, many other nineteenth-century liberal projects, including the abolition of serfdom in Russia in 1861 and the nationalist movements against the Ottoman Empire and the Austrian Empire, articulated their objectives in sentimental terms. Sentimental rhetoric—as developed in both sentimental novels and theatrical melodramas—served those projects so well because it addressed the post-Enlightenment conflict between the individual's freedom to act in his or her best private interest and the equal right to freedom of his or her fellow citizens. In sentimental novels, the resolution of this conflict favors the public good: sacrificing one's private interest for the good of one's family, community, nation, and humanity defines sentimental virtue.[28] *Uncle Tom's Cabin* contains numerous examples of such virtue: to protect his fellow slaves from being sold, Tom refuses to run away to Canada; he declines to inflict violence on Legree's other slaves; and George Shelby, moved by Tom's self-sacrifice, frees his own slaves. In these cases, individuals act against their private interests and in favor of the others' good. This qualifies their sentimental conflicts as tragic. By contrast, Eliza's escape with Harry is detrimental to Haley's economic interest and is an example of a melodramatic sentimental conflict whereby the individual acting in his own private interest (Haley) is classified as a villain, while his opponent who acts to protect the public good (in this case Eliza, protecting Harry's opportunity to grow up under his mother's care and thus the sanctity of the Christian family) is classified as a hero.[29] Mid-nineteenth-century emancipation projects drew specifically on melodramatic sentimentality, framing their struggles as conflicts between the public good, which entailed the freedom of an oppressed group, and the private interest of the unjust oppressor.[30]

Uncle Tom's Cabin also bears strong affinity to the realist novel of social awareness forged by Honoré de Balzac; given national expression by Jane Austen, Thomas Mann, and Maxim Gorky; and broadened to seemingly comprehensive social scrutiny by Charles Dickens. Stowe makes a typical

realist claim to truth by basing her narrative in testimonies, eyewitness accounts, journalism, and her own firsthand observations of slavery.[31] Like realist novels, *Uncle Tom's Cabin* is exceptionally rich in details of setting and characterization. Moreover, in his discussion with Miss Ophelia about the moral justification (or lack thereof) of slavery, St. Clare evokes the major philosophical difference between sentimentality and realism. In contrast to the sentimental conflict of opposing ideals, realist conflict is triggered by an elemental struggle for power, even though realist antagonists may try to disguise their true motivation as virtue. Augustine St. Clare calls for realism when he rhetorically asks,

> This cursed business [i.e., slavery] accursed of God and man, what is it? Strip it of all its ornament, run it down to the root and nucleus of the whole, and what is it? Why, because my brother Quashy is ignorant and weak, and I am intelligent and strong,—because I know how, and *can* do it,—therefore I may steal all he has, keep it, and give him only such and so much as suits my fancy. Whatever is too hard, too dirty, too disagreeable, for me, I may set Quashy to doing. (230)

Further in the discussion, St. Clare even declares virtue, which the sentimental Miss Ophelia considers absolute, to be merely the effect of historical circumstance and biological predisposition.

> What poor, mean trash this whole business of human virtue is! A mere matter, for the most part, of latitude and longitude, and geographical position, acting with natural temperament. The greater part is nothing but an accident! Your father . . . settles in Vermont, in a town where all are, in fact, free and equal . . . and in due time joins an Abolition society. . . . The fact is, though he has . . . embraced a democratic theory, he is to the heart an aristocrat, as much as my father, who ruled over five or six hundred slaves. (234–35)

But despite these strong gestures toward realism, the novel is sentimentally resolved. In Tom's sublime death, in George Shelby's act of freeing his slaves, and in George Harris's decision to go build a Christian nation in Liberia, sentimental virtue reigns supreme.

In addition to providing emancipation movements with an efficacious representation of the conflict between slavery and freedom as one that

strikes at the very basis of Christian civilization, sentimentality also provided anti-slavery readers and spectators with an image after which they could model themselves as a transnational public. According to Margaret Cohen, sentimental novels construct communities of "sympathy" (the eighteenth- and nineteenth-century term for what we now call "empathy") by trying to position their readers as spectators of spectacular scenes of suffering. These scenes, Cohen writes, demonstrate how much "sentimental communities owe . . . to notions of theatrical spectatorship."[32] One such scene is Eva's death. As she struggles to breathe, everyone present—Augustine St. Clare (her father), Tom, Miss Ophelia, a doctor, and eventually the entire household, including St. Clare's slaves—become a community of spectators whose differences of race and rank dissolve in their shared sympathy for Eva.[33] Importantly, around the time we first learn that Eva is ill, she unsuccessfully pleads with her mother, Marie, to make the slaves literate so they may read the scriptures and write letters to family members from whom they are separated. Eva's wish to teach the slaves to read, so that they may be true Christians, comes up again as she takes leave from them shortly before she dies.[34] Thus, the slaves and white people attending her death are united not just as Christians witnessing the passing of another Christian but also as (potential) readers. In other words, the scene suggests the possibility that literate white and black people can belong to the same community of sentimental readers (and writers), which, in the understanding of the time, was equivalent to a community of liberal subjects.

GLOBAL MARKETS, TRANSNATIONAL HISTORIES

Cohen and Dever propose that English and French sentimental literature was addressed, from its very emergence, to a transnational English and French readership, enabled by an established market for literary and other cultural commodities between the two countries.[35] By the mid-nineteenth century, the sentimental novel and its readers had spread across Europe and the Americas, and so had melodrama and its spectators.[36] These readers and spectators, who also included abolitionist activists and sympathizers, enabled the fast global spread of *Uncle Tom's Cabin*. The exact number of the novel's translations across the globe is unknown. On its website, the Harriet Beecher Stowe Center claims that the novel has been translated into more than sixty languages across the Americas, Europe, and Asia.[37] In his monograph *Mightier than the Sword: Uncle Tom's Cabin and the Battle for*

America, David S. Reynolds claimed that the book had been translated into sixty-eight languages by 1995.[38] In its special collections, the Providence Public Library holds fifty-one foreign-language editions in twelve languages. These data are at best approximations: neither the Harriet Beecher Stowe Center nor Reynolds corroborates their own numbers, and the Providence Public Library's list incorrectly designates a Slovenian translation of 1853 as Bulgarian. Fixing a definitive number or sequence to translations is not viable, short of examining every edition in every library around the world. Nonetheless, as the present collection also demonstrates, Stowe's novel is, beyond doubt, a global phenomenon. Our focus on international, transcultural, and transnational aspects of the translation and adaptation history of *Uncle Tom's Cabin* emphasizes distribution and, in some cases, influence, though influence implies an Americanocentric bias. More specifically, this collection's essays trace temporal, ethnic, linguistic, and political patterns that reveal cross-cultural dynamics and also cultures of difference faithful to the hybridity, creolization, and interculturalism characteristic of cultures effected by globalization.[39]

In his insightful discussion of the intellectual genealogy of transnationalism in literary and cultural studies, Donald E. Pease defines transnationalism as an interpretive framework that "embraces expert and subaltern knowledges"; accounts for the global political, cultural, and economic processes underlying such knowledges; and is particularly attentive to social formations in crisis and transition. In the course of such transition, social formations (e.g., nations) that have once been perceived as stable are "confront[ed] [. . .] with [their] own internal differences."[40] This transnational perspective is integral to Stowe's novel. As Augustine St. Clare compares Southern slave owners to English capitalists—and as the novel follows George Harris's family to Canada and then France (where George attends university) and finally charts their future in Liberia—U.S. readers are invited to confront, in a transnational context, the contradiction between their country's foundational ideology of liberal freedom and the fact of slavery (or, to use Pease's term, the major "internal difference" within the nineteenth-century U.S. national imaginary). As George imagines the future of Liberia as a modern Christian nation and as Topsy goes to an unspecified place in Africa as a missionary and teacher, the novel also indirectly poses the question of how the places where former slaves relocate become transformed both ideologically and materially, for, as Pease points out, "the transnational differs from the international in that it forecloses the

possibility that either nation in the transaction will remain self-enclosed and unitary."[41]

The first two essays in our collection engage with this question about the "destination points" for runaways and free blacks. In the opening essay, Tracy C. Davis compares the idealized image of Canada, as the Canaan that slaves hoped to reach, with the material realities of absorbing the fugitives in Canadian society. For Canadians, she argues, the success or failure of this absorption was an ongoing transnational issue, and the abolitionists working in Canada knew themselves to be networked across national and transcontinental borders. In the second essay, Marcy J. Dinius analyzes how the Liberian political elite used the novel to mediate the country's international image, and she compares the hopefulness of Stowe's recolonization vision, as expressed in George Harris's letter in chapter 43 of the novel, with the social realities of the segregated nineteenth-century Liberian society.

The opening essays by Davis and Dinius reflect the specific approach to reception that organizes this collection. Research in book history focuses on material production and circulation of printed texts; in this study, in contrast, we are interested primarily in the political effects that *Uncle Tom's Cabin* and works produced in its name have had across the globe—that is, in the story's performativity within and beyond print culture. The concept of reception with which we work exceeds the more widespread notion of reception as the local interpretations evidenced by the formal choices made by translators and adaptors and/or by critical discussions of those formal choices in specific periods and places. One way in which artworks (and cultural products more generally) mediate political and cultural changes is by envisioning utopias in which these changes have already occurred, such as the idealized slave-free Canada and independent black Liberia of Stowe's novel. Measuring the gap between such utopias and the actual social arrangements in the places sharing the utopias' names is integral to the reception history we present. This understanding of reception is also consistent with Venuti's notion of transnational readerships, created through translation, as communities that may be actual and yet, as many instances also show, aspirational.

The translation history that emerges through the remaining eleven essays in this collection further details the transnational political, economic, and cultural processes that helped make *Uncle Tom's Cabin* an enduring global success, even as its politics attracted new forms of critique in the United States.[42] Following its publications in the United States and Great

Britain, the novel became available in French, in multiple editions, by the end of 1852. By January 1853, when French dramatists created the first theatrical adaptations, Parisian theater audiences were well acquainted with the novel.[43] The almost immediate arrival of the novel in France was enabled by the established French-English readership, an example of transnationalism that preceded and accompanied the formation of the modern nation-state.[44] The first Spanish translation, made from English and published in Paris in 1852, is similarly a strong example of transnationalism. Its translator, the Cuban intellectual Andrés Avelino de Orihuela, whose liberal views had forced him into exile in Paris, described himself as cosmopolitan. As Kahlil Chaar-Pérez argues in his essay, Orihuela's translation was deeply informed by the political aspirations of the intellectual circles to which he belonged, including the independence of Cuba from Spain and its possible annexation to the United States.

From Paris, the early French and Spanish editions quickly reached other destinations. In 1853, two separate Romanian translations from French editions were published in the principalities of Moldavia and Wallachia, which were then under Ottoman control. This situation reflects the strong influence of French culture on nineteenth-century Romanian intellectuals, many of whom were educated in France. That same year, Orihuela's Spanish translation reached Spain, Colombia, and Argentina. Like the French and Spanish translations, the Dutch translations, the first of which were published in 1853, traveled across established routes of economic, political, and cultural influence, including colonial routes. In 1853, a Dutch translation was published serially in Surabaya in the Dutch Indies, and a book edition was advertised for sale in Batavia.

As translators approached *Uncle Tom's Cabin*, they were concerned less with truthfully conveying the novel's internal politics than with addressing political issues relevant to their own target readers. In this respect, we can implicitly connect translation history to international pathways of abolitionist discourse more broadly. For instance, according to Chaar-Pérez, Orihuela's translation imposes the ideals of secular republicanism and cosmopolitanism on the Christian morality and romantic racialism of Stowe's texts. Another popular Spanish translation of 1852, by Wenceslao Ayguals de Izco, was also framed within a liberal and anticlerical secular ideology. In fact, as Lisa Surwillo argues, Izco imprinted his standpoint so deeply on Stowe's novel that his translation became known as a progressive, rather than Christian, text. In places where *Uncle Tom's Cabin* first arrived in transla-

tion, a layering of ideologies occurred. Perhaps because French translations of the novel, informed by French racial sensibilities, first reached Moldavia and Wallachia, the novel could be used (as Ioana Szeman demonstrates) to mediate an emerging national imaginary in which the racially marked Roma could be imagined as integral to the new Romanian nation, rather than, as occurs in Stowe's original vision, as a nation's constitutive Other. Thus, the novel's circulation and uptake antedates, by more than a century and a half, what Seyla Benhabib calls the challenges of demanding recognition for "a dialogic and narrative model of identity constitution" across various forms of difference allied to claims for "the legitimacy of established constitutional democracies."[45]

Such layering was especially complex in stage, film, and television adaptations. In many places, especially where print literacy was not widespread, these adaptations were more influential than the novel in mediating local politics. The French theatrical adaptation by Phillipe Dumanoir and Adolphe Dennery, analyzed by Emily Sahakian, was translated and performed in Spain in 1864, reached Brazil in 1877, and toured around Brazil and Portugal after its opening in Rio de Janeiro in 1879. According to César Braga-Pinto, this adaptation, rather than earlier translations of the novel, established *Uncle Tom's Cabin* as an important story in the Brazilian conversation about racial and class inequalities. In analyzing how Stowe's story mediated conversations about race in Brazil, it is therefore important to account for the fact that (as Sahakian argues) Dennery and Dumanoir's adaptation significantly rewrote Stowe's source, replacing its inherently Christian position with a secular humanist one that imagined the enslaved under protection and guidance from the white paternalistic state.

For Diana Taylor, the possibility that French racial politics may have thus informed Brazilian conversations about race would be an example of how performance participates "in acts of transfer," "transmitting memories and social identity" among populations but also to others who examine the archived remnants of extinct practices.[46] It matters, for example, that three decades of exposure to American-style minstrelsy in London, where a dozen stage adaptations were licensed within months of the novel's appearance,[47] did not result in fidelity either to stage conventions of black dialect and behavior or to anything approximating accurate or plausible traits in any of the principals: "Uncle Tom, as well as Eva, spoke in most pronounced cockney accents"; evidently, "George Harris enjoyed an Oxford education"; and Topsy was "endowed [. . .] with all the astute villainies of the Artful

Dodger."[48] Such adaptation sounds absurd now, but the meaningful obser-
vation is not to inventory the infidelities to Stowe's text but, rather, to note
the matrix of associations made possible by invoking these facets of circulat-
ing repertoire where and when they constituted shared symbolic systems.[49]
Retaining the American setting of Uncle Tom's Cabin mattered wherever it
was read (or staged): to the French, it represented a lagging slavocracy; to
most Britons, a glaring fault line in republican democracy; for Germans,
schisms between those who generate wealth and those who accumulate it;
to the provincial audiences of Cadiz, Spain's own shameful involvement in
the slave trade; and to twentieth-century Soviets, capitalism's dystopia of
racial inequity. But there is also the potential for refraction by the recep-
tive culture: Uncle Tom and Eva may be separated not by race but by class
markers; George's ascendancy becomes teleological and even unnecessary
to depict, as an after-story to the main action; and Topsy poaches on estab-
lished veins of sympathy through tried-and-true tropes of antic entertain-
ment. Just as the adapter or translator supplies vernacular genres as well as
referents, the reader or viewer latches onto local meanings. Neither fidelity
to Stowe nor "accuracy" about America is a relevant yardstick in acts of
transfer. The concept of "reaccentuation" is closer to the mark.[50]

Throughout the twentieth century, Stowe's story retained its capacity to
mediate specific intersections of local and global social politics, even as the
geopolitical map of the world shifted as dynamically as it had in the previ-
ous century. Nineteenth-century liberals in various countries had used the
novel to argue against slavery, serfdom, and the oppression of coolies, and
throughout the twentieth century, the Soviets turned it into a staple propa-
ganda text in their critique of Western imperialism.[51] To do this, they had
to radically revise Stowe's Christian standpoint. Thus, Polish and Bulgarian
translations and stage adaptations strategically used or removed references
to Christianity from Stowe's source text. In Bulgarian Soviet-era transla-
tions, for instance, Senator Bird evokes Christianity to defend the Fugi-
tive Slave Law, while the abolitionist John Van Trompe, to whose house
Senator Bird eventually escorts Eliza and Harry, is an atheist and a vocal
critic of U.S. Christian ministers for their support of slavery (see Stefka Mi-
haylova's essay). Likewise, in the popular 1961 Polish theatrical production
of Uncle Tom's Cabin at the Rozmaitości Theater in Krakow, analyzed in
Katarzyna Jakubiak's essay, Eva's death did not provide a glimpse of heaven
but instead acquired a tone of despair and nihilism. As Jakubiak suggests,
however, this tone, incompatible with Christian faith, was not necessarily

taken up by all or most Polish spectators. Catholicism, which retained a strong influence on Soviet-era Polish culture despite official suppression of the faith, may have enabled modes of spectatorship resistant to the producers' political intentions.

By considering this possibility of resistant spectatorship, Jakubiak's analysis resonates with Mary Louise Pratt's idea of "contact zones" (in this case, between the Soviet imperium and Polish Catholicism) that are enabled by "the literate arts" of "transculturation, critique, collaboration, bilingualism, mediation, parody, denunciation, imaginary dialogue, [and] vernacular expression," supporting "absolute heterogeneity of meaning." Such zones can be an opportunity for resisting cultures as much as a peril for those wanting "a stable, centered sense of knowledge and reality."[52] In her analysis herein of the 2008 stage production of *Uncle Tom's Cabin* by the Bahman Cultural Arts Center in Tehran, Debra J. Rosenthal explores a similarly complex political dynamic, as she compares state-authorized approaches to Stowe's novel with director and playwright Behrooz Gharibpour's staging, which resists simplistic anti-American propaganda by bringing Stowe's novel into conversation with local folklore's representational traditions. This compelling conversation is consistent with the rich tradition of Islamic engagement with *Uncle Tom's Cabin* that Jeffrey Einboden explores in his essay. What may be read, on one level, as comparative history can be read, on another, as connected history.[53] These recirculating currents of reading are characteristic of how *Uncle Tom's Cabin* is mobilized as ideology, mutable to many circumstances.

AMERICA'S MOST MUTABLE BOOK

The variety of transformations that *Uncle Tom's Cabin* has endured since 1851 begs the question of why so many diverse readers and audiences considered it a useful tool with which to address their specific concerns about social injustice. The various translations and adaptations of Stowe's novel almost invariably create culturally specific and ideologically targeted notions of "America." In the novel's diverse contexts of reception, "America," no less than "Uncle Tom," becomes a complex transnational signifier for freedom, inequality, democracy, and capitalist oppression, among other things. As Heike Paul demonstrates, F. W. Hackländer's 1854 German novel *Europäisches Sklavenleben* (European slave life; translated into English as *Clara; or, Slave Life in Europe*, 1856) likens the sufferings of an impover-

ished translator of *Uncle Tom's Cabin* and his daughter, who dances in the local theater's corps de ballet, as enslavement on a par with that of American captives. Likewise, the anonymously published novel *Poor Paddy's Cabin; or, Slavery in Ireland* (1854) depicts the privations of the great potato famine as the backdrop for a single-minded critique of Catholicism's exploitation of the faithful. This is sentimentalism through and through, and upon emigration to America, the protagonist is given a copy of the Protestant Bible and *Uncle Tom's Cabin*. These novelists simply filled in details from their own cultures, freely imitating for sentimental effect. Though *Uncle Tom's Cabin* is as rich in specific detail as realist novels, the essays in this volume demonstrate that it has been consistently read in a sentimental fashion, a reading encouraged by the enduring political efficaciousness of sentimental rhetoric.

In the twentieth century, the ideological malleability of the novel was further encouraged by its new status as juvenile literature. As our authors show, translators in the nineteenth and early twentieth centuries did not feel bound to the English original as guarantee for the truthfulness and quality of their translations. This attitude was even more pronounced in editions for young readers. Although the first, abbreviated, Polish translation of *Uncle Tom's Cabin* was made from English in 1853 and a full translation was available in 1860, the first Polish translation for children, published in 1894, was made from a German edition for children. In Bulgaria, several partial or abbreviated translations for adults were made from English in the second half of the nineteenth century. Nonetheless, the first adaptation for children, published in 1911, drew on French, Swedish, and Russian editions for young readers. In these editions, the political and philosophical discussions of slavery that characters hold throughout the novel are abbreviated or entirely removed. In some places, such as communist Bulgaria, where the children's editions were the only available ones, the unfamiliarity of readers with Stowe's politics, as presented in these discussions, allowed for easy replacement. The same holds true for historical audiences in Southeast Asia or Brazil who did not have access to the printed books and learned the story through silent film or performance.

The extent to which translators and adaptors felt free to insert local points of view is evident by their neglect or refusal to convey the uncompromised Protestantism of *Uncle Tom's Cabin*. In Stowe's view, the values of Protestantism were inseparable from those of liberalism, and the moral axes of the story—Tom, Eliza, and Eva—evangelize variants of this perspective. It

is not incidental that the liberal community of sympathy at Eva's deathbed is also a Christian community, Eva and the slaves adhering to Methodism, her parents (or certainly her feckless mother) implied as Roman Catholics.[54] Christian allegiances mattered to readers: the *Natal Witness*, writing for British colonists in southeastern Africa, reported in 1859 that an edition of *Uncle Tom's Cabin* published in Rome made the brutal Legree "into a staunch Protestant" who "flogs Uncle Tom to death for holding the dogma of the Immaculate Conception." This adaptation served Roman Catholic preferences, but without any more mischief than the prominent Anglican scholar and hymnist J. M. Neale turning "John Bunyan into a teacher of high church doctrines."[55] More problematically for its transnational reception, the novel provides an entire Protestant repertoire: it includes hymns, details Quaker practices and politics, debates theological issues pertaining to slavery and liberal freedoms, teaches Christian self-sacrifice through example, and, in an early scene in the eponymous cabin, even gives a script for Protestant worship. This is why Jeffrey Einboden rightly refers to *Uncle Tom's Cabin* as a conversion text. Yet the radical substitution of other ideologies and religions—from communism to Islam to Buddhism—conveys the translators and adaptors' awareness of Christianity and sentimentality as tools of Western cultural assimilation. While the Western sentimental novel encouraged the transcendence of racial, class, and ethnic differences for the good of all humanity, it also attempted to impose Western moral and aesthetic standards among readers and spectators from non-Western communities. Essays in this collection examine the implications of adaptation and appropriation across religious divides, seeing *Uncle Tom's Cabin* as a vehemently Protestant text adapted for Catholic, Christian Orthodox, Islamic, and Buddhist assumptions.

Thailand, which was never colonized, represents a special case in the history of Southeast Asia yet has proven fully amenable (in the Western imaginary) to the imposition of *Uncle Tom's Cabin* as a universalized model for sentimentalized virtue. This is precisely the point of Rodgers and Hammerstein's *The King and I*. Interpolating a theatrical adaptation of *Uncle Tom's Cabin* into a royal entertainment enables the king's concubine Tuptim, who loves another man, to mobilize an argument for "consensual love in a conjugal family rather than the authoritarian rules of royal sexuality," which, as Lauren Berlant explains, sets the musical squarely within the American Cold War ideology of democratic individualism and self-determination, manifesting emancipation not just in the choice of a love object but, sec-

ondarily, as physical freedom.[56] The episode does not occur in the autobiography of Anna Leonowens or its novelization by Margaret Landon;[57] thus, its inclusion in the 1951 musical verifies Uncle Tom's Cabin "as a master sign or supertext, whose reiteration in the twentieth century magnetizes an array of distinct and often conflicting desires about the execution of cultural difference in the global postslavery era," harnessed to progressive tendencies of a revolutionary impulse in American history.[58] The matrix of difference across races is highlighted through contrasted aesthetics; the commensurability of humanity is cemented by sentimentality. Nevertheless, Leonowens admired Stowe's work and likely read Uncle Tom's Cabin when it was serialized in the Singapore Straits Times (1852–53). Leonowens claimed that Lady Son Klin (Chao Chom Manda Sonklin), who liberated her 132 slaves in a reenactment of the Emancipation Proclamation, recognized that her teachings were simply in the tradition of the Buddha's doctrine.[59]

For readers and viewers across the world, the major point of entry into the novel has been their concern over slavery and other forms of social oppression. In an 1856 letter from Florence Nightingale to Stowe, we find an example of how Uncle Tom's Cabin mobilized this familiarity to muster empathy across identity positions. Nightingale told Stowe how she had observed British soldiers reading Uncle Tom's Cabin while convalescing at the Eastern Front of the Crimean War.

> The interest in that book raised many a sufferer who, while he had not a grumble to bestow upon his own misfortunes, had many a thought of sorrow and just indignation for those which you brought before him. It is from the knowledge of such evils so brought home to so many honest hearts that they feel as well as know them, that we confidently look to their removal in God's good time.[60]

These soldiers fought another slave state, Russia, to limit its incursions on a waning empire (the Ottomans) that, in turn, countenanced and practiced slavery throughout its terrain. (Russia officially abolished serfdom in 1861, freeing twenty-two million people, or 35 percent of Tsar Alexander II's subjects, nineteen million more slaves than were freed in the United States.[61] In the 1860s, Egypt alone received twenty-five thousand slaves per year, a fivefold increase from the previous decade. The Ottoman Empire's slave trade peaked in the last third of the nineteenth century.[62]) The British army, implausibly joined with both French and Turkish allies against the Russians,

fought an ill-equipped blunder-filled debacle of the war. Reading *Uncle Tom's Cabin*, the soldiers could be imaginatively transported out of the Caucasus, the alignment of their mighty empires, and the direct and immediate observation of mortality, to think across geographies and national interests, in order to achieve an act of transfer with Stowe's characters. Had they thought too carefully of both their allies and foes, the history of the Crimean War might be told very differently than it is. Likewise, in the Soviet Bloc and post-revolutionary Iran, interpretations of the novel have latched onto the possibility of revolution (spoken by St. Clare) rather than Stowe's alignment with gradualist emancipation politics. Substituting St. Clare's non-Christian teleology for Stowe's Protestant one explains the easy adaptability of the novel to secular and other non-Christian revolutionary agendas.

There are potentially many more circumstances in which *Uncle Tom's Cabin* might arise as an inspiration, comparative source, or countertext. Seymour Drescher's *Abolition: A History of Slavery and Antislavery* begins with British efforts to curtail the slave trade out of West Africa in the 1770s and concludes with a chapter detailing several twentieth-century "reversions" within Europe, most prominently the Soviet Gulag and Germany's racial slavery under the Nazis (including forced labor and impressment). Drescher also reminds readers of the systematic and prolonged sexual slavery of Korean, Taiwanese, Chinese, Filipina, Indonesian, and Malay women in the name of imperial Japan. Forced labor was imposed by Italian, Belgian, Portuguese, and French colonial regimes throughout Africa during wartime.[63] The Universal Declaration of Human Rights (1948) may have brought language to bear against the problem but has not terminated the practice, and trafficking of children, women, and laborers continues on a global scale. No ethnicity or faith is immune or wholly innocent in these violations.

The contributors to this volume undertook its work because of our belief in the value of telling established stories differently, from subaltern as well as dominant points of view, highlighting both local complexities and global trends. We find the existing scholarship about Stowe's novel to be rigorous and sophisticated yet saturated by U.S. and British concerns. The specifics of the emancipation and abolition causes (especially the foreshadowing of the U.S. Civil War of 1861–65) dominate mid-nineteenth-century readings. The association of minstrelsy and blackface performance as a representation of the book on stage interleaves with this tradition that, at least in the United States, was racist and hateful. The book's sentimentality

has led to its relegation since the Civil War to being a mainstay of juvenile literature; alternately, it is the end case that gave a name to the stigmatized "Tom" who kowtows to racist overlords rather than fighting a system that systematically instills segregation, disadvantage, and self-deprecation, either in the name of a reward hereafter or out of complicity with a racist and racialized system. These readings represent only a fraction of the book's rich reception history.

In telling some of this reception history as transnational rather than multicultural, we acknowledge not only the value of celebrating the enrichment that a cultural work receives when it lands in a community different from the original target audience but also the value of strategic impoverishment. Like other performance and film scholars who have adopted a transnational approach, we are particularly interested in how the politics of medium intersects with larger political and social concerns;[64] in fact, in telling the story of a single work across diverse media and geographies, we confirm their insight of how crucial the history of media is to geopolitical developments.

As Debra J. Rosenthal's essay on Gharibpour's theatrical adaptation shows, the story retains its power even when Tom's regrettable acquiescence and George Harris's emigration are replaced with a revolutionary teleology, spearheaded by Cassy, who waves a banner proclaiming "Freedom" (lettered in English for the Farsi-speaking audience) as the cotton fields symbolically burn all around her. In another recent mutation, Gerold Theobalt's *Onkel Toms Hütte Reloaded* (touring Germany in 2015–16), Stowe's story is enacted by four youths detained in a rehabilitation facility on the South Side of Chicago. They find parallels between their struggles and the fictional George, Cassy, Chloe, and Emmeline, and the play ends with the manumitted slaves opting to stay on the plantation as waged workers, to the refrains of hymns and pop music.[65] This repurposing of the name and many motifs of *Uncle Tom's Cabin* as an upbeat lesson for disadvantaged inner-city youths is a fantasia of European optimism. Within the United States, few would stomach such pairings in this day and age; however, Uncle Tom is very much on the minds of Germans, whether or not they are constrained by political correctness. During the American presidential election campaign of 2008, the popular left-wing Berlin daily *Die Tageszeitung* (The daily newspaper) featured the banner "Onkel Baracks Hütte" beneath a photograph of the White House (3 June 2008), evidently likening candidate Barack Obama's aspirations to America's other most famous trans-

national black figure. The journal's deputy editor in chief, Rainer Metzger, defensively remarked that this "cheeky" cover would be read ironically, as all Germans associate *Uncle Tom's Cabin* with issues of racism. Yonis Ayeh (speaking for the Initiative of Black People in Germany) was incensed, and Kristin Moriah calls out Metzger's "feigned innocence" of the collateral meanings arising from the image. She argues that "the novel has been as important for Germans defining America and its social problems as it has been for the formation of German cultural identity," beginning with the craze over *Sklavengeschichten* (slave stories) in the mid-nineteenth century and still evident in the community built in Zehlendorf in the 1920s and now a suburb of Berlin (as Heike Paul relates). In Zehlendorf, a popular restaurant called Onkel Tom's Hütte gave rise to a public housing site of the same name. An homage to solidarity across class, racial, and national lines during the Weimar Republic, it remains a conundrum for today's visitors who are unable to read the layers of textual history and social practice— and their ideologies—either through the peaked vernacular architecture of what were originally workers' cottages and apartments or in the name of the U-Bahn stop that services the community.[66]

The Zehlendorf Onkel Tom complex—like so many other examples of the transnational palimpsest of *Uncle Tom's Cabin*—evinces what Pheng Cheah terms a "cosmopolitan optic," which enhances a sense of shared participation in humanity within the dynamic process of local self-definition and global flows.[67] Even so, as another scholar of transnational literature, Shu-Mei Shih, explains, "We live in an interconnected world defined by power relations." World literature and its material expressions must be understood within these relations. Societies sharing the same source, such as *Uncle Tom's Cabin*, connect themselves horizontally in a literary arc by intertwining symbols and ideas from the borrowed source and their own culture, connecting not only issues but temporalities.[68] These essays testify to this process.

Notes

1. *National Era* (Washington, DC), June 1851–April 1852; Harriet Beecher Stowe, *Uncle Tom's Cabin* (Boston: Jewett, Proctor, and Worthington, 1852).

2. Eric Sundquist, introduction to *New Essays on "Uncle Tom's Cabin"* (Cambridge: Cambridge University Press, 1986), 18.

3. [Gamaliel Bailey, ed.], *National Era* (Washington, DC), 15 April 1852, quoting the *Congregationalist and Christian Times.*

4. *Richmond Daily Dispatch*, 25 August 1852.

5. *Charleston Mercury*, 25 May 1852.

6. Henceforth, unless otherwise noted, all quotations from *Uncle Tom's Cabin* reference the Oxford World's Classics edition edited by Jean Fagan Yellin (Oxford: Oxford University Press, 1998).

7. *Boston Liberator*, 2 July 1852.

8. American and Foreign Anti-Slavery Society resolutions adopted on 11 May 1852, as published in the *National Era*, 13 May 1852.

9. In *Raising Cain: Blackface Performance from Jim Crow to Hip Hop* (Cambridge, MA: Harvard University Press, 1998), W. T. Lhamon notes that disputes over Stowe's racism originated during the novel's serial publication. He argues, "Although clarifying these positions has its importance, it is also diversionary. It distracts from the impassioned way Stowe's writing, as part of blackface performance, executed the cultural work of seeming to change a thing into a man, and back again, in tidal circulation. . . . Is Stowe racist? Doubtless. . . . to see that Stowe's images of blacks are sentimentally racialist is true but not whole. The racialist parts elicit counterparts that ghost around them, cohere with them, and have continued to dawn, and set, as they travel through time together" (141).

10. Harriet Beecher Stowe, *A Key to "Uncle Tom's Cabin": Presenting the Original Facts and Documents upon which the Story is Founded, together with Corroborative Statements Verifying the Truth of the Work* (Boston: J. P. Jewett, 1853).

11. Hans-Georg Gadamer, *Literature and Philosophy in Dialogue: Essays in German Literary Theory* (Albany: State University of New York Press, 1994), 112.

12. Translation theorist Lawrence Venuti defines a text that is rendered in a language different from the original as a translation if it "maintain[s] unchanged the basic elements of narrative form. The plot isn't rewritten to alter events or their sequence. And none of the characters' actions is deleted or revised. Dates, historical or geographical markers, the characters' names . . . are generally not altered." When any of these elements is changed, the resulting text is an adaptation rather than a translation. See Lawrence Venuti, "Translation, Community, Utopia," in *The Translation Studies Reader*, ed. Lawrence Venuti (London: Routledge, 2000), 470.

13. Ibid., 471. See also Lawrence Venuti, *The Scandals of Translation: Towards an Ethics of Difference* (London: Routledge, 1998), 4.

14. Venuti, "Translation, Community, Utopia," 486.

15. Sarah Meer, *Uncle Tom Mania: Slavery, Minstrelsy, and Transatlantic Culture in the 1850s* (Athens: University of Georgia Press, 2009), 9; Jennifer Griffiths, *Traumatic Possessions: The Body and Memory in African American Women's Writing* (Charlottesville: University of Virginia Press, 2009), passim; Lauren Berlant, "Poor Eliza," *American Literature* 70.3 (1998): 646.

16. David C. Wall, "Meddling with the Subject: The Imperial Dialogics of Language, Race, and Whiteness in *Uncle Tom's Cabin*," *Nineteenth Century Studies* 25 (2011): 72.

17. Carroll Smith-Rosenberg, "Dis-Covering the Subject of the 'Great Constitutional Discussion,' 1786–1789," *Journal of American History* 79.3 (1992): 849.

18. Harriet Beecher Stowe, *Coliba lui moşu Toma sau Viaţa negrilor din sudul Statelor Unite* [Uncle Tom's cabin; or, The life of Negroes in the south of the United States], traducere de pe a lui Leon Pilatte de Theodor Codresco, cu "O ochire asupra sclaviei" de M. Kogălniceanu [translation of Leon Pilatte['s version] by Theodor Codresco, with "A Brief

Overview on Slavery" by M. Kogălniceanu] (Iași: Tipografia Buciumul Roman, 1853), 4.

19. Harriet Beecher Stowe, *Bordeiul unchiului Tom sau Viaţa negrilor in America* [Uncle Tom's cabin; or, The life of Negroes in America], tradusa din frantuzeste de Dimitrie Pop professor [trans. from French by Dimitrie Pop] (Iasi: Tipografia Institutului Albinei, 1853), 4.

20. In eighteenth-century Britain, for instance, many feared that novels had the power to corrupt, by giving readers, especially young women, a taste for "adventure and intrigue," a false sense that their wisdom surpasses that of their guardians, and, eventually, false expectations for their lives. See William B. Warner, *Licensing Entertainment: The Elevation of Novel Reading in Britain, 1684–1750* (Berkeley: University of California Press, 1998), 5.

21. Bettina Hofmann, *"Uncle Tom's Cabin* in Germany: A Children's Classic," *Zeitschrift fur Anglistik und Amerikanistik* 53.4 (2005): 263–64. She refers to Robert Münchgesang's translation, *Onkel Toms Hütte, für die Jugend und das Volkherausgegeben* [Uncle Tom's hut, for the youth and the people] (Reutlingen: Enßlin und Laiblins Verlagsbuchhandlung, 1911).

22. Catherine M. Cole, "Reading Blackface in West Africa: Wonders Taken for Signs," *Critical Inquiry* 23.1 (1996): 183–215.

23. Eric Hayot, "World Literature and Globalization," in *The Routledge Companion to World Literature*, ed. Theo D'haen, David Damrosch, and Djelal Kadir (London: Routledge, 2012), 224.

24. Kevin Riordan, *"Salesman* in Abu Dhabi: The Geopathology of Objects," *Modern Drama* 57.3 (2014): 409–10.

25. Una Chaudhuri, *Staging Place: The Geography of Modern Drama* (Ann Arbor: University of Michigan Press, 1995): 15.

26. Elizabeth Margaret Chandler, writing for the *Ladies Repository*, cited in Gay Gibson Cima, *Performing Anti-Slavery: Activist Women on Antebellum Stages* (Cambridge: Cambridge University Press, 2014), 70–71.

27. Susan Leigh Foster, *Choreographing Empathy: Kinesthesia in Performance* (London: Routledge, 2011) 177.

28. Margaret Cohen, "Sentimental Communities," in *The Literary Channel: The International Invention of the Novel*, ed. Margaret Cohen and Carolyn Dever (Princeton: Princeton University Press, 2009), 106–9.

29. Ibid., 111.

30. See, for example, Saidiya Hartman, *Scenes of Subjection: Terror, Slavery, and Self-Making in Nineteenth-Century America* (New York: Oxford University Press, 1997); Kathryn Kish Sklar and James Brewer Stewart, eds., *Women's Rights and Transatlantic Antislavery in the Era of Emancipation* (New Haven: Yale University Press, 2007); Clare Midgley, *Women against Slavery: The British Campaigns, 1780–1870* (London: Routledge, 1992); Jean Fagan Yellin, ed., *The Harriet Jacobs Family Papers* (Chapel Hill: University of North Carolina Press, 2008); Alan J. Rice and Martin Crawford, eds., *Liberating Sojourn: Frederick Douglass and Transatlantic Reform* (Athens: University of Georgia Press, 1999); Amanda Adams, *Performing Authorship in the Nineteenth-Century Transatlantic Lecture Tour* (Farnham: Ashgate, 2014); Teresa C. Zackodnik, *Press, Platform, Pulpit: Black Feminist Publics in the Era of Reform* (Knoxville: University of Tennessee Press, 2011). Other transnational currents are also evident: see, for example, Enrico Dal Lago, *William Lloyd Garrison and Giuseppe Mazzini:*

Abolition, Democracy, and Radical Reform (Baton Rouge: Louisiana State University Press 2013); Tom Chaffin, *Giant's Causeway: Frederick Douglass's Irish Odyssey and the Making of an American Visionary* (Charlottesville: University of Virginia Press, 2014).

31. Stowe, *Key*.

32. Cohen, "Sentimental Communities," 111–13.

33. The only person who is at odds with this assembly is Eva's mother, the proslavery Marie.

34. "'If you want to be Christian, Jesus will help you,'" Eva says on her deathbed. "'You must pray to him; you must read—' The Child checked herself, looked piteously at them, and said, sorrowfully, 'O, dear! You *can't* read, —poor souls!' and she hid her face in the pillow and sobbed" (296–97).

35. Margaret Cohen and Carolyn Dever, introduction to Cohen and Dever, *Literary Channel*, 2.

36. See, for instance, Rudolf Neuhäuser, *Towards the Romantic Age: Essays on Sentimental and Preromantic Literature in Russia* (The Hague: Martinus Nijhoff, 1974); Jonathan E. Zwicker, *Practices of the Sentimental Imagination: Melodrama, the Novel, and the Social Imaginary in Nineteenth-Century Japan* (Cambridge, MA: Harvard University Asia Center, 2006); Joaquín Álvarez Barrientos, *The Spanish Novel in the Eighteenth Century* (Oxford: Oxford University Press, 2015); Nikolaus Wegmann, *Diskurse der Empfindsamkeit: Zur Geschichte eines Gefühls in der Literatur des 18. Jahrhunderts* [Discourse of emotions: The history of affect in nineteenth-century literature] (Stuttgart: Metzler, 1988); Annemieke Meijer, *The Pure Language of the Heart: Sentimentalism in the Netherlands, 1775–1800* (Amsterdam: Rodopi, 1998). Melodrama originated in Paris at the end of the eighteenth century and, through the mechanism of what Elizabeth Maddock Dillon calls the "performative commons," became a globalized discursive site. Its formal characteristics as a genre and its performative conventions were replicated in theaters and opera houses in every European city—metropoles as well as backwaters—and their colonies' ports. See Elizabeth Maddock Dillon, *New World Drama: The Performative Commons in the Atlantic World, 1649–1849* (Durham: Duke University Press, 2014).

37. See *"Uncle Tom's Cabin,"* https://www.harrietbeecherstowecenter.org/utc/ (accessed 18 October 2015).

38. David S. Reynolds, *Mightier than the Sword: "Uncle Tom's Cabin" and the Battle for America* (New York: W. W. Norton, 2011), 272.

39. Günter H. Lenz, "Towards a Politics of American Transcultural Studies: Discourses of Diaspora and Cosmopolitanism," in *Re-Framing the Transnational Turn in American Studies*, ed. Winifried Fluck, Donald E. Pease, and John Carlos Rowe (Hanover: Dartmouth College Press, 2011), 394–96.

40. Donald E. Pease, "Introduction: Remapping the Transnational Turn," in Fluck, Pease, and Rowe, *Re-Framing the Transnational Turn*, 4–5.

41. Ibid., 5.

42. See, for example, James Baldwin, "Everybody's Protest Novel," *Partisan Review*, 16 June 1949, reprinted in James Baldwin, *Notes of a Native Son* (Boston: Beacon Press, 1955): 13–23.

43. See Emily Sahakian's essay in this volume.

44. Cohen and Dever, introduction, 11.

45. Seyla Benhabib, *The Claims of Culture: Equality and Diversity in the Global Era* (Princeton: Princeton University Press, 2002), 16.

46. Diana Taylor, *The Archive and the Repertoire: Performing Cultural Memory in the Americas* (Durham: Duke University Press, 2003), 2.

47. Harry Birdoff, *The World's Greatest Hit: "Uncle Tom's Cabin"* (New York: S. F. Vanni, 1948), 151.

48. Ibid., 152–53.

49. This point is powerfully made by Robin Bernstein in *Racial Innocence: Performing American Childhood from Slavery to Civil Rights* (New York: New York University Press, 2011), 13–16.

50. Caryl Emerson, "Bahktin and Intergeneric Shift: The Case of *Boris Godunov*," *Studies in Twentieth and Twenty-First Century Literature* 9.1 (1984): 145–67.

51. See John MacKay, *True Songs of Freedom: "Uncle Tom's Cabin" in Russian Culture and Society* (Madison: University of Wisconsin Press, 2013).

52. Mary Louise Pratt, "Arts of the Contact Zone," *Profession*, 1991, 37.

53. Sanjay Subrahmanyam, "Connected Histories: Notes towards a Reconfiguration of Early Modern Eurasia," *Modern Asian Studies* 31.3 (1997): 745.

54. Joseph Helminski, "Harriet Beecher Stowe's Marianettes: Reconstruction of Womanhood in *The Minister's Wooing* and *Agnes of Sorrento*," in *Beyond "Uncle Tom's Cabin": Essays on the Writing of Harriet Beecher Stowe*, ed. Sylvia Mayer and Monika Mueller (Madison, NJ: Fairleigh Dickinson University Press, 2011), 175.

55. *Natal Witness*, 8 April 1859, 4.

56. Berlant, "Poor Eliza," 637–38.

57. Anna Harriette Leonowens, *The English Governess at the Siamese Court, Being Recollections of Six Years in the Royal Palace at Bangkok* (Boston: Fields, Osgood, 1870); Margaret Landon, *Anna and the King of Siam* (New York: John Day, 1944).

58. Berlant, "Poor Eliza," 637–38.

59. Susan Morgan, *Bombay Anna: The Real Story and Remarkable Adventures of the "King and I" Governess* (Berkeley: University of California Press, 2008), 149–51.

60. Letter from Florence Nightingale to Harriet Beecher Stowe, 26 October 1856, quoted in *Connecticut at the World's Fair: Report of the Commissioners from Connecticut of the Columbian Exhibition of 1893 at Chicago* (Hartford: Case, Lockwood, and Brainard, 1898), 301.

61. John MacKay, "The First Years of *Uncle Tom's Cabin* in Russia," in *Transatlantic Stowe: Harriet Beecher Stowe and European Culture*, ed. Denise Kohn, Sarah Meer, and Emily B. Todd (Iowa City: University of Iowa Press, 2006), 77, 81.

62. Seymour Drescher, *Abolition: A History of Slavery and Antislavery* (Cambridge: Cambridge University Press, 2009), 373.

63. Ibid., 415–55.

64. The strong interest of performance and film scholars in transnationalism is evidenced by recent special issues on performance, film, and transnationalism in three major journals: *Theatre Research International* 39.3 (2014); *Theatre Survey* 55.3 (2014); *Nineteenth-Century Theatre and Film* 41.2 (2014).

65. For information on the Kempf Theater (Grünwald) production, see "*Onkel Toms Hütte*," http://www.kempf-theater.de/onkel-toms-huette/ (accessed 23 December 2016). The manuscript is handled by Ahn und Simrock Bühnen- und Musikverlag GmbH (Hamburg).

66. Kristin Moriah, "Other People's Cabins: German Inversions of Onkel Tom's Hütte," *Lateral: Journal of the Cultural Studies Association* 4 (n.d.), http://csalateral.org/wp/issue/4/other-peoples-cabins-german-inversions-of-onkel/ (accessed 31 December 2015).

67. Pheng Cheah, "What Is a World? On World Literature as World-Making Activity," *Daedalus* 137.3 (2008): 27.

68. Shu-Mei Shih, "World Studies and Relational Comparison," *PMLA* 130.2 (2015): 431.

Part I

Destination Points

Tracy C. Davis

Oh, Canaan!
Following the North Star to Canada

Oh! Canada, sweet land of rest—Oh! when shall I get there?
 —Henry Bibb[1]

When I can't talk sense, I talk metaphor.
 —John Philpot Curran[2]

As Katherine McKittrick shows, "black subjects challenge how we know and understand geography," and to seek out "alternative geographic options, and the coupling of geography with black matters, histories, knowledges, experiences, and resistances," produces space differently.[3] Providing a case in point are Canada's role in the transnational history of emancipation and the importance of Canada to the legibility of *Uncle Tom's Cabin*. Rarely a matter of sustained investigation in Stowe criticism, Canada is nevertheless synonymous with one end of the polarity of freedom and ultimate peril, with the Mississippi watershed at the austral extremity. Europe, especially Great Britain, may be where the moral compass of abolition oriented, yet Canada's status as a British province until 1867 meant that Britain lay not just across the Atlantic but also on the other side of the Great Lakes and the St. Lawrence watershed from the American republic. The proximal relation of Canada to the United States underscores more than a juridical difference in the master-slave relationship, the domination achieved through forced labor, or the tyranny of violence that maintained racialized power in the middle and Southern states (extending even to the North via the 1850 Fugitive Slave Act).[4] This border represents the thinnest of geographic dividers between arrogant power and utter subjection, meted-out by a system of rights based on law and custom, on one side, and universal human freedom in a landscape of pioneer settler colonists, on the other. Even so, as Heike Paul states, "Canada rarely figures as a concrete and fully developed place where abolitionist activism was launched and took root in the fight against slavery."[5] For Stowe, Canada represented hope at one end of a migratory

axis, with the Mississippi delta representing despair at the other end. Her characters oriented toward Canada, found freedom there, yet did not put down roots or become part of the continental abolitionist community. As such, *Uncle Tom's Cabin* reflected real fugitive slaves' northward orientation but did not contribute to a wider social imaginary proportionately recognizing Canada's role in transnational migration; instead, Stowe overwrote Canada with the scriptural significance of deliverance, making it a transit point to other transnational (and figural) destinations.

Not surprisingly, Canada figures in slave narratives, pro-emancipation verses, and abolitionist fiction. The following lines from an 1853 broadside are indicative:

> I heard that Queen Victoria said
> If we would all forsake
> Our native land of slavery,
> And come across the lake,
> That she was standing on the shore
> With arms extended wide,
> To give us all a peaceful home,
> Beyond the rolling tide.
> [.]
> I'm now embarked for yonder shore,
> Where man is man by law;
> The vessel soon shall bear me o'er
> To shake the Lion's paw.
> I'll no more dread the auctioneer,
> Nor fear the master's frowns,
> I'll no more tremble when I hear
> The baying of the hounds.[6]

Uncle Tom's Cabin helped to consolidate the political reality of freedom in Canada with runaways' navigation toward freedom. In the opening scene of Frederick Douglass's 1853 novella *The Heroic Slave*, for example, a white traveler in Virginia pauses to refresh his horse at the edge of a dark pine forest. Church bells are within hearing, but it is the overheard soliloquy of a black slave, Madison Washington, that catches the traveler's attention. Washington says to himself,

This living under the constant dread and apprehension of being sold and transferred, like a mere brute, is *too* much for me. I will stand it no longer. What others have done, I will do. These trusty legs, or these sinewy arms shall place me among the free. Tom escaped; so can I. The North Star will not be less kind to me than to him. I will follow it.[7]

There is no character named Tom in Douglass's novel: this single allusion is a telling intertextual elision on the part of the abolitionist author. Though this scene is set in 1835, Washington alludes to the title character in *Uncle Tom's Cabin*, published in full the year before Douglass's novel. In providing this intertext, Douglass ignores, mistakes, or rewrites crucial plot points from Stowe: unlike Washington, Stowe's title character neither attempts escape nor travels northward.[8] Douglass's hero, like Stowe's parallel plot of the Harrises, spatializes freedom within the continental land mass. What matters for Douglass's and Stowe's characters is not the threshold from bondage to everlasting life but the northern extremity of states that enforce bondage and the territory beyond that does not.

In *Uncle Tom's Cabin*, the flight to Canada is imbricated with figurative language drawn from the Bible. Indeed, as Uncle Tom explains, the deliverance he seeks is not a worldly place but Canaan's shore (the Levant), in the spiritual realm of the new Jerusalem (268). Uncle Tom leads his fellow slaves in weekly prayer meetings where they sing of Canaan's fields, Jordan, and the Promised Land as "expressions of a vivid and pictorial nature." He identifies with a people in exile who long to return to Canaan, not as the shamed and perpetually enslaved descendants of Ham, but as offspring of Abraham, the nation of Israel. Though he leads fellow celebrants in rejoicing "as if they had fairly gained the other side of the river" (34), he never looks to the North Star.

Stowe was sensitive to the contrast. Indeed, Douglass's association of the North Star with a terrestrial path to liberty resembles a biographical source for Uncle Tom. In the *Key to "Uncle Tom's Cabin,"* Stowe acknowledged that Methodist preacher Josiah Henson was an inspiration for Tom, making Henson Canada's most famous abolitionist.[9] In 1830, Henson escaped from a Kentucky slave master and navigated the Underground Railroad by starlight to a terminus in Niagara County (Canada West). He became an internationally renowned advocate for the Dawn Settlement's training institute and commercial sawmill, took products to London's Great Exhibition of

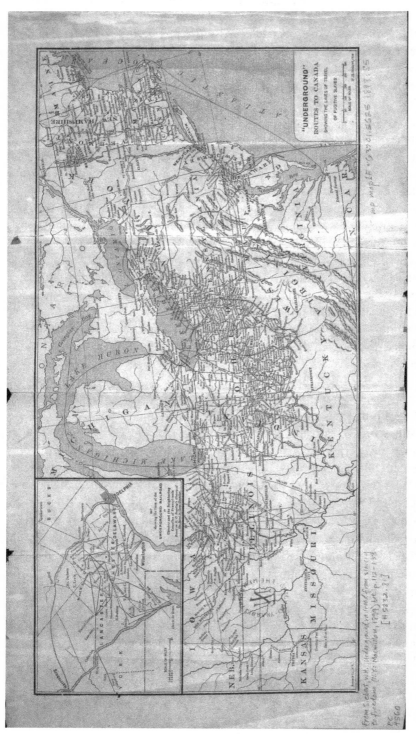

Fig. 1. "Underground routes to Canada showing the lines of travel of fugitive slaves." (From Wilbur H. Siebert, *The Underground Railroad from Slavery to Freedom* [New York: Macmillan, 1898]. Courtesy of the Newberry Library.)

Fig. 2. Map of Canada West by counties. (From *The Illustrated Atlas, and Modern History of the World Geographical, Political, Commercial & Statistical*, ed. R. Montgomery Martin [London: London Printing and Publishing, 1851]. Courtesy of Northwestern University Library.)

1851, and documented his life in an autobiography (1849, revised 1876 and 1879). Like Tom, Henson was a man of faith, but like Washington he was also a man who looked to the heavens for something more than spiritual guidance, writing, "I knew the North Star . . . Like the Star of Bethlehem, it announced where my salvation lay."[10] This orientation—if not the spiritual conviction—is what united all the fugitive, freed, self-emancipated, and free blacks who fled northward.

From the initial chapter of *Uncle Tom's Cabin*, Canada is a counterpoint to Tom's actions. His first master, Mr. Shelby, believes that fidelity to him—guided by a Christian conscience—keeps Tom in thrall to his bonds, an honest broker in his master's business affairs, and uninclined to "make tracks for Canada" when the opportunity arises (8). Readers discover Tom's

motivation to be different from Shelby's understanding: not honor or fidelity but faith in God's deliverance keeps Tom true to his human and spiritual bonds. Josiah Henson's autobiography describes how Henson's own temptation was overcome by grace. While being transported south, he resolved to kill and rob the men conveying him. At the very moment the ax was raised, as if he heard the voice of God whisper in his ear, Henson differentiated between a slave's self-defense and the act of murder he was about to commit: "I reflected that if my life were reduced to a brief term, I should have less to suffer; that it was better to die with a Christian's hope, and a quiet conscience, than to live with the incessant recollection of a crime that would destroy the value of life" and all other blessings.[11] Both Tom and Henson profess ardent Christianity, yet whereas Tom succumbs to Legree's fatal blows, Henson found a way out of bondage. He became not only a Moses, a prophet leading his fellow slaves out of Egypt, but also a Paul, an apostle who preaches the message to communities in Canada and beyond.[12]

Stowe aligns the biblical metaphors of Canaan, Jordan, and the Promised Land to ancient and steadfast faith. In Tom, this produces a tragic yet pious outcome. Whereas Canaan is a mythohistorical locus for the suffering faithful, the route to Canada is cosmically navigable for the Harris family, with the help of compassionate men and women. Failing that assistance, a fugitive could feel the side of trees where moss was longest and could orient by touch, even on a cloudy night.[13] By the time Stowe composed *Uncle Tom's Cabin* at midcentury, the desperate migration to Canada was substantiated by thousands of life stories that allied agency with faith and guts, actualized in transnational and cross-racial networks of charitable relief. As a counterpoint to Tom's faith—and fate, to die in Louisiana from his master's blows—refugees to Canada could survive because principled individuals defied what Henson calls "the land of the modern Pharaohs."[14] Like the historical holy land, Canada offered a set of specific geographic sites with legal, aspirational, and affective resonance. Among abolitionists, it was legibly aligned with debates about the attainability and configuration of life outside American bondage, especially after the enactment of the 1850 Fugitive Slave Act (also referred to by abolitionists as the "kidnapping law"), which abnegated runaways' safety in free states and imperiled even manumitted and freeborn blacks in the North.[15] The byways leading to Canadian communities that received the escapees are integral to the geopolitical history of slavery and to the politics of nations' self-definition.

In *Uncle Tom's Cabin*, the plot bifurcates when Shelby resolves to sell

George Harris's young son and Uncle Tom to cover debts; in both cases, nuclear families are to be torn asunder, the emotional tipping point for sentimental readers. George Harris rejects the nation of his birth, the nation that takes him from suitable work and, more important, empowers a slave master to make George cohabit with a woman who is not his wife. George resolves to run, proclaiming that if he cannot go peaceably, he will "fight for my liberty to the last breath" (118), get to Canada, and labor there to buy his family's freedom (24). Tom surrenders himself to go south on a riverboat, but George and his wife, Eliza, strike out separately toward Canada. Thus, Canada is woven through *Uncle Tom's Cabin* as a transhistorical and transnational referent—indeed, as liberty's earthly haven, a counterpart to heaven's divine redemption, and the thematic and directional counterpoint to bondage in the Southern plantations.

In *Uncle Tom's Cabin*, Canada carries conceptual resonances that, in turn, reflect political and juridical realities. The flight to Canada by the Harrises—modeled on a composite of women and Lewis Gerrard Clarke[16]—represents the paradigmatic stories of Canada-bound fugitives. For Eliza, the Ohio River offers the first glance of Jordan, "which lay [. . .] between her and the Canaan of liberty on the other side" (57). Having no idea how far off Canada may be, she is determined to follow the North Star and get there with her young son (91, 119).[17] In her dreams, liberty is "a beautiful country,—a land, it seemed to her, of rest,—green shores, pleasant islands, and beautifully glittering water," where her child could play happily and where her husband's loving protection could always be assured (145). George contrasts Canada with the United States juridically, concluding, "Where the laws will own me and protect me, *that* shall be my country, and its law I will obey" (118). As the little family sheltered during their last night in Ohio, "the morning star of liberty rose fair" before them (391). In their story, the word *liberty* is more than "a rhetorical flourish" of republican values (391): it is realized not through the revolting colonies' independence (as in the United States) but in the jurisprudence of the mother country (Great Britain); it is the greatest cause of nation builders, fulfilled not in the United States but in its neighboring land (Canada, not yet an independent nation), for—as is argued by St. Clare, Little Eva's poetic, tenderhearted father, who came from a family that originated in Canada—slavery's "palpable infringement of human rights" (237), like the exploitation of working people the world over, has "a *dies irae* coming on, sooner or later" (240). As the Harrises' boat completes its course across Lake Erie, turns north onto the Detroit River, and nears

Fig. 3. *Amherstburg Looking up the River*, by John Elliott Woolford (watercolor, 1821). The riverbank on the left, beyond the islands, is Michigan; the riverbank on the right is Amherstburg and the British garrison of Fort Malden. This is where the fictive Harris family took their first steps in freedom. (Reproduced with the permission of the National Gallery of Canada.)

Amherstburg (where the garrison of Fort Malden gave additional assurance to fugitives that the Queen's laws would be upheld in Canada West), "clear and full rose the blessed English shores; shores charmed by a mighty spell,—with one touch to dissolve every incantation of slavery, no matter in what language pronounced, or by what national power confirmed" (395).

As a result of *Somerset v. Stewart* (1772), British soil was synonymous with emancipation, insofar as the rights of seizure and removal by anyone claiming ownership of a human being were nullified within Britain. In the epigraph to chapter 37 (390), Stowe abbreviates John Philpot Curran's citation of the significance of the Somerset case. Curran's full passage restores the perspective of empire and the cause of worldwide abolition.

No matter in what language his doom may have been pronounced; no matter what complexion incompatible with freedom, an Indian or an African sun may have burnt upon him; no matter in what disastrous battle his liberty may have been cloven down; no matter with what solemnities he may have been devoted upon the altar of slavery; the moment he touches the sacred soil of Britain, the altar and the god sink together

in the dust; his soul walks abroad in her own majesty; his body swells beyond the measure of his chains, that burst from around him; and he stands redeemed, regenerated, and disenthralled, by the irresistible genius of UNIVERSAL EMANCIPATION.[18]

Being under British jurisdiction, Canada upheld the Somerset decision as English common law.[19] It was believed that slaves who reached Canada were protected by Lord Mansfield's decision as fully as if they crossed the Atlantic and disembarked at Liverpool. Henson describes his understanding of the principle thus: "Canada was often spoken of as the only sure refuge from pursuit, and that blessed land was now the desire of my longing heart."[20] The runaway slave Lewis Gerrard Clarke related, "When I stepped ashore here, I said, sure enough, I AM FREE."[21] Legally, Canada was a refuge, though not without a considerable taint of active prejudice.[22] Figuratively, it was the better place on earth, where liberty was assured, faith was restored to the downtrodden, families flourished in each other's loving company, and people owned themselves and the fruits of their labor. Fugitives knew to orient northward, but what were their Canadian destinations like in the period immediately preceding the publication of *Uncle Tom's Cabin*?

ÉMIGRÉS IN CANADA

In reaction to the tide of refugees fleeing the Fugitive Slave Act, abolitionists in Toronto convened the Anti-Slavery Society of Canada early in 1851.[23] In the society's first annual report, a quip that Canada "has been boastingly styled the 'Freest Country in the World!'"[24] is neither affirmed nor debunked. Rather, it stands as a challenge to better provide for the black migrants crossing international borders. By 1852, the estimated number of blacks in Canada West (bounded by the Ottawa River in the east and the Great Lakes in the south and west) was reported as thirty thousand (3 percent of the region's 952,000 people).[25] Actual numbers may have been considerably lower (the 1861 census identifies 17,053 blacks in the region), but at least half of these people were fugitive slaves, most often born in Virginia, Maryland, or Kentucky.[26] Like other émigrés to the region—especially during the Irish famine of the later 1840s—many came without property and were weakened by privation and the difficulties of their journey.[27] During October 1851, more than three hundred black families per day presented themselves along the American side of the Detroit River, "some of whom were the most distress-

ing objects of charity. [. . .] without food, money, or clothing, and [with] no prospect of shelter in a strange land."[28] The Ladies' Association of the Anti-Slavery Society of Canada directly supported one hundred families in 1852 and four to five hundred families in 1857.[29] Statistics are insufficiently reliable to ascertain how many people were unaided, though branch organizations at various border points managed local relief.

The receiving points for émigrés from west of the Adirondacks stretched from the Detroit River in the west, along Lake Erie to the south, to the Niagara River in the east.[30] For many of the estimated five to six thousand black runaways who arrived between passage of the 1850 Fugitive Slave Act and the end of the winter of 1852, the need for housing, clothes, and employment was exigent.[31] This necessitated unprecedented organization, for Canadian immigration was oriented to receive oceangoing European migrants docking much farther east, especially at Halifax and Montreal. Vigilance committees on both sides of Canada West's border aided refugees. The broadsheet *Voice of the Fugitive*, published at Sandwich and edited by Henry Bibb (a fugitive slave well known for his 1849 autobiography), helped spread the word about black settlers in Canada West, authenticate legitimate fundraising efforts, and unite the transnational abolitionist communities for two years, from January 1851 through December 1852.[32] The Refugees' Home Society, for example, sought accommodation and employment in agricultural, manufacturing, and commercial enterprises; advocated for education; and granted small loans to the Sandwich community.[33] Another publisher, Mary Ann Shadd, a freeborn black who was founder and editor of the *Provincial Freeman* in Windsor (later Chatham and Toronto) in 1854, advocated, in her pamphlet *A Plea for Emigration* (1852), that blacks who came to Canada West would find an unbiased land of opportunity.[34]

In mid-January 1851, A. L. Power crossed the river at Detroit with a cargo of donated pork, flour, cornmeal, and bedding to distribute to black refugees in need. He first stopped at the barracks near Windsor, where sixteen or eighteen families sheltered.

> Most of them were in want of food and clothing; some were sick, and others could not get employment. We rendered what assistance we could to those that appeared to be most in want, and then left these abused people with the blight of slavery still visible on their countenances, and proceeded on our way to Sandwich. There we found some families in the most deplorable state of destitution that I ever saw. Some of them

were sick, in miserable huts, without food, or clothes sufficient to cover their shivering limbs; one family of eight or nine children, some of whom were almost in a state of nudity, without a bed in the house, and the weather intensely cold. Here I thought I saw the withering blight of slavery in all its definity [sic]. [. . .] Some of them manifest a disposition to get along without help, there being one thing much more congenial to their natures than the climate, i.e. liberty.[35]

In comparison to Power's experience, Stowe's depiction of the Harris family, warmly equipped by Quaker women, involves not only considerable privilege but also security along their journey (199). Cross-dressed in disguises (young Harry as niece to Mrs. Smyth, Eliza as a prosperous white youth, and George as her valet), they drive to the wharf at Sandusky, Ohio, in a hired coach, load their baggage on a boat, and travel on in comfort.[36] The moment when they step ashore in Amherstburg is accompanied by the poetic lines

Mercy's hand turned the golden key,
And Mercy's voice hath said, *Rejoice, thy soul is free.* (395)

Mrs. Smyth guides them "to the hospitable abode of a good missionary, whom Christian charity has placed here as a shepherd to the out-cast and wandering, who are constantly finding an asylum on this shore" (396). In reality, the neediest fugitives sheltered in barns and warehouses rather than in homes and boardinghouses.

Winter arrivals were disadvantaged by the cold and the seasonal unemployment cycle. Shadd emphasizes the opportunities available to builders and other tradespeople, however, the most readily available employment was agrarian.[37] Settlers had been clearing Canada West's thickly forested old-growth Carolinian hardwoods since 1749; one hundred years later, there was still much unbroken land capable of cultivating fruit, vegetable, and grain crops. Tobacco could also be grown there[38] (the most southerly and warmest part of the province had a climate more like Baltimore or Philadelphia than Chicago, Cleveland, or Boston),[39] so farm laborers from Kentucky and the Mid-Atlantic states could readily join the agricultural labor force. This form of agrarian settler colonialism was officially encouraged for white as well as black immigrants. Hired hands strove to become tenant farmers, and tenants aspired to be freeholders.[40] Since the 1830s, vari-

Fig. 4. *Bush Farm near Chatham, ca. 1838* (watercolor). African American settlers in this region gleaned their first crops from old-growth forests like these, but the labor of clearing stumps was considerable. (Reproduced with the permission of the National Archives of Canada.)

ous schemes were tried to facilitate black settlements and to educate their young people for trades: Wilberforce, Brooklyn, Edwardsville, Oro, and New Philadelphia floundered by 1850, but other communities beckoned.[41]

By winter 1851, the town of Amherstburg had fifty-four resident black families (244 persons, including boarders), with property owned by thirteen families in the town and two in the country.[42] Towns had some capacity to absorb skilled tradesmen and female domestics, but prospects for self-improvement for multigenerational families of workers were more immediate in agriculture. Male unskilled laborers could also be employed in the railway construction that approached the western portion of this region in 1852.[43] Black settlements sometimes reunited former neighbors with shared folkways, compensated for scattered families and social ties that had been severed, and readily mounted resistance on the rare occasions when American slave catchers penetrated communities to claim runaways.[44] The Colored Industrial Society's settlement at Sandwich was

begun in 1845, when Rev. T. Willes collected donations to purchase two hundred acres of forested land. He sold ten-acre plots to black settlers and reserved land for a church and school. By 1851, several families were resident and working to clear the land. At Raleigh, Rev. William King (a Scots-Irishman who, through a Southern marriage, inherited slaves and brought them to freedom in Canada) sponsored the Elgin Settlement, also known as Buxton (1850–61), which offered homesteads for sale and consisted of ten thousand acres. The first settler there arrived at the end of 1849, the school opened in 1850, and much of the land was taken up by sixty families by the winter of 1851; in 1855, a brickyard and sawmill were established.[45] Colchester's settlement of fifteen hundred blacks dated back to the 1820s; at the New Canaan Settlement established nearby by Rev. E. Kirkland, there was a church and meetinghouse, and land was being cleared.[46] Josiah Henson resided at the Dawn Settlement, also known as Dresden (1841–52), where a vocational school opened in 1842, students farmed to support the venture, and timber was cut at the sawmill.[47] Most of these communities flourished until the American Civil War and Reconstruction drew many residents southward. The 1861 census, the first to record race, shows blacks most populous in Essex County (3,508, including sizable settlements in Amherstburg, Anderdon, Colchester, East Sandwich, and Windsor), Kent County (4,736, including populations at Camden, Gore, Chatham, Harwich, and Raleigh), and Lincoln County (911, the majority in St. Catharines). The City of Toronto had 987 black residents;[48] many were prosperous, owned their homes, and sent their children to separate or integrated schools; a few attended university, and the black community sustained several churches and a debating lyceum.[49]

In 1854–55, John Drew collected testaments from blacks living in fourteen communities between Toronto and the Detroit River. Ben Blackburn, whom Drew encountered in Windsor, had recently arrived with a gang of seventeen others following a 320-mile journey from Maysville, Kentucky. Robert Nelson, a slave from Boone County in Kentucky, came to Canada in 1845 despite fearful warnings about what he might encounter there. (Lewis Gerrard Clarke relayed hearing tales of Canadians' supposed abuses—that they "sometimes [. . .] skin the head" of fugitive slaves "and wear the wool on their coat collars" or "put them into lead-mines, with both eyes out" and that "the young slaves they eat." Clarke maintained, "However ridiculous to a well-informed person such stories may appear, they work powerfully upon the excited imagination of an ignorant slave."[50] William Johnson, who

hailed from Hopkins County in Virginia and "had been told that the De-
troit River was over three thousand miles wide," is recorded as saying, "We
knowed jess what dey tole us and no more.")[51] Nelson arrived without a
shilling, settled near Colchester, became a freehold farmer, and joined other
men of color in clearing two-thirds of the cultivated land in the township.
John Hunter received some education in Maryland and ran away when he
learned he was to be sold. He relayed that "a great many slaves know noth-
ing of Canada,—they don't know there is such a country," yet he found his
way to Toronto, over three hundred miles distant. Mrs. Isaac Riley and her
husband traveled about six hundred miles, from Perry County in Missouri
to Windsor; they settled first in a French-speaking district (possibly Te-
cumseh or LaSalle), then in St. Catharines, and finally in Buxton, where
their children attended school and studied Latin and Greek.[52]

Samuel Ringgold Ward, a fugitive slave and Congregational minister who
fled to Canada in 1851 after thwarting the capture of another slave in Syracuse,
New York, proclaimed the importance and desirability of sustaining relief as
well as abolition efforts in Canada, both for the sake of the immigrants and
to undermine the slave system itself: "If it [Canada] be not the great moral
lighthouse for the black people, free and enslaved, on this continent, I am
altogether mistaken. This seemed so to me, long before I came here; every
day confirms me in the opinion. Our enemies see it, know it, deplore it, hate
it." Recent research complicates views of the multiculturalism of this period
as well as the beacon of human rights implicated in Ward's claim,[53] however
such rhetoric was wielded in the early-1850s for a particular purpose. In the
same letter, Ward disparages the other alternative held out for black Ameri-
cans: emigration to Liberia.[54] The cause championed by the American Colo-
nization Society (1816–47), Liberian emigration was supported by Northern
states' governments and Southern individuals as a way to export the problem
of freemen abroad and bypass integration efforts at home.

For its advocates, Liberia held the promise of a black republic, a reverse
emigration project for the recolonization of Africa by black Americans. For
a man like Patrick Snead, who left Georgia in 1851 and lived in Toronto by
1855, learning about Liberia was eye-opening. Snead was an accomplished
cooper and plied this trade for a while in Savannah, where he was owned by
a free black man. He recalled,

> I went on in this way four years; then my colored employer was going to
> Liberia, with a ship load of emigrants—free people of color. He [b]ade

me goodby[e], and shook my hands; at this I felt an anxious wish to go
with him, and from that moment I felt what liberty was. I then told him,
that I hoped one day to be my own man, and if so, that I wished to go to
Liberia. He said, "I hope so, my son." He had baptized me, and was pastor
of the church to which I belonged.[55]

Despite such enthusiasm, many white and black abolitionists criticized Libe-
rian emigration for leaving the American system unreformed, especially for
failing to oppose the prejudice that counted all blacks inferior and reckoned
slaves the eternal property of masters.[56] In 1852, the *Globe*, a Toronto newspaper
published by abolitionist George Brown, reprinted a positive account of Liberia
by Captain Foote, reporting on the fertility of the tropical soil, the quality of reli-
gious services there, and on a mortality rate among its 150,000 citizens that was
3 percent lower than the rate in Baltimore, New York, and Philadelphia.[57] But
Voice of the Fugitive excoriated the Liberian plan as impractical ("What could
a poor man do in a forest with five acres of land, with a broken constitution,
among strangers where there is no employment to be had to support a fam-
ily?") and corrupt ("Commercial business is monopolized by three or four men,
with some of whom we are personally acquainted; they can and do sell at their
own prices").[58] *Voice of the Fugitive* editor Henry Bibb also reported on meet-
ings held at Chatham's African Methodist Episcopal and Presbyterian churches,
where the black population showed very little interest in African colonization,
relative to white abolitionists of the Northern states.[59]

Canadian abolitionists weighed Liberia among other emigration op-
tions—to the British West Indies, Haiti, Guatemala, Guiana, and New
Grenada—but Canada continued to "claim the first consideration."[60] As
Bibb said at an anti-colonization meeting in New York City in 1849,

There is a colony just across our northern boundary, a colony more con-
genial to our health and prosperity than Liberia. [...] But go to those
men who are so benevolent [...] and ask them to give a dollar to help
a poor fugitive slave who has escaped to go into Canada, where he may
enjoy the privileges of the gospel and have his liberty, and you will find
them clinching a sixpence till it would almost scream murder, before
they will help you. (Applause.)[61]

Though conceding that Liberian emigration should be recognized, the
black community's Committee on Emigration argued at a meeting in Am-

herstburg in 1853, "Yet we are constrained by a sense of duty to bear our testimony against the American Colonization Society, as being founded in the un-christian spirit of caste and enmity to our race, and unworthy of the support of any friend of humanity."[62] In Canada also, the committee said, there were opportunities to acquire land among a more diversified economy of smallholders and business people, with developing trade prospects; in Canada, the committee claimed, black farmers experienced no prejudice with regard to what they brought to market.[63] Granted, these are the views of blacks who had already chosen to settle in Canada—who not only were resolved to oppose the slave system in the United States but, through settlement, helped to counter a sense that without growth in Canada's population and assertion of sovereignty, annexation by the United States would be inevitable, with catastrophic consequences for human rights.[64]

TRANSNATIONAL ABOLITIONISM

At a series of fundraising lectures for the Anti-Slavery Society of Canada in April 1851, three international speakers took star turns. Samuel Joseph May, a Unitarian minister from Syracuse New York, who had renounced the colonization movement in the 1830s, offered encouragement for social uplift. George Thompson, seated member of the British Parliament and veteran speaker of abolitionist causes from the 1830s, on hiatus from a series of incendiary meetings in Massachusetts, enthralled an audience of twelve hundred, including a large proportion of Toronto's black population.[65] His address suggests why American audiences were finding him so abrasive: he condemned not just slavery but Americans' dearest tenets of nationhood, including an allusion to the offensiveness of the Liberian emigration.

> The *free people of color*, as they are called in mockery, are regarded as below contempt. Having no *marketable* value, they are nuisances, eyesores, and abominations—the very filth and offscouring of the body politic, to be got rid of as soon as means can be devised, to gather them up as the scum of humanity to be thrown off the surface of society.

Thus rejecting African colonization without needing to name it,[66] Thompson wound up his two-and-a-half-hour address by reminding his auditors in Toronto of their local and transnational responsibility.

You are dwellers on a continent with three millions of slaves. Their sighs come to you with every breeze from the South. Oh, haste to help them, that this glorious continent may be freed from its pollution and its curse. Give the fugitive your aid. You have thus far done nobly. Continue to receive kindly and to cherish hospitably, on these shores, the refugees from the house of American bondage. Give the abolitionists your sympathy. Let them hear, in tones louder than those of Niagara, your words of encouragement—your hearty God-speed. [. . .] The time shall come when, from sea to sea, and from the Arctic regions to Panama, this soil shall be sacred to freedom.[67]

By consistently wielding weapons of truth, reason, and religion, Thompson reassured listeners that they would prevail.

The third speaker was Frederick Douglass, who first allied with Thompson in 1846, as part of the Evangelical Alliance that objected to slaveholding by American Presbyterians.[68] When speaking in Toronto, Douglass did not disappoint expectations that he would denounce the Liberian colonization scheme. He condemned it "and the efforts of both states and statesmen to drive free coloured people from the whole union." In this, he was aligned with his hosts. Douglass was also expected to identify Canada as a haven for runaway slaves. At an address to the Anti-Slavery League in London in 1846, he said, "You cannot be free in the south, but there is an alternative. The British Lion prowls on three sides—there is Canada on the east; Canada on the north; and Canada on the west. Go there and be free; go to the British Lion, and be freed from the talons and the beak of the American Eagle!"[69] Yet in Toronto, "he did not even advise free coloured people to seek refuge in Canada,—believing that their present duty is to aid in resisting the operation of the fugitive law. On this point he spoke boldly."[70] Douglass's logic was syllogistic: if emigrating to Liberia extracted resistant and critical minds from the cause of undoing the Fugitive Slave Act and overthrowing slavery, an institution where resistance had the greatest impact, then emigrating to Canada would also be counterproductive, because it, too, would remove them from the sites where resistance was crucial.

Douglass called for his audience to emulate Madison Washington, hero of the Creole revolt. Douglass had yet to write The Heroic Slave, but the story was frequently on his mind. It is based on the 1841 case of a coastal trader transporting slaves from Virginia for sale in New Orleans. Washington led

eighteen other slaves to take control of the *Creole*, ordered the navigator to head for Liberia, but was persuaded instead to allow the ship to steer to the Bahamas (a British colony). Boarded at Nassau by black soldiers, the Bahamians proclaimed that the ship came under British law and that, by broad interpretation of the Somerset decision, every slave aboard was free. The nineteen insurrectionists were cleared by the courts four months later and also became freemen. Douglass allied Washington to other black liberators in his infamous 1849 speech "Slavery, the Slumbering Volcano,"[71] and a short piece he published in 1842 filled in part of the hero's backstory. According to Hiram Wilson (a Canadian ex-slave who, at the time, was involved with Josiah Henson in establishing the school at the Dawn Settlement), Washington had taken refuge with him in Canada around 1840 and resided "long enough to love and rejoice in British liberty." But as Douglass details in his novella, Washington loved his wife and returned to Virginia to try to free her.[72] He was then captured, chained and marched in a coffle, and included as part of a cargo of 135 slaves that embarked from Hampton Roads, Virginia, in the *Creole*, bound for auction in New Orleans. While in Canada, Washington was powerless to help his family or challenge the institution of slavery; back in the grip of the oppressor, he could lead himself and others to liberty in the port of Nassau, New Providence Island. Washington resurfaced repeatedly in Douglass's thoughts, including the night Douglass addressed the Anti-Slavery Society in Toronto.

This "historical analogue," as Ivy Wilson terms it,[73] shows Canada as part of the black diasporic landscape of the circum-Atlantic region, but Douglass's 1851 speech and 1853 novel differentiate between Washington's status in two British jurisdictions: as a freeman in Canada, he has run for his life; as a freeman in the Bahamas, he has demonstrated the difference between abolitionist rhetoric and emancipatory deeds. Fionnghuala Sweeney regards *The Heroic Slave* as instigating "a public dialogue around the right to resist," ultimately reinventing "black radicalism as a counter-discursive ploy to white abolitionist views of the slave as the victim of slavery rather than an agent of history."[74] Krista Walter argues that "Douglass set out to reclaim a genuine republican language and ideology for the purposes of abolition."[75] This resembles what Stowe's character George Harris seeks: after he has spent five years in Montreal and four at university in Paris and then returned to his native land (implicitly fleeing the tumult of 1848), his longing "for an African *nationality*" leads him to take his family to Liberia, where he hopes to represent them in a council of nations and to plead for the causes

that individuals have been unable to meet (440–41). In Canada, George es-
chews agrarian occupations and finds the necessary uplift to fulfill his natu-
ral capacity as a mechanic, yet this does not suffice. In Paris, he becomes a
scholar; in Liberia, he expects to become a leader. Thus, Canada is a staging
post for becoming free, and Liberia, the new republic recolonized by blacks,
is a platform for global advocacy. Without evident judgment, though at the
risk of alienating Garrisonians and other prominent abolitionist factions,
Stowe invites readers to imagine her characters in both locales.[76]

Within a year of the Toronto meetings, abolitionists would recast their
arguments, as well the rhetoric of slaves' life stories, with reference to *Uncle
Tom's Cabin*. As a committee of Amherstburg blacks stated in 1853,

> *Resolved*, That this convention in behalf of the American slaves, ten-
> der its thanks to Mrs. H.B. Stowe for her faithful exposure of American
> slavery through Uncle Tom's Cabin, together with her sympathy for the
> oppressed free colored people of the United States, and earnestly wish
> that she may lend us her aid for the general elevation of the Refugees in
> Canada.[77]

In linking characters to the life stories of fugitives, especially Canadian
residents, Stowe endorses the kinds of vernacular knowledge that guided
runaways to the northbound "railroad," yet she also implies that Canada
may not be their last or most appropriate stop. Family ties sustain the kinds
of daring return made by Jim for his mother in Ohio (119) and by Madi-
son Washington for his wife in Virginia.[78] For the Harrises, Canada is the
stopping point in the affectively laden geopolitics of slavery, resistance, and
abolition. There, they are reunited with Eliza's mother (Cassy) and George's
sister (Madame de Thoux), not in Canada West but much farther east, in
Montreal. As dependent as this reunion is on storytelling coincidence,[79] the
affective content ties together specific, meaningful locations: Canada West
as embarkation point; francophone Montreal as disembarkation point;
France (where George completed his education) and the West Indies (where
de Thoux married, was liberated, and inherited a fortune [434]) as pivots to
opportunity; and Liberia as the location where George imagines taking a
hitherto unknown form of political agency. In the *Liberator*, Robert Purvis
regards the ultimate Liberian ending as evidence that the author—like Miss
Ophelia and the American people at large—is permeated with "prejudice
and scorn" for black Americans. In response, Douglass notes, "We read that

chapter with feelings which we shall not attempt to describe. It seemed to us as if the author had spoiled her work and planted the stiletto of a murderous prejudice in the bosoms of those whom it had been her purpose to protect and befriend."[80] For most readers of Stowe's novel, Canada emerged as all the more desirable and politically appropriate destination. Certainly, many abolitionists on both sides of the border sought to make settlement there a pragmatic option as long as slavery persisted in the United States.

Recapitulation of the stories of runaways, captured slaves, and immigrants kept the need for Canadian activism alive for readers of newspapers, as suggested by the demise of *Voice of the Fugitive* at the end of 1852 and the commencement of the *Provincial Freeman* in March 1854. Though connections that oral histories and fictionalized accounts made between Canada and the northward journey in *Uncle Tom's Cabin* could be tangential or even erroneous, they always served to link affective elements. In February 1853, for example, Toronto's *Globe* captioned a story about Solomon Northup "Uncle Tom's Cabin."[81] Indeed, Uncle Tom was attributed with many cabins, most persistently Josiah Henson's in Dresden, Ontario.[82] As early as 1853, theatrical adaptations of *Uncle Tom's Cabin* that were performed in Toronto were skewed toward what Stephen Johnson calls the "'romantic' or 'sentimental' racism of Stowe's work," yet the courage of the runaways, piety of Tom, and compassionate acts of white abolitionists could not be gainsaid.[83] If anything, the spectrum of attitudes and assistance directed toward black immigrants within the communities of Canada West—black- and white-sponsored settler projects to promote landownership, education, and industry; underfunded segregated schools, integrated districts, and educational meccas for black and white children; institutionalized racism, everyday bigoted slights, and mass resistance to the extradition of runaways—complicates the story of the reception communities and the experience of black immigrants in the period preceding and coincident with Stowe's novel. Yet the performative interconnections of stage minstrelsy and Tom shows were at variance with the largely pro-abolitionist readings of the novel. Canadians read about the sensation that *Uncle Tom's Cabin* wrought in Europe, where "*Uncle Tom* shines in every *feuilleton*, rests on every center-table, and faces the foot-lights of every stage,"[84] though often in severely mutated form. On Canada's inland shores, meanwhile, both the incidents and arguments imbricated in *Uncle Tom's Cabin* and abolitionist organizing remained exigent challenges, a question less about the veracity of Stowe's claims than about responsibilities of conscience to near and distant

neighbors networked across local, regional, international, hemispheric, and intercontinental lines.

Notes

Special thanks go to Ivy Wilson for astute advice and to Elynne Whaley for research assistance.

1. Henry Bibb, *Narrative of the Life and Adventures of Henry Bibb, an American Slave*, with an introduction by Lucius C. Matlack (New York: Henry Bibb, 1849), 29.

2. John Philpot Curran, *Memoirs of the Life of the Right Honourable Richard Brinsley Sheridan*, ed. Thomas Moore (Paris: A. and W. Galignan, 1825), 1:521.

3. Katherine McKittrick, *Demonic Grounds: Black Women and the Cartographies of Struggle* (Minneapolis: University of Minnesota Press, 2006), 91.

4. Orlando Patterson, *Slavery and Social Death: A Comparative Study* (Cambridge, MA: Harvard University Press, 1982), 1–4.

5. Heike Paul, "Out of Chatham: Abolitionism on the Canadian Frontier," *Atlantic Studies* 8.2 (2011): 168.

6. "The Complaint of a Fugitive Slave, Who made his Escape from Tennessee to Canada" (Philadelphia, 1853), *American Broadsides and Ephemera*, ser. 1, no. 294.

7. Frederick Douglass, *The Heroic Slave* (1853), appendix 3 to *Uncle Tom's Cabin*, ed. Jean Fagan Yellin (Oxford: Oxford University Press, 1998), 484.

8. Stage adaptations are another matter. See "Anti-Slavery in the Theatre," *Voice of the Fugitive* (Sandwich, Canada West), 23 September 1852, 1 (reprinted from the *True Democrat*); John W. Frick, *"Uncle Tom's Cabin" on the American Stage and Screen* (Basingstoke: Palgrave, 2012).

9. Harriet Beecher Stowe, *A Key to "Uncle Tom's Cabin"* (Leipzig: Bernhard Tauchnitz, 1853), 67–72. Whatever the veracity of this attribution, it had considerable impact on Henson's reputation.

10. Josiah Henson, *Autobiography of Josiah Henson* (1879; reprint, Mineola, NY: Dover, 1969), 59.

11. Henson (1969), 54.

12. Olivette Otele, "Resisting Imperial Governance in Canada: From Trade and Religious Kinship to Black Narrative Pedagogy in Ontario," in *The Promised Land: History and Historiography of the Black Experience in Chatham-Kent's Settlements and Beyond*, ed. Boulou Ebanda De B'béri, Nina Reid Maroney, and Handel Kashope Wright (Toronto: University of Toronto Press, 2014), 146. Henson made many journeys back to the United States, to conduct business on behalf of the British American Institute and Dawn Mills sawmill and to participate in fundraising, especially in Boston. He also made three journeys to Britain, preaching in dozens of localities in England and Scotland. See Henson (1969), 164–83.

13. Benjamin Drew, *A North-Side View of Slavery: The Refugee; or, The Narratives of Fugitive Slaves in Canada Related by Themselves with an Account of the History and Condition of the Colored Population of Upper Canada* (1856; reprint, n.p.: Johnson Reprint Co., 1968), 283.

14. Henson (1969), 158.

15. Gerardo Del Guercio, *The Fugitive Slave Law in "The Life of Frederick Douglass, an American Slave" and Harriet Beecher Stowe's "Uncle Tom's Cabin": American Society Transforms Its Culture* (Lewiston: Edwin Mellen, 2013), 7.

16. Stowe, *Key*, 29, 55–59; see also Levi Coffin, *Reminiscences of Levi Coffin, the Reputed President of the Underground Railroad* (Cincinnati: Western Tract Society, 1876), 147–50. Martin Delany posits that the prototypes for the Harrises were Henry Bibb, editor of *Voice of the Fugitive*, and his first wife, Malinda ("Uncle Tom," *Frederick Douglass' Paper*, 29 April 1853).

17. Alexander M. Ross corroborated the likelihood that slaves from Virginia and the border slave states were unlikely to know that reaching Canada could be feasible. He toured the South under the pretext of collecting ornithological specimens and found ways to inform slaves about Canada. See Wilbur H. Siebert, *The Underground Railroad from Slavery to Freedom* (New York: Macmillan, 1898), 182.

18. *The Speeches of the Right Honorable John Philpot Curran*, ed. Thomas Davis (London: Henry G. Bohn, 1847), 182. This excerpt is adjusted to correctly reflect Curran's words and the entire sentence from which Stowe draws.

19. William R. Cotter, "The Somerset Case and the Abolition of Slavery in England," *History* 79.255 (February 1994): 31–56; T. Watson Smith, *The Slave in Canada* (Halifax: Nova Scotia Historical Society, 1899), 125.

20. Henson (1969), 59.

21. Lewis Gerrard Clarke and Milton Clarke, *Narratives of the Sufferings of Lewis and Milton Clarke, Sons of a Soldier of the Revolution, during a Captivity of more than Twenty Years among the Slaveholders of Kentucky, on the so-called Christian States of North America* (Boston: B. Marsh, 1846), 40.

22. Petition to the Legislative Assembly, 19 February 1849 [opposing the formation of the Buxton settlement] (Library and Archives Canada R4402-1-3-E); Josiah Henson, "Condition of the Blacks in Canada," *British Banner*, 25 August 1852; Samuel Gridley Howe, *The Refugees from Slavery in Canada West: Report to the Freedmen's Inquiry Commission* (Boston: Wright and Potter, 1864), 102; Peggy Bristow, "Whatever You Raise in the Ground You Can Sell It in Chatham": Black Women in Buxton and Chatham, 1850–65," in *"We're Rooted Here and They Can't Pull Us Up": Essays in African Canadian Women's History*, ed. Peggy Bristow (Toronto: University of Toronto Press, 1994), 71, 74; Otele, 135–36; Lloyd W. Brown, "Beneath the North Star: The Canadian Image in Black Literature," *Dalhousie Review* 50 (1970): 317–29; Jason H. Silverman, *Unwelcome Guests: Canada West's Response to American Fugitive Slaves, 1800–1865* (Millwood, NY: Associated Faculty Presses, 1985), 21–35, 62–70.

23. Fred Landon, "The Anti-Slavery Society of Canada," *Journal of Negro History* 4.1 (January 1919): 33–40. Later in 1851, the North American Convention on anti-slavery met in Toronto; see "North American Convention Proceedings," *Voice of the Fugitive*, 21 September 1851, 2.

24. Thomas Henning, *First Annual Report, Presented to the Anti-Slavery Society of Canada, by Its Executive Committee, March 24, 1852* (Toronto: Brown's, 1852), 9, Anti-Slavery Pamphlets Collection of the Boston Public Library, digitized in the *Black Abolitionist Papers*, http://bap.chadwyck.com

25. "The Anti-Slavery Society Anniversary," *North American* (Toronto), 26 March 1852, 3; 1851 Census, Library and Archives Canada, http://www.bac-lac.gc.ca/eng/census/1851/Pages/about-census.aspx (accessed 1 January 2017). Another report of 1851

states the board of the Baptist Missionary Convention of New York stipulated that there were eighty thousand blacks in Canada West ("Colored People in Canada," *Voice of the Fugitive*, 5 November 1851, 2).

26. Michael Wayne, "The Black Population of Canada West on the Eve of the American Civil War: A Reassessment Based on the Manuscript Census of 1861," *Social History* 28.56 (1995): 467, 473.

27. "Sickness among the Fugitives in Canada," *Voice of the Fugitive*, 29 January 1851, 2. Irish immigration swelled the numbers arriving in the Canadas from Great Britain and Ireland from 31,803 persons in 1845 to 109,680 in the peak year of 1847. See *Second Report of the Secretary of the Board of Registration and Statistics on the Census of the Canadas, for 1851–52* (Quebec: John Lovell, 1854), 7.

28. Henry Bibb, "Toronto Convention," *Voice of the Fugitive*, 8 October 1851.

29. Susan Marion Stanton, "Voice of the Fugitive: Henry Bibb and 'Racial Uplift' in Canada West, 1851–1852," master's thesis, University of Victoria, 2001, 49–54.

30. The most circuitous and least traveled routes on the Underground Railroad were via Lake Michigan and Lake Huron to Collingwood (on Georgian Bay) and Sarnia (at the southern extremity of Lake Huron). For slaves escaping through Kentucky, the Ohio River demarcated the state lines, with Indiana and Ohio to the north; tributaries led to Columbus and Oberlin. Lake Erie is part of a separate watershed. The complexity of these river systems accounts, in part, for why assistance was so crucial in this section of runaways' journey. See Siebert, 135–42, 148–49.

31. Fred Landon, "The Negro Migration to Canada after the Passing of the Fugitive Slave Act," *Journal of Negro History* 5.1 (January 1920): 22–36.

32. By 1852, *Voice of the Fugitive* had agents who helped to distribute the newspaper in Michigan, Illinois, Massachusetts, New Jersey, New York, New Hampshire, Ohio, Pennsylvania, Vermont, and London.

33. *Report of the Committee on Emigration of the Amherstburg Convention Presented at the First Baptist Church, Amherstburg, C.W. [Canada West] 17 June 1853* (Windsor: Bibb and Holly, 1853), 17; Stanton, 33; Silverman, 58–59.

34. Mary Ann Shadd, *A Plea for Emigration; or, Notes of Canada West* (Detroit: George W. Pattison, 1852; reprint, Peterborough: Broadview, 2016), 32.

35. A. L. Power, letter to the editor, *Voice of the Fugitive*, 12 February 1851, 1. Fundraising causes, like the Refugees' Home Society, which canvassed for alms in the United States, may have masqueraded as cunning land schemes of no benefit to blacks. Consequently, in October 1852, blacks in Windsor (led by Peter Payntz, Elisha Robinson, Mary Ann Shadd, and Thomas Jones) resolved "to put a stop to the begging system, so far as it will apply to them" ("No More Begging for Farms or Clothes for Fugitive in Canada," *Globe* (Toronto), 26 October 1852, 1, reprinted from the *True Democrat*). *Voice of the Fugitive* critiques this view, accusing others of objecting because the society only supports fugitives, not free blacks ("Anti-Slavery in the Theatre," 23 September 1852, 1).

36. Disguise was not unusual for escapees. See Siebert, 65.

37. Shadd, 32.

38. In Upper Canada, tobacco was first cultivated in 1819 by former slaves from Virginia and Kentucky (Silverman, 23).

39. "Fugitives in Canada," *Voice of the Fugitive*, 8 April 1852, 3; "The Price and Quality of Canada Lands," *Voice of the Fugitive*, 12 March 1851, 2.

40. "North American Convention Proceedings," *Voice of the Fugitive*, 24 September

1851, 2; Fred Landon, "Agriculture among the Negro Refugees in Upper Canada," *Journal of Negro History* 21.3 (July 1936): 304–12; Stanton, 50.

41. Sharon A. Roger Hepburn, *Crossing the Border: A Free Black Community in Canada* (Urbana: University of Illinois Press, 2007), 2.

42. D. Hotchkiss, letter to the editor, *Voice of the Fugitive*, 26 February 1851, 1.

43. *Voice of the Fugitive*, 8 April 1852, 2.

44. Introduction to *Black Abolitionist Papers*, ed. C. Peter Ripley (Chapel Hill: University of North Carolina Press, 1986), 28–29. Silverman (36–42) details the various extradition cases.

45. A. M. Harris, *A Sketch of the Buxton Mission and Elgin Settlement, Raleigh, Canada West* (Birmingham: J. S. Wilson, [1866]), 8; Hepburn, 116–20.

46. E.P.B., letter to the editor, "Colored Settlements," *Voice of the Fugitive*, 12 February 1851, 2.

47. Jacqueline Tobin and Hettie Jones, *From Midnight to Dawn: The Last Tracks of the Underground Railroad* (New York: Doubleday, 2007).

48. Wayne, 482–85.

49. Drew, 94–95.

50. Clarke and Clarke, 40–41.

51. Siebert, 197.

52. Drew, 333, 369–71, 114–15, 298–301. In 1872, William Still compiled another set of testaments about runaways who were aided in their efforts to escape to Canada, *The Underground Railroad: A Record of Facts, Authentic Narratives, Records, Etc.* (Philadelphia: Porter and Coates, 1872).

53. Allen P. Stouffer, *The Light of Nature and the Law of God: Antislavery in Ontario, 1833–1877* (Baton Rouge: Louisiana State University Press, 1992); B'éri, Maroney, and Wright; Hepburn.

54. Samuel Ringgold Ward, letter to the editor, *Voice of the Fugitive*, 19 November 1851, 1.

55. Drew, 101.

56. Stouffer, 116.

57. "Liberia," *Globe*, 24 August 1852, 1, reprinted from the *Baptist Registrar* in Philadelphia.

58. "Republic of Liberia," *Voice of the Fugitive*, 12 March 1851, 2.

59. "Anti-Slavery Meetings in Canada," *Voice of the Fugitive*, 9 April 1851, 2.

60. *Report of the Committee on Emigration*, 15. Shadd (54–62) also weighs Mexico and South America against these options, coming out on the side of Canada West and Vancouver Island, a British outpost off the Pacific coast.

61. Henry Bibb, "Great Anti-Colonization Mass Meeting of the Coloured Citizens of the City of New York," *National Anti-Slavery Standard*, 3 May 1849.

62. *Report of the Committee on Emigration*, 8.

63. *Report of the Committee on Emigration*, 18.

64. *Report of the Committee on Emigration*, 13.

65. Ronald M. Gifford, "George Thompson and Trans-Atlantic Antislavery, 1831–1865," PhD diss., Indiana University, 1999, 275–85; "Great Anti-Slavery Meeting in Toronto," *Voice of the Fugitive*, 9 April 1851, 2.

66. Thompson had spoken out against Liberian colonization during his 1834–35 visit

to the United States. At an American Anti-Slavery Society meeting in Boston, he stated that the American Colonization Society was "a fraud upon the ignorance and an outrage upon the intelligence and humanities of the community" (Alexander Proudfit, "Colonization Society," *New-York Spectator,* 9 July 1835.

67. *Speech of George Thompson, Member of the British House of Parliament, at Toronto, May 1851* (Cincinnati: Wright, Ferris, 1851), 14.

68. American Presbyterians offered a gift to Scottish crofters suffering the first wave of the potato blight; Thompson and Douglass urged Scottish clergy to reject it. See George Thompson and Henry C. Wright, *The Free Church of Scotland and American Slavery: Substance of Speeches Delivered in the Music Hall, Edinburgh, during May and June 1846* (Edinburgh: Scottish Anti-Slavery Society, by T. and W. M'Dowall, 1846). Later that year, they were on the same platform at Exeter Hall (George Thompson Extract Books, vol. 6, Special Collections 3449.S43, Library of Congress).

69. "Anti-Slavery League," *Patriot* (London), 17 September 1846, in George Thompson Extract Books, vol. 6, f 48, Special Collections 3449.S43, Library of Congress.

70. "Meeting Last Night," *Voice of the Fugitive,* 9 April 1851, 2. Douglass was opposed to black emigration, especially to Liberia, yet not entirely critical of *Uncle Tom's Cabin.* See Robert S. Levine, *Martin Delany, Frederick Douglass, and the Politics of Representative Identity* (Chapel Hill: University of North Carolina Press, 1997), 58–98.

71. Frederick Douglass, "Slavery, the Slumbering Volcano," 23 April 1849, in *The Frederick Douglass Papers, Series One: Speeches, Debates, and Interviews,* vol. 2, ed. John W. Blassingame (New Haven: Yale University Press, 1982), 148–58. For additional referents to Washington, see Ellen Weinauer, "Writing Revolt in the Wake of Nat Turner: Frederick Douglass and the Construction of Black Domesticity in *The Heroic Slave,*" *Studies in American Fiction* 33.2 (Autumn 2005): 193–202; Carrie Hyde, "The Climates of Liberty: Natural Rights in the *Creole* Case and *The Heroic Slave,*" *American Literature* 85.3 (September 2013): 484–89.

72. "Madison Washington: Another Chapter in His History," *Boston Liberator,* 10 June 1842.

73. Ivy Wilson, "On Native Ground: Transnationalism, Frederick Douglass, and *The Heroic Slave,*" *PMLA* 121.2 (March 2006): 454.

74. Fionnghuala Sweeney, "Visual Culture and Fictive Technique in Frederick Douglass's *The Heroic Slave,*" *Slavery & Abolition: A Journal of Slave and Post-Slave Studies* 33.2 (2012): 314, 318.

75. Krista Walter, "Trappings of Nationalism in Frederick Douglass's *The Heroic Slave,*" *African American Review* 34.2 (Summer 2000): 237.

76. The Liberian letter in *Uncle Tom's Cabin* was controversial. Stowe's source may be Augustus Washington's "African Colonization, by a Man of Color," *New York Tribune,* 3 July 1851. Washington calls for more open minds about Liberia's capacity to offer independence to black people. See Joe Webb, "The George Harris Letter and *African Repository*: New Sources for *Uncle Tom's Cabin,*" *ANQ* 21.4 (2008): 30–34.

77. *Report of the Committee on Emigration,* 10.

78. In *Uncle Tom's Cabin,* Stowe also generalizes the practice through tales by missionaries (438–39).

79. Immediately following this reunion scene, Stowe insinuates the replicability of such events: "The note-book of a missionary, among the Canadian fugitives, contains

truth stranger than fiction. [...] These shores of refuge, like the eternal shore, often unite again, in glad communion, hearts that for long years have mourned each other as lost" (438).

80. Robert Purvis, letter to the editor and response, "The Serpent of Colonization in *Uncle Tom's Cabin*," *Boston Liberator*, 29 April 1852.

81. "Uncle Tom's Cabin," *Globe*, 3 February 1853, 1, reprinted from the *New York Journal of Commerce*. The *Globe* printed the first and second chapters of *Uncle Tom's Cabin* in issues dated 24 and 27 April 1852.

82. The cabin is part of the Ontario Heritage Trust. See http://www.heritagetrust. on.ca/en/index.php/properties/uncle-toms-cabin (accessed 2 June 2017).

83. Stephen Johnson, "Uncle Tom and the Minstrels: Seeing Black and White on Stage in Canada prior to the American Civil War," *(Post)Colonial Stages: Critical and Creative Views on Drama, Theatre, and Performance*, ed. Helen Gilbert (Hebden Bridge, Yorks: Dangaroo Press, 1999) 57.

84. "Uncle Tom on His Travels," *Globe*, 3 March 1853, 1, reprinted from the *New York Tribune*.

Marcy J. Dinius

"I Go to *Liberia*":
Following *Uncle Tom's Cabin* to Africa

Since the incorporation of *Uncle Tom's Cabin* into the American literary canon in the 1980s, scholars have revisited the novel to critique how its conclusion deports its major black characters to Liberia, arguing that this move ultimately compromises the novel's good antislavery cultural work and lays bare the imperial logic undergirding Stowe's politics of domesticity.[1] Despite such expansions of our critical view to consider the novel's implications beyond the borders of the United States, literary historians have yet to follow *Uncle Tom's Cabin* itself to Africa to examine the significant role that its fictional black characters' advocacy of a nation of their own has played in Liberian colonization, nationalism, and citizenship, in both theory and practice. Granted, such "Results"—as Stowe titles the chapter that resolves the stories of the Harris family, Cassy, and Mme de Thoux by sending them all to Africa—are difficult to track, due to Liberia's limited print culture during its early national period and to the damage done to its libraries, archives, and colleges by challenging environmental conditions, fire, and civil war in the subsequent centuries.[2] But the more easily recoverable writings and experiences of actual black emigrants to Liberia also have received limited scholarly attention, even as work in African American print culture and history has flourished. The anti-colonization position of influential nineteenth-century African Americans, including David Walker and Frederick Douglass, has carried the day.[3]

In necessarily taking a wider view of *Uncle Tom's Cabin* in relation to Liberia, this essay begins to recover two underrepresented positions on Stowe's novel in relation to the controversial issue of African coloniza-

tion: that held by pro-colonization African Americans and that of actual emigrants to Liberia. The archive for the latter is not only scant but also decidedly biased in favor of the colonization mission, given the American Colonization Society's and its state-level affiliates' investment in print for advancing their mission and publicizing its results, as well as the preservation of its archives by U.S. institutions.[4] But these structural limitations and our own political problems with the racist and/or imperialist motives driving the African colonization movement should not cause us to ignore either the important roles that nineteenth-century colonizationists and emigrants to Liberia played in both shaping and responding to *Uncle Tom's Cabin* in North America, Europe, and Africa or the significant role that the novel played in shaping ideas about Liberia and its settler and native populations.[5] Taking this multidimensional view extricates us from the critical and pedagogical rut of including pro forma condemnations of Stowe's conclusion in our analyses of the novel and gives us a broader, more representative understanding of its deployment by a range of black readers in relation to the complicated issues of self-representation, self-determination, race, and nation.

In what follows, I consider how Stowe modeled her character George Harris's views after those of real-life participants in the colonization debate and project. I then turn to examine how this fictional character's views subsequently were received by U.S.-based colonizationists and actual emigrants to Liberia who assumed positions of power in the new nation; both groups were equally eager to offer up Harris as compelling proof that the young republic was an established black nation ready and eager for recognition by the world. Following *Uncle Tom's Cabin* to Liberia allows us to track Stowe's conversion of fact into fiction that was then deployed by pro-colonizationists and Liberians as fact. Tracing this circuit of fact and fiction also recovers how closely connected the Liberian response to *Uncle Tom's Cabin* was to how the world responded to the new nation of Liberia.

LIBERIAN COLONIZATION: "SUBSERV[ING] ALL SORTS OF PURPOSES"

Before following *Uncle Tom's Cabin* to Liberia, it is well worth reconsidering how Stowe's emancipated characters likely ended up there. In one of the most influential examinations of the pro-colonization conclusion of *Uncle Tom's Cabin*, Michelle Burnham challenges the novel's twentieth-century

elevation "to the status of *the* American abolitionist novel," by reminding us that colonization was unpopular with leading black and white abolitionists of the 1850s. She argues that the narrative's dispatching of Cassy, the Harrises, Mme de Thoux, and Topsy to Africa following their emancipation "compromises what would otherwise be its committed abolitionist message." For Burnham, the conclusion lays bare the novel's "problem of incorporating the bodies of Blacks into the national body once liberation is effected."[6] Reading through the lens of abolitionism alone, however, excludes more binocular perspectives that were also available at the time, embodied by the renowned African American daguerreotypist Augustus Washington, a pro-colonization abolitionist and an American emigrant to Liberia. As she was composing George Harris's pro-colonization letter for chapter 43 of *Uncle Tom's Cabin*, Stowe almost surely drew on an essay that Washington wrote in 1851.[7] On 9 July, the *New York Tribune* published Washington's essay "African Colonization," likely as Stowe was writing chapter 11 of *Uncle Tom's Cabin*, in which George Harris first disidentifies as an American and articulates his desire for a country of his own.[8] While Stowe was most directly influenced by her father, Lyman Beecher, who publicly advocated colonization, similarities between Washington's essay and Harris's letter strongly suggest that she found in Washington not just a black advocate of the project but also a model for reconciling the opposition of abolition and colonization.

Washington dedicates a good deal of his lengthy essay to considering colonization in relation to abolition, lamenting how supporters of each cause have become antagonists instead of allies. "Both of these benevolent societies," he notes, "might perhaps have accomplished more good if they had wasted less ammunition in firing at each other."[9] By "taking a liberal and more comprehensive view of the whole matter," Washington is able to conclude that "whatever may have been the faults, inconsistencies and seeming opposition" of colonization and abolition, "both have been instrumental in doing so much good in their own way," as well as that "an all-wise Providence" will resolve these differences "toward a grander and more sublime result than either association at present contemplates."[10]

In his letter, George Harris similarly acknowledges that "Liberia may have subserved all sorts of purposes" but that the "God above all man's schemes" has "overruled" opposing forces and "founded for us a nation" via the American Colonization Society (441). This parallel suggests that if Stowe was reluctant to incorporate liberated black bodies into the national

body, as Burnham has argued, she shared this reluctance with Augustus Washington, whose point of view she incorporated into her novel. In siding with abolitionists and neglecting the pro-colonization position, scholars have associated George Harris primarily with Frederick Douglass and other prominent educated blacks on whom Stowe also drew to develop the character. By doing so, we have missed not just his connection to Washington but also, significantly, more complicated understandings that were possible at the time, about abolition and colonization, fact and fiction, and the United States and Liberia.[11]

Certainly, such an understanding of the abolition and colonization movements was uncommon in the 1850s, when polarization dominated. Recognizing this, Washington dedicates his essay to carving out a more moderate position.

> For our own part, under the existing state of things, we cannot see why any hostility should exist between those who are true Abolitionists and that class of Colonizationists who are such from just and benevolent motives. Nor can we see a reason why a man of pure and enlarged philanthropy may not be in favor of both, unless his devotion to one should cause him to neglect the other. Extremes in any case are always wrong.[12]

Washington reasons that colonization promises to resolve racial antagonism rather than perpetuating it through a separate-but-equal compromise that allows two races and republics to flourish apart yet in parallel. Citing the exclusion of blacks in the United States from full and equal participation in citizenship, education, and employment, he concludes that it is "impossible [. . .] while in this country to prove to the world the moral and intellectual equality of the Africans and their descendants," and he sees little hope for ameliorating such structurally enforced inequality in the United States. As a result, he is "driven to the conclusion that the friendly and mutual separation of the two races" is "necessary to the peace, happiness and prosperity of both" and to "promote the interests of two great continents, and build up another powerful Republic."[13]

Washington acknowledges that neither this grand vision nor the reconciliation of abolition and colonization are likely to attract many supporters, given the resolutely anti-colonization stance of the "leaders of the colored people in this country." He describes himself as a "mere private businessman, with a trembling pen," who "come[s] forward alone," out of a sense of

a "great and important duty to [the] race," a responsibility its leaders have "failed to discharge." Washington could not have imagined how exponentially Stowe's pen and the presses printing *Uncle Tom's Cabin* would amplify his antislavery, pro-colonization argument and spread it around the world, including to Liberia.[14]

LIBERIA IN *UNCLE TOM'S CABIN*

While the fictional letter written by George Harris in chapter 43 of *Uncle Tom's Cabin* maintains the reconciliation of abolition and colonization in Washington's essay, Washington's moderate tone and logic are largely lost in Stowe's translation. After claiming that Liberia realizes God's vision and thereby overcomes the division of the two movements, Harris urges, "Let us, then, all take hold together, with all our might, and see what we can do with this new enterprise" (441). As with Washington, such cooperation is the means to ultimately separatist ends. But whereas Washington's turn to Liberia derives from his frustration with the structural limitations placed on blacks' opportunities for advancement in the United States, Harris's stems from a racialist understanding of nation—one that imagines full citizenship in the United States as only possible through the complete absorption of black by white. Harris therefore concludes that a fully black nation in Africa is the necessary alternative. Responding to his correspondent's suggestion that the light-skinned Harris and his family might "mingle in the circle of whites," Harris counters, "I have no wish to pass for an American, or to identify myself with them. It is with the oppressed, enslaved African race that I cast in my lot." He emphatically links race and nation by adding, "If I wished anything, I would wish myself two shades darker, rather than one lighter" (440). In imagining "an African *nationality*," which Harris defines as "a people that shall have a tangible, separate existence of its own," his vision focuses not on the United States and Liberia as twin republics, as Washington's does, but on Liberia and its potential to "plant" in Africa numerous "mighty republics, that, growing with the rapidity of tropical vegetation, shall be for all coming ages" (441).[15]

That Harris takes a more extreme position than Washington with respect to racial and imperial nationalism is an important reason why fewer critics have recognized Washington as an important influence on both the colonization debate and *Uncle Tom's Cabin*, though he would have been more readily apparent as such to nineteenth-century readers.[16] In concluding his

Tribune essay, Washington predicted that the impact of his arguments likely would be limited because of his "attempting to be just to three classes"— abolitionists, colonizationists, and blacks, whom Washington presents here as separate and competing groups who do not recognize their shared interests and aims. Recognizing that his identity as a black would trump that of colonizationist and abolitionist, he reduced his expectations to, as he presents it in his essay, "provok[ing] an inquiry among Afric-Americans [*sic*]" into Liberia.[17] But as we see in the issue of *Frederick Douglass' Paper* for 31 July 1851, Washington's piece caught and held the attention of those on both sides of the colonization debate, winning the favor of white colonizationists and provoking the black abolitionist Douglass to decry, "Mr. Augustus Washington, a colored man of more than ordinary talents, has, in the agony of despair, written a long article in the New York Tribune commending the whole infernal scheme which at present is filling the whole Colonization ranks with rejoicing. Oh! when will our people learn that they have the power to crush this viper which is stinging our very life away?"[18]

Two months later, Douglass's *Paper* published further pro- and anticolonization responses to Washington's essay. Among them is an article from the *Christian Statesman* praising Washington as "a man of superior ability and wisdom," who, with his "single article" in support of colonization, has done more "to advance the welfare and elevate the character of his race than Douglass, with perhaps equal ability, but without judgment and temper, has accomplished in ten years of mad declamation upon the present heart-broken condition of the colored brethren."[19] (Notably, Douglass tempered this praise of Washington, as well as implicitly defended himself, by publishing a letter to his *Paper*, in the same issue, condemning Washington's essay as "fulsome, incoherent, stale, [and] self-contradicting.")[20] While Douglass resisted the *Statesman's* recommendation that he model himself after Washington with respect to his stand on colonization, his *Paper* continued to publish notices about Washington's accomplishments as a daguerreotypist and even about Washington's successes after emigrating to Liberia, which suggests that Douglass was capable of a "liberal and comprehensive view" of this man who encouraged his peers to take just such a perspective, even if Douglass disagreed with Washington's politics.[21]

Douglass also viewed *Uncle Tom's Cabin* liberally and comprehensively, praising it repeatedly for its compelling antislavery message, despite its Washington-influenced colonizationist conclusion and its condemnation by other black leaders.[22] In defending the novel to Martin Delany in an ex-

change in his *Paper*, Douglass declares, "We shall not [. . .] allow the senti-ments put in the brief letter of GEORGE HARRIS, at the close of Uncle Tom's Cabin, to vitiate forever Mrs. Stowe's power to do us good."[23] Whether or not he recognized the similarities between Washington's essay and Harris's letter, Douglass clearly found aspects of Washington's life and Stowe's fic-tion similarly useful to his own arguments for the advancement of African Americans and continued to follow the progress of both in his *Paper*—all the way to Liberia.

UNCLE TOM'S CABIN IN LIBERIA

Among the "Gleanings of News" in the issue of his *Paper* for 22 April 1853, Douglass reprinted the following notice from the *Maryland Colonization Journal*:

> UNCLE TOM'S CABIN IN LIBERIA.—This work, as might be supposed, has created no little sensation in Liberia, but will not likely be translated into any native African Lingo. A *critical* remark of one of our correspondents, to whom we had sent a copy, is rather peculiar, and no doubt, will be considered quite complimentary to the author. After thanking us for the copy, and expressing his gratification in its perusal, he says, "there must be some mistake about George Harris' coming to Liberia, he certainly is not here and has not, been here, unless under an assumed name!"[24]

Douglass published the piece without adding editorial commentary. Do-ing so left his readers to interpret the compliment paid to Stowe by her unspecified Liberian reader as further evidence of the novel's realistic de-velopment of its characters—or, at least, of the frequency with which its readers so readily conflated fiction and reality. Even without his commen-tary, the republished notice suggests that Douglass recognized the lifelike nature of Stowe's characters as powerfully affecting readers, hopefully to the point that they would act on their feelings, to end slavery and advance black rights.[25]

In shifting to glean what we can from the few Liberian responses to *Un-cle Tom's Cabin* that I have been able to locate, it is significant that the brief notice in Douglass's *Paper* mentions that the novel was being read there in English and that it was unlikely to be translated into any African languages. Beyond confirming that the copies circulating in Liberia were imported

from the United States or England, as almost all books were then, it implies that the novel's audience was limited to emigrants from the United States and to native Africans who had become literate in English; only the elite of both the settler and native populations would have been able to read the novel and to afford the steep price of an imported book. As Liberia's ruling class, settler readers were especially sensitive to the novel's favorable representation of their new home, taking it as powerful confirmation that they had made the right decision to emigrate, as well as of their right to rule as an educated and cultured elite.

One such reader and leader was Edward W. Blyden, a West Indian who emigrated to Liberia in 1850 after having been refused admission to Rutgers Theological Seminary in the United States; he became a prominent advocate of the republic's successes, through correspondence with colonization supporters in the United States and England and as editor of the *Liberian Herald*.[26] An 1853 letter written to John B. Pinney of the American Colonization Society (ACS) and published in the *African Repository* reveals that Blyden was a voracious reader of print imported into Liberia, with an especially keen eye for how the contentious republic was being represented in the United States. After observing, "with much pleasure," that "several American papers take ground in favor of the recognition of Liberia by the United States government," he notes that he was "very agreeably surprised at noticing that Mrs. Harriet B. Stowe, at the close of her inimitable 'Uncle Tom's Cabin,' represents an intelligent colored man in America, educated abroad, as expressing a desire for an 'African nationality,' and as intending to emigrate to Liberia." Blyden reads George Harris's letter as evidence of Stowe "favoring the idea that it is the position which every intelligent colored man should take, and giving it to the world to understand that it is, in her opinion, the ground which every enlightened colored man ought to and eventually occupy."[27] That Blyden deployed a fictional letter and character modeled after the actual person and writing of Augustus Washington as inspiration for the position that all "enlightened" blacks should take in favor of colonization reveals the easy and frequent slippage that occurred between representation and reality with respect to Liberia and Liberians. Moreover, it reveals the power of representation—in this case, a memorable character from an extremely popular novel—to fulfill a colonizationist vision that remained more prospective than accomplished in reality.

By the time Blyden had read *Uncle Tom's Cabin*, though, Stowe herself had taken a more complicated position on colonization than Blyden's letter

suggests. At the 1853 annual meeting of the American and Foreign Anti-Slavery Society (AFASS), the society's corresponding secretary

> read an extract from a note from Mrs. Stowe to the effect, that she had no sympathy with the coercive policy of the Colonization Society, but thought Liberia now a "fixed fact," and that the opportunity there afforded of sustaining a republican government of free people of color ought not to be disregarded by them or their friends; concluding with an assurance that she was "not a Colonizationist."[28]

Stowe's personal secretary Leonard W. Bacon was present at the meeting and reported that "Mrs. Stowe had told him, that if she were to write 'Uncle Tom' again, she would not send George Harris to Liberia." Even so, Stowe imagined that Harris "would there, in freedom, establish a good name and fame, which would be important in its reaction, in abolishing distinctions of caste; and she looked to the colony as one of the great agents by which the colored race were to be elevated and dignified in the eyes of the lofty and contemptuous Saxon."[29] While the AFASS trumpeted Stowe's statements as a recanting of her novel's prominent advocacy of colonization and as resulting from negative reactions from black and white abolitionists, we see that her withdrawal of support was from the ACS only and not from Liberia and its emigrants. Among these emigrants, she imagined her fictional character—much like her novel's unspecified Liberian reader in Douglass's reprint—living as if he were a real person and helping to realize the full potential of both the young republic on distant shores and the race alike.

Stowe's character Topsy, whom the conclusion of *Uncle Tom's Cabin* sends to Africa as a missionary after her conversion to Christianity and emancipation by Ophelia, was similarly deployed in pro-colonization representations as if she were living proof of Liberia's viability. We see this in the article "A Glance at 'Topsey's' [*sic*] Home" in the ACS's October 1853 *African Repository*. Reprinted from a periodical titled the *Independent* (with an unspecified place of publication), the article is written from the perspective of someone who has seen firsthand the "thriving town of Monrovia," "walk[ed] through its wide, well-shaded streets, look[ed] at the school-houses, churches, court-house, and even pass[ed] into the 'Government Buildings,'" all of which "falsify forever the assertion, 'they are neither capable of governing or supporting themselves.'"[30] While the article discusses neither *Uncle Tom's Cabin* nor its character Topsy directly, its title invokes the latter (with an alternate

spelling) and invites readers to imagine Tops(e)y as a living person who is realizing her full capacities along with other Liberians, through emancipation, conversion to Christianity, education, and emigration to a black nation in need of just such model citizens.

Pro-colonization writers were not alone in supporting a cause by exploiting the widely familiar characters of *Uncle Tom's Cabin* as if they were actual people living in Liberia. Recognizing that the novel's readers had come to think of its characters as actual people and to feel favorably disposed toward them, a Liberian named Alfred T. Wood was tried and convicted in Monrovia in 1856 for committing a "libel on the Republic." His crime, more specifically, was defrauding English donors to a fund for a never-to-be-built church in Monrovia, by advertising George Harris and his wife as members. A notice in the January 1856 *African Repository* declared Wood's sentence of five years in prison and fine of five hundred dollars as his just deserts for using Stowe's fiction to advance his own, at the expense of the republic's fragile reputation abroad.[31] As Wood's swindle reveals, Liberia was far away from America and England and, as a result, could only be understood through necessarily mediated accounts of conditions and people there. As we have seen, representations of the distant republic typically offered up examples of successes in its early development, as grounds for imagining a full-fledged and thriving nation in the not-too-distant future. Accordingly, this inevitable tension between the republic's fictional and factual existence lent to easy slippages between fiction and reality and to opportunistic exploitations of their interchangeability, by pro-colonizationists seeking material support for the venture and by swindlers lining their own pockets.

Such representations of Liberia and Liberians had even higher stakes. Nothing less than the capacities of people of African descent for self-government and self-sufficiency were on trial in the court of global public opinion (swayed toward doubt by the racist science of ethnology), and the unsaved souls of native Africans were at risk in the eyes of evangelical Christians.[32] Powerful whites in the United States and England had invested significant capital and their reputations in the experiment, and their religious and social aims were thoroughly entangled with economic ones, as they envisioned that the untapped moral and natural resources of an entire continent were available for conversion and commoditization. As debates about the viability of the recently independent republic raged and as emigrants' reports home about conditions there frequently contradicted each other, supporters of the project were especially eager to

introduce some kind of tangible, indisputable proof that Liberia and its people were not just surviving but flourishing—spiritually, economically, and politically.

In the summer of 1854, Augustus Washington produced two daguerreotypes as just such evidence: one featured a view of Monrovia from the harbor lighthouse, and the other showed the Liberian presidential mansion. At the time, daguerreotypy was considered the most accurate and objective form of representation possible; the highly detailed images, promoted as made through the agency of sunlight and chemistry instead of subjective human hands, carried significant authority as evidence.[33] Washington mailed his daguerreotypes to Dr. J. W. Lugenbeel, the ACS's recording secretary in Washington, DC, for engraving and reproduction in the publications of the ACS and its affiliates. Lugenbeel rejected the harbor view, requesting a *"good, clear,* view of Monrovia" and emphasizing that if Washington could not get "a good clear picture it will not answer our purpose."[34] As Lugenbeel's reply makes clear, any ambiguity in evidence of Liberia's fully fledged reality would not advance the colonization project.

Like Washington's daguerreotypes, the exhibition of physical copies of *Uncle Tom's Cabin* in Liberian homes was presented as visible and material proof that the ideals of colonization had become a reality. Alexander Crummell, an American minister who emigrated to Liberia in 1853 as a missionary and who became a prominent member of Liberia's elite and an internationally known advocate for the republic, includes Stowe's novel in a list of books and periodicals that could be seen in the "residence of a thriving, thoughtful citizen" of Liberia. In an 1862 lecture on the prominence of the English language in the country, Crummell explains that among the "mass of printed matter" to be expected on the Liberian elites' "bookshelves or tables," one would discover "Bibles, Prayer or Hymn Books, Hervey's Meditations or Bunyan's Pilgrim's Progress, Young's Night Thoughts or Cowper's Poems, Walter Scott's Tales, or Uncle Tom's Cabin," as well as a range of American and English newspapers and magazines.[35] According to the aforementioned brief notice reprinted by Douglass in 1853 to announce the Liberian reception of *Uncle Tom's Cabin*, the only copies circulating in Liberia were English-language editions. That the notice indicates there were no plans to translate the novel into African languages is especially remarkable, given that the novel has Christian typological characters and a thoroughly evangelical message and that missionary work such as Crummell's was a significant motivation for African colonization. As Crummell's

list confirms, fifteen years after Liberian independence, books and other print—including *Uncle Tom's Cabin*—remained a luxury accessible only to the country's most elite settlers and possibly to natives who thought that adopting the English language and culture was vital to having any power in their homeland.

It may be that *Uncle Tom's Cabin* was not translated into the languages spoken in Liberia by native Africans because natives would have recognized that its representations of American slavery too closely resembled conditions in Liberia as well. Emigrants from the United States had imported and established many of the same discriminatory views and practices that they had fled, as we discover in a series of critical letters from Augustus Washington detailing conditions in Liberia after he and his family had emigrated in late 1853. In one of these letters, published in the *New-York Daily Tribune* in 1854 under the title "Liberia as It Is," Washington reports that the native Africans

> are humble, subdued and servile creatures. They are employed in all families as domestic drudges [...]. Some few families allow them wages, and thus their servants are decently clothed. But nearly all [...] wear nothing but a filthy rag the size of a common cotton handkerchief, about their loins, or occasionally a dirty, greasy shirt; and in this state they perform all duties about houses. In some families they are allowed per day a quart of rice, some palm oil, and otherwise well fed. In other families they are poorly fed from mere scraps of rice and cassada [*sic*]. In others again they are not only worked nearly naked, but half starved. And in nearly all families it is customary to keep a rawhide or cat-o'-nine-tails handy, to flog them when they please. And this flogging, kicking and cuffing is done to a shameful extent by upstart boys, scolding, brainless women, and gentlemen of rank and standing, calling themselves Christians.[36]

This exposé of Liberia's real social and environmental miseries records the daguerreotypist's disillusionment with the colonization ideal that he had promoted and on which Stowe had borrowed. It also offers an authoritative post-emigration corrective to the wholly positive representations of Liberia being published by the ACS and its affiliates and supporters, including those representations coming from Liberia itself and deploying characters from Stowe's novel as living and thriving in the African republic.

Despite his authority as a daguerreotypist and a member of the Liberian elite who broke ranks with both the ACS and his peers in publishing a critical firsthand account of the country, Washington was far from having the last word on Liberia as it actually existed. The ACS continued its work, and its supporters extended their advocacy of Liberia well past the American Civil War and emancipation. As before, *Uncle Tom's Cabin* figures prominently in their later arguments. In an 1883 speech given in Washington, DC, upon the sixty-sixth anniversary of the ACS, Edward Blyden—who had become the president of Liberia College—declared that the "Republic of Liberia now stands before the world—the realization of the dreams of the founders of the American Colonization Society, and in many respects more than the realization."[37] Following this familiar claim, Blyden's speech offers a long view of the history of the ACS and its supporters. Once again, Stowe's novel is introduced as "proof"—in this case, "of the great confidence felt by Mrs. Stowe in the idea of African Colonization—in the mighty results to be achieved through its means for Africa and humanity." Citing Stowe's novel as a milestone in the colonization debate, Blyden claims that "more forcible reasons" never have been "given for the emigration of persons of color from this country [the United States] to that Republic [Liberia] than are presented in the able and eloquent letter which she makes [George Harris] write to set forth is reasons for emigrating." As Blyden still sees it, Harris's letter "shows what a cultivated Anglo-Saxon and an abolitionist feels ought to be the views of an educated and cultivated colored American."[38] Assessing the novel's place in recent history, Blyden declares *Uncle Tom's Cabin* "not only the harbinger of emancipation, but also of the vast colonization which will sooner or later take place." His reasons for using the future tense to indicate this "vast colonization" as still prospective—despite the significant influence of *Uncle Tom's Cabin* and the thirty-five-year history of Liberia as an independent republic—become clearer as he concludes his discussion of the novel's ongoing reception: "And that the friends of the African should have seized upon her words in the one capacity and not in the other, can only be explained by the fact that as an angel of Abolition the nation was ready for her; but to receive her as an angel of Colonization, it is only now in the process of preparation."[39]

In traveling from Liberia to the United States to give his speech, Blyden offered not only *Uncle Tom's Cabin* but also himself as powerful evidence in support of a project that continued to be controversial after decades of continuous emigration from the United States to Liberia. The statistics are

telling. In 1851, the year that the majority of *Uncle Tom's Cabin* was published serially in the *National Era*, 676 American blacks emigrated to Liberia. The next year, when the story finished publication in the *National Era* at the beginning of April and was subsequently published as a novel, 620 emigrated, and in 1853, as its immense popularity continued, there were 783 emigrants.[40] These three years saw the greatest number of emigrants from the United States to Liberia; a comparable pattern emerges only in the three years following the Civil War.[41] In 1883, the year that Blyden gave his speech, only fifty-three emigrated from the United States to Liberia. Given black Americans' dwindling interest in Liberia—even during the difficult and violent transition from emancipation, through Reconstruction, and into the Jim Crow era—it is no wonder that Blyden returned to *Uncle Tom's Cabin* to revive the idealism of George Harris's letter and its hopeful vision of fully fledged black African republics, though the actual republic in Liberia was still struggling for viability economically and politically and had reproduced many of the social divisions that settlers had fled. When we return to this extended contest between fiction (including idealization) and reality with respect to Liberia, as well as the significant role of *Uncle Tom's Cabin* in that contest, we gain a better understanding of the novel's extensive influence well beyond American borders. We also begin to recognize the novel's utility to black activists arguing for their right to and capacity for self-determination and self-government, a utility that functioned both whether activists were for or against colonization and whether or not the novel's colonizationist conclusion was activated by racism.

CODA: "UNCLE TOM'S RELATIVES"

Even into the twenty-first century, *Uncle Tom's Cabin* continues to be read by Liberians and deployed with particular force in arguments about the complicated history and social fabric of their republic. In 2006, the *Perspective*—a "unique upscale magazine" published by the group Liberian Democratic Future and promising to "confront the issues head on by concentrating on telling the truth, exposing the root causes, underlining contributing factors and identifying the class divisions which are the undercurrent of the various problems in Liberia"[42]—published a two-part essay by Siahyonkron Nyanseor titled "The Tradition of Uncle Tom's Relatives." Making good on the magazine's promises, Nyanseor dedicated his essay to historicizing modern-day class divisions in Liberia, tracing their origins to colonization and the earliest days of the nation.

Those in Liberian society whom Nyanseor's essay designates as "Uncle Tom's Relatives" are the descendants of former slaves who emigrated from America and "assimilated and acquired the cultural arrogance"; not only did these emigrants make "invaluable contributions" to Liberia's development, Nyanseor claims, but "many of them assisted the ruling elites in oppressing the African inhabitants."[43] Their designation as "Uncle Tom's Relatives," he explains,

> is derived from Harriet Beecher Stowe's best-known novel, Uncle Tom's Cabin [*sic*], which was first published as a series between 1851 and 1852. It became an enormously popular tale of the injustices of slavery. Uncle Tom, an almost Christ-like model of goodness and charity, was a house slave who was reluctantly sold by his first owners. Ultimately, Simon Legree, a tyrannical overseer, beat Uncle Tom to death after he had exemplified many heart-rending examples of generosity and heroism in the community. The novel is believed to have been a major cause of the Civil War. It popularized the abolitionist movement in the United States. Today, the term Uncle Tom is used pejoratively to describe a black American who is too deferential to whites. Unlike the original Uncle Tom, his Relatives in the Liberian experience are a combination of Tom's tyrannical overseer, Simon Legree and individuals like the Arthur Barclays, the Bill Franks and numerous others who were well socialized and given privileged positions at the expense of the African Liberians. This group and their offspring have an antipathy towards African Liberians.

In exposing the class divisions within Liberian society and linking them to Liberia's colonial connection to the racist and slaveholding nineteenth-century United States, Nyanseor's essay echoes Augustus Washington's critical exposés of both the failed promises of a united and egalitarian black republic and the real consequences of the settler colonialism that black emigrants practiced in its stead, in the name of racial nationalism and Christian evangelism. More significantly, the essay reveals the lasting significance that Stowe's globally popular and influential novel has had for Liberians in their continuing efforts to come to terms with the conflict between the promise and the realities (too often grim) of a nation that was born from both hope and hatred; was tenuously established and sustained via persuasive combinations of fact and fiction, race, nation, and religion; has been neglected by its closest kin (the United States); and has been plagued by poverty, violence, and illness ever since. These people may indeed be rightly considered Uncle Tom's relatives.

Notes

1. Following Jane Tompkins's influential feminist recovery of the "cultural work" of *Uncle Tom's Cabin* in *Sensational Designs: The Cultural Work of American Fiction, 1790–1860* (New York: Oxford University Press, 1985), major works critiquing the imperialist logic undergirding and extending the novel's sentimentalism and investment in domesticity include Gillian Brown's *Domestic Individualism: Imagining Self in Nineteenth-Century America* (Berkeley: University of California Press, 1990); Michelle Burnham's *Captivity and Sentiment: Cultural Exchange in American Literature, 1682–1861* (Hanover, NH: University Press of New England, 1997); Amy Kaplan's "Manifest Domesticity," *American Literature* 70.3 (September 1998): 582–606; and Etsuko Taketani's *U.S. Women Writers and the Discourses of Colonialism, 1825–1861* (Knoxville: University of Tennessee Press, 2003). Most of this work uses the lens of imperialism, rather than that of colonialism or (the more specific and recently favored term) settler colonialism, to read *Uncle Tom's Cabin* and Liberian colonization. In this essay, I use the terms that were most commonly used in nineteenth-century discourse about Liberia and other proposed and established colonies for emancipated slaves and free blacks, *colonization* (as in the American Colonization Society) and *emigrants* (the word that Augustus Washington and others used to designate nonnative African settlers of Liberia). By doing so, I do not mean to suggest that Liberia was or is not an instance of settler colonialism or to ignore the complications of how this instance of settler colonialism motivated by racial nationalism and an idea of racial identity with native Africans failed to materialize in practice. Attending more fully and justly to the complications of *Uncle Tom's Cabin* with the latter, though, would require a book of its own.

2. For a helpful timeline of important publications and their lifespans in the limited print culture of early Liberia, see Momo K. Rogers Sr., "The Press in Liberia, 1826–1966: A Select Chronology," *Liberian Studies Journal* 22.1 (1997): 95–120.

3. On Walker's and Douglass's anti-colonization positions, see Robert S. Levine, *Martin Delany, Frederick Douglass, and the Politics of Representative Identity* (Chapel Hill: University of North Carolina Press, 1997); David Kazanjian, *The Colonizing Trick: National Culture and Imperial Citizenship in Early America* (Minneapolis: University of Minnesota Press, 2003). For decades, the most significant scholarship on Liberia and the colonization movement was comprised of P. J. Staudenraus's *The African Colonization Movement, 1816–1865* (New York: Columbia University Press, 1965) and Tom W. Shick's *Behold the Promised Land: A History of Afro-American Settler Society in Nineteenth-Century Liberia* (Baltimore: Johns Hopkins University Press, 1980). The twenty-first century has seen an increase in attention that includes the perspective of the American Colonization Society and its supporters as well as emigrants: see Eric Burin, *Slavery and the Peculiar Solution: A History of the American Colonization Society* (Gainesville: University of Florida Press, 2005); Lamin Sanneh, *Abolitionists Abroad: American Blacks and the Making of Modern West Africa* (Cambridge: Harvard University Press, 2001); Claude Andrew Clegg, *The Price of Liberty: African Americans and the Making of Liberia* (Chapel Hill: University of North Carolina Press, 2004); Amos J. Beyan, *African American Settlements in West Africa: John Brown Russwurm and the American Civilizing Efforts* (New York: Palgrave, 2005); Marie Tyler-McGraw, *An African Republic: Black and White Virginians in the Making of Liberia* (Chapel Hill: University of North Carolina

Press, 2007); Beverly C. Tomek, *Colonization and Its Discontents: Emancipation, Emigration, and Antislavery in Antebellum Pennsylvania* (New York: New York University Press, 2010); James Ciment, *Another America: The Story of Liberia and the Former Slaves Who Ruled It* (New York: Hill and Wang, 2013). Compilations and studies of Liberian emigrants' writings include *Liberian Dreams: Back-to-Africa Narratives from the 1850s* (University Park: Pennsylvania State University Press, 1998), edited by Wilson Jeremiah Moses, and *Back to Africa: Benjamin Coates and the Colonization Movement in America, 1848–1880*, edited by Emma J. Lapsansky-Werner, Margaret Hope Bacon, and others (University Park: Pennsylvania State University Press, 2005).

4. The American Colonization Society established Liberia as a colony in 1821; it became an independent republic in 1847. On the American Colonization Society's strategic uses of print, see Staudenraus, *African Colonization Movement*, 37, 214–16.

5. Elizabeth Ammons notes that the "opposition of leaders such as Douglass and Garrison, the history of Liberia, and the progressive condemnation of imperialism today make it difficult to find anything positive in Stowe's support for African American colonization of Liberia." See "Freeing the Slaves and Banishing the Blacks: Racism, Empire, and Africa in *Uncle Tom's Cabin*," in *Harriet Beecher Stowe's "Uncle Tom's Cabin": A Casebook*, ed. Elizabeth Ammons (New York: Oxford University Press, 2007), 242.

6. Burnham, *Captivity and Sentiment*, 120–21.

7. George Harris and Augustus Washington were first linked by Joe Webb in "The George Harris Letter and *African Repository*: New Sources for *Uncle Tom's Cabin*," *ANQ* 21.4 (Fall 2008): 30–34. For more on Washington as a daguerreotypist and an advocate for Liberian emigration, see Ann Shumard, *A Durable Memento: Portraits by Augustus Washington, African American Daguerreotypist* (Washington, DC: National Portrait Gallery); Marcy J. Dinius, *The Camera and the Press: American Visual and Print Culture in the Age of the Daguerreotype* (Philadelphia: University of Pennsylvania Press, 2012), chap. 5.

8. In this essay, I focus more on Washington's arguments for reconciling colonization and abolition than on the similarities between his essay and George Harris's letter. For my previous discussion of the resemblances between Harris's letter and Washington's essay, see Dinius, *The Camera and the Press*, 158–62.

9. Augustus Washington, "African Colonization," *New-York Daily Tribune*, 9 July 1851, reprinted in *African Repository* 27, no. 9 (September 1851): 259–65.

10. Ibid., 262.

11. For an extended analysis of the influence of Frederick Douglass and Martin Delany on Stowe's development of George Harris and the pro-colonization position of *Uncle Tom's Cabin*, see Levine, *Martin Delany, Frederick Douglass*, chap. 2. See also Robert B. Stepto's "Sharing the Thunder: The Literary Exchanges of Harriet Beecher Stowe, Henry Bibb, and Frederick Douglass" and Richard Yarborough's "Strategies of Black Characterization in *Uncle Tom's Cabin* and the Early Afro-American Novel," both in *New Essays on "Uncle Tom's Cabin*," ed. Eric J. Sundquist (New York: Cambridge University Press, 1986). Staudenraus's *African Colonization Movement* offers a detailed history of the fluctuating relationship between abolition and colonization from the eighteenth century through emancipation.

12. Washington, "African Colonization," 262.

13. Ibid., 263.

14. Ibid., 260.

15. For an extended reading of the response of "literate free blacks of the North"—especially that of Delany and Douglass—to the conflicted views on the relationship of race and nation in *Uncle Tom's Cabin*, see Levine, *Martin Delany, Frederick Douglass*, chap. 2.

16. The primary factor in scholars' neglect of Washington is Stowe's omission of him in her defense of Harris against charges that he was "overdrawn." See Harriet Beecher Stowe, *A Key to "Uncle Tom's Cabin"* (1853; reprint, Bedford, MA: Applewood Books, 1998), 13–21.

17. Washington, "African Colonization," 265.

18. Frederick Douglass, "African Colonization," *Frederick Douglass' Paper*, 31 July 1851.

19. "Frederick Douglass and Augustus Washington," *Christian Statesman*, reprinted in *Frederick Douglass' Paper*, 4 September 1851.

20. Bob Markle, "Communications: The Constitution—Colonization," *Frederick Douglass' Paper*, 4 September 1851.

21. See, for example, the article "Colored Artists" in Douglass's *Paper* of 15 April 1852, as well as Douglass's reprinting of the "Fourteenth Annual Report of the Board of Managers of the Massachusetts Colonization Society" in his *Paper* of 17 August 1855.

22. Levine offers a detailed examination of Douglass's response to Stowe's novel, in "*Uncle Tom's Cabin* in *Frederick Douglass' Paper*: An Analysis of Reception," *American Literature* 64.1 (March 1992): 71–93.

23. Letter of M. R. Delany, *Frederick Douglass' Paper*, 6 May 1853.

24. "Gleanings of News," *Frederick Douglass' Paper*, 22 April 1853.

25. For Douglass's and others' responses to Stowe's characterizations of African Americans in *Uncle Tom's Cabin*, see Levine, "*Uncle Tom's Cabin* in *Frederick Douglass' Paper*"; Yarborough, "Strategies of Black Characterization in *Uncle Tom's Cabin*." Douglass's readers might also notice the Maryland Colonization Society's knowing mockery of a black emigrant who mistakenly thought that a fictional character in a periodical with a mostly white readership was an actual person.

26. For more on Blyden's life and activism, see Hollis R. Lynch, *Edward W. Blyden: Pan-Negro Patriot* (London: Oxford University Press, 1967).

27. Edward W. Blyden, "Letter from Mr. E. W. Blyden," *African Repository* 30, no. 8 (August 1854): 237–39, 239.

28. Appendix to the *Thirteenth Annual Report of the American & Foreign Anti-Slavery Society, Presented at New-York, May 11, 1853* (New York: John A. Gray, 1853), 192–93.

29. Ibid., 193.

30. "A Glance at 'Topsey's' Home," *Independent*, n.d., reprinted in *African Repository* 29, no. 10 (October 1853): 212.

31. "Trial and Conviction of Alfred T. Wood," *African Repository* 32, no. 1 (January 1856): 29.

32. For an important analysis of influential claims that people of African descent were not capable of self-determination or self-government, made by Thomas Jefferson and other Enlightenment philosophers, and of the role that cultural production, including literature, played in such assessments and in blacks' responses to these claims, see Gene Andrew Jarrett, "'To Refute Mr. Jefferson's Arguments Respecting Us': Thomas Jefferson, David Walker, and the Politics of Early African American Literature," *Early American Literature* 46.2 (2011): 291–318.

33. Dinius (*The Camera and the Press*, introd. and chaps. 4–5) discusses this representational authority at length.

34. Quoted in Carol Johnson, "Faces of Freedom: Portraits from the American Colonization Society Collection," in *The Daguerreian Annual, 1996* (Pittsburgh: Daguerreian Society, 1997), 270.

35. Alexander Crummell, *The Future of Africa: Being Addresses, Sermons, Etc., Etc., Delivered in the Republic of Liberia* (New York: Scribner, 1862), 12–13.

36. Augustus Washington, "Liberia as It Is," pt. 2, *New-York Daily Tribune*, 14 November 1854, 6.

37. Edward W. Blyden, *The Origin and Purpose of African Colonization* (Washington, DC: American Colonization Society, 1883), 14.

38. Ibid., 21.

39. Ibid., 22.

40. For statistics on emigration compiled from ACS records, see the appendix in Staudenraus, *African Colonization Movement*, 251.

41. According to Staudenraus (ibid., 251), there were 527 emigrants in 1865, 621 in 1866, and 633 in 1867.

42. "About Us," *Perspective*, http://www.theperspective.org/editorial.html (accessed 5 May 2015).

43. Siahyonkron Nyanseor, "The Tradition of Uncle Tom's Relatives," pt. 1, *Perspective*, 22 May 2006, http://www.theperspective.org/articles/0522200601.html (accessed 5 May 2015).

Part II

Freedom's Pathways

Emily Sahakian

Eliza's French Fathers: Race, Gender, and Transatlantic Paternalism in French Stage Adaptations of *Uncle Tom's Cabin*, 1853

In France, Harriet Beecher Stowe's *Uncle Tom's Cabin*, most often translated as *La case de l'oncle Tom*, was an explosive sensation. Just days following the first publications of translated excerpts in the French feuilletons, "Tom mania," to borrow Sarah Meer's term, was already sweeping France.[1] Edith Lucas's 1930 French-language study meticulously documents the immense and unprecedented vogue surrounding Stowe and her novel in France.[2] Within ten months, eleven different French translations were published and widely read across the nation; no foreign book had ever received such prodigious success.[3] References to Uncle Tom in the French press were ubiquitous. "Everywhere you go," wrote one French critic in January of 1853, "you hear nothing but the question: Do you know *Uncle Tom's Cabin*? This question has replaced the famous: How are you?"[4] Tom mania, as Meer notes, not only "produced the meaning of Stowe's book in the culture of the 1850s" but "ensured that it took on a variety of meanings."[5] In France, as in the United States and Britain, writers, musicians, and artists sprung to adapt Stowe's novel to various media, ranging from cartoons and songs to children's books and popular theater.

In addition to exploiting the novel's commercial appeal, these adaptations reimagined Stowe's anti-slavery and pro-feminine messages, testing their relevance across cultural contexts. French adaptations of *Uncle Tom's Cabin* offered new renderings of Stowe's gendered and racialized meanings; race and gender became transnational signifiers in political struggles that appeared to bridge the Atlantic. This is evident in the humorous periodical *Le charivari*'s self-reflexive commentary on France's Tom mania. In an

1852 cartoon, Parisian bluestockings conspire, "Let's take advantage of the situation. Uncle Tom is in vogue . . . let's quickly write a novel titled Aunt Tom."[6] While this cartoon shows educated, intellectual women planning to repurpose the novel's feminist possibilities, a short fictional story attests to the challenges of translating race. As a transnational signifier, race is ambivalent and indeterminate, but it also accrues concrete associations in particular cultural contexts. The fictional story plays with these tensions by questioning what constitutes blackness and who can understand and interpret the black experience. In the story, ten of Stowe's French translators arrive at her hotel during her 1853 visit to Paris. Unable to speak English, they attempt to communicate with her in a French black dialect, which she does not understand.[7] As the story amusingly suggests, though France and the United States shared a slaveholding history, the articulation of blackness and the black experience was culturally specific and thus difficult to translate. It might also imply that Stowe, as a white woman (like her white French translators), did not really speak the language of Caribbeans and African Americans, despite her celebrity in France as a kindred advocate for abolition.

Among these adaptations of *Uncle Tom's Cabin* were three competing melodramas that appeared in the first months following the novel's initial translation. In January 1853, the popular Parisian Théâtre de la Gaîté and Théâtre de l'Ambigu-Comique opened two different adaptations. The first, a drama in five acts titled simply *Oncle Tom* and created by two of the novel's translators, Edmond Auguste Texier and de Leon de Wailly, opened at the Gaîté.[8] Two weeks later, the Ambigu-Comique opened *La case de l'oncle Tom*, a drama in eight acts by the well-known playwrights Philippe Dumanoir and Adolphe Dennery (who would subsequently change his name to d'Ennery).[9] This second, more popular adaptation foregrounded the struggles of the mixed-race married couple Eliza (Elisa in the French) and George (Georges) and replaced Stowe's Christianity with faith in humanism and the law. In contrast, Texier and Wailly's adaptation attempted to respect the multiple plotlines and Christian message of Stowe's novel more closely, but it also put Elisa and her family center stage. Opening at the Gymnase in February was a two-act comedy by Arthur de Beauplan, *Élisa, ou Un chapitre de l'oncle Tom* (Elisa; or, A chapter of Uncle Tom), which capitalized on Dumanoir and Dennery's success by making Elisa the leading, eponymous character and playing up the sensationalist theme of her overpowering desirability.[10] Several parodies, including the *Casine de l'oncle Thomas* (a play

on Stowe's title that might be translated as "Uncle Thomas's cabinette") and the *Cave de l'oncle Pomme* (Uncle Apple's cave), quickly followed.[11]

While all three serious stage adaptations were central to France's Tom mania of the 1850s, the play by the established dramatists Dumanoir and Dennery was by far the most popular and influential. In January 1853, *Le charivari* humorously portrayed the rival plays in competition: a cartoon shows two theater managers fighting over Uncle Tom in a tug-of-war (fig. 5). But Dumanoir and Dennery's freer adaptation quickly eclipsed Texier and Wailly's more Christian play. Dumanoir and Dennery's drama played to full houses for seventy-five nights (not counting matinées),[12] whereas Texier and Wailly's ran for thirty-three.[13] De Beauplan's adaptation echoed several of Dumanoir and Dennery's choices, including their emphasis on Senator Bird and featuring of a mixed-race villain who desires Elisa. It ran for twenty-nine nights.[14] Of the three plays, only Dumanoir and Dennery's was immediately reprised following its initial run—by two other theaters in Paris and then in Le Havre, Bordeaux, Nantes, Lyon, Dijon, Marseille, Strasbourg, Toulouse, and Amiens.[15] Furthermore, it has had the most lasting influence: it was restaged somewhat regularly into the early twentieth century.[16] Beyond France, Dumanoir and Dennery's adaptation was translated and performed in Spain in 1864[17] and, as César Braga-Pinto's essay (this volume) reveals, has been key to the ongoing reception of *Uncle Tom* in post-abolition Brazil.

With a focus on these three plays, I investigate how the antislavery and pro-feminine messages of Stowe's novel were ideologically transformed as the book was translated and adapted, by white male playwrights, for the French stage. Most striking about the reimagination of Stowe's novel on the French stage was how Stowe's eponymous black Christian martyr Uncle Tom was upstaged by the beautiful mixed-race mother Elisa and the men who protect her. Each of the playwrights approached the act of adaptation with different aims, and their texts display crucial differences, which I will discuss in further detail below. However, generalizing across the three plays reveals how Elisa captivated France's playwrights, critics, and audiences. This is most conspicuous in De Beauplan's shorter play, which was probably written in response to the public's fascination with Elisa in the two first plays. He went so far as to name his play *Élisa, ou Un chapitre de l'oncle Tom*, making Elisa his title character while nonetheless presenting his drama as a "Chapter from Uncle Tom." The two longer plays, respecting the unity of action, devised different ways of merging Stowe's multiple plotlines into one,

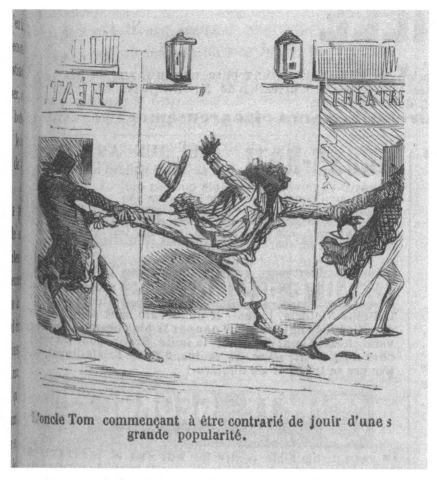

L'oncle Tom commençant à être contrarié de jouir d'une s
grande popularité.

Fig. 5. Cartoon in which two theater managers compete for Uncle Tom (From "Revue de la semaine," *Le charivari*, 23 January 1853, 3, courtesy the British Library [Lou.F.15]. © The British Library Board.)

and each of them significantly expanded Elisa's role. The struggles Elisa's family endured to be together provide the major dramatic conflict in each of the plays. Tom consequently plays a somewhat minor role in Dumanoir and Dennery's play. For their parts, Texier and Wailly make an unexpected choice in order to preserve Tom's place at the center of the action while putting the spotlight on Elisa: they make the black Uncle Tom the father of Elisa and thus another member of her family of escaped fugitive slaves.

As Meer points out, the Tom mania of the 1850s necessarily involved mutations, as adaptations of *Uncle Tom* "were often willful 'misreadings,' deliberately partial, and of course especially loaded in their attitudes to slavery."[18] Each of the adaptations, particularly Dumanoir and Dennery's most popular play, represents a secularization and masculinization of Stowe's antislavery politics. Paralleling Tom's minimization, the theme of Christianity was present in the plays but was largely overshadowed by a faith in secular humanism. The crafting of a central white male hero—a politician (Senator Bird) in two of the adaptations, a boat captain (named Kentucki) in another—represents how humanism in these plays was connected not to religion but to the law and the nation. In each of the plays, this white male character protects Elisa from the slave catchers, despite his awareness of the illegality of his actions. The playwrights emphasized, to varying degrees, Elisa's helplessness and sexual desirability, and audiences celebrated the men who protected, supported, and guided her. Furthermore, the theme of the education and civilization of the slaves was played up by each of the adaptations, discussed in reviews, and reinforced by the onstage semiotics of race and gender. Elisa's family, slaves who are almost white, were celebrated, even as black comic characters were offensively associated with monkeys.

The metaphor of paternalism, which was a common trope for understanding slavery in France and its Caribbean colonies, pervaded the remaking and reception of the Uncle Tom story on the French stage. The white men mentioned above acted as fathers toward the enslaved characters—Elisa and her family and the comic black characters—and the trope of "fathering" emblematized the slaveholding country's relationship with its enslaved Africans, who were positioned as children in need of education and cultivation. Repeated references to Elisa's desirability and subtle allusions to the unrealized possibility of a sexual encounter between Elisa and her white male "fathers" sensationally served to drive home this central schema. The trope of fathering operated at the levels of both individual characters and larger ideologies of national politics. The metaphor facilitated comment on the politics of the United States (slavery and the Fugitive Slave Act) and France (including the censorship of the theater) and implicitly positioned these countries as two "fathers" vying for the status of deserving patron of a transnational community of (feminized) black and mixed-race slaves. Whereas the play by Dumanoir and Dennery and that by De Beauplan reinforced the status quo of this paternalist vision of slavery and abolition, Texier and Wailly questioned it. By making Tom Elisa's father, these last two

playwrights undermined the white male fantasy, entertained by the other playwrights, of fathering beautiful mixed-race daughters, and they affirmed Tom's black masculinity, in paternalistic terms.

FROM PAGE TO STAGE

The reception of Stowe's novel in France was mixed, since the book was celebrated for its political merits but largely dismissed as a work of art. While none could deny its popularity, French critics questioned the literary merits of *Uncle Tom's Cabin*, which they viewed as topical and socially oriented, as opposed to objective and universal. In a letter to Louise Colet, Gustave Flaubert explained that the novel failed to meet the criteria of "art for art's sake."[19] French literary critics and authors, with the notable exception of George Sand, largely ignored the novel. As Lucas points out, despite its prominence in the French press, only three respected literary critics published serious evaluations of Stowe's novel.[20] Though elite French writers and critics were dismissive of the novel's value as a work of art, they almost unanimously agreed that the book would have a real influence in the political realm.[21] When Stowe traveled to France, she was welcomed more as an abolitionist than as a literary figure.[22] As a work of antislavery writing, *Uncle Tom's Cabin* was not without precedent in France. French-language literature, from the Enlightenment philosophers to the French romantics of the nineteenth century, had long debated and criticized the institution of slavery (albeit often ambivalently).[23] Yet Stowe's antislavery message seems to have resonated more powerfully with French-language readers than the messages of elite, now-canonical French writers, such as Montesquieu, Voltaire, or Claire de Duras. The novel's value as an antislavery work corresponded with its perceived failures as objective, "universalist" art, for it was conspicuously engaged with the current moment and with the social problem of slavery.

White women and writers of color defended the novel. As Doris Kadish has argued, the reception and translation of *Uncle Tom's Cabin* in France was crucially gendered. According to her, Flaubert's critique served to dismiss the legitimacy of women's writing.[24] Kadish points out that the defenders of *Uncle Tom's Cabin* were women, such as George Sand and Stowe's only female French translator, Irishwoman Louise Belloc. The latter argued that the book should not be judged "from a purely literary point of view," and Sand insisted that what critics perceived as the book's "defects only exist

in relation to artistic conventions that have never been and will never be absolute."[25] Haitian writer M. Saint-Remy was unequivocal in his praise of Stowe. He dedicated his 1853 edition of Toussaint Louverture's memoirs to Stowe and deemed her book a "philosophical novel," perhaps in response to her critics. "It's an homage that I believe I must pay to you," he wrote, "as a member of the oppressed race of which you have so generously, so gloriously, and so happily taken on the cause."[26]

Emotion and sentiment were key factors in the debate regarding the novel's literary merits, and Stowe's sentimental discourse made her book suited better, in many ways, for the French stage than for elite literary circles. In defense of Stowe's novel, Sand evoked the author's mastery of intense emotions, which Sand contrasted with the critics' impotent aesthetic and metaphysical criteria, asserting that if one were to watch any of Stowe's critics, "enamored of what they call structure," read any chapter at random, their eyes would "not be perfectly dry."[27] In contrast to Flaubert and other French critics' insistence on literature's objectivity, the theaters of the Parisian boulevards already had the reputation as a place where audiences went, unashamedly, to cry.[28] It is thus not surprising that the playwrights and producers of French melodrama eagerly embraced Stowe's socially oriented sentimentalism. "It was impossible," wrote one critic in January 1853, "that the emotion of the book would not pass through the theatre."[29]

As the emotion of the book passed through the theater, its meanings were ideologically transformed. The texts of the eleven different French translations of the novel already present various modifications and transformations, many of which appear to be ideologically driven.[30] In the theatrical adaptations, such transformations and misreadings were even more conspicuous; the playwrights had free rein to remake the story, since French melodrama commonly adapted popular fiction, especially novels, to the stage. John McCormick notes the important relationship between the feuilletons and the theater, which put "on the stage characters already familiar to the majority of the audiences, characters with whom they had lived, and whose adventures they had followed over the course of a year or more."[31] Theatergoers did not expect the plays to be faithful reproductions of the novel but, rather, understood them as a new incarnation of it, whose meanings simultaneously stemmed and diverged from Stowe's. Thus, one critic congratulated Dumanoir and Dennery for having known "skillfully to borrow and stage the most dramatic situations, the most touching episodes of Madame Beecher Stowe's beautiful novel."[32]

In contrast with the U.S. stage adaptations, which are commonly cred-
ited with transforming Stowe's antislavery message into a racist representa-
tion of enslaved blacks,[33] the French melodramas were generally viewed as
part of a trend of antislavery, "négrophile" drama, since there was a vogue,
at that time, of melodramas featuring black and mixed-race protagonists
and dealing with the issues of slavery and colonialism.[34] In the 1840s and
1850s, the cause of black liberation was associated with popular melodrama.
In his 1850 preface to his play *Toussaint Louverture*, Lamartine positioned
melodrama as a key genre for popularizing black emancipation.[35] Black and
mixed-race characters provided parallels with white French workers and
served to question the social meanings of race. For example, an 1846 play
by Dumanoir and Anicet-Bourgeois, *Le docteur noir* (The black doctor),
tells the story of a talented mixed-race doctor who cannot be with the white
woman he loves, due to the racism of her mother, an antediluvian mar-
quise.[36] While *Le docteur noir* suggests that racism is a problem of old, pre-
revolutionary France, the Uncle Tom plays, set in the United States, dissoci-
ate the issue of slavery from French soil. A later play, Barbier's melodrama
Cora, ou L'esclavage (Cora; or, Slavery), which opened at the start of the
American Civil War (1861), shows how the questions of racism and slavery
for French theatergoers continued to be displaced to the United States fol-
lowing France's Tom mania. Barbier's play tells the story of a refined qua-
droon beauty, Cora, who grew up happily in France but is enslaved when
she returns to America (the place of her birth).[37] These "négrophile" dramas
were only a small part of the larger repertoire, and the Uncle Tom plays
were also influenced by broader contemporary theatrical conventions and
trends.

John McCormick calls the French dramas of the 1830s through the 1850s
"social melodrama" and argues that in addressing the social issues of the
time, these plays complicated the Manichean characters and simplistic
moral messages characteristic of the earlier melodramas.[38] As a virtuous
male hero, Stowe's Uncle Tom was at odds with these trends, which may be
one reason why the playwrights chose to downplay his role.[39] Better suited
to the genre was Elisa's husband Georges, who was made an "avenger" in
the French Uncle Tom plays.[40] As for the female lead, McCormick points
out that the heroines of French social melodrama were more assertive with
their sexualities and desires than the archetypal pure victims of earlier
melodramas. In contrast, the Uncle Tom plays portrayed Elisa as the pure,
objectified victim, but they also made her sexuality a sensationalist theme.

In each of the plays, Elisa is a pure, chaste Christian woman in need of help from multiple men. In the play by Dumanoir and Dennery and that by De Beauplan, her sexual attractiveness and desirability are highly exaggerated. By emphasizing their mixed-race villains' uncontrollable desire to seduce Elisa, these plays treated the question of Elisa's sexualization sensationalistically without considering Elisa's own sexuality and desires.

In addition to the antislavery message, the playwrights also used their Uncle Tom plays as means of commenting on other social issues, particularly French censorship of the theater. With Napoleon III's escalating authoritarian power, the Bureau of Censorship became increasingly repressive in 1850 and 1852. Lucas suggests that this rise in censorship bolstered Stowe's popularity in France, since domestic writers were limited in the literature they could produce and because the censors tended to view foreign works as politically nonthreatening.[41] Theater censorship at that time was active and far-reaching.[42] Playwrights were thus aware of two different spectators: French theatergoers of the time and the censors, who could exert a series of modifications before granting permission to produce a play. The censors wished to ensure that the theater would be, as one of their directives stated, "a place of relaxation and distraction and not an open arena for political passions."[43] To that end, they sought to forestall French workers' identification with black slaves in the Uncle Tom plays.[44]

The Three Plays

While the French Uncle Tom plays differ widely in their plotlines, each selects and reshuffles certain elements of Stowe's novel to tell a new version of Elisa's story. All of the plays begin like Stowe's novel and roughly follow her plot through Elisa's heroic crossing of the Ohio River. De Beauplan's concludes shortly thereafter, at Senator Bird's house. Following her escape, Dumanoir and Dennery show a dramatic confrontation between Elisa's family and the slave catchers, in a rocky ravine (a scene that is briefly mentioned in Stowe's novel); follow Elisa to St. Clare's (Saint-Clair in the French) estate; portray a dramatic slave auction, in which multiple men bid on Elisa; and close with a duel to save Elisa's family and honor, between her husband Georges and the play's villain Harris. Whereas Dumanoir and Dennery underscore the mixed-race woman's appeal as a sexual object and conflate Stowe's Eliza, Emmeline, and Cassy, playwrights Texier and Wailly highlight Elisa's motherly role. In their play, Elisa is

conflated with Stowe's Lucy, an enslaved woman who is aboard the riverboat with Tom and commits suicide by diving into the water after her son is taken from her.[45] But Texier and Wailly's Elisa is secretly rescued by the boat's captain, Kentucki, and then happily reunited with her father and husband, the latter of whom buys back their lost son. The play by Dumanoir and Dennery and that by Texier and Wailly took advantage of stage machinery and other technological advancements in order to play up Elisa's role. Spectacularly, both plays show Elisa's crossing of the Ohio River (De Beauplan, rather than showing the feat onstage, scripts Chloé and Haley's reactions to it, as they watch from a window). The scenes in which the slave catchers chase Elisa and her family were also staged spectacularly: Dumanoir and Dennery include the aforementioned scene in the rocky ravine, and a boat chase amid the rapids and waterfalls of the Ohio River occurs at the close of Texier and Wailly's play.

A basic schematization of the three plays contextualizes Elisa's centrality within a broader view of adaptation choices (table 1). Out of necessity, the plays significantly decreased the number of different settings and combined several characters. Whereas Eliza and her family are hidden and aided by multiple men and women in Stowe's novel, the French plays craft a leading, secular, white male hero who protects them. In the play by Dumanoir and Dennery and that by De Beauplan, this character is Senator Bird, who is obsessed with the law. In Texier and Wailly's play,

Table 1. Adaptation Choices

	Playwright(s)		
	Dumanoir and Dennery	De Beauplan	Texier and Wailly
Elisa's protector	Bird (politician)	Bird (politician)	Kentucki (captain)
Villain	Harris (mixed-race)	Haley/Samuel (mixed-race)	Locker (white)
Elisa's origins	Mother was a slave	Unspecified	Tom is her father
Eva	Dolly (secular; small role)	Shelby's sister (backstory)	Evangéline (Christian martyr who does not die)
Comic black character(s)	Bengali and Philémon	Adolphe	Adolphe, and Topsy (cunning)
Listed first on the distribution of roles	Bird	Haley	Tom
End point	Harris's (Legree's) plantation	Bird's house	Canada

Captain Kentucki (also spelled "Kentucky"), preoccupied by questions of legality, fills the Bird role. Broadly speaking, Haley's attempts to seduce Elisa drive De Beauplan's play, while Dumanoir and Dennery emphasize Senator Bird's conflict between his love for the law and his compassion for Elisa's family, the fugitive slaves. For their parts, Texier and Wailly foreground geography and the reunification of Elisa's family unit. The adaptation by Texier and Wailly (who also translated the novel) appears to respect Stowe's novel most closely, despite its bizarre ending with a boat chase. Texier and Wailly reproduced many of Stowe's lines directly on-stage and included the largest number of her characters.

To varying degrees, the French playwrights secularized the Uncle Tom story. The quotations from Methodist hymns and Negro spirituals that pepper Stowe's novel were largely absent from the French stage, with the exception of Texier and Wailly's reproduction of the spiritual "Wings of the Morning," which Eva and Tom sing together, leading Eva to ask about New Jerusalem and then to proclaim that she is bound for the sky.[46] Texier and Wailly's Evangéline (given her full name in their play, a continuous reminder of religious connotations) is an important character and self-declared martyr, insofar as she wishes to die for the slaves.[47] Ultimately, however, she does not die, thanks to Tom's fervent prayer, which saves both her life and the soul of her father, Saint-Clair (by instilling in him faith in God).[48] In Dumanoir and Dennery's play, Dolly (their version of Eva) plays a much smaller role. In addition to the secularization of her name, she is described not as a Christian but, rather, as a "négrophile and abolitionist."[49] Eva does not even appear onstage in De Beauplan's play, though she is mentioned as part of the backstory: she was Shelby's sister, a beautiful blond angel who died as a child.[50] In comparison with the two other plays, Texier and Wailly's version also gives the most attention to Tom. Whereas the prop of Tom's Bible is fodder for joking in De Beauplan's play,[51] it represents the serious transfer of Madame Shelby's Christian teachings to Tom in Texier and Wailly's adaptation.[52] Yet even Texier and Wailly are ambivalent in their treatment of Tom's Christianity. As will be discussed below, Tom's zealous faith leads him to expose his daughter Elisa to the slave catchers following her escape.

It is no coincidence that the most popular adaptation, that by Dumanoir and Dennery, was also the most overtly masculinized and secularized. Their Senator Bird, a white, secular politician, completely replaces Stowe's Rachel Halliday and Phineas Fletcher and becomes the larger hero of the

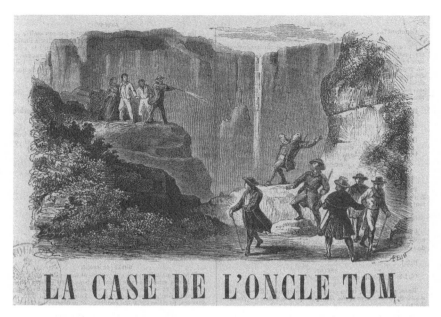

Fig. 6. Frontispiece of Dumanoir and Dennery's play *La case de l'oncle Tom*. (Courtesy of the Bibliothèque nationale de France.)

play. Bird is listed first on their distribution of roles, attributed the play's final lines, and featured in the frontispiece, which shows him protecting Elisa and her family by firing his rifle at the slave catchers in the rocky ravine (fig. 6). As they translated *Uncle Tom's Cabin* across cultures and adapted it to a new genre, the French playwrights transformed the antislavery messages in Stowe's novel and reshuffled the signifiers of race and gender. While bearing the traces of the story's original contexts, the French Uncle Tom plays remade the story to reflect the conventions of French melodrama, to engage with the dominant metaphor of slavery and colonialism as "fathering," and to reassure and flatter the consciences of French spectators.

TRANSLATING SLAVERY IN POLITICAL CONTEXTS

The French stage plays were the result of multiple transpositions of the Uncle Tom story, from one language and culture to another and across media—from a written text to an onstage performance. Rather than attempting to obstruct these multiple acts of transfer, the three plays called

attention to the Uncle Tom story's translational state. The playwrights did not transfer Uncle Tom from one context to another so much as play with its palimpsestic qualities. This allowed the French melodramas to figure Uncle Tom as, simultaneously, (1) a view into American slavery, (2) an opportunity to comment on current French politics, and (3) a transnational, transferrable parable for all (former) slaveholding nations.

France's slaveholding history was similar yet critically different from that of the United States. To be sure, France profited considerably from the enterprise of slavery. In the eighteenth century, the colony of Saint-Domingue (which would become Haiti) rose far above all other islands in terms of productivity and profits. By midcentury, it was producing more sugar for France than was produced for England on all of the British islands combined.[53] Guadeloupe was also remarkably profitable. In 1764, it ranked fourth in sugar production.[54] The tiny island of Martinique, which, as Michel-Rolph Trouillot reminds readers, is one-fourth the size of Long Island, imported more African captives than all the U.S. states combined.[55] However, even as the French slave system in the Caribbean was incredibly lucrative, there were no slaves on French soil. In fact, the maxim "There are no slaves in France" was so powerful in the French national imaginary that hundreds of slaves brought to France as servants by their colonial masters were able to obtain their freedom by arguing simply that they should be free because there were no slaves in France.[56] Furthermore, France had already abolished slavery (twice in fact) before the time of the Uncle Tom stage productions in 1853. Slavery was originally abolished in the French colonies in 1793, with the French Revolution, but Napoleon reinstated slavery in 1802. The second (and final) abolition of slavery was decreed in 1848, along with the Second Republic. Shortly thereafter, in 1852, Napoleon III declared himself emperor and granted himself dictatorial powers. In this context, the plays provided an occasion to reflect on what happens after abolition—specifically, how free people formerly enslaved would fit into colonial society.

Stowe's antislavery message was selectively relevant to French politics. French theatergoers could thus see the Uncle Tom plays as both speaking to and dissociated from French concerns. On the one hand, France had profited immensely from slavery, and its final abolition was just five years old. Since the revolutionary reforms of 1848 seemed to be giving way to a new monarchy under Napoleon III, the time of these plays' openings in 1853 might have reminded French theatergoers of 1802, with its reinstatement of slavery. On the other hand, spectators could take comfort in

their superior laws, as well as the fact that there were no slaves in France. The setting of Uncle Tom plays in the United States comfortably distanced slavery—dissociating it from France, as many French philosophical and literary texts did before them.[57] The plays offered what Sylvie Chalaye calls a "reassuring schema," flattering the consciences of French spectators, who could denounce the horrors of slavery in the United States.[58]

Simultaneously bridging and affirming cultural and political differences, the French Uncle Tom plays negotiated between evoking U.S. particularity and drawing analogies to the French context. To translate American culture, customs, and realities for French target spectators, the adaptations relied on theatrical devices such as picturesque scenic design and music evoking the landscapes and sounds of the United States. De Beauplan's play opens with the chorus singing what he deems an "American air," a lighthearted song that celebrates eating pudding and cakes.[59] Actors made self-reflexive references to similarities and differences between French and U.S. slavery. For example, echoing Stowe's note to her readers, the plays explain how slave marriages were illegal in the United States.[60] The historical situation in the French colonies was similar but not so rigid. Because married women were thought to be the most fertile and because France was anxious over the need to respect Christian values, enslaved men and women were encouraged to marry each other.[61] Especially in the early period of colonialism, slave masters would support and sanction these marriages. If two slaves from different plantations were in love, masters would often make arrangements so that they could be together.[62] Nonetheless, the slave masters had complete control over these marriages. They could force enslaved men and women to marry or could separate them, as they saw fit.[63] The Code Noir, laws passed by Louis XIV in 1685 to regulate the conditions of slavery, protected slaves' right to marry each other with the consent of the master but stated that slave masters had the right to separate slave families by selling family members once the children reached puberty.

Other elements were Frenchified—that is, domesticated—to fit target spectators' expectations. Domesticating translation choices were also treated self-reflexively onstage. When discussing slave sales, the characters drink eau-de-vie, a fruit brandy and French specialty.[64] Texier and Wailly's character Halley (Haley) remarks, "This is a fine bottle. Does it come from France?"[65] Characters also provided an onstage translation of the term *uncle*, which was used on U.S. plantations to refer to an older, trusted male slave. The plays explain the term and its U.S. usage onstage and self-

reflexively recognize that it might sound strange to spectators. Texier and Wailly's character Shelby explains that the term is for devoted servants who have been incorporated in some way into the master's family.[66] In the De Beauplan play, Adolphe says, "Uncle Tom! It's funny . . . I call you Uncle Tom. I don't know why—you aren't my uncle any more than you're any of these other fellows' uncle . . . But it's about friendship, and it's a habit."[67] This discussion alludes to the act of translation that preceded the play. In the French translations of Stowe's novel, the term *uncle* was translated sometimes as "oncle" and other times as "père" (father).[68] Such ongoing acts of self-reflexive translation served to figure Stowe's antislavery message as belonging to the source culture but also relevant to France.

The transfer of Uncle Tom to the French stage represented an ideological translation, since it downplayed Stowe's Christian and pro-feminine messages and instead emphasized, remade, and questioned her paternalistic meanings. Paternalism was not an invention of the French stage plays, since it is already a theme in Stowe's novel, present in the discussions between Miss Ophelia and St. Clare on the need to educate slaves, as well as in the final chapter (before Stowe's concluding remarks), in which George Shelby legally frees his slaves (many of whom do not even think they desire their freedom) but plans to educate them as servants on his plantation: "I expect to carry on the estate, and to teach you what, perhaps, it will take you some time to learn,—how to use the rights I give you as free men and women" (446). The French stage plays made this secondary theme of paternalism, which they linked to the rescue of Elisa and her family, central to the story's structure. In Stowe's novel, France plays a part in the freedom of Eliza's family. Madame de Thoux, George's lost sister, finds her brother in Canada and then takes the family to France, where George obtains a "very thorough education" (440). The French playwrights may have been inspired by the ways in which Stowe associated France with emancipation and education, but they do not reproduce such small details. None of the plays follow Elisa's family to France (or Liberia); rather, they end in either the United States or Canada.

The concept of paternalism was a prominent metaphor for making sense of slavery in nineteenth-century France. Doris Kadish demonstrates how early nineteenth-century antislavery writings by women used the trope of the "father" to call into question oppression exercised over women and people of color.[69] The same rhetoric was used to speak of everyday life on plantations under slavery. French white colonists commonly understood

and regulated their slave societies through a sexualized, filial logic of father-daughter/child relationships, as Doris Garraway has argued. In her theorization of the "family romance," Garraway shows how white men invoked the family unit, of the white slave master, the black female slave, and their mulatto offspring, "as a means of consolidating political authority over non-whites."[70] Moreover, as she suggests, the white male elite was preoccupied with the idea of interracial sex, and this filial logic showed the "same white male factor crossing with the mixed-race female product of his prior union, to the nth degree."[71] The family romance of the plantation, in other words, "reflects the unconscious incestuous desires of the white male elite."[72] The pervasive idea of a necessary (white or black) male protector even extended to French abolitionist rhetoric, which condemned slavery for denying black men rightful ownership of their wives and children.[73] Beyond the individual father figure, paternalism was conceived as a transatlantic metaphor, summarized by a filial relationship in which France—the nation—was conceived as the father of its colonies.[74] As in France's rhetoric of the *mission civilisatrice* (civilizing mission), the father is understood to know what is best for his children and thus controls them through education.[75]

This theme of paternalism—that is, the white man's protection and exercise of control over his slaves, in what he perceives to be their best interest—emerges forcefully in each of the plays, especially in Dumanoir and Dennery's (the most popular adaptation). In contrast, the absolute power of the father and the enslaved people's need for his education is questioned by Texier and Wailly. Sylvie Chalaye sees the Uncle Tom stage adaptations, with their association of enslaved blacks with monkeys, as a sign that theories of scientific racism had already infiltrated the public's mentality.[76] In this context, racism and antislavery sentiment went hand in hand, since the playwrights stressed the need to civilize black slaves so that they would successfully assimilate into white society. Like the broader rhetoric, paternalism in the French plays operates on both the national and individual family levels and involves slippage between the father figure and the nation as father.

PATERNALISTIC MELODRAMAS

In this final section, I offer a closer view into the French melodramas. Attention to performative dimensions of the adaptations reveals more about the plays' material conditions of writing, production, and reception, includ-

ing pressures exerted by the French censors. The published plays constitute my most important archival source, since the play text is the most complete trace of the cultural and ideological translation to which I have access. It is also important to note that the social life of the text extended beyond the evening of the performance. During the nineteenth century, as Angela Pao points out, there was a great demand for printed texts, which were often read aloud socially, facilitating ongoing engagement with a play after its performance.[77] I supplement my textual analysis with further information about the plays' staging and reception, provided by critical reviews and, when available, a score, a manuscript, line drawings, and other pertinent discussions held about the plays outside the theater.[78] My analysis is organized thematically, to explore the complex and nuanced ways in which the trope of "fathering" serves to facilitate reflection on slavery and to remake Stowe's Uncle Tom story. First, I examine the mixed-race characters, which serve to stress the arbitrariness of race and are linked to the sensationalistic theme of interracial sex. Second, I turn to the plays' portrayal of comic black characters, who are shown as in need of education and civilization by white men. Third, I argue that the plays measure "fathers" against one another, encouraging spectators to judge the extent to which a white man is worthy of having black and mixed-race "children" under his power and tutelage. In conclusion, I suggest that the plays evoked a transatlantic, metaphorical three-way relationship, in which the United States and France vied for the status of the better "father" to Elisa and her family.

Mixing Races, Trading Places

In the French stage plays, Stowe's mixed-race characters became the major protagonists, and some of Stowe's white characters additionally became *mulâtre* (mulatto). At a time when the social category of race was being delineated, these mixed-race characters served to question the meanings of race. They also enabled white spectators to identify with the plays' heroes as not essentially different from themselves. Biological race was thus shown to be arbitrary, even as education and assimilation into French culture and values were positioned as the "true" indicators of whiteness. Actors' use of blackface and brownface makeup both reinforced and disrupted the meanings of race scripted in onstage dialogue. Mixed-race characters additionally implied a history of interracial sex, which became a sensationalistic theme.

Elisa and her family are portrayed as worthy of French protection due to their perceivable whiteness. As Saint-Clair comments, visiting Shelby's plantation at the start of Dumanoir and Dennery's play, Henri is almost as white as himself and his daughter Dolly, and Elisa looks more like "a beautiful daughter of Judea" than of the African race.[79] The perception of Elisa as Jewish marks her less as an essentially racialized other than as one who can pass as white.[80] Yet, even as onstage dialogue insisted on Elisa's white appearance, actress Emilie Guyon played the role of Elisa in brown-face makeup. Similarly, Frédérick Lemaître had played the main role in *Le docteur noir*—the mixed-race, talented, educated doctor—in blackface. In these cases, the black and brown makeup served not only as a signifier of racial difference but also as a reminder of the arbitrariness of biological race (as opposed to education). These characters, in other words, were portrayed as both white and black, transgressively slipping between the two social categories. Thus the makeup could simultaneously exoticize Elisa's body and accentuate her deeper "white" education, upbringing, and values. The playwrights could exploit the sensationalist potential of a mixed-race woman onstage while conveying an antislavery political message. In their stage adaptation of *Uncle Tom's Cabin*, Dumanoir and Dennery were inspired by Richard Hildreth's novel *The White Slave*,[81] which Hildreth rewrote and reissued following the successes of *Uncle Tom's Cabin*. In contrast to Stowe's black Christian martyr, Hildreth's hero is a mixed-race male slave, whose manners and behaviors are "white" and Europeanized. Much as in Hildreth's novel, the figurative whiteness of Elisa's family serves as proof of slavery's inhumane nature. This rhetoric of the exception to the rule, of course, did not challenge the status quo of racism, but it did convey a sense of the injustice of Elisa's situation. De Beauplan's Elisa was white in both upbringing and appearance. In his list of characters, he specified that Elisa's complexion should be almost white.[82]

Because she is Tom's daughter in Texier and Wailly's adaptation, one finds fewer references to Elisa's nearly white complexion in that play. Given that her father is black (and her mother would then, probably, be white), her sensationalist appeal as a mixed-race woman was less powerful and perhaps even off-putting, given the general anxiety surrounding sexual and romantic relationships between a white woman and a black man. Nonetheless, perhaps mindful of Elisa's appeal in the other plays, Texier and Wailly's editors encouraged them to make changes to the text that further accentuated the white appearance of Elisa and her family; the playwrights declined

to incorporate many of these suggestions.[83] Even so, this play stresses Elisa's inherent whiteness, the recognition of which is contingent on the beholder's merits and sense of justice. When Locker tries to recapture Elisa, Kentucki (their version of Bird) asks Elisa publicly whether she is a slave, requesting that she simply give a yes or no answer. When she denies her enslaved status, Kentucki insists that Locker must provide evidence. Until Locker can furnish proof of her enslaved status, she remains, in Kentucki's words, "a free woman, a woman worthy of your respect, worthy of my protection."[84] A white man's word counted unequivocally above a slave's at that time. In this scene, however, so long as Elisa is not known to be a slave, her word is counted above Locker's. Kentucki's attempt to protect Elisa highlights the power of enunciation and performance, thus implying that theater held real abolitionist and antiracist potential.

The power of performance in redefining the meanings of race is even more salient in Saint-Clair's onstage declaration of Georges's whiteness. Though he has deduced Georges's identity as a mixed-race slave, Saint-Clair chooses to recognize Georges as a white man from Canada.

> You are not Georges, because I call you Charles Réade; you are not a slave who has revolted against our laws, since I welcome you into my house. Finally, you are not mixed-race, because I, whose race is pure, I touch your hand.[85]

Saint-Clair performs his power as a beholder and a fellow human, who can choose to see past the unjust laws and practices of slavery. Similarly, spectators see past the arbitrary historical category that discriminates between Georges's status and Saint-Clair's.

In addition to emphasizing the mixed-race statuses of Elisa, Georges, and Henri, each of the plays constructs a mixed-race villain, Harris (named Haley in De Beauplan's adaptation). A mixed-race slave owner or trader was a more realistic scenario in the French context, given that mixed-race men commonly owned slaves in the French Caribbean colonies. In fact, free people of color in Saint-Domingue owned one-third of the plantations, one-fourth of the slaves, and one-third of real estate.[86] Dumanoir, a native of Guadeloupe, was certainly familiar with this fact. At the start of Dumanoir and Dennery's play, Saint-Clair explains that Harris was "born a slave" and "wanted to own slaves in turn."[87] Elisa insists on his essential likeness with her family, calling him "*mulâtre* like us, and a slave like us in the past."[88]

The play stresses that Harris and Georges are both young, mixed-race men and thus that their situations might be changeable. Taking their cue from Stowe, the playwrights portray Georges as smarter and more talented than his master Harris but subject to the latter's jealous abuse of his power. Later in the play, emphasizing the arbitrariness of his social superiority, Elisa tells Harris that in Canada, free from the institution of slavery, Georges will be recognized for who he is: "It's him they will call the master, and it's you [Harris] they will take for a slave!"[89]

De Beauplan takes the villain's status as mixed-race and a former slave to the next level. In his adaptation, Haley was formerly a slave on the same plantation as Tom, where Haley was known as Samuel. Tom and Samuel were childhood friends. Tom wears a dollar (like the one given to Tom by George Shelby in Stowe's novel) that represents his and Samuel's interchangeability. One of their mothers cut the dollar in half and hung one half around each of their necks. At the end of the play, despite the Birds' attempts to disguise Elisa and Henri, Haley has deduced their identities. All seems lost, until Tom reveals Haley's true identity as Samuel. Also an antiessentialist choice, making the villain mixed-race contradicts Stowe's association of the black race with Christianity and virtue. Critics applauded the French stage adaptations for choosing to make the villain mixed-race and for avoiding what one critic called the "deification" of the black race.[90] This was also important to the censors. A follow-up report authorizing Dumanoir and Dennery's drama reveals that the playwrights made Harris (their villain) mixed-race in response to the censors.[91] Of the three adaptations, only De Beauplan's comedy was endorsed by Napoleon III. He and the empress attended the play's premiere.[92]

In each of the plays, Harris/Haley desires Elisa and attempts to trade places with Georges by having sex with his wife. Harris's desire for Elisa, introduced early on in the play,[93] is sensationalized in Dumanoir and Dennery's play. Harris wishes to own Elisa. When she is about to be sold on the auction block, Harris menacingly states that he finds her more beautiful when she is in desperation and tears.[94] Unable to resist Elisa's beauty, Harris admits that he desires Elisa's love and would spare Tom's life and give her all of his fortune if she would only love him back.[95] Likely taking his cue from Dumanoir and Dennery's successes, De Beauplan reproduces and exaggerates Haley's desire for and menacing seduction of Elisa. Taking pleasure in seeing her tremble, De Beauplan's Haley asks Elisa if she is afraid of him.[96] He offers to put her in charge of two hundred slaves and

to make her "the mistress of the house—and the mistress of the master."[97] Yet, even as he pretends to relinquish power to Elisa, Haley exerts his control over her body: his kissing of her hand will be "the down payment of the deal" (*les arrhes du marché*).[98] In the colonial imaginary, the *mulâtresse*, the mixed-race woman, was believed to be a lover of material luxuries and more sexually available than white women, but Elisa, as in Stowe's novel, is flawlessly virtuous, thus resembling the heroines of the earlier melodramas. Haley tries to entice Elisa with power and material items, but she is uninterested.[99] As the extreme model of a pure, Christian woman, Elisa, if perceived as "white," may have seemed an old-fashioned heroine to some spectators. De Beauplan's seduction scene between Elisa (whose makeup was "almost white") and Haley was, according to one review, received with indifference.[100] When she was perceived as a woman of color, in contrast, Elisa's (sexual) objectification became a sensationalistic theme.

As the ultimate object of paternalism, Elisa also becomes a sexual object. This is clear during Dumanoir and Dennery's scene of a slave auction, when multiple men bid on her. Before the bidding begins, the evil Harris declares that Elisa will belong to him, even if he must pay twice her value.[101] When the crier is about to announce her sale to Harris, Elisa desperately crawls toward Bird on her knees, begging him to save her honor.[102] Ultimately, she sells for three thousand dollars to her husband, who arrives to take Bird's place just as Bird gives up.[103] Both playwrights and spectators seemed fascinated with Elisa. Critics lauded the actress Emilie Guyon for her portrayal of the quadroon in Dumanoir and Dennery's adaptation.[104] As the heroine of the plays, Elisa is not strong and independent but, rather, portrayed as in need of protection from multiple (white and black) men—in addition to her husband. Although all three plays spectacularly dramatized Elisa's heroic crossing of the Ohio River, her brave actions are mitigated by subsequent performances of her helplessness. Stage directions script repeated instances of Elisa swooning, crying, and falling on a chair.[105] Onstage, these acts call attention to the actress's physicality and, therefore, to her vulnerability, desirability, and exoticized, racially ambiguous body. Elisa's swooning was used to punctuate dramatic moments. For example, in Dumanoir and Dennery's play, she screams and falls into Tom's arms at the close of the auction scene (in which Henri has been sold to Harris).[106]

As Harris/Haley's attraction for Elisa suggests, this theme of "trading places/races" necessarily evoked sexual innuendos. While the evil Harris desires her fervently, Elisa is passed between the hands of a white (safely

married) man, Bird, and her mixed-race husband, Georges.[107] Near the end of Dumanoir and Dennery's play, it is clear that the unrealized possibility of a sexual relationship between Bird and Elisa is intended to provoke fascination and interest from target spectators. To save Henri's life and Elisa's honor, Bird challenges Harris to a duel. Just before the duel begins, however, Georges—Elisa's true husband—enters. As he did when Bird and Harris were bidding on Elisa on the auction block, he once again takes Bird's place, affirming his role as Elisa's husband. He thanks Bird for having set the terms of the duel for him and then fights Harris himself.[108] Though the mixed-race woman stays safely with the mixed race-man, the play entertains a fantasy of Bird's substitution for Georges.

Interracial sex and the fungibility of race were together associated with Uncle Tom not only on but off the Parisian stages. An exposé of Machanette, the actor who played Tom in Dumanoir and Dennery's adaptation, recounts an anecdote in which fumes coming from his blackface makeup (hidden from view) caused several women on a trolley to faint. Machanette, having forgotten the black makeup hidden under his shirt, went to help one of the women and consequently almost asphyxiated her from the fumes. No one knew what the cause of the fainting was, until another lady saw the blackface makeup peeking out from under Machanette's shirt. To save time between showings of *Uncle Tom's Cabin*, he had removed the makeup only from his face and hands.[109] Machanette's blackface makeup, a sign that white men could become black onstage, provoked (sexualized) fascination and anxiety in the press.

Making Men

While the "whiteness" of Elisa's family proves slavery's injustice, comic black characters mitigate the antislavery message. Through several comic characters, the plays suggest that before black slaves are freed, they need to be educated by their masters. Onstage dialogue links the black comic characters with monkeys on stage. For instance, in Texier and Wailly's adaptation, Adolphe is called "half-monkey, half-black," and, in Dumanoir and Dennery's play, Bird likens the slave Philémon to the monkey he carries.[110] In line with French melodrama's preoccupation with putting the "real" onstage,[111] the performances used live monkeys.[112] This performance history is preserved in the stage directions: for example, "[Bengali] is followed by

Philémon, who is dressed as a bellboy and carries a small monkey."[113] These characters offered performances of blackness akin to minstrelsy conventions, insofar as they hit and kick each other, sing and dance for others, and speak in a patois-type speech. The patois invented by Dumanoir and Dennery incorporated Creole words and used incorrect grammar. For example, Philémon says, "Moi finir li plis tard" (which might be translated as "Me finish dat lata").[114] Texier and Wailly interspersed Topsy's statements with her laughing "hi hi hi."[115]

These comic performances of blackness served to reinforce the importance of France's civilizing mission. Depicting these black characters as France's children, Dumanoir and Dennery's Bird proclaims,

> The black slave is a child; all his life is nothing but a long, minor existence under the tutelage of the master. I say that if you haven't prepared him for emancipation—which may be the project of a century—he will make a sad use of his misunderstood freedom. By the devil! [Diable!] If you want to make free men of them, then begin by making them men![116]

Several critics of this play remarked that though slavery itself was an unjust institution, Bengali and Philémon attested to the need to educate blacks (repeating Senator Bird's rhetoric quoted above) and initiate them into a superior, moral civilization.[117] Bengali and Philémon are foils for Elisa and her family.[118] Whereas Elisa's family of "white" slaves is depicted as in need of paternalistic protection from the horrors and injustices of American slavery, it is suggested that Bengali and Philémon might have been better kept in the conditions of enslavement. Bengali's mistress frees him on his deathbed (because he took good care of her beloved pet monkey), but Bengali does not know how to behave in white society, and he cannot calculate or manage money. Bengali serves as an example of a slave who should not have been freed before being schooled. He is, as Bird states, a slave freed by his master's caprice.[119] Near the end of the play, Bengali chooses to relinquish his freedom. He sells himself to (a now reformed) Haley: he will be not his slave but a servant in Haley's shop, which will provide a sort of apprenticeship to make Bengali into a man.[120] Even Tom does not desire his freedom. Early on in the play, he states that he has never learned how to bring up his children and thus relies on his good master Shelby to do that.[121]

In contrast with Dumanoir and Dennery, Texier and Wailly question the rhetoric of paternalism. Whereas Bird insists on making men, Ken-

tucki stresses the importance of treating enslaved blacks like men: "Treat them like men, and you'll have men at your service."[122] Though the play does feature (former) slaves who appear unprepared for their freedom, it pokes fun at France's civilizing mission. Adolphe, who is comically extravagant, is a perpetual child. He wishes not for his freedom but, rather, to belong to a master worthy of his comically refined tastes for riches and luxuries.[123] More subversively, Texier and Wailly's Topsy is a cunning character who feigns her simplicity in order to help Elisa and her family.[124] In fact, at the end of the play, Topsy—the emblematic minstrel character in many of the U.S. stage adaptations—saves the fugitives by hitting Locker with an ax, then sacrifices her own life by steering his boat into the deadly rapids of the Ohio River. Tom, Elisa, Georges, and Henri are consequently able to reach Canada. Texier and Wailly's more radical message was not as popular in the press—apparently because the playwrights were not paternalistic enough. One reviewer, admitting to slavery's injustice, criticized the playwrights for not putting enough stress on the need to civilize and educate blacks.[125]

Judging the Father

In each of the plays, a white man fills the symbolic role of the father, acting as Elisa's protector in the absence of her husband. These characters are similar to Penetrate in American dramatist Henry Conway's stage adaptation, since they are each secular humanists who have faith in the law.[126] In Texier and Wailly's play, Kentucki secretly saves Elisa's life and crafts a false death certificate after she jumps overboard. In Dumanoir and Dennery's version, Bird shoots at the slave catchers to protect Elisa and her family and to save Georges from the punishment to which he, as a slave, would be subjected for shooting at white men. Critics lauded the well-known actor Chilly for his portrayal of Bird. A line drawing shows Chilly in his Senator Bird costume, with the rifle he uses to shoot the slave catchers, despite the illegality of his actions (fig. 7).

Other father figures in the plays are measured against Bird, and the plays question how well each of these "fathers" take care of their slaves. This judgment of fathers is symbolically linked with geography. Whereas Stowe was careful to avoid equating the South with slavery and villainy, the French stage adaptations drew clear lines between the U.S. North and Canada, associated with progress, and the U.S. South, associated with racism, back-

Fig. 7. Unpublished drawing of Chilly as Senator Bird in Dumanoir and Dennery's *La case de l'oncle Tom*. (Courtesy of the Bibliothèque nationale de France.)

wardness, and even barbarism. When called on to fight Harris in a duel, Bird comments that Southern duels are barbarous and ferocious, unlike the duels common in old Europe.[127] In this brutal tradition, the two opponents, armed with shotguns, hunt each other in the woods. That Bird is named Kentucki in the Texier and Wailly adaptation reinforces the North-South distinction.

Taking their cue from Stowe, the French stage adaptations question the extent to which a slave who has a "good" benevolent master is in a safe or desirable position. The play by Dumanoir and Dennery and that by De Beauplan show how slaves can be put in precarious situations when their good masters die or are forced to sell them due to extenuating circumstances, such as debt. Texier and Wailly once again question the paternalist discourse by presenting a more ambivalent view of the so-called good master. In the other adaptations (as in Stowe's novel), Shelby is reluctant to sell Tom and Henri, but Texier and Wailly show him as encouraging Halley to take Tom and giving in pretty easily when Halley asks for Henri.[128] When asked by his wife how he could have sold Tom and Henri, their Shelby simply replies that they are worth more money than his other slaves.[129] Their Elisa is tragically misguided when she regrets having doubted Shelby. "It is bad of me to doubt such good masters?" she exclaims, before learning that he has sold her young son.[130]

Radically, Texier and Wailly present Tom as another father figure. From a dramaturgical standpoint, the choice to make him into Elisa's father allowed them to unite the two subplots into one story and thus to preserve the focus on Tom, while also profiting from the public's interest in Elisa and her family. This somewhat displaces Kentucki (their Bird) from the metaphorical father role and puts the metaphorical father's necessary whiteness to question. However, Tom is portrayed as not a powerful father but, rather, an ineffective one. Due to his Christian zeal, he is tragically unable to protect Elisa. When Kentucki announces that the slave catchers must prove that Elisa is a slave, Elisa almost escapes. With trepidation, she chooses to lie, excusing herself before God by muttering, "Lord I am Christian, but I am a mother."[131] In contrast, Tom's faith in God comes before all else, even his dedication to his family. When Tom is asked to swear on the Bible, he cannot help but admit that Elisa is his daughter and a slave from the Shelby planation. Departing from the script of the white father reinforced by the other plays, Texier and Wailly include the black Tom as one of Elisa's "fathers." However, as in the other plays, they measure these fathers against

one another, urging spectators to judge who can best protect Elisa; the black Christian martyr is not positioned as Elisa's worthiest father.

Transatlantic Paternalism

All the plays portray Elisa as in need of not one father but several. In each case, a combination of white and black men (and a black woman, Topsy, in Texier and Wailly's more subversive play) bring about her and her family's happy ending. In Dumanoir and Dennery's adaptation, Georges ultimately kills the villain Harris in a duel, while Bird saves Georges and Elisa's son Henri. In De Beauplan's play, mistaken identities both protect and imperil Elisa. His Bird shelters Elisa, keeping her safe from Haley by claiming that she is their servant Noémie, but Georges (having mistaken Haley for Bird) accidentally exposes her identity. The villain almost triumphs, but Tom reveals Haley's true identity as Samuel and thus saves Elisa and her family. In Texier and Wailly's version, Tom takes a bullet for his grandson Henri (but does not die), Georges navigates their little boat to safety, and Topsy kills their pursuer Locker. In each of the plays, a community of (mostly) men is mobilized to save Elisa.

The final lines of both Texier and Wailly's play and Dumanoir and Dennery's adaptation are revealing for the ways in which the father figure is displaced by a metaphorical, larger father—the law or the nation. In Texier and Wailly's ending, by a glossing over or perhaps a misapprehension of U.S. geography, the fugitive slaves come to Canada in their small boat by way of the rapids of the Ohio River. Elisa asks where they are. Georges responds, "On Canadian soil! Promised land, free land!"[132] Following this religiously inflected rhetoric, the family kneels together as the curtain closes. At the end of Dumanoir and Dennery's play, Tom has been badly beaten, but Elisa, Georges, and Bird happily discover that he is still alive. Revived, Tom kneels by the body of Harris (killed in the duel by Georges) and asks God to pardon the dead man. Bird responds, "Come on—there are still some amendments to make to the law."[133] While Texier and Wailly's final lines imply that Canada (with its more just laws) can ultimately save the family, Dumanoir and Dennery suggest that Bird can change the law and thus alter the situation for Elisa's family. At the end of these French melodramas, the nation and the law, respectively, displace Elisa's paternalistic protectors and come to substitute for Stowe's emphasis on Christianity.

In each of the plays, but extremely in Dumanoir and Dennery's, Bird's/

Kentucki's protection of Elisa is presented in relation to the law. Spectators witness Bird's internal conflict between his humanist empathy for Elisa and his dutiful respect for the law. He experiences what he deems a conflict between his heart and his head.[134] To raise the stakes of this inner turmoil, Dumanoir and Dennery specify that Bird authored the Fugitive Slave Act. In this play, Bird's references to the law abound.[135] Comically, it seems as though Bird cannot do anything without commenting on the legality of his actions. After shooting at the slave catchers and watching Haley fall into the ravine, Bird's first thoughts are of the law: "By the devil! What I've just done is very illegal!"[136] Spectators later learn that Bird took himself to court following that incident, out of respect for the law.[137] Though Haley never pressed charges, Bird judged and condemned himself to a fine of one thousand dollars. At the end of the play, he plans to pay another fine for shooting Harris's henchman Quimbo, though shooting him saved Henri's life.[138] The play by De Beauplan and that by Texier and Wailly likewise show Elisa's protector as preoccupied with the law.[139] De Beauplan's Bird proclaims that though his conscience will reproach him for having violated the law, he cannot help but aid Elisa.[140] While the law preoccupies the plays' heroes, so long as slavery is in place, it is on the side of the villains. Texier and Wailly's slave catchers come for Elisa "in the name of the law."[141] When De Beauplan's villain Haley has almost prevailed, he gloats that the law is on his side.[142] Dumanoir and Dennery's Bird admits that the law is with the slave catchers, but he implores them to spare the fugitives "in the name of humanity."[143] Humanism (rather than Christianity) is the higher value that redeems Bird despite his intentions to respect the law, and it ultimately frees the fugitives.

This preoccupation with the law served several purposes. It was a judgment of the United States, both for the Fugitive Slave Act and for having not yet abolished slavery; with abolition in its colonies in 1848, France had already resolved the tensions that plagued Bird. His conflict was also a reflection of a particular tension in French law. The Declaration of the Rights of Man and of the Citizen (1789) guaranteed a master's rights to his "property" but also recognized the rights of all men. Dumanoir and Dennery's Bird works through this contradiction. When he encounters Elisa, he calls her escape a theft (stealing her master's property, i.e., herself)[144] and reasons that he is taking care to protect her because she is someone else's sacred property.[145] He plans to amend the law, first announcing that he will change the Fugitive Slave Act to state that people should shelter, feed, and care for

runaway slaves so as not to "deteriorate another's property."[146] At the end of the play, he declares that he will make further changes to the law, insinuating that he will now value human rights over the right to property.

In plays that self-reflexively presented themselves as cultural translations, the theme of the law served to position France on a global topography, in relation to other slaveholding nations, particularly the United States. As Lucas points out, at a time when U.S. democracy impressed and fascinated Europeans, publications in the French press (including translations of English travel narratives) criticized the United States for condoning slavery, which one critic called the "aristocracy of the skin."[147] At the same time, Bird, as a senator, was part of a democratic process that enabled amendments to the law. This contrasted with Napoleon III's rising authoritarian control and with his censorship of the theater. French law at that time repressed theater artists, but the plays slyly suggested that performance might be a tool for changing the political situation. De Beauplan's Bird is amusingly associated with the theater as he reads criticism of his speech that closed the discussion of the Fugitive Slave Act; in the newspaper, critics comment on Bird's performance and elocutionary style.[148] Insofar as their Bird makes amendments to the law, Dumanoir and Dennery's hero is likened to the playwrights themselves. The law—like the Uncle Tom story—can be adapted and rectified. On the French stage, Stowe's legalistic argument was adapted to resonate simultaneously on several levels: as a comment on U.S. politics, as a representation of a contradiction in the French law, and as a sly subversion of the censors' control.

For the French public of the 1850s, Uncle Tom's Cabin was a palimpsest, written over by both linguistic translation and adaptation across genres. Popular melodrama represented an arena for paying homage to, resisting, and transforming Stowe's messages. While critically different from one another, all three French stage adaptations of Uncle Tom put the spotlight on Elisa, portrayed other black characters as children in need of education, and showed a white male hero who respects, defies, and rewrites the law. These plays made meaning from the Uncle Tom story by staging, reinforcing, and contesting the predominant metaphor for understanding slavery in nineteenth-century France: paternalism. Stowe's call to a higher, Christian God was largely replaced with the racialized and gendered rhetoric of "fathering," which facilitated reflections on the social role of the enslaved in the aftermath of abolition, France's status vis-à-vis the United States, and theater artists' power and need for freedom from censorship. Within the

framework of cultural translation and adaptation, the ideology of paternalism took on diverse meanings, enabling the playwrights to comment on U.S. politics, French politics, slavery as a transnational issue, and the material realities of theater making in nineteenth-century France.

Notes

1. Sarah Meer, *Uncle Tom Mania: Slavery, Minstrelsy, and Transatlantic Culture in the 1850s* (Athens: University of Georgia Press, 2005).

2. E. Lucas, *La littérature anti-esclavagiste au dix-neuvième siècle: Étude sur Madame Beecher Stowe et son influence en France* [Antislavery literature in the nineteenth century: A study of Madame Beecher Stowe and her influence in France] (Paris: Boccard, 1930).

3. Ibid., 67.

4. Hipp. Magnard, cited in Lucas, *La littérature anti-esclavagiste*, 95. All otherwise unattributed translations throughout this essay are mine.

5. Meer, 8.

6. Honoré Daumier, "Actualités" [Current events], *Le charivari*, 18 November 1852, 3, reproduced in Meer, 131.

7. Harry Birdoff, *The World's Greatest Hit: "Uncle Tom's Cabin"* (New York: S. F. Vanni, 1947), 170–72.

8. Edmond Texier and L. de Wailly, *L'oncle Tom: Drame en cinq actes et neuf tableaux* [Uncle Tom: A drama in five acts and nine tableaux], followed by Gustave Vattier and Émile de Najac, *Chasse au lion: Comédie en un acte en prose* [Lion hunt: One-act comedy in prose] (Paris: Michel Lévy Frères, 1853), consulted via Gallica, the digital catalog of the Bibliothèque nationale de France (BnF). The French text is available through Gallica.

9. MM. Dumanoir and d'Ennery, *La case de l'oncle Tom: Drame en 8 actes* [Uncle Tom's cabin: Drama in eight acts], followed by *Griseldis, ou Les cinq sens: Ballet-pantomime en trois actes et cinq tableaux* [Griseldis; or, The five senses: Pantomime-ballet in three acts and five tableaux] (Paris: Michel Lévy Frères, 1858), consulted via Gallica, BnF. The French text is available through Gallica.

10. M. Arthur de Beauplan, *Élisa, ou Un chapitre de l'oncle Tom: Comédie en 2 actes, mêlée de chants* [Elisa; or, A chapter of Uncle Tom: Comedy in two acts, with songs] (Paris: Michel Lévy Frères, 1853), consulted at the BnF, RF 38.137. Because this play is only available in the archives and cannot be consulted through Gallica, I have retained the original French in the present essay's endnotes.

11. Lucas, *La littérature anti-esclavagiste*, 151.

12. Ibid., 141.

13. Ibid., 148.

14. Ibid., 152.

15. Ibid., 141.

16. Theater announcements consulted via Gallica, BnF.

17. Birdoff, 175.

18. Meer, 9.

19. Doris Y. Kadish, "Translation in Context," in *Translating Slavery: Gender and Race in French Abolitionist Writing, 1780–1830*, ed. Doris Y. Kadish and Françoise Massardier-Kenney, 2nd ed. (Kent: Kent State University Press, 2009), 1:54–55.

20. Lucas, 94.

21. Ibid., 98–99.

22. Stowe recalled receiving numerous visits from members of former French abolitionist organizations. See Lucas, *La littérature anti-esclavagiste*, 134 (quoting Stowe's recollection from *Sunny Memories of Foreign Lands*).

23. For investigations of French-language antislavery writing and its relation to race, gender, and the debates surrounding cultural memory, see Doris Y. Kadish, *Fathers, Daughters, and Slaves: Women Writers and French Colonial Slavery* (Liverpool: Liverpool University Press, 2013); Kadish and Massardier-Kenney, *Translating Slavery*; Christopher L. Miller, *The French Atlantic Triangle: Literature and Culture of the Slave Trade* (Durham, NC: Duke University Press, 2008); Catherine A. Reinhardt, *Claims to Memory: Beyond Slavery and Emancipation in the French Caribbean* (New York: Berghahn Books, 2006).

24. Kadish, "Translation in Context," 53–54.

25. Both Belloc and Sand are quoted in Kadish, "Translation in Context," 56.

26. M. Saint-Remy, *Mémoires du Général Toussaint-L'Ouverture, ecrits par lui-même* [General Toussaint Louverture's memoirs, written by himself] (Paris: Pagnerre, 1853). I thank Doris Kadish for sharing this source.

27. Quoted in Kadish, "Translation in Context," 56.

28. See, for instance, Henri Daumier's *Fifth Act at the Gaîté*, an illustration of melodrama's sobbing spectators, reproduced in John McCormick, *Popular Theatres of Nineteenth-Century France* (London: Routledge, 1993), 82.

29. Review by Philippe Busoni, quoted in Sylvie Chalaye, *Du noir au nègre: L'image du noir au théâtre (1550–1960)* [From Black to Negro: Images of blackness in theatre (1550–1960)] (Paris: L'Harmattan, 1998), 235.

30. For an analysis of the different translations, see Lucas, 65–92. For an evaluation of Belloc and La Bédollière's translations that considers gender and race, see Kadish, "Translation in Context," 54.

31. McCormick, 202.

32. Julien Lemer, "Théâtres et Concerts" [Theaters and Concerts], *La Sylphide*, 1853, 31, consulted via Gallica, BnF.

33. Scholars have nonetheless nuanced this characterization of the U.S. stage productions. See Adena Springarn, "When Uncle Tom Didn't Die: The Antislavery Politics of H. J. Conway's *Uncle Tom's Cabin*," *Theatre Survey* 53.2 (2012): 203–18, and Amy E. Hughes, *Spectacles of Reform: Theater and Activism in Nineteenth-Century America* (Ann Arbor: University of Michigan Press, 2012).

34. French antislavery drama was certainly never confined to melodrama, as evidenced by the well-known example of Olympe de Gouges's *L'esclavage des noirs, ou L'heureux naufrage* [Black slavery; or, The happy shipwreck], which premiered in 1789 at France's preeminent national theater, Molière's Comédie-française.

35. Alphonse de Lamartine, preface in *Toussaint Louverture*, ed. Léon-François Hoffman (Exeter: University of Exeter Press, 1998).

36. Auguste Anicet-Bourgeois and Philippe Dumanoir, *Le docteur noir: Drame en sept actes*, ed. Sylvie Chalaye (Paris: L'Harmattan, 2009).

37. Paul-Jules Barbier, *Cora, ou L'esclavage*, ed. Barbara Cooper (Paris: L'Harmattan, 2006).

38. For a gloss of the general distinctions between the two traditions, see McCormick, 180–82.

39. See ibid., 181.

40. In Texier and Wailly's play, Georges announces his own role, explaining that one at his age does not give in but avenges (17).

41. Lucas, 239–41.

42. See Odile Krakovitch, *Hugo Censuré: La liberté au théâtre au XIXe siècle* [Censuring Hugo: Freedom at the theater in the nineteenth century] (Paris: Calmann-Levy, 1985); Angela C. Pao, *The Orient of the Boulevards: Exoticism, Empire, and Nineteenth-Century French Theater* (Philadelphia: University of Pennsylvania Press, 1998), 62–77.

43. Quoted in Pao, 65; see also Krakovitch, 235.

44. Pao, 75.

45. Texier and Wailly, 14; Harriet Beecher Stowe, *Uncle Tom's Cabin*, ed. Jean Fagan Yellin (Oxford: Oxford University Press, 1998), 135–37.

46. Texier and Wailly, 18.

47. Ibid.

48. Ibid., 19.

49. Dumanoir and d'Ennery, 2.

50. De Beauplan, 5.

51. Adolphe, who enjoys commenting on fashion, jokes that Tom should attend the ball—without his Bible (ibid., 6).

52. Madame Shelby gives Tom her Bible as a gift when he is sold (Texier and Wailly, 6).

53. Doris Garraway, *The Libertine Colony: Creolization in the Early French Caribbean* (Durham, NC: Duke University Press, 2005), 8, drawing from Paul Butel and Robin Blackburn.

54. Arlette Gautier, *Les soeurs de solitude: La condition féminine dans l'esclavage aux Antilles du XVIIe au XIXe siècle* [Solitude's sisters: The condition of women under slavery in the Caribbean from the seventeenth to the nineteenth centuries] (Paris: Editions Caribéennes, 1985), 91.

55. Michel-Rolph Trouillot, *Silencing the Past: Power and Production of History* (Boston: Beacon Press, 1995), 17. This total more accurately represents the number of enslaved Africans taken to both Antillean islands. Guadeloupe acquired most of its slaves via Martinique rather than from French carriers arriving from Africa. See David Eltis, "The Volume and Structure of the Transatlantic Slave Trade: A Reassessment," *William and Mary Quarterly* 58.1 (2001): 35, 37.

56. Sue Peabody, *"There Are No Slaves in France": The Political Culture of Race and Slavery in the Ancien Régime* (New York: Oxford University Press, 1996), 3.

57. See Miller; Peabody; Reinhardt.

58. Chalaye, 236–37.

59. De Beauplan, 2.

60. De Beauplan, 10; Texier and Wailly, 4.

61. Arlette Gautier, 62–68.

62. Ibid., 65.

63. Ibid.

64. De Beauplan, 8; Texier and Wailly, 1, 8.

65. Texier and Wailly, 1.

66. Texier and Wailly, 2.

67. "Oncle Tom! C'est drôle . . . je vous appelle oncle Tom . . . je ne sais pas pourquoi, car vous n'êtes pas plus mon oncle que celui de tous ces faquins-là . . . Affaire d'amitié . . . d'habitude" (De Beauplan, 6). See also Texier and Wailly, 2.

68. Lucas, 68.

69. Kadish, *Fathers, Daughters, and Slaves*, 2.

70. Garraway, 272.

71. Ibid., 262.

72. Ibid., 277.

73. Myriam Cottias, "Free but Minor: Slave Women, Citizenship, Respectability, and Social Antagonism in the French Antilles, 1830–90," in *Women and Slavery*, vol. 2, *The Modern Atlantic*, ed. Gwyn Campbell, Suzanne Miers, and Joseph Calder Miller (Athens: Ohio University Press, 2008), 190.

74. Richard D. Burton makes a similar point in his far-reaching study *La famille coloniale: La Martinique et la mère patrie, 1789–1992* [The colonial family: Martinique and the mother country, 1789–1992] (Paris: L'Harmattan, 1994), arguing that Martinique and the other French overseas departments have long been cast in the role of France's "children" rather than autonomous entities.

75. In the twenty-first century, this paternalistic rhetoric has not disappeared, as evidenced by former French president Nicolas Sarkozy's proposition of the controversial 2005 law requiring that schools teach the positive (civilizing) side of colonialism.

76. Chalaye, 238.

77. Ibid., 31–32.

78. This research was conducted at the BnF sites at Richelieu (Département des Arts du Spectacle, Département de la Musique, and iconography collections) and Arsenal, as well as at the Archives nationales in Paris.

79. Dumanoir and Dennery, 2.

80. The playwright Dennery was himself Jewish, and his choice to change his name to d'Ennery was part of a larger pattern of Jews in France changing their names to assimilate into French society.

81. Lucas, 135; Richard Hildreth, *The White Slave; or, Memoirs of a Fugitive* (Boston: Tappan and Whittemore, 1852).

82. De Beauplan, 1.

83. Manuscript dated 10 January 1853, F/18/922, N 1564, Archives nationales, Paris.

84. Texier and Wailly, 13.

85. Ibid., 17.

86. Reinhardt, 109.

87. Dumanoir and d'Ennery, 2; see also 20.

88. Ibid., 3.

89. Ibid., 20.

90. See reviews by J. Brisset and René de Rovigo, cited in Lucas, 143.

91. Pao, 75.

92. Lucas, 152.

93. Dumanoir and d'Ennery, 4.

94. Ibid., 25.

95. Ibid., 28.

96. De Beauplan, 37, 42.

97. Ibid., 43: "la maîtresse de la maison—et la maîtresse du maître."

98. Ibid., 44.

99. Ibid., 42–43.

100. Jean Hippolyte Auguste Delaunay de Villemessant, *La Sylphide: Journal de modes, de littérature, de théâtres et de musique* (Paris, 1853), consulted through Gallica, BnF.

101. Dumanoir and d'Ennery, 23.

102. Ibid., 24.

103. Ibid., 25.

104. See, for example, A. Gaïfe, "Théâtre de l'Ambigu, La case de l'oncle Tom, drame en huit actes, par MM. Dennery et Dumanoir" [Ambigu Theatre, *Uncle Tom's Cabin*, drama in eight acts by MM. Dennery and Dumanoir], 20 January 1853, 40.653, BnF.

105. See, for example, Texier and Wailly, 3, 16; Dumanoir and d'Ennery, 24, 26.

106. Dumanoir and d'Ennery, 26. Her fainting becomes a sort of tragic flaw in Texier and Wailly, since it enables the slave catchers to take Henri from her.

107. See Dumanoir and d'Ennery, 17, 29; Texier and Wailly, 22.

108. Dumanoir and d'Ennery, 29.

109. Microfilm, Machanette Collection, RT 9112, BnF.

110. Texier and Wailly, 14; Dumanoir and d'Ennery, 12.

111. McCormick, 169.

112. The stage adaptations' references to monkeys were not unprecedented, insofar as Belloc had already added language referencing monkeys and dogs to her French translation. See Kadish, "Translation in Context," 59.

113. Dumanoir and d'Ennery, 12.

114. Dumanoir and d'Ennery, 7. *Li* is a French Creole word, here meaning "it" or "that."

115. See, for example, Texier and Wailly, 13.

116. Dumanoir and d'Ennery, 12.

117. See Lucas, 142–43.

118. When Haley's slave-catching dogs sniff out Elisa's presence at Bird's house, Bird answers that his dogs were not wrong, for they smelled his visitors Philémon and Bengali (Dumanoir and d'Ennery, 14).

119. Dumanoir and d'Ennery, 12–13.

120. Ibid., 23.

121. Ibid., 7.

122. Texier and Wailly, 9.

123. Ibid., 12, 15, 20.

124. Ibid., 13, 22.

125. Vinet, paraphrased in Lucas, 150.

126. H. J. Conway, "Uncle Tom" (unpublished manuscript, 1852), http://utc.iath.virginia.edu/onstage/scripts/conwayhp.html

127. Dumanoir and d'Ennery, 28.

128. Texier and Wailly, 1–3.

129. Ibid., 4.

130. Ibid., 3.

131. Ibid., 14.

132. Ibid., 23.
133. Dumanoir and d'Ennery, 30.
134. De Beauplan, 32; Dumanoir and d'Ennery, 17.
135. Dumanoir and d'Ennery, 13–14, 17–19, 22, 25–26, 30.
136. Ibid., 19.
137. Ibid., 22.
138. Ibid., 30.
139. Texier and Wailly, 11, 13–14, 16, 19, 21; De Beauplan 28, 32, 47.
140. De Beauplan, 32.
141. Texier and Wailly, 13.
142. De Beauplan, 47.
143. Dumanoir and d'Ennery, 18.
144. Ibid., 13.
145. Ibid., 15. Bird also explains that slaves are property recognized by the law (12).
146. Dumanoir and d'Ennery, 22.
147. Lucas, 41.
148. De Beauplan, 25–27.

Lisa Surwillo

Representing the Slave Trader: *Haley* and the Slave Ship; or, Spain's *Uncle Tom's Cabin*

In their introduction to *The Stowe Debate*, Mason Lowance, Ellen Westbrook, and R. C. De Prospo place Harriet Beecher Stowe's *Uncle Tom's Cabin* (1852) in the mid-nineteenth-century dialogue over slavery, "the dominant argument of the English-speaking world on both sides of the Atlantic."[1] But another central conversant in this discussion was Spain, the last European country with a colonial slave economy in the Americas. As both Dale Tomich and Christopher Schmidt-Nowara have argued, Spain's reconfigured ("second slavery") colonial project in the nineteenth century made it a powerful voice in the "refashioning" of slavery throughout the Atlantic world.[2] In turn, Spanish slave policies placed Cuba at the center of the international discussion regarding abolition, the transatlantic slave trade, and the imperial intentions of the United States in the Americas.

Officially, Spain had outlawed *la trata* (the trade) in treaties with England in 1817 and 1835 and approved "La ley penal contra los traficantes en esclavos del 28 de Feb. de 1845" (The penal law against slave traders of 28 February 1845).[3] Nevertheless, as economic interests in Spain were heavily vested in the slave trade, the government refused to define it as piracy. Indeed, by some accounts, the queen mother, María Cristina de Borbón, was the chief beneficiary of the contraband trade.[4] Because Spain routinely disregarded the treaties, enforcement was left to the British cruisers authorized to seize and search suspected slavers in the Caribbean. Most traffickers evaded their blockade,[5] and ten thousand Africans were brought illegally to Cuba annually in the 1840s and 1850s.[6] The year 1853 marked the climax of

international tensions over the incessant and illicit slave trade to Cuba. The continued breach of treaties had strained relations with England but was a calculated risk. The perceived need to retain control over the coveted "pearl of the Antilles" and to prevent geopolitical irrelevance, in light of the grand imperial designs of other European powers, overshadowed arguments in favor of modifying Cuban policy. Meanwhile, the United States, fueled by the Young America faction's ideals of Manifest Destiny, hoped to extend its domains into the Gulf of Mexico, and Cuba's thriving slave economy made it appealing as a future slave state.

During this period of imperial crisis, Spanish writers and cultural critics also participated in the international dialogue regarding slavery, through the frame of Stowe's *Uncle Tom's Cabin*. Although Stowe's novel was foreign in its geography and religious culture, the issues of slavery and slave traffic transcended the national boundaries of their fictional landscape and had a real, immediate importance for Spanish readers. Once granted the censor's approbation, Stowe's abolitionist novel enjoyed unbridled proliferation and offered an adaptable lens through which to consider Spain's role in the slave trade across the Atlantic, outside official discourse. Beyond the initial prose translations, a number of theatrical adaptations offered nuanced and sometimes ironic recastings of Stowe's plot and ideology.

In this essay, I first present the publishing history of *Uncle Tom's Cabin* in the political context of Spain's policies regarding slavery and the transatlantic slave traffic. Editions and adaptations of Stowe's book reflected the various Spanish opinions on slavery and the colonial status of Cuba, ranging from outright abolitionist thinking, to calls for a suppression of the transatlantic slave trade (but not of slavery in Cuba), to the perception that both the illegal slave trade and legal slavery were necessary to maintain economic and political control of the province. After addressing the transatlantic reception of Stowe's condemnation of American slavery, I analyze the curious plot of one adaptation, *Haley, ó, El traficante de negros* (Haley; or, The slave trafficker), by Ángel Maria de Luna and Rafael Leopoldo Palomino, first performed in Cadiz in 1853. I argue that this theatrical adaptation was a response to the crisis over American expansionist intentions in Cuba and was a cultural and political critique of the slave trade to Cuba. Its authors converted *Uncle Tom's Cabin* into a play about the pivotal role of the slave trader in society, to suggest that the solution to Spain's political woes would be an end to the trade, coupled with the conservation of a pro-slavery Cuban policy. Purportedly offering a mere dramatization of Stowe's

story, *Haley* made an allegorical plea for the death of human traffic, a plea that the Spanish government would never have permitted in a nonallegorical form.

FROM UNCLE TOM TO TÍO TOM

Translations of foreign novels were generally popular in nineteenth-century Spain, but *Uncle Tom's Cabin* appeared in more editions in a single year (1853) than had any other novel imported in that century. Many novels by Alexandre Dumas and Eugène Sue held trans-Pyrenean appeal, and Chateaubriand's *Atala* enjoyed sustained publication in Spain,[7] but Stowe's explosive best seller was unequaled in its rate of diffusion.[8] Strictly in terms of number of readers, the impact of this text was phenomenal. Within six weeks of its initial offering in December 1852, readers purchased all four thousand copies of the first edition of Wenceslao Ayguals de Izco's translation. The second edition and six other translations also sold quickly. In addition, readers who had not encountered the novel as an installment by Ayguals or other editors had likely seen at least a section of it serialized in *La época* (The epoch), *Las novedades* (Novelties), *La nación* (The nation), or *El clamor público* (The public voice), daily political papers with a liberal ideology, which inundated the capital and provincial cities with independent translations of *Uncle Tom's Cabin* in early 1853. These four newspapers were among the eight with the largest subscription rates in Spain.[9] It is difficult to ascertain the absolute number of issues printed; based on postal records (about half of all issues were sent to subscribers outside the capital city), daily circulation was about fifteen thousand for *Las novedades* and, about four thousand for *El clamor público*.[10] Even casual readers not committed to following the entire story had ample opportunity to see one or two fragments of the famous work and become familiar with the main characters and themes.

Discussing the installment-novel phenomenon generally in Spain during the second half of the nineteenth century, Jean-François Botrel has emphasized the great influence that the fragmented format had on the development of readership. Basing his calculations on the rates of twelve to fifteen thousand copies per newspaper or installment edition and 3.5 readers per copy, Botrel estimates that each serialized work had between forty-two and fifty-five thousand readers—a sizable segment of the national population.[11] But *Uncle Tom's Cabin* had not one but at least fifteen publications in

one year: ten in Madrid, two in Barcelona, one in Cadiz, one in Valencia, and one in Paris (in Spanish).[12] If we assume conservative diffusion rates of four to fifteen thousand copies per edition, the estimated number of readers of *Uncle Tom's Cabin* in Spain in 1853 was between 210,000 and 787,500. With a literate population of 3,835,000 in Spain in 1860, this novel therefore reached approximately 5 to 20 percent of all potential readers, or 1 to 5 percent of the entire national population of 15,673,000.[13] The illiterate persons who became familiar with the work from having heard it read aloud constitute another layer of readership. By means of this massive spread of the text, the American Uncle Tom was transformed into Tío Tom, a veritable celebrity among the dramatis personae of Spanish literature. In months, the character and the novel were frequently referred to in the periodical press, even in magazines that never fully discussed the work.

The clamorous reception of *Uncle Tom's Cabin* in Spain was unique; even more surprising, it took place during a period of intense censorship of fiction and commentary about the overseas provinces and the slaves that lived there. In a time when politics was reported as creatively as novels were written, works of fiction were as vigilantly censored as political articles. Indeed, by the Royal Order of 23 April 1852, the two genres were to be read, analyzed, and censored indistinguishably. The same censor appointed by the Crown to assess novels was also charged to read "todos los artículos y escritos relativos á Ultramar, observándose para estos casos las mismas formalidades y disposiciones que prescriben los anteriores artículos respecto de las novelas" (all articles and writings related to the Overseas Provinces, observing for these pieces the same formalities and dispositions that the previous articles [of this royal order] prescribe for novels).[14] As novelists continued to frustrate the royal censors' efforts to suppress all criticism of the government or social mores, the minister of government (*ministro de la gobernación*) dealt a blow to literature with the October 1852 prohibition of popular novels by socially conscious foreign writers such as Eugène Sue, George Sand, Frédéric Soulié, Augustin-Eugène Scribe, and Dumas.[15]

These measures were deplored by the Madrid daily *El heraldo* (The herald): "En cuanto á la censura de novelas y de noticias de Ultramar, es increible lo que hemos padecido" (As far as censorship of novels and news about the Overseas Provinces is concerned, what we have suffered is incredible). This moderate paper of the opposition (led by the future *conde de San Luis*) claimed that it had a "treasure" of news about the Philippines and Cuba, the conveying of which was simply prohibited by the government.[16]

Given that journalists could not anticipate censors' reactions to their columns, *El heraldo* claimed that it had to resort to writing in

> parables and apologues, hoping that they would be understood in the midst of the darkness in which we wrapped them . . . playing hide-and-seek in our columns, sometimes masking our thoughts behind the veil of foreign politics, seriously discussing a ridiculous point other times; at times even taking shelter in the realm of advertisements in order to talk about politics.[17]

For a readership accustomed to deciphering the daily news through such rhetorical acrobatics, the American fictional landscape of *Tío Tom* offered rich and fertile ground for a transplanted consideration of the urgent affairs of Spain's own slave traffic, precarious imperial unity, and concerns about abolition. Ayguals wisely retained the American terms for race (Enrique and Elisa are both described as *cuarterón*, a direct translation of the foreign concept "quadroon") rather than engage with the complexities of *mestizaje* and its nomenclature.[18]

Given the repression of literature during these months, the government approval of *Uncle Tom's Cabin* is extraordinary. There is no currently accessible record of the government censor's comments regarding the book. The copy deposited at the National Library in Madrid shows that Ayguals, the translator and editor responsible for the novel's introduction in Spain, went through the censorship process and acquired the copyright for his editions on 17 January 1853.[19]

As a publisher, Ayguals de Izco exerted an enormous influence on the publication of Spanish novels and the translation of foreign novels in the mid-nineteenth century. He was, above all, a social critic, attentive to literature's potential to effect social change, a mission reflected in his own anticlerical, proletarian, and progressive installment novels. He professed that he was drawn to literature in order to "defend the oppressed" and "luchar con las armas del raciocinio contra los verdugos de la humanidad" (fight with the arms of reason against the executioners of humanity).[20] The translation of *Uncle Tom's Cabin* and its introduction into Spain as an abolitionist novel were explicitly part of this agenda. Whatever the real social consequences of his literary endeavors, Ayguals's stature and influence were perceived to be sufficiently subversive for his work to appear on the Index of Prohibited Books.[21]

Before obtaining approval for publication, Ayguals heavily advertised *Uncle Tom's Cabin* in a wide variety of Spanish newspapers, stirring interest among the public and perhaps forcing the censor's hand. Among his marketing tactics, he emphasized the favorable reception of the piece in "enlightened" countries, placing Spanish censors in the uncomfortable position of either approving *Uncle Tom's Cabin* or confirming the Spanish anxiety of being perceived as culturally backward. After government approbation, the novel's popularity served as advertisement; as supply met demand, a number of progressive editors and publishers sold the book, and one editor even gave it away for free.

The subsequent serialization of the work in newspapers is not only evidence of its popularity but also an illustration of its political use beyond abolitionism. As the government suppressed second and third editions of politically progressive newspapers in the late winter of 1853, their editors simply replaced the censored articles with sections of *Uncle Tom's Cabin*—no longer a literary novelty, but a way to hint at what had been suppressed. A foreign and translated novel was used as a frame for criticism of the government's slave policies. A vibrant literary circle in Cuba was engaging with this issue. The development of the Cuban novel was shaped by the cultural tensions inherent in the issues of slavery and empire.[22] Throughout the midcentury, the group of writers associated with Domingo Del Monte and his literary salon created a series of texts with an antislavery (or antitrade) discourse, such as Anselmo Suárez y Romero's *Francisco* (1839).[23] Some of these important works of literature were markedly in favor of celebrating the African element of Cuban nationalism, and others favored an explicit "whitening" of Cuba, but their accessibility to Spanish readers was limited until later in the century.[24] Quite simply, the Cuban texts were too critical for Spanish censors. For example, Gertrudis Gómez de la Avellaneda's radical abolitionist and feminist *Sab* (1841), written only eleven years before *Uncle Tom's Cabin* (and independently from the Del Monte circle), was prohibited in Cuba and initially had a restricted circulation in Spain.[25] In contrast, Stowe's novel condemning the social and political policies of Spain's political adversary, the United States, was allowed to circulate freely. Not every Spanish citizen read a translation of *Uncle Tom's Cabin*, but its availability and familiarity situated the characters and explosive themes of slavery and the slave trade—both exotically North American and domestically Spanish—squarely in the national cultural imagination.

THE INTERNATIONAL POLITICS OF *TÍO TOM*

In Cadiz, a major port city with close cultural and commercial ties to Cuba but removed from the literary elite in Madrid (and Havana), Luna and Palomino adapted *Uncle Tom's Cabin* into a new play, *Haley*, to interrogate the slave trade and its threat to Spain's colonial power in the face of British and American interests and a growing Afro-Cuban population. *Haley* did more than incite pity for slaves and suggest an analogy between those in the southern United States and Cuba. It refocused criticism on Spanish overseas policies, because the illicit slave trade had helped the Cuban slave economy thrive and thus make the island so attractive to U.S. expansionists. Whereas Stowe's novel had condemned the institution of slavery, the play from Cadiz avoided that question and instead dared to challenge Spain to reconcile clandestine activities and its official position on the transatlantic slave trade.

Haley was written in early 1853, approved by government censors in April, and first staged in Cadiz in October of the same year. By midcentury, Spain was nearly bankrupt, and its control over its wealthiest colony was precarious. Several years earlier, Spain had essentially mortgaged the island: British interests held legitimate financial claims to seize Cuba after Spain defaulted on the loans, but England instead allied with France in an attempt to prevent Cuba's annexation by the United States. Meanwhile, the United States unofficially urged Cubans to separate from Spain and transfer their allegiance to Washington. Moreover, they tacitly permitted the armed invasion of Cuba by private citizens, or *filibusteros* (filibusters), while secretly authorizing Pierre Soulé, the French-born American ambassador to Spain, to purchase the island for $130,000,000.[26] Although less rich in detail, the version of the political crisis available to the general reading public was quite alarming. The fate of the overseas provinces was discussed in Spanish papers nearly every day between October 1852 and December 1853, and the various attempts by the United States to annex Cuba kept the nation's focus on "the ever-faithful isle."

For reasons of commerce and imperial pride, the Cuban crisis instigated a general mobilization in Spain. On 29 October 1852, the Spanish public read that the government had begun sending reinforcements to Cuba.[27] A few weeks later, driven by a sense of patriotism for the "conservacion de nuestra preciosa Antilla" (conservation of our precious Antille), volunteers from the province of León requested authorization to embark for Cuba.[28]

Spaniards were keenly aware that the United States, far from sated after the annexation of Texas, was eager to invade Cuba. The Spanish newspapers defined Presidents Millard Fillmore and Franklin Pierce as men of state according to the degree to which they treated the filibuster invasions as "American piracy."[29] Perhaps most important, the press did not hide the world's opinion of the Spanish slave trade, and at the height of the *Tío Tom* fervor, Spaniards read that the United States used Spain's continued transatlantic trade to justify the U.S. foreign policy of expansionism, based in Manifest Destiny, in Cuba.

The editors of *El clamor público* commented on the American refusal to join France and England in guaranteeing Spain's possession of Cuba. They reported that the U.S. government was unable to renounce hopes for the future annexation of Cuba, an event that would be prompted by an agreement between the United States and Spain, by an appeal from Cuba's inhabitants, or "bien por una *guerra legítima*" (by a *legitimate war*). Digesting for readers the official American stance, the editors sadly predicted an invented war for economic gain: "La anexion á mano armada: hé aquí la última palabra de la política americana. Muy pronto hemos de ver los suterfugios [sic] de que se valen los oradores americanos para justificarla" (Annexation by force: this is the last word of American politics. Very soon we will see the subterfuges that American orators employ to justify it).[30] The United States had economic, political, and military superiority over Spain, which feared but expected the seizure of its wealthiest province.

Near the end of the Fillmore administration, *El heraldo* (among several other Spanish papers) published U.S. Secretary of State Edward Everett's lengthy speech on American policy regarding Cuba. True to the racist ideology of Manifest Destiny, Everett justified geographic expansionism by a fear of African "barbarism."

> I must not fail to mention an evil of the greatest degree, that is, the commerce in African slaves, whose suppression is of vital interest to France and England; an evil that today constitutes the greatest harm to Christian civilization and perpetuates the barbarism of Africa, and for which we fear there cannot be a complete cure as long as Cuba continues to be a Spanish colony.[31]

Everett's concern was not the plight of slaves either while in transit or on arrival in Cuba; his alarm at the continued transatlantic slave trade came

from his perception of its racial and cultural effects on Cubans and, poten-
tially, the nearby southern United States. In the eyes of the relatively nonin-
terventionist Fillmore administration, a Spanish Cuba was detrimental to
the American definition of civilization and was grounds for its seizure by
the United States. But whereas Fillmore was vocally against an armed inva-
sion of Cuba, his successor, Pierce, was correctly seen in Spain as actively
pro-annexationist. Spaniards read Pierce's arrogant threat of annexation in
his 4 March 1853 inaugural speech, placed (just above a chapter of *Uncle
Tom's Cabin*) on the front page of *Las novedades*: "No debemos disimular-
nos que nuestra actitud como nacion y nuestra posicion en el globo, hacen
en estremo importante para nuestra proteccion la adquisicion de ciertas
posesiones que no dependen de nosotros" (It is not to be disguised that our
attitude as a nation and our position on the globe render the acquisition of
certain possessions not within our jurisdiction eminently important for our
protection).[32] When he assumed the presidency of the United States, the
fear of Spain's impending loss of Cuba intensified.

FROM *TÍO TOM* TO *HALEY*

A basic, nearly indisputable principle of Spain's overseas "second slavery"
policy was the assumption that the traditional plantation slave economy en-
sured the fiscal health and imperial conservation of Cuba.[33] Officially, these
slaves were to come from within the Americas. But Spaniards read about
the slave traders in the Atlantic and knew exactly how the slave economy
and conservation of the island were being secured. Poetic traditions aside,
they were fully aware that the traffickers were characters far more com-
plex than romanticized, free-spirited pirates and, moreover, that the politi-
cal consequences of their exploits were grave. In addition, many Spaniards
feared that a continued "Africanization" of Cuba through the transatlantic
trade would lead to a massive slave rebellion such as that in Haiti. Brief
updates on the contraband trade were published in the press (sometimes
simultaneously with the serialization of *Uncle Tom's Cabin*). For example,
in its front-page review of the state of affairs in Cuba in January 1853, *El
heraldo* reported that "la fragata ingles la Vesta habia capturado en las aguas
de la isla tres buques negreros" (the English frigate the *Vesta* has captured
three slave traders' ships in the waters of the island).[34] Slave ships were as
recognizable to Spaniards as the slaves were remote and unknown.

Although the slave-based economy was firmly entrenched in nineteenth-

century Cuba, the Spanish Empire followed a path forged by other Atlantic powers in treating slavery and the transatlantic slave trade as separate concerns. The United Kingdom abolished the slave trade in 1807 and outlawed slavery in its colonies in 1834; France criminalized the trade definitively in 1835 but maintained slave labor until 1848; the United States had perhaps the widest spread, outlawing the transatlantic slave trade in 1808 but seeing the demise of legal slavery only at the conclusion of the Civil War. International pressure on Spain to cease slavery was not great during the mid-nineteenth century, and even the fiercest of abolitionists, such as Richard Madden, could only indict Spain for infraction of treaties dealing with the transatlantic slave trade: slavery was an internal matter.

Most Spaniards had never seen a slave. In *Haley, ó, El traficante de negros*, Luna and Palomino brought their public closer to the story by replacing the slave Tom with the trader Haley as the titular character, dramatizing the slave trade through the commerce in the crosshairs of international attention. Structurally, the play was built on something else familiar to the audience in Cadiz's Balón Theater: Stowe's story. The play follows Haley in his attempts to capture the runaway slaves Elisa (Eliza), Jorge (George), and their young son Enrique (Harry or Henry), whom he had purchased from Arturo (Arthur) Shelby. The first two acts of this adaptation closely match episodes from the novel in characterization, dialogue, and action; the second two acts radically invert character development, offer new dialogue, and redirect the plot. The differences between the two works are key to analyzing the uses made of *Uncle Tom's Cabin* as a tool to criticize Spain's handling of the immediate political crisis and, at the same time, elude the censors.

The first real change that pointedly implicates the Spanish audience occurs at the end of act 1. Elisa breaks the theater's fourth wall and directly addresses the audience as she prepares to flee with Enrique. Her speech causes the Spanish public to draw her from the fictional Kentuki and place her in their historical present. An American story becomes a Spanish moral issue through Elisa's direct appeal to the sense of maternal love and duty in all the actual mothers in the theater. She obliges the merchant class of Cadiz to consider her plight according to Spanish social mores and to imagine her as a member of their community.

Only after a familiar retelling of Jorge and Elisa's story during the first two acts does substantial transculturation of Stowe's novel occur, in the form of topographic adaptation. Act 3 places Wilson—resting after a failed

search for Elisa—at an inn on the shores of the Ohio River. But in the altered dramatic landscape, the inn is patronized not by Stowe's rugged Kentuckian hunters but by sailors, stereotypical inhabitants of the port city of Cadiz. These are the play's harshest critics of the slave trade. They cheer when a poster about the runaway Jorge is defaced, and their spokesman, the innkeeper Samuel, unequivocally denounces the trade: "¡Verguenza es para nuestro pais . . . que se tolere semejante tráfico!" (It is to our country's shame . . . that such a trade is tolerated!).[35] The implication is that the spectators in Cadiz should join their onstage representatives and call shame on Spain for tolerating such commerce.

Following dialogue and action taken directly from the novel, the plot assumes a new path and ideological purpose in act 4, adapting the story of American slavery more into a Hispanic consideration of the slave trade. Haley's assistant, Loker, catches Elisa, and the frame shifts: the larger philosophical concerns underpinning the work no longer come from Stowe's novel. Jorge and Elisa begin to lose agency, and their quest for freedom is eclipsed by the question of whether Haley's soul will be damned or saved. A significant amount of dialogue is dedicated to the slave trader's defense of his commerce, and all the characters (initially divided into supporters and opponents of the trade) become aware of the evils of human traffic. Lest the moral agenda of *Haley* remain unclear, the dramatists indicate that the entire cast is to be reintroduced in front of an empty slave ship during the final scenes of the play.

Act 4 opens with a passage that echoes a famous scene in the contemporary play *Don Juan Tenorio*.[36] Loker and Haley pause to brag of their feats as heartless traffickers and compare their success at separating mothers from their children, shocking the audience much as Don Juan Tenorio and his rival, Luís Mejías, scandalized them in a strikingly similar recitation of their crimes against women. Moreover, both Haley and Don Juan transgress social mores, gamble with the fates of their souls, and are saved while repenting in their last breaths. The specter of Don Juan in the Haley character furthers the cultural adaptation by suggesting a parallel between the nineteenth-century trafficker and a famous literary figure born in and representative of the Spanish Golden Age and the height of the Spanish Empire. Despite his crimes, Don Juan was seen as a positive character who embodied the international cultural identity Spain had acquired from its glorious past, whereas the *traficante* symbolizes the decline of Spain's international prestige and the source of its troubles in contemporary inter-

national politics. But Haley too can become a hero of his society through repentance and death.

Beside the traffickers, the entire Shelby-Wilson clan unites on stage, while a distraught Elisa cries at her separation not only from Enrique but also, remarkably, from her owner, Emilia Shelby. Haley's other slaves march onto the steamship in the background, and the physical and emotional realities of human traffic are fully depicted before the Cadiz public. Senator Wilson, who has served as the onstage spectator for the audience, delivers a long lament on the woes of Africa but urges Africa to rise and assume its appointed role in human civilization, predicting for it a future of "splendors." Both Africa and legitimate slave society, at either end of the Middle Passage, suffer at the hands of the trader.

Jorge suddenly arrives, to responsibly halt the chain of events. In the disguise of a Spanish Creole landowner, he legally purchases Enrique from Haley, thus reuniting father and son, guaranteeing the Shelby family honor, and returning a slave (Elisa) to her benevolent mistress and her prescribed place in society. Regarded as a Spanish landowner, he conforms to good slave law, but once he rashly unmasks himself as a runaway slave, he becomes a volatile element to be subdued. Jorge draws his pistols to escape from his wife, his owner, and society, but Loker promptly attempts to disarm him. In a classic *deus ex machina*, one of the guns accidentally discharges. Haley falls, fatally wounded, as the rampant Spanish fears of a "Haitian" race war in Cuba are staged in Jorge's armed revolt against his legal owner.

The threat of further slave rebellion and Haley's deathbed morality bring about the final resolution to the play. Immediately after the gunshot, the sound of the lifting anchor fills the stage: Haley's boat of slaves is about to depart, and so is his soul. Seizing the opportunity to repent, he frees all slaves aboard and thus gains eternal salvation by renouncing the trade at the last possible moment. He expires, and the ideological message is again delivered, rather heavy-handedly, in the final scenes, with the death of personified traffic as the means to the reconstitution of the traditional family-based (and slaveholding) society.

The final tableau poses a group of emancipated slaves—including Jorge (no longer symbolizing the threat of a race war after the death of traffic), Elisa, and the Shelbys—on their knees around the dead body of Haley. Senator Wilson, the representative of the state, remains standing and closes the play with the call "¡Justicia del cielo!" (Heaven's justice!). The implication is that under this guidance shared by the power of Christian morality and

the power of government intervention, past and future disorder may be resolved.

In terms of scenery, the introduction of the *buque negrero* (slave ship) in the final act brilliantly stages the focus of international crisis. Haley's Mississippi steamship is a scenographic adaptation of Stowe's analogy of the horrors of the American slave trade to the Middle Passage (chap. 31). Moreover, ships are a symbol of the commercial wealth on which Cadiz was built, including the commerce in slaves during the eighteenth century.[37] In revealing the nightmarish truth of the slaver, the stage scenery capsized the merchant vessel's respectability and provoked guilt in the public. As an element of textual adaptation, the ship in act 4 performs the symbolic function of Uncle Tom's cabin in the final section of the novel, invoking in all spectators the memory of the effects of the trade.

STAGING AND UPSTAGING *UNCLE TOM'S CABIN*

Haley delivers a shocking and unexpected ending—a coup that represents an important Spanish interpretation of the *Tío Tom* story. *Haley* is not an abolitionist play but, rather, a reformist play, concerned with the impact of the slave trader on individuals and society. The play carefully splices the outlawed maritime traffic in enslaved persons, which kept British attention on Cuba, and the institution of slavery itself, both legal and largely supported as the means to retaining imperial control over Spain's remaining wealthy colony. Haley's self-redemption frees only those slaves who are in transit, who are being trafficked; Elisa, for example, remains enslaved and is apparently content to return to her mistress. The success of the *dénouement* was predicated on a residual sentimentality among the public from the experience of reading the abolitionist novel and on their surprise at the differences between the two works. Specific references and instances of abridgment continually draw the public from the play to the novel and back again, into a comfortable hybrid space of *déjà lu* and *déjà vu*. Luna and Palomino achieved this intertextuality (and thereby fortified the impact of their drama) by staging several of Stowe's crucial narrative or descriptive passages. In one form or another, *Haley* contains Eliza's escape across the Ohio, Lucy's suicide, and Tom's death.

The play's focus on Haley, Jorge, and Elisa and its omission of other prominent characters from subplots of the long novel do not detract from the unity of the play as a whole. Striking, however, is Tom's absence from

the cast of characters in *Haley*. Along with Eva, Tom was the novel's most celebrated character, featured on the cover of the illustrated edition in Madrid. In the novel, George and Tom represented opposing (but effective) paths to liberty; in the play, no voice of passivity counters Jorge and Elisa's active quest for freedom. In *Haley*, only one victim of the illegal and immoral slave trade policies, slave society itself, is saved. Yet Uncle Tom's presence resonates through the play's final scenes.

Specifically, the dramatic Haley appropriates Tom's redemptive power. Once fatally wounded, the trader begins to consider the state of his soul.

HALEY. Ah!
LOKER. Good Heavens!
HALEY. I am dying!
WILSON. Let's help him!
HALEY. No, leave me. My wound is here . . . in my soul . . . it is God who
has wounded me.[38]

The trafficker witnesses his own death and, interpreting it as the resolution of a divine social order, is inspired to become a liberator like young George. He promptly sends Loker to the barge: "Stop that boat . . . go, unload the blacks, let them all be free!" This statement is not only a literary adaptation of Tom's martyrdom but a direct political reference. Haley's order enacts precisely the part of the international treaty that pertains to the Spanish contraband *negreros*. Captured slavers were to be brought before judges, the slaves aboard their ships set free.[39] Unfortunately, *Haley* could not stage a full compliance with the Anglo-Spanish treaty, which would have included a spectacular demolition of the slave ship and the sale of its pieces—much as if the captain's own family were destroyed bit by bit (as Stowe argued that slave families were) by the trade: "Dicho buque será hecho pedazos inmediatamente despues de condenado, y se procederá á su venta por trozos separados" (Said boat will be immediately smashed to bits upon its condemnation, and then each section will be sold separately).[40] By translating their message into scenographic language (and Haley's judge into God), Luna and Palomino further elude censorship of their sharp criticism of Spain's breach of the treaty.

In his protracted death scene, Haley, like Tom, brings the witnesses of his death to Christ. Chiefly, he orders Jorge to become Christian, gasping, "Jorge . . . now you are free . . . be Christian." This overtly religious

command carries a political and cultural charge to a Spanish audience. Spaniards traditionally referred to themselves as *cristianos* (Christians) and to their language as *cristiano* (Christian); the latter term also implies speaking clearly and sensibly. Therefore, by directing Jorge to "become Christian," Haley essentially orders him to "be Spanish," both culturally and politically, and to return to the traditional norms of behavior. Jorge's assent is visually confirmed in his kneeling submission to the Christian God and an earthly political system represented by Wilson, in the final tableau that closes the piece.

Jorge's tirades about independence, national identity, and separatism in acts 1 and 3 are married to religion (e.g., he declares, "I am not Christian," just as he is about to run away) and, consequently, to nationality. In addition to his personal rebellion, an action that suggests the violent ethnic and cultural consequences of a protracted traffic to Cuba, he points to the real political instability of a province that was beginning to reexamine its identification as Spanish.[41] Historically, a reevaluation of race, culture, and nationality as different from those of Iberia at midcentury framed the political debate regarding Cuba's sovereignty and relation to Spain as well as the various contemporary attitudes toward slavery and trade (the aforementioned Del Monte circle had been foundational in establishing these debates).[42] In *Haley*, a suppression of the trade guaranteed the subjugation and reincorporation of Jorge's troublesome Spanish identity back into the imperial family, under the control of the *madre patria* (motherland).

Jorge's Spanishness is first questioned in act 3, when he arrives at the inn where Wilson is relaxing and talking with sailors. In the equivalent passage from Stowe's novel, the runaway George appears Spanish but introduces himself with an American name and later explains that he had darkened his skin and hair. *Haley*'s Jorge completes the transformation, presenting himself as "Lopez de Mendoza," a Spanish businessman from New Orleans, one of the cities where Spanish Creoles negotiated invasion and annexation with the United States. The Spanish press (in favor of continuing imperial control over Cuba) harshly condemned these separatists as pompous traitors and ridiculed their cause and their name, Salvadores de Cuba (Cuba's Saviors), "como si esta isla, rica y feliz bajo la bandera española, pudiese querer la salvacion de manos de la gente más perdida de los Estados de la Union, de la escoria que la Europa envia diariamente al nuevo mundo" (as if this island, rich and happy under the Spanish flag, could want salvation from the hands of the most vile people of the United States, from the

scourge that Europe sends off daily to the New World).[43] Although both George and Jorge fled slavery in a Spanish disguise, the mask had a different cultural valence in Spain than it did in the United States.[44] Jorge is not simply blurring ethnic lines between European and African; his representation as a nonwhite Spanish Creole has specific nationalist and political implications. Indeed, among contemporary concerns was the question of whether Cubans were being Africanized by the trade to such a degree that they were no longer Spanish, much as the American statesman Everett had claimed. Jorge, the false Spaniard of act 3, will thus be told to be *cristiano*, for according to Luna and Palomino, the rightful place of both slaves and Spanish Creole Cubans is under the control of the Spanish state.

THE POLITICS OF *HALEY*

Luna and Palomino are marginal figures in the annals of Spanish theater. The total number of plays attributed to Palomino is eight, and Luna wrote no other known plays.[45] In the cultural history of mid-nineteenth-century Cadiz, however, they were prominent men of letters and vociferous social critics. The dossier on their activities as editors of the newspaper *La palma* (The palm frond), currently stored in the provincial archive, documents a melodramatic tale of their challenges to censorship and evasion of imprisonment. Like Ayguals de Izco, they saw *Uncle Tom's Cabin* as a powerful tool for social criticism, but they tailored it to address the domestic issue of Spain's tolerance of the transatlantic trade. *Haley* was their first foray into drama, and their social earnestness is accompanied by almost schoolboyish fidelity to the basic elements of Aristotelian tragedy.

Luna and Palomino did not set their play in Cuba, nor did they explicitly codify Haley as Spanish. Nevertheless, *Haley* represented their attempt to avoid government censorship while broaching the subject of the transatlantic slave trade. Spanish theater of the previous fifty years was replete with examples of allegorical works transparently set in the past or distant lands, and the geographic relocation in this piece was perfunctory. In a note to readers included in the printed edition of the play, Luna and Palomino give their markedly nonliterary reason for recasting the story of American slavery as a play, claiming that theater, not the novel, is the most expedient means of instilling a new moral understanding in the public.

Haley was not government propaganda but, rather, a popular theater piece directed at a provincial bourgeois public that enjoyed, at best, indirect

access to the powers of the imperial administration. Nevertheless, the play coincided with more than one strain of reformist policy. In December 1852, the president of the council of ministers, Bravo Murillo, was unseated, and the ensuing political upheaval brought about a new administration headed by the Count de San Luis (whose newspapers had serialized *La cabaña del tío Tom* [*Uncle Tom's Cabin*]). His colonial strategy was informed by a desire to pacify Great Britain and gain international support for Spanish control of Cuba. Most important, he appointed a famously strict enforcer of the transatlantic slave trade treaties, the military officer Juan de la Pezuela, as captain general of Cuba, reversing a tradition (since 1834) of institutionalized bribery and semiofficial tolerance of the illegal trade. Pezuela implemented further changes to prevent traffic, aided the illegally imported Africans already in Cuba, and made the island significantly less appealing to the United States. Not surprisingly, Cuban slave owners, who claimed that favorable treatment of blacks would lead to race warfare, resisted these measures.[46] Pezuela was ultimately forced to compromise: the trade continued, slavery was not abolished until 1880, and Cuba remained a Spanish province until the Spanish-American War (1898).

TRANSATLANTIC THEFTS OF LITERARY PERSONHOOD

The physical abuse at the hands of his master that George describes in passages of *Uncle Tom's Cabin* evoke disgust and pity in the reader yet are not that different from what was suffered by other slaves in Stowe's novel. The greatest outrage committed against George (and him alone) is not physical but intellectual. His crowning accomplishment at the factory, where he was recognized as a talented manager, is the invention of a useful machine. Under the system of slavery, his jealous, dim-witted master—the owner of George's person and the products of his personhood, be they intellectual or physical—becomes the legal owner of the patent and all attributions and remunerations from it. This affront to George's obvious intellectual superiority leads George to question the legitimacy of his owner's dominion over him. In the larger structure of the narrative of *Uncle Tom's Cabin*, the lawful theft of George's intellectual property justifies the slave's belief that he has a right to flee to a country where he can be treated as a man, not a beast.

The right of all free persons to own property is one of the tenets of modern liberal society, and the concepts of "intellectual property" for "use-

ful" inventions and "literary property" for creative works are thoroughly modern.[47] In the mid-nineteenth century, Spain developed its own set of "literary property" laws, in which compositions were understood to emanate from the individual genius of a private person; an author's personhood and individual rights were made manifest by the recognition of his or her authorial identity and property.[48] Although the relation among liberalism, slavery, and abolition is complex, it bears noting that the notions of individuals' literary property rights are similar, in some ways, to those behind abolition in contemporary Spain. One line of argument that denounced slavery and the slave trade emphasized the slaves' rights to their own individual persons. For example, the anonymous author of the treatise *La cuestion africana en la Isla de Cuba, . . . por un cubano propietario* (The African question on the island of Cuba, . . . by a Cuban landowner) (1863), which was representative of the abolitionist rhetoric in Spain during the 1860s, argues for the restitution of the "derecho de personalidad á los esclavos" (right of personality to slaves along the same principles of individualism).[49] The theft of property rights was analogous to the theft of personhood. Indeed, the primary definition of the term *plagiario* (plagiarist or plagiary) in Spain throughout the nineteenth century referred to the Roman term for kidnapping and enslaving a free person. The subsequent use of the term *plagiarism* for the theft of another's ideas or writing was metaphoric. Throughout the nineteenth century, the term *plagio* (plagiarism) was used in Cuba to refer to the enslavement of free persons.[50]

Whereas Luna and Palomino's critique of Spain's tolerance of the transatlantic slave trade was grave and audacious, its form was surprisingly ironic. Despite the name recognition of both Stowe and *Uncle Tom's Cabin*, neither is mentioned in the newspaper announcements for *Haley*'s performances or printed on the title page of the published edition. Half of the play is composed of passages translated verbatim from Stowe's novel, but her name appears only in a note to readers on the book's last page. Luna and Palomino energetically claim that their play is not a translation but an original work—that its story, although developed from Stowe's, is new. The intertextuality can be perceived only by someone who sees or reads the play and thus participates in a use of *Uncle Tom's Cabin* unintended by its American author. Given no attribution (much less remuneration or distribution rights) for *Haley*, Stowe is herself a victim of a metaphoric transatlantic *plagio*: she is introduced into the Spanish literary market-

place via a contraband vessel that employs her story to ideological ends radically different from her own.

The dialogue across the Atlantic world regarding slavery and the illegal trade was not restricted to its English-speaking interlocutors; it had immediate consequences for Spain and Cuba. Nevertheless, there was a concern in contemporary Spain that the general population was either uninformed about the issues of slavery and empire (in part because of censorship) or simply uninterested. In a period when public opinion was beginning to constitute a limited social force, public interest and concern for the conservation of the empire was considered necessary but utterly lacking. In 1853, José de la Concha, the former governor of Cuba, began his published memoirs by excoriating Spaniards for failing to concern themselves sufficiently with the conservation of the island.[51] Similar reprimands appeared in the press.[52] A later expression of this worry is found in Pérez Galdós's novel *Tormento*, whose young protagonist, Amparo Sánchez Emperador, innocently asks a returned *indiano* (a Spaniard who returned from temporary emigration to Spanish-speaking American lands) if he saw tigers and dragons in Mexico and Texas—a criticism of the ignorance of the Spanish middle class about the Americas in general as much as of women's poor education.

The extent of this supposed inattention by Spaniards to the questions of slavery and empire must be reconsidered. Another history of public opinion regarding the Cuba question lies in the role of *Uncle Tom's Cabin* as a frame for Spaniards' understanding of their nation's slave policies. The views on Spanish slave and traffic policies were as numerous and varied as the versions of the novel itself. First, through its multiple translations and publishing formats, the American story was multiplied into a series of adaptations and editions with varying cultural and philosophical objectives. Whereas publishers such as Ayguals de Izco agreed with Stowe's political agenda, Luna and Palomino engaged with the passion and social awareness of Stowe's work to condemn the fundamental quandary of the empire: the slave trade. Spaniards' participation in the international dialogue regarding slavery quickly moved beyond the story of Tío Tom and his cabin to a consideration of Haley, his slave ship, and a variety of political, national, and economic concerns. Through adaptations like *Haley*, the public at large was presented with Hispanicized versions of the issues of national unity, the morality of the transatlantic slave trade, and the humanity of slaves—issues that roiled the Atlantic world through the end of the century.

Notes

1. Mason I. Lowance Jr., Ellen E. Westbrook, and R. C. De Prospo, introduction to *The Stowe Debate* (Amherst: University of Massachusetts Press, 1994), 1.

2. Dale Tomich, "The Wealth of Empire: Francisco Arango y Parreño, Political Economy, and the Second Slavery in Cuba," *Comparative Studies in Society and History* 45.1 (2003): 4–28; Christopher Schmidt-Nowara, *Empire and Antislavery: Spain, Cuba, and Puerto Rico, 1833–1874* (Pittsburgh: University of Pittsburgh Press, 1999), 3.

3. José Luciano Franco, *Comercio clanestino de esclavos* [The clandestine slave trade] (Havana: Ciencias sociales, 1985), 379. All otherwise unattributed translations in this essay are mine.

4. Franco, 379; "Cuba and the Slave Trade," *New York Daily Times*, 17 January 1853, 1.

5. Arthur F. Corwin, *Spain and the Abolition of Slavery in Cuba, 1817–1886* (Austin: University of Texas Press, 1967), 94.

6. David Eltis, *Economic Growth and the Ending of the Transatlantic Slave Trade* (New York: Oxford University Press, 1987), 245. For the most complete study of the slave trade between the late sixteenth and nineteenth centuries (including ship voyages of both licit and clandestine commerce), see David Eltis, David Richardson, and Herbert S. Klein, eds., *The Trans-atlantic Slave Trade* (Cambridge: Cambridge University Press, 1999), CD-ROM.

7. Jose Fernandez Montesinos, *Introducción a una historia de la novela en España en el siglo XIX, seguida del esbozo de una bibliografia española de traducciones de novelas, 1800–1850* [Introduction to a history of the nineteenth-century Spanish novel, followed by a brief Spanish bibliography of translations of novels, 1800–1850] (Madrid: Castalia, 1980), 186.

8. In comparison, Eugène Sue's megahit *El judío errante* (*Le juif errant*; The wandering Jew) had eleven editions in Spain between 1845 and 1871 and was published simultaneously in 1844 by three Madrid firms and one in both Cadiz and Barcelona. See Antonio Palau y Dulcet, *Manual del librero hispanoamericano* [Handbook of the Hispanoamerican bookseller], vol. 22 (Barcelona: Palau y Dulcet, 1970), 286; Elisa Martí-López, *Borrowed Words: Translation, Imitation, and the Making of the Nineteenth-Century Novel in Spain* (Lewisburg: Bucknell University Press, 2002), 37. Dumas's *El conde de Montecristo* [*The Count of Monte Cristo*] had four different translations in 1846 (Montesinos, 186).

9. Mercedes Cabrera et al., "Datos para un estudio cuantitativo de la prensa diaria madrileña, 1850–1875" [Data for a quantitative study of the daily Madrid press, 1850–1875], in *Prensa y sociedad en España* [The press and society in Spain] (Madrid: n.p., 1975), 103.

10. José Javier Sánchez Aranda and Carlos Barrera, *Historia del periodismo español: Desde sus orígenes hasta 1975* [History of Spanish journalism: From its origins to 1975] (Pamplona: Universidad de Navarra, 1992), 142; Cabrera et al., 117.

11. Jean-François Botrel, "La novela por entregas." See also Jean-François Botrel and Serge Salaün, eds., *Creación y público en la literatura española* [Creation and publics in Spanish literature] (Madrid: Castalia, 1974), 132.

12. The following translations of *Uncle Tom's Cabin* were available in mid-nineteenth-century Spain:

La cabaña del tío Tom, serialized in *La nación* beginning 20 January 1853.
La cabaña del tío Tom, trans. A. A. Orihuela (Barcelona: Juan Olivares, 1853).
La cabaña del tío Tom, trans. A. A. Orihuela (Paris: Ignacio Boix, 1852).
La cabaña del tío Tomás, serialized in *El clamor público*, 6 January 1853–14 April 1853.
La cabaña del tío Tomás, serialized in *La época* beginning 26 January 1853.
La cabaña del tio Tomás, serialized in *Las novedades* beginning 9 January 1853.
La cabaña del tío Tomás, trans. *El clamor público* (Barcelona: Manuel Sauri, 1853).
La choza del negro Tomás (Madrid: J. D. Marés, 1853).
La choza del tío Tom (Cádiz: Arjona, 1853).
La choza del tío Tom, trans. José A. Matute, serialized in the "Biblioteca Española" [literary section] of *Album pintoresco* beginning 9 January 1853.
La choza del tío Tom, trans. Peregrín García Cadena (Valencia: José Rius, 1853).
La choza de Tom, trans. J. P. Ruiz (Madrid: Biblioteca selecta, 1853).
La choza de Tom, trans. Wenceslao Ayguals de Izco (Madrid: Ayguals de Izco, 1852).
La choza de Tom, ed. and trans. Wenceslao Ayguals de Izco, 2nd ed. (Madrid: Ayguals de Izco, 1853).
La choza de Tomás (Madrid and Paris: Mellado, 1853).

13. These are the exact numbers for 1860 from Botrel: of a national population of 15,673,481, 24 percent, or 3,835,770, were literate. Botrel, "La novela por entregas." David Ringrose points out the scarcity of reliable census data for the nineteenth century but estimates the national population in 1857 at 15,454,000 and that of Madrid in 1853 at 231,866: see *Transportation and Economic Stagnation in Spain, 1750–1850* (Durham: Duke University Press, 1970), 133; *Madrid and the Spanish Economy* (Berkeley: University of California Press, 1983), 27.

14. Spain, Royal Order of 23 April 1852, art. 8, Gob. Civil, leg. 117, no. 75, Archivo Histórico de la Provincia de Cadiz.

15. *La nación*, 12 October 1852, 1.

16. Another example of such withholding is the following notice, or "Boletín del día," from Madrid's *La época* (24 October 1852, 2; 29 October 1852, 1), reporting that all is officially well in Cuba but hinting at news: "Por la via de los Estados-Unidos se han recibido noticias interesantes de la isla de Cuba, á que daremos publicidad luego que sean aprobadas por la censura. Seguia reinando la tranquilidad en aquellas leales provincias. La *Gaceta* nada dice hoy acerca de estas noticias." (Via the United States there has been interesting news about Cuba, which we will publish as soon as it is approved by the censors. Tranquility reigns in those loyal provinces. The *Gaceta* [an official publication of the government] has said nothing about this news today.)

17. "Parte política," [Political dispatch], *El heraldo*, 30 December 1852, n.p.

18. In *Mulatas and Mestizas: Representing Mixed Identities in the Americas, 1850–2000* (Athens: University of Georgia Press, 2003), Suzanne Bost offers a detailed reading of the ideologies girding both systems.

19. *La choza de Tom*, trans. Wenceslao Ayguals de Izco (Madrid: Ayguals de Izco, 1852).

20. Iris M. Zavala, "Socialismo y literatura: Ayguals de Izco y la novela española" [Socialism and literature: Ayguals de Izco and the Spanish novel], *Revista de Occidente* 27 (1969): 178.

21. The Italian translation of a novel by Ayguals de Izco, *Maria la spagnuola: Storia contemporanea de Madrid* [Spanish Maria: A contemporary story of Madrid], edited by F. Giuntini, was place on the index on 6 September 1852 (*La censura, revista mensual* [Censorship, a monthly review], October 1853). The pope placed *Uncle Tom's Cabin* on the index on 18 September 1853. See Frank J. Klingberg, "Harriet Beecher Stowe and Social Reform in England," *American Historical Review* 43 (1938): 545.

22. Ivan Schulman, "The Portrait of the Slave: Ideology and Aesthetics in the Cuban Antislavery Novel," *Annals of the New York Academy of Sciences* 292 (1977): 356.

23. Anselmo Suárez y Romero, *Francisco*, ed. Mario Cabrera Saqui (Havana: Publicaciones del Ministerio de Educación, Dirección de Cultura, 1947). The longer version of the novel was published in New York by N. Ponce de Leon in 1880.

24. Consuelo Naranjo Orovio and Miguel Angel Puig-Samper Mulero, "El legado hispano y la conciencia nacional en Cuba" [The Hispanic inheritance and national consciousness in Cuba], in *Revista de Indias* 50 (1990): 795.

25. Gertrudis Gómez de Avellaneda, *"Sab": Novela orijinal* (Madrid: Imprenta Calle del Barco num. 26, 1841).

26. Basil Rauch, *American Interest in Cuba, 1848–1855* (New York: Columbia University Press, 1948), 281.

27. "Boletín del día," [Daily bulletin], *La época* (Madrid), 24 October 1852, 2; 29 October 1852, 1.

28. "Variedades" [Varieties], *El clamor público*, 13 January 1853, 1.

29. *Correo de Barcelona*, 5 April 1853, 1.

30. "Correo estrangero" [Foreign correspondence], *El clamor público*, 29 January 1853, n.p.

31. *El heraldo*, 22 February 1853, 1.

32. "Novedades" [Novelties], *Las novedades*, 23 March 1853, 1; Franklin Pierce, inaugural address, 4 March 1853, *The Avalon Project*, Lillian Goldman Law Library, Yale Law School, http://avalon.law.yale.edu/19th_century/pierce.asp (accessed 10 November 2016).

33. Corwin, 22; Dale Tomich, "The Wealth of Empire: Francisco Arango y Parreño, Political Economy, and the Second Slavery in Cuba," *Comparative Studies in Society and History* 45.1 (2003): 4–28.

34. *El heraldo*, 12 January 1853.

35. Ángel Maria de Luna and Rafael Leopoldo Palomino, *Haley, ó, El traficante de negros: Drama en cuatro actos, en prosa* [Haley; or, The slave trafficker: Drama in four acts and in prose] (Cadiz: Pantoja, 1853), 3.10.

36. José Zorrilla, *Don Juan Tenorio*, ed. David Gies (Madrid: Castalia, 1994).

37. Bibiano Torres Ramírez, *La Compañía Gaditana de Negros* [The Cadiz company of blacks] (Sevilla: Escuela de Estudios Hispano-Americanos de Sevilla, 1973).

38. Luna and Palomino, 4.12 (ellipses in original).

39. Spain, "Tratado entre las coronas de España é Inglaterra para la abolicion del tráfico de esclavos; firmado en Madrid el 28 de junio de 1835" [Treaty between the Crowns of Spain and England for the abolition of the slave trade, signed in Madrid on 28 June 1835], in *Tratados, convenios y declaraciones . . . 1700 hasta el día* (Madrid: Alegría, 1843), art. 13.

40. Ibid., art. 12.

41. Leading this reexamination were several members of the Del Monte literary circle.

For a discussion of the reformist position promoted by these writers, see William Luis, *Literary Bondage: Slavery in Cuban Narrative* (Austin: University of Texas Press, 1990).

42. Orovio and Mulero, 791.

43. *El mensajero*, 12 April 1853, n.p.

44. For a discussion of the performance of Spanishness in the context of the United States, see Julia Stern, "Spanish Masquerade and the Drama of Racial Identity in *Uncle Tom's Cabin*," in *Passing and the Fictions of Identity*, ed. Elaine K. Ginsberg (Durham: Duke University Press, 1996), 103–30.

45. Paul Patrick Rogers, *The Spanish Drama Collection in the Oberlin College Library* (Oberlin: Oberlin Printing, 1940), 329.

46. José G. Cayuela Fernández, *Bahía de Ultramar: España y Cuba en el siglo XIX: El control de las relaciones coloniales* [The overseas bay: Spain and Cuba in the nineteenth century; The control of colonial relations] (Madrid: Siglo veintiuno, 1993), 12.

47. Mark Rose, *Authors and Owners: The Invention of Copyright* (Cambridge: Harvard University Press, 1993), 3.

48. Manuel Dánvila y Collado, *La propiedad intelectual* [Intellectual property], 2nd ed. (Madrid: Correspondencia de España, 1882), 78.

49. *La cuestion africana en la Isla de Cuba, considerada bajo su doble aspecto de la trata interior y esterior, por un cubano propietario* [The African question in the island of Cuba, considered in its dual aspects of interior and exterior trade, by a Cuban landowner] (Madrid: El clamor público, 1863), 39.

50. Luis, 125.

51. José de la Concha, *Memorias sobre el estado político, gobierno y administración de la Isla de Cuba* [An account of the political state, government, and administration of the island of Cuba] (Madrid: Trujillo, 1853), vi.

52. *El nacional*, 5 March 1853, n.p.

Kahlil Chaar-Pérez

The Bonds of Translation:
A Cuban Encounter with *Uncle Tom's Cabin*

Through numerous translations, adaptations, and performances, mid-nineteenth-century sentimental communities across the world embraced Harriet Beecher Stowe's plea in *Uncle Tom's Cabin* to "feel right" in opposing chattel slavery as "a system which confounds and confuses every principle of Christianity and morality" (452–53). Although the British and French governments had already abolished it, slavery was still rampant in the United States, Brazil, and the Spanish colonies of Cuba and Puerto Rico during the 1850s, while serfdom subsisted in Russia. Moved by the novel's affecting depiction of the horrors of enslavement, a transatlantic public coalesced around the universalist moral values through which Stowe expressed her call for abolition: "See, then, to your sympathies in this matter! Are they in harmony with the sympathies of Christ? or [*sic*] are they swayed and perverted by the sophistries of world policy?" (452). In the Protestant brand of sentimentalism found throughout *Uncle Tom's Cabin*, the experience of sympathizing with the enslaved other is circumscribed within a pre-ideological order of feelings. In the pursuit of a "right" feeling determined by the universal spirit of "Christianity," the ideal sympathetic subject is able to transcend the artificial divisions fostered by the political sphere ("world policy"). Even as Stowe explicitly dedicates *Uncle Tom's Cabin* to the people of the United States, her rhetoric invokes a public that transcends the boundaries of her country. The novel's religious sentimentalism strives to touch all (Christian) hearts across the globe, intersecting with the heterogeneous romantic forms of "cosmopolitan interestedness" that, as Ian Baucom analyzes in *Specters of the Atlantic*, began to surface

in the late eighteenth century in opposition to the "sophistries" of modern politics and capitalist production.[1] Specifically, *Uncle Tom's Cabin* forms part of the literary tradition of the sentimental novel, a genre that, as Margaret Cohen puts it, represented "the vanguard of formulating the notion of an affectively charged association among distanced readers."[2] Yet, as critics ranging from Hortense S. Spillers to Lauren Berlant have noted, the universalist thrust that intertwines Stowe's abolitionist politics with the "sympathies of Christ"—embodied in the sacrificial spectacle of Uncle Tom's passive death—erases not only the agency of enslaved and black subjects but also the history of chattel slavery itself.[3]

In the process of helping *Uncle Tom's Cabin* become an international best seller, transnational publics reimagined Stowe's invitation to "feel right." They rewrote the novel's plot, characters, ideology, and aesthetics in counterpoint to the social worlds in which they consumed, translated, and adapted it.[4] Among the numerous figures from Latin America who intervened in the open-ended "text-network" of *Uncle Tom's Cabin* was Andrés Avelino de Orihuela, who wrote the first full translation of Stowe's novel into Castilian Spanish, only months after its original publication in book form.[5] Born in 1818 in the Canary Islands, Orihuela lived his formative years in Havana, where he studied law and became active among local liberal circles, which led to his exile. As he traveled through the U.S. South, Spain, France, and back again to Cuba, Orihuela participated actively in debates against Spanish colonialism and slavery, writing pamphlets, novels, and poems that he often confronted the excesses of colonial society. He spent the last years of his life defending the republican cause in Spain, where he presumably died in 1873.[6] In the preface to his novel *El sol de Jesús del Monte* (Jesús del Monte's sun) (1853), Orihuela labels himself as a "true cosmopolitan whose homeland is the world, whose brother is the friend, whose family is all humanity," without any mention of Cuba or the Canary Islands.[7] In his self-representation as a citizen of the world, Orihuela appeared to situate his work beyond contemporary patriotic and nation-building discourses. Having been born in the Canary Islands—which Peninsular Spaniards perceived as a society inferior to the mainland—and then having received his formal education in Cuba, he had to negotiate a complicated process of transatlantic identification and disidentification. In his works cited in this essay, Orihuela never declares his Canarian descent, focusing on his social and political experiences in Cuba. At the same time, his language does not

correspond fully with the patriotic style of the Cuban intellectuals of the time.

Cosmopolitanism does not, however, necessarily preclude regional or local affiliations: in *Dos palabras sobre el folleto "La situación política de Cuba y su remedio"* (Two words on the pamphlet "Cuba's Political Situation and How to Solve It"), which was published a year before *El sol de Jesús del Monte*, Orihuela advocated the annexation of Cuba into the United States.[8] In translating *Uncle Tom's Cabin*, Orihuela reinforced his bond with the United States at the same time that he adapted it for not only the Cuban liberal elite but also Hispanophone readers in Europe and the Americas. First published in Paris in 1852 as *La cabaña del Tío Tom*, Orihuela's translation would see new editions in Colombia, Spain, and Argentina only a year later, contributing to the expansion of the transnational network of Stowe's classic. His translation builds a sense of sentimental community with the antislavery vision of Stowe, but, as I will show here, it also constrains the original's Christian morality and its romantic racialism, producing a distinctively "transamerican" narrative that translated the ideals of secular republicanism and cosmopolitanism into the racially fraught colonial politics of Cuba.[9] Even as Orihuela's "Cubanization" of *Uncle Tom's Cabin* articulates an ambivalent racial politics linked to his gradual abolitionism, it also produces a critique of how both Stowe and the Cuban elite approached the representation of blackness.

Orihuela explains his fascination with *Uncle Tom's Cabin* in his translation's preface, which he presents as a letter addressed to Stowe.

> When the book that you have just conceived reached my hands, I devoured its pages; the tears that this reading elicited are the most expressive testimony of the character of the feelings that unite us. . . . My lady, you have known how to speak to the heart, wounding its most delicate fibers. . . . your golden quill holds the exclusive privilege of disseminating, through its novel, the pure and saintly seed that will shortly yield its results, to the solace of the African race and the honor of modern civilization.[10]

Here, the rhetoric of moral sentiment takes the form of an affective wound that compels the subject into action—in this case, into translating and circulating the book's antislavery gospel. The wound functions as a sign of

Orihuela's sentimental identification with Stowe: in being moved to tears, the translator develops a close connection with not only the text but also the author, articulating a bond of unity between the United States and Cuba through the sentimentalization of slavery.[11] Writing on the limits of "liberal sentimentality" in Stowe, Lauren Berlant has perceptively observed how fictions of protest structured around sentimental bonds produce what she calls a "fantasy scene of national feeling."[12] According to Berlant, such fictions of collective empathy—represented in the text by Orihuela's tears—risk occluding the difference of the suffering other and the "structural inequities" of slavery and racism. Orihuela's prologue is exemplary in this regard: it does not inquire into the enslaved Other's predicament or voice but concentrates on the text's sentimental effect and how it will "yield" the abolition of slavery, honoring "modern civilization" in the process.

As Orihuela's use of the phrase "modern civilization" reveals, this "fantasy scene" is not solely a matter of "national feeling." Not only does it apply to Cuba and other slaveholding countries, but it is a burden that weighs on all of Western modernity. In the preface to *El sol de Jesús del Monte*, Orihuela defines his cosmopolitan self according to a personal experience of "nomadic life," a pursuit of "new impressions" that will take him from "the capital of the civilized world," Paris, to an exoticized "Orient."[13] This self-narrative replicates the dominant forms of cosmopolitanism one typically associates with the modern bourgeois writer, a Eurocentric ethos of rootlessness "obsessed," as Bruce Robbins puts it, "with embodying a preconceived totality."[14] In the case of Orihuela, cosmopolitan totality or universalism would seem to be determined through his ideal of a "modern civilization" represented by *Uncle Tom's Cabin*, Paris, and the United States. At the same time, Orihuela does not erase the particulars of his experiences in Cuba. *El sol de Jesús del Monte* narrates, in part, the struggles of people of African descent in Cuba and even lionizes the *mulato* poet Plácido, who was accused by the colonial authorities of participating in the slave conspiracy of La Escalera in 1843 and was consequently executed.[15] In addition, Orihuela begins his letter to Stowe by mentioning his upbringing in Cuba and declaring that he became an abolitionist because he had witnessed, as a child, the "cry of the slave and the masters' cruelty."[16] In the following sentence, he remarks on his surprise upon learning, in his travels through the U.S. South, that the same barbarous practices "also" exist in "the true bastion of man's liberty," where he was able to observe "in relief the sad scenes that [. . .] you so faithfully sketch

in *Uncle Tom's Cabin*."[17] Beyond the questionable reliability of Orihuela's assertion about his ignorance of chattel slavery practices in the United States, the relationship traced in the text between the South and Cuba stands out. Orihuela traces a parallel between his perceptions of slavery in Cuba and of Southern slavery, distinguishing the latter only through the idealistic reference to U.S. liberty. This parallel is mediated through literature, specifically through the "faithful" representation of slavery in *Uncle Tom's Cabin*. In commending the novel's realism, Orihuela privileges the sentimental narrative's ability to capture the truth of slavery. Bridging the worlds of slavery in Cuba and the United States through the intersection of realism and sentimentalism, *Uncle Tom's Cabin* is thus presented to the reader as a text that can condense a local reality and disseminate it, as a "pure and saintly seed" for foreign, cosmopolitan readers such as Orihuela to cultivate and translate, as they insert themselves and their particular social and political visions within the novel's text-network. Orihuela's translation addressed the formation of a Cuban counterpublic that not only identified with U.S. republicanism but also sought political unification with their northern neighbor.

ORIHUELA AND THE CUBAN COUNTERPUBLIC: "THERE IS NOTHING MORE POETIC IN US THAN THE SLAVES"

For the most part, scholars of Cuban literature and culture have not engaged in depth with *Uncle Tom's Cabin*, its possible convergences with the sentimental and abolitionist traditions in Cuba, or its reception among the local elite. When they have done so, their purpose has been to underscore the existence of a distinctly Cuban genealogy of romantic antislavery fiction that precedes Stowe's novel, particularly Félix Tanco y Bosmeniel's *Petrona y Rosalía* (1838), Anselmo Suárez y Romero's *Francisco* (1839), and Gertrudis Gómez de Avellaneda's *Sab* (1841).[18] Ignoring the specifics of *Uncle Tom's Cabin* or reducing it to the status of propaganda, such comparisons affirm the originality and autochthony of the Cuban literary tradition over the value of a nineteenth-century classic that belongs to the U.S. tradition, articulating a binary opposition that ironically plays out the uneven, conflicted history of relations between Cuba and the United States. By demarcating thus the national boundaries of the cultural production of Cuba (and the United States), we face two risks: overlooking the intricate historical links that connect Cuba with the United States, and of reinforcing conse-

quently the nationalist fictions of exceptionalism that still haunt the history of both countries. One cannot stress enough the porosity of their borders during the era of *Uncle Tom's Cabin*: the United States had already become the colony's chief trade partner, as its government contemplated annexing the island; meanwhile, many members of the Cuban elite lived or were educated in the United States and professed a profound identification with the country, even when they did not favor political annexation. For example, the Cuban intellectual José Antonio Saco, who never allied himself with the Cuban annexationist movement, wrote in 1837, "if [Cuba] had to throw itself on the arms of a stranger, none would be as honorable and glorious as those of the great North American federation."[19] Through an image that implicitly feminizes Cuba under the embrace of the chivalrous federation, Saco expresses a generalized sentiment among most Cuban elites of the period: an admiration of the republican values of the United States and its growing power in the hemisphere.

During the 1830s, the white Cuban elite was in the midst of producing what critics have identified as the beginnings of a national literature in the colony, under the tutelage of the wealthy man of letters Domingo del Monte. Inspired partly by the poetry and autobiography of the former slave Juan Francisco Manzano, young writers such as Félix Tanco y Bosmeniel combined romantic and realist aesthetics with the explicit aim of capturing the autochthonous character of Cuban society. In particular, they fictionalized the social world of Cuba's enslaved inhabitants who were depicted largely as idealized figures of passive victimhood.[20] Through their works, which were circulated clandestinely and published on foreign soil, these intellectuals challenged the colonial authorities and their repressive measures, articulating a heterogeneous counterpublic that extended, in the 1840s and 1850s, to Paris, Madrid, New York, and other cities in the Americas.[21] This diverse, ever-shifting political network cannot be neatly reduced to a single ideology, except a generalized rejection of the colonial status quo, as defined by the Spanish Constitution of 1837. The new constitution provided the Crown with special powers over its territorial possessions, leaving Cuban-born subjects with little, if any, political agency, while Spanish administrators and merchants continued to take advantage of a burgeoning economy driven by the local sugar boom. The ensuing years in Cuba were increasingly turbulent: censorship was tightened, while slave uprisings erupted, culminating in the mass conspiracy of La Escalera in 1843, which led to the torture and execution of hundreds of enslaved and

free blacks, many of whom were innocent. The colonial crackdown on the conspiracy also resulted in the arrest and exile of Domingo del Monte and many of his followers, who were deemed suspicious because of their liberal and abolitionist tendencies. Historians have clearly established, however, that Domingo del Monte and most of his associates did not participate in the conspiracy. In fact, the majority of them were, as Sibylle Fischer puts it, "moderate abolitionists": they advocated a gradual process of emancipation and condemned all slave rebellions, which they associated negatively with the potential Africanization of Cuba and its transformation into another "Haiti."[22] After the Haitian Revolution of 1791–1804, Cuba replaced Saint-Domingue as the top sugar producer in the world and, in the first half of the nineteenth century, absorbed thousands of enslaved Africans into its flourishing plantation system. According to the colonial census, enslaved and free people of color outnumbered the white population in this period, which fed into the Cuban and Spanish elite's anxiety about a black revolution.

Writing in exile one year after the conspiracy, Del Monte expressed his fears about an impending crisis in Cuba to the Spanish ambassador in Paris.

> The island of Cuba finds itself today under the imminent risk of loss, not only for Spain but for the white race and the civilized world, if the Spanish government does not take forceful and immediate measures to contain the catastrophe. Those who know Cuba have declared that the only two revolutions that can occur there are: of soldiers or blacks.[23]

Like his friend José Antonio Saco, Del Monte articulated an exclusively white discourse of patriotism, excluding peoples of African descent from the definition of a Cuban identity, separate from the Spaniards. For Del Monte and his followers, slavery was a barbaric institution that went against the values of the "civilized world," but they also perceived enslaved subjects as barbaric. For them, blackness represented an excess that had to be cleansed away from the homeland, through reformist policies such as gradual abolition, white immigration, and the expatriation of people of color to the African continent—echoing the failed plan to resettle all U.S. blacks to Liberia, which was supported by numerous liberal public figures, ranging from Harriet Beecher Stowe to Abraham Lincoln. The mid-nineteenth-century Cuban elite's moderate abolitionism and their attention to representing slavery through literature was not tantamount to the national myth

of multiracial integration that emerged decades later with the revolution-
ary nationalist movement. On one hand, this vision of integration blamed
Spanish colonialism for slavery and racial disharmony in the island; on the
other hand, it "made the revolution a mythic project that armed black and
white men together to form the world's first raceless nation."[24] In contrast
to the rhetoric of later revolutionary figures such as José Martí, the "whit-
ening" discourse of Del Monte's generation served to police the symbolic
boundaries between blackness and an emerging sense of national selfhood.
In this manner, the members of the Cuban elite sought to distance them-
selves from the island's pervasive culture of miscegenation, a practice that
was illegal at the time but common among the colony's inhabitants.

What value did the representation of black subjects have, then, for the
Cuban elite? In his letters to Del Monte, Tanco asserted most forcefully the
importance of depicting Cuba's enslaved communities. For instance, in
an 1836 letter, he observes, "there is nothing more poetic in us than the
slaves; *poetry* that is being spilled everywhere, through fields and towns."[25]
Through this romantic equivalence with "poetry," the enslaved subject is
turned into a fully aestheticized object, a source of literary inspiration. At
the same time, the figure of the slave is disseminated throughout the is-
land, as a product of the white elites' cultural and economic investment. In a
grotesque displacement of signifiers, Tanco's use of "spill" (*derramar* in the
original) echoes not only the flow of the writer's ink over the page but also
the actual loss of the slave's blood, which embodies the violence of enslave-
ment. In addition, Tanco places the enslaved black other in close proximity
to his own community; the black other's poetry is inherent to the (white)
Cuban "us." In a succeeding letter written a month after the new Spanish
constitution was passed, Tanco affirms that the "spirit of Cuba" is composed
of only "sugar" and "blacks": for him, "everything else" in Cuba "is superflu-
ous and mere luxury, liberty as well as despotism."[26] In both letters, Tanco
appears to distance himself from his friend Del Monte and other Cuban
intellectuals, particularly from their discourse of "whitening." His penchant
for hyperbole and his strident tone heighten the sense of imminent violence
behind Del Monte's fears of "losing" Cuba. In fact, in observing that "lib-
erty" is already "superfluous" or a "mere luxury" in the colony, Tanco ap-
pears to suggest that, from such a perspective, Cuba has already been lost.

These distinctions do not entail that Tanco adhered to a more radical or
egalitarian vision of abolition and race relations than his peers. The refer-
ences to "blacks" and "sugar" as signifiers of Cuba's "spirit" embody the co-

lonial economy's driving force: enslaved labor and the colony's main export commodity. The letter scathingly insinuates that the colony's only transcendental value is its economic production and, hence, that capitalist interest determines all deliberations on the meanings of "liberty" and "despotism" in Cuba. In his novella *Petrona y Rosalía*, Tanco y Bosmeniel centers his gaze on the slave owner's domestic sphere, which he depicts as a horrific world of unbridled greed and depredatory sexual desire. Moral horror is a genealogical theme in the novella: first, the Spanish sugar magnate Don Antonio rapes Petrona, a black domestic slave; later, his *criollo* son Don Fernando violates her *mulata* daughter, Rosalía, without knowing that she is his sister. When Doña Concepción, Antonio's wife, learns that Petrona and Rosalía are pregnant, she banishes them to the plantation, where they perish from extreme working conditions. The only value Petrona and Rosalía have in the social order represented in the novella, which reads as an allegory of Cuban plantation society, is as economic and sexual objects, a point driven hard by the text's last words, pronounced simultaneously by Fernando and Concepción: "Patience, a thousand pesos have been lost!"[27]

Tanco's negative portrayal of the plantation-owning class's moral abjection and his reduction of the enslaved subject to a figure of passive sacrifice is comparable to Stowe's depictions of the repeated abuse Uncle Tom suffers under his last owner, Simon Legree. Indeed, the incendiary tone of *Petrona y Rosalía* lends it a propaganda-like effect analogous to the discourse of social protest articulated in *Uncle Tom's Cabin*. At the same time, *Petrona y Rosalía* adds a narrative theme not explored in *Uncle Tom's Cabin*: miscegenation as incest. An essential feature of nineteenth-century Cuban elite culture was its anxious fascination with interracial relations, particularly the *mulata* figure. Through an expansive textual, visual, and performative archive, both the Spanish and white Cuban elite imagined the *mulata* as what Vera Kutzinski calls "a dangerous combination of beauty and malice," an eroticized, sexually threatening force that imperiled the stability of their identities.[28] Following Sibylle Fischer, the incest leitmotif in such representations can be interpreted as a "traumatic fantasy about the Creole self" in which the *mulata* stands for an encounter with Cuban sameness: through horror, she is assimilated into the fragile genealogy of Cubanness at the same time that her autonomy goes unrecognized.[29]

In *Petrona y Rosalía*, the representations of slavery and forced miscegenation combine as a critique of the inherent violence of Cuba's social structures. Yet the "pure" white Cuban self that local intellectuals like Del Monte

envisioned is also implicated in this violence. For Tanco, no subject position within the colonial order can rupture this vicious cycle: Cuba is "lost," but only as a Spanish colony. In 1843, writing as the conspiracy of La Escalera transpired and as colonial repression intensified, Tanco vilified Cuba as "a horrifying, repugnant island," declaring to an exiled Del Monte that it was impossible to develop any patriotic sentiment in such a place.[30] In the same letter, he pledged to raise his children in the United States, presaging his eventual support of the U.S. annexation of Cuba.[31] For Cuban writers who progressively looked toward the north as a potential sanctuary, the depiction of the intimate horrors of slavery was synonymous with developing a vision of anticolonial liberation from the moral corruption they saw as inherent to the Spanish colonial order. But this vision did not include colonial reforms or political independence; such liberation was to be developed under the protection of the United States.

As more and more of its members were forced into exile, the Cuban elite's admiration for the United States fueled a small yet significant movement of revolutionary annexationists that took form in the late 1840s and lasted until the eruption of the Civil War. Because of their association with the U.S. military adventurers who invaded Central America and the Caribbean, such as William Walker, these groups were also called *filibusteros* (filibusters). As mentioned before, the economic ties between Cuba and the United States already ran deep during this period: in 1850, the latter displaced Great Britain and Spain as the colony's foremost commercial partner. Looking to consolidate these relations and to eliminate the repressive colonial system under Spain, a group of Cuban plantation owners and intellectuals participated in a transnational network of rebellion with the active backing of U.S. entrepreneurs, at the same time that politicians, including President James K. Polk, sought to incorporate the colony through diplomatic means.[32] During the 1840s and 1850s, Cuban revolutionaries stationed in New Orleans, Philadelphia, and New York addressed the U.S. public sphere while they fostered a surge of Cuban patriotism in the exile communities, sharing and debating their often conflicting views through newspapers and pamphlets that circulated in Europe and the Americas.

As David Luis-Brown has noted, a common element in the discourse of Cuban annexationism was the appropriation of the republican and cosmopolitan values that proliferated with the European revolutions of 1848 and the ascent of the French Second Republic.[33] The democratic ideals of frater-

nity, liberty, and equality were resurrected not only in France but throughout the globe. Cuban exile publications celebrated the revolution in France, aligning their political vision with the promise of what an 1848 manifesto, published in the New York newspaper *La Verdad* (The Truth), called "universal fraternity and happiness." Simply titled "To the inhabitants of Cuba and Puerto Rico" and signed by a "Peninsular cubano" (Cuban Spaniard), the manifesto additionally locates this promise in the future of the United States: "Bellicose France will bring about this blessing in Europe, and is preparing to do so; the Great Republic of the United States will do so earlier, for its sisters in the world of Columbus."[34] Combining the radical rhetoric of 1848 with U.S. liberal republicanism in order to call for an anticolonial revolution against Spain, annexationists also drew from the popular expansionist propaganda of Manifest Destiny, which the journalist John L. O'Sullivan originated in a famous series of writings that advocated the annexation of Texas. Not coincidentally, O'Sullivan was one of the main benefactors behind *La Verdad* and the failed revolt of 1850, a fact that highlights the profound alliances between Cuban annexationists and U.S. imperial interests.

Although it appears that he did not have a leading role in any of the annexationist cells, Orihuela was a clear supporter of the movement. In *Dos palabras*, the 1852 pro-*filibustero* pamphlet where he criticizes José Antonio Saco's writings against the incorporation of Cuba into the United States, Avelino de Orihuela applauds the work of *La Verdad* and the different secret societies and political groups that spread the gospel of annexation, describing the movement as a "revolution in ideas." Orihuela connects this revolution directly to the United States, which he acclaims as "the only bastion in the civilized world that preserves liberty, properly understood, in its bosom" (3).[35] In this passage, Orihuela idealizes the United States as the sole national bearer of freedom in the Western tradition, a rhetoric that echoes the imperialist discourse of Manifest Destiny. In order to deny the existence of U.S. expansionist interests behind the possible annexation of the Spanish colony, Orihuela goes on to establish a parallel between Cuba and the recent incorporation of Texas into the United States, which he sees as "voluntary": "The United States have clearly proven that they essentially do not aspire to territorial expansion, and they have demonstrated this with their pacific retreat from their military occupation of most of the Mexican territory."[36] In endorsing the U.S. intervention against Mexico as a benevolent enterprise in the name of the "civilized world," Orihuela disregards the devastating territorial losses suffered by Mexico—in what is now called the

Southwest of the United States—as a result of the war. In addition, he overlooks the war's repercussions in the escalating national crisis over slavery, particularly the fateful Compromise of 1850, which declared Texas a slave state and, through the Fugitive Slave Act, ordered officials in free states to assist in the return of fugitives to their masters.

Through these omissions, Orihuela reaffirms the annexationist desire of associating Cuba with the authority of what was already becoming a global power and, thus, of fulfilling the wish for "civilizing" the Cuban people. Limiting his analysis to *El sol de Jesús del Monte*, David Luis-Brown interprets Orihuela's politics as an "antiracist" form of "cosmopolitanism," in opposition to the "U.S.-style racist republicanism" that he associates with the editor of *La Verdad*, Gaspar Betancourt Cisneros, and other leading filibusters who did not support the immediate abolition of slavery.[37] However, although Orihuela denounces slavery in *Dos palabras* as a "vile institution," he endorses a gradualist, pragmatic approach to abolition.

> In respect to Cuba, we will say, incidentally, that when the moment of figuring as another star in the North American flag arrives; when its special laws are given, with contemplation of its needs, it will take into consideration the degree of restrictions on slavery according to what is most convenient to its interests [. . .] its well-being and the prosperity of its commerce.[38]

One way to explain Orihuela's cautious words on the process of abolition is to read them as a rhetorical ploy to gain support for the annexation cause from gradualist and even pro-slavery circles in Cuba and the United States. Nevertheless, they reveal where his priorities lay: in his view, political revolution and the incorporation of Cuba into the United States would necessarily precede the consideration of emancipation. While Orihuela certainly stood out for his virulent attacks against slavery, which are epitomized by his cosmopolitan identification with *Uncle Tom's Cabin*, his abolitionism was no more radical than that of Del Monte or Betancourt Cisneros. As Orihuela's translation of Stowe's novel reveals, he replicated aspects of the dominant discourse against blackness. At the same time, the translation choices in *La cabaña del Tío Tom* offer flashes of a cultural and racial imaginary critical of the Cuban elite's politics of whitening and of Stowe's Protestant brand of romantic racialism.

BETWEEN CUBA AND THE UNITED STATES:
AN ANNEXATIONIST TRANSLATES *UNCLE TOM'S CABIN*

Like all translations, *La cabaña del Tío Tom* reimagines the original: its accord
with *Uncle Tom's Cabin* is offset by what Lawrence Venuti calls the "domestic
remainder" of translation, "an inscription of values, beliefs, and representa-
tions linked to historical moments and social positions in the receiving cul-
ture."[39] The work of displacement that goes hand in hand with translation—
its production of historically situated markers of linguistic and cultural
otherness—make it a distinct text, and in this difference "lies the hope that
the translation will establish an imagined community that shares an interest
in the foreign."[40] Both *Uncle Tom's Cabin* and *La cabaña del Tío Tom* share an
interest that transcends a mere investment in "foreign" cultural production.
Their cosmopolitanism is of another kind; it is based on the promise of a
"universal" community that shares a sentimental investment in the figure of
the slave and against the institution of slavery. In the case of *La cabaña del
Tío Tom*, it frames this universalist promise from the particularity of Ori-
huela's secular and Cuban-oriented cosmopolitan worldview. A significant
alteration, in this regard, is his elimination of the original's chapter epigraphs,
which are sometimes extracted from the Christian scriptures. The role of
Protestant Christianity is, of course, fundamental in *Uncle Tom's Cabin*: as
Jane Tompkins says, *Uncle Tom's Cabin* reads as a "jeremiad" that "does not
simply quote the Bible" but "rewrites the Bible as the story of a Negro slave."[41]
In the novel, the reader is reminded continually of the lessons of the gospel,
particularly the moral value of self-sacrifice, through the narrator's interven-
tions and the words and actions of numerous characters. Orihuela does not
erase this rhetoric in his translation; to do so would have involved effacing the
original's discursive and ideological foundation. But, in omitting the novel's
epigraphs and other references of religious meaning, such as Uncle Tom sing-
ing the famous folk hymn "Amazing Grace," *La cabaña del Tío Tom* produces
a narrative less determined by the values of Christianity. Orihuela also has a
pattern of expunging seemingly accessory elements in the novel, including
the description of culinary culture: he even omits the mention of a dish of
Hispanic origins, the *olla podrida* (meat stew) cooked by Uncle Tom's wife,
Aunt Chloe (108). But this type of erasure is secondary, if not inconsequen-
tial, when compared to the absence of the epigraphs—which, as paratexts,
frame the narrative's Christian discourse—or the singing of "Amazing Grace,"

a key moment in which Uncle Tom affirms his unwavering religious faith in the face of Legree's mounting abuses.

In contrast to Stowe's religious antislavery discourse, Orihuela's appeal to the abolition of slavery in the prologue is not expressed through any form of spiritual rhetoric; the redemption of enslaved people is associated not with the sacred but with the secular—with the progress of "modern civilization."[42] In *Sol de Jesús del Monte*, the reader has a glimpse of Orihuela's position on Roman Catholicism, the dominant religion among the white elite in Cuba: the *criollo* man of letters Federico, whose role in the narrative is partly to offer a critique of colonial society, disparages the Catholic Church for its corrupting influence in the colony. Furthermore, in *Dos palabras*, Orihuela makes no allusions to religious culture as a source of his vision of a "revolution of ideas" connecting Cuba with the United States. Like other Cuban intellectuals who sympathized with abolitionist and annexationist causes, Orihuela was most likely a defender of the separation of church and state. It would not be far-fetched to interpret the translation's omission of the epigraphs and other sacred references as an alignment with a secular community of Hispanophone readers. While Stowe articulated her cosmopolitan vision through the language of religious eschatology, which establishes the world's unity through the suffering and redemption of Christ, Orihuela's vision, rooted in the ideals of republicanism, is of secular fraternity, which he associates, as he declares in the prologue to *Sol de Jesús del Monte*, to a sense of "complete independence."[43]

As the protagonist of Stowe's novel, Uncle Tom exemplifies the Christian message that drives the narrative. When he first appears, inside his cabin and with his family and friends, the narrator underscores the power of Tom's religious performance.

> Having, naturally, an organization in which the *morale* was strongly predominant, together with a greater breadth and cultivation of mind than obtained among his companions, he was looked up to with great respect, as a sort of minister among them; and the simple, hearty, sincere style of his exhortations might have edified even better educated persons. (35)

A Christ-like figure that both imparts and embodies these moral lessons until his death, Uncle Tom lies at the center of the novel's spectacle of sacred fervor. At the same time, he is the most visible racialized figure in this narrative spectacle, which, following the conventions of contemporary

romantic racialism in Europe and the Americas, idealizes black people as naturally Christian beings with moral values superior to U.S. whites. As George Frederickson notes, "For romantic racialists, the Negro was a symbol of something that seemed tragically lacking in white American civilization."[44] The racialized idealization of Uncle Tom can be evinced in how the narrator defines his morality as a "natural" value, intrinsic to his "organization." Romantic racialism suffuses the description of all characters, white and black: their racialized physiognomy is meant to express a fixed conception of character. For instance, the narrator relates, "Your Kentuckian of the present day is a good illustration of the doctrine of transmitted instincts and peculiarities" (110). In the case of the mixed-race couple Eliza and George Harris, who decide to flee when threatened with the possibility of being separated from their child, this "doctrine" links their independent will to their white genealogy. In other words, their agency as fugitives is connected directly to whiteness. George is described thus: "From one of the proudest families in Kentucky he had inherited a set of fine European features, and a high, indomitable spirit. From his mother he had received only a slight mulatto tinge, amply compensated by its accompanying rich, dark eye" (114–15). In contrast, Uncle Tom's characteristics and actions, particularly the docility associated with his lack of desire to escape from his masters, are defined as a "natural" essence of the black self.

Orihuela does not erase Stowe's romantic racialism from his translation, but he attenuates its power significantly.[45] In his translation of the narrator's description of Uncle Tom's interiority, the references to nature are actually eliminated: "Gifted with clear reasoning, wholesome intelligence, and having received more education than most of his companions, he enjoyed an extraordinary moral influence. His exhortations were persuasive, and they would have even enlightened persons better educated than the ones that formed part of his apostolate."[46] In this heavily altered portrayal, Uncle Tom's traits are identified as individual *dotes* (gifts) and are hence disconnected from his "natural" heritage. Contrary to Stowe's original, Orihuela's narrator does not recognize "morality" as Uncle Tom's main attribute; this value—transformed into *influencia moral* (moral influence)—is positioned at the same level as his reasoning, intelligence, and education. The first two of these qualities do not appear in Stowe's original, where the references to Uncle Tom's "breadth and cultivation of mind" suggest only his spiritual education through Bible reading, instead of inherent characteristics. Also, Orihuela omits all references to the "style" of Uncle Tom's discourse, which

contribute to his image in Stowe's original as a "simple" yet "sincere" fervent Christian.[47] The only adjective Orihuela utilizes to define Uncle Tom's discursive style is "persuasive"—in reference to the latter's "exhortations"—which echoes the preceding use of "moral influence" and defines the value of his speech in accord with its effect on his audience. When read as a whole, the translation's overall result in this passage and others is a fuller, more complex representation of Uncle Tom that complicates Stowe's romantic equivalence between blackness and morality.

In other instances, *La cabaña del Tío Tom* replaces the characters' names used in the original with a racial marker—for example, *cuarterona* (quadroon) substitutes the narrator's mention of Eliza in the original text—reducing their selfhood to Hispanic and Cuban hierarchies of blackness. From a first reading, the introduction into the text of a racial taxonomy specific to Cuba, which ranges from terms like *negro* and *criollito* (a Cuban-born black child) to *cuarterona* and *mulato*, signifies a "Cubanization" of Stowe's novel. These words, it would seem, bring the text closer to the discursive register of race in Cuban society, where the definition of racial categories was and continues to be more heterogeneous and fluid than in the United States. In Cuba, as in other Latin American contexts, the word *mulato* does not have the pejorative connotations the English *mulatto* has in the United States. Also, there are numerous other Spanish terms, with both positive and negative associations, that encapsulate a wide-ranging racial continuum in which the binary opposition of black versus white is not absolute.

Yet, when it comes to the abundant regional, racial, and class-based dialects that Stowe sought to reproduce through her characters' speech, Orihuela chooses not to transform them according to Cuban conventions. In mid-nineteenth-century Cuba, contemporary writers and performers such as José Crespo y Borbón developed a distinctive literary and theatrical tradition that captured the oral and popular cultures of the colony. As Jill Lane indicates, these "popular ethnographies" often simulated voices of African descent, producing a "discursive blackface" analogous to the images of "authentic" black orality in *Uncle Tom's Cabin*, which borrowed from the black minstrelsy darky figures that were widely popular in the nineteenth-century United States.[48] For instance, when Aunt Chloe speaks, Stowe textualizes the character's speech, particularly its phonetic elements: "Ah! let me alone for dat. Missis let Sally try to make some cake, t' other day, jes to *larn* her, she said" (27). In *La cabaña del Tío Tom*, Orihuela dissolves these markers of oral difference and employs the same for-

mal speech for all the characters' lines. Evoking the elite Castilian Spanish found in most Hispanic literary texts of the time, Aunt Chloe's words lose the distinctiveness of the original: "El otro día quiso la señora que Sally le hiciera uno, solamente para aprender, como ella decía. [. . .] Vaya déjeme Vd. á mí." (Ah, Let me do it myself. The other day the mistress wanted Sally to make one, just to learn, she said.)[49] This choice might be attributed to Orihuela's cosmopolitan politics and the importance of building as broad a public as possible for the cause of abolition, through a language that could be easily grasped by readers of Spanish across the hemisphere and in Europe.[50] In turning to the language of the Hispanic elites as the exclusive medium of expression for all characters, the text indirectly defines it as a global vernacular, subsuming the assorted local languages from Cuba that could have been appropriated and incorporated into the text. In this regard, Orihuela's Eurocentric, liberal approach to cosmopolitanism comes to the fore. However, the lack of a linguistic difference in the representation of blackness could be read as an equivalence that puts into question the racialized hierarchy of value that marks black difference as inferior: the enslaved subject expresses himself in the same language as his masters.

Orihuela's complex negotiation between his cosmopolitanism and the racial imaginaries of Cuba and the United States can also be detected in his translation of the historically charged word *nigger*, which is repeated continually in Stowe's classic. A popular word among the colonial elites that could have captured the intensity of this racial epithet is *negrito*, a condescending diminutive term used to belittle blacks. But in all cases, Orihuela utilizes the word *negro*. In addition, the original's references to "negro" and "black" subjects are replaced with the same word. Orihuela selects a word that does not necessarily have a pejorative connotation: its meaning in Spanish depends on the context and tone of the speaker. For example, when the slave trader Mr. Haley resorts to the expression "negro," its demeaning quality is made apparent by Haley's profession and the racist arguments he develops about black people's inferiority in his conversation with Arthur Shelby. In other passages, however, the word's meaning is restricted to defining racial identity, as in the use of "black." By subsuming the differing values of "nigger," "negro," and "black" under the Spanish word *negro*, *La cabaña del Tío Tom* produces a sense of ambiguity around the valence of racial representation—how it travels and is adapted across linguistic and cultural boundaries.

Another moment that captures *La cabaña del Tío Tom*'s ambiguity sur-

rounding racial discourse is Orihuela's translation of the designation "white nigger." In Stowe's original, these words appear in a heated debate between a field-worker and a domestic servant as they wait to be sold to their new masters: "'Lor, now, how touchy we is,—we white niggers! Look at us now!' and Sambo gave a ludicrous imitation of Adolph's manner; 'here's de airs and graces. We's been in a good family, I specs'" (336). By mocking Adolph as a "white nigger," Sambo calls attention not only to his mixed-race background but also to how the social construction of race intertwines with social status. Sambo's use of "white" here is an indicator not so much of Adolph's phenotypic traits but of the classed identity he enacts through his social performance, the "airs and graces" he learned and developed while laboring for his rich master Augustine St. Clare. In *La cabaña del Tío Tom*, the use of the pejorative disappears and is replaced by categories of racial hybridity that rupture the link between whiteness and the enslaved subject's social background: *mestizo* and *mulato moderno* (the first denotes a mixed-race identity, either white and black or white and indigenous; the latter signals Adolph's fashionable clothing style).[51] Again, by focusing on Adolph's mixed identity instead of reaffirming the binarism between whiteness and blackness, the translation resignifies *Uncle Tom's Cabin* according to the Cuban racial continuum.

The translation also adds another layer of meaning through the adjective *moderno*. In calling attention to Adolph's sense of fashion, Orihuela reiterates the dandyish characteristics that the narrator of *Uncle Tom's Cabin* attributes to Adolph when he is first mentioned: "Foremost among them was a highly dressed young mulatto man, evidently a very *distingué* personage, attired in the ultra extreme of the mode, and gracefully waving a scented cambric handkerchief in his hand" (170).[52] As Jason Richards observes, Sambo's words to Adolph serve to highlight the incongruence between Adolph's identity as an enslaved subject and his performance of social distinction. They signal, in other words, how Adolph's "airs and graces" of distinction are made meaningless by the world of slavery.[53] As the story line of Uncle Tom and Adolph shows, an unexpected turn of events, like the death of a master, can lead the domestic servant back to the slave warehouse and into an ominously "undistinguished" position. In Orihuela's awkward translation, however, the mocking tone of Sambo's words becomes more ambiguous, lacking any clear derogatory effect. The description of Adolph might be another way of marking his social performance as an act, for to be fashionable or modern is a characteristic linked to the "white" norms

of the time. One might even venture to interpret the text literally, understanding the limitations of expressing humor across cultural boundaries. In Orihuela's reconstruction of *Uncle Tom's Cabin*, Adolph may very well be a figure of the "modern civilization" he alludes to in the preface, as defined by a Eurocentric worldview of modernity in which the politics of whitening are operative in cultural terms but not as a project of racial cleansing, like in the case of Del Monte and Saco.

Orihuela's mediation of romantic racialism can be further explored through the other "mulatto" character that stands out in Stowe's novel, George Harris. George's story line is quite different from Adolph's: with the assistance of white abolitionists, he and his wife Eliza (also of mixed-race heritage) become fugitives; after enduring several ordeals, they reach Canada and are finally free. As his letter establishes at the end of the narrative, George and Eliza's happy ending is to be consummated through their return to Africa, specifically Liberia, a colony of former enslaved subjects. In this letter, George expresses his desire to be part of a community of "African nationality," with "a tangible, separate existence of its own" (440). Full independence, in George's view, entails full separation not only from the society that had enslaved him and his fellow Afro-descendants but also from any white-dominated society. Part of the significance of George's letter is that in outlining a future for U.S. blacks, it compares the "African race" to "Anglo-Saxon[s]": "I think that the African race has peculiarities, yet to be unfolded in the light of civilization and Christianity, which, if not, the same with those of the Anglo-Saxon, may prove to be, morally, of even a higher type" (442). Through the words of George, the discourse of romantic racialism reaffirms itself, with the difference that, in this context, the morality associated with blackness is not wholly inherent or natural. The future moral value of the black subject is to be shaped by way of a (white) cultural education, based on the virtues of "civilization and Christianity."

Orihuela's translation of George's letter replicates the original's racial binary, but in abridging the text in a substantial manner, it offers a divergent perspective.[54] Among these erasures are Stowe's references to morality, civilization, and Christianity. Orihuela translates, "I think that the African race perhaps has particular qualities superior to those of the Anglo-Saxons."[55] At first, the absence of Stowe's words appears to result in a more simplified form of romantic racialism that insinuates a racialized hierarchy of value in accordance with the alleged intrinsic character of the "African" and "Anglo-Saxon" races. At the same time, Orihuela alters the temporal

framework of George's statement, relocating it within the present instead of the future, which suggests that black superiority already exists. In addition, Orihuela's version does not specify the qualities to which George refers, whereas the original inscribes them in the order of Christian morality. Thus, the only impression the reader is left with is of George's affirmation of his race's contemporary preeminence, disconnected from any particular social or religious content.

A similar issue occurs in the translation of the letter's references to Haiti, which George rejects as a potential new homeland. The original reads, "The race that formed the character of the Haytiens was a worn-out, effeminate one; and, of course, the subject race will be centuries in rising to anything" (440). Reproducing again the idea that the black subject's character is constituted through contact with a civilizing white agent, George's dismissal of Haiti represents also a rejection of the Haitians' former masters: the "worn-out, effeminate" race that "formed" their character is, of course, the French. Orihuela's rendering of this passage adds other meanings to George's understanding of the identity of Haitians and their relationship with the French: "This country's inhabitants were educated by an effeminate, worn-out people, and centuries will have to pass so they can return to the state they should occupy."[56] By replacing the notion of an inherent "character" with education, the translation substitutes the biological determinism of the original with a cultural form of determinism. While the new version still reproduces a racialized discourse by identifying Haitians as passive recipients of French "education," it does not define Haitian identity as a natural or inherent value. Furthermore, the tenor of George's last words is completely altered in the translation. Both give a pessimistic vision of the future of Haiti, but Orihuela's alteration proposes a reading of Haitian history that is altogether absent in the original. Although the content of this past is not outlined overtly, one can surmise that it would precede the era of French colonialism, since the latter is identified negatively in the text. In what could be described as a transhistorical romantic image of the Haitian people, their progress as a free republic signifies the justified "return" to a natural "state" of liberty, before the imposition of slavery. Orihuela's translation thus incorporates Haiti into the path of Western modernity, defined according to the values of liberal cosmopolitanism.

In *Uncle Tom's Cabin*, the theme of Haiti also appears in the debate between Augustine St. Clare and his brother Alfred about slavery and the global upheavals of the era. Throughout their conversation, Augustine ex-

presses his sympathies for the European revolutions of 1848, Haiti, and the possibility of a slave rebellion in the United States, invoking the idea that "if there is anything that is revealed with the strength of a divine law in our times, it is that the masses are to rise, and the under class become the upper one" (276). As Larry J. Reynolds notes, the political musings of Augustine do not coincide with Stowe's conservative vision, which was founded on Protestant Christianity.[57] Yet the revolutionary register of Augustine's words might have interpellated kindred spirits whose ideology did not coincide altogether with Stowe's. Like others around the world, it is not unfathomable that Orihuela and his fellow *filibusteros* identified with the ideals of Augustine, who is portrayed as a cosmopolitan freethinker until Eva's death leads him to a Christian awakening. Transnational publics joined together through the sentiments of sympathy that *Uncle Tom's Cabin* produced around the figure of the slave. But they also united around particular (mis)readings of the novel, which led to forms of identification that often did not coincide with and even contradicted Stowe's Christian moral politics.

In the case of Orihuela and the Cuban counterpublic in which he participated, *La cabaña del Tío Tom* entailed an intervention in the "revolution of ideas" through which the Cuban elite articulated its transamerican affiliation with liberal republicanism, moderate abolitionism, and the "bastion of liberty" they admired so much, the United States. This was a process that involved sentimental investment as much as strategic politics, based on the elite's differing diagnoses of the present and future social and economic well-being of Cuba. The negotiation of racial relations would continue to be at the center of these diagnoses, which would progressively shift from a politics of "whitening" that negated the black other entirely from their patriotic visions to a project of gradual inclusion and harmony, if not of equality or recognition of black difference. Perhaps inadvertently, Orihuela's translation of *Uncle Tom's Cabin* seems to point to the latter direction through its rewriting of Stowe's romantic racialism. But as he confirms in *Dos palabras*, his position on slavery was more complex and calculating than meets the eye. The republicanist "revolution of ideas" that he and other members of the Cuban elite projected unto *Uncle Tom's Cabin* might have encompassed the black other in a sympathetic embrace, but it ultimately defined "liberty" and "modern civilization"[58] according to their self-interests. At the same time, flashes of a truly emancipatory critique erupt throughout the texts of Orihuela, evoking a spirit of anticolonial and antiracist revolution that would materialize more forcefully as the century drew to a close.

Notes

1. Ian Baucom, *Specters of the Atlantic: Finance Capital, Slavery, and the Philosophy of History* (Durham, NC: Duke University Press, 2005), 180.

2. Margaret Cohen, "Sentimental Communities," in *The Literary Channel: The International Invention of the Novel*, ed. Margaret Cohen and Carolyn Dever (Princeton: Princeton University Press, 2002), 106.

3. Hortense J. Spillers, "Changing the Letter: The Yokes, the Jokes of Discourse: or, Mrs. Stowe, Mr. Reed," in *Slavery and the Literary Imagination*, ed. Deborah E. McDowell and Arnold Rampersad (Baltimore: Johns Hopkins University Press, 1989), 25–61; Lauren Berlant, "Poor Eliza," *American Literature* 70.3 (1998): 635–68.

4. Denise Kohn, Sarah Meer, and Emily B. Todd, "Reading Stowe as a Transatlantic Writer," in *Transatlantic Stowe: Harriet Beecher Stowe and European Culture*, ed. Denise Kohn, Sarah Meer, and Emily B. Todd (Iowa City: University of Iowa Press, 2006), xi–xxxi.

5. Susan Gillman coins the term *text-network* to define the multiple works that arise from diverse cultural, national, and historical traditions around a particular cultural form, such as *Uncle Tom's Cabin*. See "Whose Protest Novel? *Ramona*, the *Uncle Tom's Cabin* of the Indian," in *The Oxford Handbook of Nineteenth-Century American Literature*, ed. Russ Castronovo (Oxford: Oxford University Press, 2012), 381.

6. The biographical information on Orihuela is limited, and few critical works have been published about him. Details about Orihuela's life are extracted from Paloma Jiménez del Campo, *Escritores canarios en Cuba: Literatura de la emigración* [Canarian writers in Cuba: The emigrants' literature] (Las Palmas de Gran Canaria, Spain: Ediciones del Cabildo de Gran Canaria, 2003); Miguel David Hernández Paz, *Andrés Orihuela Moreno y El sol de Jesús del Monte: La novela histórica antiesclavista de un canario en la Cuba del siglo XIX* [Andrés Orihuela Moreno and Jesús del Monte's sun: The antislavery historical novel of a Canarian in nineteenth-century Cuba] (Santa Cruz de Tenerife: Ediciones Idea, 2007); David Luis-Brown, "Slave Rebellion and the Conundrum of Cosmopolitanism: Plácido and La Escalera in a Neglected Cuban Antislavery Novel by Orihuela," *Atlantic Studies* 9.2 (June 2012): 209–43.

7. Andrés Avelino de Orihuela, preface to *El sol de Jesús del Monte: Novela de costumbres cubanas* [Jesús del Monte's sun: A novel of Cuban customs], ed. Miguel David Hernández Paz (Santa Cruz de Tenerife: Ediciones Idea, 2007), 7–8.

8. Andrés Avelino de Orihuela, *Dos palabras sobre el folleto "La situacion política de Cuba y su remedio," publicado en Paris, por Don José Antonio Saco, en octubre de 1851* [Two words on the pamphlet "Cuba's Political Situation and How to Solve It," published in Paris by Don José Antonio Saco, in October 1851] (Paris: Blondeau, 1852).

9. In calling this narrative "transamerican," I follow the examples of Kirsten Silva Gruesz, Anna Brickhouse, and José David Saldívar, who have illuminated the cross-cultural flows and networks that have both united and divided the United States and Latin America. See Brickhouse, *Transamerican Literary Relations and the Nineteenth-Century Public Sphere* (New York: Cambridge University Press, 2004); Gruesz, *Ambassadors of Culture: The Transamerican Origins of Latino Writing* (Princeton: Princeton University Press, 2002); Saldívar, *Trans-Americanity: Subaltern Modernities, Global Coloniality, and the Cultures of Greater Mexico* (Durham, NC: Duke University Press, 2012).

10. Orihuela, preface to *La cabaña del Tío Tom: Novela*, trans. Andrés Aveline de Orihuela (Paris: Librería Española y Americana de D. Ign Boix, 1852), 3.

11. Here, I follow June Howard's definition of the sentimental: "When we call an artifact or gesture sentimental, we are pointing to its use of some established convention to evoke emotion; we mark a moment when the discursive processes that construct emotion become visible" ("What Is Sentimentality?," *American Literary History* 11.1 [Spring 1999]: 76).

12. Berlant, "Poor Eliza," 636, 646.

13. Orihuela, preface to *El sol de Jesús del Monte*, 7–8.

14. Bruce Robbins, "Comparative Cosmopolitanisms," in *Cosmopolitics: Thinking and Feeling beyond the Nation*, ed. Pheng Cheah and Bruce Robbins (Minneapolis: University of Minnesota Press, 1998), 253.

15. I have kept the Spanish forms of racial and ethnic labels in order to keep their specific meanings in the Cuban context. *Mulato* has the same meaning as *mulatto* in English, but it does not carry an inherent pejorative connotation within the wide-ranging racial continuum of Cuba. In contrast, *criollo* meant born in Cuba or other parts of Spanish America; in the nineteenth century, it often functioned as a racialized category, defined as exclusively white.

16. Orihuela, preface to *La cabaña del Tío Tom*, 2.

17. Ibid., 2–3.

18. For example, in his classic history of Cuban literature, Max Henríquez Ureña calls attention to the fact that *Sab* came ten years before *Uncle Tom's Cabin* and, unlike the latter, was not a protest novel or a political pamphlet (*Panorama histórico de la literatura cubana* [Historical panorama of Cuban literature] [New York: Las Americas, 1963], 8). As Carolyn L. Karcher notes, this type of statement obviates the rich tradition of antislavery representations in the United States before the 1840s, including the works of Lydia Marie Child; see Karcher, "Stowe and the Literature of Social Change," in *The Cambridge Companion to Harriet Beecher Stowe*, ed. Cindy Weinstein (Cambridge: Cambridge University Press, 2004), 204–5.

19. José Antonio Saco, "Paralelo entre Cuba y algunas colonias inglesas" [Parallel between Cuba and some English colonies], in *Obras*, ed. Eduardo Torres-Cuevas (Havana: Imagen Contemporánea, 2001), 3:155.

20. The critical literature on the simultaneous emergence of a national and antislavery literary tradition in Cuba is extensive. Similar to the case of *Uncle Tom's Cabin*, critics have addressed this tradition from both positive and negative angles. While scholars such as Mercedes Rivas and William Luis have emphasized the tradition's discourse of resistance, others, such as Sibylle Fischer and Jerome Branche, have focused on its racialist politics and moderate abolitionism. See Mercedes Rivas, *Literatura y esclavitud en la novela cubana del siglo XIX* [Literature and slavery in the Cuban novel of the nineteenth century] (Sevilla: Escuela de Estudios Hispano-Americanos de Sevilla, 1990); William Luis, *Literary Bondage: Slavery in Cuban Narrative* (Austin: University of Texas Press, 1990); Sibylle Fischer, *Modernity Disavowed: Haiti and the Cultures of Slavery in the Age of Revolution* (Durham, NC: Duke University Press, 2004); Jerome C. Branche, *Colonialism and Race in Luso-Hispanic Literature* (Columbia: University of Missouri Press, 2006).

21. Here, I follow Michael Warner's conception of counterpublics as "spaces of circulation in which it is hoped that the poesis of scene making will be transformative, not

replicative merely" (*Publics and Counterpublics* [New York: Zone Books, 2002], 122). As the example of Cuban intellectuals illustrates, this transformative aspect is not necessarily equivalent to a radical politics of emancipation or equality. In his useful study of Caribbean public spheres and literatures, Raphael Dalleo proposes an opposition between a "republic of the lettered" that associated itself with transnational abolitionism and "a literary public sphere of anticolonialism" (*Caribbean Literature and the Public Sphere: From the Plantation to the Postcolonial* [Charlottesville: University of Virginia Press, 2011], 35). However, applied to the Cuban context, this opposition ignores that the Cuban elite that supported the abolition of slavery also produced a literary archive that criticized Spanish colonialism directly: newspapers and journals published by Cuban exiles in the United States and Europe typically included patriotic poems that often attacked Spain viciously. Poems like these were compiled in the collection *El laúd del desterrado* [The exile's lute], published in 1858 in New York in the Imprenta "De la Revolución."

22. Fischer, *Modernity Disavowed*, 18, 107–28.

23. Domingo del Monte, "Memoria sobre la Isla de Cuba presentada a Martínez de la Rosa, embajador de España" [Report about the Island of Cuba, presented to Martínez de la Rosa, Spanish ambassador], in *Escritos de Domingo del Monte* [Writings of Domingo del Monte], ed. José Antonio Fernández de Castro (Havana: Cultural, 1929), 1:179.

24. Ada Ferrer, *Insurgent Cuba: Race, Nation, and Revolution, 1868–1898* (Chapel Hill: University of North Carolina Press, 1998), 3.

25. Félix Tanco y Bosmeniel to Domingo del Monte, 5 November 1836, in *Centón epistolario de Domingo del Monte* [The letter collection of Domingo del Monte], ed. Manuel Rodríguez Mesa (Havana: Imprenta "El Siglo XX," 1957), 7:80.

26. Tanco to Domingo del Monte, 15 October 1837, in *Centón epistolario*, 90.

27. Félix Tanco y Bosmeniel, *Petrona y Rosalía*, in *Cuentos cubanos del siglo XIX: Antología* [Anthology of nineteenth-century Cuban tales], ed. Salvador Bueno (Havana: Editorial Arte y Literatura, 1975), 131.

28. Vera M. Kutzinski, *Sugar's Secrets: Race and the Erotics of Cuban Nationalism* (Charlottesville: University Press of Virginia, 1993), 31.

29. Fischer, *Modernity Disavowed*, 127.

30. Tanco to Domingo del Monte, 8 November 1843, in *Centón epistolario*, 188, 185–86.

31. Ibid., 186.

32. Efforts to annex Cuba go back to 1823, when John Quincy Adams famously expressed his desire to incorporate the Spanish colony into the United States. During the 1840s and 1850s, most U.S. supporters belonged to the south, where the possibility of incorporating a slaveholding state into the federation was hailed as a way to counteract the mounting power of the "free" states.

33. David Luis-Brown, "An 1848 for the Americas: The Black Atlantic, 'El Negro Mártir,' and Cuban Exile Anticolonialism in New York City," *American Literary History* 21.3 (Fall 2009): 431–63. The classical histories of Cuban annexationism defend the liberal politics of the movement, considering its association with U.S. entrepreneurs and politicians as strategic. See José Ignacio Rodríguez, *Estudio histórico sobre el origen, desenvolvimiento y manifestaciones prácticas de la idea de la anexión de la isla de Cuba a los Estados Unidos de América* [Historical study on the origin, development, and practical manifestations of the idea of the annexation of the island of Cuba to the United States of

America] (Havana: Impr. La Propaganda literaria, 1900); Herminio Portell-Vilá, *Narciso López y su época* [Narciso López and his times] (Havana: Cultural, 1930–57). From a nationalist perspective, later Cuban historiography has situated the political discourse of *filibusterismo* outside the boundaries of the national culture of Cuba. See, for example, Jorge Ibarra, *Ideología mambisa* [Ideologies of revolution] (Havana: Instituto del Libro, 1967). In the most recent book-length study of the Cuban annexation movement, Josef Opatrný complicates both of these approaches, offering a more nuanced analysis of its contradictions: see *U.S. Expansionism and Cuban Annexationism in the 1850s* (Lewiston, NY: E. Mellen Press, 1993).

34. *La Verdad*, 2 November 1848, 2.

35. Orihuela, *Dos palabras*, 3.

36. Ibid., 3.

37. Luis-Brown, "Slave Rebellion and the Conundrum of Cosmopolitanism," 211.

38. Orihuela, *Dos palabras*, 4.

39. Lawrence Venuti, "Translation, Community, Utopia," in *The Translation Studies Reader*, ed. Lawrence Venuti (New York: Routledge, 2004), 498.

40. Ibid., 498.

41. Jane P. Tompkins, *Sensational Designs: The Cultural Work of American Fiction, 1790–1860* (New York: Oxford University Press, 1985), 556, 550.

42. Orihuela, preface to *La cabaña del Tío Tom*, 3.

43. Orihuela, preface to *El sol de Jesús del Monte*, 7.

44. George M. Fredrickson, *The Black Image in the White Mind: The Debate on Afro-American Character and Destiny, 1817–1914* (Middletown, CT: Wesleyan University Press, 1987), 108.

45. In translating passages from *La cabaña del Tío Tom* into English, I have tried to be as literal as possible in order to capture the differences between Stowe's original story and Orihuela's version. This objective cannot be fully accomplished, of course, since the work of translation invariably produces a distinct text. In notes, I have included Orihuela's Spanish text.

46. "Dotado de un claro raciocinio, sana inteligencia, y más instruido que la mayor parte de sus compañeros, gozaba de una influencia moral estraordinaria. Sus exhortaciones eran persuasivas y hubieran edificado aun a personas más cultas que las que constituia su apostolado" (Orihuela, *La cabaña del Tío Tom*, 29).

47. The description "simple" is also omitted in the translation of a passage in which the narrator of *Uncle Tom's Cabin* refers to Uncle Tom's conception of the Bible as "so evidently true and divine that the possibility of a question never entered his simple head" (159).

48. Jill Lane, *Blackface Cuba, 1840–1895* (Philadelphia: University of Pennsylvania Press, 2005), 21, 31.

49. Orihuela, *La cabaña del Tío Tom*, 23.

50. Orihuela was not alone among his fellow writers in using a common language for the speech of characters from different social, racial, and regional identities: Félix Tanco did the same in *Petrona y Rosalía*. In a letter that describes his novel to Domingo del Monte, Tanco explains, "My blacks speak Spanish very clear, like it is truly spoken by *criollos*" (Tanco to Domingo del Monte, 20 August 1838, in *Centón epistolario*, 113).

51. *La cabaña del Tío Tom*, 228.

52. Orihuela's version reads, "En primera línea estaba un mulato jóven que parecia un

personage de distincion por su trage esmerado, el fraco cortado á la ultima moda y un pañuelo de batista perfumado en la mano" (*La cabaña del Tío Tom*, 125). In both Stowe's original version and Orihuela's translation, Adolph is compared favorably to a dandy.

53. Jason Richards, "Imitation Nation: Blackface Minstrelsy and the Making of African American Selfhood in Uncle Tom's Cabin," *Novel: A Forum on Fiction* 39.2 (Spring 2006): 214.

54. In Orihuela's version, the Harrises head directly to Liberia after Canada.

55. "Creo que la raza africana tiene cualidades particulares superiores tal vez a la de los anglo-sajones" (Orihuela, *La cabaña del Tío Tom*, 313).

56. "Los habitantes de este país fueron educados por un pueblo afeminado y agotado, y será preciso que pasen siglos para que vuelvan al estado que deben ocupar" (Orihuela, *La cabaña del Tío Tom*, 312).

57. David S. Reynolds, *Mightier than the Sword: "Uncle Tom's Cabin" and the Battle for America* (New York: W. W. Norton, 2011), 53.

58. Orihuela, *Dos palabras*, 3.

Ioana Szeman

"Black and White Are One": Anti-Amalgamation Laws, Roma Slaves, and the Romanian Nation on the Mid-nineteenth-century Moldavian Stage

In 1853, two Romanian-language translations of *Uncle Tom's Cabin* were published in Moldavia; both translators, Dimitrie Pop and Theodor Codrescu, worked from French editions. In his response, Gheorghe Asachi (a Western-educated Moldavian intellectual nobleman, playwright, politician, historian, and abolitionist) noted that Moldavian readers would find an unfortunate resemblance between the fate of "the Negroes in America and the Negroes of our country."[1] One might assume that Asachi drew a metaphorical association between slavery in the United States and serfdom in Moldavia, however this is not the case. Instead, the "Negroes of our country" to whom he refers were not serfs (feudal dependents in the Romanian principalities of Moldavia and Wallachia, two regions in modern Romania and within central and southern areas of the Russian Empire) but enslaved Roma (known locally at that time as Țigani).[2] Asachi referred to the fact that Roma were enslaved in Moldavia and Wallachia by the Crown and monasteries until 1844; others remained enslaved by nobles (*boyars*) until 1856.[3] The Roma are the largest ethnic minority in Europe today, but their long-standing systematic exploitation in these Balkan principalities (occasioning the only intra-European abolition movement of the nineteenth century), their renewed targeting in the Nazi labor camps, and their continuing difficulties within the independent Romanian nation marks the intertwining of *Uncle Tom's Cabin* with the Moldavian abolition movement as historically significant.

Pop's translation passed the censors' scrutiny. Codrescu's translation included a preface, "A Brief Overview on Slavery," by Mihail Kogălniceanu, a

Western-educated intellectual *boyar*, politician, orator, historian, and abolitionist. In it, Kogălniceanu addresses the long history of enslaving Roma in the Romanian principalities. The preface's final section, which highlights the persistence of *boyars* owning Roma and the condition of peasants, was censored. Kogălniceanu was one of the most outspoken voices in support of emancipation, resisted for a long time by most *boyars*. In 1856, when privately owned slaves were freed, Asachi's now-forgotten play *Țiganii* was issued by the same publisher as Pop's translation of *Uncle Tom's Cabin* (the Bee Institute's Printing House) and performed for the first time in Iași (the capital of Moldavia), to celebrate emancipation and the end of all forms of slavery in Moldavia. Though not an explicit adaptation of *Uncle Tom's Cabin*, Asachi's play is in conversation with the novel and with V. A. Urechia's unfinished adaptation of it, *Măriuca's Cabin*, which transposes Stowe's story to Moldavia and discusses Roma slavery.

This essay discusses the representations of Roma slavery in nineteenth-century Moldavian theater and how abolitionist authors and intellectuals, including the two translators of *Uncle Tom's Cabin*, viewed and translated their experience of Roma slaves in relation to race and slavery in America. In addition to Asachi's *Țiganii*, other performances engaged with Roma slavery in Moldavia, such as Matei Millo's operetta *Baba Hârca* (1848) and his production of Bernardin de St. Pierre's *The Mulatto* (1847). So did Vasile Alecsandri's short stories "Vasile Porojan" and "The Story of a Golden Coin," which specifically address the representation of women. The politics of race and the vision of the nation after emancipation can be glimpsed in Codrescu's translation of *Uncle Tom's Cabin* and are made explicit in theater performances that represented Roma, particularly in Asachi's play, where his use of racial terms such as "white" and "black" in relation to Roma become clear. While Codrescu's and Pop's Romanian translations are faithful to Léon Pilatte's French translation, which closely follows Stowe's original, some of the translators' choices, coupled with the portrayal of Roma slaves in Asachi's play, provide insight into Moldavian intellectuals' and abolitionists' cross-cultural understanding of slavery. Unlike Western representations of Roma slaves in this period, which portrayed them as people of African descent, Moldavian writers' representations of Roma were informed by direct knowledge of Roma in bondage and by support of abolitionist ideas. At the same time, however, their use or translation of American terms was informed by their own biases, including their knowledge of slavery in Moldavia. For example, the ter-

minology that classified American slaves according to their ancestry was irrelevant in the Moldavian context, where legal status maintained social and ethnic distinctions that were otherwise difficult to ascertain.

I suggest that racial differences between Romanians and Roma during slavery were created and maintained through marriage legislation, anti-amalgamation (racial intermarriage) laws, and unwritten laws of sexual control and exploitation of female Roma slaves. The play *Țiganii* makes visible these mechanisms of social and sexual control. Romanian scholar Andrei Oișteanu argues that *ius primae noctis* (the right to the first night) gave slave masters sexual rights to a new bride when two slaves married.[4] In *Țiganii*, a female Roma slave, Anghelina, rejects the marriage arranged by her master and instead chooses a Romanian shepherd. Through his portrayal of Anghelina, Asachi challenges sexualized stereotypes of Roma women in general and slaves in particular. Even though the play is an idyll that views the emancipation of the Roma through rose-tinted glasses, *Țiganii* exposes and criticizes the realities of slavery, including the codified laws of anti-amalgamation and the customs of masters exerting sexual control over their slaves. In this sense, *Țiganii* reflects a similar critique to *Uncle Tom's Cabin* vis-à-vis Cassy's sexual exploitation by Legree and the threat he poses to Emmeline. (In *Măriuca's Cabin*, by contrast, the focus is on a male Roma slave, though a Roma woman was portrayed as overly sexual and a sorceress.) *Țiganii* even goes so far as to portray the reality of sexual domination as a metaphor for slavery; this is contrasted, after emancipation, through the union between a Romanian shepherd and a newly freed Roma woman, as a representation of the Roma's assimilation.

In the mid-nineteenth century, Romanian nationalism and abolitionism were subaltern movements seeking recognition from the West, as Moldavia was under the influence of the empires surrounding it—the Ottomans (Turks), Romanovs (Russians), and Habsburgs (Austrians).[5] Revolutionaries saw the emancipation of the Roma as a necessary step toward Romanian independence. Theater and printed texts created the imagined community of the Romanian nation,[6] articulating the role that the revolutionaries and abolitionists imagined for the Roma in the new independent nation. Yet, even though Romanian nationalists urgently demanded Roma emancipation, nineteenth-century racial science and gendered stereotypes about "Gypsies" informed the depiction of Roma life in most abolitionist texts. Unlike many Western authors (including a contributor to Charles Dickens's *Household Words*) who likened Roma slaves to African people,[7] Moldavian

depictions differentiated the racialization of the Roma from African American slaves. While the existence of anti-amalgamation legislation and the sexual control of Roma female slaves are similar to the realities described by Stowe, the specifics of the process of racialization of Roma slaves depart from the racialization of African American slaves in *Uncle Tom's Cabin*. Despite the use of the terms "black" and "white" in Asachi's writing about Roma, his and other Moldavian authors' understanding of "black" and "white" differed from the terms' usage in the American context.

Among the characters in Stowe's novel, George and Eliza are most similar to Anghelina and the other Roma characters in Asachi's play, in that they can pass as white and non-Roma respectively. I argue that the racialization of the Roma during slavery and after emancipation was performative and dependent on context. External markers of class and status distinguished Roma from non-Roma, but in most cases, it was difficult to distinguish a slave from a free person based on physical characteristics alone. Contrary to Asachi's vision of the post-emancipation union between Roma and Romanians, most Roma experience discrimination and are denied basic rights and cultural citizenship today, despite formal Romanian citizenship. In my work, based on ethnographic research in post-socialist Romania, I discuss the performative processes of gendered and classed racialization and misrecognition through which Roma fail to access actual citizenship, both materially and symbolically.[8] Roma are either erased from or appropriated into the nation: when recognized as Roma, they are excluded from the nation; when they pass as non-Roma, their passing secures their acceptance as Romanians.

During the nineteenth century, the situation of the Roma differed from other ethnic groups in the Balkans, including Romanians, in that there was no nationalist movement seeking to build a nation-state for this intrinsically transnational minority that spread across Europe and beyond. Descriptions of Roma slavery are exclusively written by non-Roma, and this history is part of the larger transnational history of oppression of the Roma across Europe. As Donald E. Pease argues, "In raising basic questions about the meaning of national belonging and cultural identification for dispersed populations with different historical trajectories, the transnational can also call forth different representations of the past. It does not negate the past, but it does foster a rethinking of the national in the light of the newly invented spatial and temporal coordinates."[9]

A transnational historical approach does not take for granted ethnogenesis and the unification of territories into nation-states, and it records the voices of both successful and forgotten visionaries. There were divergent nationalist creeds among Moldavian abolitionists, as their vision of the Romanian nation differed. Kogălniceanu, active in the 1848 revolution, militated for the union between Moldavia and Wallachia: with the support of Western powers, this came about in 1859. Asachi, of an older generation, shared the abolitionist and nationalist agendas but did not support the union and was not among the revolutionaries. In *Țiganii* and Asachi's written response to *Uncle Tom's Cabin*, in Kogălniceanu's texts about slavery, and in the Romanian translations of *Uncle Tom's Cabin*, Romanian or Moldavian national aspirations were expressed by associating the Roma cause with American abolitionism; in turn, it was hoped that the great European powers would support the Romanian nationalist movement for independence.

TRANSLATING ABOLITIONISM AND SLAVERY BETWEEN THE UNITED STATES AND MOLDAVIA, VIA FRANCE

Stowe's novel garnered interest in abolitionist circles during a period when the persistence of slavery was considered a "deep stain" on Moldavia's and Wallachia's reputation. Theodor Codrescu's translation was published in two volumes, for registered readers from across the Romanian principalities (Moldavia, Wallachia, and Transylvania) who had signed up to receive the novel. Most of the readers were Romanian intellectuals, though they included a few newly freed Roma in addition to the elite. Codrescu's translation opened with the censored preface by Kogălniceanu, which set a revolutionary ethos wherein Romanian nationalism and abolitionism went hand in hand. This preface, on the history of slavery from antiquity to the present, illustrates how relevant the novel was seen to be in Moldavia, because of the presence of slavery there and in the United States. Kogălniceanu notes in the preface that the Roma were the only slaves left in a Christian nation in Europe. Indeed, from the fifteenth century through the nineteenth, the territories of Moldavia and Wallachia were the only European locations where Roma (or any other group) were systematically enslaved.[10] Kogălniceanu states that "Europe only lends its sympathy and support to countries that aspire to adjust their institutions to the institutions of the civilized world."[11]

Significantly, when Codrescu's translation of *Uncle Tom's Cabin* was pub-

lished, the Moldavian state had already freed state- and monastery-owned slaves. In his translation, Codrescu introduces an explanatory note for the word *abolitionist*.

> In the United States, philanthropists form several societies for the abolition—that is, the suppression—of slavery. These societies, whose members are called abolitionists, hold public meetings and publish books and newspapers to prepare public opinion against slavery; they make financial contributions and raise funds to redeem and free the Negroes. In Moldavia, the government, by giving freedom to its own and monastery slaves and by creating an annual capital for the redemption of private țigani, is consequently an abolitionist government.[12]

There is no such note in Pilatte's French translation, on which both 1853 Romanian translations are based, or in the Pop translation. (Furthermore, Pop avoids the term *abolitionist* altogether and translates it as "forgiving.")[13] Pop's translation was approved by censors, as a note on the verso of its title page announces. Edith Lucas argues that among the nineteenth-century French translations of *Uncle Tom's Cabin*, Léon Pilatte's stands out as well researched and faithful to the original.[14] Pilatte added notes to explain some of the terms that would be less familiar to French readers. Most of these notes, with some exceptions, can be found in the two Romanian-language translations, and Codrescu added some notes of his own, including terms for "abolitionist" and "quadroon." In an attempt to make the novel more relevant to France, Stowe's preface to Pilatte's French translation focuses on the religious aspects of the novel, beyond the details of slavery, and discusses Tom as a Christ figure. After the novel traveled to France, where slavery had been abolished, the Romanian translations from the French brought the novel back into a context where slavery was a contemporaneous reality. Codrescu's translation and its preface by Kogălniceanu firmly set Roma slavery as the reality against which the novel is to be read, and they aim to decry the last bastions of Roma slavery in Moldavia. The censoring of the preface shows that that these issues continued to be controversial up until the emancipation of private Roma slaves in 1856.

While Moldavian abolitionists saw parallels between African American and Roma slavery, the two institutions also significantly differed. The sheer scale of slavery in America and of the displacement of people from one

continent to another differentiated African American from Roma slavery, and the racialization of the Roma differed significantly from that of African American slaves. Nevertheless, the institution was of long standing in the region: the first documents to attest the existence of Roma slavery date from the fourteenth century for Wallachia and the fifteenth century for Moldavia. The enslavement of prisoners originated in the wars against Tatars (though initially slaves were named "Tatars"—a term gradually replaced with "Țigani"—the slaves had always been Roma).[15] A relatively small number of Roma came to the Romanian territories from east of the Dniester River, where conflicts with the Tatars took place. Most Roma arrived in Wallachia and Moldavia in the fourteenth century, by crossing to the northern bank of the Danube to escape wars in the territories of present-day Bulgaria and Serbia. When they entered the Romanian lands, legislation regarding Țigani made them slaves and property of the Crown.[16] Whether their owner was the Crown, a *boyar*, or a monastery, slaves appeared on property inventories along with cattle and other goods,[17] and they were at the mercy of their owners and potentially subject to any kind of mistreatment short of being killed. For the dominant class in feudalism, slavery was a stable and solid institution strengthened through church support. The slave-owning princes and *boyars* endowed monasteries with large numbers of slaves and thus gained these religious institutions' endorsement of slavery. Monastery slaves were the most numerous and the most oppressed.[18] Because of this, the Romanian-language translations comment directly on the status of religion and religious freedom in the United States.

In *Uncle Tom's Cabin*, religion is deemed to be the factor that would sway the readers to oppose slavery and bring about its end. Translators, including Pilatte, Codrescu, and Pop, explain the state of religious belief in American society in relation to Mrs. Shelby's indictment of slavery in *Uncle Tom's Cabin*: "It is a sin to hold a slave under laws like ours—I always felt it was,—I always thought so when I was a girl,—I thought so still more after I joined the church" (39). Pilatte glosses the phrase "I joined the church" as follows:

This phrase must appear obscure to anyone who does not remember the system of separation between church and state in the United States. There one is not born [into a faith]; one becomes a member of a church or a religious society. After one is introduced to the teachings of any religious society, one requests to be admitted. Very respectable people have no shame in declaring that they do not yet belong to any church. *To*

join a church or *to belong to one* are phrases that mean publicly declaring one's positive commitment to a religious belief.[19]

In addition to translating the above note into Romanian, both Codrescu and Pop end its first sentence with the addition "system presented and defended in the newspaper *La Presse* by Emile de Girardin."[20] These notes, present in both Romanian and French translations, attest to Europe's interest in the United States and admiration for its freedom of religion, despite the sense that slavery was a proof of backwardness. At the end of the note, Pop adds, "The system of separation between state and church is not favorable to the establishment of large church institutions, but is very favorable to sincerity."[21] In these notes, the two translators hint at the incompatibility between religious beliefs and support for slavery, especially as monasteries had been the most important institutional slave owners after the state. In *Mǎriuca's Cabin*, V. A. Urechia goes one step further and explicitly critiques the hypocrisy of *boyar* slave owners who displayed piety and religious feelings in their public appearances.

> They read the Apostle in church, cross themselves at length in front of every icon, and when they come home they swear on those of the Ţigani, or ask the bailiff to apply this many whips to the Ţigan bastard who did not properly prepare his horse [. . .] or [the *boyar*] talks to his lady about which Ţigan to have marry whom, and which Ţigan woman to give in marriage to whom.[22]

While neither the translators nor Urechia believed that institutionalized religion would contribute to the abolition of slavery in Moldavia, *Ţiganii* credits the revolutionary ideals of the younger generation educated in France, represented by Andronic, as instrumental in the road to emancipation.

In most European contexts, Roma were minority populations known for their nomadic lifestyle and were forced to live outside or on the outskirts of cities. The situation in Moldavia was rather different. There were five different Roma groups in the nineteenth century. Layesh, also known as Kalderash or Kelderara, were coppersmiths and the property of either *boyars* or monasteries.[23] Goldsmiths, later known as Rudara, were the property of the Crown and, over time, had to give up working with gold, which was scarce, and become wood-carvers. Lingurara, or spoon makers, fabricated wooden objects and were the property of the

Crown or *boyars*. Ursara, or bear handlers, were nomads who belonged to the Crown. Most Kelderara were nomads, permitted to wander as long as they paid dues to their overlord. In summer, they traveled across the country selling various metal household items to villagers. In winter, they withdrew near forests and lived in huts. Vatrash, the most numerous group, were agricultural workers and the property of either *boyars* or monasteries, and many of them were sedentary, tied to the land. From among them came the musicians renowned for fiddle playing.[24] Status differences among various groups existed even during slavery. The Layesh, as craftspeople, had more freedom and a better material situation than the Vatrash. Among the latter, fiddle playing was the most prestigious occupation. Chiefs, also known as *bulibasha*, who maintained the connection between their groups and the majority population, including the slave owners, were better off than the average slave. The situation of the Vatrash was closest to that of African American slaves: *Ţiganii* highlights factors common to both contexts, specifically the sexual exploitation of female slaves and the maintenance of racial difference through legislation.

For centuries, Moldavia and Wallachia had been under the influence of the Ottoman Empire, which named the princes who would rule the principalities. The latter were also under the Russian protectorate and had limited autonomy. Following the 1848 revolutions in Austria, Hungary, and elsewhere in Western Europe, a Wallachian and Moldavian revolution sparked. As social historian Daniel Chirot shows, the goals of this "national bourgeois" revolution were to end Ottoman and Russian domination and to create a modern nation-state.[25] This was one of the first attempts to establish the Romanian nation. The revolutionaries' emphasis was mostly nationalist and political rather than social or economic. The peasantry, whose folk traditions were espoused as the embodiment of the Romanian national character, lived in extremely precarious conditions, while the Roma were enslaved and marginal to the national imagination. The emancipation of Roma slaves was an objective of the 1848 Moldavian revolutionaries, stipulated in a program drafted by Kogălniceanu. Joint Russian-Ottoman military action quashed the revolution in both Moldavia and Wallachia, and Russia remained the protector of Wallachia and Moldavia, while the Ottoman Empire continued to be the nominal overlord. The independence-seeking elite continued their struggle underground until 1853, when the run-up to the Crimean War brought the region into the Western powers' focus. The principalities' geopolitical significance increased in 1853, when

Russia invaded; the Western powers decided to support the independence
and unification of the two provinces in order to gain influence in the Bal-
kans and to lessen Russian influence there.

REPRESENTING THE NATION AND ROMA SLAVES
ON THE MOLDAVIAN STAGE

The two Romanian translations of *Uncle Tom's Cabin* were published during
this peak of nationalist and pro-emancipation fervor. Just as the America
represented in *Uncle Tom's Cabin* must have appeared comparatively ret-
rograde to Moldavian abolitionists, Moldavian nationalists felt that Mol-
davia lagged behind the rest of Europe. Hence, comparing Roma slavery to
black slavery in the American South (especially vis-à-vis how black slavery
informed nationalist debates in the United States) allowed abolitionists to
make a case for Roma emancipation and to draw attention to the fate of the
Roma. The evidence of this important cross-cultural comparison is found
in the Romanian-language theater repertoire of the period. The few exam-
ples of Moldavian abolitionist theater performances that represented Roma
slaves or engaged with slavery made visible the performative aspects of the
racialization of the Roma and paved the way for Asachi's vision of one na-
tion after emancipation in *Țiganii*. The 1847 production of Bernardin de St.
Pierre's play *Mulatto* is one case in point. On 19 October 1847, the produc-
tion of *Mulatto* by Matei Millo (an actor and director from a *boyar* family
and considered a founder of modern Romanian theater) represented the
fate of black colonial slaves. The actors played in blackface and made several
references to the Roma slaves in Moldavia. The conspicuous association be-
tween slaves in the French colonies and Roma slaves led the estate-owning
boyars to regard the play as an attack on them. They petitioned the Crown,
which not only closed the show but dismantled the troupe, on the grounds
that its members were poorly skilled in the art of theater.[26] The banning
of Millo's company was temporary: in 1848, it resumed putting on perfor-
mances, but without making analogies to Roma slavery.

Romanian-language theater played a key role in the creation of the imag-
ined community of the nation and, to a lesser extent, in representing and
critiquing Roma slavery. Both Asachi and Kogălniceanu were instrumental
in building a national theater in Iași, Moldavia. On 27 December 1816, Asa-
chi's play *Mirtil and Chloe* (a pastoral idyll further adapted from a play by
Salomon Gessner, adapted by Jean-Pierre de Florian) was the first theater

production in the Romanian language in Moldavia and took place on an improvised stage in the living room of Costache Ghica's house. Featuring characters dressed in peasant clothes and speaking Romanian, this performance marked the birth of Romanian theater. In the preface to the play, published in 1850, Asachi marks the elevation of Romanian to the national language through its usage in stage performance: "The modest muse put on peasant garb, and with the help of this prestige and of the national costume [. . .], hearts were delighted and ears started to become accustomed to the language that until then they had been calling dialect."[27] However, the authorities discouraged a progressive autochthonous theater movement in the prerevolutionary period, and there was a big time gap until the following Romanian-language performances in Moldavia. In 1840, Kogălniceanu, Vasile Alecsandri, and Costache Negruzzi, all young *boyars* educated in the West, took over the leadership of the Romanian and French theaters in Moldavia, an initiative that only lasted two years, due to the authorities' disinterest and to competition from foreign professional troupes, which were preferred by audiences.

In 1846, Matei Millo and Prince Nicolae Șuțu became leaders of the Moldavian theater. While the prince headed both the French- and Romanian-language repertoires, Millo was functionally in charge of the Romanian-language theater. The theater moved to an improvised location, in the house of the Moldavian ruler Mihail Sturdza. Censorship laid out the rules for the performances. For example, only approved scripts could be performed onstage, with no improvised additions, and the *aga* (chief of local police) was responsible for making sure this rule was respected. Actors, directors, and playwrights were exiled on several occasions when performances made allusions that critiqued the corruption of Sturdza's regime.[28]

After the censoring of the 1847 performance of *Mulatto*, which alluded to Roma slaves, a Roma character took center stage for the first time in Moldavia in 1849, in the comic operetta *Hârca the Hag* (*Baba Hârca*). The title character, played by Matei Millo in drag, presents a stereotypical version of the Roma woman as the frightening old hag. In this play, the cross-dressed Millo and the other non-Roma actors who played Roma slaves wore "țigan costumes."[29] This way of demarcating Roma suggests that the racialization of the Roma was performative and dependent on context and that it relied on markers of social status, such as clothing and geographical location. In *Mulatto*, blackface was used to represent slaves of African origin, but in both *Hârca the Hag* and *Țiganii* (the next theater performance to represent

Roma slaves as main characters), the stage representation of Roma slave characters by non-Roma actors was signaled through costume only. In the stage performance of *Țiganii*, the lack of physical differentiation between Roma and non-Roma characters makes possible the seamless transition to a post-emancipation nation of peasants and free Roma where "Black and White are one," that is, the same.

ROMA WOMEN, ANTI-AMALGAMATION LAWS, AND SEXUAL EXPLOITATION IN *ȚIGANII*

Written in 1856 to celebrate the complete abolition of slavery in Moldavia, *Țiganii* is an "idyll" (as its author calls it) inspired by Theocritus, the creator of ancient Greek bucolic poetry. It tells of the love between a female Roma slave, Anghelina, and a Romanian man, Cimbru, in a union that was illegal at the time. This forbidden love story echoes that between George and Eliza in *Uncle Tom's Cabin*. However, in the play, the two lovers are not both slaves: one is Roma, the other Romanian. Anghelina, described as a beautiful but dumb young woman, has a twin sister, Ardela, described as ugly but smart. The *boyar* arranges for Anghelina to marry Gevrila, the blind son of the *bulibasha*, the head of the slave community owned by a *boyar*, and puts Nistor, his Romanian bailiff, in charge of the protocols. Anghelina and Cimbru are in love, despite the illegality of their relationship. Similarly, the forbidden love in *Măriuca's Cabin*, Urechia's adaptation of *Uncle Tom's Cabin*, is between a Roma and a Romanian: Vasile, a Roma slave, is in love with a Romanian woman. This adaptation of one of the novel's plots to Moldavian circumstances reveals how racial politics were distinct from those in America. While the exploitation of Roma slaves mirrors that of African American slaves, marriage between Roma and lower-class non-Roma represents a specific aspect of Roma slavery. In *Țiganii*, Anghelina rejects the arranged marriage, and her father, Tufoi, tries to concoct a plan that would have both his daughters marry at the same time, to fulfill his deceased wife's wish that Ardela not remain unmarried. Tufoi is a blacksmith who manufactures objects for the *boyar*, including punishment tools for runaway slaves, an irony that does not escape him. The conflict is solved through a *deus ex machina*: the *boyar's* son, Andronic, announces the new law that abolishes slavery and allows Anghelina and Cimbru to marry, and Gevrila decides to marry Ardela.

Despite the pastoral and comedic tone, Asachi makes it clear, from the

beginning, that the stakes of the abolition of Roma slavery are about Moldavia's entry into the family of civilized Europe. The play exposes the absurdity of the anti-amalgamation laws, which Nistor recites.

> Civil Code, first part, second heading, pages 22 & 154: "there can be no legitimate union between free people and slaves"; Anghelina is a slave and Cimbru is a free man, but not free to marry who he wants. Did you all follow that? So, like I said, one and one make two, two and two make three, oh, I mean four, white and black are different.[30]

Moldavian law both echoed and differed from American miscegenation legislation, where the one-drop rule (according to which any person with even one ancestor of sub-Saharan African ancestry was considered black) was designed to maintain differences between the black and white races. Across the centuries, in both Moldavia and Wallachia, laws were in place to maintain the distinction between Romanians and Roma slaves. These laws evolved over the years, and new stipulations took into account a wide range of situations, from a free person marrying a slave unknowingly to a priest knowingly performing a marriage ceremony between a slave and a free person.[31] The presence of such stipulations in the Moldavian legislative code suggests that "mistakes" were not unusual and that, in addition to slaves born from illicit sexual encounters between *boyars* and female slaves, there were unions and mixings between Roma and Romanian peasants. In most situations, the unions were outlawed, but if they happened by mistake, the slave could become a free person (though when they happened knowingly, the free person could lose their freedom). At one point, the Moldavian Civil Code stated that "if a Gypsy slave should rape a white woman, he would be burnt alive," whereas if a Romanian should "meet a girl in the road" and "yield to love," he "shall not be punished at all."[32] In nineteenth-century Moldavia, these laws mostly applied to lower-rank Romanians, such as peasants.

I argue that the use of "white" and "black" in the play, along with Nistor's reminder that "white and black are different," reflects the performative nature of the racialization of the Roma and the fact that many, if not all, Roma slaves could pass as free people. In the two 1853 Romanian-language translations of *Uncle Tom's Cabin*, the translators' notes for racial terms used in America provide an insight into non-Roma's perceptions of the Roma in Moldavia. The term *quadroon*, translated with the word *carteron*

by Pilatte in the French version as well as by both Codrescu and Pop, hints that the translators were unaware of the complex classification of slaves in America, based on their ancestry and the degrees of mixing as stipulated by law. There is no explanatory note for the term in Pilatte's French translation, which suggests that French readers may have been familiar with it. Codrescu, however, stipulates for his readers that a *carteron* is someone "born from a mulatto and a European woman or from a European man and a mulatta,"[33] and Pop stipulates that it is "the child born from a Negro woman and European man or from a European woman and a Negro."[34]

The anti-amalgamation laws did not affect the *boyars*, and like slave masters in America, they had direct access to enslaved women and fathered many children with them, whether or not it was under the pretext of *ius primae noctis*.[35] As Ann Laura Stoler argues for the colonial context, inclusion or exclusion from the category of the colonizer required "regulating the sexual, conjugal, and domestic life of *both* Europeans in the colonies and their colonized subjects."[36] Although Roma were thought of as racially different, the difference between them and Romanians was very slippery, especially in view of the sexual exchanges between *boyars* and female Roma slaves; this is why the boundaries between Romanians and slaves, especially among the lower classes and the peasants, were strictly policed. Nevertheless, Roma women were subject to sexual abuse and exploitation by the *boyars*.[37]

In the aftermath of the emancipation of private slaves, the play *Țiganii* presents the laws of anti-amalgamation as backward and absurd. At the same time, rather unusually for a text of the time, *Țiganii* presents and critiques the unwritten rules that allowed *boyars* and their aides sexual access to Roma slaves. Anghelina, who proves to be a lot smarter than her character description in the beginning of the play, rejects her arranged marriage and the advances of the *boyar's* bailiff Nistor. I argue that through his portrayal of Anghelina, Asachi critiques the sexualization of Roma women. At one point, Anghelina catches a dove chased by a hawk and wonders about the significance of the event.

The hawk is clearly the ugly Gevrila, and the dove is probably me, but who will save me from this ugly hawk? This is difficult to guess. Oh, if it were Cimbru, I know he would want to but cannot; he is white, I am black, he is Romanian and I am a Țiganca, and the law of the land, I say, does not forgive our union. Oh, what an injustice! Who made this law?

Well, people did, but God made Romanians and Țigani after his law. But the bailiff says all the time that that is the law and asks my father to marry me to the ugly one; oh, this will destroy me.[38]

Anghelina here voices the pain that arises from being legally prohibited from being with Cimbru. Nistor's mission is to marry her to Gevrila, and it becomes apparent that his vested interest stretches beyond just following the *boyar*'s order. He tells Anghelina,

How could you marry Cimbru, you will remain a virgin when you're a hag! For God's sake, do you not know that such a thing is not allowed? How could the boyar lose the male and female slaves that would be born from a female slave, the rightful property of the boyar, which he bought following all the laws of the land, three hundred lei per soul, and some of which he received as rightful inheritance from his ancestors?[39]

Unapologetically, Nistor reminds Anghelina of the laws that govern her people in Moldavia and of the added monetary value of female slaves, whose offspring would enhance the *boyar*'s property. The situation of female slaves is complicated, as this play suggests on close reading. Nistor's enthusiasm for getting Gevrila and Anghelina married and for reiterating the letter of the law against a union between Anghelina and Cimbru is likely fired by either his own or the *boyar*'s sexual interest in her. This is hinted at in the following lines by Nistor: "You will be greeted by the people at the court, of whom I will be the first, as it is my order from the *boyar* to get you married; if you only knew what gift I have prepared for you, a gift truly suitable for a lady."[40] The stage directions suggest that he sweet-talks her, and I argue that the lines above show that he has expectations of what would ensue follow-ing her marriage to Gevrila. Researchers, including Oișteanu, have shown that *boyars* regularly slept with Roma slaves, a practice that would reflect a situation in the United States, where female slaves had offspring with their owners and were routinely sexually abused. In *Uncle Tom's Cabin*, the story of Cassy is a case in point. In the play, it is suggested that the Romanian servants may have enjoyed similar prerogatives as the *boyars*. Tufoi states toward the end of the play, "Without the help of servants we could not make ends meet; they are our masters and teachers."[41] This is an indication that some servants had a lot of authority over the slaves.

Anghelina's response to Nistor is a further indication that the innuendos

in Nistor's lines present a situation that she is aware of and a danger that she is trying to avert.

> I've heard everything, but I do not want to understand it; do not think that among us there aren't women with a fear of God, and I am surprised that you, who say that you are the boyar's man and who say that you are protecting the law of the land, are the one who tries to lead me to commit a crime! If you marry me to Gevrila, you will find a bride in the Prut [River] the next day.[42]

Anghelina here challenges the Western and regional stereotypical images of female Roma slaves as sexually available and promiscuous. She argues points of law with Nistor: if it is illegal for white and black (Romanian and Țigan) to be together, Nistor is trying to make her commit a crime by suggesting she should have sexual intercourse with a Romanian—at the same time that he claims to protect the law by not allowing her to be with Cimbru. Later in the play, Nistor announces that on the occasion of the wedding, the *boyar* would "forgive them of their dues until Saint George's Day."[43] This material consequence for the slaves suggests that the master saw multiple benefits in the wedding. As feminist scholar bell hooks demonstrates, the so-called loose morals of African American female slaves came not from their own beliefs but, rather, from their powerlessness.

> Although stereotypical images of black womanhood during slavery were based on the myth that all black women were immoral and sexually loose, slave narratives and diaries of the 19th century present no evidence that they were in any way more sexually "liberated" than white women. The great majority of enslaved black women accepted the dominant culture's sexual morality and adapted it to their circumstances. Black slave girls were taught, like their white counterparts, that virtue was woman's ideal spiritual nature and virginity her ideal physical state, but knowledge of the acceptable sexual morality did not alter the reality that no social order existed to protect them from sexual exploitation.[44]

Roma slaves were in a similar position. Indeed, as Anghelina shows in the play, her morality prevented her from heeding Nistor's propositions. Her father, however, could have agreed to her arranged marriage with Gevrila if it had not been for his deceased wife's wish. As he fears her curses from

beyond the grave, he delays Anghelina's marriage until he finds someone to marry Ardela.

Nistor's cynical reply shows that this is not his first attempt at persuading women to marry, as he switches to a ruthless tone. "That's how they all are, Țigan women. They show off, are proud, until you put their neck in the yoke; leave it up to me, I am not a bailiff for nothing."[45] Nistor here cynically explains Anghelina's rejection as mere "showing off" and is referring to one of the punishments applied to runaway Roma slaves at the time, the "horns," a necklace with iron protruding nails that prevented the punished from sleeping.[46] In response to Nistor's threat, Anghelina warns him that she will emulate her cousin who committed suicide: "I swore that I would be Cimbru's or I would die, just as my cousin Tufoase did, when they stopped her from marrying a Romanian."[47] Anghelina here diverges yet again from the representations of the sexually available and promiscuous Roma female slave and threatens to kill herself, a tragic fate shared by Alecsandri's character Zamfira in the short story "The Story of a Golden Coin." The cousin who took her own life by drowning echoes the extreme emotions and decisions taken by Lucy in chapter 12 of *Uncle Tom's Cabin*, who drowns herself in despair at being forever sold away from her husband and child.

At this juncture, Anghelina's father reminds her of the actual situation and their social condition.

Now lass, come on, come back to your senses and do not spoil your father's joy; don't you know that this would be a sin; it is true that people should match each other, but you are black and he is white, you're a slave, and he is not, so no more bickering; the boyar will marry you to Gevrila. (*Aside*) Aye, if only he could come sooner to untangle this mess.[48]

Tufoi here states the irreconcilable difference between Cimbru, the Romanian peasant, and Anghelina, the Roma slave: one is white and the other black; in other words, the "black" one has constrained agency. Tufoi arranges a farcical double marriage for the twins, to convince Anghelina and to respect his defunct wife's wishes. He asks the cook, also a slave and married with children, to pretend to marry Ardela for the ceremony.

Anghelina's fate is not tragic, relative to other fictional accounts such as Alecsandri's "The Story of a Golden Coin," where the rebellious Roma slave dies. Her experience is unlike that of the tragic mulatta epitomized

by Cassy's character in Stowe's novel. Instead, Anghelina is saved by emancipation, news of which is brought onto the stage by the *boyar's* son, Andronic, whereupon Anghelina is allowed to marry the Romanian shepherd Cimbru. The play celebrates the abolition of the official laws of slavery; the chorus declares onstage that Roma and Romanians are one, thus suggesting that Anghelina's social and sexual liberation are resolved in the new nation, where "black and white are one." Both Asachi and Kogălniceanu adopt a vision of the post-emancipation period based on a model of assimilation—a French influence on these Western-educated *boyars*—where the freed Roma would seamlessly become Romanians. While their solution is paternalistic, it differs greatly from that given by Stowe, where African American characters find a future not in their own nation but in Liberia.

For Asachi, emancipation leads to liberation from *ius primae noctis* and anti-amalgamation as well as to freedom from slavery. While the play is upbeat in its conclusion, offering hope to the Roma women, it also reflects on Kogălniceanu's texts by critiquing the predominant representations of Roma women as sexually available, treacherous, and prostitutes. For example, in his overview of the situation of Gypsies in Europe, Kogălniceanu describes young Gypsies in France as "the lasses, with black, big, lascivious eyes, with sun-burnt faces, barefoot and with their skirt cut or rather torn at the knees, [who] dance in front of the crowd." The sexualization of women and young girls is a common trope in nineteenth-century descriptions of Gypsies, depicted as exotic, mysterious, and dangerous at the same time. Kogălniceanu's description continues, "These girls, some of whom are barely sixteen, have never known innocence. Brought onto this world in corruption, they wilt even before giving themselves and prostituting themselves before puberty."[49]

As scholars have argued, these Gypsy stereotypes were prevalent in the nineteenth century and created a whole set of signifiers—rarely based on reality—that were employed in literature, music, and the visual arts. Adriana Helbig notes,

> The alleged lack of morals among the Gypsies was vehemently applied to the critique of their sexual practices and their disregard for decency and respect toward the body, especially by Gypsy women. In much of the art, music, and literature of the 19th century, the female Gypsy in particular was characterized and stereotyped as free-spirited, strong, deviant, demanding, sexually arousing, alluring, and dismissive. This

romantic construct of the Gypsy woman may be viewed in direct op-
position to the proper, controlled, chaste, submissive woman held as
the Victorian European ideal. This "oriental" fascination with the for-
bidden and taboo world of the Gypsy other in music is best character-
ized in the opera *Carmen*.[50]

Helbig's point is relevant for Moldavia and Wallachia, as similar representa-
tions can be found in the literature and arts of the period, complicated by
the specific sexual realities under slavery. As bell hooks discusses in relation
to African American female slaves and the representations of their sexual
subjugation,

> It was difficult for abolitionists to discuss the rape of black women for
> fear of offending audiences, so they concentrated on the theme of pros-
> titution. But the use of the word prostitution to describe mass sexual
> exploitation of enslaved black women by white men not only deflected
> attention away from the prevalence of forced sexual assault, it lent fur-
> ther credibility to the myth that black females were inherently wanton
> and therefore responsible for rape.[51]

Kogălniceanu discusses the Vatrash Roma and states that the women are
"Beauties, but as soon as they become mothers, their beauty disappears,
and makes place to a repugnant ugliness and the Beauty turns into a Hag."
About the Layesh, he states that "chastity is unknown to them" and that
"even though they do not practice prostitution," the women "never refuse
to satisfy the desires of anyone who promises them a few parale [coins]."[52]

Despite some of the more progressive elements in *Țiganii*, Asachi rep-
resents the Roma slaves as full of vices. In a text that celebrates the aboli-
tion of slavery, he asks, "What good does it do to have cheap labor from
these hands, if their vices envenomed the hearts of those who are our dear-
est ones?" He here refers to *boyars'* children who would come in contact
with morally corrupt slaves and would breathe in "the unclean atmosphere
they were surrounded by." Though he brands Roma slaves as vicious and
morally corrupt, he here hints that the atmosphere is not to be blamed on
the slaves entirely, yet he stops short of accusing the *boyars*. Asachi makes
it clear that these negative characteristics are not innate but, rather, arise
from the conditions of slavery. His views about the future of the slaves after
emancipation become clear in the final act of the play, when emancipation

is announced. He deems that special measures should be implemented to effect change: "It is left [for the government] to open to the Ţigan youth of both sexes the doors to education establishments, to adopt for this purpose stimulating and rewarding measures, so that through a beneficial influence, from both government and society, the Ţigani can emancipate themselves from their vices!"[53]

EMANCIPATION, SEXUAL LIBERATION, AND THE NATION: "BLACK AND WHITE ARE ONE"

For Asachi and other Romanian abolitionists, the cause of emancipation could not be divorced from the national cause. The end of *Ţiganii* posits a nation in which the abolition of slavery promises a new dawn for the liberated slaves and brings Moldavia closer to its European family. In an 1837 essay about the history, customs, and language of the Roma (written in French at the encouragement of Alexander von Humboldt and the Hanover prince), Kogălniceanu, who actively militated for the abolition of slavery, stated that Romanian people had an unrealized responsibility toward the Roma. The Europeans, according to Kogălniceanu, "form philanthropic societies for the abolition of slavery in America, while in the heart of their continent, in Europe, there are 400,000 Ţigani who are slaves and a further 200,000 who are covered by the shadows of ignorance and barbarism! And nobody cares to civilize them!"[54] Abolitionists such as Asachi believed that with emancipation and education, the Ţigani would blend into the Romanian nation. At the beginning of *Ţiganii*, Cimbru sings,

> In the mountains, in the fields,
> My herd has been well fed,
> Alas, my heart only wanted you
> Because white and black are a color [*sic*]
> For a tender love.[55]

When emancipation is proclaimed—"From today, slavery in Moldavia's soil has been abolished: every man that sets foot in this land is as free as a Romanian!"—Cimbru exclaims, "black and white are one," implying that through emancipation and education, the Roma will become no different from Romanians.[56] (The Romanian text can literally be translated, "From now on white and black are the same.")[57] This suggests that racialized classi-

fications only made sense under the institution of slavery, to distinguish be-
tween peasants and slaves, and that such distinctions would become moot
after emancipation. This suggestion is made explicit in Kogălniceanu's 1837
essay, where he mentions that the Vatrash, visually indistinguishable from
Romanians, are "more civilized than the peasants and deserve that their
masters finally grant them the freedom they are worthy of. The Boyars have
the right to free them and many of them, those enlightened by the bright-
ness of civilized Europe, use often this privilege, granting them a right that
nature has given to all humans."[58]

Boyars who knew Roma slaves in Moldavia did not use the category
"black" in quite the way Western authors did when discussing the same
slaves. Readers of Charles Dickens's *Household Words*, for example, en-
countered a grotesque description of Gypsy slaves in Wallachia, a de-
scription permeated with fears lest they migrate to Western Europe upon
emancipation. This racialized description portrays Roma almost as Afri-
can, which suggests views based on stereotypes rather than direct obser-
vation. According to Roma scholar Ian Hancock,

> Westerners were (and still are) much more familiar with the enslavement
> of Africans in the Americas than they were with the enslavement of Ro-
> manies in Europe, and because of this, inaccurate portrayals of Gypsies
> relied upon the literary clichés of the period, describing in stereotypical
> terms the kind of slave a Victorian audience was more likely to have en-
> countered in the literature.[59]

Thus, Western authors projected familiar images onto Roma slaves. How-
ever, when Asachi called the Roma "the negroes of our country," he made
an analogy that only applied to some of the slave characters in *Uncle Tom's
Cabin* (specifically the slaves of mixed race).

At the end of *Țiganii*, the bearer of good news is the *boyar*'s son, An-
dronic, representative of the new generation of *boyars* who opposed slavery.
Andronic stands for those Western-educated *boyars* who, like Asachi and
Kogălniceanu, became abolitionists upon returning to Moldavia. A chorus
of Romanians and freed slaves celebrate the news of emancipation. The Ro-
manians exclaim, "Long live His Highness! Long live the boyar! From now
we are one!" (His Highness was Prince Grigore Alexandru Ghica, signatory
to the abolition law and the dedicatee of a prologue Asachi wrote for the be-
ginning of a *Țiganii* performance.)[60] Cimbru exclaims, "Well, if we are one,

let me be one with Anghelina!"[61] This line confirms that social freedom and sexual freedom go together in the play. With the performative announcement of the proclamation, the representation on the stage changed from slaves (black) and free (white) people divided by law to a unified nation signified through characters' freedom to choose and to be equals under the law. The conflict is thus solved by intervention of the prince, who is not onstage yet orchestrates the proceedings on a metalevel. The idyll, therefore, is not so much an unrealistic solution of the conflict as it is a programmatic vision for the future.

But if "black and white are one," who are the freed slaves after emancipation? As mentioned before, "Țigan" was synonymous with "slave," and Asachi suggests that the freed slaves are no longer "Țigani" but Moldo-Romanians.

On the country's sacred day
Today is the new year,
 Free is from now on
The one who was a Țigan.
Long live he [Prince Ghica] who orders
 A gift to humanity,
 Long live he who prospers
On the country's altar![62]

Asachi suggests that freed slaves are no longer Țigani, a statement that reduces the meaning of Țigan to slave, canceling its ethnic connotations. Moldavian abolitionists envisioned the Roma blending into the majority, and the stage performance of *Țiganii* visually represented this process. Herein lies the problem, however, as Roma identity and culture seem to be overlooked in this equation. Just as the cultural contrasts between Moldavia and America are sidestepped, the challenges of abolition and independence are soft-pedaled.

In the new context after emancipation, the young *bulibasha* Gevrila asks, "What will I, bulibasha, do with the mantle and the whip?" These were the symbols of bulibashas' power over the other slaves. Andronic replies,

ANDRONIC: Their power has been destroyed! [...] But let these signs of our shame be gathered and stored, for remembering that the Moldo-Romanian, through justice, redeeming his sin, is worthy of a happy future!

ALL: Long live the Moldo-Romanians!

TUFOI: Well, if it is so, lads, I shall make from the leftover metals, only for these ugly signs, a case with 12 locks and close it with 100 nails that will guard it like a dragon so that it never opens![63]

The message of the play is that the nation must ensure that slavery's evil signs are stored and locked up yet not forgotten. Tufoi's metal case is supposed to act as a memorial to the era of slavery, while still qualifying Moldavia for a happy future within Europe. The union of black and white, Roma and Romanians, all into Moldo-Romanians is invoked here, but there is another union, between Moldavia and Wallachia, for which revolutionaries like Kogălniceanu militated.[64]

Memorializing Roma slavery in the new Romanian nation has proven to be a lost cause. In twentieth-century editions of Asachi's works, this little-known play is censored, showing how its depiction of a Moldo-Romania is out of sync with the nation-state Romania has become. With hindsight, we can say that the union the play heralded between Roma and Romanians was a problematic solution: inevitably, slavery left deep marks on Romanian society—including segregation and the stigma of Țigani as impoverished and outlaws—yet the history of this slavery is remembered neither in Romania nor outside. Under communism, Roma ethnocultural identity was officially denied, and negative stereotypes flourished. The term Țigan is still used to describe Roma, but the historical relationship between Roma slavery and Romanian nationalism that was articulated in the nineteenth century was obscured during the twentieth. Furthermore, despite its problematic underpinnings, the positive embrace of the Roma into the nation, imagined by Asachi and his contemporaries, could not be farther from today's reality in Romania: Roma continue to be seen as outsiders to the nation, despite the official recognition of the Roma as a minority in 1991. As Roma continue to experience marginalization across Europe and as Roma from Romania and elsewhere have migrated to Western Europe in recent years, leading to violent expulsions from countries such as France, the complex history of the Roma as a transnational minority in Europe and the specifics of Roma history in such contexts as Moldavia are important to revisit to understand the underpinnings of racial politics in Europe today.[65] Asachi's play, the two Romanian translations of Uncle Tom's Cabin, and the other theater performances discussed here reflect a pivotal moment in Romanian and Moldavian history, when nationalist and abolitionist ide-

als converged and coalesced and when Romanian intellectuals and artists felt connected to the abolitionist ideals and nationalist fervor in the rest of Europe and the United States, using literary texts and stage performances to express their own visions for a slavery-free and independent nation.

Notes

1. Gheorghe Asachi, "Bordeiul unchiului Tom și coliba moșului Toma" [*Uncle Tom's Hut* and *Old Tom's Cabin*], in *Opere* [Works], ed. N. A. Ursu, vol. 1 (Bucharest: Editura Minerva, 1973), 636–37, 637. All translations from Romanian and French in this essay are mine.

2. I use the term *Țigan* as it appears in Romanian when translating texts from the period. Elsewhere, I use the term *Roma* to refer to members of this ethnic group, though the accepted historical term in Moldavia was *Țigan* (synonymous with slave). Because *Roma* was and is the self-ascription in the Romani language, it is not technically anachronistic. I use *Gypsy* in relation to English-language texts (as used by specific authors) or to highlight stereotypes.

3. Peasants had previously experienced serfdom, a condition widespread across feudal Europe. In these regions, they were emancipated in 1749 and lived as landless laborers by the mid-nineteenth century.

4. Andrei Oișteanu, "Ius primae noctis: Privilegiile sexuale ale boierilor asupra roabelor țigănci" [*Ius primae noctis*: The sexual privileges of *boyars* over Țigan female slaves], pt. 1, *Revista* 22 (20 November 2012), http://www.revista22.ro/ius-primae-noc tis-privilegiile-sexuale-ale-boierilor-asupra-roabelor-tiganci-i-19307.html (accessed 31 August 2014).

5. By the late nineteenth century, Romanian nationalism had become hegemonic. The new nation-state formed in 1918 sought to assimilate ethnic minorities, as nationalism turned from a struggle for freedom to an instrument for the subjection of fellow citizens. See Katherine Verdery, *National Ideology under Socialism: Identity and Cultural Politics in Ceausescu's Romania* (Berkeley: University of California Press, 1991).

6. Benedict Anderson, *Imagined Communities: Reflections on the Origin and Spread of Nationalism* (London: Verso, 1983).

7. Bayle St. John, "The Gipsy Slaves of Wallachia," *Household Words*, 8 October 1853, 139–42.

8. See Ioana Szeman, *Staging Citizenship: Roma, Performance, and Belonging in EU Romania* (New York: Berghahn, forthcoming); Ioana Szeman, "Playing with Fire and Playing It Safe: With/out Roma at the Eurovision Song Contest," in *Performing the 'New' Europe: Identities, Feelings, and Politics in the Eurovision Song Contest*, ed. Karen Fricker and Milija Gluhovic (New York: Palgrave Macmillan, 2013), 20–38; Ioana Szeman, "Collecting Tears: Remembering the Roma Holocaust," *Performance Research* 15, no. 2 (2010): 54–59.

9. Donald E. Pease, "Introduction: Remapping the Transnational Turn," in *Reframing the Transnational Turn in American Studies*, ed. Winifred Fluck et al. (Dartmouth: Dartmouth College Press, 2011), 5.

10. Different theories exist in Romania as to whether Roma were slaves before or

became enslaved after their arrival to the Romanian territories. Non-Roma Romanian historian Viorel Achim argues that Roma were slaves in medieval Bulgaria and Serbia, before they entered Romanian territories (*Ţiganii in Istoria României* [The Roma in Romanian History] [Bucharest: Editura Enciclopedică, 1998], 33). Non-Roma historian Nicolae Grigoraş maintains that Roma who migrated to Wallachia and Moldavia became enslaved after their arrival. After crossing the border into Wallachia, some free Roma sold themselves to pay their debts or became enslaved by marrying slaves. See Nicolae Grigoraş, "Robia în Moldova" [Slavery in Moldavia], in *Robia ţiganilor în Ţările Române: Moldova* [Ţigan slavery in the Romanian principalities: Moldavia], ed. Vasile Ionescu (Bucharest: Ed. Aven Amentza, 2000), 79. Roma scholar Nicolae Gheorghe refutes the thesis according to which Roma's slave status was prior to their arrival to the Romanian territories. He argues that this hypothesis attempts to shift blame and responsibility for their marginalization and to attribute it to an innate condition ("Origins of Roma Slavery in the Romanian Principalities," *Roma* 7 [1983]: 12–27, 15).

11. Mihail Kogălniceanu, "O ochire asupra sclaviei" [An overview on slavery], in *Coliba lui moşu Toma sau Viaţa negrilor din sudul Statelor Unite* [Uncle Tom's cabin; or, The life of Negroes in the south of the United States], by Harriet Beecher Stowe, trans. Theodor Codrescu (Iasi: Tipografia Buciumul Roman, 1853), 42.

12. Kogălniceanu in Stowe, *Coliba lui moşu Toma*, 48.

13. Harriet Beecher Stowe, *Bordeiul unchiului Tom sau Viaţa negrilor in America* [Uncle Tom's cabin; or, The life of Negroes in America], trans. Dimitrie Pop (Iaşi: Tipografia Institutului Albinei, 1853), 48.

14. Edith Lucas, *La littérature anti-escalavagiste au dix-neuvième siècle* [Nineteenth-century anti-slavery literature] (Paris: E. de Bocard, 1930), 78.

15. Grigoraş, "Robia in Moldova," 75–172.

16. Ibid., 77.

17. Ion Radu Mircea, "Termenii rob, serb şi holop în documentele slave şi române" [The terms "slave," "serf," and *holop* in Slavic and Romanian documents], in Ionescu, *Robia ţiganilor în Ţările Române*, 61–74, 61.

18. Grigoraş, "Robia in Moldova," 85.

19. Léon Pilatte, *La case de l'oncle Tom ou la vie des Nègres aux Etats-Unis* [Uncle Tom's cabin; or, The lives of Negroes in the United States] (Paris: 1853), 35.

20. Stowe, *Coliba lui moşu Toma*, 48; Stowe, *Bordeiul unchiului*, 48.

21. Pop in Stowe, *Bordeiul unchiului*, 45.

22. Quoted in Raluca Tomi, "Legislatie-Reforma-Emancipare: Miscarea abolitionista din Principate si impactul ei asupra legislatiei de dezrobire (1849–1856)" [Legislation-reform–emancipation: The abolitionist movement in the principalities and its impact on emancipation legislation (1849–1856)], *Revista istorică* 21, nos. 1–2 (2010): 57–71, 61.

23. Viorel Achim, *Ţiganii in Istoria României* [The Roma in Romanian history] (Bucharest: Editura Enciclopedică, 1998), 75.

24. Ibid., 78.

25. Daniel Chirot, *Social Change in a Peripheral Society: The Creation of a Balkan Colony* (New York: Academic Press, 1978), 111.

26. Ion Anestin, *Schiţă pentru istoria teatrului românesc* [Essay for the history of Romanian theater], (Bucharest: Vremea, 1928–38), 41.

27. Gheorghe Asachi, preface to *Mirtil şi Chloe* [Mirtil and Chloe] (1850), quoted in

Mihai Vasiliu, *Istoria teatrului românesc* [The history of Romanian theater] (Bucharest: Editura didactică și pedagogică, 1995), 19.

28. Vasiliu, *Istoria teatrului*; Anestin, *Schiță pentru istoria*.

29. Teodor T. Burada, *Istoria teatrului din Moldova* [The history of theater in Moldavia], vol. 2 (Iași: Tipografia "H. Goldner," 1922), 34.

30. Asachi, *Țiganii* [The Gypsies], in Ursu, *Opere*, 81–103, 100.

31. Grigoraș, "Robia in Moldova," 75–172.

32. C. I. Panaitescu, *Robii: Aspecte Țiganești* (Bucharest, Tipografiile României Unite 1928), quoted in Ian Hancock, "The Gypsy Stereotype and the Sexualization of Romani Women," in *"Gypsies" in European Literature and Culture*, ed. Valentina Glajar and Domnica Radulescu (New York: Palgrave Macmillan, 2008), 181–92.

33. Stowe, *Coliba lui moșu Toma*, 4.

34. Stowe, *Bordeiul unchiului Tom*, 4.

35. Oișteanu, "Ius primae noctis."

36. Ann Laura Stoler, "Carnal Knowledge and Imperial Power: Gender, Race, and Morality in Colonial Asia," in *Gender/Sexuality Reader*, ed. Micaela di Leonardo and Roger Lancaster (New York: Routledge, 1997), 13–35, 14.

37. Oișteanu, "Ius primae noctis."

38. Asachi, *Țiganii*, 88.

39. Ibid., 92.

40. Ibid., 92

41. Ibid., 93.

42. Ibid., 92.

43. Ibid., 99.

44. bell hooks, *Ain't I a Woman: Black Women and Feminism* (London: Pluto Press, 1982), 54.

45. Asachi, *Țiganii*, 92.

46. Mihail Kogălniceanu, "Schiță asupra moravurilor și limbii țiganilor" [Essay on the customs and language of Țigani] (1837), trans. Vasile Ionescu and Dragoș Palade in Ionescu, *Robia țiganilor în Țările Române*, 233–52, 246.

47. Asachi, *Țiganii*, 98.

48. Ibid.

49. Kogălniceanu, "Schiță asupra moravurilor," 238.

50. Adriana Helbig, *Carmen* (New York: New York City Opera Project, 2004), 1.

51. hooks, 34.

52. Kogălniceanu, "Schiță asupra moravurilor," 250.

53. Asachi, "Emanciparea Țiganilor" [Țigan emancipation] (1855), in Ursu, 718–20.

54. Kogălniceanu, "Schiță asupra moravurilor," 234.

55. Asachi, *Țiganii*, 89.

56. Ibid., 101.

57. Ibid., 100.

58. Kogălniceanu, "Schiță asupra moravurilor," 248.

59. For example, Ian Hancock lists several nineteenth-century writers whose depictions of Roma slaves fall into this category: "Ozanne wrote that the Romani slaves in Wallachia had 'crisp hair and thick lips, with a very dark complexion,' and [. . .] 'a strong resemblance to the negro physiognomy and character' (J. W. Ozanne, *Three Years in Roumania* [Ilfracombe: Arthur Stockwell, 1878], 62, 65). St. John wrote that 'the men

are generally of lofty stature, robust and sinewy. Their skin is black or copper-coloured; their hair, thick and woolly; their lips are of negro heaviness, and their teeth white as pearls; the nose is considerably flattened, and the whole countenance is illumined, as it were, by lively, rolling eyes.'(St. John, 140.) An anonymous writer three years later wrote, 'On a heap of straw in the middle, in the full heat of the blazing sun, lay four gipsies asleep. They were all four tall, powerful men, with coal-black hair as coarse as rope, streaming over faces of African blackness'" ("The Gipsies of the Danube," *Chambers's Journal of Popular Literature* 122 [1856]: 273). See Ian Hancock, "The Gypsy Stereotype and the Sexualization of Romani Women," in Glajar and Radulescu, 181–92, http://www.radoc.net/radoc.php?doc=art_d_identity_sexualization&lang=fr

60. Burada, *Istoria teatrului*.

61. Asachi, *Țiganii*, 102.

62. Ibid., 103.

63. Ibid., 102.

64. From reading the play in its version published in 1973, one could assume that Asachi speaks of the union between Moldavia and Wallachia, which would happen in 1859. It is possible to read the play as such, except that according to Asachi's characters in the dialogue quoted above in text, it is Moldavia that will triumph. Unlike Kogălniceanu, Asachi was not in favor of the union between Moldova and Wallachia, for various reasons, including his close relationship with the prince of Moldavia, his pro-Russian sentiments, and probably because Iași, the capital of Moldavia, would lose its status in favor of Bucharest. For his divergent views "against his times," as his Romanian exegesis describes him, he was censored by posterity in this very play. While he is enthusiastically pro-emancipation and pro-independence and advocates for Moldavia taking its place in the family of civilized Europe, a missing stanza, marked by an ellipsis in the 1973 edition, appeared in an 1856 review of the production and helps elucidate the mystery. It features Cimbru speaking after emancipation.

> Now rumor has it in the land
> That this spring
> We will be herding sheep in Bugeac,
> With my Anghelina in my arms,
> With a flute and a rifle
> Let me cross the Prut and the Bic
> Let me still be in my country!
> (*Gazeta de Moldavia* 8 [26 January 1856])

Upon reading the full version of the play, it becomes clear that even when he mentioned a union, Asachi meant a larger Moldavia, including the territories of Bessarabia, bordered by the rivers Bugeac and Bic and occupied in 1812 by the Russian Empire.

65. See Szeman, *Staging Citizenship*.

Heike Paul

"Schwarze Sklaven, Weiße Sklaven": The German Reception of Harriet Beecher Stowe's *Uncle Tom's Cabin*

"For better or worse, it was Mrs. Stowe who invented American blacks for the imagination of the whole world"[1]—thus Leslie Fiedler succinctly sums up one aspect of the long and complex reception history of the novel *Uncle Tom's Cabin*, a book that is still rated "the most influential book ever written by an American."[2] In this essay, I draw attention to one particular history of reception, the German one, and look more closely at the immense popularity that Stowe's book, with its representation of African Americans and slavery, has enjoyed in the nineteenth-century German states and in twentieth-century Germany. How has this "invention of American blacks" (to echo Fiedler) been received, appropriated, and perhaps even recoded? What are the terms of engagement for a German audience in the mid-nineteenth century and after?

Five decades after the initial publication of *Uncle Tom's Cabin*, Grace Edith MacLean located more than "75 separate editions in the German language; 41 distinct versions [. . .]; 11 abridgments for children; one dramatic adaptation, and one volume of illustrations."[3] Selling by the thousands, the novel by Stowe, supposedly a book for women and children only, was also, it seems, a book for Germans. For over a year after the initial German-language publication of *Uncle Tom's Cabin* in 1852, journals and newspapers regularly ran ads, reviews, and notices on the book, as well as columns on the author and her family history. They even published sheet music, accompanying editions with songs "from" the novel.[4] In general, German responses to the book were similar to those in the United States, and a "flood of imitative drama, poetry, and songs that capitalized on its most saccharine

scenes" can be found in German literary history:[5] in short, an *Onkel Tom* industry developed.[6]

On the basis of recent Stowe scholarship regarding the politics and poetics of the text and its recanonization, undertaken by scholars such as Jane Tompkins, Thomas Gossett, and Winfried Fluck, I explore the kind of cultural work the novel performed in the German context and the function it has had for German-American discourses. My argument is threefold. First, German readers took to the novel because it allowed for adaptation of its rhetoric of slavery, emancipation, and humanity to a specifically German social and political situation and for an expression of a German Zeitgeist of the 1850s. Regarding the events of 1848, Grace Edith MacLean even wonders, "What would have been the result if the book had reached Germany eight or ten years earlier? Who can estimate the flame of feeling it would have produced?"[7] The dynamic of a cultural translation is evident not only in the contemporary German reviews of the book but also in its many spin-offs in German popular literature, feeding the awakened public demand for *Sklavengeschichten* (slave stories).[8] These "rewritings" focus on the subject of slavery, as does Stowe, and usually introduce a number of German protagonists to the American scene. Some of them—such as Friedrich Wilhelm Hackländer's *Europäisches Sklavenleben*—even substitute the United States with Germany, the African American male protagonist with a white woman (or man), race with class, and the historical concreteness of American slavery with a vague and popularized version of the Rousseauian paradigm of universal slavery.

Second, *Uncle Tom's Cabin* becomes a touchstone for perceptions of America by German immigrants, travelers, and writers at a time when German immigration to the United States peaked. Representations of America draw on the book, and American realities are often read through the lens of Stowe's fictional representation. Thus, it provided an important tool for making sense of America (via the figure of the African American slave) and also accounted for some of the ways in which Germans inserted and imagined themselves in an American landscape. In that sense, *Uncle Tom's Cabin* presents a discursive intervention into the German writings about the United States.

Prior to *Uncle Tom's Cabin*, James Fenimore Cooper had been the single most important American writer read in German-speaking lands; his historical romances were widely read by Germans in the first half of the nineteenth century, and his representation of Native Americans in-

fluenced Germans' perception of America. German textual production about America grew in unprecedented ways during the 1840s and 1850s, in the shape of travel writing, journals, advice literature, novels, letters, and diaries. As Hildegard Meyer points out, by the mid-nineteenth century, German-American writing had developed all of its major topoi (engaging either positively or critically with the United States), which then continued to be echoed in German-American writing, throughout the nineteenth and twentieth centuries, as "das Nachklingen eines einmal angeschlagenen Tones" (the lingering of a note once struck).[9] The German Stowe reception is a kind of intervention into this existing discourse—not so much changing it as giving it a new spin and making visible some of its workings.

I see the reception of *Uncle Tom's Cabin* as negotiating Germans' social and cultural identity as "white slaves" (or masters) in a German or American social and economic order. The sense of vulnerable and unstable racial and classed subject positions pervades the reception and rewritings of Stowe's text and generates a peculiar transatlantic "dialogue" that relegates African Americans (the black slaves)—the ostensible topic of Stowe's novel—to the margins of the discussion. Another aspect underlies the contemporaneous reception process: that Harriet Beecher Stowe was a woman writer is registered unfavorably by most German reviewers and rewriters. Even those commentators who share her agenda and critique of slavery find offense with her "female" (i.e., deficient) representational strategies. Thus, in German readings of the book, not only are the "deep-laid patterns of escape, bondage and rebellion" severed from the African American experience of slavery, but Stowe's feminism, with its precarious critique of the "bondage of woman within the domestic idea," is effaced, if not reversed.[10]

Third and finally, the reception history of the novel in the late nineteenth and early twentieth centuries reveals a German popular and material culture that appears to be even further removed from Stowe's text, by displaying a disturbing romanticization of slavery and a nostalgic, even remorseful view of its "pastness." "Uncle Tom's Cabin" became a preferred name for hotels, boarding houses, restaurants, and beer gardens that offered the pleasures and comforts of leisure and entertainment. Making the geography of *Uncle Tom's Cabin,* quite literally, part of their own spaces of consumption, Germans spent their time in gastronomic facilities named after the book. Promotional postcards, then on the rise as a modern form of communication, attest to these cultural practices and document the outings and en-

joyments in those "cabins." A brief look at this peculiar kind of material popular culture concludes this essay.

REWRITING *UNCLE TOM'S CABIN*

Adaptation of the rhetoric of *Uncle Tom's Cabin* to a German context and substitution of race with class matters in the German reception of Stowe's novel are evident in the analogies used by reviewers of the book. Take, for instance, the following example from Karl Gutzkow's *Die Gartenlaube*:

> *Uncle Tom's Cabin*, the book that elicited so many tears and good resolutions, has found an enormous circulation in Germany as well. It is dished up to the readers of seven monthlies in monthly portions, and in addition twenty to thirty translations have appeared with and without illustrations, several of which are already in second editions. [. . .] For the sake of humanitarianism, we would like the book to yield fruit. Slaves do not only exist in America; there are more than enough in Germany, only we call them by other names. A slave in America is often treated more humanely and benignly than a poor servant girl in Germany.[11]

Comparison of the suffering of the "poor servant girl in Germany" and the black American slave sets up a hierarchy of oppression, and this reviewer suggests that even slaves in America, "land of freedom," receive better treatment than do servants in Germany. He thus appeals to his readers and, empowered by Stowe's novel, addresses issues and concerns closer to home. He hopes that the popularity of the novel in Germany will lead to greater awareness and sympathy for other, more immediately relevant social causes. In characteristic fashion, the signifier of slavery is disconnected from its historical and geographical specificity, and the hope is that the German maid will now profit, in some ways, from Stowe's popularity and critique of slavery.

Following the publication of *Uncle Tom's Cabin* in Germany, a whole new popular literary genre of *Sklavengeschichten* developed: in a German context of "blackness without blacks," as Sander Gilman ironically phrases it,[12] the symbolic power and potential of blackness drawn from Stowe's novel was expanded in ever new images, modes, and scenarios (as suggested by the review quoted above), often having very little to do with African Americans or the American institution of slavery. One example of this se-

mantic and semiotic recoding is Friedrich Wilhelm Hackländer's popular novel *Europäisches Sklavenleben* (*European Slave Life*, 1854), a work of four volumes and fourteen hundred pages, written in direct response to and in dialogue with *Uncle Tom's Cabin*. Hackländer's detailed representation of different social milieus (bohemian, bourgeois, aristocratic, and working-class) focuses on slavery as a mode of dependency and oppression experienced by all of his characters: within various situations, they are white slaves of circumstance.[13] Chapter headings such as "Sklavinnen" (Female slaves), "Sklavenleben" (Slave life), "Sklaven-geschichten" (Slave stories), "Sklavenhandel" (Slave trade), and "Sklavenloos" (The fate of slavery) reveal the ubiquitous rhetoric of slavery and the way in which the author draws on this leitmotif in his dramatization of German life. The plot presents a number of interlocking narratives in which each protagonist experiences his or her own kind of slavery.

The first of these narratives introduces Clara Staiger, a ballet dancer who lives in poverty with her father, sister, and brother in an unnamed German city. Clara's job stigmatizes her and exposes her to attempted seductions by different men (all of whom she resists). While Clara seems not to have any choice but to dance for a living in the shady world of the theater, her widowed father works "like a slave" for a publisher and translates foreign-language texts under time pressure and for very little money. Pointedly, a novel Staiger translates is Harriet Beecher Stowe's *Uncle Tom's Cabin*. While he tries hard to support his family in order to save his daughter from the moral pitfalls of her bohemian environment, he cannot but compare his own situation to that of the African American slaves about whom he is reading. This comparison suggests the latter to be tolerably well-off.

> The interior of Uncle Tom's Cabin is described as quite comfortable and not at all that wrong; it is a decent, firm building with a little garden in front of it; on the stove, a fire is blazing and is spreading a cozy warmth in the room [. . .] the very idea of a fireplace is something very cozy . . . Aunt Chloe stands at the kitchen fire and from her pan comes the smell of something good; she had just given a piece of bacon into it and remarks that the cake is changing its color beautifully. [. . .] Oh! There is something so very excellent about such a cake![14]

For Staiger, instead of cake and bacon, dinner is pieces of bread soaked in milk, and even this has to be begged from a neighbor. Again we encoun-

ter the stylistic device of comparison, attesting to the harsher victimiza-
tion of Germans vis-à-vis black slaves. The apparent idyll in Tom's cabin
(which merely marks the counterpole in Stowe's text to successive plot
developments that destroy it) is taken as a sign of the slaves' prosperity
and well-being. Staiger's monologues are overheard by his children, and
Clara has to explain to the younger ones: "Papa spricht nur vor sich hin
aus dem Negerleben von Amerika" (Daddy is only talking about Negro
life in America). The little brother and sister are perplexed: "Neger, die
arm sind und Kuchen essen?" (Negroes, who are poor and eat cake?).[15] It
is suggested that Staiger would gladly trade places with Tom. Omitted is
Stowe's critique of slavery—no "idyll" lasts long under the arbitrary rule
of slaveholders, and inevitable are separation of families, physical and
psychological abuse, and, ultimately, death.

Next to these intertextual elisions that refute and relativize Stowe's origi-
nal intent and reinvest the narrative with German social problems, Hack-
länder's references to *Uncle Tom's Cabin* also convey the broad effect that
the book must have had in his time. In each of the social microcosms that
the author portrays, it is read and discussed, becoming the reference point
and touchstone for many dialogues. At the theater, for instance, Clara and
her fellow dancers make it the topic of their conversations.

"A new book has been written," Clara said; "have you heard about it?
My father is translating it at home for a bookseller and I am reading the
proofs." "Of course, I have read it," another dancer responds, "and the
author's intention is certainly commendable; but it is ridiculous how
people are raving about it, how people lasciviously cherish foreign, of-
ten imagined and exaggerated misery while there is the same, in much
larger dimension, directly under their noses. [. . .] I know people who
look to the slavery so many thousand miles away from them and who
stumble over it at home, who daily and hourly lament the misery of
those unhappy human beings and are, in their own homes and for their
own fellow beings, the worst kind of slave traders."[16]

This criticism not only targets Stowe's representational strategies and the
facticity of her book but also attacks an escapism on the part of the enthusi-
astic German readers of romantic popular writing: the exotic and removed
form of oppression is invested by German readers with a sense of pleasure
and lust that overshadows the actual grievances at home. Hackländer's char-

acters seem to agree with many nineteenth- and twentieth-century critics who have found fault with Stowe's melodramatic and sentimental narrative; at the same time, speaking for the author, they seem to be opposed to the German reception of American popular culture in general, as they repeatedly contrast the faraway places and plots of the imported best seller to the more relevant here and now of the German society and setting.[17]

The substitution of race with class and of the United States with Germany is topped by yet another narrative strategy: while Stowe emphasizes the arbitrariness of racial politics and oppression via mixed-race characters, the German reception appears to ignore this central tenet by (re)creating a dichotomy between black and white and by monopolizing the question of equality for a whites-only context. As one of Clara's fellow dancers phrases it,

> Our slavery is much harder, much longer, and much crueler. Those who are born into this world with a darker face know very well that there is a difference between them and their white sisters; why else has God created the two races? He must have had his reasons. But we, slaves by birth and circumstance, our faces not one bit darker than that of the others who look down on us with contempt, [. . .] we have the right to feel our condition as more desperate than those others [with a darker face].[18]

Here, the practices of injustice addressed by Stowe are negated, even reversed. Whereas Stowe depicts how, in the American South, "blood" justifies harsher or at least differential treatment, Hackländer's novel likens whiteness to a "higher" form of being/consciousness that renders the poverty and exploitation of whites unjust. Outrightly rejecting the idea of racial equality, it is clear that for the character quoted above, "slavery" (whatever kind of oppression it may signify) is considered more of a social evil when it affects white people.

To sum up, Hackländer—using his characters as convenient mouthpieces—elaborates (1) a comparison and relativization of issues of (American) slavery and oppression, (2) a critique of German escapist reading practices of American popular culture, and (3) a set of racial prejudices undermining Stowe's call for emancipation and equality of African Americans, in order to downplay the message of her best seller. While building his critique very much under the shadow of Stowe's text, he rechannels her emotional appeals to other sites and scenarios. Using and abusing *Uncle*

Tom's Cabin, he wants to profit from Stowe's cultural work by transferring it to a German social context. *Uncle Tom's Cabin* is directly referred to in almost every chapter of Hackländer's book. All of his characters seem to have read it, and they mostly dislike it and take issue with its theme (they find the depiction of slavery "exaggerated" and simply "false") as well as with its style: Hackländer's realism clashes with Stowe's romantic sentimentalism. Therefore, Hackländer's book suggests, it takes "a second Mrs. Stowe,"[19] a man (namely, Hackländer himself), to truthfully depict the conditions of "real" slavery. Hackländer's novel sheds light on the German reception of *Uncle Tom's Cabin* not only by stressing the frame of reference that made German identification with the text possible but, more important, as a critique of Stowe's book—a kind of "map for (re)reading" (to use Annette Kolodny's phrase) in spelling out its specific symbolic potential for German readers.[20] Hackländer has written a book about his reading experience of *Uncle Tom's Cabin* and, as he goes along, "performs" the act of transforming a sentimental novel of reform that critiques slavery into a somewhat didactic realist novel of social criticism regarding class distinctions and, by extension, every kind of social structure. Hackländer's text is a forerunner of realism on the German literary scene, putting him at a distance from romanticism and its literature of sensibility. The latter is quite characteristically exemplified by Stowe, and we can read the controversy over aesthetics as a thinly veiled controversy over female and male authorship: Stowe is repeatedly chided as a "woman writer" whose limited craft results in books such as the one under scrutiny. Hackländer's attack betrays more than a little anxiety over the "scribbling woman" and her sweeping success, which he tries to rival but (despite the popular success of his own novel) cannot match.

Censorship may have played a role in Hackländer's strategy of sticking close to Stowe's text, even if in a critical fashion. Wolfram Siemann has pointed to the limited freedom of the press in Germany, despite the fact that censorship had officially been abolished.[21] Hackländer may have shielded his own social critique from official objections by presenting it foremost as a critique of Stowe and only secondarily as a critique of German society and living conditions. Stowe, as an American writer and a woman writer, did not have to fear censorship in the same way as male German writers. Möhrmann recounts that censorship procedures threatening the publication of one of Fanny Lewald's books were curbed after her identity as "only" a female author had been established.[22]

Hackländer's narrative project is representative of an avalanche of texts that, in the wake of *Uncle Tom's Cabin*, fabricate popular fictions of "slavery" that attempt to close the gap, so to speak, between the "original" American novel and the imaginary investments of German readers. Yet why did Stowe's novel lend itself so exceptionally well to transfer and translation? Winfried Fluck suggests that this substitution is possible because of Stowe's own rhetorical configurations, which he has diagnosed both as "power and failure of representation."[23] In a reading of the first scene of the novel, he demonstrates how the signifier of blackness in the portrayal of Tom is opened up to allow the audience to perceive new and more positively connoted meanings.[24] Stowe's literary familiarization of African American characters stresses sameness over difference in order to make them fit for representation as main protagonists in mid-nineteenth-century American literature.[25] At the same time, this openness and familiarization prompts and enables the chain of substitutions that Fluck registers, particularly in the novel's modern readings in which he sees the typological dimension of the text as well as its excessive sentimentalism superimposed on other meanings. Yet I suggest that these infusions are obvious already in the historical context of the 1850s, when the race/class analogy particularly becomes a key issue in the intercultural negotiations over the meaning of the book.[26] The price Stowe pays for having the tragic fate of enslaved African Americans successfully appeal to her (international) audience is that those slaves are perceived no longer merely as historically situated individuals but as universal types as well. As one reviewer suggests,

> It is a live book, and it talks to its readers as if it were alive. It first awakens their attention, arrests their thoughts, touches their sympathies, rouses their curiosity, and creates such an interest in the story it is telling, that they cannot let it drop until the whole story is told. [. . .] If it were the story of a Russian Serf, an evicted Milesian, a Manchester weaver, or an Italian State prisoner, the result would be the same.[27]

This universalist stance explains the far-reaching success of the novel as an early instance of wide dissemination of American popular culture abroad, yet its sweeping rhetoric needs to be complemented by specific readings that individual contexts have produced, adding to *Uncle Tom's Cabin* stories about other characters, including, in a German context, poor maids and

ballet dancers. In that sense, Hackländer's novel is simultaneously a German reading and rewriting of Stowe's novel.

SEEING AMERICA THROUGH *UNCLE TOM'S CABIN*

Uncle Tom's Cabin has been influential in shaping German perceptions of the United States and in interpreting the German presence, role, and status in America. For example, a review of the book rails at its treatment of new immigrants,

> Did Mrs. Stowe raise her voice in the face of all the misery that befalls thousands of white immigrants as a consequence of their terrible treatment in this country? [. . .] Why did not the wailing of the immigrants about the horrible conduct of the Commission of Emigration [*sic*] in New York penetrate Mrs. Stowe's ears? But it is a fashion in some New England circles to eloquently lament about the Negro slavery in words that cost nothing, and it is fashion to look down with nativist puritan pride on the immigrating Germans and Irish and to expose them to the most shameless exploitation![28]

As this reviewer correlates the marginalization of Germans (and Irish) with that of African Americans, he places Germans (as victims of a white American society) in competition with and in symbolic proximity to black slaves, mixing up race and class in a context in which the social mobility and legal rights of immigrants are distinguishing factors between the groups. As this passage anticipates, German-American literature after 1852 often makes recourse to Stowe's text as an organizing and structuring device (either affirming or rejecting the novel's tenor), to develop a textuality for describing America and then to insert the German immigrant into this textuality. The peak of German immigration to the United States in 1852–53 occurred on the tail of a writing boom negotiating the "meaning of America." Prior to *Uncle Tom's Cabin*, race and slavery had already preoccupied both Germans writing about America and German readers,[29] and analogies between Germans and African Americans do not begin with the reception of Stowe's novel: since the beginning of the century, German writers made use of this comparison to address the social standing of German immigrants in the New World.[30] Yet Stowe's novel seems to have propelled a new interest in

American slavery and a new way of positioning the German-American presence.

Although the German perspective on America after 1852 is partially prefigured by earlier works, *Uncle Tom's Cabin* made a singular impact: it is mentioned in every travel account, piece of advice literature, and novel on the topic of America, and excerpts from it are often copied directly into German-American texts. *Uncle Tom's Cabin* offered a way to understand America through the institution of slavery, coining a rhetoric and repertoire of literary topoi to describe iconic experiences. Its popularity propelled a process that increasingly merged America, as a lived experience, with textual topoi. Whereas the reviewer quoted above contrasts *Uncle Tom's Cabin*, as a "false" fictional document, with "reality" and the "real" conditions of immigrants in 1853, references to the book are integrated into travel accounts as a kind of narrative code. As Karl Scherzer and Moritz Wagner traveled the slave states in 1852 and 1853, they observed the horrors of slavery and found the Southern landscape to be pervaded by racial trauma. Resting for the night in New Orleans, they recount,

> The sleep we tried to abandon ourselves to was not very deep; after a few hours [. . .] our heads buzzed with all those horrible scenes from *Uncle Tom's Cabin*. [. . .] Thus we were extremely glad to be delivered from these dreary apparitions by a bright morning.[31]

This account illustrates the place *Uncle Tom's Cabin* has in the nineteenth-century German cultural imaginary: it helps to articulate a critique of slavery, and it shows Stowe's novel on an equal footing with authentic cases of immigrants taken into slavery. The latter aspect functions as a kind of *Angsterzeugungsplot*, aimed at inducing anxiety in its readers, which has the German reader and traveler of America experience slavery "skin-deep" (and not only by way of a metaphorical transference), suggesting that a "white slave" need not be merely a "cultural oxymoron."[32]

Scherzer and Wagner allude to a woman who was a "white slave" and whose story circulated in many different versions in nineteenth-century German-American writing, as the factual counterpart to Stowe's novel. George Washington Cable (novelist and chronicler of nineteenth-century Louisiana life) and Carol Wilson and Calvin D. Wilson (more recent historians) recount the details of this tale. Salomé Müller (also known as Sally/ Salome Miller/Muller) was a native of Alsace, in France not Germany,

though Cable concedes that people in that area at the beginning of the nineteenth century "were still, in speech and traditions, German."[33] Salome and her family arrived in New Orleans in March 1818, not without trouble.

The Mullers' misfortune began on the journey and would continue in the United States. The mother had died during the voyage. Upon arrival, father Daniel Muller took his three young children along when he went to work as a redemptioner (indentured servant) on a plantation in Louisiana's Attakapas region. A few weeks later, relatives learned that he and his son had died, and when they sent for the two girls, the sisters had disappeared. One was never heard from again; nothing was known of Sally until 1843.[34]

In that year, Frau Karl, who had come to the United States on the same ship as the Müller family, recognized Salome working as a slave in Louis Belmonti's wineshop in New Orleans. Cable recounts the scene as follows:

Madame Karl paused in astonishment. [. . .] It was as if her aunt Dorothea, who had died on the ship twenty-five years before, stood face to face with her alive and well. There were her black hair and eyes, her olive skin, and the old familiar expression of countenance that belonged so distinctly to all the Hillsler family. [. . .]

"My name," the woman replied to her question, "is Mary." And to another question, "No; I am a yellow girl. I belong to Mr. Louis Belmonti, who keeps this 'coffee house.' He has owned me for four or five years. Before that? Before that, I belonged to Mr. John Fitz Miller, who has the saw-mill down here by the convent. I always belonged to him." Her accent was the one common to English-speaking slaves.

But Madame Karl was not satisfied. "You are not rightly a slave. Your name is Müller. You are of pure German blood. I knew your mother. I know you. We came to this country together on the same ship, twenty-five years ago."[35]

Mrs. Karl took Salome home with her and, with the help of her cousin and godmother Eva Schuber, who immediately recognized Salome, sued for her freedom. A long and complicated court case ended with the restoration of Salome's freedom on 19 May 1845. The protracted court proceedings demonstrate the difficulty that illegally enslaved victims had in regaining their

free status. Only on the basis of witness accounts could Salome be success-
fully vindicated.

The implications of this story for German and German-American read-
ers were tremendous, as it meant that the "peculiar institution" was turn-
ing immigrants into victims of slavery. The practice of kidnapping newly
arrived immigrants is evidenced by recent historical scholarship attesting
to the historical validity of literary allusions and references such as the one
appearing in Richard Hildreth's novel *The White Slave; or, Memoirs of a Fu-
gitive* (the revised and expanded 1852 reprint of his 1836 novel *The Slave*,
which was received well in Germany).[36] A slave trader in Hildreth's novel
spells out an uncanny procedure: "Just catch a stray Irish or German girl
and sell her—a thing sometimes done. She turns into a nigger at once, and
makes just as good a slave as if there were African blood in her veins."[37]
Particularly after passage of the Fugitive Slave Law in 1850, the North could
be appropriated as new ground for various practices of slavery. Ultimately,
this meant that German immigrants could become "naturalized" into the
American system in more than one way. Jeopardizing the scheme of up-
ward mobility, the specter of enslavement figures as *the* immigrant night-
mare about America and intensely stresses the inescapability of racial vio-
lence within an institution endlessly craving victims. Plots of kidnappings
abound in German-American literature and seem in no way proportionate
to the actual occurrences of white slavery. However, they can be read as the
specter of slavery hovering over the German immigrant.[38]

Uncle Tom's Cabin, like other abolitionist writing, strategically blurs the
boundaries between black and white, drawing on the light-skinned charac-
ter to criticize the system of slavery.[39] In the scene of a slave auction (chap-
ter 30), the narrator describes the male and female slaves "from the purest
ebony to white" (337). The ability to pass for white may work in favor of
light-skinned slaves making their way to the North, as it does for Stowe's
Eliza. Yet it may also work against white immigrants, whom we can infer,
by contrast, may be enslaved despite their whiteness or their resemblance
to a mulatto or quadroon. By juxtaposing the fate of Tom and Eliza, the
fate of being sold down South and of making one's way to freedom, *Uncle
Tom's Cabin* gives two blueprints, a narrative of descent and a narrative of
ascent, which German immigrant readers could use to make sense of their
own American experience. This explication of a German reading practice
of *Uncle Tom's Cabin*, which is sustained by commentaries and reflections
in reviews, novels, and travel writing, refers us not only to the institution of

slavery as a central characteristic of American society but also to the preva-
lent nativist discourse of the 1850s subjecting German and Irish immigrants
to strong and lasting discrimination.[40] Matthew Jacobson points to the ra-
cializations of nativist rhetoric that reflect the status of immigrants as not
being of Anglo-Saxon stock. Moving beyond a clear-cut black-and-white
dichotomy, Jacobson detects "different kinds of whitenesses" in nineteenth-
century public discourse and analyzes the way whiteness could be stigma-
tized in combination with class, religion, and other factors.[41] German writ-
ers and commentators of America before and after Stowe have responded
to the race rhetoric of nativism by taking up racialized scenarios to situate
German immigrants and to negotiate their social, economic, and political
status. Therefore, Stowe's novel, appearing only a few years after Salome
Muller's case received a great deal of publicity, lent new force and new viru-
lence to the "white slavery" debate.

WOMEN AND SLAVERY

In general, mid-nineteenth-century Germans and German-Americans
tended to oppose the institution of slavery on the grounds that it stood
in blatant contradiction to cherished ideas of American freedom and lib-
erty. Much has been made of the abolitionist efforts of the generation of
the Forty-Eighters exiled in the United States.[42] Yet just as pro-abolitionists
could be racists, they could also hold conservative points of view; in-
deed, German immigrants were strongly opposed to the emancipation of
women.[43] This curious and characteristic blend of liberal authoritarianism
(or authoritarian liberalism, for that matter) also informed the reception
of Harrier Beecher Stowe's novel; the author was seen as representative of
a self-confident, professional, and highly successful class of females from a
country in which the upgraded social status of women (relative to German
standards) was frowned on and regarded as a threat by most German observ-
ers. Reviewers and commentators took issue with Stowe's female authorship
and used heavily gendered language when commenting both on the author,
as a *Blaustrumpf* (bluestocking)[44] and a *Frauenzimmer* (wench),[45] and on
her writing, as *Geschreibsel* (scribbling), *Wortschwall* (barrage),[46] and *Fana-
tismus* (fanaticism)[47] of little artistic value.[48] *Uncle Tom's Cabin* would serve
internationally as "a striking example of the collaborative and overlapping
efforts of women in the production, translation, criticism and promotion of
progressive literature,"[49] but in the German context, Stowe was criticized by

a whole generation of male translators and reviewers who opposed slavery yet questioned a woman's expertise to properly represent it.[50] Many translators had no qualms about adding their own interpretations in the form of prefaces and epilogues. Whereas this was common practice in the marketing of literature, the wording of these paratexts often betrays a male German chauvinism vis-à-vis the American woman writer.

The opposition of German authors toward a liberal view of gender is a long-standing theme in German-American texts and lingers into the post–Civil War era, at times leading to strange new rhetorical figurations. In addition to the two types of white slaves encountered in Hackländer's novelistic spin-off and in the story of Salomé Müller, a third type is found in the writings of German-American authors. This type plays on the supposed oppression of American men by their emancipated female counterparts, Stowe being one of them. German observers of the American scene claimed that after emancipation of African American slaves, white American men needed a movement to be freed from the "tyranny of the American woman."[51] German writers documented the sad state of the *"unsterbliche[r] Pantoffelheld"* (immortal henpecked husband),[52] repeatedly narrating scenes of alleged public punishments of white men at the hands of women, such as public whippings performed by the American "Peitschen-Amazonen" (Amazons of the whip).[53] In portraying the bondage of American men, these scenes illustrate two things: first, German writers had a hard time adjusting to a society in which women had their say, and the writers somewhat overreacted to this new situation; second, insignias of racial violence—like those that had been popularized by Stowe's novel—were still circulating in the United States after slavery had ceased to exist. By the end of the nineteenth century, German authors writing about America—having read all about slavery and having familiarized themselves with its various manifestations—gave their own spin to the racializations of the New World.

INTO THE TWENTIETH CENTURY: POSTCARDS FROM "UNCLE TOM'S CABIN"

Whereas mid-nineteenth-century responses to Stowe's novel dwelt on the subject positions of victims suffering in slavery or servitude on both sides of the Atlantic, the responses modulated toward the end of the nineteenth century. In the face of urbanization and industrialization, nostalgic notions of the rural—specifically the rural American South—seemed, surprisingly

enough, attractive to Germans. Thus, on the map of Berlin today, we find the name "Onkel Toms Hütte" (Uncle Tom's Cabin), referring to a subway stop named for a street between the famous boulevard Kurfürstendamm and the Grunewald forest district. At the end of the nineteenth century (long before the subway stop was built), this area was a popular place for outings to the forest and nearby lakes. In 1884, the city gave permission to build a tavern with a large stable next to one of the lakes. This rustic inn with a thatched roof was nicknamed "Onkel Toms Hütte" by Berliners, who, at this point, had been voracious readers of Harriet Beecher Stowe's novel for more than three decades and in more than thirty German-language editions. "Onkel Toms Hütte" became the official name of the beer garden, as shown by promotional postcards from 1901, 1902, and 1904, at the beginning of what Tom Phillips calls the "Postcard Century" (figs. 8–10).

Irony is at work in the adoption of this name, through which we witness the retrospective stylization of slavery as a kind of premodern way of life in the American South, in which the home of the African American slave epitomizes a pastoral idyll, a place of leisure and pleasure. This antimodern, romanticized vision of American slavery makes use of a falsely constructed American pastoral rather than making recourse to a powerful German romantic legacy much closer at hand. In late-nineteenth-century German popular culture, the imported, geographically and historically removed image of the log cabin of a slave embodies contentment, peacefulness, and German *Gemütlichkeit* (coziness). Yet who ever heard of a slave in a beer garden?

The Berlin beer garden's naming is not an isolated incident. All over Germany, beer gardens, restaurants, hotels, motels, and campgrounds (some of which still exist) were named "Onkel Toms Hütte." Many of these establishments had promotional postcards printed and offered them to their guests (fig. 11).[54] These cards can be considered a kind of modern material culture, bespeaking characteristics of the Kaiserreich and the Weimar Republic: technological developments and changes in media culture and consumption as well as a new class-specific leisure-time activity. As Phillips notes, "Germany led the way with illustrated greeting cards depicting resorts and tourist sites. These invariably feature the words *Gruss aus* [Greetings from] and allow space for writing on the picture side. They were the models on which most early cards were based." At the time, the medium of the postcard was still referred to as a new "happy invention," and in terms of communication, it soon became "the phone call of the early part of the century."[55]

Fig. 8. Promotional postcard from Onkel Toms Hütte, Berlin, 1902. (Collection of the author.)

Fig. 9. Promotional postcard from Onkel Toms Hütte, Berlin, 1903. (Collection of the author.)

Gruss aus dem Grunewald, 27. März 1904.

Onkel Toms-Hütte

Kunstverlag: J. Goldiner, Berlin

Fig. 10. Promotional postcard from Onkel Toms Hütte, Berlin, 1904. (Collection of the author.)

Fig. 11. Promotional postcard from Onkel Toms Hütte Biergarten in Dresden from the early twentieth century. (Collection of the author.)

Looking at these postcards today, we may fall prey to the "nostalgic fallacy" (as Phillips and others warn us), easily "rob[bing] them of their original modernity."[56] The nostalgia/modernity dichotomy seems to be enhanced by the "message" the cards convey: spending a day off from work, a week, or a long weekend at *Onkel Toms Hütte* is pleasurable. Thus, these postcards embody a contradictory narrative of modernization—as paradoxical as what Bill Brown has noted regarding the mass production of cheap novels about the American West during the same period: in Brown's argument, technological advancement in media culture is coupled with the "closing" of the frontier and the celebration of a particular kind of rural pastness, consumed by predominantly urban readers "synchroniz[ing] the realm of leisure in the rhythms of work and industry."[57] Similarly, the popularity of the beer gardens bearing the name "Onkel Toms Hütte" evidences a pastime investment in a temporally and culturally removed pastness that is perceived as evoking an intimate setting of well-being and relaxation.

These places bespeak a racist pastoralization of slavery in the German context of reception. Or should we instead consider them in the realm of the imagination? Why would such pastoralization have been popular at this time? At the beginning of her novel, Stowe sketched the seemingly ideal world of Tom and his family—all of them well-fed and properly cared for slaves living in their homely cabin—before showing the dramatic turn of Tom's fate. This narrative strategy may have abetted a turn in the German reception of the text, leading, in the last decades of the nineteenth century, to a disregard for her actual critique of slavery, at least in the German reception. In the fourth chapter of the novel, "An Evening in Uncle Tom's Cabin" (almost the only overt presence of the cabin in the book), the reader is introduced to Tom's cozy place, and one may wonder whether most German readers only read until that point in the book. Given the authoritarian structure of German society in the Kaiserreich in times of social and economic instability, many German readers of the novel apparently came to appreciate and idealize slavery as a stable, paternalistic (and possibly benignly feudal) social order, with fiduciary duties on the part of the slaveholder, an order that seems to contrast with the harsh conditions they perceived all around themselves—of early capitalism, industrialization, and urbanization. Nothing is wrong with Uncle Tom and his life as a slave, it is argued, until his good-natured and caring owner runs into debt. Slavery itself is not the problem, runs the argument; the profit-oriented trading and

mistreatment of slaves at the hands of immoral and brutal owners give slavery its bad name.

Thus, one may contend that the German *Onkel Tom* gastronomic industry adds another level of commodification to the reception of Harriet Beecher Stowe's novel, which had already seen the publication of sheet music, wallpaper, handkerchiefs, and dresses (à la Eliza). It offers another way of consuming the text—quite literally as leisure, food, and drink—and leaves a record (i.e., a postcard) of this experience. It further affirms and amplifies the racist myth of the happy slave, "a myth that finds happiness in the violence of colonial subjection" in a perverse pastoralism and a misguided nostalgia, German style. Black studies and recent cultural critics of affect (prominent among them Sara Ahmed) have pointed to the cultural work of the image of the happy slave as having "a powerful function, suggesting that slavery liberates the other to happiness."[58] This renders the German cottage an idyllic place of happiness and well-being in the midst of modernization's toll. Thus, *Onkel Toms Hütte* emerges, quite literally, as a place in the German cultural imaginary—specifically as a place of good feeling—associated with food and drink, music and laughter, and pleasure rather than pain. Following Raymond Williams's work on the "structure of feeling,"[59] we may come to think of *Onkel Toms Hütte* as a cipher for the peculiar sentimental public feeling of *Gemütlichkeit* that seems evocative and suggestive of a particular German kind of affective economy of happiness, even as unhappiness of the profoundest kind (pain, trauma, and loss) is the affective state experienced in slavery and its aftermath.[60] Germany's *Onkel Toms Hütten* once more prove how pertinent James Baldwin's critique is when he identifies the cruelty of sentimentalism/sentimentality in public feeling as the opposite of genuine compassion. If "happiness functions as a promise that directs us toward certain objects, which then circulate as social goods,"[61] *Uncle Tom's Cabin* is used to create its own distinct affective economy as a comfort zone, a place of comfortable familiarity, even intimacy, away from home. At the same time, the German visitors do not, of course, identify with the black slave all the way. In visiting their own sanitized brand of "slave cabins," they expect to be served, and this expectation is firmly tied to their own whiteness and their status as citizens of Germany's empire.

The notion of American slavery as a peaceful rural idyll is not limited to postcards of beer gardens but can also be traced in various strands of

German popular culture and marketing. The novel's title scene is used in a series of bonus cards added to the bouillon cubes of meat extract produced and packaged by the famous Liebig Company and sold across the country. These collector's cards were reproduced in high print quality to signal the exclusivity of the product, a new marketing strategy to win customer loyalty. Liebig was a trendsetter in 1872 and ran the collector's series until 1940. The series on *Uncle Tom's Cabin* from 1904 visualizes the cabin itself and five other, more sensationalist scenes from the novel (including Eliza's escape, Tom's rescue of Evangeline, and Tom's death). A caption on the back side of the card featuring the cabin summarizes the scene. Uncle Tom's home is introduced as "a small log cabin in the South of the North American union." While Aunt Chloe is baking cake, a couple of "wool-headed boys" play, and Uncle Tom practices writing, instructed by his young master George. Liebig's gimmick (contemporaneous with the beer gardens in Berlin and elsewhere) adds to the kind of "soaping" of American slavery we encounter in these decades in various contexts. It effects a trivialization of slavery and an abrogation of its critique. As another manifestation of the seemingly ubiquitous commodification of "Uncle Tom" (both the book and the character) in various popular formats in Germany, the Liebig collector cards signal notions of a harmonious feudal social order and of the reciprocity of mutually beneficent master-slave relations. Again, the combination of the innovative medium ("bonus cards")—in terms of printing technology and marketing strategy—and their anything but modern content presents us with a riddle and a paradox that is well captured by the slogan "Vorwärts in die Vergangenheit" (Forward into the past), also the title of a book by Wynfrid Kriegleder on German-American textual production.[62] The discrepancy between a claim to modernity and the desire to return to a premodern past, which is here imagined as a benign form of slavery, is characteristic of a whole range of race-related German cultural productions of the Wilhelmine and Weimar periods.

Liebig collector's cards and the *Onkel Toms Hütten* promotional postcards are two manifestations of the same phenomenon. Clearly, the cultural mobility of Uncle Tom and his ubiquity in Germany should not be taken as evidence for genuine public interest in the fate of African Americans (let alone a general anti-slavery consensus) or, more generally, for any straightforward political agenda. To the contrary, the trivialization of the slave cabin as an idyllic beer garden and the like had a different cultural function at a time when Germans, newly united as a nation, were starting to become col-

onizers themselves, to take possession of African soil, and to rule over black bodies and even to enslave them. Coincident with downplaying the cruelty of slavery in the reception of Stowe's novel after 1870 and particularly from the 1880s onward, there was also a remarkable change in the way German commentators described African Americans in the United States—those ex-slaves they formerly and famously pitied as slaves. In fact, German writing about the United States in the last decades of the nineteenth century and the first decades of the twentieth can be read as a projective justification of German colonial intentions and colonizing politics and thus may be part of the German state fantasy work of "othering." Placing German travel writing about the United States—especially about encountering African Americans in their social, cultural, and political contexts[63]—next to the postcards with greetings from *Onkel Toms Hütten* reveals this highly problematic co-construction of German pleasure and African American pain. Of about sixty-five texts written by Germans about their American experiences in the period from 1870 to 1914, many condone brutal mistreatment (and lynching) with explicit reference to the African colonies. In fact, the observation and/or advocacy of violence against contemporaneous free black people correlates and coexists uneasily with the nostalgic invocation of slavery as a "vanished" institution.

While German colonialism and racism are certainly important frames of reference for the German Uncle Tom fandom, its popularity extends beyond that specific historical moment. In the 1950s, one hundred years after the publication of Stowe's novel, some of those inaptly named beer gardens and restaurants were still around. Toward the mid-twentieth century, their commemorative postcards were issued in color, such as those printed by a hotel on the island of Amrum in the North Sea (fig. 12) and by a motel and campground in Schleswig-Holstein (figs. 13–14). On closer examination, the latter seems to be signifying Americanness and Americanization—a spacious motel, car culture, and scenes of nature evoking the frontier (as much as the slave quarters) and a state park environment. Here, the word *Kabinen* (cabins) specifically refers to the garages for the cars in which the motel guests travel, rather than the accommodation itself. The modern cabin is shelter for the car and (perhaps inadvertently) chillingly evokes the "thinghood" of the car (and of the slave, making the nostalgic fallacy particularly poignant). On this postcard, we encounter the machine (not the slave) in the garden, at a site watched over by the ADAC (the German automobile association). The sentimental modernity cultivated by those

Fig. 12. Promotional postcard from a hotel on the island of Amrum in the North Sea, 1962. (Collection of the author.)

Fig. 13. Promotional postcard from Onkel Toms Hütte campground, motel, and restaurant in rural Holstein, 1960. (Collection of the author.)

Fig. 14. Onkel Toms Hütte motel with cabins. (Collection of the author.)

postcards and sites is hardly ever addressed directly by those who send out greetings. For example, one postcard reads, "Von unserer Pfingstfahrt bei herrlichem Sonnenschein senden wir von hier aus Euch die herzlichsten Grüße!—Papa, Mama, Onkel Otto, Tante Bertha, Onkel Walter und Tante Elsa!" [From our trip on Pentecost with wonderful sunshine we are sending you heartfelt wishes!—Daddy, Mummy, Uncle Otto, Aunt Bertha, Uncle Walter, and Aunt Elsa!].[64] We may wonder whether Onkel Otto and Onkel Walter ever thought twice about Onkel Tom.

Toni Morrison has referenced American slavery as a "playground for the imagination" that has perversely enriched American literature and culture.[65] This is the case for many literatures and cultures outside of the United States

as well. Stowe's narrative of American slavery did indeed travel widely and found particular local echoes. Since the last decades of the nineteenth century, we encounter popular trends in Germany that belittle all matters related to black slavery and that nostalgically imagine a safe haven from modernity in the cabin of a black slave, starting at the very moment African Americans themselves left their slave cabins for good.

KEYS TO *UNCLE TOM'S CABIN*

A reconstruction of nineteenth-century and early twentieth-century readings of and responses to *Uncle Tom's Cabin* illuminates various metaphorical and visceral dimensions and interpretations of the novel that bespeak German as well as German-American sentiments and experiences in terms of race, class, gender, and nationality. Stowe herself drew on black discourse— laid bare in *A Key to "Uncle Tom's Cabin"*—consisting of stories, anecdotes, and autobiographies rendered and experienced by African American writers, usually ex-slaves.[66] *Uncle Tom's Cabin* is thus a sort of adaptation of material that Stowe successfully processed to amplify the range of its influence. This amplification has received mixed responses over time.[67] It is not surprising that black agency on behalf of abolitionism, which is veiled, rather than revealed, by *Uncle Tom's Cabin*,[68] reached Germany only sporadically and with temporal delay; perhaps one has to appreciate the fact that it did so at all.

African American narratives made their appearance on the German literary market through a translation of Stowe's sourcebook, the *Key*, and in the shape of three firsthand texts: Frederick Douglass's *Sklaverei und Freiheit* (*My Bondage and My Freedom*), Frank Webb's *Die Garies und ihre Freunde* (*The Garies and Their Friends*), and a version of Josiah Henson's slave narrative *The Life of Josiah Henson, Formerly a Slave* published as *Lebensgeschichte des Onkels Tom in Frau Beecher-Stowe's "Onkel Tom's Hütte."* The Douglass project is remarkable and well documented.[69] The German journalist Ottilie Assing, Douglass's translator and friend, made it her explicit intention to counter the fictional slave stories on the German market with a factual, autobiographical one, "eine wahre Geschichte" (a true story)[70] written by a former slave. However, by the beginning of the 1860s, the literary market was saturated with *Sklavengeschichten* (as Assing notes in her preface), and the larger-than-life introduction that Assing gives Douglass in her preface completely undermined the intended gesture of

authenticity. Douglass there appears to be a fictional hero, an impression bolstered by the literary strategies Douglass uses in his autobiographical self-fashioning;[71] as a consequence, even today, Assing appears in many bibliographies as the author and not the translator of the book.[72] At the same time, the devaluation of Stowe's fictional strategies and the presentation of her book as somehow "true" had already blurred the lines between fact and fiction, authentic record and writerly imagination. Thus, Josiah Henson's autobiographical story about himself as the former slave who was claimed to be the model for Stowe's Tom is not announced by the translator and "adaptor" Marie Schweikher as at all contradicting Stowe, "[die] vom künstlerisch-literarischen Standpunkte aus [ihren] Onkel Tom notwendig sterben lassen mußte" (who, from an aesthetic point of view, necessarily had to let Uncle Tom die).[73] It only announces the fortunate fact that "Onkel Tom" has not died in captivity but is still very much alive, living in Canada and traveling, even touring England.[74]

Notes

1. Leslie Fiedler, *The Inadvertant Epic: From "Uncle Tom's Cabin" to "Roots"* (New York: Simon and Schuster, 1979), 26.

2. Jane Tompkins, *Sensational Designs: The Cultural Work of American Fiction, 1790–1860* (New York: Oxford University Press, 1985), 122.

3. Grace Edith MacLean, *"Uncle Tom's Cabin" in Germany*. Americana Germanica 10 (New York: Appleton, 1910), 23.

4. Ibid., 89–101.

5. Eric J. Sundquist, introduction to *New Essays on Uncle Tom's Cabin*, ed. Eric J. Sundquist (Cambridge: Cambridge University Press, 1986), 4.

6. In addition to MacLean's valuable 1910 study on *Uncle Tom's Cabin* in Germany, the following studies have analyzed the European repercussions of the book's publication: Harry Birdoff, *The World's Greatest Hit: "Uncle Tom's Cabin"* (New York: S. F. Vanni, 1947); James Woodress, "*Uncle Tom's Cabin* in Italy," in *Essays in American Literature in Honor of Jay B. Hubbell*, ed. Clarence Gohdes (Durham, NC: Duke University Press, 1967), 126–40; J. G. Riewaldt, "The Translational Reception of American Literature in Europe, 1800–1900: A Review of Research," *English Studies* 60 (1979): 562–92; Sherry Simon, *Gender in Translation: Cultural Identity and the Politics of Transmission* (London: Routledge, 1996); Sarah Meer, *Uncle Tom Mania: Slavery, Minstrelsy, and Transatlantic Culture* (Athens: University of Georgia Press, 2005); Denise Kohn, Sarah Meer, and Emily B. Todd, eds., *Translatlantic Stowe: Harriet Beecher Stowe and European Culture* (Iowa City: University of Iowa Press, 2006).

7. MacLean, 22–23.

8. Anna-Christie Cronholm, "Die Nordamerikanische Sklavenfrage im deutschen Schrifttum des 19. Jahrhunderts" [The North American slavery question in nineteenth-

century German literature] (PhD diss., Freie Universität Berlin, 1958). Cronholm counts sixty novels and stories published in the 1850s and in the first half of the 1860s that address American slavery in the wake of Stowe's success. Only one of them, Friedrich A. Arming's *Weiß und Schwarz: Historische Erzählung aus der ersten Zeit des Sonderbundkrieges in Amerika* [White and Black: Historical narrative from the first years of the Civil War in America] (Leipzig: H. J. Haefele, 1865), actually defends slavery, while all others attack it.

 9. Hildegard Meyer, *Nord-Amerika im Urteil des Deutschen Schrifttums bis zur Mitte des 19. Jahrhunderts: Eine Untersuchung über Kürnbergers "Amerika-Müden"* [North America in the judgment of German literature up the mid-nineteenth century: An analysis of Kürnberger's *The Man Who Grew Weary of America*] (Hamburg: Friedrichsen, de Gruyter, 1929), 6.

 10. Sundquist, introduction to *New Essays on "Uncle Tom's Cabin,"* 20.

 11. Review of *Uncle Tom's Cabin, Die Gartenlaube* 3 [1853]: 32.

 12. Sander L. Gilman, *On Blackness without Blacks: Essays on the Image of the Black in Germany* (Boston: G. K. Hall, 1982).

 13. Friedrich Wilhelm Hackländer, *Europäisches Sklavenleben* [European slave life] (Stuttgart: Grabbe, 1854), 83–84.

 14. Hackländer, 65.

 15. Ibid., 66.

 16. Ibid., 32–33.

 17. Ibid., 76; cf. MacLean, 60.

 18. Hackländer, 31.

 19. Ibid., 370.

 20. Annette Kolodny, "A Map for Rereading; or, Gender and the Interpretation of Literary Texts," *New Literary History* 11.3 (1980): 451.

 21. Wolfram Siemann, *Gesellschaft im Aufbruch: Deutschland, 1849–1871* [Society in transformation: Germany, 1849–1871] (Frankfurt am Main: Suhrkamp, 1990), 66.

 22. Renate Möhrmann, *Die andere Frau: Emanzipationsansätze deutscher Schriftstellerinnen im Vorfeld der Achtundvierziger Revolution* [The other woman: Approaches to emancipation in German writing prior to the 1848 revolution] (Stuttgart: Metzler, 1977), 146.

 23. Winfried Fluck, "The Power and Failure of Representation in Harriet Beecher Stowe's *Uncle Tom's Cabin,*" *New Literary History* 23.2 (1992): 319–38.

 24. Ibid., 11–15.

 25. Ulfried Reichardt, *Alterität und Geschichte: Funktionen der Sklavereidarstellung im amerikanischen Roman* [Alterity and history: Functions of representations of slavery in the American novel] (Heidelberg: C. Winter, 2001), 105.

 26. The same race-class analogy was also at the core of an American-British controversy regarding the book, as Stowe has Augustine St. Clare compare the condition of American slaves favorably to that of British workers (chapter 19). Following harsh criticism of this comparison, Stowe retracted from such a parallel. See Joan D. Hedrick, *Harriet Beecher Stowe: A Life* (New York: Oxford University Press, 1994), 244. The same parallel has also been repeatedly refuted by African American authors such as Frederick Douglass and William Wells Brown. See Alasdair Pettinger, *Always Elsewhere: Travels of the Black Atlantic* (London: Cassell, 1998), 94. Nonetheless, it has played a crucial role in nineteenth-century working-class rhetoric. See Betty Fladeland, *Abolitionists and*

Working-Class Problems in the Age of Industrialization (Baton Rouge: Louisiana State University Press, 1984); David R. Roediger, *The Wages of Whiteness: Race and the Making of the American Working Class* (London: Verso, 1991).

27. Anonymous review quoted in "Uncle Tomitudes," *Critical Essays on Harriet Beecher Stowe*, ed. Elizabeth Ammons (Boston: G. K. Hall, 1980), 39.

28. Review of *Uncle Tom's Cabin*, *Das Ausland*, 21 May 1853, 486.

29. Jeffrey Sammons, *Ideology, Mimesis, Fantasy: Charles Sealsfield, Friedrich Gerstäcker, Karl May, and Other German Novelists of America* (Chapel Hill: University of North Carolina Press, 1998), x.

30. Cf. Moritz Fürstenwärther, *Der Deutsche in Nordamerika* [Germans in North America] (Stuttgart: Cotta, 1818); Ludwig Gall, *Meine Auswanderung nach den Vereinigten Staaten in Nord-Amerika, im Frühjahr 1819 und meine Rückkehr nach der Heimath im Winter 1820* [My emigration to the United States of America in the spring of 1819 and my return home in the winter of 1820] (Trier: F. U. Gall, 1822); Ernst Brauns, *Ideen über die Auswanderung nach Amerika: Nebst Beiträgen zu genauern Kenntniß seiner Bewohner und seines gegenwärtigen Zustandes* [Ideas about emigration to America: Additional contributions relating to a better knowledge of its inhabitants and its present state] (Göttingen: Vandenhoeck und Ruprecht, 1827); G. F. Streckfuss, *Der Auswanderer nach Amerika* [The emigrant to America] (Zeitz: Immanuel Webel, 1836).

31. Carl Scherzer and Moritz Wagner, *Reisen in Nordamerika in den Jahren 1852 und 1853* [Travels in North America in the years 1852 and 1853], 2nd ed. (Leipzig: Arnold, 1857), 357–58.

32. Werner Sollors, *Neither Black nor White yet Both: Thematic Explorations of Interracial Literature* (New York: Oxford University Press, 1997), 260.

33. Apparently, George Washington Cable (quoted below) is correct when he refers to her as Salome Miller; this, at least, was the name under which she arrived in the United States. See George Washington Cable, *Strange True Stories of Louisiana* (1888; reprint, Gretna, LA: Pelican, 1999), 145.

34. Carol Wilson and Calvin D. Wilson, "White Slavery: An American Paradox," *Slavery and Abolition* 19.1 (1998): 5.

35. Cable, 164–65.

36. Wilson and Wilson, "White Slavery"; Stephen Talty, "Spooked," *Transition* 85 (2000): 48–75.

37. Richard Hildreth, *The White Slave; or, Memoirs of a Fugitive* (Boston: Tappan and Whittemore, 1852), 337.

38. The Salome Müller case is referred to again and again in German-American writing. See Ludwig Baumbach, *Briefe aus den Vereinigten Staaten von Nordamerika in die Heimath mit besonderer Rücksicht auf deutsche Auswanderer* [Letters home from the United States of North America with special concern for the German emigrant] (Cassel: Fischer, 1851); Scherzer and Wagner, *Reisen in Nordamerika*; Theodor Griesinger, *Freiheit und Sclaverei unter dem Sternenbanner oder Land und Leute in Amerika* [Liberty and slavery under the Stars and Stripes; or, People and places in America] (Stuttgart: Kröner, 1862). For fictionalized accounts of similar incidents and anxieties, see, among others, Franz von Elling, *Des Lebens Wandlungen* [Life's changes] (Stuttgart: Carl Mäcken, 1854); Graf Adelbert von Baudissin, *Peter Tütt: Zustände in Amerika* [Peter Tütt: Conditions in America] (Altona: Mentzel, 1862); Ludwig Gothe, *Am Red River*

oder Sklavenleben in Nord-Amerika [At the Red River; or, Slave life in North America] (Berlin: Lindow, 1863); Gothe, *Die Maron-Neger, oder Sklavenempörung am Red River* [The Maron-Negroes; or, The slave rebellion at the Red River] (Berlin: Lindow, 1864).

39. Sollors, 255–62. Looking at black and white discursivity, one can see that not only German-American sources dwell on Salome's story. Incidents of white slavery as the "secret weapon of Abolitionists" (Talty, 51) are also strategically placed by freed African American authors. William Wells Brown (*Clotel; or, The President's Daughter: A Narrative of Slave Life in the United States,* ed. William Edward Farrison [1853; reprint, New York: Carol, 1969]) refers to Salome Müller (altering some details of the case) and, in his "Narrative," describes meeting a white male slave. William and Ellen Craft (*Running a Thousand Miles for Freedom* [Boston: Anti-Slavery Office, 1847], 61–62) also mention the Salome Müller occurrence. See Daneen Wardrop, "Ellen Craft and the Case of Salomé Müller in *Running a Thousand Miles for Freedom,*" *Women's Studies* 33.7 (2004): 961–84.

40. John Higham, *Strangers in the Land: Patterns of American Nativism, 1860–1925* (1955; reprint, New York: Atheneum, 1963); Matthew Jacobson, *Whiteness of a Different Color: European Immigrants and the Alchemy of Race* (Cambridge, MA: Harvard University Press, 1998); Seymour Martin Lipset and Earl Raab, *The Politics of Unreason: Right-Wing Extremism in America, 1790–1970* (New York: Harper and Row, 1970).

41. Jacobson, 6–8, 68–90. Next to the "different kinds of whiteness," there were, at least up to the mid-nineteenth century, also "different kinds of slavery." In *The Wages of Whiteness,* David Roediger has investigated the changing semantics of work relations in the context of white (immigrant) labor and African American slavery, noting that the term *slavery* signals African American chattel slavery as well as other kinds of exploitative labor conditions.

42. Hartmut Keil, "German Immigrants and African-Americans in Mid-nineteenth Century America," in *Enemy Images in American History,* ed. Ragnhild Fiebig-von Hase and Ursula Lehmkuhl (Providence: Berghahn, 1997), 137–58; Carl S. Wittke, *Refugees of Revolution: The German Forty-Eighters in America* (Philadelphia: University of Pennsylvania Press, 1952).

43. Sammons, 163–65.

44. Review of *Uncle Tom's Cabin, Das Ausland,* 30 June 1854, 622.

45. Review of *Uncle Tom's Cabin, Literaturblatt,* 5 January 1853, 5–7.

46. Review of *Uncle Tom's Cabin, Das Ausland,* 21 May 1853, 485–86.

47. Review of *Uncle Tom's Cabin, Magazin für die Literatur des Auslandes* 139 (18 November 1852): 554.

48. Review of *Uncle Tom's Cabin, Morgenblatt* 19 (8 May 1853): 189.

49. Simon, 60.

50. Fanny Lewald, one of the outstanding women writers of the Vormärz (pre-March era or Age of Metternich), indirectly chides sentimental reaction over Stowe's book by those people who simultaneously perpetuate "female bondage" in Germany: "That parents do not shriek when they have a daughter, who will be determined by her sex to eternal dependence and support, never fails to amaze me. They cry over Uncle Tom in his cabin and tell their daughter, who may be a medical genius or a great entrepreneurial talent: you knit socks, you learn household management, you will have schooling only enough for you to see what would be desirable and in reach for you, if only someone would let you develop your skills. But you are not allowed to develop them—you are a

woman. You don't have to complain about it, it is your job" (*Für und Wider die Frauen* [For and against women] [Berlin: Janke, 1875], 14). In *Die andere Frau*, Möhrmann convincingly demonstrates that for women writers of the Vormärz period, such as Luise Mühlbach, Fanny Lewald, and Louise Aston, the literary and sociopolitical *Frauenfrage* (women's question) was tied up with aspects of race.

51. Representative of these critical voices is Ernst Grafen zu Erbach-Erbach, who bemoans (in his *Reisebriefe aus Amerika* [Letters from America] [Heidelberg: C. Winter, 1873], 56–57), "Ich finde die Frauen-Emancipation etwas Entsetzliches" (I find this female emancipation to be something abominable).

52. Paul Grzybowski, *Amerikanische Skizzen: Land und Leute in Amerika* [American sketches: People and places in America] (Berlin: F. Schneider, 1896), 180.

53. Ibid., 176.

54. As Yoke-Sum Wong notes, "Using the postcard as a medium for advertising was not unusual" ("Beyond (and Below) Incommensurability: The Aesthetics of the Postcard," *Common Knowledge* 8.2 [2002]: 341).

55. Tom Phillips, *The Postcard Century: 2000 Cards and Their Messages* (London: Thames and Hudson, 2000), 12. For an anthropological account of the postcard in its heyday from 1890 to 1940, see Malgorzata Baranowska, "The Mass-Produced Postcard and the Photography of Emotion," *Visual Anthropology* 7 (1995): 171–89.

56. Phillips, 13.

57. Bill Brown, introduction to *Reading the West: An Anthology of Dime Novels* (Boston: Bedford / St. Martin's, 1997), 30.

58. Sarah Ahmed, *The Promise of Happiness* (Durham, NC: Duke University Press, 2010), 257.

59. Raymond Williams, *Marxism and Literature* (London: Oxford University Press, 1977), 129.

60. See Ann Cvetkovich, *Depression: A Public Feeling* (Durham, NC: Duke University Press, 2012), especially the chapter titled "From Dispossession to Radical Self-Possession: Racism and Depression" (115–53).

61. Ahmed, 29.

62. Wynfrid Kriegleder, *Vorwärts in die Vergangenheit: Das Bild der USA im deutschsprachigen Roman von 1776 bis 1855* [Forward into the past: The image of the USA in the German-language novel, 1776–1855] (Tübingen: Stauffenburg, 1999).

63. See Heike Paul, *Kulturkontakt und Racial Presences: Afro-Amerikaner und die deutsche Amerika-Literatur, 1815–1914* [Cultural contact and racial presences: African Americans and German literature about America, 1815–1914] (Heidelberg: C. Winter, 2005).

64. Postcard addressed to Mr. and Mrs. Günther Meyer in Neu-Isenburg bei Offenbach; from the author's personal collection.

65. Toni Morrison, *Playing in the Dark: Whiteness and the Literary Imagination* (Cambridge, MA: Harvard University Press), 38.

66. Harriet Beecher Stowe, *A Key to "Uncle Tom's Cabin"* (Boston: John P. Jewett, 1853).

67. For black and white critics' divergent comments on the novel, see James Baldwin, "Everybody's Protest Novel," in *Notes of a Native Son* (Boston: Beacon, 1955), 9–17; Thomas F. Gossett, *"Uncle Tom's Cabin" and American Culture* (Dallas: Southern Methodist University Press, 1985); Mason I. Lowance Jr., Ellen E. Westbrook, and R. C. De

Prospo, eds., *The Stowe Debate: Rhetorical Strategies in "Uncle Tom's Cabin"* (Amherst: University of Massachusetts Press, 1994); Richard Yarborough, "Strategies of Black Characterization in *Uncle Tom's Cabin* and the Early Afro-American Novel," in Sundquist, *New Essays on "Uncle Tom's Cabin,"* 45–85.

68. Sabine Bröck, "One More Trip to the Quarter: *Uncle Tom's Cabin* Revisited with Toni Morrison," unpublished manuscript, n.d.

69. Maria Diedrich, *Love across the Color Lines: Ottilie Assing and Frederick Douglass* (New York: Hill and Wang, 1999); Keil, 137–58.

70. Assing in Frederick Douglass, *Sclaverei und Freiheit* (Hamburg: Hoffmann und Campe, 1860), ix.

71. John Ernest, *Resistance and Reformation in Nineteenth-Century African-American Literature: Brown, Wilson, Jacobs, Delany, Douglass, and Harper* (Jackson: University Press of Mississippi, 1995), 140–79.

72. See Peter Brenner, *Reisen in die Neue Welt: Die Erfahrung Nordamerikas in deutschen Reise- und Auswanderungsberichten des 19. Jahrhunderts* [Journeys to the New World: The experience of North America in nineteenth-century German travel and emigrant literature] (Tübingen: Niemeyer, 1991), 366.

73. Josiah Henson, *Wirkliche Lebensgeschichte des Onkel Tom in Frau Beecher-Stowe's "Onkel Tom's Hütte,"* trans. Marie Schweikher (Bremen: Verlag des Tractathauses, 1878), 2.

74. On the controversial identification of Josiah Henson with Stowe's Tom, see Robin W. Winks, "Introduction: Josiah Henson and Uncle Tom," in *Four Fugitive Slave Narratives,* ed. Robin W. Winks et al. (Reading, MA: Addison-Wesley, 1969), v–xxx. For a more detailed analysis of the black discursivity in German translation in the nineteenth century, see Heike Paul, "The German Reception of Black Writing and Black Authorship in the 18th and 19th Century," in *Germany and the Black Diaspora: Points of Contact, 1250–1914,* ed. Honeck Mischa, Martin Klimke, and Anne Kuhlmann-Smirnov (New York: Berghahn, 2013), 115–33.

Part III

Recirculating Currents

César Braga-Pinto

From Abolitionism to Blackface: The Vicissitudes of *Uncle Tom* in Brazil

On 15 May 1969, two days after the eighty-first anniversary of the abolition of slavery in Brazil, an article in *Jornal do Brasil* reported that a group of black artists from São Paulo were protesting the casting of actor Sérgio Cardoso in three central roles for the telenovela (soap opera) *A cabana do Pai Tomás* (Uncle Tom's cabin). Cardoso was Brazil's most renowned stage and television star and was widely considered the country's most versatile actor. The three roles he had been selected for in the telenovela were those of Abraham Lincoln, a new character named Dimitrius, and Uncle Tom himself—in blackface.[1] The first section of the newspaper article was entitled "Incoerência" (Incoherence), an allusion to the protesters' conviction that Globo TV's casting decision contradicted the egalitarian message of Harriet Beecher Stowe's novel. The protesters denounced the choice of a white actor for the part of Uncle Tom as a lack of "professionalism" and "humanism," especially considering that in a country where at least half of the population was black or of mixed race, hardly any significant roles were available for black actors, most of whom, the protesters claimed, were unemployed.

The second part of the article, under the subheading, "Poeta Negro" (Black poet), reported on another incident that likewise involved allegations of racism and lack of opportunity for blacks in Brazilian society. Two days earlier, during the official 13 May celebrations of the anniversary of the abolition of slavery, a thirty-year-old black construction worker and dilettante poet cut his wrists in front of the Monumento à Mãe Preta (Monument to the Black Mother/Wet Nurse) in downtown São Paulo (fig. 15). The

Fig. 15. Monumento à Mãe Preta (Monument to the Black Mother / Wet Nurse, 1955), by Júlio Guerra, November 2015. (Photo by the author.)

man, Hilton Alves Murray, claimed that his gesture was a protest against racial discrimination in Brazil, which was preventing him from getting a job. According to his mother, as reported in the article, Alves had been unemployed for fifteen days, and his desperation had culminated two days earlier, on Mother's Day, when he realized he had no money to buy her a present. He instead decided to write and dedicate a poem to her, expressing his revolt against the social and material conditions of the black woman in Brazil.

Another mainstream newspaper, *O estado de S. Paulo*, tells a slightly different story in its coverage of the 13 May celebrations, citing several other figures who were present at the ceremonies: Minister of Justice Luis Antonio da Gama e Silva, who gave a speech in front of the Monumento à Mãe Preta; "several people of color" who manifested in favor of the reinstatement of 13 May as a national holiday; and Maria Madalena Penteado, known as the symbol of the Mãe Preta. Finally, the newspaper describes the actions of a white poet named João Rodrigues Santiago de Oliveira, who at-

tended the celebrations every year with a tribute to all black Brazilians. This year, he had decided to attach to the monument a poster containing a poem he had written, entitled "Estou aqui mãe" (Here I am, Mother), in which he expressed his nostalgia for "his" black mother and his guilt (and supposedly the guilt of all white Brazilians) regarding the national past.[2]

In this essay, I discuss how the public events of 13 May 1969 encapsulate a moment in which the legacies of slavery and the profound racial division that mark Brazilian society became quite explicit, even under the auspices of homage and conciliation. By tracing the dubious legacy of Harriet Beecher Stowe's classic narrative in Brazil, I suggest that those events also reveal how narratives of abolition lent themselves to a variety of interpretations and political purposes. To shed light on this complex history, I briefly trace the vicissitudes of *Uncle Tom's Cabin* in Brazil from its early publication in the nineteenth century to the symptomatic events of 1969, with their extraordinary cast of historical characters and symbolisms. By focusing on intersections between official histories, personal histories, literature, and popular culture, I hope to show how the trajectories that culminated in 1969 in São Paulo are connected not only to the history of *Uncle Tom's Cabin*, but also to other national and global narratives of racial emancipation and to other forms of systemic racism.

BLACKFACE (AND BLACK FACES) IN BRAZILIAN THEATER

Harriet Beecher Stowe's novel was extremely popular among Brazilian readers throughout the entire second half of the nineteenth century.[3] In addition to numerous translations, *Uncle Tom* fever reached Brazil's lettered elite in a variety of formats and fashions.[4] Theatrical adaptations brought *Uncle Tom* to larger audiences and ultimately led to the work playing a relatively important role in the abolitionist movement. During the 1850s, the theme of slavery was still considered somewhat improper for the stage and was often the object of censorship (at best, slaves were secondary characters), but by the mid-1860s, the topic of slavery began to occupy a more significant space both in the repertoire of theater writers and in public events aimed at promoting the abolitionist movement.[5]

Published in 1864 by Portuguese playwright Aristides de Sousa Abranches, *A mãe dos escravos* (The mother of the slaves) was explicitly inspired by *Uncle Tom's Cabin*. It was staged for the first time in Portugal in 1863—apparently with little success[6]—and became increasingly

popular around and after 1888, with performances in several Brazilian provinces/states, including Pará, Ceará, Maranhão, Espírito Santos, Santa Catarina, and Minas Gerais. But *Uncle Tom* became an emblem of slave emancipation in Brazil by way of the French drama *La case de l'oncle Tom* (1853), co-authored by Adolphe Dennery (who subsequently changed his name to d'Ennery) and Guadeloupe-born playwright Phillipe François Pinel Dumanoir.[7] Although the only known printed Portuguese translation of that French play dates from 1881, the play was presented for the first time at the Teatro São Pedro de Alcântra in Rio de Janeiro in 1876 and later toured around Brazil as well as Portugal.[8] There are reports of rehearsals in São Paulo by Guilherme da Silveira as early as 1877, when the opening was canceled due to censorship by the local police.[9] On 13 May 1888, the very date of the abolition of slavery, the play was staged at an abolitionist festival in Rio, in the presence of the renowned abolitionist *Conselheiro* Sousa Dantas, the writer-statesman Joaquim Nabuco, and the (mixed-race) "hero of abolition" José do Patrocínio.[10]

It is difficult to determine in any detail how the French *Uncle Tom* might have been adapted to Brazilian stages in terms of plot, figuration, scenery, characterization, and, particularly, casting. At least throughout most of the nineteenth century, the play was staged as a melodrama, with various political and pedagogical intentions. However, after May 1888, its association with the abolitionist movement started to fade, as slavery soon began to be perceived as a spatially and temporally distant problem. In fact, even before abolition, some advertisements cautiously emphasized that the play's action took place elsewhere (the United States) and in bygone days (1850). Thus, although the performance of 13 May 1896 at the renowned Teatro São Pedro was preceded by a speech from José do Patrocínio, a critic three years later—when the work was again being staged as part of the celebrations of the anniversary of the abolition, both at the Lucinda Theater and at an evening gala ceremony at the Variedades Theater—noted that the impact of the drama was no longer the same "now that slavery seemed far away."[11] Likewise, in 1917, a newspaper advertisement praised a production at the Carlos Gomes Theater for its good acting, with emphasis on some of the play's comic aspects, but ultimately called it a bit "démodé."[12] Thus, whereas Dennery and Dumanoir's *La case de l'oncle Tom* (as well as *A mãe dos escravos*) continued to be regularly staged around Brazil and through the early 1930s as part of the commemorations of 13 May, its focus and appeal might have undergone

substantial transformations.[13] Furthermore, newspapers of the time rarely mention whether dramatic conventions, prior to or after abolition, mandated the use of blackface or brownface in the representation of black and mixed-race characters and whether black actors played even the smallest parts in plays such as *Uncle Tom's Cabin*.

A straightforward history of black actors and black impersonation in Brazilian stages is still lacking. According to the few theater historians who have discussed the issue, it seems that at least until the first decade of the nineteenth century, when professional actors began to be brought to Brazil from Portugal and Italy, acting had long remained the improvised business of a few disreputable women and a majority of black men and poor mulattos (who often played white and female characters). They performed for the entertainment of mostly white audiences, apparently with their hands and faces painted in white or red.[14] European travelers of the time reported that face painting was fairly common in popular culture, and the famous 1823 painting *Scène de carnaval* by French artist Jean Baptiste Debret (1768–1848) suggests that blacks used powder to paint their faces white and red during street carnivals.[15]

Until the late 1820s, when "respectable" theater was in the hands of French, Portuguese, and Italian companies, it was still common to see black men and mulattos playing some of the secondary roles (of white characters), even at the opera.[16] Ironically, with the development of national theater in the late 1830s—that is, with the emergence of local writers who included national themes in their plays for the first time and with the appearance of the first Brazilian professional actors—(identifiable) nonwhites seem to have slowly disappeared from the Brazilian stage, at least in the central roles. Throughout the second half of the nineteenth century, actors in the nation's capital were drawn from the middle and lower middle strata, including Portuguese immigrants and other groups who were conceivably of mixed race. Thus, black characters in mainstream theater were most likely played by "white" actors, although it is not entirely clear whether they painted their faces and bodies. American minstrel shows were not unknown to Brazilian audiences, at least in Rio de Janeiro: on 23 August 1869, the emperor himself attended a performance of Christy's Minstrels (which deployed blackface) at the Teatro Lyrico Fluminense in Rio,[17] and the amateur minstrel performance "White Lilies" was shown at the Teatro Gymnasio on 15 October 1881.[18] At the same time, according to historian Celso Castilho, even among abolitionists in the northeastern city of Recife,

black impersonation appeared to be a legitimate political strategy that con-
veyed the need to civilize the nation and, ultimately, to leave slavery (and
the African heritage) behind: in 1881, "a carnival association, the Club Beija
Flor,[19] or the Hummingbird Club, constructed its own Africanisms as it set
out to make visible its antislavery efforts. The group presented scenes from
Uncle Tom's Cabin, and, according to the newspaper report, the Beija Flor
'pretended to be slaves, speaking and singing in the special language of the
Africans.'"[20]

Although it is likely (though not certain) that most black characters in
nineteenth-century Brazilian theatrical productions were played by white
actors in blackface, there is hardly any mention in newspapers as to whether
the light-skinned performers wore brownface to impersonate mulatto char-
acters, such as Elisa and Harris (Georges's master) in *Uncle Tom*, or whether
there might have been a handful of mixed-race actors playing white char-
acters, with or without face paint. Indeed, although dark-skinned profes-
sional actors in the second half of the nineteenth century were indeed rare
(if existing at all), newspapers of the period are consistently silent about
mixed-race actors, as it was often considered bad form to mention the skin
color of nonwhite public and respectable figures.[21] In addition, since the
protagonist in the *Uncle Tom* that landed in Brazil from France was the
white Senator Bird, the actors who played the black characters (e.g., Jorge,
Tomás, Clorinda, Fileno, Beija Flor, and "the slaves") are usually unnamed
or difficult to identify, as they are referred to by their first names only.

The popularity of *Othello* in the nineteenth century may have had a sig-
nificant impact on how blackness was staged in Brazilian theater. There are
a number of reports of actor João Caetano (1808–63) performing with "tez
bronzeada" (a tanned face).[22] Caetano was credited with creating the first
professional theater company in Brazil in 1838 and played Othello twenty-
six times between 1837 and 1860 in Jean François Ducis's 1790s adaptation.[23]
By some reports, Caetano sought inspiration in the performance of Afri-
can American actor Ira Aldridge, the first black actor to play Othello, in
1833—though the Othello in Ducis's play seems to have been conceived as
white.[24] In one of the scenes of the play *Os ciúmes de um pedestre* (A jealous
officer), a parody of *Othello* written by Martins Pena in 1845 and staged a
year later, the protagonist paints his own face black and speaks in "black
dialect" as he attempts to disguise himself as a runaway slave.[25] In the first
and most famous Brazilian staging of Shakespeare's *Othello* in 1871, the Ital-
ian actor and producer Ernesto Rossi does not seem to have darkened his

face.[26] Thus, it seems that, like the deployment of racial categories in Brazil, the use of blackface in tropical Brazil was inconsistent and perhaps even impractical, as suggested by a contemporary reviewer who mocked the fluctuating characterization within a single performance by Andrea Maggi, the Italian actor who played Othello in 1891 in Rio: "He first appeared as a 'caboclo' [a person of indigenous/mixed race descent], then white, as if he had been blackened in the coal trade, and, finally, pitch black!"[27] A 1904 review in a newspaper from the northeastern state of Espírito Santo criticized the actors' implausible characterization of blacks in a running performance of *Uncle Tom*. According to the reviewer, even though it was possible to find light-skinned slaves in the nineteenth century, the truth was that "individuals with straight hair, white skin, oval face, aquiline nose etc etc could hardly be descendants of Africans." The critic suggests, "It wouldn't have been bad if they had used a bit of paint on those white slaves who last Sunday were extras on the stage of the Melpomene theater, in order to give them at least a certain air of mulatto-ness [uns longes de mulatice]."[28]

In sum, conventions regarding face painting on Brazilian stages in the second half of the nineteenth century were far from rigid, and although blackface was often practiced there, it does not seem to have been mandatory, especially in drama and high theater. However, the boundaries between serious or light theater, on the one hand, and popular theater, on the other, were not always clearly defined. The catalog of publications printed on the first pages of the 1881 Brazilian translation of the French *Uncle Tom*, for example, lists eight comedies authored by the Afro-Brazilian actor and writer Francisco Correia Vasques (1839–92).[29] Vasques became known as a comic and popular actor whose repertoire competed with the French operettas, light theater, and vaudevilles that were presented at the famous concert café Alcazar in Rio de Janeiro. In 1868, Vasques started his own company, the Companhia Fênix Dramática, which presented operettas and *cançonetas* (chansonettes). That same year, at the Alcazar, he staged his *Orfeu na roça*, a parody of Offenbach's *Orphée aux enfers* (Orpheus in the underworld) and one of nineteenth-century Brazilian theater's greatest successes at the box office.[30] Since then, light and musical theater began to occupy a prominent place on Brazilian stages, with shows that included magic, operettas, vaudevilles, *burletas* (short farces that alternated with songs on national themes), and *revistas do ano* (a genre of Portuguese and French origins that combined music, theater, dance, and allegorical political commentary, in which a "compère" or "commère" often mocked the principal events of

the year).[31] At the Teatro Santana in 1886, Vasques, known as a comic actor, played the title role in *O caboclo*, a drama by Aluízio de Azevedo and French-born Emílio Rouède. In that play, the main character is obsessed with playing the part of Othello, which he rehearses at one point, thus reciting some of the lines of Shakespeare's play.[32] In addition, in 1860, Vasques himself had played the jealous Calisto in Joaquim Manuel de Macedo's farce *O novo Otelo*,[33] in which the main character says a number of lines from Gonçalves Magalhães's translation of Ducis's version of the Shakespearean play. Vasques's diction seems to have mocked both João Caetano and Ernesto Rossi, two of the most renowned Othello performers.[34]

In short, black impersonation, whether it was intended for mimetic or comic effect, must have varied greatly until the turn of the century. Whereas it is safe to affirm that distinctively black actors were absent from dramatic performances, that black protagonists were most often played by whites in blackface, and that mixed-race actors were generally confined to minor and comic roles, there is evidence of black impersonation without face painting, as well as of mixed-race performers who played dramatic roles. Comical or stereotyped impersonation of slaves and other Afro-Brazilians by white performers (likely in some form of blackface) and aimed at mostly white audiences was also frequent in nineteenth-century musical performances.

The history of the reception and transformations of "Uncle Tom" in Brazil demonstrates the extent to which the racial and social divide—expressed by black performers and activists in the 1960s as an "incoherence" or contradiction between the allegedly sympathetic (but, in reality, mostly stereotypical) representation of Afro-Brazilian life, on the one hand, and the exclusion of Afro-Brazilian actors, on the other—had become naturalized around the turn of the twentieth century. At least through the 1930s, Dennery and Dumanoir's *Uncle Tom* continued to be staged mostly as a dramatic, "serious" play, in theaters and at gala events, by some of the most renowned companies of the time. But as it distanced itself from historical abolition, the play also incorporated elements of light or popular theater. In 1911, for example, a performance at the Teatro São Pedro was preceded by a speech from the nation's president, Hermes da Fonseca. At the same time, since mainstream theaters had different prices and, therefore, a relatively diverse audience, it is likely that the French play underwent significant transformations, in both plot and characterization, in order to secure its appeal.[35] A great deal of improvisation must have occurred, considering that theater companies most often performed a play for no more than two

or three sessions, with scarcely any time to rehearse. For example, when *Pai Thomaz* was presented on 12 May 1917 (directed by João Barbosa, with the part of Elisa's six-year-old son, Harry/Henrique, played by the young and probably white actress Esperança), the play was advertised as a "cape and sword" drama, thus highlighting the final duel between Harris and George.[36] In addition, the Brazilianized *Uncle Tom* seems to have incorporated elements of musical theater and the *revistas*, which had become the most popular theatrical form among the elite in the nation's capital.[37] Several newspaper advertisements of the time indicate, for example, that the play ended with an "apotheosis," a typical element of *revista* theater, a kind of grand finale tableau that closed each of the two acts and was meant to celebrate an event or a public figure.

The passages in the French play that had comical intentions, particularly those involving the duo Beija Flor and Fileno, seem to have gained increasing prominence in local performances and even may have been detached from the play. The figure of the twenty-five-year-old slave Beija Flor (in French, Bengali) was intended to form not only a comic but also a truly clownish pair with Fileno. Like Topsy in Stowe's novel, Beija Flor's speech is inarticulate and naïve. But in contrast to Stowe's character, the Franco-Brazilian Topsy is purely comical: he is not seen as potentially teachable, and Senator Bird unfavorably compares him with a monkey.[38] That the character's prominence seems to have increased toward the end of the century is suggested in an advertisement published on 13 May 1892, which announces that the main attraction of the performance at Rio de Janeiro's Teatro Phenix Dramática will be the presence of the "celebrated" actor Leonardo, appearing, for the first time, in the role (until then minor) of Beija Flor.[39] In 1908, advertisements for the performance of *Uncle Tom* in the southern state of Paraná highlighted the tango "Beija Flor," which was to be performed by Narciso Costa (as Beija Flor) and Maximo Silva (Fileno).[40] When the Companhia Dramática Brasileira achieved enormous success with the production of *Uncle Tom's Cabin* at the Carlos Gomes Theater during the 1917 anniversary of the abolition of slavery, the part of Beija Flor was played by Procópio Ferreira (1898–1979), who was to become one of the most renowned Brazilian actors of the twentieth century.[41] At the occasion, Ferreira (who, needless to say, was white) was acclaimed for his "great comic vein."[42]

This intricate web of impersonations and exchanges between popular and "serious" theater was not one-sided and underwent further complica-

tions with the rapid popularization of foreign circus companies in Brazil after the 1860s, which not only contributed to the decline of audiences at more legitimate theaters but also forced those theaters to incorporate elements from the circus tradition.[43] Both Brazilian and foreign circuses that performed in Brazil increasingly incorporated narrative sketches in pantomimes with elements reminiscent of commedia dell'arte, including characters (e.g., clowns, or the figures of Pierrot and Harlequin) in whiteface and blackface or wearing masks.[44] The popular Circo Casali, for example, included among its many attractions (acrobatics, equestrianism, gymnastics, burlesques) the pantomime "O Sapateiro de Madrid" (The showmaker from Madrid),[45] in which one of the black characters, identified as "um carapina, negro" (a black carpenter), was played by the well-known clown Antonico (Antonio de Sousa Correa). The same clown is also known to have performed in blackface at the occasion of the Casali Circus in São Paulo in 1876, when he sang the "Lundu do Escravo" (Slave lundu).[46]

Perhaps the most curious and noteworthy case of race impersonation is that of actor and clown Benjamin de Oliveira (1872–1954), based in Rio de Janeiro. Oliveira, a son of slaves, ran off with a circus company to become a clown, mime, actor, theater writer, singer, and musician. He is known to have played white characters in whiteface, as well as the part of the indigenous Peri, in "redface," in the play *D. Antônio e os Guaranis* (D. Antônio and the Guarani Indians), performed at the Circo Spinelli in 1902, 1903, 1905, and 1908 and inspired by José de Alencar's classic romantic novel *O Guarani*. On 13 May 1909, as the Cinema Palace in Rio played continuous screenings of the Brazilian film adaptation of *Uncle Tom's Cabin* from 1:00 p.m. to midnight, the Circo Spinelli presented *A escrava mártir* (Slave and martyr), Benjamin de Oliveira's own adaptation of the 1875 romantic novel *A escrava Isaura* (The slave Isaura), which was widely considered the Brazilian equivalent to *Uncle Tom's Cabin*. The musical play, staged first as part of the commemoration of the abolition, was repeated later as a tribute to Benjamin's wife, Victoria, who apparently played the central role of Martha, Mr. Ramires's slave.[47] As there is no record of the script, one can only wonder whether the black actress played a light-skinned slave, in whiteface, or whether the play stressed the blackness of the protagonist. In any case, the final tableau (or apotheosis) presented a series of allegorical tributes: to Isabel "the redeemer," to the abolitionist José do Patrocínio, and to personified Liberty and History. During the celebrations of 13 May 1916, while *Uncle Tom* was being presented at the mainstream and reputable Teatro São

José in Rio de Janeiro, the Circo Spinelli advertised the performance of its own version of the French *Uncle Tom* (directed by Francisco Mesquita).[48] Benjamin de Oliveira was part of the cast, probably as Tom or perhaps as Beija Flor.[49] His *Pai Thomaz* continued to be performed in circuses until at least 1935.[50] Through the years, Oliveira and his wife, likely the first dark-skinned actors in twentieth-century Brazil, enjoyed an enormous prestige, and newspapers repeatedly referred to them with utmost respect and admiration.

Not only did black actors and actresses continue to be consistently excluded from Brazilian stages, however, but the theatrical representation of dark-skinned blacks also became increasingly derogatory, frequently employing versions of the Topsy, or Beija Flor, type—ignorant, inarticulate, naïve, and comical. Not until 1924 did the use of U.S. minstrel-style blackface become explicit, as in the scene entitled "Jazz Band" in the *revista Secos e molhados* (Assorted groceries) by Luís Peixoto (the producer of *Forrobodó*), in which white rings were painted around the performer's eyes.[51] In the 1920s, the musical revue began to attain the status of show business, expanding its transnational and cosmopolitan connections. As Lisa Shaw has suggested, "U.S. musical genres such as the fox-trot, ragtime, shimmy, the Charleston and jazz, as well as tap dancing, became commonplace in the revues of the 1920s," such that that they were often considered part of national culture.[52] One of the effects of this transnational exchange was the emergence of the first black actresses in Brazilian revue theater.

> The traditional Companhia do Teatro São José, for example, underwent a process of modernization in the mid-1920s, with the introduction of scantily clad chorus girls, luxurious sets and costumes, and more sophisticated humor. . . . The re-vamped company's first production, *Pirão de areia* of 1926, featured the Afro-Brazilian woman Rosa Negra "e as 'black-girls'" and "toilettes de um luxo asiático como nunca se viu nem na Velasco, nem na Bataclan." In this revue the *compère* proudly comments: "As artistas já não se pintam de preto—são pretas autênticas" [The artists no longer paint themselves black—they are authentic blacks].[53]

Yet the emergence of the first black actresses in musical theater did not eliminate prejudice and stigmatization. With the intent of ridiculing black women in show business, a popular entertainment magazine of the time published a fake interview with Anscendina Santos—famous for her par-

ticipation in Gastão Tojeiros's Companhia carioca de burletas (Rio de Ja-
neiro's *burleta* company)—that is reminiscent of Topsy's dialogue, both in
the characterization of "black dialect" and the representation of the black
woman's naïveté and ignorance regarding her own origins. The "interview,"
which was supposed to have taken place in the actress's "bungalow," starts
with the "journalist" asking how Ascendina Santos had become, or how
"she was made," an artist, to which she responds, in "black" dialect: "Ué,
gente, que bobage. Eu não me fiz, não sinhô, me fizéro. Aonde é que o sinhô
já viu arguem fazê? Quem é bom já nasce feito."[54] (Hey folks, how silly. I
did not make myself; someone made me. Have you, sir, seen anyone make
oneself? The good ones are born already made.)

It is possible that lesser companies or planners of private events orga-
nized performances of *Uncle Tom* using black actors. On 13 May 1936, the
play was performed at the Teatro Casino Antarctica in São Paulo, sponsored
by Instituições da Raça Negra.[55] On the same date five years later, the Circo
Piolin, also in São Paulo, staged *Uncle Tom* in honor of the Sociedade dos
homens de cor (Society of Men of Color).[56] However, black actors in main-
stream theater were rare, and not until the late 1940s did a group of black
actors undertake the project of creating a major theater company with black
actors performing dramatic works, Teatro experimental do negro (Black
Experimental Theater, hereinafter TEN). Under the leadership of Abdias do
Nascimento, TEN then undertook the project of staging its own *Emperor
Jones*, because the play "summarized the experience of a black person in
the white world."[57] Nascimento's *Imperador Jones* opened on 8 May 1945.
Among the actors who started their careers with TEN was Ruth de Souza,
who would also play roles in O'Neill's 1945 *Todos os filhos de Deus têm asas*
(All God's chillun got wings), his 1946 *O moleque sonhador* (The dreamy
kid), and Lúcio Cardoso's 1947 *O filho pródigo* (The prodigal son). Ruth de
Souza became arguably the most important black actress in Brazil during
the twentieth century. In 1969, she played Chloé, the female protagonist of
the telenovela *Uncle Tom's Cabin*, next to Sérgio Cardoso, who performed
in blackface.

AMERICAN MOVIES, TOPSY, AND THE MAD WOMAN
IN THE BRAZILIAN CARNIVAL

Throughout the first half of the twentieth century, *Uncle Tom's Cabin* was
rarely associated with its author, Harriet Beecher Stowe. The work's associa-

tion with the French play and the abolitionist movement, common until the 1920s, likewise began to fade, eclipsed by a plethora of cinematic adaptations. When a new edition of the book *A cabana do Pai Tomás* was released in 1942, a São Paulo newspaper explained that this was the novel that had become known among Brazilians thanks to the 1927 film.[58] Cinema had introduced the novel's cast of characters to larger audiences and under an entirely new light. Ultimately, *Uncle Tom* became a symbol of the wealth and prestige of the American film industry, at the same time that it introduced new stereotypes for the representation of blacks in Brazil.

Prior to the arrival of large U.S. cinematic productions, however, *A cabana do Pai Tomás* (1909) was one of the first fictional feature films ever produced in Brazil,[59] released at the height of the national cinema's so-called belle époque (1907–11). The film was screened at the Cinema Palace in Rio in 1911, as part of the 13 May celebrations.[60] It was billed as an adaptation of Stowe's novel, but since no copies of the film are extant and since little information can be found in the newspapers, it is impossible to know the extent to which it was faithful to the original. Newspaper advertisements of the time indicate that *A cabana do Pai Tomás* ended with "a brilliant and fantastic apotheosis [or tableau] of the heroes of the Liberation of Slaves in Brazil: Visconde de Rio Branco and José do Patrocínio." The cast is unknown, making it impossible to determine whether there were any black actors or whether face painting was deployed. In any case, even though black actors could only play minor and mostly comical roles, the use of blackface in the history of Brazilian cinema seems to have been rare, with a few exceptions: a scene in *Aitaré da praia* (1925)[61] and another in *Pureza* (1940),[62] by the Portuguese director Chianca de Garcia, where the Cuban-born actress Conchita de Moraes plays the mammy role of Felismina in darkened face. Still, until the end of the 1940s, few (if any) black actors played significant roles in Brazilian cinema beyond musical numbers.

After World War I, with the decline of the Brazilian and European film industries, American productions dominated the local market. Brazilian audiences became accustomed to seeing all types of blackface in the movies, including those belonging to the minstrel show tradition, such as *The Birth of a Nation* (1915, directed by D. W. Griffith) and *The Jazz Singer* (1927, directed by Alan Crosland, screened in Brazil as *A última canção* [The last song], opening in December 1929), a number of which derived from adaptations of Stowe's novel. As early as 1910, for example, several newspapers in São Paulo announced "a great novelty": the screening of Vitagraph's *A*

cabana do Pae Thomaz, ou a emancipação dos Negros da América do Norte (Uncle Tom's cabin; or, The emancipation of the Negroes of North America), a thousand-meter film that opened in November at the Cinema Ideal in Rio, to be shown in three parts.[63] In 1920, newspapers announced the screening of the 1918 version of *Uncle Tom's Cabin* (directed by J. Searle Dawley, produced by Adolph Zukor), featuring the "endiabrada" (devilish) Margaret Clark, the thirty-five-year-old actress who played both Little Eva St. Clair and Topsy.

No other adaptation received as much publicity, both worldwide and in Brazil, as the 1927 production of *Uncle Tom's Cabin* directed by Harry Pollard and celebrated as third among the most expensive pictures of the silent era (at a cost of $1.8 million). A year earlier, Brazilian newspapers had already announced the Universal Studios production as the narrative of "heroic moments of the American people, when the captivity of blacks still afflicted the children of the great republic."[64] When the film finally opened in several Brazilian cities in 1928, it was referred to as "the new wonder of the century," and during the first weeks of its run at the luxurious Pathé Palace, it broke the record at the box office, with over a hundred screenings.[65] According to one critic, the viewer could not help but "laugh with the interesting Topsy, love the little Eva, feel pity for Uncle Tom, and hate Simon Legree."[66] More often, though, reviewers were enchanted with Mona Ray, who played the "interesting" Topsy. The success of Universal's *Uncle Tom* soon brought *Topsy and Eva* (1927, directed by Del Lord and D. W. Griffith and featuring the Duncan sisters), which opened in Brazilian theaters in March 1928. The magazine *Careta* (Grimace) reported that the film was an example of those "most interesting traits of the contact between the races in America" and that "the little black child is generally a living doll who touches our hearts with joy, vivacity, and a curious mind."[67]

As part of the same wave, *A alma de uma nação* (*We Americans*, 1928, directed by Edward Sloman) opened in theaters nationwide in November of that same year. The film was advertised as a complement or rival to *Uncle Tom's Cabin*, even though no blacks are shown in the images in *Scena muda* (The silent scene).[68] In 1933, the popular youth magazine *Tico Tico* published Walt Disney's comic "A história do ratinho curioso" (The story of the curious mouse, a printed rendition of the 1933 film *Mickey's Mellerdrama*), in which Mickey Mouse and his friends stage a performance of *Uncle Tom's Cabin*, with Mickey playing the title character as well as that of Topsy, both in blackface.[69] In 1937, William A. Seiter's *Dimples* (1936) opened in Rio as

Princesinha das ruas (The little street princess), containing a famous scene in which *Uncle Tom's Cabin* is staged with one of the most grotesque of all Topsys, played by twelve-year-old Betty Jean Hainey, obviously in blackface, next to the crowd-pleasing Shirley Temple in the role of Eva. A year later, *Diabinho de saias* (Everybody sing) opened at the Metro Theater in Rio. It similarly contained a highly advertised musical number in which the ever-so-adored Judy Garland played Topsy, also in the blackface tradition of the minstrel show, white circles around the mouth and all. The film, which a newspaper called "the happiest film of the year," played continuously in Rio from August to December of 1937.

At a time in which mixed-race types such as the sensuous *mulatta* and the *malandro* (rogue) were becoming iconic figures in Brazilian culture, one of the most remarkable effects of American cinema, particularly its various adaptations of *Uncle Tom*, was its contribution to the consolidation of the Topsy-like figure of the black woman or girl as ugly, funny, linguistically inarticulate, and borderline insane. This normalized form of abjection was ostensibly expressed in the growing practice of impersonating images of dehumanized black women, not only on the stages but also, particularly, during Carnival celebrations. On 16 February 1933, the recently created Sociedade pró-arte moderna (Society for Modern Art), known as SPAM, organized a gala Carnival ball, which was held in a hotel at the Anhangabaú in São Paulo and designed by Lasar Segall, with the collaboration of some of the most celebrated names of the modernist movement in Brazil, including Anita Malfati and Paulo Mendes de Almeida, along with music by Camargo Guarnieri and choreography by Chinita Uhlman. Among the traditional Carnival costumes, there were the English explorer, the protestant pastor, and, obviously, "the" black woman.

> Miss Paul Dana, *née* Mag Nogueira, [who] was graciously dressed as Topsy, the "negrinha" [little black girl] from Uncle Tom's Cabin, wearing a checkered chita [cheap cotton] dress, her hair braided, and with a pronounced, firm and dark color. A little lighter, but in the same style, Miss Clóvis Martins de Camargo was also very well in character.[70]

By the end of the 1930s, Topsy had become an established part of the Brazilian cast of racial stereotypes, alongside *malandros, baianas* (literally, women from the state of Bahia, an archetype based on black street vendors), *mulattas*, Pai Joãos, and Uncle Toms. This image of the "devilish"

black girl (a female version of harlequin-like characters such as the boy Pedro in Alencar's 1857 *O demônio familiar* [The family devil] and Bengali [or Beija Flor, in the Portuguese translation] in the French *La case de l'oncle Tom*) took on new life in 1950, when it became the inspiration for what would become one of the most popular costumes in the Brazilian Carnival. According to the (white) popular music composer Fernando Lobo, his friend Evaldo Ruy, a (mixed-race) samba composer, recounted to Lobo an anecdote in which Ruy had observed a black woman (*crioula*) who was carrying a baby approach a man playing pool. Though the man kept denying it, the woman claimed that the baby was his. Ruy then spontaneously thought of the first lines for a samba:

> I was playing pool
> when a crazy black woman
> popped up
> She came with a child in her arms
> telling everybody
> the kid was my son
> take him, cause he's your son
> keep what God gave you . . .[71]

"Nega maluca" (Crazy black woman) was recorded by Linda Batista and became one of the top hits that year. According to Lobo, when one of the owners of the costume store Exposição Avenida suggested that a Carnival costume should go with the samba, he immediately thought of Topsy from *Uncle Tom's Cabin* and went on to draw a sketch: "a bunch of red dresses with white polka dots, kinky hair and braids with red ribbon, the face painted black, black stockings, short heels."[72] The costume became the rage of upper-class Carnival balls that year, joining sailors, Arizona cowboys, American Indians, and Zulu kings.[73] That same year, it became the theme of a musical comedy at the Recreio Theater, with a cast of stars such as Nelson Gonçalves, Lourdinha Bittencourt, and Dercy Gonçalves, the latter in the role of Nega Maluca, who, accompanied by twenty-three dancers and nine "boys" and wearing blackface, parodied Josephine Baker's "dance sauvage" and her interpretation (in Portuguese) of "Boneca de pixe" (Tar baby) at the Cassino da Urca in Rio a decade earlier, where, apparently, Baker incorporated elements of Afro-Brazilian rituals.[74] In 1959, the Afro-

Brazilian diva Angela Maria wore a Nega Maluca costume at the Baile do rádio, a famous Carnival ball in Rio, and in 1964, the white and upper-class Maysa Matarazzo was caught on camera wearing a similar costume for a ball at the Teatro Municipal. The Nega Maluca also made occasional appearances on Brazilian screens: a scene in *Esse mundo é meu* (This world is mine, 1963, directed by Sérgio Ricardo)—a feature film with leftist/populist intentions—shows a drunk and toothless black woman with a naked white doll in her hands, singing the samba "Nega Maluca." Even today, the Nega Maluca costume continues to be worn during Carnival by both blacks and whites, men and women, rich and poor.[75] The stereotype was also reproduced on television, as in *Zorra total*, a comedy show aired on the Globo TV network since 1999, where the black and toothless Adelaide is played by a white actor (Jorge da Silva) in blackface.[76]

It is likely that the Topsy-inspired character invented by Lobo for the Carnival industry contradicted the racial and sexual violence implied in Ruy's original inspiration for the song "Nega Maluca." We do not have Ruy's version of the story, and little is known about his dealings with racial stereotypes. But Lobo, who provided the account of the origin of the song, also told of a time when the two friends went out with a Cuban or Argentine woman who claimed to hate blacks. According to Lobo, the woman invited the mixed-race Ruy to a dance, to which he allegedly replied, "We can dance, but when they turn on the lights, my lady will be very disappointed."[77] Four years after the release of the "Nega Maluca," Evaldo Ruy committed suicide. Although it is impossible to gauge the part that the experience of racism played in his death, one cannot help but associate it with Hilton Murray's gesture fifteen years later and compare Lobo's appropriation of Ruy's song with Cardoso's performance of blackness in *Uncle Tom's Cabin*.

13 MAY 1969

Announced as the most expensive Brazilian telenovela ever aired on Brazilian television, the production of *Pai Tomás* encountered a number of obstacles, including an actors' strike over unpaid salaries[78] and a fire in the São Paulo studio on 15 July, which destroyed both props and previously recorded episodes only a week after the telenovela went on the air. Ultimately, the show was a flop. Nevertheless, the controversial casting of Sérgio Cardoso as the eponymous character of *Pai Tomás* represented an emblematic

moment in Brazil's contested racial politics. It evidences the deepening of the fracture between aesthetic and political representation that, I argue, was already present in Stowe's original plot.

There is no clear evidence that blackface had previously been used in early Brazilian TV.[79] It was not entirely uncommon for a few telenovelas—a genre that became established in the aftermath of the military coup of 1964—to include actors and actresses of African descent, although they often appeared only in minor, subaltern roles or in remote historical contexts such as Cuba or Haiti. Two exceptions are worth mentioning: *A cor de tua pele* (The color of your skin, Tupi TV, 1965),[80] often credited as the first soap opera to feature a black (or mixed-race/mulatta) protagonist, told the story of a love affair between a Portuguese teacher (Leonardo Villar) and a black cook (Yolanda Braga); and *Vidas em conflito* (Lives in conflict, Excelsior TV, 1968–69)[81] portrayed a love affair between a black man (Zózimo Bulbul) and a white woman (the sex symbol Leila Diniz), with a cast of several black actors and actresses playing members of a middle-class family for the first time in Brazilian television. That the plot of *Vidas em conflito* initially centered on the Afro-Brazilian family was highlighted in newspaper advertisements during the first weeks of airing, but the family was phased out, allegedly in response to negative reactions from the public.[82]

When the Globo TV channel started to broadcast *A cabana do Pai Tomás* on 7 July 1969 (it aired through 1 March 1970, in 205 episodes), the most recent film adaptation of *Uncle Tom's Cabin*—the 1965 French-German-Italian-Yugoslavian coproduction *Onkel Toms Hütte* (Uncle Tom's cabin, directed by Géza von Radvanyi)—was still running in some Brazilian theaters.[83] Moreover, it had not been long since the prolific and versatile Laurence Olivier had played the eponymous role in the 1965 film version of Shakespeare's *Othello* by the National Theater in London. Sérgio Cardoso was celebrated precisely as sort of a Brazilian Olivier, and when the newspapers announced the telenovela's premiere, the Brazilian actor's versatility was highlighted: "Hamlet, Cara Suja, Dr. Valcour, Samuel Mayer, Antônio Maria, and now living the life of three characters in *A cabana do Pai Tomás*."[84] For many people, it seemed natural that Cardoso, who had previously played an Italian immigrant from Calabria in *O cara suja* (The man with a dirty face, 1965) and the disfigured Dr. Valcour in *O preço de uma vida* (The price of a life, 1965–66) and who had worn blue contacts to play the role of the Jewish Samuel in *Somos todos irmãos* (We are all brothers, 1966),[85] should be chosen to play Tomás, in addition to Lincoln and the handsome villain Dimitrius.

At the same time, *Pai Tomás* was celebrated for having the largest cast of black actors in the history of the Brazilian telenovela. The playwright Nelson Rodrigues, who, in his own *Anjo negro* (The black angel) almost twenty years earlier, had lamented the use of blackface as well as the lack of opportunity for black actors on the Brazilian stages, sided with the TV star. A few months before Globo TV began to air the telenovela, he argued publicly with Plínio Marcos, another renowned white playwright and allegedly Rodrigues's disciple, said to have started a campaign against Cardoso's use of blackface in the telenovela. On 2 May, in his regular newspaper column "Navalha da carne" (Knife in the flesh), Marcos published the first of a series of articles in which he proposed that the use of blackface in Brazil should be outlawed.[86]

> These old actors open their traps to say that there is nothing wrong if a white actor dyes his face black. And thus they blabber, on and on. All of them have dyed themselves black to perform. And they intend to dye themselves black again in order to play Othello. And they find this normal. Now I ask: is there any great black actor left from this twisted [*matusquela*] generation? Nope. If there was a good black actor, it now remains forgotten. The great roles on the stages were all played by dyed whites. And these whites, who are famous, think there's nothing wrong with this. . . . It is very hard to see great white actors dreaming of dying themselves black in order to play Othello. But can a black actor dream of dying himself in order to play Iago? Othello was always played by dyed whites. . . . Oh my comrades [*cupinchas*], blacks are the laughingstock of society. No law protects blacks. This is why we are now fighting to create a sacred law that shall prohibit dyed actors on stage. Enough of one race making a caricature of the other. We are going to fight for this law, act, decree, signature, whatever. We shall defend human rights.[87]

In response, the recognizably controversial Nelson Rodrigues attacked Marcos (whom he claimed was simply envious of other artists' success), defended the TV network, and denied that there was racial prejudice on Brazilian stages. Rodrigues seems to find no contradiction between his awareness of the marginalization of blacks and Cardoso's use of blackface.

> For God's sake! Laurence Olivier played Othello, Paulo Autran played Othello, if you painted Plínio Marcos himself with burned cork, he would also play Othello. This has never been an issue. And don't tell

me that in the cast of *A cabana do Pai Tomás*, the black man suffers. He suffers all over Brazil. I have written a hundred times about the brutal "black solitude." No one has ever seen a black man in a tailcoat, an equestrian statue with a black man, or a black refined man. . . . The black Brazilian has always been humiliated and insulted. So why hasn't [Marcos] ever treated the issue in drama, an issue that is only now raised for mere competitive reasons?[88]

With a few exceptions, most white actors and a few black actors supported Cardoso.[89] Yet actress Ruth de Souza, who played Chloe and was one of the great advocates for black performers in Brazil, recounts how, at the time, the white actors and actresses in the telenovela began to object to her protagonism. As she reports, Sérgio Cardoso approached her to say that the others were bothered that her name was highlighted in the credits, and she was asked if she minded if her name were listed after that of the other actresses. According to Souza, her role in the telenovela began to lose importance from that time.[90] On another occasion, Souza defended the illustrious Cardoso: "Those who criticized the fact that the main actor in *A cabana do Pai Tomás* painted himself black did not understand that attitude of Sérgio, who by the way, is the least prejudiced person I have ever encountered in my life. He was a great friend of [the black actress] Jacira da Silva, a great friend of mine, one of the most open persons I've known."[91] Still, Souza continuously deplored the fact that despite being one of the most celebrated black actresses on Brazilian TV, she only twice played a central character, in *A cabana do Pai Tomás* and in the TV drama *Quarto de despejo* (Trash room, Globo TV, 1975, based on Carolina Maria de Jesus's diaries published in English as *Child of the Dark*).

Sérgio Cardoso tried hard to reinforce his image as an unprejudiced friend of Brazilian blacks.[92] A month after the broadcast of the telenovela started, he organized an excursion to the Mangueira favela, accompanied by white and black actors and actresses, for an event called "A noite de Pai Tomás" (Uncle Tom's evening). At the occasion, the president of the Mangueira samba school allegedly declared that the event was a manifestation of their discontent with the "nasty campaign attributed to men of color" against Sérgio Cardoso. To prove himself, the actor expressed his knowledge of the customs of the community, rehearsed some samba steps, and promised to return frequently and learn some other secrets, as he might

need them for another telenovela.[93] Ultimately, Cardoso expressed pride for
his careful construction of the central character in *A cabana*.

First I asked the TV network to import a very thin and transparent paste
capable of thickening my nose. Then I tried several shades of "pancake"
until I arrived at the color I wanted. When I put on the clothes and the
kinky hair, I was happy with Pai Tomás's appearance. . . . But as I camou-
flaged myself in black, protests poured in from all over against my white
skin. However, I had not taken the place of any black actor. Globo TV
simply thought of me, chose the text and the character who happened
to be black, as he could be white or yellow. . . . By the way, I would like
people to understand that I am the most antiracist person in the world.
I have several colored friends who are just like my brothers; I have god-
children who are little black boys and whom I love as if they were my
children. [Skin] color does not mean anything to me: it is something like
a very fragile envelope, which only serves to deceive the snobs.[94]

Meanwhile, throughout Brazil and most prominently in São Paulo, of-
ficial celebrations on 13 May 1969 commemorated the anniversary of the
abolition of slavery and the heritage of the Mãe Preta, in gatherings that
included a number of representatives of Afro-Brazilian groups and, in the
case of São Paulo, military officials.[95] An exhibit inside the Nossa Senhora
do Rosário dos Homens Pretos, a Catholic church where Mass was cele-
brated at 9:00 a.m. that day, displayed objects related to the history of slav-
ery in Brazil, including instruments of torture; a passport granting permis-
sion for a slave to travel from the state of Bahia to São Paulo; some jewelry;
a slave's certificate of life insurance; newspaper advertisements announcing
runaway slaves; and the original official decree of 13 May 1888 signed by
Princesa Isabel, called "the redeemer."[96] Outside the church, in front of Júlio
Guerra's 1955 Monument to Mãe Preta—which, since 1960, members of the
Afro-Brazilian Clube 220 had embraced as the site for the 13 May com-
memorations, which they had renamed Mãe Preta Day—a mix of official
and popular events and manifestations were also taking place. Representing
the nation's president at the event was Minister of Justice Gama e Silva, who
appeared along with the army general Arthur da Costa e Silva as well as rep-
resentatives of the governor and the mayor. The officials all gave speeches
in praise of the "contribution" of blacks in Brazilian national history. Later

that day, at the Palácio dos Bandeirantes, the governor of the state of São Paulo, Abreu Sodré (recently appointed by the military government, since elections were suspended), met with representatives of the "coletividade negra" (black community), including singer Jair Rodrigues; Olympic athlete Adhemar Ferreira da Silva; Frederico Penteado, president of Clube 220 and organizer of the black beauty pageant Bonequinha do café (The coffee dolls); soccer star Leonidas da Silva; poet and actor Solano Trindade; city council representative (*vereadora*) Theodosina Rosário Ribeiro; and the current contestants in the Bonequinhas do café beauty pageant.[97]

At the end of the day, São Paulo's mayor, Paulo Maluf, inaugurated the new lighting around the Igreja do Rosário and participated in an extraordinary session of the City Council (*Câmara dos vereadores*), intended to close the commemorations of the eighty-first anniversary of the abolition of slavery.[98] During a tribute delivered at the session, João Carlos Meirelles began with a call for the nation to repent for the sins of its past, only to quickly turn the language of bondage and freedom into a trope in favor of universal freedom and equality in Brazil, thus calling for the emancipation of the entire "human family." Freitas Nobre followed with a speech sprinkled with quotes from Pascal that commemorated the major figures of the abolitionist movement, celebrated Brazil's "fraternal vocation" and racial integration—"Everything unites us to those men and women of dark skin who illuminated the dawn of our history"—and sentimentally recalled the African roots of Brazilian lullabies. He was followed by David Roysen, who began by recalling how the League of Nations had created the conditions enabling his Jewish father to migrate to the "welcoming nation" of Brazil after World War I. He also stressed how his father had taught him that by loving and being thankful to the black nanny who raised him, he would learn to reciprocate the love, care, and comprehension his family had found in Brazil. Roysen went on to plea, in the name of "our" ancestors, for forgiveness for the past, reading a poem by his "brother" and negritude poet Eduardo de Oliveira (the author of the "13th of May Anthem," who was present at the event along with Frederico Penteado Junior): "Negritude / before anything is an offering / it is a benign and generous gift / by all those who desire / to love the entire Humanity."[99]

Following these repeated gestures of appropriating the historical holiday through the universalization of human bondage, Oliveira Laet (another city councilman) compared race relations in Brazil to those of the United States and South Africa, suggesting that greater freedom could be

found in South America than elsewhere. (Less than five months later, the military dictatorship would issue Institutional Act Number Five, which resulted in the forfeiture of mandates, local intervention by the federal government, and the suspension of constitutional guarantees, measures that led to widespread censorship and the institutionalization of torture, among other things.) "Is it possible to say we do not enjoy freedom?" Laet asked. "No! . . . What we cannot do is confuse liberty with licentiousness, liberty with attacks on the constituted authority. In no country is the latter allowed or consented." The "liberty" in question, he claimed, had been forged thanks to the efforts of "our sacrificed, humiliated, mistreated, enslaved brothers." Laet concluded his speech with a tribute to "the generous milk of the Mãe Preta" and was followed by Caio Pompeu de Toledo, who read the poem "Irene no céu" (Irene in heaven) by the modernist poet Manuel Bandeira: "Black Irene / Kind Irene / Irene always in a good mood. / I imagine Irene entering heaven: /—'Say there, sir, is it all right if I come in?' / And Saint Peter, good-natured, / —'Come on in, Irene. You don't have to stand there asking.'"[100] Councilman Laet added, "When I think of Manuel Bandeira's poem, when I think of the good Irene, what comes to mind is the fact that any of us—black, white, yellow—could be Irene, [. . .] simple and humble and yet, valued as a human person." According to Toledo, Brazilians should make new efforts to integrate before a racial movement might emerge.

The next day, David Roysen opened the ordinary session of the council by returning to the topic of racial integration in Brazil. He referred to an article published that same day in the *Diário da noite*, in which Frederico Pimentel (who had been present for the previous day's session)[101] had expressed his outrage over the use of blackface in *A cabana do Pai Tomás* and called for the organization of a commission to denounce it. Pimentel had argued that the use of blackface was a form of "stepping on our shoulders."

We must unite ourselves, right now, immediately. Actors in general, whites and blacks, since even white actors are frankly against the practice that is being used. A strong union, meant to mobilize all those who have a TV set. We are going to boycott it, turn off the TV each time the telenovela is aired with the white man painted in black. And hereby we launch our appeal: let whoever is against racial segregation join us.[102]

Expressing his full support for Pimentel, Roysen stated that Brazilians needed to be aware that, unlike the United States, which had to look for someone with the voice of Al Jolson to sing American spirituals, Brazil had the most-talented black actors. He begged TV producers not to engage in dangerous provocation and urged them not to accentuate "something that has not manifested itself, and God forbid it shall ever be manifested, in our blessed Fatherland."[103] The year 1969 came at the beginning of the darkest era of the military regime, known as the "anos de chumbo" (years of lead, 1968–74), when political protest and social movements, including the black movement, were repressed and targeted as subversive.

THE (FADING) MEMORIES OF HILTON MURRAY

Hilton Alves Murray (fig. 16) was born in 1940. His father, Milton Messiah Murray, migrated to the northern region of the Brazilian Amazon from the British colony of Barbados together with numerous British Caribbean men who were brought to work on the Madeira-Mamoré Railroad. As a British citizen, Milton Murray was recruited in September 1918 to fight with the allies in World War I, along with forty-eight other Barbadian workers.[104] After the war, he moved to São Paulo to work for the Canadian São Paulo Tramway, Light, and Power Company, residing there until his death in 1954. Fifteen years later, at the age of twenty-nine, his son Hilton attempted to tell his own story in a dramatic gesture-performance at Largo do Paissandu (Paissandu Square) in São Paulo, a notorious site of Afro-Brazilian gatherings. In my interview with Mr. Murray, he remembered the Paissandu as "praia preta" (black beach). Unemployed at the time, Hilton Murray had been a construction worker and enjoyed learning languages, particularly Esperanto. Police records from the Departmento de ordem política e social (DOPS) show that less than two months after the military coup of 1964, Hilton's name appeared among the membership of the União Cultural Brasil-U.R.S.S. (Brazil-USSR Cultural Union), which Hilton recalls as primarily a language institute.

The forgotten narrative of Hilton Murray, with which I began and now conclude this essay, literally cuts across the dubious official narratives of national conciliation and African heritage that were featured in the 13 May 1969 speeches as well as the passive and benign image of a made-up Uncle Tom that would be aired several months later on the telenovela A cabana

Fig. 16. Hilton Alves Murray, November 2014. (Photo by the author.)

do Pai Tomás. The blood and the wound that Murray dramatically exposed that day in front of the Mãe Preta and the official authorities represented a radical response to the history of "stolen milk,"[105] reinterpreted in national narratives of maternal benevolence. Rather than the symbolic Mãe Preta, who persisted only as a diffuse form of national guilt and figurative debt, Murray's performance evoked his own biological mother, Placidina Alves Murray, a black woman who worked as a maid, probably for a white family, to support her entire household.

According to newspaper reports, Murray was taken to the DOPS police station for interrogation after the incident, though no record of his arrest

can be found in the state archives. Ironically, he would retire on the same month and day forty years later, on 13 May 2009. Today, he resides with his son on the outskirts of São Paulo, in the low-income town of Francisco Morato. He suffers from the early stages of Alzheimer's disease but is still amused to recount the events of 1969. He refers with gratitude to the poet Eduardo de Oliveira, who, according to Hilton, always gave him great support and published some of his poems, which he believes are lost somewhere in a pile among Esperanto manuals, old magazines, and other books that barely survived a recent flood in his house. Hilton and his younger brother Samuel have many stories to tell about black life in downtown São Paulo in the 1960s. He remembers clearly the controversy around the telenovela and the protests of 13 May, from which he still carries scars on both wrists and which he repeatedly referred to in our conversation as Dia do Zumbi (Zumbi Day).

I want to read Mr. Murray's mistaking the anniversary of the abolition for the new black consciousness day as his own way of rewriting the memory of black protagonism in Brazil. Since 2003, a new official holiday was designated, in São Paulo and elsewhere in the country, to celebrate black awareness and replace the 13 May commemoration. The new holiday falls on 20 November, the day of the death in 1695 of Zumbi dos Palmares, leader of the largest runaway slave society in Brazil's history. Though blackface and other symbolic appropriations are still reproduced in Brazilian culture, downtown São Paulo and particularly Paissandu Square, where Hilton Murray performed his act against racism, remain a vibrant center of Afro-Brazilian traditions that have not been altogether erased by mainstream culture, a site that continues to be enriched with new waves of immigrants from Africa and the Caribbean.

Notes

I thank Eduardo Cavalcante, who assisted me with the preliminary research for this essay; the personnel of Arquivo do Estado de São Paulo and the Biblioteca Mário de Andrade; telenovela director Daniel Filho, with whom I conducted a Skype interview at the preliminary stages of this work; Tracy C. Davis, for patience in reading early versions of the essay; João Roberto Faria, for his careful and generous reading; and particularly Samuel Murray, who took me to his brother's house for an interview and told me fascinating stories about the 1960s in São Paulo.

1. *Jornal do Brasil* (Rio de Janeiro), 15 May 1969.

2. The newspaper reproduces the entire poem: "Mother, you were not a saint for

those who did not feel your love. Your tender gesture irradiates forgiveness toward rebels and instills harmony in the souls of those who plea for happiness. Mother, I would not mind feeling in my body your correction of my mistakes, just as I still feel in my soul all the good you have done for me. The time I have spent has distanced me from your voice and drawn me ever closer to your teachings. Today, there remains nothing but nostalgia, cloaked in the contentedness of having had a mother" (*O estado de São Paulo*, 14 May 1969). All translations in this essay are mine unless otherwise indicated.

3. See Hélio de Seixas Guimarães, "Pai Tomás no romantismo brasileiro" [Uncle Tom and Brazilian romanticism], *Teresa* (São Paulo) 1 (2013): 421–29.

4. For example, in May 1882, a writer called Caetano Salazar Sanches in the northern province of Maranhão started a series of articles called "Codó: Impressões com a leitura da Cabana do Pae Thomaz" [Codó: Impressions from the readings of *Uncle Tom's Cabin*], *Diário do Maranhão*, 11 May 1882.

5. Silvia Cristina Maria de Souza, "Cantando e encenando a escravidão e a abolição: História, música e teatro no Império Brasileiro" [Singing and staging slavery and the abolition: History, music and theater in the Brazilian Empire] (paper presented at the 4º Encontro Escravidão e Liberdade no Brasil Meridional [Fourth Slavery and Freedom in Southern Brazil Meeting], Curitiba, Brazil, 13–15 May 2009), 5. The play *Os ingleses no Brasil* (The British in Brazil, 1850), by José Lopes de la Vega, criticizes the end of the slave trade. See João Roberto Faria, "Notas sobre o naturalismo teatral no Brasil" [Notes on theatrical naturalism in Brazil], *Luso-Brazilian Review* 35.2 (1998): 97. For a discussion of the role of theater in the abolitionist movement, see Souza, "Cantando e encenando a escravidão"; Angela Alonso, "A teatralizaçao da política: A propaganda abolicionista" [The theatralization of politics: The abolitionist propaganda], *Tempo social: Revista de Sociologia da USP* 24.2 (2012): 111; Celso Thomas Castilho, "Performing Abolitionism, Enacting Citizenship: The Social Construction of Political Rights in 1880s Recife, Brazil," *Hispanic American Historical Review* 93.3 (2013): 377–409.

6. Aristides de Sousa Abranches, *A mãe dos escravos: Drama em quatro actos, baseado no assumpto do romance "A cabana do pae Thomaz"* [*The Mother of the Slaves*: A drama in four acts, based on the theme of the novel *Uncle Tom's Cabin*] (Lisbon: Typ. do Panorama, 1864). According to the printed edition, the play was staged for the first time at the Teatro do Gimnásio (Lisbon) on 16 October 1863, although the *Diário do Rio de Janeiro* (19 November 1963) reported that it was playing in Lisbon on 28 September 1863. According to the *Diário do Rio de Janeiro* of 18 September 1874, the new production staged ten years later in Rio was highly applauded. Other performances took place in February 1886, with Lúcia Rocha playing Evangelina (*Diário de notícias*, 2 February 1886); in November of the same year, it was produced by the company Phenix Dramática, with the actor Montedonio; and it was presented at the Club da Gávea in 1891. The play continued to be staged as late as 1940, with Sebastião Arruda. See Sábato Magaldi and Maria Thereza Vargas, *Cem anos de teatro em São Paulo: 1875–1974* [One hundred years of theater in São Paulo, 1875–1974], 2nd ed. (São Paulo: Senac, 2001) 168.

7. See Sahakian's essay in this volume.

8. *Jornal do Comércio* (Rio de Janeiro), 7 July 1876.

9. *Correio Paulistano* (São Paulo), 14 December 1877.

10. *Gazeta de notícias*, 13 May 1888.

11. *Jornal do Brasil*, 13 May 1899. Roberto Schwarz reminds us that "the hymn to

the Republic, written in 1890, two years after the abolition of slavery, by Medeiros e Albuquerque, a self-proclaimed 'decadent' poet," forcibly attempted to erase the shameful past and to include Brazil in the modern liberal world (*Misplaced Ideas: Essays on Brazilian Culture*, ed. John Gledson [London: Verso, 1992], 26). One line of the hymn goes, "We cannot believe that in another age / Slaves there were in so noble a country."

12. *O imparcial* (Rio de Janeiro), 13 May 1917.

13. Most of the examples I use in the following pages are taken from the nation's capital, but similar representations were found elsewhere. *A mãe dos escravos* was regularly staged in Rio, in June 1891 (at the Club familiar da Gávea), July 1901, April and May 1904, and July 1914, among other dates. One year after abolition, the Tasso Club held a social event that included a performance of the work, followed by a dance that lasted until 6:00 a.m. (*Diário do commercio* [Rio de Janeiro], 2 December 1889). *Pai Thomaz* was staged at the Teatro Phenix Dramática during the commemorations of 13 May 1892, with Cardoso da Motta in the role of Jorge, and again in 1894. On 13 May 1896, it was performed at the São Pedro de Alcântara, in an opening gala session, in the presence of José do Patrocínio. The most famous companies opened in Rio and traveled around the country.

14. Mario Cacciaglia, *Pequena história do teatro no Brasil* [A short history of theater in Brazil], (São Paulo: Edusp., 1986), 32; Lothar Hessel and Georges Raeders, *O teatro no Brasil da colônia à regência* [Theater in Brazil from colony to the regency] (Porto Alegre: Universidade Federal do Rio Grande do Sul, 1974), 13. See also Miriam Garcia Mendes, *O negro e o teatro Brasileiro* [The black man and Brazilian theater] (São Paulo: Fundação Cultural Palmares, 1993), 49.

15. See Maria Clementina Pereira da Cunha, *Ecos da folia: Uma historia social do carnaval carioca entre 1880 e 1920* [Echoes from the festival: A social history of Rio's Carnival between 1880 and 1920] (São Paulo: Companhia das Letras, 2001), 57–58.

16. Hessel and Raeders, *O teatro no Brasil da colônia à regência*, 115.

17. *Diário do Rio de Janeiro*, 23 August 1869.

18. *Anglo-Brazilian Times* (Rio de Janeiro), 13 October 1881.

19. I wonder if the club's name may have been inspired precisely by the Portuguese name given to the character Bengali, the French version of Topsy.

20. Castilho, "Performing Abolitionism, Enacting Citizenship," 40.

21. See Emilia Viotti da Costa, "The Myth of Racial Democracy: A Legacy of Empire," in *Brazilian Empire: Myths and Histories* (Chapel Hill: University of North Carolina Press, 2000), 240.

22. See Pires de Almeida, "João Caetano dos Santos e o teatro de Shakespeare: Lendas para a história do Theatro Fluminense" [João Caetano dos Santos and the theater of Shakespeare: Legends for the history of the Fluminense Theater], *Brazil-theatro* 2 (1903): 622. Almeida includes illustrations of the actor in blackface playing both Shakespeare's (417) and Ducis's (421) Othellos. Almeida suggests that Caetano switched to Vigny's version because he insisted on characterizing Othello as dark-skinned, but newspaper advertisements show him in Ducis's play several times as late as the late 1850s. See also Eugênio Gomes, *Shakespeare no Brasil* (Rio de Janeiro: Ministério da Educação e Cultura, 1960), 16.

23. Ducis's adaptation was translated (or, according to critics at the time, adulterated) from the French by the prestigious romantic poet Gonçalves de Magalhães. Although

a new translation by Rebello da Silva, allegedly from Duci's and Vigny's versions (three first acts) and from the English original (last two acts) became available in 1956, there is no evidence that Caetano adopted it. *Correio da tarde* (Rio de Janeiro), 29 April 1956.

24. Ira Aldridge also played white characters in whiteface. See Bernth Lindfors, "'Mislike Me Not for My Complexion': Ira Aldridge in Whiteface," *African American Review* 33.2 (1999): 348.

25. Luís Carlos Martins Pena, "The Jealous Officer; or, The Fearsome Slave Catcher," trans. Sarah J. Townsend, in *The Stages of Conflict: A Critical Anthology of Latin American Theater and Performance*, ed. Diana Taylor and Sarah J. Townsend (Ann Arbor: University of Michigan Press, 2008).

26. See Marvin Carlson, *The Italian Shakespearians* (Washington: Folger Books, 1985), 118.

27. "Primeiro apareceu caboclo, depois branco, enegrecido pelo comércio de carvão e, finalmente, negro retinto!," *Jornal do Brasil*, 6 May 1891.

28. *Estado do Espírito Santo* (Vitória), 20 December 1904, 2. Among the cast were Caetano Alves, Claudino d'Oliveira, and Francisca Britto.

29. Procópio Ferreira wrote Vasques's first biography, *O ator Vasques: O homem e a obra* (São Paulo: Oficinas J. Magalhães, 1939).

30. See Ferreira, *O ator Vasques*; Antonio Herculano Lopes, "Vasques: Uma sensibilidade excêntrica," *Nuevo Mundo, Mundos Nuevos*, published online 9 March 2007. http:// nuevomundo.revues.org/3676 (accessed December 16, 2014). In particular, see Andrea Marzano, *Cidade em Cena: O ator Vasques, o teatro e o Rio de Janeiro (1839–1892)* (Rio de Janeiro: Folha Seca and Faperj, 2008).

31. Marzano, *Cidade em Cena*, 68.

32. Roberto Faria, "Notas sobre o naturalismo teatral no Brasil," 32.

33. *Diário do Rio de Janeiro*, 4 June 1861.

34. Daniela Ferreira Elyseu Rhinow, "Visões de Othelo na cena e na literatura dramática brasileira no século XIX" (PhD diss., University of São Paulo, 2007), 1:185.

35. The prices for the 1917 performance at the Carlos Gomes ranged from 125 reis (*camarotes* [box seats]) to 500 reis (general admission).

36. *Correio da manhã*, 12 May 1917.

37. See Flora Sussekind, *O negro como Arlequim: Teatro e discriminação* [The black man as Harlequin: Theater and discrimination], (Rio de Janeiro: Achiamé, 1982); Lisa Shaw, *Tropical Travels: Brazilian Popular Performance, Transnational Encounters, and the Construction of Race, 1850s–1950s* (Austin: University of Texas Press, 2018). The manuscript was kindly made available to me by the author, with permission to quote.

38. Senator Bird asks, "Qu'elle différence y-a-til entre ceci (il montre Bengali) et cela (il montre le singe). . . . Ah! si fait, il y en a une . . . je le reconnais. Le singe est moins bête, il ne parle pas. (44). (What's the difference between this one [he points to Bengali] and that one [he points to the monkey]. . . . Oh, yes, there is one . . . I recognize it. The monkey is less stupid, he doesn't talk.)

39. *Gazeta de noticias*, 13 May 1892.

40. *A república* (Curitiba), 22 July 1908.

41. *O imparcial*, 12 May 1917.

42. *O imparcial*, 13 May 1917.

43. Erminia Silva, *Circo-teatro: Benjamim de Oliveira e a teatralidade circense no Brasil*

[Benjamin de Oliveira and theatrical circus in Brazil], (São Paulo: Altana, 2007), 68. According to Silva, from the early nineteenth century onward, some circus directors and artists bought or hired black or mixed-race slaves to join their casts of artists (70–71).

44. According to Dario Fo (2004, quoted in Erminia Silva, *Circo-teatro*, 304–5), the *pagliaccio* of *commedia* appeared in whiteface, later becoming known as Gian-Farina (Four John) and then Pierrot Fo.

45. *Correio Paulistano*, 20 April 1872.

46. Lundu is an Afro-Brazilian musical form. In a 1928 interview, writer Mário de Andrade recalls hearing Circo Casali clown Antoninho Correio singing the "Lundu do escravo" wearing blackface in São Paulo in 1896. See José Ramos Tinhorão, *Cultura popular: Temas e questões* [Popular culture: Themes and questions] (São Paulo: Editora 34, 2001), 60.

47. *Jornal do Brasil*, 13 May 1909.

48. *Jornal do Brasil*, 13 May 1916. The list of actors in the cast does not indicate their racial backgrounds. It includes Francisco de Mesquita, Alvaro Costa, Roberto Guimarães, João Ayres, and Mário Brandão, among others. Admission prices varied according to seat location.

49. *A noite*, 5 September 1947.

50. Most circuses, such as the Dorby, had heterogeneous audiences, separated by ticket prices, but some circuses, such as the Circo França from the Rio neighborhood of Laranjeiras, were frequented mainly by the middle and upper classes (*Diario carioca*, 26 July 1932). The Companhia Olimecha staged *Uncle Tom's Cabin* at the Circo-Teatro Dorby in 1932 and again, preceded by J. Osorio's *Mãe Preta* (with Benjamin), in 1933. The Dorby Circus was created in 1932 on São Luiz Gonzaga Street in the Rio de Janeiro neighborhood of São Chirstóvão and was later established in the "elegant" neighborhood of Botafogo (1936) under the auspices of Clotylde Dorby. The São Christóvão location opened with *Amor de gaucho* in 1932.

51. Shaw, *Tropical Travels*, 14.

52. Ibid., 10.

53. Ibid., 7.

54. *O malho*, 13 February 1936. In chapter 20 of Stowe's novel, the dialogue between Miss Ophelia and Topsy goes as follows: "'How old are you Topsy?' 'Dun no Missis,' said the image, with a grin that showed all her teeth. 'Don't know how old you are? Didn't anybody ever tell you? Who was your mother?' 'Never had none!' said the child, with another grin. 'Never had any mother? What do you mean? Where were you born?' 'Never was born!' persisted Topsy" (Harriet Beecher Stowe, *Uncle Tom's Cabin* [New York: Norton, 2010], 220–21).

55. *Correio de São Paulo*, 7 May 1936.

56. *Correio Paulistano*, 13 May 1941.

57. Abdias do Nascimento, "Teatro Experimental do Negro: trajetórias e reflexões." *Estudos Avançados* 18.50: 209–24, quotation at 212.

58. *O estado de São Paulo*, 31 December 1942.

59. Antonio Serra, *A cabana do Pai Tomás* (Rio de Janeiro: Photo-Cinematographia Brasileira, 1909), 35 mm.

60. The film was announced to premiere at Cinema Palace. Advertisements feature

the actors Antonio Serra, Eduardo Leite, Asdrubal Miranda, Machado Careca, Amadeu Santos, Balsemao Mendonca, Palladini Matos, Luís Bastos, Pilar de Bastos, Julieta Pinto, Elvira Beneventi, Albertina Ramirez, and Guarany Duarte.

61. Gentil Roiz, *Aitaré da praia* (Recife: Aurora Filmes, 1925), 35 mm. See Noel dos Santos Carvalho, "O negro no cinema brasileiro: o período silencioso" [The black man in Brazilian cinema], *Plural* (São Paulo) 10 (2003): 168.

62. Chianca de Garcia, *Pureza* (Rio de Janeiro: Cinédia S.A., 1940), 35 mm.

63. J. Stuart Blackton, *Uncle Tom's Cabin* (New York: Vitagraph, 1910), 35 mm. The film also opened at the Cinema Chic in December 1910 and at the Excelsior in Rio in March 1911. According to John Frick, unlike the two earlier versions Blackton's "returned Uncle Tom to his abolitionist origins." Frick also observes that this was the third American film adaptation of *Uncle Tom's Cabin*. The two others were from 1903, one by Edwin S. Porter (New York: Edison Manufacturing) and one by Siegmund Lubin (Philadelphia: Lubin Manufacturing). See John W. Frick, *"Uncle Tom's Cabin" on the American Stage and Screen* (New York: Palgrave, 2012), 182–222. I have found no evidence that any of the other six adaptations of *Uncle Tom's Cabin* produced between 1903 and 1927 were shown in Brazil.

64. *Leitura para todos*, 1928.

65. *Cinearte*, 18 July 1928.

66. *Correio Paulistano*, 11 April 1928.

67. *Careta* (Rio de Janeiro), 10 March 1928.

68. *Scena muda* (Rio de Janeiro), 19 December 1929.

69. *Tico Tico*, 23 and 30 August, 13 and 20 September, and 18 October 1933. The entire series was republished in the December 1934 special edition.

70. *Folha da manhã* (São Paulo), 18 February 1933.

71. "Tava jogando sinuca / uma nega maluca / me apareceu / Vinha com o filho no colo / e dizia pro povo / que o filho era meu / toma que o filho é seu / guarde o que Deus lhe deu." See Fernando Lobo, *À mesa do Vilariño* (Rio de Janeiro: Record, 1991), 85–87.

72. Lobo, *À mesa do Vilariño*.

73. According to a survey at the most popular stores in Rio (Exposição avenida, Galeria carioca, Exposição juvenil, Casa K, Exposição carioca, and Casa Mathias), Nega Maluca was the best-selling costume of that year, followed by Marinheiro da Banda (The Sailor from the Band), Brotinho (Little Girl), Legionário (Legionary), Rei Zulu (King Zulu), Carioquinha, Gostosão, Índio Boca Negra (Black-Mouth Indian), Cowboy do Arizona (Arizona Cowboy), and Superman (*Tribuna de Imprensa* [Rio de Janeiro], 16 February 1950).

74. Edmar Morel, "A sambista Josephine Baker," *O cruzeiro* (Rio de Janeiro), 1 July 1939, 116.

75. The Nega Maluca figure is so widespread in Brazil that it has become a popular cloth doll, sold in many arts and crafts stores throughout the country.

76. The show began airing in 1999 and was still ongoing at the time of this writing.

77. Lobo, *À mesa do Vilariño*, 88.

78. According to Luiz Eduardo Borgeth's memoirs, "Creating tumult in my waiting room, black American slaves are leaving the cotton plantations, led by the blackest of them all, Sérgio Cardoso, also known as Pai Tomás. They warn that they are quitting the

fields, that they will abandon the plantation and their master's cruelty unless they receive their back pay" (*Quem e como fizemos a TV Globo* [Who created Globo TV and how] [São Paulo: A Girafa, 2003], 178).

79. Judging from the photos in magazines of the time, it is not unlikely, however, that red or brownish face painting was used by Henrique Martins for his role as an Arab in "O sheik de Agadir" (The sheikh from Agadir, Globo TV, directed by Gloria Magadan, 1966).

80. A columnist at the time writes that he received several letters in protest that accused the telenovela of humiliating the black race (*Diário de notícias*, 30 December 1965).

81. See Joel Zito Araújo, *A negação do Brasil: O negro na telenovela brasileira* [The negation of Brazil: The black man in the Brazilian soap opera], (São Paulo: Senac, 2000), 84–88. Araújo lists *Os rebeldes* (Tupi, 1968), but this seems to be the translation of the American series *The Outcasts* (1968–69), with Otis Young and Don Murray, for which the ad in the Brazilian newspapers announced, "Separados pela cor, mas unidos pela violência" (Separated by color, united by violence). Other, less reliable sources indicated the title as a Tupi production (1967–68), a classroom drama by Geraldo Vietri. In 1956, the newspapers announced the series *E o vento levou* (*Gone with the Wind*), broadcast twice a week by TV Tupi, with Maria Fernanda in the role of Scarlett O'Hara (*Correio da manhã*, 2 March 1956).

82. See Araújo, *A negação do Brasil*, 96.

83. *Onkel* opened in Rio and São Paulo in March 1967. There was much publicity about this film, which, according to local newspapers, was originally planned to include Louis Armstrong and Ella Fitzgerald in the cast of African actors (*Folha da manhã*, 5 February 1965). See Einboden's essay in this volume.

84. *O globo* (Rio de Janeiro), 7 July 1969.

85. *Diário popular*, 11 September 1966.

86. Plínio Marcos, "Lincoln só queria a igualdade dos homens" [All Lincoln wanted was the equality of men], *Última hora* (São Paulo), 2 May 1969. Marcos continued to write on the subject in four subsequent 1969 articles: "13 de Maio" (13 May), "Como se marginaliza a gente" (14 May), "Em causa justa não enjeito pau" [For a just cause I do not decline a fight] (17 May), and "A carta da mãe do Benê" [The letter from Benê's mother] (20 May).

87. Plínio Marcos, *Última hora*, 19 May 1969. See also Fred Maia, Javier Arancibia Contreras, and Vinícius Pinheiro, *Plínio Marcos: A crônica dos que não têm voz* [Plínio Marcos: The chronicle of those without a voice], (São Paulo: Ed. Boitempo, 2002), 140.

88. *O globo*, 15 May 1969, reproduced in Nelson Rodrigues, *A cabra vadia: Novas confissões* [The vagrant she-goat: New confessions] (São Paulo: Companhia das Letras, 1996), 129.

89. *O globo*, 16 May 1969. Among the black actors who protested were Antonio Pitanga and Milton Gonçalves.

90. See the film *A negação do Brasil*, directed by Joel Zito Araújo (Rio de Janeiro: Casa de Criação, 2000), DVD.

91. Sandra Almada, *Damas negras: Sucesso, lutas e discriminação; Xica da Silva, Lea Garcia, Ruth de Souza, Zezé Motta* [Black ladies: Success, struggles, and discrimination; Xica da Silva, Lea Garcia, Ruth de Souza, Zezé Motta] (Rio de Janeiro: Mauad, 1995), 158. See also Júlio Cláudio da Silva, "Relações raciais, gênero e memória: A trajetória de

Ruth de Souza entre o Teatro Experimental do Negro e o Karamu House (1945–1952)" [Racial relations, gender, and memory: Ruth de Souza's trajectory between the Black Experimental Theater and the Karamu House (1945–1952)] (PhD diss., Universidade Federal Fluminense, 2011).

92. For a discussion of the use of blackface today in Brazil, see Hebe Mattos, "Racismo à Brasileira e os Black Faces do Século XXI" [Racism Brazilian style and blackface in the twenty-first century], *Conversa de Historiadoras* (blog), 11 August 2015, http://conversadehistoriadoras.com/author/hebemattos/

93. *O globo*, 11 August 1969. The television network owns the source newspaper.

94. *Manchete* (Rio de Janeiro), 2 August 1969.

95. On the projects of building monuments to the Mãe Preta in Rio de Janeiro and São Paulo, see Paulina Alberto, *Terms of Inclusion: Black Intellectuals in Twentieth-Century Brazil* (Chapel Hill: University of Noth Carolina Press, 2011).

96. *Jornal do Brasil*, 14 May 1969.

97. *Diário da noite* (São Paulo), 14 May 1969.

98. See *Diário oficial do estado de São Paulo*, 20 February 1969, 52–54.

99. The "Hino 13 de Maio" was written in 1942 and registered in the Escola nacional de música in 1966. It is also known as the "Hino à Negritude (Cântico à Africanidade Brasileira)" [Hymn in praise of Brazilian Africanness].

100. Manuel Bandeira, "Irene in Heaven," in *This Earth, That Sky: Poems*, trans. Candace Slater (Berkeley: University of California Press, 1989).

101. Theodosina Rosário Ribeiro, the only Afro-Brazilian representative on the council, was not present.

102. *Diário da noite*, 14 May 1969.

103. *Diário oficial do estado de São Paulo*, 20 May 1969, 54.

104. See Francisco Matias, "A Madeira-Mamoré e a I Guerra Mundial" [The Madeira-Mamoré Railroad and World War I], Série 100 anos de Porto Velho (Series 100 years of Porto Velho), *Gente de opinião*, 1 September 2014, http://www.gentedeopiniao.com.br/lerConteudo.php?news=129389

105. I take this expression from Marcus Wood, *Black Milk: Imagining Slavery in the Visual Cultures of Brazil and America* (Oxford: Oxford University Press, 2013).

meLê yamomo

Medializing Race:
Uncle Tom's Cabin in Colonial Southeast Asia

The absence of international copyright protection during the era of its initial publication propelled the presence of *Uncle Tom's Cabin* in cities across the world. Meanwhile, within a decade of initial publication, the global spread of print and entertainment-related capitalism enabled its adaptations to appear in different cultural expressions and popular media idioms. This essay investigates how *Uncle Tom's Cabin* "medialized" the racial knowledge formation of the imperial administrations in colonial Southeast Asia, especially in the ways that contemporaneous media showcased how colonizers imagined and employed the hierarchical racial categories within imperial territories. These are observed in news reports, announcements, opinion pieces, and entertainment articles in newspapers from the British Straits Settlements, Manila, and the Dutch Indies. In Southeast Asia, the colonial powers' imperial administrations employed *Uncle Tom's Cabin* to propagate discreet racial discourses as well as to criticize neighboring colonies' racial policies and practices of indentured labor. However, at the turn of the twentieth century, these colonial understandings of race began to clash with local "medializations" that gave room for indigenous race understandings and strategies that emanated from anti-colonial nationalism.

By the late nineteenth century, the newspaper was an important transnational medium through which information and ideas were circulated across nations, empires, and cultures. News reports from distant cities and continents were translated and reprinted in local newspapers. Communities around the globe imagined a transnational/transimperial world as they read

the same news and books and saw and heard the latest theater and music circulated via the transcontinental steamships. As a material and discursive phenomenon, *Uncle Tom's Cabin* traversed these networks, and its circulation can be traced through them.

UNCLE TOM'S CABIN IN COLONIAL SOUTHEAST ASIA

"*Uncle Tom's Cabin* [is] a wonderful 'leaping fish' that suddenly appeared and was able to 'fly anywhere' through different media," observes literary scholar Jim O'Loughlin.[1] Similarly, Jo-Ann Morgan argues that beyond the appeal of the literary aspects of the novel, there was widespread interest in the "visual culture" that emerged from related book illustrations, theater posters, and performances, forming a matrix of racial iconography.[2] Thanks to the new transcontinental and translocal transportation and communication technologies, the novel and its various theatrical, musical, and cinematic adaptations found audiences as far afield as the Asian Pacific.

Uncle Tom's Cabin leaped and flew across genres and locales, becoming juvenile literature, serialized novels, theater performances, moving pictures, cantatas, and so on. Daily newspapers from Singapore, Manila, and the Dutch Indies (including the cities of Batavia, Surabaya, and Medan) serialized the novel.[3] They also followed Stowe's career, advertised editions of the book, and printed news articles relating to the global phenomenon of *Uncle Tom's Cabin* between 1852 and 1920. A year after its publication in the United States, the novel was translated into Dutch and serialized in *De Oostpost* in Surabaya in the Dutch Indies. In June of the same year, the translation *De Hut van Oom Tom of het Leven der Negerslaven in Noord-Amerika* (Uncle Tom's Cabin; or, The life of the Negro Slave in North America) was advertised for sale in Batavia. Various editions of the book continued to be advertised by bookstores in Singapore, Manila, and the Dutch Indies until the 1940s. Not a lot is known of its readership. However, a report in the *Eastern Daily Mail and Straits Morning Advertiser* on 8 February 1907 about an award-giving ceremony at the exclusive Singapore Chinese girls' school mentions that a copy of the book was awarded as a special prize to commendable students.[4] This event suggests that, as was true elsewhere in the world, the book was considered juvenile literature in this region half a century after it began to circulate there.

Stowe's fame was also well documented in regional newspapers. Her travels around the United States and in Europe, political events involving

her name (e.g., the burning of her effigy in a student demonstration in Virginia in 1856),[5] and news of her birthdays in her old age and of her sickness and death were reported in Batavia, Surabaya, and Singapore. That even the most quotidian reportages about Stowe were reprinted from major U.S. dailies by newspapers in European, Australian, and Asian cities shows the transnational interest in and the prominence of the author of *Uncle Tom's Cabin*.

Newspaper announcements, reviews, and entertainment columns reveal adaptations of the novel into different popular entertainment forms, including theater, film, musical performances, and other media. The first known performance based on *Uncle Tom's Cabin* in the Dutch Indies was by Professor Risley's circus in June 1862. This troupe, led by American acrobat Richard Risley, debuted in California in 1855. It embarked from Hawaii on a Pacific-wide tour in 1858. The troupe took a six-month residency in Batavia in 1862 before proceeding to Manila, Singapore, Calcutta, Bangkok, Hong Kong, Shanghai, and Japan.[6] The troupe did not stage an entire *Uncle Tom's Cabin* show but, rather, included minstrelsy acts relating to the novel as part of the circus's variety format.[7]

Two decades later, in 1883, the touring Mastodon Colored Minstrels came to Southeast Asia with a theatrical repertoire that included an *Uncle Tom's Cabin* show.[8] This minstrel group was comprised of former members of two traveling American troupes, Charles Hicks's Georgia Minstrels and the L. M. Bayless Dramatic Company, which toured the Antipodes from 1878 to 1880.[9] These companies joined efforts in 1881 to produce an extravagant production of minstrel shows, jubilee-style concerts, and *Uncle Tom's Cabin* shows, touring from India to New Zealand and Australia over the course of three years. This company of thirty-two performing artists and musicians eventually split into two smaller companies that went to Shanghai and Hong Kong and then, respectively, to Java and the Straits. In July 1883, the troupe reunited in Singapore, where it had a ten-evening run at the Town Hall.[10]

A decade later, in March 1899, another traveling troupe, the Dallas and Musgrave Dramatic Company, arrived in Singapore "with a first class reputation." Following a twenty-four-day run in Calcutta, it was en route to Shanghai and Hong Kong.[11] In July of the same year, the company returned to Singapore "crowned with Laurels."[12] At the Singapore Town Hall, it performed a repertoire of dramatic plays that included a production of *Uncle Tom's Cabin*. The unattributed review in the *Singapore Free Press and Mer-*

cantile Advertiser found the performance disorienting. Though its format was typical of "Tom shows" in the United States and Europe during the late nineteenth century, its divergence from the well-known novel was noted in Singapore.

> It is obviously based on Mrs. Harriet Beecher Stowe's great story, and the scenes from that are distinctly tragic and saddening. But mixed up with the tragedy, there is so much burlesque and comedy, sometimes with, but occasionally without, any apparent connection with the tragedy, that one gets bewildered. It is an April play; a mixture of sunshine; a tragedy-burlesque alternating between solemnity and the most outrageous fun; exalted sentiments about freedom and manhood cheered to the echo by gallery, and absurd quips and cranks; a blend of the Adelphi and the Gaiety.[13]

This review provides insight into the evolving interpretations of the material as encountered by locals at the time. A similar review describing the theatrical incongruity of the 1853 production by Mark London and Tom Taylor at the Adelphi Theatre in London, reprinted in the *Straits Times*, shows that precedents can be traced back to the inception of Uncle Tom dramatizations.[14]

A major shift in media transpired after the turn of the twentieth century, when moving pictures increasingly became an important global form of entertainment. *Uncle Tom's Cabin* was then adapted to the various technologies of image projections and sound machines. March 1906 saw the traveling Gaumont Tent set up in Fort Canning in Singapore, running a program of chronophone films for local audiences.[15] The "singing pictures," including a production *Uncle Tom's Cabin*, "caused endless surprise to the natives," according to a report in the *Eastern Daily Mail and Straits Morning Advertiser*. The Uncle Tom show delighted the audiences and was repeated.[16] Later, in October of the same year, *Uncle Tom* was screened by magic lantern at the Methodist Church's Anglo-Chinese School.[17] By the second decade of the twentieth century, several cinema houses were operating in the Straits Settlements capital. In October 1916, the World Film Corporation production of *Uncle Tom's Cabin* (1914) was screened at the Alhambra.[18] This five-reel version was directed by William Robert Daly and loosely adapted from the play by George L. Aiken. The same version was run again at the Palladium in July and August of 1918.[19]

RACE IN MEDIA

In the nineteenth-century globalized world—where mass movement and migration of different peoples, cultures, and ideas was increasingly the norm—local and national conceptions and understandings of race were entangled in transnational discourses. Likewise, in globally shared mediascapes,[20] epistemologies of race were intertwined in artistic works' medialities. Writing on race knowledge formation in British Malaya, Sandra Khor Manickam, a historian on Southeast Asia, analogously claims racial epistemology as a necessary facet of media.

Manickam views the traditional notion of mass communication media (the newspaper) in the same way as Ian Proudfoot and Benedict Anderson, scholars in Southeast Asian studies who emphasize the important role of the newspaper as a "serialized" medium. Following Anderson's lead, Manickam notes,

> Reading created "a new kind of social relationship which depended not upon personal networks or neighbourhood obligations but upon the shared interests of individual subscribers." As outlined by Benedict Anderson, this new medium of writing and communication fostered by groups outside of the courts enabled people to express issues that were distinct from those found in the court manuscripts.[21]

For example, in the case of native intellectuals' early articulations using the term *Malay*, the term "was imbued with various connotations by newspaper writers, such that it was difficult to determine who was and was not Malay." The difficulty was complicated by the ongoing "newspaper debates of the late nineteenth century between publishers vying for a similar readership in Singapore and the Malay states.[22]

German media theorist Bernhard Siegert notes the academic shift of the "rewriting of cultural history as a history of media."[23] This effectively reconfigures Ernst Cassirer's neo-Kantian formula "The critique of reason becomes a critique of culture," into the alternative formula "The critique of reason becomes a critique of media."[24] Joseph Vogl expounds on this understanding of media as embracing "prehistoric registers of the tides and stars to the ubiquitous contemporary mass media, encompassing physical transmitters (such as air and light), as well as schemes of notation, whether hieroglyphic, phonetic, or alphanumeric."[25] In this sense, media "includes

technologies and artifacts like electrification, the telescope, or the gramophone alongside symbolic forms and spatial representations such as perspective, theater, or literature as a whole."[26] Such a formulation expands the conventional understanding of mediatization that premises cultural analyses, to embrace expressions in traditional "representational" mass media (newspaper, film, television) and, more recently, the new media (video games and the Internet). This is a crucial underpinning to understanding the mediatization of racial discourse about *Uncle Tom's Cabin* in colonial Southeast Asia.

Marshall McLuhan's dictum "The medium is the message" summarizes such mediatization very well; Vogl further expounds on how media "determine our situation" so that "everything we learn and know, we learn and know through media."[27] Vogl's analysis of Galileo's telescope highlights the seventeenth-century understanding of the cosmos as inextricably mediated by the technology of the telescope, the printing press, and, indeed, Galileo's eyes. The validity of this knowledge is, in turn, rooted in the picture of the cosmos that these media technology are able to represent. According to this framework, studying technologies (as media) that provide transparency of representation reveals the more obvious ways through which these media/technologies make legible the analysis of media intersections with the knowledge media aims to represent. Therefore, *Uncle Tom's Cabin* and its adaptations into various artistic media serve as a "telescope" through which to understand the mediality of race epistemology in nineteenth-century colonial societies in Southeast Asia, taking into account that such understanding of race is contingent with the epistemology of media.

Siegert explains that this paradigm shift from "transcendental" cultural studies (*Kulturwissenschaften*) toward mediality of cultural techniques (*Kulturtechniken*)[28] "replaced the emphasis on authors or styles with a sustained attention to inconspicuous technologies of knowledge." In German media theory, these technological media are "located at the base of intellectual and cultural shifts" and "make up for the most part what we now refer to as cultural techniques."[29] In this framework, the notion of cultural technique is premised on the inseparability of culture, technology, and media.

Hans Belting's theory of the anthropology of image is particularly useful in accounting for how image and media form our embodied cognition through sight. He presents the triangulation of its three fundamental components: the picture, image, and human body.[30] Belting defines the picture (which, for him, is interchangeable with "medium") as the translation of an

image into a material or electronic medium, whether as painting, sculpture, film, or photography (in physical or digital format). The interchangeability of his usage of the "picture" and "medium" underscores how the understanding of the picture is dependent on its mediatized expression and manifestation. Thus, we perceive through the materiality and conventions of media. In comparison, image is "neither on the wall (or on the screen) nor in the head alone."[31] Image does not exist by itself. Rather, it happens through its transmission and perception.[32] Image and media/picture are inextricable from each other. Belting explains that "no visible images reach us unmediated." Our perception of images relies on their particular mediality, "which controls the perception of them and creates the viewer's attention."[33] In this sense, the nineteenth century's colonial imagination of race is inextricable from that period's media, including the various medializations of *Uncle Tom's Cabin*. The third aspect in this theory—the one that is most essential in our analysis of race—is the human body. The body realizes the image through its perception of the medium (picture) projected into the mind's eye and activated through embodiment. The human body also reproduces the image through the material production of the picture as the mediatized representation of the image.

An image "happens" or is "negotiated" between the body and the medium. At the same time, the body also functions as a living medium that performs images—whether as private individual or public collective bodies. Our bodies, as Belting points out, "always carry a collective identity in that they represent a given culture as a result of ethnicity, education, and a particular visual environment." Through time, bodies are constantly shaped "by their cultural history and thus never cease to be exposed to mediation via their visual environment."[34]

Thus, understandings of race are not just a matter of the apprehension of the human body and its color or other characteristics; rather, there is a complex process through which race is composed as an image, mediatized, and subsequently intermediated to the body. This is how the body becomes an important epistemological site in the "performance turn" within cultural studies. This analysis of the body as a medium of cultural technique allows us to analyze how understandings of identities are mediated by the individual's performed embodiment. Methodologies in performance studies reveal how social categories of gender, class, and race are repertoires of performed behaviors (e.g., Judith Butler's examination of drag performance; Diana Taylor's investigation of gestures in theater, events, and protests; and Said-

iya V. Hartman's analysis of nineteenth-century popular theater and slave performances).[35] Such understanding allows for analyzing the performative matrix that constitutes the epistemology of race as a constantly reconfigured system of production and perception.

The epistemology of race in colonial Southeast Asia began as a statistical and bureaucratic necessity for colonial administrations' categorization of inhabitants. Later, understanding of race formation was enhanced via media materializations. In turn, racial epistemology was reflected through media and intertwined with the ideologies that propel the distribution and consumption of these very media. Race construction was thereby formulated within the matrix of cultural technique, through performative medialization and its embodiments as projected onto bodies.

By extricating the medium, the body, the image, and the ideologies behind them from their entanglement, we can broach how they serve to normalize social and cultural understanding. By seeing performativity as medialized functions of the body, we recognize race less as an ontological category and more as a bodily mediated construct. In colonial Southeast Asia in the late nineteenth and early twentieth centuries, *Uncle Tom's Cabin* medialized ongoing issues and discourses relevant to the time, materializing particular cultural articulations with specific forms of legibility. *Uncle Tom's Cabin* became a yardstick through which literary, theatrical, and cinematic commercial success was measured. Entertainment news in the early twentieth century often cited Stowe's novel as the epitome of success.[36] Feature articles on writers and celebrities mentioned *Uncle Tom's Cabin* as an important literary influence.[37] Further, film adaptations of the novel were boasted to have the most expensive production budgets and to be successful hits at the box office.[38] These early "entertainment" items—which were becoming important features of commercial newspapers of Western metropoles— were regularly reprinted in Asian colonial newspapers. Through this global serialization of entertainment narratives, *Uncle Tom's Cabin* became a "media event" in the different colonial capitals.

In articulating how media operates, it is not just enough to separate it from its invisible entanglement with image, ideology, and the body. We have to take into account its "medialization," or what Vogl calls "becoming media" (the "media event"). The notion of media as an action underscores its interdependency with its historical eventuality. The transformation of elements, devices, technologies, actors, and bodies into media, Vogl states, "does not imply a generally valid concept of media." In this process, "it is

a question of a specific, local, and limited becoming-media, in which the confluence of various factors decides on the emergence of a medial function."[39] He further explains "that events are communicated through media, but the very act of communication simultaneously communicates the specific event-character of media themselves."[40] In the same line, a history of media is a history of media events "in a double sense: a history of events that determine the production, the representation, and the formation of events."[41] This also implies that our notions and epistemologies are concomitant to the media event on which they hinge.

"MEDIALIZING" RACE THROUGH UNCLE TOM'S CABIN

The ways in which Uncle Tom's Cabin became (global) media were inextricably linked with the concurrent racial discourses that were then circulating transnationally. We see this in how the incipient discourses of racial, imperial, and postcolonial national identities found their early formulations through the reprints of political reports from Europe and in the local news of anti-colonial struggles going on in Southeast Asia. For example, concomitant with Uncle Tom's Cabin fueling the abolitionist movement in the United States, the British Empire found alternative supplies of cheap labor in its colonial holdings of India and China. With new and increasing demands for products grown on colonial plantations in South America, Africa, and Southeast Asia, the demand for "slave labor" brokered by the British came through ports in India and China. By the mid-nineteenth century, the coolie trade (colonial slave trade) was a multinational business conducted by the British (through their global steamship network) and aided by American, French, Spanish, German, Dutch, Portuguese, and Peruvian intermediaries. Jeffrey Lesser notes this trade strategy among "progressive" plantation owners "who saw the end of slavery approaching and looked simply to replace African slaves with another servile group." Abolitionists were "convinced that Chinese contract labor would be a step forward on the path to full wage labor."[42] But as global historian Jürgen Osterhammel patently points out, the supply of Chinese coolie laborers was drawn from abduction and impressment.[43]

In the eyes of "progressive" Southeast Asian colonizers, the abolitionist concerns of Uncle Tom's Cabin aligned with discourses about humanitarian issues in coolie trade. Cross-imperial critiques of colonial and indentured labor policies would often cite Uncle Tom's Cabin as a literary, visual, perfor-

mative, and acoustic reference. In this sense, the various representations of *Uncle Tom's Cabin*—characters, visualizations, scenes, and sound/music— provided medialization of the early articulations of humanitarian recognition and racial identities of the colonial subjects and the coolies.

To cite a specific case, in 1875, with the growing need for laborers to build infrastructure in colonial Sumatra, the Dutch Indies officer W. P. Groeneveld was sent as commissioner to recruit Chinese coolies in Hong Kong and Canton. The Dutch saw the Chinese coolies as cheap hardworking laborers, who were contracted not per head but en masse, under a group leader.[44] A Dutch author, writing under the pseudonym "Delianus" for the *Bataviaasch handelsblad* (Batavian newspaper), penned a series of opinion pieces entitled "Deliana," which exposed the legal, political, and economic problems surrounding coolie laborers employed in Medan (within the sultanate of Deli).[45] In the sixth edition of the series, Delianus criticized the medieval and feudal condition of coolie labor in Deli. By way of a conclusion, he remarked that if the state of affairs there were to have been written up as a realistic novel, it would have turned out to be *Uncle Tom's Cabin*.[46]

Parallelism between the American black slaves from Stowe's novel and colonial indentured laborers found precarious grounds in an 1883 *Uncle Tom's Cabin* production by the Hollandsch Toneel at the Grand Théâtre des Variétés in Amsterdam.[47] In the production, directed by Abraham Israël van Lier, "30 to 40 native Javanese," indentured at the time in the Netherlands as polder workers, played the African American slaves. An article published in the *Soerabaijasch handelsblad* (Surabayan commercial newspaper) three months after the performance in Amsterdam, entitled "Some Observations on Theater, Actors, and Plays," draws a comparison between the "funny Negro talk" and the Javanese misuse of Dutch grammar. Such keenness for the sardonic parallelism extended further to "a variety of body contortions, which are supposed to be constantly carried out by Negros; through numerous kicks, steps, and other punishments, and as a result equal amount of feigned signs of fear, grief or anger." The same article bizarrely expresses worry that the cruel representation of the Javanese playing Negro slaves— for example, being traded in the market and hunted by dogs—might give the wrong impression to any Javanese among the audience, specifically that the Javanese might "get into the delusion that their brethren, because of their inability to conceive and explain the allegory—are really treated like slaves by the Dutch, and that it is good to seek to emancipate themselves and escape from their [the Dutch] domination." The article goes on

to express concern that when the Javanese performers return to Java, their memory of this appearance on stage might "in the end cause more evil than good," which, in this case, refers to the harm it will cause the Dutch colonial control of the East Indies.[48]

Stories of abolition and emancipation struggles from other continents were also circulated in Southeast Asian print media. For instance, a reprint of a report on problems of the coffee industry in Brazil appeared in the *Soerabaijasch handelsblad* in July 1892, recounting slaves' emancipation struggle. Influential to this movement was the establishment of the local newspaper *Redempçâ* (Redemption), which serialized the Portuguese translation of *Uncle Tom's Cabin*. The editor who translated *Uncle Tom's Cabin* drew ideas from it for his incendiary writings.[49] Elsewhere, newspapers used literary and theatrical references to *Uncle Tom's Cabin* for a variety of purposes. The oppressed Uncle Tom, for example, stood in for different subjugated subjects, as was the case in a reprinted article on anarchism in the *Soerabaijasch handelsblad*, where Prince Pyotr Kropotkin's anarchist politics were triggered by his experience of his father's serfs, said to be reminiscent of *Uncle Tom's Cabin*.[50]

Within Southeast Asian colonies, Uncle Tom characters and motives were often projected onto colonial subjects and coolie laborers. Uncle Tom's characterization as a well-mannered, well-dressed servant during his servitude under George Shelby and Augustine St. Clare were typically used as references to colonial subjects who had acculturated to the colonizer's European lifestyle. In 1915, following the seizure of the German colony of Naura Island by the British, a letter from an Australian Forces officer appeared in the "Letter from the Front" section of the *Singapore Free Press and Mercantile Advertiser*. Referring to the natives of the sequestered territory, the officer describes how an "old chief goes to church in a top hat and frock coat, and looks like 'Uncle Tom' of Mrs. Ward Beecher Stowe [sic]."[51]

Likewise, in serving the interests of imperial ideologies, the characters of Uncle Tom's oppressors were projected onto villains. A Parisian opinion piece reprinted in the *Strait Times* in September 1884 contradictorily both criticized France's refusal to accept its self-eviction from Egypt and emphasized France's role in defending Egypt from the anti-Christian and anti-Jewish riots waged by the nationalist Ahmed Arabi. The article states, "There was a time when [France] would have vied with any power in the humane task of protecting the Uncle Toms of Egypt from the kurbash [whip] of their task masters."[52] In this case, a colonial power masks its im-

perial interests by highlighting its humane interests and projecting the role of oppressor onto tyrannical nationalist revolutionaries.

Even when *Uncle Tom's Cabin* was referenced in legal hearings, the politics of the novel could easily be fashioned or scorned to serve colonial interests. The Indian Immigration Bill was debated for three years by the Singapore Legislative Council, under the initiative of the Indian colonial government, with the intention of giving Indian coolies legal protection against plantation owners. This bill required "certificated immigrants" to possess a passport prior to their travel to the territory of their indentureship. While the law's main purpose was to secure legal documents that would verify Indian coolies' identity as subjects of the British Empire, the new passport system (which was key to the law's implementation) would regulate the mobility of those who were "certificated immigrants," differentiating them from those who were not. During the discussion on 10 October 1884, amendments were proposed to eradicate the use of passports altogether. The argument was put forward by council member W. H. Read, who blamed *Uncle Tom's Cabin* for demonizing the image of plantation owners. In his speech, Read overplayed how

> one would be led to suppose that the framer of this Bill looked upon every planter as a Legree, and upon every coolie as an Uncle Tom, who was to expect barbarity of treatment unheard of, except in a sensational novel. One would think that the drafter of this Bill must have had Uncle Tom on the brain, and I am in the opinion of a great many of the restrictions are unnecessary.[53]

Read's proposed amendments were rejected, and the law was passed before the year was over—though it caused bureaucratic problems even decades after its enactment.

Uncle Tom's Cabin not only reverberated in opinion articles and colonial legislative halls where concerns about coolies and other colonial subjects were at the fore; it also served as a reference point for nonhuman beings. In September 1897, the Netherlands Indian Association for the Protection of Animals recommended literature, including the children's book *Edelzwart* (the Dutch translation of Anna Sewell's *Black Beauty*), which was considered the "*Uncle Tom's Cabin* of the horse world."[54] It is worth noting here the unabashed parallelism of animal and slave rights. Its implication can be best understood in the likening of coolies to animals. Delianus explains

that though the coolies in Medan were very well cared for, this was in "the manner in which one takes care of a stud farm or a cattle herd—taking care of one's capital."[55]

The medialization of the racial imagining in the colonial world was as much aural as visual. Musicologists and literary scholars have analyzed the importance of church music in the plot structure of the novel, with most of the main characters having at least one hymn linked to them.[56] Musical and theatrical adaptations of the novel also produced new religious songs and music that were to become repertoire in Protestant churches in the English-speaking world by the end of the nineteenth century.

In the 1890s and the first decade of the twentieth century, church-sponsored music services and concerts featuring *Uncle Tom* music became part of the aural experience of colonial Singapore. On 27 September 1895, the choir of the Epworth League performed a service of songs entitled *Uncle Tom* at the Singapore Methodist Church.[57] The service intermixed readings from the novel by the Methodist pastor Reverend Morgan with songs sung by a twenty-four-person choir, accompanied on the organ by Herbert Polglase and conducted by John Polglase, the local preacher in charge of the English city mission.[58] The choir's *Uncle Tom* service was performed again on 22 September 1904 at the Anglo-Chinese School, a Methodist school for British and Chinese residents.[59] In the same trend, the Presbyterian Church presented *Eva*, a cantata based on *Uncle Tom's Cabin*, on 3 August 1898.[60] Identifying the version(s) of the songs performed at the services and in the cantata is impeded by a lack of archival data, but as the American music historian Thomas Riis points out, Uncle Tom music in America in the 1890s was "so large and eclectic that performers probably interpolated songs much as they did with other shows of the period based on their current popularity rather than relevance to plot or dramatic appropriateness."[61] In Southeast Asia, the circulation of *Uncle Tom's Cabin* through musical adaptations would likely have been similar: the acquisition of original scores would have been a challenge, yet the absence of copyright laws would have facilitated staging.

More than the performance of these musical works, the acoustic medialization of inter-imperial racial discourses in nineteenth-century Southeast Asia was formulated through "sonic images"—which I shall hereinafter refer to as "soni"—some of which were drawn from *Uncle Tom's Cabin*. For example, the ships *Frederic* (burned and shipwrecked in Java) and *Italia* (wrecked in Anjer) both carried Chinese coolies. The surviving Chinese

workers who were being transported for trade were temporarily housed in Batavia, after which a large number of them were indentured by a Mr. Baud of the Netherlands Trading Company. Later, after a serious turmoil caused by the Chinese laborers, Mr. Baud attempted to get rid of the coolies by contracting Captain Nacaise of the wrecked *Frederic* to transport them to Cuba onboard the *Esperance*. Upon hearing of the plan, the Chinese coolies escaped and disappeared. Captain Nacaise, together with the police, organized a search for them. The report of their capture from the newspaper *Java-bode* (Java messenger) was reprinted in the *Straits Times* and describes the coolies "brought to the boom tied to one another in tens, and conveyed on board in armed boats." The report continues, "The unwilling ones, bound like pigs, were seen transported in carts, and many a European inhabitant of Batavia, not to speak of the Chinese and natives, looked upon these scenes with great aversion."[62] In the original report in *Java-bode* (December 1870), the follow-up report in *Bataviaasch handelsblad* (February 1871), and the English translation in the *Straits Times Overland Journal* (March 1871), the hunt for the fleeing coolies was likened to Stowe's scene of slave hunting, "only wanting the hounds of which we read in *Uncle Tom's Cabin*."[63] Despite the Dutch reporter writing about the plight of the Chinese coolies, the *soni* of howling dogs in the chase scene in *Uncle Tom's Cabin* reverberates strongly for journalist and reader alike. The readiness of transmission into English translation in British Singapore demonstrates that besides the action of the hunt, the particular sound reference from the novel and theatrical performances created *soni* transmitted and understood transnationally.

UNCLE TOM'S CABIN IN ANTICOLONIAL SOUTHEAST ASIA

Media becomes a media event when it becomes invisible as media. For colonial administrations and societies in Southeast Asia, the medialization of race in *Uncle Tom's Cabin*—the fact that it became a "media event"—lies equally in its aesthetic and "anesthetic" functions. While the forms and conventions of the media enable aesthetic experiences to be elicited, this could only transpire as the media "erase themselves and their constitutive sensory function, making themselves imperceptible and 'anesthetic.'" Vogl explains that this anesthetic function "cannot be predetermined with any certainty because it is in each case differently constituted as an assemblage, a 'dispositive' (in Foucault's sense) of heterogeneous conditions and elements."[64] Kati

Röttger, a scholar in theater and media studies, also points out the difficulty in defining the ontology of a medium, but she expounds that "only during the process of transmission into another medium" can the aesthetic neutrality of a medium break, after which "the medium appears in a visible or audible way."[65]

As shown in this essay, remediation of the performances was achieved through newspaper articles, which, in turn, enable a twenty-first-century scholar to trace the legibility of these historical media events. As made apparent by the opinions and sociopolitical racial discourses that appeared in colonial newspapers, the literary, theatrical, and cinematic media of *Uncle Tom's Cabin* eclipsed the ongoing racial images and ideologies within a circular loop of the media, image/ideology, and body. But as transnational media, it is also important to note how the migration of media allowed *Uncle Tom's Cabin* to decouple from the images/ideologies and bodies it initially intended to mediatize. The constellation of particular images, ideologies, artistic media, and bodies that allowed *Uncle Tom's Cabin* to become a media event—within the United States and, later, in the colonial societies to which it migrated—would reconfigure, disconnect, or (as with the case of anti- and post-colonial Southeast Asia) cease to function as a media event altogether. When native communities fought against the imperial powers, *Uncle Tom's Cabin* failed to become media in the struggle toward anti-colonial nationalism.

One important consideration here is local populations' ability to read the novel. In the nineteenth century, the literacy rate in Indonesia was less than 10 percent in Bahasa and less than 1 percent in Dutch.[66] Meanwhile, according to the 1921 British Malaya census, Singapore had a general literacy rate of 36.6 percent in the different local languages but only 8.3 percent in English.[67] *Uncle Tom's Cabin* was translated into Dutch and serialized in a local newspaper, and the book was regularly advertised by bookshops in major cities in the Dutch Indies, yet only a small fraction of the native population would have been able to read it. The same problem can be construed in Singapore, despite the increase in advertisements of new editions of the book in the early twentieth century. The circulation of the book was primarily among colonial expatriates and the native elites. It could be argued that this would have been what was necessary for the small group of educated native elite to draw images and media from *Uncle Tom's Cabin* in their fight for emancipation. But anti-colonial racial and nationalist discourses in the region were medialized through the novel's

literary progenies, rather than the novel itself. The genealogy of ideas is traceable via several anti-colonial writers.

The Dutch author Eduard Douwes Dekker, best known under his pseudonym "Multatuli," wrote the novel *Max Havelaar, of De koffieveilingen der Nederlandse Handelmaatschappij* (Max Havelaar; or, The Coffee Auctions of the Dutch Trading Company) in Amsterdam in 1860. Working as a colonial civil servant in the Dutch East Indies between 1839 and 1857, Dekker published the novel upon his return to the Netherlands, in protest against the abusive Dutch colonial system. Southeast Asian scholar and historian Benedict Anderson refers to Dekker as a colonial iconoclast.[68] In a 1999 *New York Times* article, Indonesian nationalist author Pramoedya Ananta Toer calls *Max Havelaar* "the book that killed colonialism." He relates it to Stowe's novel, writing that "just as 'Uncle Tom's Cabin' gave ammunition to the American abolitionist movement, 'Max Havelaar' became the weapon for a growing liberal movement in the Netherlands, which fought to bring about reform in Indonesia."[69]

Writing in a self-reflexive manner, Dekker was well aware of the paradox between the politics of colonialism about which he was writing and the problem of literature as a medium of written words. In *Verzamelde Werken* (Collected works), Dekker reflected philosophically on "truth" and "nature" and on how these constructs are undermined by the dominance of written words in the creation of epistemologies within Western civilization. Dutch literature scholar Saskia Pieterse highlights how "the novel explicitly reflects on its own (in)capability of speaking the truth." An important aspect of Dekker's writing is his strategy of breaking his narrative with self-reflection and constantly stating, "I am not a writer." Pieterse also underlines how Dekker was conscious of placing himself in the same self-reflexive literary tradition of Heinrich Heine, Laurence Sterne, and Miguel de Cervantes and how *Max Havelaar* interweaves references to these authors.[70]

In chapter 17 of *Max Havelaar*, in his reflection on "truth" and the limits of the conventions of fiction (mediality), Dekker compares his book to Stowe's work, asking,

Can the main thing—truth—be denied to 'Uncle Tom's Cabin,' because there never existed an Evangeline? Shall people say to the author of that immortal protest—immortal, not because of art or talent, but because of tendency and impression—shall they say to her, 'You have lied: the slaves are not ill-treated; for there is untruth in your book—it is a novel?' Had

not she to give a tale, instead of an enumeration of barren facts, a tale which surrounded those facts, to introduce them into our hearts? Would her book have been read if she had given it the form of a law-suit? Is it her fault or mine, that *truth*, to find entrance, has so often to borrow the DRESS of a *lie*?[71]

Because of his self-reflexivity (in his politics and artistic medium), Dekker's contemporaries and today's post-colonial literary scholars consider him to be artistically superior to Stowe. In the first English translation of *Max Havelaar* (published in Edinburgh in 1868), the translator, Baron Alphonse Johan Bernard Horstmar Nahuÿs, wrote in the preface that Dekker's novel "proves that what was formerly written in *Uncle Tom's Cabin* of the cruelties perpetrated upon the slaves in America" is "nothing in comparison to what happens every day in the Dutch Indies."[72] Nahuÿs's comparison was not an equation, as he stated,

> I compare *Max Havelaar* to *Uncle Tom's Cabin*, but do not compare Multatuli, the champion and the martyr of humanity and justice, to Mrs. Stowe, for I am not aware that that lady, with all her merits, has sacrificed future fortune, and all that makes life agreeable, for a principle—for right and equity—as has been done by Eduard Douwes Dekker.[73]

In an article in 2006, Benedict Anderson gave a similar opinion, saying, "It is pretty clear that [Dekker] thought his 'campaign' for the Javanese paralleled hers [Stowe's] for the American slaves, but he had all the genius that she lacked."[74]

The literary influence of *Uncle Tom's Cabin* can also be traced in the works of José Rizal, a Filipino writer and propagandist. Rizal read *Uncle Tom's Cabin* during his sojourn in Madrid and found in the novel parallelism between the struggles of the Negro slaves in America and colonial oppression in the Spanish Philippines.[75] The book was considered a literary influence on Rizal's first novel, *Noli Me Tangere* (*Touch Me Not*), originally published in Berlin in 1887. Whether a direct influence or simply the literary convention of the time, *Noli* and *Uncle Tom* shared similar sentimental and melodramatic prose styles. A parallel with Stowe's politics is evident in Rizal's early political stance of advocating for equal treatment of all Spanish imperial subjects—including Filipinos—regardless of color. Thus, racial

discourse was imagined within an enclosed political state and not as a nationalist liberation strategy.

Notably, in 1888, a year after the publication of *Noli Me Tangere*, Rizal came across *Max Havelaar* while in London. In a letter written on 6 December of that year to his Austrian ethnologist friend Ferdinand Blumentritt, he wrote,

> Multatuli's book, which I will send you as soon as I can obtain a copy, is extraordinarily exciting. Without a doubt, it is far superior to my own. Still, because the author is himself a Dutchman, his attacks are not as powerful as mine. Yet the book is much more artistic, far more elegant than my own, although it only exposes one aspect of Dutch life on Java.[76]

Rizal's encounter with Dekker's literary work inflamed his anti-colonial political interest, the consequence of which is evident in his second novel. The sentimental prose of *Noli Me Tangere* would be superseded by the themes of personal and political revenge in *El filibusterismo* (published in Ghent in 1891 and in English, as *The Reign of Greed*, in 1912). Incensed by the colonial and ecclesiastical exposé in *Noli*, the colonial government and local parish church maltreated Rizal's mother and brother. Rizal exacted his revenge in *El filibusterismo* in a shift toward advocating for armed struggle leading toward an independent nation state, triggering the Philippine Revolution, which, in turn, influenced the Indonesian struggle for national independence.

In the case of theater productions, entry to the performances was controlled by expensive tickets and control over admittance to performance venues. More accessible cinemas segregated their auditoriums by race and class. Even so, the movie versions of *Uncle Tom's Cabin* were mostly adaptations of the Tom shows. In adaptations of *Uncle Tom's Cabin* into other art forms, Stowe's story was at once removed from local populations, and her polemics may not have remained perceptible. Therefore, while audiences were exposed to conventions of blackface minstrelsy, the original political intent of the novel was diluted, if not subsumed and normalized, by the medialization of cinematic adaptation.

Emanating from the United States, *Uncle Tom's Cabin*, as a popular media object, found parallelism in the "progressive" colonizer's arguments for the humanitarian treatment of the colonized and the coolie. In the South-

east Asian colonizer's vision of racial discourses, the colonial subjects and indentured laborers deserved humane treatment, albeit while remaining as colonial subjects. From the perspective of the colonized, *Uncle Tom's Cabin* failed to medialize the local racial politics and discourse, and as a medium, it failed to form the matrix of the image of the anticolonial nationalist vision. Despite its popularity across the globe, its particular historical intersection within the bigger social milieus of native Southeast Asians did not allow it to become media. The gap between the native intellectuals and imperial intellectualization of race was in the very media that would have made their (contrasting) imaginations legible.

At the turn of the twentieth century, while Stowe's vision of racial struggle was being imagined within the young American nation, the Southeast Asian anti-colonial and racial struggle developed toward national liberation. Local racial hierarchies were subsumed within the post-colonial nation-state and remained unproblematized into the twenty-first century. As historian and political scientist Filomeno Aguilar Jr. points out, the new nation-states would "reinforce national sentiments and perpetuate the myth of social class structures as exclusively 'national,' thus weakening transnational solidarities." This new global system tends to intensify class (and racial) inequalities as "'national' class structures are intermeshed," creating "transborder oppositional relationship between state and migrant labor."[77] The impact of this is still palpable in many postcolonial nation-states today, both in how practices of these "archaic" methods of domestic labor persist, unaddressed by nation-states, and in how the segregation of the global labor class (which often overlaps with categories of race) serves to justify inequalities in national labor laws, particularly in controlling migrant workers.

Notes

1. Jim O'Loughlin, "Articulating Uncle Tom's Cabin," *New Literary History* 31.3 (2000): 583. See also Henry James, *A Small Boy and Others* (New York: Charles Scribner's Sons, 1913), 159–60.

2. Jo-Ann Morgan, *"Uncle Tom's Cabin" as Visual Culture* (Columbia: University of Missouri Press, 2007). On notions of visual culture and *Uncle Tom's Cabin*, see also Ellen J. Goldner, "Arguing with Pictures: Race, Class, and the Formation of Popular Abolitionism through *Uncle Tom's Cabin*," *Journal of American and Comparative Cultures* 24.1–2 (2001): 71–84.

3. In 1853, the Dutch translation *De Negerhut of het Leven der Negerslaven in Noord-*

Amerika [The negro cabin; or, The life of Negro slaves in North America] was serialized in the Surabaya daily newspaper *De Oostpost: Letterkundig, wetenschappelijk en commercieel nieuws—en advertentieblad* [The eastern post: literary, scientific, and commercial news and advertising paper]. In 1885, the Manila newspaper *La Oceañía Española* [Spanish Oceania] was also the main distributor of the Spanish translation of the novel in the Spanish Philippines.

4. *Eastern Daily Mail and Straits Morning Advertiser*, 8 February 1907, 4.

5. *Java-bode: Nieuws, handels—en advertentieblad voor Nederlandsch-Indie*, 4 June 1856.

6. Frederik L. Schodt, *Professor Risley and the Imperial Japanese Troupe: How an American Acrobat Introduced Circus to Japan—and Japan to the West* (Berkeley: Stone Bridge, 2012).

7. See, for example, the advertisement of Risley's circus in *De Oostpost: Letterkundig, wetenschappelijk en commercieel nieuws—en advertentieblad*, 4 June 1862, 2.

8. Not to be confused with Jack H. Haverly's United Mastodon Minstrels, which toured exclusively in the United States and in England, the group Mastodon Colored Minstrels was formed in Australia by American minstrel performers R. B. Lewis and Clarke Wilson.

9. Matthew W. Wittmann, *Empire of Culture: U.S. Entertainers and the Making of the Pacific, 1850–1890* (PhD diss., University of Michigan, 2010), 267.

10. *Straits Times*, 11 July 1883, 2.

11. *Singapore Free Press and Mercantile Advertiser*, 17 July 1899, 3

12. Ibid.

13. Ibid.

14. *Straits Times*, 1 February 1853, 3.

15. *Eastern Daily Mail and Straits Morning Advertiser*, 17 March 1906, 3.

16. *Eastern Daily Mail and Straits Morning Advertiser*, 19 March 1906, 3.

17. *Singapore Free Press and Mercantile Advertiser*, 5 October 1906, 4.

18. *Straits Times*, 17 October 1916, 6.

19. *Singapore Free Press and Mercantile Advertiser*, 29 July 1918; 30 July 1918, 2; 3 August 1918, 2; *Straits Times*, 29 July 1918, 12; 3 August 1918, 7.

20. By the term *mediascapes*, I refer to Arjun Appadurai's concept of one of the different "scapes" through which modernity is imagined, such as "ethnoscapes," "financescapes," and "ideoscapes." See Arjun Appadurai, *Modernity at Large: Cultural Dimensions of Globalization*, Public Worlds 1 (Minneapolis: University of Minnesota Press, 1996).

21. Sandra Khor Manickam, "Common Ground: Race and the Colonial Universe in British Malaya," *Journal of Southeast Asian Studies* 40.3 (1 September 2009): 595.

22. Ibid., 597.

23. Bernhard Siegert, "Cacography or Communication? Cultural Techniques in German Media Studies," in "New German Media Theory," special issue, *Grey Room* 29 (2007): 27.

24. Ibid.

25. Joseph Vogl, "Becoming-Media: Galileo's Telescope," trans. Brian Hanrahan, in "New German Media Theory," special issue, *Grey Room* 29 (2007): 14–25.

26. Ibid.

27. Ibid. Vogl points out that "everything they store and mediate is stored and medi-

ated under conditions that are created by the media themselves and that ultimately comprise those media" ("Becoming Media,"16). As opposed to content analysis or semantics of representation, Bernhard Siegert asserts that German media theory "shifted the focus from the representation of meaning to the conditions of representation, from semantics to the exterior and material conditions that constitute semantics." In Siegert's framework, media is not just an "alternative frame of reference for philosophy and literature but also an attempt to overcome French theory's fixation on discourse by turning it from its philosophical or archaeological head on to its historical and technological feet" ("Cultural Techniques; or, The End of the Intellectual Postwar Era in German Media Theory," *Theory, Culture, and Society* 30.6 [2013]: 50).

28. The German term *Kulturtechnik* can be translated as either "cultural technique" or "cultural technology." Following Siegert's usage of the first translation (which accounts more for bodily practices than for just external technologies) is favored here.

29. Siegert, "Cacography or Communication?," 50.

30. Hans Belting, "An Anthropology of Images: Picture, Medium, Body," in *An Anthropology of Images: Picture, Medium, Body* (Princeton: Princeton University Press, 2001), 9–36; Hans Belting, "Image, Medium, Body: A New Approach to Iconology," *Critical Inquiry* 31.2 (2005): 302–19.

31. Ibid., 302.

32. Ibid., 302–3.

33. Ibid., 304.

34. Ibid., 311.

35. Judith Butler, *Gender Trouble: Feminism and the Subversion of Identity* (London: Routledge, 1990); Diana Taylor, *The Archive and the Repertoire: Performing Cultural Memory in the Americas* (Durham, NC: Duke University Press, 2003); Saidiya Hartman, *Scenes of Subjection: Terror, Slavery, and Self-Making in Nineteenth-Century America*, Race and American Culture (Oxford: Oxford University Press, 1997). See also K. Stengel, "Bodies That Matter," *Social Studies of Science* 36 (2006): 809–13.

36. See, for example, Edward Canninham's article on the novel *De slechtse vrouw in London* (The most disreputable woman in London) in *Soerabaijasch handelsblad* on 30 August 1898, comparing the popularity of that title in London to that of *Uncle Tom's Cabin*.

37. Writers and celebrities who mentioned *Uncle Tom's Cabin* as an important literary influence include Eduard Douwes Dekker, Dutch author of *Max Havelaar* (discussed later in the present essay); Dutch writer Isaäc Groneman (who wrote under the pseudonym "Si-Anoe"), the royal physician of the sultan of Jogjakarata, a regular contributor to the *Bataviasche handelsblad*, and author of *Indische schetsen* (Indian sketches, 1875) (see the editorial "Een navolgenswaardig voorbeeld" [An example worthy of imitation], *Bataviaasch handelsblad*, 9 March 1888); Scottish poet and novelist Andrew Lang, quoted in an interview reprinted in the *Singapore Free Press and Mercantile Advertiser* on 6 May 1905; and Queen Marie of Romania, whose article on *Pall Mall* is summarized in the *Straits Times* of 17 November 1908.

38. For example, the news article "Fortunes on the Screen: Immense Cost of Coming Films," which appeared in the *Singapore Free Press and Mercantile Advertiser* on 10 January 1928, mentions the upcoming Universal film *Uncle Tom's Cabin* as one of the most expensive productions of the season, at £600,000; *Uncle Tom's Cabin* was in the list of "film successes of past years to be revived" that was reprinted in the *Straits Times* on 13 January 1937. In promoting local screenings and performances in Southeast Asia,

theater and film advertisements in colonial newspapers also refer to the successes of the productions in the European colonial capitals.

39. Vogl, "Becoming-Media," 23.

40. Ibid., 16.

41. Ibid., 23.

42. Jeffrey Lesser, "Neither Slave nor Free, Neither Black nor White: The Chinese in Early Nineteenth Century Brazil," *Estudios interdisciplinarios de América Latina Y El Caribe* [Interdisciplinary studies of Latin America and the Caribbean] 5.2 (1994), http:// eial.tau.ac.il/index.php/eial/article/view/1213/1241 (accessed 1 January 2017). For an Asian Studies perspective, see Lisa Yun, *The Coolie Speaks: Chinese Indentured Laborers and African Slaves in Cuba* (Philadelphia: Temple University Press, 2009).

43. Osterhammel states, "Naive farmers' children would be lured away from their parents with various tricks and tales of fabulous riches. Abduction was the simplest way for the recruiting agents to obtain exportable manpower. It was not an abhorrent practice characteristic of Asian 'barbarians'. Until 1814, the Royal Navy had frequently used impressment to crew its warships" (*The Transformation of the World: A Global History of the Nineteenth Century* [Princeton: Princeton University Press, 2014], 184–85).

44. Paul van't Veer, *De Atjeh-Oorlog* [The Aceh War] (Amsterdam: Uitgeverij De Arbeiderspers / Wetenschappelijke Uitgeverij, 1980), 170–71.

45. The title "Deliana" and the pseudonym "Delianus" are wordplays on *Deli*, the name of the sultanate state where Medan is located. In a defensive response by an author who signed K.W., "Delianus" was also referred to as "D. E. Liaan" (*De Sumatra post*, 27 November 1899). From 1862, the sultanate of Deli was in a political contract with the Dutch East Indies colonial government in Java.

46. *Bataviaasch handelsblad*, 6 November 1893, 1. The concluding remarks of the article read, "Het zou een vaardiger pen dan de mijne, in de handen van een beter of merker, het geheele estate leven mee gemaakt hebbend, niet moeijelijk vallen een realistischen roman te schrijven, waardoor een kreet van verbazing zou opgaan, wellicht niet minder, dan indertijd, toen *Uncle Tom's Cabin* verscheen." (For a more skillful pen than mine, in the hand of someone better or more perceptive, who had experienced the entirety of estate life, it would not be difficult to write a realistic novel, that would induce a cry of amazement, perhaps no less, than at the time, when *Uncle Tom's Cabin* was published.); my translation, with gratitude to Lonneke van Heugten for her help in clarifying the many idiomatic expressions in this sentence.

47. *De locomotief: Samarangsch handels—en advertentie-blad*, 10 September 1883, 1.

48. *Soerabaijasch handelsblad*, 6 December 1883, 1.

49. *Soerabaijasch handelsblad*, 23 July 1892, 1–2.

50. *Soerabaijasch handelsblad*, 3 March 1883, 2.

51. *Singapore Free Press and Mercantile Advertiser*, 14 May 1915, 7.

52. *Straits Times Weekly*, 17 September 1884, 9.

53. *Straits Times Weekly*, 25 October 1884, 1.

54. "[Edelzwart] kan worden vergeleken met de 'Hut van Oom Tom' in de paardenwereld" (*Soerabaijasch handelsblad*, 16 September 1897, 5).

55. "De koelie wordt hier goed behandeld, maar op dezelfde wijze, waarop men eene stoeterij of een kudde vee zou verzorgen—hij vertegenwoordigt een deel van het kapitaal" (*Bataviaasch handelsblad*, 11 June 1893, 1).

56. See Cheryl C. Boots, "Harriet Beecher Stowe's Abolition Soundtrack in *Uncle Tom's*

Cabin," *Forum on Public Policy* 2 (2010): 1–14; Dean L. Root, "The Music of *Uncle Tom's Cabin,"* 2007, http://utc.iath.virginia.edu/interpret/exhibits/root/root.html (accessed 1 January 2017).

57. See *Mid-day Herald,* 25 September 1895, 3; *Straits Times,* 30 September 1895, 3.

58. John Morrison Reid and John Talbot Gracey, eds., *Missions and Missionary Society of the Methodist Episcopal Church* (New York: Hunt and Eaton, 1895), 82–83.

59. *Straits Times,* 23 September 1904, 5.

60. *Singapore Free Press and Mercantile Advertiser,* 3 August 1898, 2.

61. Thomas L Riis, "The Music and Musicians in Nineteenth-Century Productions of *Uncle Tom's Cabin,"* *American Music* 4.3 (1986): 268–86.

62. "Bij tientallen zag men hen aan elkander gebonden naar den boom brengen om met gewapende sloepen naar boord te worden vervoerd. Als vargens gebonden zag men de onwilligen op een kar transporten, en menig Europeesch inwoner dezer plaats, om niet van de Chinezen of inlanders te spreken, heeft met grooten afkeer die scènes aanschouwd." The original Dutch article appeared in *Java-bode* (21 December 1870); a follow-up report on the status of the Chinese coolies, with a reprint of the original article from *Java-bode,* was printed in *Bataviaasch handelsblad* (6 February 1871, 2); the English translation was reported in the *Straits Times Overland Journal* (15 March 1871, 3).

63. *Straits Times Overland Journal,* 15 March 1871, 3.

64. Vogl, "Becoming-Media," 16.

65. Kati Röttger, "Questionner l' 'entre': Une approche méthodologique pour l'analyse de la performance intermédiale," in *Théâtre et intermédialité* (Quebec City: Presses universitaires du Septentrion, 2015), 121.

66. Acknowledging that there are "no reliable literacy figures for the nineteenth century," M. C. Ricklefs points out, "We do know that in the 1930 census—after several decades of effort by Islamic, Christian, government, and other schools—the literacy rate in indigenous languages across Indonesia was only 7.4 percent. The literacy rate in Dutch was only .3 percent" (M. C. Ricklefs et al., *A New History of Southeast Asia* [Basingstoke: Palgrave Macmillan, 2010], 222).

67. J. E. Nathan, *The Census of British Malaya, 1921* (London: Waterlow and Sons, 1922), 322, 332.

68. Benedict Richard O'Gorman Anderson, *Language and Power: Exploring Political Cultures in Indonesia* (Jakarta: Equinox, 2006), 252.

69. Pramoedya Ananta Toer, "Best Story: The Book That Killed Colonialism," *New York Times,* 18 April 1999, http://www.nytimes.com/1999/04/18/magazine/best-story-the-book-that-killed-colonialism.html (accessed 1 January 2017).

70. Saskia Pieterse, "'I Am Not a Writer': Self-Reflexivity and Politics in Multatuli's *Max Havelaar,"* *Journal of Dutch Literature* 1.1 (2010): 56.

71. Eduard Douwes Dekker, *Max Havelaar; or, The Coffee Auctions of the Dutch Trading Company,* trans. Baron Alphonse Nahuÿs (Edinburgh: Edmonston and Douglas, 1868), 352–53.

72. Ibid., vi–vii.

73. Ibid., ix.

74. Benedict Anderson, "Max Havelaar (Multatuli, 1860)," in *The Novel,* vol. 2, *Forms and Themes,* ed. Franco Moretti (Princeton: Princeton University Press, 2006), 453.

75. See Charles Edward Russell and E. B. Rodriguez, *The Hero of the Filipinos: The*

Story of José Rizal; Poet, Patriot, and Martyr (London: Allen and Unwin, 1924), 88; Camillo Osias, *José Rizal: His Life and Times* (Manila: Oscol Educational Publishers, 1948), 98.

76. Translation by Benedict Anderson, from "Nitroglycerine in the Pomegranate: José Rizal; Paris, Havana, Barcelona, Berlin—1," *New Left Review* 27 (2004): 113. See also Benedict Anderson, *Under Three Flags: Anarchism and the Anti-colonial Imagination* (London: Verso, 2005). The original letter is quoted in "Cartas entre Rizal y el Profesor Fernando Blumentritt, 1888–1890" [Correspondence between Rizal and Professor Fernando Blumentritt], in *Correspondencia Epistolar* [Epistolary correspondence] (Manila: Comisión nacional del centenario de José Rizal, 1961), vol. 2, book 2, pt. 2, p. 409.

77. Filomeno V. Aguilar, "Global Migrations, Old Forms of Labor, and New Transborder Class Relations," *Southeast Asian Studies* 41.2 (2003): 138.

Katarzyna Jakubiak

The Divided Poland: Religion, Race, and the Cold War Politics in the Rozmaitości Theater's Production of *Uncle Tom's Cabin* in Kraków in 1961

In an article written in 1950 for the Polish émigré journal *Wiadomości* (The news), published in London, Zygmunt Nowakowski tells a story of his encounter with a copy of *Uncle Tom's Cabin* in one of London's stores of used books.[1] After buying the book, on account of its power to transport him back to his "lad days" in Poland, Nowakowski is surprised to discover a reference to his country in St. Clare's description of his father's politics: "He could have divided Poland as easily as an orange, or trod on Ireland as quietly as any man living" (234). Nowakowski is quick to justify the absence of this quote from his cherished childhood copy of the novel: it was, after all, a children's version, only about a hundred pages long and devoid of any extensive political divagations. However, inspired to do a library search, Nowakowski finds the reference missing also from other, "adult" Polish translations, including one published in 1865 under the tsar's censorship, which transformed the quote to "He could have divided *any country* as easily as an orange [. . .]."[2]

Nowakowski's account can be viewed as symbolic of the common workings of *Uncle Tom's Cabin* in the Polish culture of the nineteenth and twentieth centuries—the book's cherished position, its status as primarily a children's text, and the manipulations and abbreviations to which the novel became subject. Most important, Nowakowski's anecdote illustrates the book's problematic relationship with political authority—in this case, the tsar's censorship that, in 1865, seized control of the text to make it compliant with the interests of the Russian, Prussian, and Austrian empires that held power over the partitioned Poland. A hundred years later, attempts at polit-

ical co-optation of *Uncle Tom's Cabin* occurred in Poland again in a parallel context: the communist government tried to manipulate the novel's message into compliance with Soviet ideology and Soviet Cold War politics.[3] Because American race problems constituted the strongest trump card for Soviet criticism of American capitalism,[4] the book, by virtue of its popularity, was an attractive source of arguments for the official anti-capitalist propaganda in Poland.

However, just as the nebulous tsarist revision "any country" could not completely mask the original reference to Poland, the communist goal of harnessing the novel's message for just one political purpose proved unattainable. The Christian content of *Uncle Tom's Cabin*, the novel's use of racial stereotypes, and the universal appeal of its portrayal of oppression made the book's smooth alignment with Soviet ideology difficult, ultimately revealing the weakness of that ideology to hold power over Polish identity. As such, the tensions between the novel's content and Soviet ideology made it possible for Polish readers to interpret *Uncle Tom's Cabin* in ways that actually resisted the Soviet influence, as when Nowakowski, in further parts of the same article, connects St. Clare's words with the recent Yalta Conference: "The remark about Poland divided like an orange seems to have been written today."[5] The theatrical production of *Uncle Tom's Cabin* that premiered on 27 June 1961 at Kraków's Rozmaitości (Variety) Theater—currently the Bagatela (Bagatelle) Theater—is a good illustration of how compliant and resistant ways of reading the novel could co-exist in the same interpretation. At the same time, an analysis of this production reveals how these two ways of reading were linked to the most common tensions underlying the Polish reception of the novel during the Cold War period: affirmation of religion versus its criticism, racism versus anti-racism, and universalism versus specificity.

Regarding the "usefulness" of *Uncle Tom's Cabin* to communist politics, it is likely not coincidental that 1961, the year of the Kraków production's premiere, was the year when the Polish government strengthened its supervision and censorship of theaters all over the country.[6] After Władysław Gomułka, Poland's leader at the time, publicly condemned theaters for "promoting bourgeois drama," local authorities gained power to control repertoires in their districts and openly instructed theaters to produce works of social engagement with clear propagandistic content.[7] At the same time, on the wave of Soviet efforts to draw international attention to American race problems, Polish public institutions showed an

increased interest in artistic expressions that portrayed African American history. From the late 1940s, the Polish press routinely published works by Langston Hughes and Richard Wright, while James Baldwin's writings appeared year after year in multiple editions.[8] In performance arts, an African American presence was initiated in Warsaw by Paul Robeson's visit in 1949, followed by the 1959 performance of *Porgy and Bess* by New York's Everyman Opera. While the Kraków staging of *Uncle Tom's Cabin* was the first post–World War II domestic production that focused on African American issues, it was soon followed by a series of plays by contemporary African American authors: three productions of Lorraine Hansberry's *A Raisin in the Sun* in 1962 (Theater and Film School, Łódź; Wilam Horzyca Theater, Toruń; Adam Mickiewicz Theater, Częstochowa),[9] a production of James Baldwin's *Blues for Mister Charlie* in 1967 (Ludowy [People's] Theater, Kraków), and a staging of Amiri Baraka's *Dutchman* in 1969 (Współczesny [Contemporary] Theater, Warsaw).

Because of the special place of Stowe's novel in Polish culture, an adaptation of *Uncle Tom's Cabin* seemed uniquely suited to initiate this period during which Polish theater saw an increased presence of plays with African American themes. Prior to this stage production, the existence of *Uncle Tom's Cabin* in Polish print culture had been long and dynamic. The novel's first translation, made directly from English by Franciszek Dydacki though condensed from forty-five to thirty-six chapters, was published in 1853. The first full translation by Wacław Przybylski and Ignacy Iwicki appeared in 1860. By 1960, approximately twenty-eight different versions of *Uncle Tom's Cabin* had been published in the Polish language, many in multiple editions;[10] however, only six of these versions could be classified as books for adult readers or mixed audiences. The remaining twenty-two were designed specifically as books for children or young adults, all of which included radical abbreviations or outright rewritings of the plot. The most popular of these versions, translated from German and published by Gebethner and Company, had sixteen editions between 1894 and 1949 and was included as a "lektura uzupełniająca" (supplementary reading) in the national curriculum for elementary schools, from 1937 to 1943.[11] The book appeared again in that curriculum in 1958, when an abbreviated edition of a new translation by Irena Tuwim and Julian Stawiński was approved as mandatory reading for students in the fifth grade.[12] As suggested by Nowakowski's article and other articles about *Uncle Tom's Cabin* that were published in the Polish press in the 1940s through the 1960s, the novel's status as a book for chil-

dren and a text studied in schools caused adult Polish readers to approach it with a sense of familiarity and nostalgia. For example, in an article commemorating the fiftieth anniversary of Stowe's death, the author thinks of *Uncle Tom's Cabin* as part of "the country of our youth," full of "colorful fairy tales and stories of extraordinary heroes," always viewed "as if through a mist."[13] Five other articles strike a similarly nostalgic tone, asking a version of the following rhetorical questions: "Is there anyone among us who did not read *Uncle Tom's Cabin* as a child? Anyone who did not shed a childish tear over the sorry fate of the good slave Tom? Anyone who did not fear for George and Eliza and their son, little black Harry?"[14]

Notably, after associating *Uncle Tom's Cabin* with a childhood reading experience that evokes a sense of community among Polish readers, the articles published in Poland (unlike Nowakowski's article published in London) use the discussion of the book to support the Soviet propaganda that highlighted racism in the contemporary United States. Four articles that celebrate the centennial of Stowe's novel are particularly critical in their tone, citing numerous examples of civil rights abuses against blacks, including the miscarriages of justice against the Scottsboro Boys and the Trenton Six and the government's harassment of Paul Robeson.[15] The most radical of these articles goes so far as to claim that the treatment of blacks in Truman's America had regressed since Stowe's times "from slavery to genocide," quoting extensive passages from the 1951 petition *We Charge Genocide* submitted to the United Nations by the Civil Rights Congress.[16]

A similar mechanism of exploiting the cultural status of *Uncle Tom's Cabin* to fulfill goals of Cold War politics possibly contributed to the Rozmaitości Theater's decision to stage an adaptation of the novel. Polish readers' intimacy with the book likely served as a buffer that enabled the theater to satisfy the government's demand for propaganda art without alienating its audience. According to actor Andrzej Kozak, who played Shelby Jr. in the Kraków production, Maria Biliżanka, the director of the Rozmaitości Theater, strove to creatively circumvent government control of her institution. Because the theater's primary audience was "młody widz" (a young viewer)—a broad label that encompassed children, adolescents, and college students—Biliżanka was given more freedom in her artistic choices than other directors at the time, who were generally pressured to employ social-realist aesthetics.[17] In Kozak's opinion, targeting an audience of young viewers enabled the Rozmaitości Theater to employ the best Polish stage designers, musicians, composers, and choreographers and, thus, to

stage high-quality productions of both "light" and "serious" plays that also attracted adult audiences thirsty for entertainment.[18]

The production was an elaborate, high-quality three-hour show that engaged almost the entire ensemble of the Rozmaitości Theater (about forty people). It featured dancing as well as songs and music written specifically for the occasion, by poet Tadeusz Śliwiak and composer Lucjan Kaszycki. Reviewers praised the production's pathos, humor, and fast-paced action, culminating in the spectacular fistfight between Legree and the young Shelby, apparently modeled on scenes from American Western films.[19] All of these factors must have contributed to the play's relative popularity; it was performed ninety-six times over three theater seasons (1961–63) and was seen by 58,082 viewers.[20]

For the American audience, the aforementioned "entertainment" elements of this adaptation, combined with the use of blackface and an all-white cast, inevitably bring to mind minstrelsy and degrading nineteenth-century "Tom shows," but it is hard to determine the Polish producers' awareness of the links between their play and the American blackface tradition. Minstrelsy never functioned in Poland in the same way as in the United States. Although circus shows with "real or dressed-up Zulus or Dahomeyans" existed in Poland as a form of entertainment throughout the nineteenth century, black-skinned characters appear to have been largely absent from theater.[21] Krystyna Kujawińska Courtney claims that before the time of Ira Aldridge's six visits to Poland (in 1853–67), Polish audiences rarely experienced watching "even actors in blackface."[22] However, the international popularity of Uncle Tom's Cabin as a stage text eventually brought some elements of the minstrel tradition to Polish theater. In 1854, the novel's French theatrical adaptation by A. P. Dennery and P. F. P. Dumanoir was translated into Polish, which led to eight different productions of the play in seven Polish cities between 1854 and 1903, including in Kraków in 1856.[23] While few records of these performances have survived, those that are available suggest that the productions may not have been particularly successful or popular. The 1856 production prepared by Teatr Krakowski (Kraków Theater) had just a single performance. Reviewers of another production based on Dennery and Dumanoir's adaptation—by Teatr Lwowski (Lwów Theater) in 1866—note that the play was performed to an almost empty audience, and they attribute the production's relative failure to Polish theater's lack of familiarity with "Negro and mulatto" characters and to the "enormous difficulty" of representing them.[24] Another adaptation of Uncle Tom's

Cabin that was circulating internationally, Henry Jarrett and Harry Palmer's production, was much better received in Breslau (now Wrocław), where it played for six weeks in 1879—though it is significant that the city was then part of Prussia, albeit with a large Polish population.[25] Also, almost half a century later, Harry Pollard's film version became a popular depiction of the novel, screened in major Polish cities in 1927.

None of these three international adaptations of *Uncle Tom's Cabin* that traveled to Poland can be classified as fully representative of minstrelsy. Dennery and Dumanoir's play, at least in its Polish translation, incorporates many stereotype-defying representations of African Americans, including one of Uncle Tom resisting his oppressors actively, gun in hand.[26] While the productions based on Dennery and Dumanoir's play used Polish actors in blackface, the visiting Jarrett and Palmer's production employed mostly black performers and was modeled on George Aiken's play, which presented a generally sympathetic view of African Americans. Nevertheless, both of these theatrical versions of *Uncle Tom's Cabin* embraced some elements of the minstrel tradition: Dennery and Dumanoir's play featured two new characters, Bengali and Filemon, a comic duo of dim-witted, quarrelsome friends, whom reviewers likened to animals; Jarrett and Palmer's production enacted minstrelsy through comic representations of black dance (especially the big song-and-dance scene on Legree's plantation) and through sentimentalism.[27] Similarly, Pollard's version, though generally perceived as anti-racist, presented minstrel-like scenes of slave dances and slapstick behavior among black musicians, as well as a grotesque portrayal of black children, including an over-the-top interpretation of Topsy.[28] Pollard's film was strongly promoted in Poland along with a new translation of *Uncle Tom's Cabin*, brought out by the publisher Rój in the Cinema Library series and illustrated with photo stills.[29] Through such transnational modes of circulation, minstrel images trickled into the Polish culture. The two best-known black characters in Polish literature, Kali from Henryk Sienkiewicz's novel *In Desert and Wilderness* (1912) and Little Bambo from Julian Tuwim's poem "Murzynek Bambo" (Bambo the little Negro, 1924), both characters in children's books still studied in Polish schools, show characteristics strongly evocative of minstrel representations: unruly behavior (Bambo), self-serving moral reasoning, and pidgin language (Kali).[30]

On the other hand, in Poland in the 1960s, blackface was generally accepted as a neutral theatrical device, used to satisfy the demands of realistic conventions that dominated theater practices at the time. In a country with a

black population of less than two thousand (mostly visiting African students) and virtually no black actors, all Polish theater productions featuring black characters used blackface; the practice was applied even in the five aforementioned productions of plays by Hansberry, Baldwin, and Baraka, and participants hardly ever questioned this choice.[31] Some scholars of transnational performance have argued that outside the United States, in certain contexts, including those of realistic theater, blackface performance can be viewed as detached from minstrelsy and the ideological weight associated with race hierarchies.[32] However, regardless of the conventions of the times and the producers' intentions, such detachment would be difficult to justify for the Kraków production of *Uncle Tom's Cabin*. As Sarah Meer has demonstrated, Stowe herself borrowed from minstrelsy when constructing her character types and patterns of dialogue.[33] The international success of the novel, in turn, facilitated the global circulation of racial imagery present in minstrelsy. The novel's entanglement in the minstrel tradition was thus a source of one of the major tensions underlying the 1961 Kraków production: while the play reproduced many degrading global stereotypes of black people (a point that I develop in later parts of this essay), its official goal, dictated by Cold War politics, was to condemn racism in both American and global contexts.

Such anti-racist rationale for the staging of *Uncle Tom's Cabin* is presented in two articles included in the production's playbill—one written by the author of the adaptation, Lidia Słomczyńska; the other by the co-producer, Tadeusz Śliwiak. Słomczyńska initially justifies the theater's decision to "revisit . . . distant and gloomy chapters of American history" by the need to draw parallels with contemporary "wild, fanatic cruelty" against black citizens, "manifested in the U.S. legislation." Both she and Śliwiak cite examples of present-day segregation and lynchings in America; however, they are careful to note that the play addresses a universal problem of racial discrimination, which is "not unique to the American continent."[34] Słomczyńska links Uncle Tom's world with the Polish audience's recent World War II experiences, comparing the plantation system in the American South to the Nazi concentration camps.[35] On the basis of this parallel, she builds a universalizing argument that the message of *Uncle Tom's Cabin* transcends specific temporal and geographic contexts: "It is not exactly about the law established in a society, but about shameful, cannibalistic tendencies. It is about dismantling the myth of nations destined to rule and dominate, and of others created supposedly for inferior tasks. Finally, it is about a fight against the evil racist ideology."[36]

Śliwiak's commentary continues Słomczyńska's claims about the universalism of *Uncle Tom's Cabin*, but it turns the argument in a surprising direction: Śliwiak explains that the event immediately motivating the theater's decision to stage the novel was the assassination of Patrice Lumumba, the first democratically elected prime minister of the Republic of Congo.[37] The assassination took place just three months before the Kraków premiere, inspiring one of the largest international controversies of the Cold War period, as Lumumba was murdered under circumstances that implied the support of both Belgian and U.S. authorities. At the time, the U.S. government denied any participation in the murder, but the Soviet Union emphatically denounced the United States as guilty of the charges.[38] Śliwiak's association of *Uncle Tom's Cabin* with the Congo events implicitly points a finger at the United States as well, since it encourages the audience to draw connections between nineteenth-century American slavery and contemporaneous Western imperialist interests in Africa. At the end of his article, Śliwiak goes so far as to present the leaders of African decolonization, including Lumumba, as modern versions of Uncle Tom, albeit more mature and defiant; no longer "martyr[s] humbly accepting beatings and death from the hands of oppressor[s]," they are now "fighter[s], who can defend [themselves] effectively."[39]

An even more direct link between Lumumba and Uncle Tom is drawn at the very opening of the playbill, through a fragment (notably translated from Russian to Polish) of Lumumba's poem "May Our People Triumph," featuring the following lines:

'Twas then the tomtom rolled from village unto village,
And told the people that another foreign slave ship
Had put off on its way to far-off shores
Where God is cotton, where the dollar reigns as King.
There, sentenced to unending, wracking labour,
Toiling from dawn to dusk in the relentless sun,
They taught you in your psalms to glorify
Their Lord, while you yourself were crucified to hymns
That promised bliss in the world of Hereafter.[40]

With these lines, the producers present Lumumba almost as an interpreter of Uncle Tom's story, underpinning their attempt to produce a reading of it that is compliant with the official line of Cold War politics. Through refer-

ences to "another foreign slave ship," "cotton," and "the dollar," the poem connects American slavery with colonialism, drawing attention to the transnational dimension of the events depicted in the production. Moreover, through portrayal of religion as a tool of subjugation, the poem sets the ground for a critical reception of the play's Christian content, an aspect of *Uncle Tom's Cabin* that caused the greatest ideological tension not only in the Kraków production but in the overall Polish reception of the novel during the Cold War period.

Controversy surrounded the presence of religion in the translations of *Uncle Tom's Cabin* published in Poland during the Cold War. The Kraków adaptation, written by Lidia Słomczyńska, was based on the 1954 translation by Tuwim and Stawiński, generally considered the most complete and accurate one ever published in the Polish language. Their translation preserves all the original Christian references intact and limits criticism of the novel's religious message to several passages of the introduction, where Stowe's religiosity is referenced as "a childish mysticism" that produced images "far-removed from reality."[41] That the officially anti-religious Polish government allowed such relatively lenient treatment of the Christian content in this translation could be attributed to the immediate political context of its publication. In December 1954, the month when the translation was launched, a wave of widespread social protests, not surprising in a society that was 99 percent Catholic, forced the Polish government to temporarily adopt a moderate approach toward the Catholic Church and its role in Polish public life.[42] However, when the second edition of the translation, abbreviated by Adam Leszczyński, appeared four years later, the government had just started its new anti-Catholicism "offensive," which, in addition to anti-religious propaganda and persecution of clergy, involved a program of secularization of the education system and culminated in the 1960 ban on teaching religion in schools.[43] Since the 1958 edition of Tuwim and Stawiński's translation was made mandatory reading in primary schools, it seems logical that Leszczyński's abbreviations affected primarily the novel's Christian content: most references to Tom's faith and his teaching of it to other people were removed, with the exception of several instances of prayer on Legree's plantation, a strategy that was later repeated in Słomczyńska' adaptation. In an enthusiastic review of the 1958 edition, Krystyna Kuliczkowska rightly observed that making the cuts foregrounded comments on religion as a tool of oppression, articulated by George Harris and Augustine St. Clare.[44] Kuliczkowska's review also gives one a glimpse into the rhetoric of the of-

ficial justifications for the manipulation of the novel. She noted, "Evidently, there are books whose original versions should be read by professionals only but whose essential social tasks can be accomplished in modified or abbreviated versions."[45] In line with this philosophy, the full text of the 1954 translation by Tuwim and Stawiński was never again published in Poland; the two consecutive editions, published in 1960 and 1966, were of the abbreviated version. Significantly, each of the three abbreviated editions had a print run of eighty thousand copies, while the original translation ran to twenty-five thousand copies.

Even the abbreviated version of the translation must have proven ideologically problematic for the communist regime in Poland. In 1964, the Department of Publishing, the Ministry of Art and Culture's unit that controlled national publishing plans, commissioned a new version of *Uncle Tom's Cabin* for young adults, from the writer Stanisław Stampf'l. Unabashedly labeled an independent novel, "written on the basis" of Stowe's work, this de facto adaptation of *Uncle Tom's Cabin* introduced changes into the plot that not only undermined the depth of Tom's faith but also rendered his Christ-like martyrdom futile. In Stampf'l's version (unlike in the original), Legree's overseers Sambo and Quimbo do not convert to Christianity under the power of Tom's charisma, nor do they alter their exploitative attitude toward their fellow slaves. Similarly, George Shelby neither emancipates his slaves nor vows, as he does in the original, to "drive out [the] curse of slavery from [his] land" (429). The book ends with Chloe mourning after receiving news of Tom's death. In addition, many times throughout the book, the third-person omniscient narration openly questions the sense of religion and the existence of God, as in the following reflection after Legree's fatal beating of Tom: "The sky was dense with clouds. Darkness covered the Earth. The universe has so many stars, so many suns and planets where the Creator could rest his eyes. Was God's face turned toward the Earth at that moment? Did he see Cain killing Abel under the protection of laws established by humans, under the cover of the Church's acquiescent silence?"[46] Despite the fittingness of this version of *Uncle Tom's Cabin* in the official communist ideology, Stampf'l's adaptation did not replace the 1958 edition of Tuwim and Stawiński's translation as mandatory reading in schools. Still, it proved to be the most popular Polish version of *Uncle Tom's Cabin* in the Cold War period, with six editions published between 1964 and 1993.

As in the translations discussed above, the Christian content in the text of Słomczyńska's adaptation prepared for the Rozmaitości Theater was

subject to gradual transformations and cuts. As evidenced by the available archival sources, Słomczyńska, in her treatment of religion, initially followed a strategy similar to that adopted by Tuwim and Stawiński in their 1954 translation. In Version 1 of her play, preserved in a typescript in the archives of the Bagatela Theater, Słomczyńska made minimal interventions into the religious message of Tom's story and criticized the book's evangelism only in the accompanying lengthy production notes, written apparently to guide the theater crew in the ideologically correct staging of the text. Later, most likely after an intervention of censorship, Słomczyńska wrote Version 2, which takes many more liberties with the novel's Christian references, steering the audience toward a decisively negative perception of the role of religion in Tom's life. Version 2 was eventually published in an official booklet, which was addressed to other theater groups interested in staging the play and which also included a slightly revised version of the production notes. While it is impossible to tell with absolute certainty whether Version 2 made it to the Kraków stage in the form in which it appears in the official publication, there is strong evidence that this text, with its major anti-religious elements, formed the basis of the performance. The main clue is the anti-Christian "Black Heaven" scene, present only in the text of Version 2 and indicated in the archival photographs and two reviews of the play.[47] Other evidence is the sheet music preserved in the archives, which features scores for all the secular songs appearing in the text of Version 2 and none for the religious songs from Version 1. (I discuss both the "Black Heaven" scene and the songs later in this essay.) The only discrepancy between the text of Version 2 and the records of the performance involves the scene of Eliza's escape across the Ohio River, which appears only in the text of Version 1 but is noted in the photographs, sheet music, and reviews.[48] As the play focused on Tom's story, the scene of Eliza's escape was likely cut out, for structural reasons, in textual revision, then restored in performance, due to its essential place in the cultural imaginary surrounding *Uncle Tom's Cabin*.[49]

All in all, it would have been logical for the Rozmaitości Theater to perform Version 2, considering that this version is most consistent with the compliant reading of the novel's Christianity that Słomczyńska gives in her production notes. Claiming to have discerned Stowe's true sympathies that are not immediately apparent in the novel, Słomczyńska argues that the book's evangelism is merely an outcome of Stowe's upbringing and her desire to follow the moral and aesthetic conventions of her milieu. Thus,

Słomczyńska contends, readers should not be misled by the "evangelical poetics of Uncle Tom's character" or the "multiple overtones of affirmation of his Christian humbleness"; for her, the irony of Tom's violent death and the young Shelby's belated offer to buy his freedom is key evidence that Stowe promotes active resistance against oppression. "The mind and heart of the author are with those who fight," Słomczyńska asserts, and she urges potential producers of her play to make this "hidden but essential" message of the novel more obvious on stage than it has been in print.[50] One of the ways that Słomczyńska recommends for achieving this effect is a careful presentation of Tom as "the true hero of the play, not someone who annoys [the audience] with his evangelical meekness." She notes that the casting considerations are crucial in this respect; rejecting the American tendency to portray Tom as an old man, Słomczyńska insists that the actor playing Tom should be tall, athletic, energetic, and healthy, creating an impression of someone who "knows his strength but does not want to use it."[51] Significantly, the Rozmaitości Theater seems to have respected Słomczyńska's recommendation, assigning the role to forty-two-year-old Eugeniusz Fedorowicz, formerly a second lieutenant of the Polish Home Army.

Słomczyńska further suggests that Tom's religiosity should not appear as a stable feature of his character; instead, it should be manifest as a coping mechanism, "a growing mysticism resulting from misfortunes that befall him." She maintains that Tom's true source of strength and hope throughout his odyssey should be his love for his family and a dream of being reunited with them.[52] In congruence with this recommendation, both text versions of Słomczyńska's play open with the scene of "the evening in Uncle Tom's cabin" rendered in a way that constructs Tom primarily as a father, husband, and friend and only secondarily as "a patriarch in religious matters, in the neighborhood" (35). At the end of the scene, Tom does lead the congregation in singing a religious hymn, which is a compilation of various lyrics quoted in chapter 4 of the novel (with music by Kaszycki).[53] However, before doing that, Tom engages in other significant acts: singing a lullaby (written by Śliwiak and Kaszycki) to Polly; soliciting the young Shelby's help to free George Harris from his master; and, finally, joking and gossiping with other slaves as they arrive at the meeting in his cabin. While the stage dialogue indicates that Tom's singing of the hymn is only a start of the meeting proper, the rest of the meeting is not portrayed. Thus, the actors' banter and the exchange of plantation gossip come to dominate the scene, so that, unlike in the novel, the meeting appears to be mostly social rather

than religious. In fact, in her production notes, Słomczyńska emphasizes that the meeting's function should appear to the viewers as "ritualistic, not mystical"—a mechanical preservation of tradition rather than a fulfillment of a true spiritual need.[54]

After the opening scene, revisions of the Christian content between Version 1 and Version 2 show Słomczyńska's efforts to present religion as Tom's evolving coping mechanism. Changes in the use of religious hymns are a good illustration of Słomczyńska's revision strategies in this respect. In Version 1, after the hymn sung in his cabin, Tom sings four more hymns whose lyrics are taken directly from the novel: three during his stay on Legree's plantation and one at Shelby's house, shortly before Eva's death.[55] In Version 2, the hymn in the opening scene is the only one sung by Tom, though he sings a portion of it again in act 3, scene 1.[56] The other three hymns are either removed or strategically replaced with secular songs. Before Eva's death, Tom sings to her the same lullaby he sang to his daughter Polly in act 1, an image that again emphasizes the importance of parenthood, rather than religion, in his character.[57] Most strikingly, in act 3, scene 4, instead of the original "When I Can Read My Title Clear,"[58] a celebration of God's power to protect and console, Tom sings a song with the opposite message. The lyrics, written by Śliwiak, read like a charge against God for his contribution to the suffering of black people.

> The bitterness of my lament
> changes all my years
> into a tart, bitter prank,
> the juice of sugar canes.
> Let a Negro touch the strings,
> bitterly the sweet cane rings.
> *It was my God who made the cane*
> *for his black servants.*[59]

The decrease in Tom's attachment to his faith between Version 1 and Version 2 is also noticeable in his interactions with other people. For example, Tom's friendship with Eva, which the original story and Version 1 firmly ground in common prayers, hymn singing, and the study of the Bible, has a secular character in Version 2. Their joint appearances on stage usually involve silly games and pranks, and though Eva does inform her father that Tom teaches her songs about "New Jerusalem and angels," the song that

the two actually perform together is a somewhat nonsensical fable about a turtle and a monkey.[60] As a result of these revisions, Eva's subsequent death, mystical and saintlike in the original, acquires a tone of despair, to the point of nihilism, in Version 2. In both the original and Version 1, Eva replies happily to her father's urging "Tell us what you see!": "O! love,—joy,—peace!" (304).[61] In Version 2, St. Clare's request is met with dramatic silence.

In agreement with Słomczyńska's recommendation that Tom should appear more religious the more he is made to suffer, the only parts of Version 2 in which he actively teaches others about Christianity are in act 3, scenes 1 and 4, set on Legree's plantation. According to Słomczyńska's production notes, Tom's desire to "seek refuge in religion" in these scenes should be portrayed as a desperate response to the accumulation of his misfortunes—the death of St. Clare, the consequent dampening of Tom's hope for freedom, and his cruel treatment by Legree.[62] At the same time, Słomczyńska believes that Tom's turn to religion should be presented as a major factor that leads to his downfall.[63] She is critical of Tom's refusal to assassinate Legree at Cassy's urging, calling it a "chance" that he casts away in exchange for a vague religious "salvation."[64] Nevertheless, she also warns the producers against simplifying the scene: it should be clear that the decision does not come easily to Tom, and his expression should communicate the power of temptation present in Cassy's proposal. A photo of the scene indicates that, again, the Kraków ensemble followed Słomczyńska's guidelines (fig. 17); the facial expression and dramatic bodily posture depicted by Fedorowicz in the picture express a mixture of contradictory impulses, not a confident rejection of the murder that would result from unshaken Christian principles.

Of all the scenes in the play, one whose construction Słomczyńska describes as crucial to ensuring the audience's proper response to religion is the very scene of Tom's death. Słomczyńska firmly asserts that the performance of this scene should inspire viewers' "revolt, anger and protest," teaching them that "the struggle for political and social equality and dignity cannot be replaced with misty promises of afterlife."[65] Revisions made to this part of the play document Słomczyńska's progressive efforts to achieve such an effect. In Version 1, Tom's death scene is still strongly affirmative of religion. Although the novel's most enthusiastic appeals to Christianity are absent,[66] Tom's words spoken throughout this scene retain many original devout evocations of God. He prays for the conversion of Sambo and Quimbo ("My Lord . . . I beg you . . . give me these two souls")[67] and speaks joyfully of his vision of approaching heaven. Most astonishingly, imme-

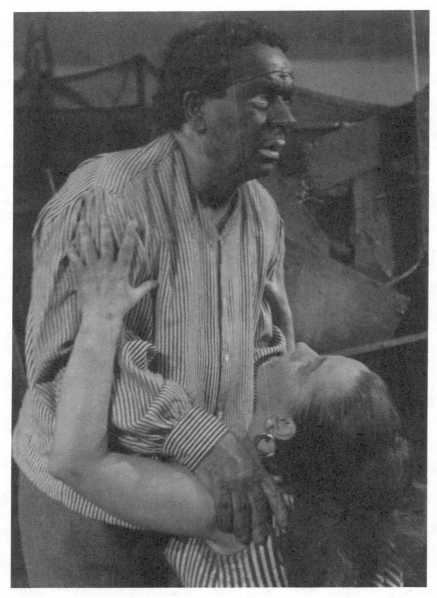

Fig. 17. Tom and Cassy in the Rozmaitości Theater's production of *Uncle Tom's Cabin*. (Photo by Feliks Nowicki. Courtesy of the archives of the Bagatela Theater, Kraków.)

diately before dying, Tom is shown as mustering enough strength to sing a song with the following triumphant lyrics of "Amazing Grace," in close translation by Tuwim and Stawiński:

> And when this mortal life shall fail
> And flesh and sense shall cease,
> I shall possess within the veil
> A life of joy and peace.[68]

In contrast, in Version 2, Tom's death is presented in a gloomy, dispirited tone, with minimal references to religion. While Tom forgives Sambo and Quimbo and thus inspires their repentance, his original prayer for their souls is paired down to the vague "My Lord . . . I beg you," which might easily be a cry of agony.[69] Moreover, his final words before death are consistent with Słomczyńska's emphasis on family, not spirituality, as the source of his strength. Addressing Shelby Jr., Tom accepts death but laments the fate of his wife and children: "Don't call me poor, master . . . Now, all has passed . . . Master, do not tell poor Chloe how you found me . . . My poor children . . . And the youngest one"[70]

These changes in Tom's final words, from the optimistic vision of "joy and peace" in Version 1 to an anxious invocation of Tom's orphaned children in Version 2, certainly bring Słomczyńska closer to the goal of inspiring the audience's "anger and protest." However, the most radical revisions that help the production communicate a message of condemnation of religion are made in the ending of the play. In both versions, the ending brings together the entire cast in the choral performance of "O, Where Is Weeping Mary," a song described in Stowe's novel as "a [common] funeral hymn among the slaves" (340). In addition to the two stanzas quoted directly from Tuwim and Stawiński's translation, Słomczyńska incorporates a new, third stanza in this performance, adding Tom's name to the existing call-and-response structure of the lyrics.

> O, where is Uncle Tom of Kentucky?
> O, where is Uncle Tom of Kentucky?
> Gone to God's land
> He is dead and gone to heaven,
> He is dead and gone to heaven,
> Arrived in God's land.[71]

In Version 1, this vision of Tom's arrival in heaven has the traditional positive connotations, especially as it is followed by the young Shelby's oath—made on the Bible—to get rid of slavery, an indication that Tom's sacrifice has not been in vain. In Version 2, however, Shelby's oath precedes the performance of the hymn, and the hymn itself becomes part of a new final scene, labeled "Black Heaven," which aims to subvert the Christian concept of "going to heaven."

As Słomczyńska explains in the production notes, "Black Heaven," a pantomime scene written specifically to flesh out the anti-religious message she claims is latent in Stowe's novel, was meant to portray "the heavenly kingdom" as "Tom's last auction block."[72] The stage design for the scene, described in the production notes and depicted in photographs, included props already used earlier in the slave market and plantation scenes of the play: an auction podium and a tree with scales hanging on its branches, at once a practical instrument for weighing cotton and an ironic symbol of "justice" (fig. 18). These familiar props were embellished to produce an ironic effect of a childlike vision of the afterlife. Słomczyńska gives the following recommendations for the stage design of "Black Heaven," strongly evocative of children's craft: "The tree top made of paper with green paper leaves pasted all over it. Paper sun painted golden-yellow hangs on the scales' beam. One of the metal pans holds a paper heart painted dark red."[73] The actors singing Tom's funeral hymn entered this setting as a "choir of black angels" (fig. 19), whose appearance was again modeled on juvenile worldviews: "They are dressed in traditional angelic garments, *the way children imagine angels*: long white robes and white wings."[74] The idyllic design of "Black Heaven" was supposed to correspond with Tom's expectations about afterlife at the moment of his death, which Słomczyńska describes as "*naïve, child-like joy* about leaving this vale of tears." Thus, the scene of Tom's actual entry into heaven, as described in the production notes, was to communicate his disappointment. In Słomczyńska's words, when arriving in "black heaven," Tom should behave "as he behaved earlier in other auction-block scenes; he ascends the podium calmly, majestically, indifferently, like a living symbol of 'black merchandise.'"[75]

Despite Słomczyńska's official proclamation of "Black Heaven" as antireligious, an important discrepancy between the descriptions of the scene in the production notes and the stage directions in the text of the play in Version 2 suggests that the author of the adaptation may have given the producers a chance to construct "Black Heaven" in a pro-Christian and,

Fig. 18. Stage design for the "Black Heaven" scene in the Rozmaitości Theater's production of *Uncle Tom's Cabin*. (From Lidia Słomczyńska, *Chata wuja Toma* [Warsaw: Centralna Poradnia Amatorskiego Ruchu Artystycznego, 1962]. Courtesy of the Bagatela Theater, Kraków.)

thus, resistant way. While the production notes describe Tom as ascending the podium in "tattered clothes" that contrast with other actors' "angelic garments,"[76] the stage directions depict him, at the same moment, as wearing "a white robe,"[77] a nod toward the idea of Tom's salvation or even sanctification. Although no pictures of Tom ascending the podium in this scene exist and, thus, the actual decision of the Kraków producers cannot be re-created, the reviews of the performance provide further evidence that, contrary to the scene's officially intended meaning, the audience may have interpreted "Black Heaven" as a gesture of religious affirmation. In a review for the *Gazeta Krakowska* (Kraków newspaper), one of the media outlets of the ruling Communist Party, Bober criticizes "Black Heaven" as a superfluous "heavenly deathbed vision" of Tom, which disrupts Słomczyńska's otherwise praiseworthy ability to "shift the ideological accents of the story."[78] Kudliński, whose review appeared in a more politically neutral forum, calls the scene Tom's "apotheosis" and praises the appeal of its visual design, ap-

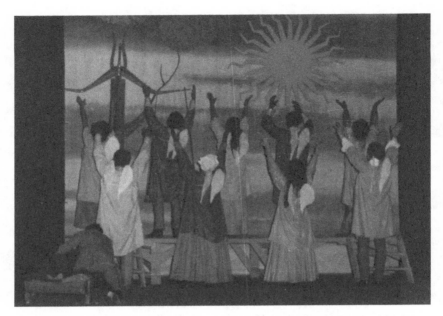

Fig. 19. The "Black Heaven" scene in the Rozmaitości Theater's production of *Uncle Tom's Cabin*. (Photo by Feliks Nowicki. Courtesy of the archives of the Bagatela Theater, Kraków.)

parently missing the irony of the design's naïveté as explained in the production notes.[79] Bober's reference to the play's ideological "shift" indicates that many of the adult audience members, some of whom may have studied *Uncle Tom's Cabin* at school before World War II, were familiar with those translations of the novel that preserved its evangelical content. This knowledge may have influenced the audience's reception of "Black Heaven," making them impose the triumphant Christian message of Tom's original death scene onto this theatrical depiction of his arrival in heaven. Actor Andrzej Kozak remembers that "Black Heaven" always met with a lively response, ringing ovations from the audience.[80] It is possible that the ovations were at least partly a reaction to the scene's subversive potential: the image of Christianity triumphing under persecution must have been politically charged in the 1960s in Poland, where the Catholic Church, as the main site of resistance against the communist system, had been a target of constant government repression. In Kraków itself, just over a year before *Uncle Tom's Cabin* premiered, a government ban on constructing churches in the city's new industrial district (Nowa Huta) initiated a political conflict with

national and perhaps even global repercussions, as one of the local priests actively opposing the ban was Karol Józef Wojtyła (years later elected Pope John Paul II).[81]

In addition to exposing the relative futility of the Kraków producers' attempts to turn *Uncle Tom's Cabin* into an anti-Christian story, "Black Heaven" highlights the tension between the play's proclaimed condemnation of racism and its use of racial stereotypes. After all, the scene's naïve depiction of heaven, representative of Tom's understanding of the afterlife, draws on the common, minstrel-like stereotype of black people as simple and immature. Surprisingly, Bober's review, which, as a voice of one of the government media outlets, could be expected to be more race-conscious, does nothing to refute this stereotype, when it describes the "heaven" depicted in the final scene as "the prop of the primitive and fantastical perception of justice, common at the time in the imagination of Negroes."[82] There is also evidence that this very stereotype was part of Słomczyńska's imagining of black people as she wrote the play. The first version of the production notes includes several remarks, later deleted from the published article, which take African American immaturity for granted. For example, in her analysis of the supporting cast of black characters, Słomczyńska stresses their contribution to "the colorful image of this *primitive but interesting* Negro community."[83] Further, she condemns St. Clare for giving his servants access to "superfluity and fanfaronade, to which *these big children* are especially susceptible."[84] Even though phrases such as these were removed from the published version, the patronizing attitude toward African Americans from which they originated pervaded the production.

Aside from "Black Heaven," an element of the production that manifests the patronizing attitude most clearly are the characters of Topsy and Adolph (St. Clare's servant), both discussed by Lott and Meer as types that Stowe borrowed from minstrel shows. Adolph, whom Lott and Meer recognize as the Zip Coon stereotype,[85] appears in several archival photographs with his fellow servant Rose, always in exaggerated poses and with grotesque facial expressions, strongly evocative of minstrel humor. Reviewers' comments on the performance of Adolph and Rose confirm the tension between the production's representation of these characters and the play's declared anti-racism. The most outspoken in this respect is Jaszcz, a journalist for the largest national newspaper, the *Trybuna Ludu* (People's tribune), who, in his mostly negative review, harshly criticizes the servants' "dog tricks and buffoonery," which, for him, "considerably blunt the propaganda edge of the work."[86]

While Słomczyńska's production notes show no awareness of any potential problems tied to the performance of Adolph and Rose, she does there warn the producers to be cautious in their portrayal of Topsy, whom Lott and Meer interpret as Stowe's female version of Jim Crow.[87] Paradoxically, Słomczyńska's directions for casting Topsy and other black children perpetuate racial stereotypes even as they aim to dismantle them: "[Black] children are no different than the white ones. This is how [Stowe] perceives them, and this is how they should be presented on stage. *Surely, they are more temperamental and vivacious* than the children of the white race; however, their stage behavior should by no means resemble 'little animals,' as this would skew the message of the story."[88] The internal contradiction of Słomczyńska's caution may have contributed to the production's failure to present Topsy in a bias-free way. In the production photographs, not only is Topsy darker than other African American characters, but her gestural vocabulary seems stereotypically excessive. For example, the photograph of her song-and-dance act shows her body grotesquely contorted (fig. 20), indeed bringing to mind Jim Crow characters. In a direct contradiction of Słomczyńska's directions, Kudliński's review praises the actress playing Topsy for "an interesting performance of a *little wild animal*."[89]

Another illustration of the production's bias in representing African Americans is their exoticization. In many scenes, the culture presented on stage seems to portray an imagined African, rather than African American, community. As descriptions and stage design sketches included in the production notes indicate, Tom and other slaves on the plantations live in straw huts rather than log cabins (see the drawing of the huts in the background of fig. 18).[90] When the slaves are working on Legree's plantation at the beginning of act 3, they move "to the rhythm of drums."[91] Most curiously, the songs written by Śliwiak and Kaszycki to replace the original Christian hymns connote a stereotypically African, rather than African American, reality. Some elements of the songs' "Africanness"—the animal fables and trickster humor—can again be linked to the American minstrel tradition.[92] However, the "African" references extend even further: the songs include nonsensical lines that supposedly imitate African languages ("hej ilungu, haj ilungu" and "bwama ku ku lu"),[93] they are full of images of tropical landscapes (burning sun, dry winds, red-hot stones, and mango trees), and they feature exotic fauna (lizards, monkeys, parrots, scorpions, and boas).

While it is possible that the Africanization of the slave culture in this production was a conscious choice made to highlight the link between

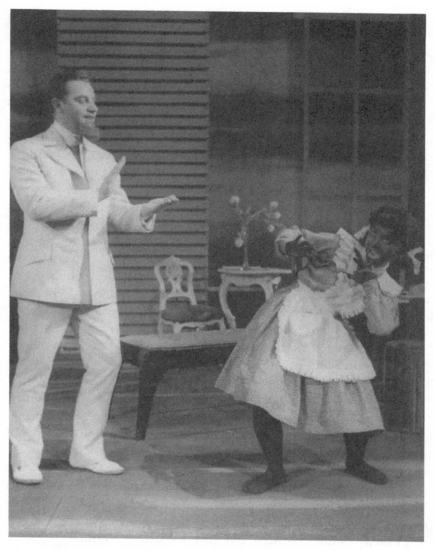

Fig. 20. Topsy sings an "African" song in the Rozmaitości Theater's production of *Uncle Tom's Cabin*. (Photo by Feliks Nowicki. Courtesy of the archives of the Bagatela Theater, Kraków.)

Uncle Tom and Lumumba, this exoticized portrayal directly reflects the popular ways in which blacks have been constructed as "the Other" in Polish culture. Ząbek notes that in Poland in the 1960s, even social science scholars treated all "Negroes" as one ethnic group, "one collective body, with little internal differentiation."[94] Such homogenous "othering" of blacks was partly tied to Polish people's insecurity about their own identity and its place in the global hierarchy of nations, which became manifest in Polish political aspirations after 1918 (the year when the country regained its sovereignty after over a hundred years of partitions). Between 1918 and 1938, the Maritime and Colonial League (originally the Polish Colonial Society), an organization of more than one million members, influenced Polish public opinion and lobbied the government for a concentrated effort to seek colonies in Africa, South America, and Oceania—an agenda that was trammeled only by World War II.[95] Ząbek argues that these colonial appetites, quite irrational given Poland's economic struggles at that time, were not dictated by any specific financial or political interest. Instead, they were driven by a desire to define Poland's newly shaping identity as "European," popularly equated with "imperial culture" and superiority over "uncivilized" peoples.[96] As David Roediger shows, a similar longing guided Polish immigrants in the United States in the early twentieth century, in their "work toward whiteness." Perceived as racially "inbetween people" within the American microcosm of nations, Poles shaped their "self-image [. . .] in more or less conscious counterpoint" to stereotypes of African Americans, in order to elevate their social status.[97] As stereotypes and generalizations are common tools of imperial epistemic violence, the presence of these tools in the Kraków adaptation of *Uncle Tom's Cabin* indicates the producers' desire (even if an unconscious one) to identify with the white master/colonizer rather than the black slave. In consequence, despite its explicitly articulated anti-colonialism, the production failed to apply the story of Uncle Tom to the Congo events in any meaningful way. Presenting a skewed image of African American slaves, the production further fell short of replacing the specificity of American slavery with the specificity of colonialism. The reference to the Congo got lost in the generalized and stereotypical image of Africa and Africans that the production created.

While the Congo parallel did not succeed, it is worth asking what impact this failed attempt at a universalization of *Uncle Tom's Cabin* had on the politics of resistant and compliant readings of the novel. To answer this question, it may be useful to refer, again, to the discussions of minstrelsy by

Meer and Lott, both of whom claim that the effects of black stereotyping in minstrel shows were more complex than just perpetuation of prejudice. Meer argues that while the "black mask"—understood as both blackface and a way of acting—represented black people in a denigrating way, it could also serve as a "disguise" from which working-class audiences would "attack middle-class strictures." This ambiguity entailed a contradiction; minstrelsy could "direct the class anxiety of white workers at potential black rivals and at the same time suggest the possibility of allegiance." [98] It is viable to apply Meer's argument about minstrelsy to the Kraków production of *Uncle Tom's Cabin*. As the stereotypes and generalizations in this production turned blackness into a metaphor, rather than a social reality, the "black mask" became a disguise that allowed Poles to articulate their resistance against the Soviets, so perfectly veiled by the exotic imagery as to be undetected by censorship.[99] Thus, paradoxically, the tools of disidentification from blacks, borrowed from the imperial culture, simultaneously gave Poles a chance to identify with African Americans and their oppressive condition.[100]

I have already shown how Christianity may have been used as an articulation of resistance in the play, despite the producers' efforts to force it into compliance. Further articulations of resistance can be found in the playbill, one of them in Śliwiak's introduction, which erroneously cites 1865 as the year of the first Polish translation of *Uncle Tom's Cabin* and adds that this translation "was severely abridged by the tsar's censors, for whom the Negro characters evoked the rebellious Poles."[101] While Śliwiak seems to repeat the error after Stawiński's introduction to his translation, by mentioning the year 1865 (a date that evokes the anti-Russian Polish uprising of 1863–64) and by referring to the tsar's censorship, Śliwiak implicitly motivates the audience to reflect on the political context of their own reception of *Uncle Tom's Cabin*, which once again involved Russian-dictated censorship that affected the very adaptation they were watching. By extension, Śliwiak's remark encourages the audience to see themselves and their "rebellious" potential in "the Negro characters."

Yet another text featured in the playbill subtly encourages the audience to identify with the black slaves' desire for freedom and may lead to a resistant reading of the play. The poem "To Citizen John Brown," written in 1859 by the nineteenth-century Polish patriot-poet and political activist Cyprian Norwid in response to John Brown's execution, claims to be a "song-gift" sent "over the Ocean" from one freedom fighter (the poet himself) to another (John Brown). While the poem focuses on criticizing American slav-

ery, the final stanza moves beyond the American context, to express a belief
in the general power of literature to stir a desire for freedom in a nation.

> Thus, before Kościuszko's shadow and Washington's
> Will tremble—accept the first bars of this song, o! John . . .
> *Before the song matures, man will die again*
> *Yet ere the song dies, people will rise.*[102]

Because the poem became canonical in Polish literature only in the twen-
tieth century, the invocation of the "rising" of a "people" in the last line
has traditionally been read as a reference to Poles just as much as African
Americans. After 1989, it has even been applied to Poland's "rising" from the
communist system. Moreover, by mentioning Tadeusz Kościuszko, a revo-
lutionary who not only fought for Polish and American independence, but,
in his will, dedicated all his American assets to the education and liberation
of the U.S. slaves, the poem appeals to the sentiments in Polish culture that
run counter to Polish imperial sympathies and encourage allegiance with
members of the black diaspora, as fellow seekers of freedom.[103] Laden with
such connotations and placed in the closing of the playbill, Norwid's poem
provides a counterbalance to Lumumba's poem in the opening, pointing
to a different trajectory for the universalizing interpretation of the play.
This new trajectory could lead the viewers to read the generalized image of
"blackness" in the production as a disguise for Poland.

In closing, it is worthwhile to evoke St. Clare's remark about Poland
again, and to note that the remark itself creates a connection between Afri-
can American slaves and "the divided Poland" through the mechanism of
generalization. St. Clare uses Poland and Ireland as analogies for his father's
compassionless politics toward all oppressed people, placing both countries
in the general category of "the downtrodden," without regard to their spe-
cific national histories. When Nowakowski uses the remark in his article
as a departure for his reflections on *Uncle Tom's Cabin*, the remark's gen-
eralized nature allows him to disregard the differences between Poles and
African Americans and to focus only on those aspects of the novel's content
that can be applied to Poland after the 1945 Yalta Conference. The following
impassioned passage from Nowakowski's article indicates thoughts about
the Soviet domination of the Eastern Bloc, which the novel could have
provoked in Polish readers: "Two slave traders, Roosevelt and Churchill,
resurrected slavery, letting it devour millions of people, who had until re-

cently been free. The book by Mrs. Beecher Stowe has become particularly relevant. Physical and psychological torture, a separation of mothers and children, husbands and wives, life enslavement in appalling conditions, violation of all human rights—all this is becoming the fate of half of the globe. The remark about Poland divided like an orange seems to have been written today."[104] Significantly, although Słomczyńska preserved some of St. Clare's comments about his father in her adaptation of *Uncle Tom's Cabin*, she did not include the reference to Poland in either version of her play. In light of Nowakowski's exhortation, the absence of this remark in the text of Słomczyńska's play is symbolic of the production's political ambiguity; it reflects, simultaneously, the production's potential for a resistant reading of Uncle Tom's story and the producers' suppression of this potential in compliance with the dictates of the communist government.

Notes

1. Zygmunt Nowakowski, "Chata wuja Toma" [Uncle Tom's cabin], *Wiadomości* (London) 15–16 (1950): 1.

2. Nowakowski, 1; my emphasis. All translations from Polish in this essay are mine unless otherwise indicated.

3. Recent English-language studies show that *Uncle Tom's Cabin* was used during the Cold War period as an important source of arguments for communist governments in other countries of the Eastern Bloc as well. See John MacKay, *True Songs of Freedom: "Uncle Tom's Cabin" in Russian Culture and Society* (Madison: University of Wisconsin Press, 2013); Shiao-ling Yu, introduction to "*Cry to Heaven*: A Play to Celebrate One Hundred Years of Chinese Spoken Drama by Nick Rongjun Yu," *Asian Theatre Journal* 26.1 (2009): 1–10.

4. See Mary Dudziak, *Cold War Civil Rights: Race and the Image of American Democracy* (Princeton: Princeton University Press, 2000); Penny Von Eschen, *Satchmo Blows Up the World: Jazz Ambassadors Play the Cold War* (Cambridge, MA: Harvard University Press, 2004).

5. Nowakowski, 1.

6. Andrzej Friszke, "Kultura czy ideologia? Polityka kulturalna kierownictwa PZPR w latach 1957–63" [Culture or ideology? The cultural politics of the leadership of the Polish United Workers' Party in 1957–63], in *Władza a społeczeństwo w PRL* [Government and society in the Polish People's Republic], ed. Andrzej Friszke (Warsaw: Instytut Studiów Politycznych PAN, 2003), 115–45.

7. Ibid., 141.

8. See Katarzyna Jakubiak, "Challenging the Cold War Legacy: Translating African American Literature into Polish," in *America's Worlds and the World's Americas*, ed. Amaryl Chanady et al. (Ottawa: University of Ottawa Press, 2006), 247–55.

9. See Katarzyna Jakubiak, "The Black Body in Translation: Polish Productions of Lorraine Hansberry's *A Raisin in the Sun* in the 1960s," *Theatre Journal* 63.4 (2011): 541–69.

10. My estimate is based on the following bibliographical sources: Bibliography Institute of the National Library of Poland, "Bibliografia polska 1901–1939" [Polish bibliography, 1901–1939] (National Library of Poland, in progress); Julian Dybiec, *Polska w orbicie wielkich idei: Bibliografia polskich przekładów obcojęzycznych piśmiennictwa 1795–1918* [Poland in the orbit of great ideas: The bibliography of Polish translations of foreign-language writing, 1795–1918], vol. 2 (Kraków: n.p., 2014); Karol Estreicher, *Bibliografia polska XIX stulecia* [Polish bibliography of the nineteenth century], vol. 4 (Kraków: Akademia Umiejętności, 1878); Karol Estreicher, *Bibliografia polska XIX stulecia, lata 1881–1900* [Polish bibliography of the nineteenth century, years 1881–1900], vol. 4 (Kraków: Spółka Księgarzy Polskich, 1916); Alina Grefkowicz et al., *Bibliografia literatury dla dzieci i młodzieży 1901–1917* [Bibliography of literature for children and adolescents, 1901–1917] (Warsaw: Biblioteka Publiczna M. St. Warszawy, 2005); Alina Grefkowicz and Bogumiła Krassowska, *Bibliografia literatury dla dzieci i młodzieży* [Bibliography of literature for children and adolescents] (Warsaw: Biblioteka Publiczna M. St. Warszawy, 1995); Teresa Kieniewicz, *Recepcja literatury amerykańskiej w Polsce w dwudziestoleciu międzywojennym* [The reception of American literature in Poland between the world wars] (Warsaw: Wydawnictwo UW, 1971). I have also researched the collection of the National Library of Poland. It is hard to determine the exact number of Polish translations of *Uncle Tom's Cabin*, because most of them exist in multiple versions. Also, some translations borrow liberally from others.

11. Only the first edition of Gebethner's version includes information that it was translated from German; unfortunately, it does not document on which German translation it was based. The name of the Polish translator is missing as well. The information about the "supplementary reading" status of the book comes from the catalog entry of the National Library of Poland.

12. The first edition of this translation was published in 1954. I discuss this translation and its abbreviated 1958 edition later in this essay. About the translation's status in schools, see Krystyna Kuliczkowska, "W stulecie 'Chaty wuja Toma'" [On the centennial of *Uncle Tom's Cabin*], *Nowe Książki* [New books] 5 (1959): 269–70.

13. Tadeusz Jankowski, "Nieznana autorka znanej książki" [The unknown author of a well-known book], *Świat* [World] 8 (1946): 2.

14. Janusz Ostaszewski, "Niewola i niedola czarnych: Z okazji 100-ej rocznicy *Chaty wuja Toma*" [The slavery and the misery of blacks: On the 100th anniversary of *Uncle Tom's Cabin*], *Dziś i Jutro* [Today and tomorrow] 35 (1952): 3, 8. For the other four articles containing very similar rhetorical questions, see Nowakowski, 1; Julian Stawiński, "Chata wuja Toma," *Wieś* [Country] 20 (1952): 2–7; Roman Dyboski, "Południe i żywioł murzyński w literaturze" [The South and the Negro element in literature], in *Wielcy pisarze amerykańscy* [Great American writers] (Warsaw: Pax, 1958), 284–308; Tadeusz Kudliński, "Wuj Tom się nie zestarzał" [Uncle Tom hasn't aged], *Dziennik Polski* [Polish daily] 116 (1961): 3.

15. See Ostaszewski; Stawiński, "Chata wuja Toma"; Irena Sawicka, "Książka walki i nadziei" [The book of struggle and hope], *Życie Warszawy* [Warsaw life] 154 (1951): 3;

WISZ, "W epoce wuja Toma" [In the era of Uncle Tom], *Życie literackie* [Literary life] 1 (1953): 5.

16. Stawiński, "Chata wuja Toma," 2; *We Charge Genocide: The Historic Petition to the United Nations for Relief from a Crime of the United States Government against the Negro People* (New York: Civil Rights Congress, 1951). The tone and vocabulary of Stawiński's article strongly echo the introduction to the 1950 Russian translation of *Uncle Tom's Cabin* quoted by MacKay in *True Songs of Freedom* (81–82). While this may be a coincidence, it is possible that Stawiński, the future co-author of a new Polish translation of *Uncle Tom's Cabin*, was familiar with the Russian edition. Interestingly, Stawiński later published two revised versions of his 1951 article, as introductions to the 1954 and 1958 editions of his translation. With each new revision, the tone of Stawiński's comments about American racism becomes less inflammatory. See Julian Stawiński, introduction to *Chata wuja Toma*, by Harriet Beecher Stowe, trans. Irena Tuwim and Julian Stawiński (Warsaw: Iskry, 1954); Julian Stawiński, introduction to *Chata wuja Toma*, by Harriet Beecher Stow, trans. Irena Tuwim and Julian Stawiński, ed. Adam Leszczyński (Warsaw: Iskry, 1958).

17. George Shelby is called "Alvin" in this production, possibly to distinguish him from George Harris. The character was so named in Gebethner's editions of the novel as well.

18. Andrzej Kozak, personal interview with the author, 28 July 2009.

19. Jerzy Bober, "Aktualny wuj Tom" [The relevant Uncle Tom], *Gazeta Krakowska* [Kraków newspaper] 112 (1961): 5.

20. The data is from *Almanach Sceny Polskiej* [Almanac of the Polish stage], an annual publication of the Polish Academy of Science.

21. Maciej Ząbek, *Biali i Czarni: Postawy Polaków wobec Afryki i Afrykanów* [The whites and the blacks: Attitudes of Poles toward Africa and Africans] (Warsaw: DiG, 2007), 53.

22. Krystyna Kujawińska Courtney, *Ira Aldridge (1807–1867): Dzieje pierwszego czarnoskórego tragika szekspirowskiego* [Ira Aldridge (1807–1867): The story of the first black Shakespearean tragic actor] (Kraków: Universitas, 2009), 225. Aldridge actually died while on a tour in Poland and is buried in the Polish city of Łódź.

23. Jan Michalik, *Dramat obcy w Polsce 1765–1965* [The foreign drama in Poland, 1765–1965], vol. 1, *A–K*, ed. Stanisław Hałabuda (Kraków: Księgarnia Akademicka, 2001), 191.

24. Unsigned review of *Chata wuja Tomasza*, by A. P. Dennery and P. F. P. Dumanoir, trans. Jan Nepomucen Kamiński, *Gazeta Narodowa* [National newspaper] 107 (1866): 2. See also unsigned review of *Chata wuja Tomasza*, *Gazeta Lwowska* [Lwów newspaper] 99 (1866): 417–18; J. S., review of *Chata wuja Tomasza*, *Dziennik Literacki* [Literary daily] 18 (1866): 287–88.

25. Jeffrey Green, Rainer E. Lotz, and Howard Rye, *Black Europe* (Holste-Oldendorf: Bear Family Productions, 2013), 27.

26. See A. P. Dennery and P. F. P. Dumanoir, "Chata wuja Tomasza," trans. Jan Nepomucen Kamiński [ca. 1854], MS RACZ T-527, Raczyński Library, Poznań, Poland.

27. See George F. Rowe's script of Jarrett and Palmer's production in the database *Uncle Tom's Cabin & American Culture*, http://utc.iath.virginia.edu/onstage/scripts/row ehp.html (accessed 11 June 2017). For discussion of George Aiken's *Uncle Tom's Cabin*,

especially the play's sentimentalism, see Eric Lott, *Love and Theft: Blackface Minstrelsy and the American Working Class* (New York: Oxford University Press, 1993), 211–33.

28. See clips from the film and its text in the database *Uncle Tom's Cabin & American Culture*, http://utc.iath.virginia.edu/onstage/films/mv27hp.html (accessed 11 June 2017). For discussion of the film and its American reception, see David S. Reynolds, *Mightier than the Sword: "Uncle Tom's Cabin" and the Battle for America* (New York: W. W. Norton, 2011), 230–37.

29. See Harriet Beecher Stowe, *Chata wuja Toma*, trans. A. Wolf (Warsaw: Rój, 1927).

30. See Ząbek, 56.

31. See Jakubiak, "Black Body in Translation."

32. See Catherine M. Cole, "Reading Blackface in West Africa: Wonders Taken for Signs," *Critical Inquiry* 23.1 (1996): 183–215; William Huizhu Sun, "Power and Problems of Performance across Ethnic Lines: An Alternative Approach to Nontraditional Casting," *Drama Review* 44.4 (Winter 2000): 86–95.

33. See Sarah Meer, *Uncle Tom Mania: Slavery, Minstrelsy, and Transatlantic Culture in the 1850s* (Athens: University of Georgia Press), 21–50.

34. Playbill of *Chata wuja Toma*, directed by Maria Biliżanka, Rozmaitości Theater, Kraków (1961), Archives of the Bagatela Theater, Kraków.

35. An earlier article also compares Legree's plantation to a Nazi concentration camp. See Ostaszewski.

36. Playbill of *Chata wuja Toma*.

37. Ibid.

38. The 1975 declassification of the Congo cables revealed that, although not directly responsible, the U.S. government was complicit with the murder by providing material support to Lumumba's political rivals. Also, the CIA made a failed attempt to assassinate Lumumba in 1960. See Madeleine G. Kalb, *The Congo Cables: The Cold War in Africa—from Eisenhower to Kennedy* (New York: Macmillan, 1982).

39. Playbill of *Chata wuja Toma*.

40. Patrice Lumumba, "May Our People Triumph," translated from Russian by Thomas Schmidt, available at https://www.marxists.org/subject/africa/lumumba/xx/poetry/triumph.htm (accessed 11 June 2017). The poem is also known in English under the title "Weep, Beloved Black Brother." Schmidt's translation is closer to the Polish version than another existing English translation, done by Lillian Lowenfels and Nan Apotheker directly from French, in which the poem was originally composed.

41. Stawiński, introduction to *Chata wuja Toma* (1954), 17.

42. See Bartłomiej Noszczak, "Polityka państwa wobec kościoła rzymskokatolickiego w Polsce w latach 1944–1956" [The Polish state's policy toward the Roman Catholic Church, 1944–1956], in *PRL od lipca 44 do grudnia 70* [Polish People's Republic between July 1944 and December 1970], ed. Krzysztof Persak and Paweł Machcewicz (Warsaw: Bellona, 2010), 139–66. The widespread protests reacted against the persecution of the clergy, mostly the 1953 arrest of the popular primate Stefan Wyszyński.

43. Wojciech Roszkowski, *Historia Polski 1914–2005* [The History of Poland, 1914–2005] (Warsaw: Wydawnictwo Naukowe PWN, 2009), 248, 264.

44. Kuliczkowska, 270.

45. Ibid., 269.

46. Stanisław Stampf'l, *Chata wuja Toma* (Warsaw: 1964), 285.

47. See Kudliński; Bober.

48. See Kudliński.

49. In both Version 1 and Version 2, the subplot of Eliza and George is moved to the background. While those two characters do appear on stage at the beginning of the play, most of their later story is related through other characters.

50. Lidia Słomczyńska, *Chata wuja Toma* (Warsaw: Centralna Poradnia Amatorskiego Ruchu Artystycznego, 1962), 60.

51. Ibid., 64.

52. Ibid.

53. The lyrics appear in close translation from the English, taken directly from Tuwim and Stawiński (1954).

54. Słomczyńska, *Chata wuja Toma*, 64.

55. The hymns are "Wings of the Morning" (Stowe, 268) in act 2, scene 1; "Song of Mary" (Stowe, 351) in act 3, scene 1; "When I Can Read My Title Clear" (Stowe, 401) in act 3, scene 3; and "Amazing Grace" (Stowe, 399–400) in act 3, scene 5.

56. Słomczyńska, *Chata wuja Toma*, 43.

57. Ibid., 40.

58. Lidia Słomczyńska, "Chata wuja Toma" [ca. 1961], TS, Archives of the Bagatela Theater, Kraków, 104.

59. "Gorycz moich skarg / zmienia każdy rok / w gorzki, cierpki żart, / w trzcin cukrowych sok. / Gdy strun dotknie dłoń Murzyna, / gorzko dzwoni słodka trzcina. / Stworzył ją mój Bóg / dla swych czarnych sług" (Słomczyńska, *Chata wuja Toma*, 49; my emphasis).

60. Ibid., 26.

61. Słomczyńska, "Chata wuja Toma," 86.

62. Słomczyńska, *Chata wuja Toma*, 64.

63. Ibid., 65.

64. Ibid., 60.

65. Ibid.

66. I have in mind the appeals "*Heaven has come!* I've got the victory!—the Lord Jesus has given it to me! Glory be to His name!" and "O, Mas'r George! What a thing 't is to be a Christian!"—as well as Tom's final words, which quote the Bible: "Who,—who,—who shall separate us from the love of Christ?" (426–27).

67. Słomczyńska, "Chata wuja Toma," 117. Stowe's original reads, "O Lord! Give me these two more souls, I pray" (423).

68. "Gdy ziemski żywot skończy się / Ustanie serca bicie / Czekać mnie będzie skryte w mgle / Radosne, jasne życie. / I choć po wiekach nawet stu / Jasnością lśniąc wspaniale / Będziemy tak jak w pierwszym dniu / Śpiewać o Jego chwale" (Słomczyńska, "Chata wuja Toma," 120). The lyrics are quoted by Stowe (399) and in Tuwim and Stawiński (1954), 471. In the translation by Tuwim and Stawiński, the source of the lyrics is not identified, so it is unclear whether Słomczyńska was aware that she was quoting "Amazing Grace." The official Polish translation of the hymn is different from that of Tuwim and Stawiński, and it was sung only in Protestant churches in the 1960s. Still, had the song been included in the performance, even without a reference to its source, its Chris-

tian message would have been powerful enough to make an impression on the predominantly Catholic audience.

69. Słomczyńska, "Chata wuja Toma," 55.

70. Ibid., 56. In the original, the passage reads, "Ye mustn't, now, tell Chloe, poor soul! how ye found me;—'t would be drefful to her. Only tell her ye found me going to glory; and that I couldn't stay for no one. And tell her the Lord's stood by me everywhere and al'ays, and made everything light and easy. And oh, the poor chil'en and the baby!—my old heart's been most broke for 'em, time and agin! Tell 'em all to follow me—follow me!" (426).

71. Słomczyńska, "Chata wuja Toma," 121.

72. Słomczyńska, Chata wuja Toma, 60.

73. Ibid., 74.

74. Ibid., 69; my emphasis.

75. Ibid., 66; my emphasis.

76. Ibid., 69.

77. Ibid., 57

78. Bober, 5.

79. Kudliński, 3.

80. Kozak, interview.

81. See Roszkowski, 264.

82. Bober, 5.

83. Lidia Słomczyńska, "Od autorki adaptacji" [From the author of the adaptation] [ca. 1961], TS, Archives of the Bagatela Theater, Kraków, 25; my emphasis.

84. Ibid., 14; my emphasis.

85. Lott, 222; Meer, 41.

86. Jaszcz [Jan Alfred Szczepański], "Kraków, wizyta teatralna" [Kraków, a theater visit], Trybuna Ludu 300 (31 October 1961), available in the Polski Wortal Teatralny database, http://www.e-teatr.pl/ (accessed 31 May 2015).

87. Lott, 222; Meer, 36–37.

88. Słomczyńska, Chata wuja Toma, 68; my emphasis.

89. Kudliński, 3; my emphasis.

90. Słomczyńska, Chata wuja Toma, 73. In the Polish translation of the novel's title, the word chata could mean both "cabin" and "hut."

91. Ibid., 43.

92. For the discussion of this feature of minstrel shows, see Derek B. Scott, Sounds of the Metropolis: The Nineteenth-Century Popular Music Revolution in London, New York, Paris, and Vienna (Oxford: Oxford University Press, 2008), 153–57.

93. Słomczyńska, Chata wuja Toma, 23, 36.

94. Ząbek, 122.

95. Ibid., 68–69.

96. Ibid., 69–71.

97. David Roediger, Working Toward Whiteness (New York: Basic Books, 2005), 109–10.

98. Meer, 11.

99. A similar subversive method of resistance was deployed seventeen years later by Ryszard Kapuscinski, whose book The Emperor criticized the Polish communist government, under the disguise of a description of Haile Selassie's regime in Ethiopia. See

Ryszard Kapuściński, *The Emperor: Downfall of an Autocrat*, trans. William R. Brandt and Katarzyna Mroczkowska-Brandt (New York: Vintage, 1989).

100. A similar paradox was present in other Polish productions in 1960s of plays with African American themes. See Jakubiak, "Black Body in Translation."

101. Playbill of *Chata wuja Toma*. 1865 is the year when the second edition of the 1860 translation was published by the Warsaw publisher Blumenthal.

102. "Więc, nim Kościuszki cień i Waszyngtona / Zadrży—początek pieśni przyjm, o! Janie . . . / Bo pieśń nim dojrzy, człowiek nieraz skona, / A niźli skona pieśń, naród pierw wstanie" (Cyprian Norwid, *Poems*, trans. Danuta Borchardt, in collaboration with Agata Brajerska-Mazur [New York: Archipelago Books, 2011]).

103. A moment in Polish history that best illustrates the existence in Poland of both imperial and anti-imperial sympathies with the African diaspora was Polish participation in Napoleon's offensive against the Haitian Revolution. In 1803–04, approximately fifty-five hundred Polish legionnaires arrived in Saint-Domingue with Napoleon's forces, hoping to receive, in return, his support for Polish liberation. Once there, however, demoralized by their poor treatment by the French and sympathizing with Haitians as another nation who sought liberation from foreign tyranny, several hundred of the Polish soldiers deserted Napoleon to join the ranks of the Haitian revolutionaries. See Jan Pachoński and Reuel K. Wilson, *Poland's Caribbean Tragedy* (New York: Columbia University Press, 1986).

104. Nowakowski, 1.

Stefka Mihaylova

Raising Proper Citizens: *Uncle Tom's Cabin* and the Sentimental Education of Bulgarian Children during the Soviet Era

In 1954, the Bulgarian state-owned publisher Narodna Mladezh published the first Soviet-era Bulgarian translation, from the English original, of *Uncle Tom's Cabin*.[1] Between 1954 and 1998, this translation, made by the novelist and translator Anna Kamenova, underwent eleven editions and became a staple of the Bulgarian literature curriculum for middle school. The afterword to the second edition, written by the prominent translator and scholar of British and American literature Vladimir Filipov, prescribes an ideologically correct reading of Stowe's novel.

> [*Uncle Tom's Cabin*] did more than the abolitionists' entire organized propaganda for engaging the people's masses in the struggle against slavery[...]. We must also note that progressive Americans were not the only ones who opposed slavery. So did also the bourgeoisie of the industrialized Northern states, who needed cheap wage labor [...]. We read *indignantly* about the cruelty of people such as Haley and Legree; about the slave markets where Negroes were sold like cattle; about the merciless separation of children from their parents [...]. *Uncle Tom's Cabin* is a realist novel that brightly depicts the lives of Negroes in slaveholding America of the mid-nineteenth century. But the book's value is not only historical. Today, too, [...] Negroes in the USA are in fact slaves. They are subject to all kinds of discrimination and persecution[...]. [Stowe's] narrative stirs in us *disgust* not only toward Haley and Legree but also toward their present-day heirs. And this [disgust] strengthens our will to fight against their efforts to enslave all other nations and thwart the building of our happy future. We will not let this happen.[2]

Over the next three decades, Filipov's interpretation of Stowe's novel was faithfully echoed in prefaces, afterwards, literary criticism, and instruction manuals for teachers. This renders his afterward truly programmatic. Three major interpretive strategies stand out there. First, Stowe is singled out as a voice of "the people's masses" (i.e., the workers and the peasants) against slavery. Next, the opponents of slavery in the United States are divided into progressives, who truly aspire to racial equality, and a bourgeoisie, who seeks to re-enslave black Americans as wage laborers. Finally, *Uncle Tom's Cabin* is classified as a realist narrative that not only accurately depicts the history of black Americans as slaves but also, through inducing proper feelings, moves "us," progressive people from all nations, to a course of action against post–World War II U.S. imperialism and toward "a happy future."

Reflecting and reinforcing Kamenova's own translation choices, these strategies, common to all Soviet-era criticism of *Uncle Tom's Cabin*, helped convert Stowe's Christian sentimental novel into a socialist realist narrative. Underlying this conversion, I argue, is a theory of affect that sought to mold Bulgarian schoolchildren into proper subjects of Soviet internationalism, a political doctrine and practice that pursued the global spread of communism. In the course of this conversion, Kamenova's translation and the accompanying critical commentary also created lasting perceptions of racial difference. In fact, the novel has served at least three generations of Bulgarians as their primary source of information about the history of African Americans and race relations in the United States.

UNCLE TOM'S CABIN BEFORE COMMUNISM: MODELING ENLIGHTENED CITIZENS

Although the conversion of *Uncle Tom's Cabin* into a socialist realist narrative may seem radical, it was facilitated by the novel's pre-Soviet reception in Bulgarian culture, as well as by the transnational success of sentimental literature and sentimental political discourse. *Uncle Tom's Cabin* was first translated in 1858, while Bulgaria was still part of the Ottoman Empire. The first eight chapters were serially published in *Bulgarski knizhitsi* (Bulgarian letters, 1858–62), a popular periodical created to support the emergent modern Bulgarian literature and culture, as well as to inform Bulgarian readers of developments in modern science, culture, economics, and politics around the world. The inclusion of the first chapters of *Uncle Tom's Cabin* in *Bulgarski knizhitsi*'s first volume is therefore emblematic, render-

ing the novel part of the Bulgarian Enlightenment project that sought to prepare the Bulgarian subjects of the Ottoman Empire for their future as citizens of an independent modern nation through exposure to the achievements of modernity, including exposure to famous works of modern world literature.[3]

Reading the preface and introduction to his translation alongside his introduction to *Bulgarski knizhitsi's* first issue provides some clues as to why the novel's translator and *Bulgarski knizhitsi's* founding editor, Dimitar Mutev, considered Stowe's narrative so suitable for the purposes of the Bulgarian Enlightenment project. "[*Uncle Tom's Cabin*] has had immense success all around the world. This success is accounted for in the following words from the introduction to one of the book's editions," Mutev writes. He then quotes extensively from an introduction that probably belongs to the 1852 London edition by Clarke and Company.[4]

> The purpose of this book is to disabuse humanity of the notion that God, who let man rule over the fish of the sea and over the fowl of the air and over the cattle on the earth, has bestowed this rule only on some generations of a certain color, while including others in the rank of cattle [. . .]. Let us recall Brougham's words: "Do not talk to me of rights, do not tell me that the planter is a master of his slaves. I deny this right and reject this rule. Our natural feelings and principles rebel against them [. . .]. In vain are you telling me that laws make this ownership sacred [. . .]. According to [God's] eternal and unchangeable law, every man who detests rapine and bloodshed will be outraged by the criminal thought that a man can own another man."[5]

The author's reliance on "our natural feelings and principles" as the basis of his argument against slavery renders the preface an example of modern reasoning, even as the equal importance of feelings and principles (i.e., reason) also marks his argument as sentimental. In the author's mind, reasoning based on nature is clearly compatible with Christian ideology; hence, the argument belongs not to the anticlerical strand of Enlightenment philosophy that we find in thinkers such as Diderot and Voltaire but to the Protestant strand according to which rationality is fully compatible with Christianity because God created nature as a rational entity.[6]

While the intellectuals and merchants who wrote and funded *Bulgarski knizhitsi* were Orthodox Christians,[7] they were aware of Protestant ideas.

Mutev had most likely been exposed to modern Protestant thought while studying philosophy and physics in Bonn and Berlin in the late 1830s and early 1840s, and under his editorship, the journal published Protestant educational texts.[8] Such contacts with Protestantism seem to have reinforced the conviction, already present among Bulgarian intellectuals and political leaders, that Christianity and modern reasoning can be fruitfully aligned. This conviction was central to the Bulgarian nationalist movement that saw the struggle for an independent Bulgarian church and the effort to establish modern Bulgarian schools as equally important means to political independence. It was also central to *Bulgarski knizhitsi*. Accordingly, the journal's inaugural issue begins with a call to the Lord.

> Glory and gratitude to God! Finally we, too, have a journal whose mission is to be a constant source of light and knowledge in our poor and dark fatherland. Oh, such an event is great for us and very consoling—because it is a special sign that we have begun understanding the usefulness of the sciences and their beneficial effects on the intellectual and moral powers of humanity; because it shows that we, too, have begun understanding how unfortunate a people is and how unable to reach its great and noble predestination when this people deprives itself of the sciences, education, and enlightenment.[9]

Following this introduction, Mutev offers his readers a hagiography of Saint Clement of Ohrid: a prominent disciple of Saints Cyril and Methodius—the Byzantine Greek missionaries who, in the ninth century, created the first Slavic alphabet and the first translation of the Bible into the Slavic dialects—Clement founded one of the first schools of higher learning in medieval Bulgaria. Having thus made an argument for the inseparability between the Orthodox Christian faith and modern knowledge (and before proceeding to an article explaining meteorology and its uses), Mutev further reassures his readers that "there will be always room for God's word" in the new journal.[10]

This stance on the Enlightenment explains why Stowe's novel, which presents Christian faith and education as inseparable from African Americans' emancipation, found such a warm welcome in *Bulgarski knizhitsi*. Even more resonant would have been the novel's contention that slavery is both un-Christian and indefensible by modern reason.[11] By the mid-nineteenth century, a series of measures against slavery had drastically

reduced the number of Caucasian slaves, and most of the sultan's Christian subjects across the Ottoman Empire possessed economic and political freedoms that made their lives very different from those of slaves in the American South, yet the representation of Bulgarians as Christian slaves to the Muslim sultan was a major trope in Bulgarian nationalist literature.[12] Its rhetorical strength drew from the memory of *devşirme* (blood tax), a fifteenth- and sixteenth-century practice (vividly recorded in Bulgarian folklore) whereby Ottoman soldiers recruited and abducted Christian boys (typically aged from seven to ten), converted them to Islam, and enlisted them in the army and civil service.[13] As Betty Greenberg points out, this memory would have easily triggered Bulgarian readers' sympathy for Eliza as a mother who strives to save her child from being sold by the Shelbys.[14]

The story of Eliza saving her child from being sold into slavery is, of course, typical of the sentimental social novel that pits personal interest (that of the slave traders) against the public good (the intact Christian family) and defines virtue as an active stance for the public good.[15] By the 1850s, sentimentality was a mainstream literary and political discourse in the Western world, but the first Bulgarian sentimental works were just being written.[16] Therefore, it is not too far-fetched to suggest that Mutev's translation contributed to framing the pro-nationalist Bulgarian rhetoric in sentimental terms whereby Bulgarians were described as victims of the private interest of an unjust ruler.

Sentimental fiction famously eschews the details of physical environment and physical appearance (so dear to the realist novel), focusing instead on the virtuous protagonist's spiritual struggle as revealed through his or her actions.[17] As a late sentimental novel trying to rally specifically for the emancipation of black slaves in the United States, *Uncle Tom's Cabin* is exceptionally rich in such detail. Appreciating the political importance of this richness, Mutev tried to convey the difference between black slavery in the United States and the Bulgarians' situation in the Ottoman Empire. When referring to Stowe's enslaved characters, he used the word *неволник* (*nevolnik*) to refer to a person without free will (from the Russian *невольник*, "slave, captive, prisoner"), in addition to *роб* (*rob*, "slave"), the more common Bulgarian word for "slave." He was especially careful to use the Russian-derived term where the narrative addresses the legal status of slaves in the American South, as when George Harris points out to Eliza, in chapter 3, that slaves cannot be legally married. Likewise, Mutev made an effort to convey the racial hierarchy in nineteenth-century America. The

word *Negro* was not known to his readers. The description "black" referred mostly to complexion and could connote both physical and moral ugliness. Hence, Mutev used another term derived from Russian: негритянин (*negrityanin*), a masculinized version of the Russian word негритянка (*negrityanka*), meaning "a black woman." But Mutev struggled to convey the various terms used for mixed-race characters. While Stowe describes Eliza and Harry as "quadroons," Mutev described them as "mulattoes," perhaps deciding that the American range of terms for mixed-race people would confuse his readers. On another occasion, a character whom Stowe describes as "a colored boy" (45) becomes арабче (*arabche*), a variation of "Arab," in Mutev's text (41).[18] But while Bulgarians commonly referred to a person of African descent as арапин (arapin), the word also connoted a Muslim. This must have been confusing to Mutev's readers, given that many of Stowe's black characters are explicitly described as Christian. Mutev also struggled with finding Bulgarian equivalents for U.S. institutional and political terms, such as *senate, constitution*, and *state*. As a result, the political reality of living within the "peculiar institution" of American slavery became difficult to communicate.

Lawrence Venuti points out that translators are often tempted to play down some of the foreign aspects of a text in order to make it more appealing to their "domestic" target readerships.[19] But having introduced and defined (in footnotes and parentheses) a number of foreign terms, Mutev seems to have worried that his translation may alienate his readers. Hence, he "domesticated" (as Venuti would say) aspects of the world of Stowe's characters, balancing out the untranslatable foreign ones. Thus, Stowe's description of Aunt Chloe as "silent, and with a heavy cloud settled down on her once joyous face" (46) is translated as "[Aunt Chloe] was silent, gloomy, like the Balkan range."[20] Likewise, instead of the cakes and biscuits eaten by Stowe's characters, Mutev's renditions eat *baklava* and *burek*.[21] Since Mutev had been exposed to foreign cuisines (especially German and Russian) through his travel and studies, the domestication of American food in his translation seems to have been intentional.

Bulgarian translations and editions from the later nineteenth and early twentieth centuries reflect Bulgarians' growing knowledge about the United States. This knowledge seems to have come from two major sources: journalistic reports about the Civil War, which the Bulgarian nationalist press avidly followed; and the establishment of American Protestant cultural and educational institutions in the Bulgarian lands.[22] This growing knowledge

is apparent in Ivan Govedarov's 1898 translation, the only unabbreviated Bulgarian translation of the novel to date. Mutev's 1858 preface describes the novel as a polemic against slavery in general; the expression "generations of a certain color," which he uses as an equivalent of the English original's "races of a certain color," does not communicate the biological understanding and social implications encoded in the American notion of race. In contrast, Govedarov's preface describes the book as an argument specifically against "the slavery of black people" in the American South.[23] Throughout his text, he refers to the enslaved characters as *негри* (*negri*, i.e., Negroes); the word had evidently entered the Bulgarian vocabulary at that point. He also refers to them as "black," perhaps hoping that his readers' new knowledge about the American South will help them distinguish between "black" as a signifier for race and the more established Bulgarian meanings. Govedarov is also more specific about the Christianity of Stowe and her characters. In his preface, he describes Stowe's family as "evangelical" and her point of view as "Puritan."[24] Likewise, his translation strives to fully and accurately convey all elements of the novel's Protestantism, including hymns and rituals.

Importantly, Govedarov's preface shifts the focus of the ideal reader's identification from the enslaved black Americans, as Bulgarians' fellow oppressed Christians, to Stowe herself, as an exemplary modern Christian who has used both her position as a teacher and her faith to help the oppressed.[25] His preface is a short biography of Stowe, and it provides the minimum information about slavery and the Civil War that readers may need to appreciate Stowe's extraordinary service to humanity. Historically, this shift makes sense. In 1898, Bulgarians were no longer subjects of the sultan; since 1878, they had been citizens of a self-governing nation.[26] Hence, they no longer needed models of virtuous victimhood, such as Eliza or Uncle Tom, but instead required models of virtuous citizenship. Govedarov's choice of the evangelical Christian Stowe as such a model conveys a vision of Bulgarians as fully integrated in post-Enlightenment Christian civilization, the same vision that motivated the founding of *Bulgarski knizhitsi*. In fact, Govedarov's translation was part of a series that introduced Bulgarian readers to world-famous works, such as Shakespeare's *Macbeth* and Henryk Sienkiewicz's *Quo Vadis* (1896).[27] Yet, in inviting his readers to identify with Stowe rather than her enslaved characters, Govedarov also sets up a tendency for the future critical commentary about the novel, whereby the focus on Stowe once again obscures the particularities of living as a black slave in the antebellum South.

The implications of this shift are made apparent in the first Bulgarian edition prepared especially for children, D. Mavrov and G. Palashev's 1911 adaptation.[28] Their preface is also a biography of Stowe, though nineteen pages long compared to Govedarov's three. It is a tale of model modern Christian womanhood, culminating in the triumphal social and political success of *Uncle Tom's Cabin*, a book "written not for fame or money, but out of Christian love and fervent sympathy for the oppressed and the humiliated."[29] Imagining Harriet Beecher Stowe's life as the daughter of a Protestant pastor in America would have been as difficult for Bulgarian schoolchildren in 1911 as it is now. This is why Mavrov and Palashev make much of the early loss of her mother, her love of books and learning, and her dedication to teaching. The sentimental figure of the industrious orphan who gets richly rewarded is a staple of Bulgarian folktales.[30] Additionally, teachers enjoyed considerable respect in Bulgarian society in the late nineteenth and early twentieth centuries and were expected to embody patriotic and modern values.[31] In Mavrov and Palashev's preface, the reward for the orphan-teacher Stowe is the immense public impact of her work. Not only did she prove "most convincingly that the Negro is human, equal in reason to his white brother, his suffering as unjust as that of any innocent person," but "the poor people, who had previously had only a vague understanding of the Bible," found her description of Tom's piety so impressive that "they started buying the holy book."[32] Stowe is thus presented as a model enlightened citizen: one who possesses modern and Christian virtues in equal measure. Three pictures portraying Stowe across her lifetime—in her youth (the target readers' age), as a married woman, and in her seventies—reinforce this narrative, further encouraging Bulgarian children (especially girls) to follow in Stowe's footsteps.[33] By contrast, the preface gives black people little attention, both textually and visually. The only visual image of blackness in the preface is a picture of the chain-link bracelet that Stowe received from the Duchess of Sutherland in appreciation for Stowe's contribution to the abolitionist cause (fig. 21). Black Americans, omitted from Stowe's story, are thus synecdochically represented as slaves rather than as citizens.

This reductive representation of blackness continues in the text of Mavrov and Palashev's adaptation, as they cut much of the religious content from Stowe's text. For example, the debate between Miss Ophelia and Augustine St. Clare in chapter 19, over the compatibility of slavery with Christianity, takes up seventeen printed pages in the 2002 Oxford World's Clas-

Златната верижка въ формата на робска верига, която Судерландската херцогиня е
подарила на писателката Бичеръ-Стоу въ 1853 год. въ Лондонъ.

Fig. 21. Reproduction of an engraving by Wat Drake depicting "the golden bracelet,
imitating slave shackles, that the Duchess of Sutherland gave as a gift to the writer
Beecher-Stowe in 1853, London." (From Harriet Beecher Stowe, *Chicho Tomovata
koliba*, adapted by D. Mavrov and G. Palashev [Sofia: Kartinna galleria, 1911].)

sics edition and only four in Mavrov and Palashev's adaptation. Similarly,
in chapter 9, where Senator Bird takes the fugitives Eliza and Harry to the
safety of John Van Trompe's house, Mavrov and Palashev cut Van Trompe's
confession that he changed churches because the pastor whose church he
had previously attended defended slavery. While Stowe's Christian and
civic virtues may have made her pedagogically attractive, her Protestant-
ism, schismatic and uncentralized, must have been deemed confusing and
unsuitable for young readers. Even as Bulgarians appreciated American
Protestants' contribution to modern Bulgarian culture, many looked upon
Protestantism as a tool for foreign interests.[34] By cutting religious content
that emphasized the difference between Orthodox and Protestant Chris-
tian practices (especially the Protestant reading of the Bible without the
guidance of an ordained priest, which occurs several times in *Uncle Tom's
Cabin*), Mavrov and Palashev made Stowe more acceptable. Yet they also
impoverished Stowe's depiction of blackness of much of its nuance, as
Christian piety is one of the major refractions through which she repre-

sents black culture. This impoverishment is especially obvious in Mavrov and Palashev's treatment of the prayer meeting in chapter 4, "An Evening in Uncle Tom's Cabin." In Govedarov's edition, this scene takes up four printed pages and includes full translations of the hymns sung by the black congregation and of the testimony given by an elderly black woman. Govedarov also includes the following passage, in which Stowe tries to convey African Americans' specific racial characteristics:

> There were others, which made incessant mention of "Jordan's banks," and "Canaan's fields," and the "New Jerusalem"; for the Negro mind, impassioned and imaginative, always attaches itself to hymns and expressions of a vivid and pictorial nature; and, as they sung, some laughed and some cried, and some clapped hands, or shook hands rejoicingly with each other, as if they had fairly gained the other side of the river. (34)

By contrast, Mavrov and Palashev summarize the entire prayer meeting in half a page, informing us, in the briefest possible manner, that the guests sang "church hymns," that George read "from a book with religious content," and that Uncle Tom led everyone into prayer. No commentary on "the Negro mind" is given.[35]

THE NOVEL'S SOVIET-ERA TRANSLATION:
HARRIET BEECHER STOWE MEETS MAXIM GORKY

When the Bulgarian communist ideologues decided to include *Uncle Tom's Cabin* in the middle-school curriculum in the 1950s (less than a decade after Bulgaria became a Soviet satellite), much of the groundwork had been laid for them by the pre-Soviet-era translators and adaptors. The novel had already been received as an argument against oppression and a model for civic virtue. It had already been translated with pro-internationalist objectives in mind; modern Bulgarians had to be at once patriotic and members of the enlightened modern world beyond the Bulgarian lands. Following the success of Mavrov and Palashev's adaptation, the novel had become established as a text for schoolchildren, its Christian content abbreviated.[36] A strong link between their adaptation and the Soviet approach to the novel is suggested by the fifth edition of their text, published in 1946, the year when Bulgaria became a "people's republic," by adopting a new constitution, and officially joined the Soviet sphere. In the preface to this edition, not only is

Stowe presented as a voice against oppression, but the defining influence of Christianity on her abolitionist work is deemphasized. Still, the preface mentions that many Christian churches supported the abolitionist cause. Throughout the text, many characters still describe themselves as Christian and call to God in times of distress.[37] It is also important to acknowledge the Russian influence on the pre-Soviet translations, the result of a centuries-long cultural exchange between the Bulgarian and Russian societies. Mutev's translation of Stowe's first name as "Garrieta" (which reflects the absence of the *h* sound in Russian) and his use of the Russian-derived words неволник (*nevolnik*) for "slave" and негритянин (*negrityanin*) for "Negro" suggest that he drew on the 1857 Russian translation of the novel.[38] Likewise, Mavrov and Palashev's biography of Stowe in their 1911 preface draws heavily on the Russian author Ivan Ivanov's biography of Stowe, which was translated and published in Bulgaria in 1900.[39] In view of these factors, the Soviet-era appropriation of *Uncle Tom's Cabin* appears not as a radical break from the novel's earlier reception but as continuous with it.

Contributing to this continuity is yet another manifestation of sentimentality's longevity, the socialist realist novel that, from the 1950s on, dominated literary production and political rhetoric in Bulgaria. Like *Uncle Tom's Cabin*, the socialist realist novel is a sentimental social novel despite the Christian ideology of the former and the anti-Christian stance of the latter; as Margaret Cohen remarks, "sentimental social novels voice ideas that cross the political spectrum."[40] Therefore, what defines a sentimental social novel is not the political point of view it takes but the conflict between individual freedom and collective obligation, inherited from Enlightenment political thought. In the general case, the sentimental protagonist sacrifices his or her own personal desires for the greater public good, whereas the protagonist in the sentimental social novel represents the suffering public; he or she is a member of a dominated social group victimized by the selfish interest of a socially empowered antagonist. This is precisely the position of Stowe's black characters. This is also the position of Pelageya Vlasova, the poor factory worker's widow from small-town tsarist Russia who is the central character of Maksim Gorky's 1906 novel *Mother*, which pro-Soviet critics considered one of the best examples of socialist realism.[41] Strictly speaking, Pelageya does not start out as a protagonist. Rather, she occupies the position of the ideal spectator who witnesses the protagonist's struggle and models actual readers' sympathetic responses. In the first part of the novel, the protagonist is Pelageya's son Pavel, a young factory worker, who

sees no meaningful future for himself in the typical life of a man from his class—a life of drudgery, drinking, and (most likely) a loveless marriage—and joins a socialist group. As he transforms from a dissatisfied youth into a leader for workers' rights, Pelageya, too, transforms from a witness of her son's socialist conversion into a socialist leader in her own right.

Numerous aspects of Pelageya's journey qualify it as a sentimental social narrative, from her double oppression as both a woman and a lower-class subject to her tragic end as a martyr for a just society, a cause entailing thorough legal and social transformation.[42] The narrative is also frequently interrupted by the mandatory tableaux, scenes in which the brutal domination of social norms is spectacularly embodied by members of the victimized group.[43] In *Uncle Tom's Cabin*, such scenes include Tom lying smote under Legree's enraged blows and the iconic depiction of Eliza running from the slave catchers' hounds across the river, her child in her arms. Gorky's novel, likewise, includes at least two memorable tableaux. In the first one, Pelageya witnesses the cruel beating of the peasant leader Rybin at the hands of the tsarist police. This scene prefigures the final tableaux, where Pelageya herself dies a spectacular death from police violence, as workers, already awakened to the reality of their situation, gaze empathetically upon her suffering. Additionally, *Mother* upholds the sentimental value of active virtue that, in Gorky's novel, is equated with teaching through personal example. Pavel sees his path as a teacher of the socialist gospel. Pelageya, likewise, learns to read and then teaches others about the international brotherhood of all workers. Similarly, at the end of *Uncle Tom's Cabin*, Topsy, the unruly black child entrusted to the Protestant Miss Ophelia, becomes baptized, "at the age of womanhood" and "by her own request," and leaves on a mission to Africa, where she becomes a teacher of "the children of her own country" (443).

Last but not least, socialist realism partakes in the sentimental credo that feelings and reason are equally important factors in forming a correct perception of reality and attaining harmony between individual freedom and the public good: "Socialist realism engages in a rational and emotional analysis of the relationship among past, present, and future," writes the Bulgarian Soviet-era critic Ivan Popivanov.[44] The same could be said of many sentimental social novels, but socialist realism is distinct for the specific affect that bonds together the members of the utopian community it constructs. In classic sentimental novels, the utopian community is built on empathy for the suffering protagonist, and the ideal sentimental spec-

tators are often shown as shedding empathetic tears. We find one such typical scene in chapter 9 of Stowe's novel, where Eliza tells the story of her escape with Harry to Senator Bird's family. As she talks, the narrator tells us, "every one around her" shows "signs of hearty sympathy." Then everyone present sheds tears—the children sobbing, their heads buried in Mrs. Bird's skirt; Mrs. Bird hiding her face in a handkerchief; the black servant Dinah letting tears stream freely down her face; and so on (90). By contrast, in the socialist realist novel, the affect bonding the utopian community together is joy. Sacrificing yourself for the public good is joyful, Pavel's socialist friends insist. "At times I feel such joy, such happiness," says Natasha, a teacher who has severed her connections with her well-off family and dedicated her life to the socialist cause. She continues, "If you knew—if you but understood what a great joyous work we are doing! You will come to feel it!"[45] And so Pelageya does. At the outset of the novel, she sheds tears and prays to Christ for the lives of hardship and peril that her son and his socialist friends have chosen. As she begins working for the socialist party, spreading leaflets with socialist messages among workers and peasants, she starts praying less and experiencing more spontaneous moments of joy. This joy covers a range as varied as the sentimental repertoire of shedding tears; usually uplifting, it can also be paradoxically sad and tormenting.[46] Even as Pelageya witnesses the painful death of Rybin and, finally, when she understands that she is going to die in the hands of the police, her faith in the joyous socialist future that she has helped build alleviates her distress. But most importantly, her immense capacity to feel deeply—to empathize with another's grief and inspire joy—renders her a model socialist. Social transformation "begins not in the head, but in the heart," the peasant leader Rybin contends in *Mother*.[47]

Proponents of socialist realism seem to be at least somewhat aware of the genre's kinship with sentimentality. "As is well-known," writes Popivanov, "socialist realism shares some features with romanticism"[48] (romanticism being the larger and more respected category within which sentimentality fits). At the same time, they are dismissive of sentimentality. "Occasionally [*Uncle Tom's Cabin*] is tearfully sentimental, almost melodramatic," Anna Kamenova writes in an afterword to her translation of Stowe's novel.[49] In saying so, she blatantly disregards how her own commentary echoes the novel's sentimentality. "Today, too, readers approach [Stowe's] book with interest and feeling," Kamenova notes,[50] adding that "[Stowe] affectionately portrays the noble men and women who warmly and cordially welcome

fugitive slaves as their equals."[51] The denial of socialist realism's sentimental roots is widespread in Soviet-era criticism. Instead, Soviet-era critics measure the genre against the classic realism of Balzac, Zola, and Flaubert. These authors, too, Margaret Cohen writes, invested much effort in downplaying their indebtedness to the sentimental novel, whose codes they appropriated, "transvaluing [their] significance."[52] What both socialist realism and classic realism claim as one major distinction from sentimentality is their arguably more rigorous social analyses. "[Stowe] was unable to evaluate and account for the social and economic aspects of slavery; instead she found it sufficient to emphasize only its moral aspects," comments Kamenova;[53] for her, this is what renders Stowe's novel "tearfully sentimental." But *Uncle Tom's Cabin* does address the economic and social aspects of slavery—for instance, in St. Clare and Miss Ophelia's discussion of slavery in chapter 19, which Kamenova, like Mavrov and Palashev before her, radically abbreviates. In any case, *Uncle Tom's Cabin* provides as much (or as little) social and economic analysis of oppression as Gorky's *Mother*.

Soviet-era critics tried to draw a firm line between socialist realism and sentimentality, against all objective evidence for their kinship, because of the Soviet ideological competition with the West in all spheres, including culture. Even pro-Soviet critics consider classic realism one of the most successful cultural achievements of modern capitalist societies. Socialist realism, intended as a proof of the Soviet Bloc's superior culture, is supposed to excel at what classic realism does best: insightful social analysis expressed through detailed descriptions of physical environment and characters' individual traits. Moreover, socialist realism aspires to surpass classic realism, venturing where classic realism will not or cannot go, drawing an objective picture of the ideal socialist future society. The conviction that this can be done derives from the Leninist premise that human history has been set on an inevitable course toward socialism and that the future can be scientifically deduced from socialism's past and present accomplishments.[54]

Because socialist realism is burdened with such high expectations, Soviet-era critics appear particularly sensitive to any actual or imagined hints that the genre is a lesser realism. B. Emelyanov writes, "Nilovna [i.e., Pelageya Nilovna Vlasova] is one of the most astounding characters in world literature: her deep individuality is incontestable, and at the same time she is an epic character. Her joyless youth and difficult marriage [. . .] describe the fate of countless women."[55] In fact, there is little individualism in Pelageya's character. In *Mother*, Gorky rarely provides the specific

detail of physical environment and the access to a character's interior world through self-reflection, typical of realist characterization. Not only has Pelageya's life of poverty and victimization prevented her from forming personal desires (other than having enough food and not being beaten), but when such desires finally emerge, they are perfectly aligned with the public good. Ironically, she begins to approximate a realist character only when she moves into the middle-class home of the socialist intellectuals Nikolay and Sofya. As Sofya plays the piano and Nikolay shares his atlases and encyclopedias—objects that signify a middle-class status—Pelageya starts actively reflecting on her past, acquiring classic realist interiority. Hence, rather than surpassing classic realism, *Mother* only begins to approximate it when it submits to its "bourgeois" conventions. In contrast, Stowe frequently uses realist conventions. Detailed settings, including the eponymous cabin, are used to suggest personality features. The characters' aesthetic choices—such as Tom's neat clothes and Topsy's affinity at arranging flowers—are suggestive of individual traits. True, the interiority of Stowe's characters is constructed sentimentally, as a conflict between opposing ideals rather than as a conflict based on power struggles, but even sentimental conflicts are reduced to a minimum in *Mother*. Occasionally Pavel is shown gazing gently in his comrade Sasha's face, suggesting that he is not immune to the conventional feelings of attraction and intimacy. Yet he states that he is never to get married; his true family is the international brotherhood of workers. Likewise, when Pavel is first imprisoned, Pelageya worries that he may be tortured. Eventually, however, she is reconciled with his fate; she has accepted her role as the mother of the international brotherhood of workers. To this socialist utopia, individual destinies and traditional familial attachments simply do not matter.

But Soviet-era critics' insistence that socialist realist characters are individuals is not just misrepresentation; rather, it conveys a specific understanding of individuality. Consider Popivanov's following defense of the genre:

> Bourgeois literary scholars often scornfully speak of socialist realism, describing it as monotonous, schematic, and propagandist.... Here is proof to the contrary. When our [Bulgarian] writers go abroad, foreigners tell them astonished: who could have imagined your poetry—so humane, so harmoniously encompassing the intimate and the social, so varied [...]. Socialist realism does not constrain our writers'

creativity—they write as their hearts command, and their hearts belong to the people and to the [Communist] Party.[56]

Underlying the last sentence of the preceding quote is not the Freudian understanding of individuality associated with classic realism but a Pavlovian behaviorist understanding. Just as Freudian psychoanalysis remains strongly associated with classic realism (consider, e.g., Freud's analyses of Ibsen's characters),[57] Pavlovian behaviorism is associated with socialist realism, both because the Bolsheviks gave Pavlov's theories a canonical status and because Gorky himself admired Pavlov's work and used his influence to provide Pavlov with optimal conditions to conduct research.[58] In classic realist characters, sentimental interiority is replaced by the unconscious—psychic space created through familial dynamics and social pressures to form a unique pathology. Socialist realist characters do not have an unconscious. Rather, they respond to something akin to the Pavlovian classic conditioning: specific stimuli produce specific responses. For instance, at the beginning of the novel, Pelageya's character—from her thoughts to her posture—is described entirely as a response to poverty and domestic violence: "She was tall and somewhat stooping. Her heavy body, broken down with long years of toil and the beatings of her husband, moved about noiselessly and inclined to one side, as if she were in constant fear of knocking up against something."[59] As the stimulus changes—that is, as poverty and beating are replaced by poverty and communist proselytizing—a feeling of "universal kinship [with] the workers of the world [. . .] move[s] the mother, [. . .] straighten[s] and embolden[s] her."[60] As *Mother* demonstrates, in socialist realism, Pavlov's theory seems to tie in with the Marxist conviction that individuals and societies change for the better if their false consciousness is replaced with a proper, materialist view of the world. The materialist view here is the stimulus; individual and social change is the response.

The resulting socialist realist take on individuality and social change applies equally to workers across cultures. "For us there is no nation, no race," Pavel's comrade the Little Russian tells Pelageya. "And, Mother," he continues, "the Frenchman and the German *feel* the same way when they look upon life, and the Italian also. We are all children of one mother—the great, invincible idea of the brotherhood of the workers of all countries over all the earth."[61] Again, the same (correct) worldview produces the same (joyous) feelings across cultures. In this Pavlovian-

Marxist theory of subject formation, the sentimental emphasis on af-
fect is socialist realism's signature contribution. Popivanov's defense of
socialist realism is a variation on the same theme: writers who partake
in the same Marxist philosophy, whether Bulgarian or not, feel the same
about the world; consequently, they all uphold socialist realism as the
best aesthetic to describe it.[62] Socialist realism does not constrain their
creativity, because their creativity is already aligned with socialist real-
ism through both reason and feeling.

Thus socialist realism replaces the sentimental transnationalism of
sympathy with a joyful communist internationalism, the communist
project for a union among nations, driven by the shared interests of their
working classes. It is not to be confused with Western "bourgeois cos-
mopolitanism" that, Soviet theorists claim, seeks to recolonize the world
through global political and financial institutions.[63] Moreover, socialist
realism is expected not to just uphold the tasks of socialism and commu-
nist internationalism but to actively help fulfill them. As Popivanov fur-
ther writes, socialist realism "prepares the moral and psychological basis
of communism."[64] Hence, its function is performative; it does not seek just
to reflect on reality (as classic realism has controversially claimed to do)
but sets out to engender the socialist utopia. Soviet-era criticism similarly
views its functions as performative. Pages can be written examining the
feelings of provincialism and cultural inferiority in Popov's image of the
astonished foreigner awakened to the true power of Bulgarian socialist
creativity (a stock figure in communist propaganda), but the gist is that
the communist critic's mission, just like the communist writer's, is to help
those of weak faith move toward the truth.

Anna Kamenova and the Soviet-era commentators on *Uncle Tom's Cabin*
understand their objective similarly: to align the novel with socialist real-
ism and the internationalist ideology it serves. To do this, Kamenova re-
moves from Stowe's text as many references to Christianity as possible. For
instance, whereas Mavrov and Palashev briefly summarize the prayer scene
in the cabin, Kamenova completely eliminates it. From the debate between
Mrs. Bird and Senator Bird over the morality of the fugitive slave law, Ka-
menova erases Mrs. Bird's Christian objections to the law that specifically
refer to the Bible. In Kamenova's translation, Mrs. Bird's position against
slavery derives "naturally" from her being a woman and mother. Kamenova
does not edit Senator Bird's point, early in the discussion, that his support
for the law is "no more than Christian and kind" toward his slave-owning

brethren in Kentucky (84), as this reference usefully aligns Christianity with capitalist oppression.

Predictably, Kamenova's most extreme editorial intervention is in chapter 40, "The Martyr," where, following Tom's refusal to reveal Cassy and Emmeline's plans to escape, Legree beats Tom to death. In the original, Legree's plantation becomes Tom's Calvary, and Tom's beating is the counterpart to crucifixion. I discuss some characteristic passages here. Having been summoned to talk to Legree, Tom knows that his refusal to betray the fugitives will bring Legree's murderous rage upon him: "But he felt strong in God to meet death, rather than betray the helpless" (419). Kamenova translates this sentence as "But he would rather go to death than betray the two helpless women."[65] Next, Stowe tells us that Tom "sat his basket down by the row, and looking up said, 'Into thy hands I commend my spirit! Though hast redeemed me, oh Lord God of truth!' and quietly yielded himself to the rough, brutal grasp with which Quimbo seized him" (420). In Kamenova's version, Tom "sat his basket down, looked up, and let himself be brutally taken away by Quimbo."[66] Finally, before he dies in the original, Tom forgives the seemingly incorrigible Sambo and Quimbo for having beaten him, and they are so moved by his forgiveness, as emblematic of Christ's mercy, that they profess belief. The magnitude of Tom's act is further supported by Stowe's description of his final facial expression as "that of a conqueror." "Who,—who,—who shall separate us from the love of Christ?" he asks rhetorically (quoting Romans 8:35), before he passes away with a smile on his face (427). In Kamenova's version, Tom is too weak to talk; hence, he does not forgive anyone, and no one gets converted. Tom simply smiles and dies.[67] Because Kamenova cuts most of the Christian references that comprise much of what Tom says in his final hours, her translation presents Tom's exceptional stoicism as completely unrelated to religion and, hence, not unlike the stoicism that communist guerrillas from countless socialist realist stories display as they die by the hands of the capitalist police.

Despite Kamenova's efforts, she could not entirely eradicate Stowe's foundational Christian theme without destroying the novel. Enough of this theme remains to enable moments of resistant reading. For instance, in a footnote to chapter 13, "The Quaker Settlement," Kamenova defines the Quakers as a "sect," using a Bulgarian word that strongly connotes religious fanaticism.[68] This definition makes little sense in view of the Quakers' favorable portrayal as supporters of fugitive slaves, which Kamenova retains. As a result, a strong positive manifestation of Christianity remains in the

Bulgarian translation, creating a possibly productive ambiguity. Commentators have taken it upon themselves to resolve such ambiguities, including the major one: that a Christian author created such a powerful condemnation of oppression. To do so, they have presented Stowe as a victim of her environment. As the daughter of one pastor and the wife of another, Stowe could not have thought of religion in any other way but as "a force capable of transforming people and eradicating social inequality and evil," Filipov writes in his afterword. This conviction, he continues, explains the "improbable" transformation of the slave catcher Loker into "'a good person'" under the Quakers' influence.[69] Nonetheless, Filipov concedes, "Stowe unwittingly, albeit indirectly, exposed the disgraceful role of the church," which supported slave owners by teaching Negroes to be meek and docile.[70] Thus, in Filipov's account, Stowe undergoes a transformation somewhat similar to Pelageya's in *Mother*. Both start out as Christian—a moral defect caused by their environment—but a non-Christian truth eventually starts speaking through them. Just as Kamenova attempts to do in her translation, Filipov omits the information that there are numerous Christian denominations within the United States, only some of which supported slavery, and that Stowe's anti-slavery Christian stance was not exceptional in the Northern states.

Filipov also strategically downplays the centrality of Tom's fate to the novel's anti-slavery message. Stowe's religious worldview, he contends, instills Tom with "passivity and resignation," which makes him "the least persuasive [. . .] character."[71] In fact, from Stowe's Protestant point of view, Tom's martyrdom—his ability to win souls for Christ through the example of his death—is anything but passive. For Filipov, however, because Tom believes in a better life hereafter, he cannot be the book's moral center. Instead, the novel's moral center is embodied by "all Negroes in the United States," represented by characters such as Eliza and George Harris, "who fight for their freedom and happiness."[72] In Stowe's original, both Eliza and George are Christian. George wavers early on, as he faces the dilemma of either escaping from his master (thereby running the risk of never seeing his family again) or staying with him (as is arguably his duty) and partnering with a woman of his master's choosing, but he seems to have recovered his faith by the end of the novel. In his letter announcing his intention to relocate his family to Liberia, he specifies that he sees Africa's future as "essentially a Christian one" (442). Kamenova erased George and Eliza's Christianity, however, to offer Bulgarian readers positive non-Christian black charac-

ters. Filipov takes the additional step of downplaying their individuality by claiming that they represent "all Negroes."[73] This is a typical socialist realist move, not only in asserting the value of the collective (a social group, a people, etc.) over that of the individual, but also in deemphasizing race ("For us there is no nation, no race," intones the Little Russian in *Mother*).[74] Even as they stand for "all Negroes," George and Eliza are fair-skinned blacks. "I might mingle in the circles of whites, in this country [Canada], my shade of color is so slight, and that of my wife and family scarce perceptible," George writes in his final letter (440). Thus, fair-skinned and prepared to "fight for their freedom and happiness," they are ready to be reimagined as members of the international brotherhood of workers, their middle-class aspirations notwithstanding. This is precisely the direction that Filipov takes as he slips from "Negroes" to "progressives" in the last sentence of his commentary: "[Today] Negroes and all progressive people in the USA are fighting against the American capitalists" who strive to "enslave all other nations."[75]

Filipov's critique of Christianity and his blurring of the line between race and class are typical of virtually all other analyses of the novel.[76] So is his emphasis on the feelings the novel evokes. "Stowe's characteristic pathos and dramatism contributed much to the novel's popularity," Victor Sharenkov remarks.[77] Similarly, Filipov draws attention to the novel's ability to evoke indignation and disgust—the affects that, in his view, will most effectively move readers against American imperialism.[78] Like sentimental novelists, Soviet-era critics believed in the centrality of emotion to moral education and political action. They also viewed the teaching of literature as the most suitable tool for creating an effective alignment between emotions and a correct ideological worldview. In the middle-school literature classroom, Milan Enchev writes, "we must raise the emotional temperature of literary education [. . .]. We must fight [any tendency toward] passionless analysis."[79] Literary analysis, Enchev continues, is always at once ideological and aesthetic, and training good readers entails "helping them acquire a communist worldview and aesthetic taste, enriching their emotional range, and developing their intellect."[80] Thus, the literary education of Bulgarian children during the Soviet period was truly a sentimental education. A 1982 manual for teaching literature to grades 4–6 even includes lists of feelings to be taught in each particular grade. The list for the fourth grade—in which *Uncle Tom's Cabin* was taught—includes such feelings as endless sorrow, anxiety, despair, indignation, hatred for the enemy, hope, exultation, rapture, enjoyment, delight, astonishment, magnanimity, mother's cour-

age, brotherly love, love for the socialist fatherland, love for the USSR, and "the people's gratitude to Lenin." Students' understanding of these feelings is supposed to accompany the introduction of historical concepts such as slavery, Ottoman slavery, fascism, and the USSR.[81]

As such manuals suggest, Soviet-era ideologues thought of identity as constructed. But unlike late twentieth-century theorists of constructed identities, such as Michel Foucault and Judith Butler, who propose that identity is continually influenced by social processes but that no single individual or group can willfully shape another person's identity, Soviet theorists formulated a Pavlovian hypothesis of social engineering: proper education will mold anyone into a good socialist subject, provided that every social and historical concept is matched with an appropriate feeling. Theorists who view identity as constructed are typically materialist theorists, and Soviet critics and educators thought of themselves as materialist. But how materialist is their hypothesis?

Consider an experiment that Bulgarian scholars conducted to test the success of their method of teaching literature. In the experiment, students were asked to choose one episode from *Uncle Tom's Cabin* that they found particularly moving and to think about why they found it so. One female student chose the scene in chapter 25, "The Little Evangelist," in which Eva, sensing her imminent death, says good-bye to her family, including the slaves. (Predictably, Kamenova removed from the text Eva's plea to the servants to be good Christians.) The student describes Eva

> leaning back on a pillow, her hair falling on her face, her cheeks burning. Her big blue eyes focus intently on each visitor. And the visitors are the Negroes, slaves on St. Clare's plantations, who have come to see their beloved little mistress and receive locks from her gorgeous hair. Even in her last hours, she has not forgotten them, because her small heart has gathered much love for the poor Negroes.[82]

The description suggests that the scene spoke louder to the reader's heart than to her mind. Though moved by the sentimental imagery—Eva's face burning with fever, her big blue eyes looking intently, much love in her small heart—the student misunderstood an important detail: though St. Clare owns slaves, he does not own a plantation, let alone plantations. Because he abhors the backbreaking toil to which plantation slaves are subject, he has given his share of the family plantation to his brother. Precisely

this kind of misunderstanding would support antisentimentalist fears that sentimentality encourages readers to substitute sympathy for true understanding.[83] Yet the researchers conducting the experiment are not troubled by the student's mistake. "The scene described by the student," they write, "is one of the emotional climaxes in the novel [. . .]. The reader experiences little Eva's death as failure of the black slaves' illusion of the 'good' master's noble nature."[84] Clearly, the researchers' interpretation here has little to do with the student's description of Eva as the slaves' "beloved little mistress." Even more important, the researchers' interpretation is not just inaccurate; it is typical of this kind of research. (Recall Popivanov citing the made-up anecdote of the astonished foreigner as "proof" for the high literary qualities of socialist realism.) What such examples demonstrate is not a materialist approach to evidence but its willful manipulation so that the researchers' hypothesis—that by evoking strong feelings, socialist realism enables readers to form a correct perception of reality—may appear confirmed. Such willful manipulation is not necessarily a sign of cynicism. Rather, the researchers' approach to evidence reflects the teleology of the Marxist-Leninist philosophy on which they drew. According to this philosophy, history is on an inevitable course toward communism; humans have started on an unalterable path toward a "proper" (i.e., Marxist-Leninist) understanding of the world. By the same logic, one day the reader will come to see Eva's farewell as the failure of capitalist illusion, simply because the researchers' communist credo does not allow for any other interpretation. Logically faulty as it may be, this is an idealist position.

LESSONS (NOT) LEARNED

Just as the Soviet socialist realist novel inherits the transnational sentimental tradition of the nineteenth century, the Soviet-era use of *Uncle Tom's Cabin* for Bulgarian children's moral betterment follows in the steps of a larger, transnational educational trend. According to Suzanne Keen, British Victorian thinkers, just like Soviet-era pedagogues, explored "the malleability of the reading mind, especially as regards readers' morals," and hoped that it could be improved through literary education.[85] Psychologist Darcia Narvaez identifies the same faith in narrative's ennobling powers in the late twentieth-century American primary and middle-school literary classroom. Her empirical research suggests that though reading stories that illustrate core values improves students' academic performance, they have

no significant effect on students' behavior and attitudes.[86] So how successful was the Bulgarian communist cooptation of *Uncle Tom's Cabin* in instilling the moral values of Soviet internationalism? Unlike Narvaez, I have found no reliable empirical research to help me answer this question. Likewise, I have found only one study examining race relations in communist and post-communist Bulgaria: the 2005 collection *Immigration in Bulgaria*.[87] In her essay in the collection, Denitsa Kamenova outlines the history of the African community in Bulgaria from the 1960s, when the Bulgarian communist state began subsidizing higher education for African students as part of the Soviet Bloc's effort to gain supporters in the developing world. Kamenova's conclusion is unequivocal: being black in Bulgaria is hard. She cites regulations from the 1960s that introduced a curfew for African students (arguably for their own security) and interviews with African immigrants who report their experiences of systemic prejudice, discrimination, and racial violence while living in Bulgaria during the early twenty-first century.[88] There are several reasons why such research is still scarce and incomplete twenty-six years after the fall of the Berlin Wall marked the official end of communism in Eastern Europe: the refusal on the part of pro-Russian political factions to make parts of the Soviet-era archives available to the public, the public's fatigue with stories about communism's evils, and, most important, the relatively recent interest in race as an analytical category among Bulgarian social scientists.[89] In this sense, the Soviet-era translation of *Uncle Tom's Cabin* and the related coverage of Western racism in the Soviet-era press did not create an understanding and respect for racial difference—which is not surprising, since neither understanding nor respect was the real objective.

Nevertheless, as part of the Soviet-era curriculum, *Uncle Tom's Cabin* was extremely influential in giving Bulgarians a vocabulary for talking about blackness. Unaware that the novel's taxonomy of blackness—from black through mulatto, quadroon, and octoroon—has been denounced as racist in the United States and elsewhere, most Bulgarians use these terms as if they were racially neutral. For instance, in informal conversation, former U.S. president Barack Obama is sometimes referred to as "the mulatto president." The two generations of Bulgarians who grew up during the communist regime also correctly saw the novel's translation as the propaganda tool it was meant to be. To pro-Soviet and pro-Russian Bulgarians who have spoken negatively of the United States, other Bulgarians have often responded, "Yes, in America the Negroes are getting beaten," meaning

"Your communist-style anti-Americanism is quite transparent." Bulgarians who use this expression are aware that racism in the United States has not been eradicated. But for Bulgarians today, acknowledging the continuing racial inequality in the United States is tied up in doublethink: to assert the fact that American blacks are being beaten is to be perceived as parroting communist-style anti-Americanism. This doublethink, in turn, originates specifically in the communist interpretation of *Uncle Tom's Cabin*, as taught to generations of Bulgarian middle-school students. Since Bulgaria joined the European Union in 2007, there has been much talk about the need to change the literature and history curricula for public school, so that they may better represent the increasingly diverse world in which post-communist Bulgarians live. So far, however, Anna Kamenova's translation of *Uncle Tom's Cabin* remains the literature curriculum's only work that directly represents race.

Notes

1. An earlier translation compatible with Soviet ideology was made from Russian in 1949. See Harriet Beecher Stowe, *Chichovata Tomova koliba* [Uncles Tom's cabin], trans. Marko Marchevski (Sofia: Narodna mladezh, 1949).

2. Vladimir Filipov, "Za Hariet Bicher-Stou" [About Harriet Beecher Stowe], in *Chicho Tomovata koliba* [Uncle Tom's cabin], by Harriet Beecher Stowe, trans. Anna Kamenova, 2nd ed. (Sofia: Narodna mladezh, 1956); my translation and italics.

3. Under Dimitar Mutev's tenure as editor, *Bulgarski knizhitsi* also published Charles Dickens's *A Christmas Carol*. See Betty Greenberg, "*Bulgarski knizhitsi* and the First Bulgarian Translation of *Uncle Tom's Cabin*," in *Essays in American Studies: Cross-Cultural Perspectives*, ed. Madeleine Danova (Sofia: Polis, 2001), 40.

4. Vladimir Filipov, who discusses Mutev's translation in his study of the Bulgarian reception of English and American literature in the nineteenth century, suggests that Mutev borrows the quote from an English-language edition, which Filipov was unable to identify. See Vladimir Filipov, *Pronikvane na angliiskata i amerikanskata knizhnina v Bulgaria prez Vazrazhdaneto* [The spread of English and American literature in Bulgaria during the Bulgarian Revival period] (Sofia: Universitetsko izdatelstvo Sv. Kliment Ohridski, 2004), 38. The most likely source is Harriet Beecher Stowe, *Uncle Tom's Cabin; or, Negro Life in the Slave States of America, with Fifty Splendid Engravings* (London: Clarke, 1852). "[T]he purpose [of this book]," reads its preface (iii–vi), "is to disabuse large communities of mankind of the belief that the Lord our God, when He gave dominion to men 'over the fish of the sea, and over the fowl of the air, and over the cattle,' bestowed this dominion only on prospective races of a certain color, and included under the designation 'cattle' other prospective races of another color [. . .]. 'Tell me not of rights,' said Lord Brougham, 'talk not of the property of the planter in his slaves. I deny the right, I acknowledge not the property. The principles, the feelings of our common

nature rise in rebellion against it [. . .]. In vain you tell me of laws which sanction such a claim [. . .]. [B]y [God's] law, unchangeable and eternal, while men despise fraud, and loathe rapine, and abhor blood, they will reject with indignation the wild and guilty phantasy that man can hold property in man.'" The Lord Brougham mentioned is the British politician Baron Henry Peter Brougham (1778–1868), a dedicated abolitionist.

5. Harriet Beecher Stowe, *Chicheva Tomova koliba* [Uncle Tom's cabin], trans. D. Mutev, pt. 1 (Tsarigrad-Galata: V knigopechatnitsata na D. Tsankova I B. Mirkova, 1858), 2–3; my translation.

6. Musicologist James R. Gaines provides a succinct explanation of the reconciliation between Enlightenment thought and Christianity in the German philosophical tradition, in *Evening in the Palace of Reason: Bach Meets Frederick the Great in the Age of Enlightenment* (New York: HarperCollins, 2006), 153–55.

7. Orthodox Christianity is the most popular Christian denomination in the Balkans and in Russia. Doctrinally, it is closest to Catholicism, from which it split in 1053, in the first step of the formal separation (the so-called Great Schism) between the Greek East and the Latin West. Bulgarians accepted Christianity from the Byzantine Empire in the ninth century. After the Ottomans conquered the Balkans in the fourteenth century, the Bulgarian Christians were placed under the jurisdiction of the (Greek) Constantinople patriarchy. Fearing Greek cultural assimilation through religion, nineteenth-century Bulgarian nationalist leaders defined the struggle for an independent Bulgarian Orthodox Church as integral to the struggle for an independent Bulgarian state.

8. See Greenberg, *"Bulgarski knizhitsi,"* 43.

9. *Bulgarski knizhitsi* (Tsarigrad-Galata) 1.1 (1858): 1–2; my translation.

10. Ibid., 15; my translation.

11. There is both direct and indirect evidence about pro-nationalist Bulgarians' interest in the novel. Todor Shishkov, a translator and literary critic, prepared a complete translation of the novel from the French but seems to have been unable to publish it. See Greenberg, *"Bulgarski knizhitsi,"* 1. The publication of Mutev's translation as a separate book edition in the same year as its publication in *Bulgarski knizhitsi* suggests that the serialized translation was popular among readers. See ibid., 50.

12. See Y. Hakan Erdem, *Slavery in the Ottoman Empire and Its Demise, 1800–1901* (New York: St. Martin's, 1996), 43–62.

13. Ibid., 1–11.

14. Greenberg, *"Bulgarski knizhitsi,"* 51.

15. See Margaret Cohen, *The Sentimental Education of the Novel* (Princeton: Princeton University Press, 1999), 35.

16. An early example is Teodosii Ikonomov's comedy *Lovchanskiat vladika* [The bishop of Lovech], written in 1857 and first published in 1863. It tells the story of a corrupted Greek bishop who seduces the Greek wife of a Bulgarian clockmaker. Written in support of the Bulgarian struggle for independence from the Greek Orthodox Church, it aimed to expose the alleged debauchery among the Greek clergy.

17. Cohen, *Sentimental Education*, 145.

18. Stowe, *Chicheva Tomova koliba*, 41.

19. Lawrence Venuti, "Translation, Community, Utopia," in *The Translation Studies Reader*, ed. Lawrence Venuti (London: Routledge, 2000), 482.

20. Stowe, *Chicheva Tomova koliba*, 42; my translation.

21. Ibid., 23–24.

22. In the 1860s and 1870s, American Protestant schools were established in several major Bulgarian cities, including Plovdiv, Stara Zagora, Sofia, and Samokov. The Protestant Robert College in Istanbul, established in 1863, is emblematic of American missionaries' contribution to the development of modern culture and politics in the Ottoman Empire. Numerous Bulgarians received higher education there, and some joined its faculty.

23. Ivan G. Govedarov, "Henrieta Bicher Stou," in *Chichovata Tomova koliba, ili zhivotat na negrite v Amerika* [Uncle Tom's cabin; or, The lives of Negroes in America], by Harriet Beecher Stowe, trans. Ivan G. Govedarov (Sofia: Ivan G. Govedarov, 1898), iv.

24. Ibid., iii.

25. "Immersed, from her very childhood, in an atmosphere of philanthropic and religious ecstasy," writes Govedarov, "[Stowe] was still a young woman when she distinguished herself for seriousness of character, Puritanical sympathies and viewpoints, and a fervent—yet productive—devotion to serving God and the suffering Mankind. She was only fifteen when she began her hard-working [professional] life as an assistant in her older sister's teaching activities" (ibid.; my translation).

26. In 1878, part of the Bulgarian lands became a tributary state under the name "Principality of Bulgaria." Another part acquired administrative autonomy within the Ottoman Empire under the name "Eastern Rumelia." In 1885, the Principality of Bulgaria and Eastern Rumelia declared their unification, which was accepted by the nations of Western Europe. In 1908, the unified state finally declared complete independence from the Ottoman Empire.

27. See Ani Gergova, *Bulgarska kniga: Entsiklopedia* [Bulgarian literature: An encyclopedia] (Sofia: Pensoft, 2004), 128.

28. In their preface, Mavrov and Palashev specify that their adaptation is based chiefly on Govedarov's translation and that they have also consulted Russian, French, and Swedish adaptations of the novel for children. See D. Mavrov and G. Palashev, "Kak se e poiavila knigata 'Chichovata Tomova koliba' i belezhki za zhivota na avtorkata" [Origins of the book *Uncle Tom's Cabin* and notes about the author's life], in *Chichovata Tomova koliba* [Uncle Tom's cabin], by Harriet Beecher Stowe, adapted by D. Mavrov and G. Palashev (Sofia: Kartinna galleria, 1911), 21.

29. Ibid., 3; my translation.

30. In one well-known story, *The Golden Girl*, an orphan is driven away into the woods by her stepmother. There, she finds the hut of an old woman who takes her in. Impressed by the orphan's work ethic and homemaking skills, the old woman dips the girl into a golden stream and gives her a pot of gold before sending her back to her village. See Anguel Karaliichev, "Zlatnoto momiche" [The Golden Girl], in *Imalo edno vreme* [Once upon a time] (Sofia: DPK "D. Blagoev," 1979), 53–68.

31. One of the most memorable characters of Ivan Vazov's immensely popular novel *Under the Yoke* (first published in 1894, only four years before Govedarov's translation of *Uncle Tom's Cabin*), is an orphan (raised in a convent) who becomes a teacher in a school for girls, falls in love with a leader of the historic 1876 April Uprising against the sultan, and dies in the uprising. While *Under the Yoke* is a realist novel, this character is clearly influenced by sentimentalism. See Ivan Vazov, *Pod igoto* [Under the yoke] (Sofia: Bulgarski pisatel, 1980).

32. Mavrov and Palashev, "Kak se e poiavila knigata," 8, 16; my translation.

33. See ibid., 5, 9, 13. Mavrov and Palashev do not include information about the sources of the images, but I was able to identify the first image (presumably of Stowe as a young woman) as her 1853 portrait by Francis Hall.

34. Vladimir Filipov analyzes nineteenth-century Bulgarians' suspicions of Protestantism at length in *Pronikvane na angliiskata i amerikanskata knizhnina v Bulgaria prez Vazrazhdaneto*. The prejudice against Protestantism as a tool of foreign interests persisted in the twentieth century. See Maria Koinova, "Ethnic and Religious Minorities in Bulgaria," *SEER: Journal for Labor and Social Affairs in Eastern Europe* 2 (1999): 155–57.

35. Stowe, *Chichovata Tomova koliba*, adapted by D. Mavrov and G. Palashev, 27; my translation.

36. At least three more adaptations of *Uncle Tom's Cabin* for children, by different translators and adaptors, were published between 1911, when Mavrov and Palashev published their first edition, and 1944, when the Soviet army occupied Bulgaria and imposed the communist regime: *Chicho Tomovata koliba* [Uncle Tom's cabin], trans. unknown (Sofia: St. Atanasov, 1919); *Chicho Tomovata koliba*, razkazana za deca ot H. E. Marshall [Uncle Tom's cabin, adapted for children by H. E. Marshall], trans. R. Markov (Sofia: T. F. Chipev, 1932); *Chicho Tomovata koliba*, iliustr. Sakr. Izd. Za deca I iunoshi [Uncle Tom's cabin, illustrated edition. Abridged edition for children and young adults], trans. D. Simidov (Sofia: Zlatna biblioteka, 1935). All these adaptations introduce further cuts.

37. Harriet Beecher Stowe, *Chichovata Tomova koliba* [Uncle Tom's cabin], trans. D. Mavrov (Sofia: Hemus, 1946), 5–10.

38. See Greenberg, "*Bulgarski knizhitsi*," 45.

39. Ivan Ivanovich Ivanov, *Uchitelka na vyzrastnite i drugarka na decata: Bicher-Stou* [A teacher of adults and a friend of children: Beecher Stowe], trans. Ts. Kalchev (Turnovo: Knizharnitsa na E. P. Hristov, 1900).

40. Cohen, *Sentimental Education*, 136.

41. See, for instance, Boris I. Bursov, *"Maika" na Maksim Gorki i vaprosite na socialisticheskia realizam* [*Mother*, by Maxim Gorky, and the characteristics of socialist realism], trans. Ivan Tsvetkov (Sofia: Bulgarski pisatel, 1952).

42. Unlike classic sentimental novels, sentimental social novels frequently present marriage as an oppressive system rather than a positive moral duty. See Cohen, *Sentimental Education*, 128.

43. Ibid., 143.

44. Ivan Popivanov, "Esteticheski problemi na socialisticheskia realizam" [Aesthetic characteristics of socialist realism], in *Aktualni problemi na socialisticheskia realizam* [Topical questions about socialist realism], ed. Stoyan Iliev (Sofia: Bulgarski pisatel, 1985), 46; my translation.

45. Maksim Gorky, *Mother* (New York: D. Appleton, 1921), 42.

46. The range of socialist realist joy is demonstrated, for instance, in the scene in which Pelageya learns of Pavel's decision to lead a worker's demonstration at his factory: "A great ardent thought burned in her bosom, animating her heart with an exalted feeling of sad, tormenting joy" (Gorky, *Mother*, 174).

47. Ibid., 76.

48. Popivanov, "Esteticheski problemi," 41; my translation.

49. Anna Kamenova, "Za knigata i neinia avtor" [About the book and its author], in *Chicho Tomovata koliba* [Uncle Tom's cabin], by Harriet Beecher Stowe, trans. Anna Kamenova (Sofia: Izdatelstvo Otechestvo, 1985), 309; my translation.

50. Ibid., 308; my translation.

51. Ibid.; my translation.

52. Cohen, *Sentimental Education*, 12.

53. Kamenova, "Za knigata," 309; my translation.

54. See Popivanov, "Esteticheski problemi," 53, 65.

55. B. Emelyanov, "Gorki I povestta *Maika*" [Gorki and the Novella *Mother*], in *Maika* [Mother], by Maxim Gorky, trans. Stoyan Karolev (Sofia: Narodna kultura, 1963), 349; my translation.

56. Popivanov, "Esteticheski problem," 45; my translation.

57. In his famous essay "Some Character-Types Met with in Psycho-Analytic Work" (1916), Freud analyzes Ibsen's play *Rosmersholm*. See Sigmund Freud, *On Creativity and the Unconscious: The Psychology of Art, Literature, Love, and Religion*, ed. Benjamin Nelson (New York: Harper Perennial, 2009), 84–110.

58. See Daniel P. Todes, "Pavlov and the Bolsheviks," *History and Philosophy of the Life Sciences* 17.3 (1995): 392, 402.

59. Gorky, *Mother*, 12–13.

60. Ibid., 47.

61. Ibid., 47–48; my italics.

62. Popivanov's examples of socialist realist authors include writers as aesthetically diverse as Bertolt Brecht, Gabriel Garcia Marquez, and Pablo Neruda.

63. Merle Kling, *The Soviet Theory of Internationalism* (Saint Louis: Washington University Press, 1952).

64. Popivanov, "Esteticheski problem," 66; my translation.

65. Stowe, *Chicho Tomovata Koliba*, trans. Kamenova (1985), 287; my translation.

66. Ibid.; my translation.

67. Ibid., 291.

68. Ibid., 113.

69. Filipov, "Za Hariet Bicher-Stou," 394; my translation.

70. Ibid., 395; my translation.

71. Ibid., 394; my translation.

72. Ibid., 395; my translation.

73. Ibid., 395.

74. Gorky, *Mother*, 47.

75. Filipov, "Za Hariet Bicher-Stou," 396; my translation.

76. See, for instance, Viktor Sharenkov, *Amerikanska literatura* [American literature] (Sofia: Nauka I izkustvo, 1961), 74–81; Georgi Rashkov, "Hariet Bicher-Stou," *Rodna rech* [Native speech] 6 (1962): 42–43.

77. Sharenkov, *Amerikanska literatura*, 80; my translation.

78. Filipov, "Za Hariet Bicher-Stou," 394, 396.

79. Milan Enchev, *Izgrazhdane na teoretiko-literaturni poniatia, v IV–VII klas* [Building literary theoretical concepts, for the fourth through seventh grades] (Sofia: Darzhavno izdatelsvo "Narodna Prosveta," 1987), 4; my translation. At the time, Bulgarian middle schools encompassed grades 4–8.

80. Ibid., 4–5; my translation.

81. Iskra Kotova, Milan Enchev, and Nevena Mateeva, *Literaturno obuchenie i razvitie, 4–6 klas* [Literary education and development, from fourth to sixth grade] (Sofia: Darzhavno izdatelsvo "Narodna Prosveta," 1982).

82. Ibid., 162; my translation.

83. Cohen, *Sentimental Education*, 68–69.

84. Kotova, Enchev, and Mateeva, *Literaturno obuchenie*, 162; my translation.

85. Suzanne Keen, "Introduction: Narrative and the Emotions," *Poetics Today* 32.1 (2011): 3.

86. Darcia Narvaez, "Moral Text Comprehension: Implications for Education and Research," *Journal of Moral Education* 30.1 (2001): 43–54; Keen, "Introduction," 11–12.

87. Anna Krusteva, ed., *Imigraciata v Bulgaria* [Immigration in Bulgaria] (Sofia: Mezhdunaroden Centar za izsledvane na maltsinstvata, 2005).

88. Denitsa Kamenova, "Africanskata obshtnost v Bulgaria" [The African community in Bulgaria], in Krusteva, *Imigraciata v Bulgaria*, 56, 62–65.

89. Kamenova, for instance, writes that she was unable to establish the number of Africans and Bulgarians of African descent currently living in Bulgaria (ibid., 59).

Jeffrey Einboden

Harriet Beecher, from Beirut to Tehran: Raising the *Cabin* in the Middle East

Reflecting his repute as America's "Apostle to Islam," Samuel Marinus Zwemer (1867–1952) organized and convened the Second Missionary Conference on Behalf of the Mohammedan World, delivering his opening address for this conference in Lucknow on 23 January 1911.[1] Outlining contemporary opportunities and obstacles to evangelization, Zwemer's address urgently reports on the rise of a "new Islam," alerting his fellow missionaries to the "rationalization" of "the old orthodoxy" across the Muslim world.

> The philosophical disintegration of Islam, which began in Persia by the rise of Moslem sects, is now being hastened through newspaper discussions. The attack on orthodox Mohammedanism was never so keen or strong on the part of any missionary as has been the recent attack from those inside Islam. In Russia the new Islam is rapidly creating a new literature by translations and adaptations. A Tartar translation of "Uncle Tom's Cabin" has just been printed, and the Moslem newspapers at Baku earnestly contend that *it is possible to rationalize Islam*, stating that its present immobility and superstition is only a temporary condition which does not characterize it any more than Catholic superstitions, the Inquisition, or the stake were real Christianity in the Middle Ages.[2]

Spanning geographic continents and historical contraries, Zwemer's survey straddles diverse areas—from Persia to Russia—and divergent tensions, balancing between religion and rationalism, tradition and progress, orthodoxy and reform. Intersecting these international polarities of the

"new Islam," however, Zwemer also inserts a subtle marker of his national heritage, alluding to a singular text that is distinctly American in origin and Christian in its concern, *Uncle Tom's Cabin*. Invoked even as Zwemer pursues his "missionary" conversion of the "Mohammedan World," this American novel emerges in a state of conversion, Stowe's Civil War fiction freshly rendered into not only a new land but also a new language, appearing in a "Tartar translation" that has "just been printed."

Ironic as it is to find a "valued touchstone of American history" exemplifying the "new Islam," Zwemer's passing appeal to *Uncle Tom's Cabin* as he seeks Christian conversions in colonized lands also appears apt, rehearsing issues of authentic interest to Stowe herself, as well as to her most celebrated novel.[3] As implied by the very title of Nancy Koester's recent biography *Harriet Beecher Stowe: A Spiritual Life* (2014), the author of *Uncle Tom's Cabin* was motivated by religious imperatives, with her "life" and literary labors unmistakably activated by Christian commitments. Popularly remembered for her political influence—canonized as the "little lady who started this great war"—Stowe composed anti-slavery polemics that were themselves predicated on "spiritual" sentiments; as Koester reminds us in her biography's introduction, Stowe "believed strongly in Jesus, and her Christian faith was central to her life and work."[4] This "faith" is perhaps nowhere more evident than in *Uncle Tom's Cabin*, a novel that "insists on religious conversion as the necessary precondition for sweeping social change" and that recounts a narrative enlivened by a "rhetoric of conversion."[5] Complementing and contrasting its own conversionary imperative with its personal appeal to spiritual interiority, *Uncle Tom's Cabin* also includes, in its finale, a seeming apology for political colonization abroad. Perhaps the novel's most controversial episode, the conclusion of *Uncle Tom's Cabin* features a "troubling affirmation of the colonization movement," appearing to condone "African-American repatriation" to Liberia.[6]

Recalling Stowe's 1852 novel by name, even while promoting his conversionary and colonizing efforts in 1911, Zwemer's allusion to *Uncle Tom's Cabin* also inadvertently reaches forward, anticipating this fiction's particular afterlife in the "Mohammedan World." Marveling at the rendition of *Uncle Tom's Cabin* for a "Moslem" readership in the first years of the twentieth century, Zwemer gestures to the opening of a vibrant tradition of translation that still unfolds more than a century later. In the hundred years that have passed since its reported "Tartar translation," *Uncle Tom's Cabin* has been printed repeatedly in a variety of Middle Eastern languages,

attracting attention from some of the region's most elite literati, while also sustaining a broad and general readership. Published in multiple volumes and Middle Eastern vernaculars—including Turkish, Persian, and Arabic— the novel's popularity in the Muslim world has been ensured by the wide availability of two prominent translations in particular, one in Arabic and one in Persian, both originally published in the 1950s and still in print today.[7] Appearing first in 1953, the most enduring Arabic edition—entitled *Kūkh al-ʿAmm Tūm* (كوخ العم توم)—was produced by one of the Arab world's most prolific figures in twentieth-century publishing, Munīr Baʿlabakkī (d. 1999),[8] linguist, translator, and founder of an active Beirut publishing house (Dār al-ʿIlm lil-Malāyīn). The breadth and bulk that mark Baʿlabakkī's literary career are impressive. Producing works in a dizzying array of genres, he is perhaps best remembered for his popular Arabic–English dictionary, *al-Mawrid*; however, Baʿlabakkī also regularly served as a translator of American literary classics—tackling not only Stowe's *Cabin* but also novels by such U.S. authors as Hemingway—while translating histories of Islam and the Arab world, including a life of the Prophet Muhammad.[9] The success of Baʿlabakkī's *Kūkh al-ʿAmm Tūm* is seen not only in its remaining in print for over a half century, with multiple editions appearing posthumously in the twenty-first century, but also in its prompting other Arab publishers to follow its lead, with a rival Arabic edition of Stowe's novel released in 2002 by the Beirut press Dār al-Biḥār, for example.[10] In Persian, Stowe's novel has attracted equally prominent and public attention. Most recently, *Uncle Tom's Cabin* was dramatized by renowned playwright Behrooz Gharibpour.[11] A half-century before Gharibpour's contemporary adaptation, however, Stowe's novel was already available to Persian readers in an extensive prose translation produced by Munīr Jazanī: his *Kulbah-e ʿAmū Tum* (كلبهٔ عمو تم) was first published in Tehran in 1956/57 and has subsequently undergone a dozen editions, with the latest appearing in 2009/10.[12]

That an American novel achieved such significant and sustained attention in the literary marketplaces of the Middle East may seem extraordinary; however, the achievement is not entirely unprecedented. As I suggested in my 2013 *Nineteenth-Century U.S. Literature in Middle Eastern Languages*, the translation of nineteenth-century American classics played a pivotal role in twentieth-century literary advances in Arabic, Persian, and Hebrew.[13] For example, two iconic U.S. novels published in the two years preceding Stowe's 1852 *Uncle Tom's Cabin*—Nathaniel Hawthorne's 1850 *The Scarlet Letter* and Herman Melville's 1851 *Moby-Dick*—also attracted trans-

lations from seminal authors and academics writing in Persian and Arabic.[14] However, unlike fellow American novelists or, indeed, other figures of the "American Renaissance," such as Walt Whitman and Henry Wadsworth Longfellow, Stowe's overtly Christian commitments and her imputed embrace of colonialism seem to render her fiction a rather strange and surprising candidate for Middle Eastern translation. Unlike the expected alterities of history, culture, and religion that must be faced by translators of novels such as *Moby-Dick* or poems such as *Leaves of Grass*, *Uncle Tom's Cabin* is unapologetically evangelical in aspiration, seeking to convert its readers to Christian conviction as well as political activism, a tendentious agenda that appears to complicate its publication for Muslim-majority readerships.

Yet *Uncle Tom's Cabin* has enjoyed a popularity in the Middle East that surpasses nineteenth-century American peers, attracting more attention in Arabic and Persian than *The Scarlet Letter* and *Moby-Dick* combined. Although produced by leading authors and academics—*The Scarlet Letter* was translated into Persian by pioneering Iranian novelist Sīmīn Dāneshvar, *Moby-Dick* into Arabic by prolific Palestinian scholar Iḥsān ʿAbbās—Middle Eastern editions of these iconic U.S. novels have appeared far less regularly than the two translations of Stowe's novel generated by Munīr Baʿlabakkī and Munīr Jazanī.[15] The current essay seeks to account for why this could be the case, examining the translatory approaches to *Uncle Tom's Cabin* that have allowed Stowe's novel to become not only palatable to Middle Eastern audiences but popular and profitable in Middle Eastern marketplaces. Attentive to the detailed choices of diction and style, I here discuss the celebrated editions of *Uncle Tom's Cabin* produced by Baʿlabakkī and Jazanī, examining how their Arabic and Persian reformulations of Stowe's English seek not to delete but to divert her evangelical aims.[16] Speaking in 1911, Samuel Marinus Zwemer was perhaps the first to recognize that Stowe's novel was attracting Muslim readers; however, his passing comment is most prescient in situating *Uncle Tom's Cabin* within contexts of Islamic revision and rejuvenation, this American fiction belonging to a tradition not of "translation" merely but of "translations and adaptations." In the most popular Arabic and Persian editions of Stowe's novel, her own "rhetoric of conversion" is newly converted, with the Christianity of her American fiction subtly refashioned to speak instead from "inside Islam." Ironically, while America's "Apostle to Islam" alluded to *Uncle Tom's Cabin* as he pursued his own mission to the Muslim world in 1911, the novel has itself had its religious message reoriented, newly emerging as an apostle for Islam through twentieth-century Middle Eastern translations.

FROM THE *CABIN*'S DIALECTS TO CASSY'S DRINKING

As translators begin their work on *Uncle Tom's Cabin*, posing the most urgent problems in its opening pages is not the novel's overarching concerns—social, political, religious—but, rather, its specific expressions and idioms. Challenged not with rendering a single American English, translators must instead tackle multiple dialects, negotiating an array of registers spoken by Stowe's characters. Distinguished through shifting accents and orthography, Stowe's dialogues seek to simulate antebellum America's dialectal variety, imitating the nation's spoken language(s) as a means of marking the race and region of her protagonists, as well as their political class and even personal character.[17] Consider, for example, the novel's opening conversation between the Kentucky "gentleman" Arthur Shelby and the cruel slave trader Mr. Haley; advised by Haley that he should prevent his slaves from harboring unrealistic "'spectations,'" Shelby responds politely, with Haley's rejoinder following.

> "I'm afraid mine are not properly brought up, then," said Mr. Shelby.
> "S'pose not; you Kentucky folks spile your niggers." (22)

Expressing divergent views through differing vocabularies and voices, Shelby and Haley are distinguished as much by their idioms as by their ideas, the first speaking a "standard" American English, the second using a dialect that Stowe distinguishes by irregular orthography and abbreviations, as well as vicious racial slurs. Such stark juxtaposition in expression and intonation, which animates dialogues throughout Stowe's novel, is tacitly recognized as impossible to reproduce by Middle Eastern translators, evidenced by treatments such as the following, offered by Munīr Jazanī in his Persian edition:

آقای شلبی گفت: « من می ترسم برده های من خوب تربیت نشده باشند. »
ـ خیلی احتمال دارد. چون شما مردم کنتاکی برده هایتان را لوس می کنید

> [Mr. Shelby said, "I fear that my slaves have not been well brought up."
> "Very likely. For you men of Kentucky spoil your slaves."][18]

As I seek to suggest in my translation of Jazanī's version, he makes little attempt to replicate Stowe's differentiation via dialect, preventing Persian

readers from distinguishing the identities of Shelby and Haley based solely on the incongruous idioms they employ; rather than Haley's nonstandard "S'pose not" in Stowe's original, for instance, Jazanī offers the rather unexceptional "Very likely" (خیلی احتمال دارد). Smoothing over Stowe's abrupt shifts between vernaculars and voices, Jazanī's version regularizes not only general expressions but also specific epithets. In English, Haley blames Kentuckians for "spil[ing]" their slaves, while also utilizing a vile racial term; in Persian, he merely warns against "spoil[ing]" Kentuckian "slaves"— برده هایتان—the precise term also employed by Shelby in Persian, invoked in the very exchange rendered above (i.e., برده های من, "my slaves"). Relinquishing not only register difference but also markers of racial discrimination, the Middle Eastern versions of *Uncle Tom's Cabin* prevent readers from instantly recognizing the relative positions and profiles of Stowe's characters merely through their speech. However, such linguistic flattening is perhaps less important for conversations conducted between Stowe's white characters—such as Shelby and Haley—and more important for interracial exchanges featured later in her novel; unlike the original *Uncle Tom's Cabin*, Middle Eastern editions fail to differentiate between dialects spoken by various white "masters" and African Americans, as evidenced in examples provided below. In Arabic and Persian, these opposing sides of the slavery divide are instead endowed with the same standard vernacular. This linguistic divergence from Stowe's original oddly amplifies her fiction's animating social aims, with foreign translators' leveling of linguistic difference across class and race ironically complementing the American novel's own critique of ethnic and economic hierarchies.[19]

Whereas *Uncle Tom's Cabin* confronts Middle Eastern translators with American-specific idioms that prove inimitable, the novel also ironically presents passages that are uniquely ripe for Arabic and Persian translation, featuring names and nomenclature with meanings not only communicable in, but highly congenial to, Middle Eastern languages. Although acknowledged most often as a site of semantic "loss," the act of translation also possesses the capacity to enrich, rather than merely enervate, literary significance, with native resources of a target language serving to amplify original texts. Such enrichment is occasioned, for example, in the Middle Eastern translation of the name of Stowe's character Cassy, an ambivalent protagonist who emerges near the novel's conclusion, distinguished by both her own drinking of alcohol and her bringing Tom a cup of water as he endures

his Christ-like suffering at the cruel hands of Legree (367, 384). Although entirely unforeseen by Stowe, the very name she chose for this character so associated with drinking presents a ready-made wordplay in both Arabic and Persian, as the common term in these languages for a drinking cup, *ka's*, assonates strongly with the name *Kāssī*, as Cassy's name is transliterated by Middle Eastern translators. Ensuring that his own edition profits from this innate correspondence between *Kāssī* and *ka's*—"Cassy" (كاسي) and "cup" (كأس)—Munīr Ba'labakkī not only simply translates these terms from English into Arabic but clusters them together in close proximity, offering renditions of Stowe's source that are reasonable but ironically sound more resonant than her original. For instance, in chapter 36 in her novel, Stowe emphasizes Cassy's alcohol dependence, recounting her recommendation that her fellow female slave Emmeline not reject drinking.

> "You'd better drink," said Cassy. "I hated it, too; and now I can't live without it. One must have something;—things don't look so dreadful, when you take that." (384)

In his Arabic edition, Ba'labakkī slightly extends Stowe's original, presenting his own readers with a pun entirely absent in English.

فأجابت كاسي:

ـ « من الخير لك أن تشربي. لقد كنت أكرهها أيضاً. أما اليوم فأنا لا أستطيع أن أعيش بدونها . . . ذلك أن الأمور لا تبدو مخيفة جداً حين يحتسي المرء كأساً من الخمر!»

> [And Kāssī answered:

> "It's of benefit for you to drink. I used to hate it also. But today, I am unable to live without it. . . . That's as things don't seem so very dreadful when one sips a cup (*ka'san*) of wine!"][20]

Supplying specifics to the last clause spoken by Stowe's Cassy, Ba'labakkī replaces her generic English "when you take that" not with a plain Arabic equivalent but with the parsing annotation "when one sips a cup of wine" (حين يحتسي المرء كأساً من الخمر). Rather than simply inserting detail, Ba'labakkī's more explicit translation also introduces a double entendre, with the speaker

of these lines, *Kāssī* (كاسي), finding her own name echoed back to her in the very object she endorses, *kaʾs* (كأس), "a cup." Amplifying significances implied by Stowe's *Cabin*, Baʿlabakkī's Arabic allows readers to imbibe a more sonorous connection between the "cup" and "Cassy," with this link implied not only by the novel's plot but also by a personal name. Mirroring character and content through a pun unavailable to Stowe's original audience, Baʿlabakkī's version uniquely justifies Cassy's own insistence that she cannot "live without" her "wine," with Arabic assonance suggesting Cassy's identity to be not only synonymous but also harmonious with her cup.

"SUBMITTING" THE *CABIN*'S "COUNTENANCE"

At the opening of chapter 33—entitled "Cassy"—in Stowe's zoriginal novel, her readers find the following first sentences:

> It took but a short time to familiarize Tom with all that was to be hoped or feared in his new way of life. He was an expert and efficient workman in whatever he undertook; and was, both from habit and principle, prompt and faithful. Quiet and peaceable in his disposition, he hoped, by unremitting diligence, to avert from himself at least a portion of the evils of his condition. He saw enough of abuse and misery to make him sick and weary; but he determined to toil on, with religious patience, committing himself to Him that judgeth righteously, not without hope that some way of escape might yet be opened to him. (359)

Whereas the name *Cassy* permits Middle Eastern translators to enrich significance through simple assonance, Stowe's chapter "Cassy" opens with religious complexities that challenge straightforward rendition. Pictured as he acclimatizes to his "new way of life" under the harsh hand of Simon Legree, Tom is portrayed in terms of both patience and piety in the first paragraph of chapter 33, where he is praised especially for his "hope," a word that occurs three times in just this short selection alone. Broadly religious in tone, the opening of "Cassy" also concludes with a specifically Christian text; although not marked as a quotation, Stowe signals her use of a biblical citation by again shifting dialects, employing not regional American slang but antiquated English (i.e., "judgeth"). A direct echo of the first epistle of Peter, *Uncle Tom's Cabin* alludes to a New Testament passage that identifies Christ as an "example," characterizing him as the one

Who, when he was reviled, reviled not again; when he suffered, he
threatened not; but committed *himself* to him that judgeth righteously.[21]

Recruiting this scriptural precedent to portray Tom as a figure both sacred
and sacrificial, Stowe's weaving of the Authorized Version into her Ameri-
can narrative suggests the Christian fabric of *Uncle Tom's Cabin*, which pres-
ents recurrent problems for translators targeting Middle Eastern audiences:
how should such passages, both implicitly and explicitly indebted to the
New Testament, be effectively rendered for Muslim-majority readerships?
Recognizing that the scriptural ethos of such passages must be both con-
veyed yet contoured, Baʿlabakkī refuses verbatim translation, even while
retaining his source's sacred vocabulary; replacing Stowe's biblical charac-
terization of Tom as "committing himself to Him that judgeth righteously,
not without hope that some way of escape might yet be opened to him,"
Baʿlabakkī instead offers

ولكنه آثر أن ينصرف إلى رب العالمين، لا يقطع الرجاء من أن يُفتح له باب من أبواب النجاة،
في يوم من الأيام.

[But he elected to devote himself to the Lord of the Worlds, not cutting
off hope that there be opened for him a door of the doors of salvation in
a day of the days (i.e., someday).][22]

As emphasized in my overly literal version of Baʿlabakkī's Arabic, his
translation ends with a series of elegant elatives, "door of the doors" (باب
من أبواب) and "day of the days" (يوم من الأيام), repetitious comparatives spe-
cific to Arabic style. Formally distinguished by these genitive constructs,
it is an earlier genitive, however, that endows Baʿlabakkī's version with a
sense of the divine, namely "رب العالمين" ("Lord of the Worlds"), a two-term
Arabic phrase that replaces the English "Him that judgeth righteously."
Although not an exact equivalent, this expression creatively conveys the
sense of Stowe's original, comprising one of the most common Arabic
characterizations for God as sovereign judge. If consistent in significance,
however, this phrase's source contrasts strongly with Stowe's Christian us-
age in her *Cabin*. The Arabic epithet "Lord of the Worlds" is the very first
two-word phrase that describes Allah in the Qurʾān, occurring initially in
the second verse of the Muslim scripture's inaugural chapter.[23] Covertly
offering a sacred substitution, Baʿlabakkī retains the religious tenor of his

textual source even while replacing Christian quotation with Qur'ānic, with Tom's piety preserved in translation but turned toward Allah, "Lord of the Worlds."

A pair of words uniquely reminiscent of the Qur'ān, the phrase رب العالمين (Lord of the Worlds) is not unique to chapter 33 in Ba'labakkī's Arabic *Uncle Tom's Cabin* but is utilized earlier in his edition. In the midst of chapter 17, entitled "The Freeman's Defence," Stowe includes a lengthy exchange between Simeon Halliday and George Harris, the former encouraging the latter to adopt a spiritual view of slavery's injustices. Grappling with the seeming contradiction between divine goodness and human grief, George questions why "God *lets*" slave masters persist in criminality and cruelty. Opening with his complaint against God, George's conversation with Simeon is quoted on the left in the table below, paired with Ba'labakkī's highly stylized translation of this same passage, on the right.[24] As made clear merely by the comparative size of the passages, Ba'labakkī significantly truncates his source, condensing Stowe's original from its 330 words to less than 50 words in translation. The primary casualty of Ba'labakkī's cutting is the psalm as recited by Simeon; while more than half of Psalm 73 is specifically reproduced for English readers, Arabic readers are generically informed merely of the recitation of "some psalms" (بعض المزامير). More pivotal in this passage than what is curtailed, however, is how it is contoured. Domesticating Stowe's spiritual message, rather than dispensing with it altogether, Ba'labakkī not only excises biblical quotations from this episode but also inserts Qur'ānic echoes, endowing this exchange between George and Simeon with audible Islamic overtones. The concluding words of the selection comprise the same Qur'ānic phrase discussed previously, رب العالمين (Lord of the Worlds); however, rather than relying solely on this isolated phrase, Ba'labakkī prefaces his Islamic allusion with contextual material that is equally Qur'ānic.

While Stowe portrays George as spiritually pacified by Simeon's psalmic recital, noting that he "sat with a gentle and subdued expression on his fine features," Ba'labakkī breathes new energy into George's conversionary act, noting that "he submitted his countenance to the Lord of the Worlds" (أسلم وجهه لرب العالمين, *'aslama wajhahu li-rabb 'l-'ālamīn*). Opening with verbal activity, rather than "sitting" passively, George is not "subdued" in Arabic translation but, rather, "submits" (أسلم, *'aslama*)—the very verb which also forms the term "Islam" itself, this religion's name signifying "submission" (*Islām*).[25] Between this essential Islamic etymology (*'aslama*) and a com-

"They buy 'em and sell 'em, and make trade of their heart's blood, and groans and tears,—and God lets them."

"Friend George," said Simeon, from the kitchen, "listen to this Psalm; it may do thee good."

George drew his seat near the door, and Eliza, wiping her tears, came forward also to listen, while Simeon read as follows:

"But as for me, my feet were almost gone; my steps had well-nigh slipped. For I was envious of the foolish, when I saw the prosperity of the wicked. They are not in trouble like other men, neither are they plagued like other men. Therefore, pride compasseth them as a chain; violence covereth them as a garment. Their eyes stand out with fatness; they have more than heart could wish. They are corrupt, and speak wickedly concerning oppression; they speak loftily. Therefore his people return, and the waters of a full cup are wrung out to them, and they say, How doth God know? and is there knowledge in the Most High?"

"Is not that the way thee feels, George?"

"It is so indeed," said George,—"as well as I could have written it myself."

"Then, hear," said Simeon: "When I thought to know this, it was too painful for me until I went unto the sanctuary of God. Then understood I their end. Surely thou didst set them in slippery places, thou castedst them down to destruction. As a dream when one awaketh, so, oh Lord, when thou awakest, thou shalt despise their image. Nevertheless, I am continually with thee; thou hast holden me by my right hand. Thou shalt guide me by thy counsel, and afterwards receive me to glory. It is good for me to draw near unto God. I have put my trust in the Lord God."

The words of holy trust, breathed by the friendly old man, stole like sacred music over the harassed and chafed spirit of George; and after he ceased, he sat with a gentle and subdued expression on his fine features. (198–99)

إنهم يشترونهم ويبيعونهم، ويتاجرون بدماء

قلوبهم وتأوهات صدورهم، ودموع

أعينهم، وإن الله ليرى ذلك كله ثم

يدعهم في طغيانهم يعمهون!»

وسمع سايمون ما يتحدث به جورج فتلا عليه

بعض المزامير وحثه على أن لا يقنط من

رحمة الله، فاطمأنت نفس جورج

«وأسلم وجهه لرب العالمين.*

["They buy them and sell them, and make trade in the blood of their hearts and the groans of their breasts, and tears of their eyes. And verily Allāh sees all of this, then lets them wander blindly in their wrongdoings!"

And Simeon listened to what George spoke to him, and then recited to him some psalms, and urged him not to despair of Allāh's mercy. Then George's psyche was calmed, and George submitted his countenance to the Lord of the Worlds.]

*For Ba'labakkī's Arabic translation, see *Kūkh al-'Amm Tūm*, 87; however, in Ba'labakkī's 2006 edition, which I regularly cite, the verb يعمهون (wander blindly)—which appears in prior editions of Ba'labakkī's translation and is preserved here in my quotation—reads يعربدون (revel).

mon appellation for Allah (Lord of the Worlds), Baʿlabakkī's short sentence makes mention of George's "countenance" (*wajh*)—an insertion that may initially seem strange but is, again, entirely consistent with the Qurʾān, recalling verses such as 2:112, which asserts (emphasis added),

بَلَىٰ مَنْ أَسْلَمَ وَجْهَهُ لِلَّهِ وَهُوَ مُحْسِنٌ فَلَهُ أَجْرُهُ عِنْدَ رَبِّهِ

[Nay, but whosoever **submits his countenance to** *Allāh* [*ʾaslama wajahu li-llāh*], being a good-doer, his reward is with his Lord.][26]

Recalling a range of Islamic precedents in portraying George's "calm" conversion in Arabic, George's complaint against God is perhaps the most unusual aspect of Baʿlabakkī's version, featuring another significant scriptural intervention. In Stowe's original, George rails against slavery's injustice in American slang: "They buy 'em and sell 'em," George complains, "and God *lets* them." To render merely this final phrase, Baʿlabakkī offers the creative equivalent

وإن الله ليرى ذلك كله ثم يدعهم في طغيانهم يعمهون!

[And verily *Allāh* sees all of this, then lets them wander blindly in their wrongdoings!]

Substituting formal Arabic for informal English, Baʿlabakkī's version also extends his abbreviated source; most conspicuous is the complex characterization here supplied for slave owners, described as men who "wander blindly in their wrongdoings" (في طغيانهم يعمهون, *fī ṭughyānihim yaʿmahūn*), a striking conceit entirely absent from Stowe's *Cabin*.

Although appearing odd in English, Baʿlabakkī would expect his audience to understand this Arabic addition, as it comprises not a new coinage but, rather, a sacred quotation. This precise phrase forms a distinctively Qurʾānic formula, occurring in multiple verses of the Muslim scripture, including 2:15, 6:110, 7:186, and 10:11; the last, for instance, recounts Allah's declaration, "We leave those, who look not to encounter Us, wandering blindly in their wrongdoings [*fī ṭughyānihim yaʿmahūn*]."[27] Intriguing as it is to find yet another Islamic import within his Arabic, Baʿlabakkī's borrowing from the Qurʾān here seems of special interest, as it emerges without

any prompt from his source; rather than revising religious language supplied by Stowe, this specific Qur'ānic intervention is wholly Ba'labakkī's own innovation, with George's simple protest "and God *lets* them" replaced surprisingly by speech regarded by Muslims as most sacrosanct. Extraordinary in its spiritual import, Ba'labakkī's striking interpolation impacts the story of *Uncle Tom's Cabin* as well. While Stowe dramatizes an unfolding Christian conversion in this scene from chapter 17, portraying George's progress from bitter skeptic to serene believer, Arabic readers find a religious experience that both ends and opens with Islamic echoes, hearing George cite the Muslim scripture before his own "submission" to the "Lord of the Worlds." Even in his complaint against God, George proclaims God's own speech. In Arabic translation, George's spiritual conviction seems less a progress of piety and more a fait accompli, with George's supposed conversion ironically enveloped by quotations from the Qur'ān.

"LET IT BE A MEMORIAL"

The climax of *Uncle Tom's Cabin* features the novel's most iconic religious imagery, with Tom's own torture and death serving to reenact and dramatize the passion of Christ[28]—a reenactment intended to prompt "Stowe's readers [to convert] to Christ and to anti-slavery at the same time," as Nancy Koester has recently suggested.[29] The sacred frame for Tom's sacrificial death is made explicit from the very name of the novel's decisive chapter 40, which Stowe resonantly entitled "The Martyr" (416).[30] Etymologically Greek— derived from μάρτυς, a word literally signifying "witness"—Stowe's "Martyr" is a term rich in significance and yet also readily translatable into Middle Eastern languages, replaced by both Arabic and Persian editions with the same equivalent. In the translations of Ba'labakkī and Jazanī, chapter 40 is identically entitled, respectively, *al-shahīd* (الشهيد) and *shahīd* (شهيد). An Arabic term that matches *martyr* closely, *shahīd* literally means "witness" but has also come to imply a believer who dies for the sake of faith, and it is now regularly applied to acts of "martyrdom" in the Middle East.[31]

Semantically similar to Arabic *shahīd*, Stowe's *martyr* is, of course, decidedly Christian in connotation, as her chapter 40 clarifies unmistakably at its conclusion. Picturing Tom as he "witnesses" to the very slaves who torture him—Quimbo and Sambo—chapter 40 closes with a dramatic conversion, ending with the following exchange:

"O, Tom!" said Quimbo, "we's been awful wicked to ye!"

"I forgive ye, with all my heart!" said Tom, faintly.

"O, Tom! do tell us who is *Jesus*, anyhow?" said Sambo;—"Jesus, that's been a standin' by you so, all this night!—Who is he?"

The word roused the failing, fainting spirit. He poured forth a few energetic sentences of that wondrous One,—his life, his death, his everlasting presence, and power to save.

They wept,—both the two savage men.

"Why didn't I never hear this before?" said Sambo; "but I do believe!—I can't help it! Lord Jesus, have mercy on us!"

"Poor critters!" said Tom, "I'd be willing to bar' all I have, if it'll only bring ye to Christ! O, Lord! give me these two more souls, I pray!"

That prayer was answered! (422–23)

If Stowe's entire novel implies a "rhetoric of conversion," her chapter 40 is where this rhetoric becomes reality, culminating with the conversion of two "wicked" criminals in response to Tom's passionate suffering. Petitioning the "Lord Jesus" and his "everlasting presence," while concluding with Tom's "answered prayer" for two "souls" to be saved for "Christ," this vignette and its theological vocabulary appears difficult to domesticate for Muslim readerships. However, Middle Eastern editions of Stowe's *Cabin* have proven successful in muting the Christian motifs of this climactic close to chapter 40, offering careful excisions and extensions. For example, in Persian, the personal addressee of Tom's final petition is subtly shifted; instead of Stowe's last lines

said Tom [. . .] 'O, Lord! give me these two more souls, I pray!'

That prayer was answered! (423)

Jazanī supplies merely

تم می گفت: « [. . .] این دو روح را هم به من بده! »

و این دعا به گوش خداوند رسید.

[Tom said [. . .] "These two souls, both give to me!"

And this prayer was heard by God.]³²

Refusing to specify Tom's target for his prayer in Persian, Jazanī's translation removes Tom's opening invocation: "O Lord!"—an invocation with decidedly Christian implications, echoing Sambo's own petition to the "Lord Jesus" immediately above. Removing the addressee of Tom's entreaty, Jazanī not only suppresses specifics but also further specifies Stowe's original. While chapter 40 in English concludes with a curiously passive construct— "That prayer was answered!"—Jazanī's version adds details, clarifying the destination of Tom's devotion: و این دعا به گوش خداوند رسید, "And this prayer was heard by God" (or, more literally, "And this prayer reached the ear of God"). While Tom's supplication for the salvation of his torturers is Christ-centered in Stowe's *Cabin*, Jazanī's insertion certifies that Tom's prayer is heard instead by *Khudāvand* (خداوند, "God" or "the Lord"), a term for the divine invoked regularly by Iranian Muslims when referring to Allah.³³

If Stowe's chapter 40—"The Martyr"—portrays Tom's torturous passion, it is not until the next chapter that his martyrdom comes to a close, with Tom's death forming the center of the *Cabin's* chapter 41, entitled "The Young Master." As with chapter 40, however, chapter 41 features yet another act of faithful witnessing, as well as a consequent conversion, with Tom's last words deeply affecting the "young master" himself, George Shelby.

> "Who,—who,—who shall separate us from the love of Christ?" [Tom] said, in a voice that contended with mortal weakness; and, with a smile, he fell asleep.
>
> George sat fixed with solemn awe. It seemed to him that the place was holy; and, as he closed the lifeless eyes, and rose up from the dead, only one thought possessed him,—that expressed by his simple old friend,— "What a thing it is to be a Christian!"
>
> He turned: Legree was standing, sullenly, behind him. (427)

Expressing his Christian convictions through biblical quotation, Tom's last line is borrowed from the book of Romans, citing verse 35 of chapter 8 of the King James Version, "Who shall separate us from the love of Christ?" Stuttering this single sentence at his death, it is a more "simple" statement for which Tom is instantly remembered, however, with George "possessed" by an adage entirely original to his "old friend," "What a thing it is to be a

Christian!" Perhaps the novel's most pivotal scene—with Tom's transition to the next world transforming not only people but even the "place" itself—this passage also poses the greatest challenge for linguistic transformation, prompting Stowe's Middle Eastern translators to generate revised versions such as the following authored by Ba'labakkī in his Arabic edition:

«من، ـ من ـ من ذا الذي يستطيع أن يفصلنا عن حب المسيح؟»

قال ذلك في صوت كالهمس وبابتسامة وادعة أغفى توم إغفاءة الأبد.

نهض جورج ثقيل القلب، مهيض الجناح، واستدار على عقبيه فإذا به وجهاً لوجه أمام ليكري

["Who—who—who is the one able to separate us from the love of the Messiah?" He said this in a voice like a whisper, and with a calm smile Tom fell into eternal sleep. George rose heavy of heart, broken of wing, and turning upon his heels, behold, he was then face to face in front of Legree.][34]

Beginning with a close translation of Tom's biblical quote, Ba'labakkī allows Tom to enter his "eternal sleep" with the same sentence he speaks in English, even retaining the faltering hesitation of Tom's final words, opening with من ـ من ـ ،من (Who—who—who). The verbatim character of Ba'labakkī's version ceases, however, with the end of Tom's life; rather than impressed by "holiness," George is rendered "heavy of heart" as he departs, not uplifted by "solemn awe" as in Stowe's original, but despondent and "broken of wing." More significantly, Tom's posthumous statement is missing, his remembered exclamation—"What a thing it is to be a Christian!"—entirely forgotten in Arabic. No longer "possessed" by "only one thought," George's memory is erased by Ba'labakkī, his own readers prevented from perceiving Tom's final Christian testimony.

A more fulsome, if no more "faithful," version of Tom's death and George's departure is provided in Persian, with Jazanī translating this same scene from chapter 41 as follows:

با صدایی که دیگر به زحمت شنیده می شد زمزمه کرد: « هیچکس نمی تواند عشق به خدا را از دل ما بیرون کند! . . . » و با لبخندی به خواب ابدی رفت.

ژرژ با احترام و بیحرکت همانجا نشست . . . برای او این مکان مقدس بود . . . چشمهای تم

را برای همیشه بست . . . و هنگامی که از جا برخاست این جملهٔ دوست باوفایش را در ذهن
داشت، « دوست داشتن! دنیا فقط همین یک لذت را دارد! »

[In a voice that was barely audible, [Tom] whispered, "No one is able to
extract the love of God from our hearts! . . ." And with a smile he went
to eternal sleep.

George, with solemn respect, sat there, motionless. . . . It seemed to him
this place was holy. . . . He closed Tom's eyes forever . . . , and as he rose
from that place, he held in his mind this sentence of his faithful friend:
"Love! The world just possesses this single joy!"][35]

Prefacing Tom's last words in Persian, Jazanī first frames his final sentence
by suggesting that it was spoken "in a voice that was barely audible"—a pro-
viso that seems particularly ironic, as it is Jazanī himself who mutes Tom's
martyrdom, rendering inaudible its Christian intent. Replacing a rhetorical
question with an emphatic declaration, Jazanī also redirects Tom's dying
confession to an alternate source of divine "love"; rather than his original
inquiry in English ("Who,—who,—who shall separate us from the love of
Christ?"), Tom instead pronounces in Persian,

"هیچکس نمی تواند عشق به خدا را از دل ما بیرون کند؟",

"No one is able to extract the love of God from our hearts!" Silencing the
Christian witness of Tom's whispered citation, Jazanī's edition "extracts" Je-
sus himself from Romans 8:35, exchanging "Christ" for *Khudā* (God). This
targeted replacement, however, also anticipates a more total revision later in
Jazanī's version, with Tom's posthumous echo replaced entirely in Persian.
While Baʿlabakkī had quietly excised the exclamation recalled by George—
"What a thing it is to be a Christian!"—Jazanī rewrites this recollection al-
together, innovating another "sentence" that haunts George's "mind" as he
mourns his "faithful friend":

"دوست داشتن! دنیا فقط همین یک لذت را دارد!",

"Love [literally, "To have a friend"]! The world just possesses this single
joy!" Intimate yet universal, Jazanī's comprehensive "love" replaces Stowe's
"Christian" commitment—a "global" replacement that also shifts away from

spiritual individuality and toward the social "world," emphasizing not sectarian adherence but, rather, a "single" aesthetic "joy." Offering Muslim readers an equivalent that refrains from championing another religion, Jazani's creative revisions also supply a seeming response to the very question that tacitly prompts his translation. While this episode of *Uncle Tom's Cabin* had launched with a biblical query ("Who shall separate us from the love of Christ?"), the novel's Middle Eastern translations offer an oblique answer to this challenge, seeking to "separate" Stowe's fiction from its religious roots, "just" emphasizing "love" rather than the *Cabin's* original Christian commitments.

The readiness to revise George's recollection of Tom's martyrdom—a readiness exhibited by both Arabic and Persian translations of Stowe's chapter 41—is especially significant considering the conclusion to *Uncle Tom's Cabin*. In the final paragraph of the novel's narrative proper, George recounts Tom's passion, fashioning a moral from his friend's memory at the end of chapter 44.

> George here gave a short narration of the scene of [Tom's] death, and of his loving farewell to all on the place, and added,
>
> "It was on his grave, my friends, that I resolved, before God, that I would never own another slave, while it was possible to free him; that nobody, through me, should ever run the risk of being parted from home and friends, and dying on a lonely plantation, as he died. So, when you rejoice in your freedom, think that you owe it to that good old soul, and pay it back in kindness to his wife and children. Think of your freedom, every time you see UNCLE TOM'S CABIN; and let it be a memorial to put you all in mind to follow in his steps, and be as honest and faithful and Christian as he was." (447)[36]

Recalling Tom's own last words, the last words of *Uncle Tom's Cabin* are religiously concerned, emphasizing "faith" as much as "freedom," encouraging not only American abolitionism but Christian conviction. However, while Tom's martyrdom had inspired George's own spiritual memories in chapter 41, chapter 44's final paragraph passes this spiritual memory on to us, recommending Tom's pious "example" to a broader readership. Complexly self-reflective, this ending not only enjoins the audience to recall Uncle Tom and "to follow in his steps" but also features the novel's own

reference to itself, its title here named in capitalized letters, with "UNCLE TOM'S CABIN"—both the fictional building and the book of fiction—erected to serve as a "memorial" for "you." Culminating her conversionary aims, Stowe's *Cabin* concludes with a final evangelical act, closing with the imperative to be "honest and faithful and Christian"—a proselytizing effort that Middle Eastern translators unsurprisingly find problematic, prompting Baʿlabakkī to end his own Arabic edition with the following words instead:

فكروا في حريتكم كلما رأيتم كوخ العم توم. واتخذوا منه ذكرى تحدوكم أبداً على أن تترومو ا خطاه، وتكونا أوفياء مخلصين مؤمنين بقدر ما كان هو وفياً مخلصاً مؤمناً! »

[Think of your freedom, every time you see Uncle Tom's Cabin. And take from it a reminder [*dhikrā*] urging you always to follow his footsteps, and that you be faithful, sincere, and believing as much as he was faithful, sincere, and believing!]

Recalling the rendition of Tom's valediction in chapter 41, the valediction of *Uncle Tom's Cabin* is here vacated of its denominational markers, with generic religious virtues in Arabic replacing the American novel's own Christian-specific vocation. Deliberately diverting the command offered by Stowe in her conclusion, Baʿlabakkī's readers are advised to be "faithful," rather than to ascribe to any one "faith." However, in enjoining his readers to be "faithful, sincere, believing," Baʿlabakkī not only dampens the *Cabin*'s Christian discourse but recruits diction characteristic of the Qurʾān; the participle مخلصين (sincere) is particularly suggestive of the Muslim scripture, as this single term is frequently invoked to designate "believers" in Islam.[37] In light of his prior religious revisions—quietly editing Stowe's Christian allusions, while interjecting Qurʾānic idioms—Baʿlabakkī's modified last lines (which are similar to those implemented in Persian by Jazanī) may seem unsurprising.[38] Yet these final revisions also seem to surpass in significance all former adjustments, accruing additional weight due to not only their climactic placement at the *Cabin*'s conclusion but also their self-conscious resistance to the novel's "rhetoric of conversion." While Stowe seeks to mold the "memory" of her readers by offering a last religious imperative, her Middle Eastern translators intentionally misremember their original, suppressing the final identity enjoined by their source, cutting all mention of Tom's being as "Christian as he was."

Encouraging his Arabic audience to "think" of their liberty as they "see Uncle Tom's Cabin," it is perhaps not literal, but literary, "freedom" that emerges as we regard *Uncle Tom's Cabin* in Ba'labakkī's Arabic or Jazanī's Persian. Recommending that their readers "follow footsteps," even as the translators themselves forge fresh routes of rendition, Ba'labakkī and Jazanī increasingly embrace translatory liberty as they "think" through to the end of *Uncle Tom's Cabin*, ironically answering Stowe's own imperative by revising her *Cabin* into a resonant Middle Eastern "reminder," or *dhikrā* (ذكرى, another term with clear Qur'ānic precedents).[39] Although Zwemer recognized in 1911 that the recent appearance of Stowe's novel signaled "a new literature by translations and adaptations" rising in the Muslim world, perhaps his missionary zeal prevented him from also predicting that *Uncle Tom's Cabin* would itself become reborn in its linguistic conversion, this novel repeatedly made "new" through its own Middle Eastern "translations and adaptations."

Notes

1. On Samuel Marinus Zwemer and his repute as the "Apostle to Islam," see *Islam and the Cross: Selections from "The Apostle to Islam,"* ed. Roger S. Greenway (Phillipsburg, NJ: P&R Publishing, 2002). Zwemer's opening address to the 1911 Lucknow conference, entitled "An Introductory Survey," is included in the published conference proceedings, *Islam and Missions: Being Papers Read at the Second Missionary Conference on Behalf of the Mohammedan World at Lucknow, January 23–28, 1911*, ed. E. M. Wherry, Samuel M. Zwemer, and C. G. Mylrea (New York: Fleming H. Revell, 1911), 9–42.

2. Zwemer, "Introductory Survey," 33–34.

3. For traditional readings of *Uncle Tom's Cabin* as a "valued touchstone of American history," see Claire Parfait, *The Publishing History of Uncle Tom's Cabin, 1852–2002* (Aldershot: Ashgate, 2007), 1.

4. Nancy Koester, *Harriet Beecher Stowe: A Spiritual Life* (Grand Rapids, MI: William B. Eerdmans, 2014), xi. Koester does not portray Stowe's Christianity as either simple or settled but, rather, frames her faith in terms of "struggles" and "quest."

5. Jane Tompkins, *Sensational Designs: The Cultural Work of American Fiction, 1790–1860* (New York: Oxford University Press, 1985), 132; Jo-Ann Morgan, *Uncle Tom's Cabin as Visual Culture* (Columbia: University of Missouri Press, 2007), 65.

6. Sarah Robbins, *The Cambridge Introduction to Harriet Beecher Stowe* (Cambridge: Cambridge University Press, 2007), 106; Gillian Brown, "Reading and Children: *Uncle Tom's Cabin* and *The Pearl of Orr's Island*," in *The Cambridge Companion to Harriet Beecher Stowe*, ed. Cindy Weinstein (Cambridge: Cambridge University Press, 2004), 77–94 (for "African-American repatriation," see p. 84).

7. In addition to the Arabic and Persian editions treated in this essay (cited immediately below), *Uncle Tom's Cabin* has appeared in multiple Turkish editions, including, most recently, *Tom Amca'nın Kulübesi*, translated by Celal Kırlangıç (Ankara: Gugukkuşu, 2001), as well as the earlier edition *Tom Amca Kulübesi* (Altin Kitaplar, 1984).

8. The edition of Baʿlabakkī's Arabic *Uncle Tom's Cabin* cited in the present essay is *Kūkh al-ʿAmm Tūm* [كوخ العم توم] (Beirut: al-Markaz ath-Thaqāfī al-ʿArabī and Dār al-ʿIlm lil-Malāyīn, 2006). The translation was initially issued in 1953, published under the extended title كوخ العم توم او الحياة مع المعذبين في الارض [*Uncle Tom's cabin; or, Life among the sufferers in the earth*] (Beirut: Dār al-ʿIlm lil-Malāyīn).

9. Baʿlabakkī's *al-Mawrid* has continued to appear in new editions even after his death and was published most recently by Dār al-ʿIlm lil-Malāyīn in 2012. Baʿlabakkī's translatory span is reflected in his tackling of English-language texts that include Ernest Hemingway's *Farewell to Arms* (published by Baʿlabakkī as *Wadāʿ lil-Silāḥ!*) and Muhammad Ali's biography of the Prophet Muhammad (published by Baʿlabakkī as *Ḥayāt Muḥammad wa-Risālatuh* [*The Life of Muhammad and his Message*]), both produced by Beirut's Dār al-ʿIlm lil-Malāyīn.

10. See Harriet Beecher Stowe, *Kūkh al-ʿAmm Tūm* (Beirut: Dār al-Biḥār, 2002). In the single foregoing study of Stowe in Arabic, Al-Sarrani offers an overview of the Arabic editions of *Uncle Tom's Cabin* and suggests that the Dār al-Biḥār edition "strongly depends" on Baʿlabakkī's *Kūkh al-ʿAmm Tūm*. See Abeer Abdulaziz Al-Sarrani, "Challenges of Cross-Cultural Translation of American Literary Works into Arabic: Harriet Beecher Stowe's *Uncle Tom's Cabin* as a Case Study" (PhD diss., Indiana University of Pennsylvania, 2011), 75.

11. On Behrooz Gharibpour's dramatic adaptation of *Uncle Tom's Cabin*, see Debra Rosenthal's essay in the present collection.

12. In this essay, I cite the eleventh edition of Jazani's Persian *Uncle Tom's Cabin*, *Kulbah-e ʿAmū Tum* [کلبهٔ عمو تم] (Tehran: Kitābhā-yi Parstū, 1974/1975). Most recently, *Kulbah-e ʿAmū Tum* was published in 2009/10 by the Tehran press Shirkat-i Sihāmī-i Kitābhāy-i Jaybī.

13. See Jeffrey Einboden, *Nineteenth-Century U.S. Literature in Middle Eastern Languages* (Edinburgh: Edinburgh University Press, 2013).

14. For more on Hawthorne's *The Scarlet Letter* translated into Persian as *Dāgh-e Nang* by Sīmīn Dāneshvar (Tehran: Nil, 1955) and Melville's *Moby-Dick* translated into Arabic as *Mūbī Dīk* by Iḥsān ʿAbbās (Beirut: Dār al-Kitāb al-ʿArabī, 1965), see chapters 3 and 4, respectively, of my *Nineteenth-Century U.S. Literature in Middle Eastern Languages* (75–98, 99–122).

15. Dāneshvar's translation of *The Scarlet Letter* and ʿAbbās's translation of *Moby-Dick* have each been published twice, with Dāneshvar's 1965 *Dāgh-e Nang* reissued in 1990 and with ʿAbbās' 1965 *Mūbī Dīk* reissued in 1998; by contrast, the two translations of *Uncle Tom's Cabin* addressed in the present essay—Jazani's Persian and Baʿlabakkī's Arabic—have appeared in print more than ten times each.

16. Although Al-Sarrani's unpublished PhD dissertation addresses Arabic editions of Stowe's novel as examples of "cross-cultural translation," he does not quote, critique, or provide close readings of the actual Arabic used in translation.

17. For Stowe's controversial use of dialect, including an overview of its criticism, see Michael J. Meyer, "Toward a Rhetoric of Equality: Reflective and Refractive Images in Stowe's Language," in *The Stowe Debate: Rhetorical Strategies in Uncle Tom's Cabin*, ed. Mason I. Lowance Jr., Ellen E. Westbrook, and R. C. De Prospo (Amherst: University of Massachusetts Press, 1994), 236–54 (243).

18. Jazani, *Kulbah-e ʿAmū Tum*, 17.

19. The incapacity of Arabic to reproduce the dialectal variety of Stowe's novel has

been previously recognized by Abeer Abdulaziz Al-Sarrani; in his 2011 "Challenges of Cross-Cultural Translation of American Literary Works into Arabic," he notes, "Due to the standard rule of writing in the standard form, the Arabic translations [of Stowe's *Cabin*] are not able to present such intention of using the colloquial dialect" (114). He also references Haley's speech in particular (including his opening exchange with Shelby) to exemplify Stowe's use of dialect (110)—although Al-Sarrani does not quote and critique Haley's speech as it is rendered into Arabic specifically.

20. Baʿlabakkī, *Kūkh al-ʿAmm Tūm*, 234. In Stowe's original, at the opening of chapter 34, Cassy "raised [Tom's] head, and gave him drink" (367), and in chapter 36, she champions her own alcohol drinking (384), as discussed below.

21. 1 Peter 2:23. This quotation is from the King James Version (1611); as Claudia Stokes has recently noted, the KJV is "the default translation" of Stowe's *Cabin* (*The Altar at Home: Sentimental Literature and Nineteenth-Century American Religion* [Philadelphia: University of Pennsylvania Press, 2014], 57).

22. Baʿlabakkī, *Kūkh al-ʿAmm Tūm*, 210.

23. While the divine names that open the Qurʾān's first book and chapter proclaim Allah as "Merciful" (*ar-raḥmān*) and "Beneficent" (*ar-raḥīm*), the phrase *rabb 'l-ʿālamīn* (رب العالمين), which occurs in the Qurʾān in verse 2 of book 1, is the scripture's initial multiword phrase that refers to Allah.

24. Translations of the Qurʾān provided in this chapter are adapted from A. J. Arberry's *The Koran Interpreted* (New York: George Allen & Unwin, 1955). Although Al-Sarrani does not quote specific Qurʾānic echoes in extant Arabic translations of Stowe's *Cabin*, he does recognize that "religious challenges have made the Arab translators exclude most of the Biblical verses and allusions used by Stowe," and also recommends that future Arabic translators "maintain the Biblical verses within the body of the translated text [of *Uncle Tom's Cabin*] and include similar Quranic verses"; see "Challenges of Cross-Cultural Translation of American Literary Works into Arabic," 192.

25. The noun *Islām* (submission) is derived from the same verbal form (i.e., form IV) as the verb *ʾaslama* (he submitted), both deriving from the triliteral root *S-L-M*. Baʿlabakkī's version also possesses an Islamic resonance in its phrase اطمأنت نفس (rendered here as "[his] psyche was calmed"), as this phrase recalls Qurʾānic precedents, such as النَّفْسُ الْمُطْمَئِنَّةُ, "the contented soul" (89:27).

26. In *The Koran Interpreted*, Arberry provides a slightly less literal translation for this verse: "Nay, but whosoever submits his will to God, being a good-doer, his wage is with his Lord, and no fear shall be on them, neither shall they sorrow." For another occurrence of وجه (*wajh*) in the Qurʾān, see also 4:125.

27. Arberry's translation of this verse reads instead "But We leave those, who look not to encounter Us, in their insolence wandering blindly."

28. Morgan, *Uncle Tom's Cabin as Visual Culture*, 64–100.

29. See Koester, *Harriet Beecher Stowe*, 28.

30. On "the term *martyr*" as "part of the legal lexicon of the Greek court, strictly indicating a witness," see Shmuel Shepkaru, *Jewish Martyrs in the Pagan and Christian Worlds* (Cambridge: Cambridge University Press, 2006), 280.

31. For these chapter titles, see, respectively, Baʿlabakkī, *Kūkh al-ʿAmm Tūm*, 254; Jazanī, *Kulbah-e ʿAmū Tum*, 484. The Arabic *shahīd* (شهيد) derives from the verbal root *Sh-H-D* (شهد), which signifies "to witness."

32. Stowe, *Uncle Tom's Cabin*, 423. Jazanī's version of Stowe's chapter 40 (*Kulbah-e 'Amū Tum*, 484ff.) not only concludes with these adapted final lines but also replaces names such as "Jesus" and "Christ" (to whom Tom hopes to bring souls for salvation, even "willing to bar' all") with the Arabic term مسیح (Messiah)—a reasonable translation, yet one that is also amenable to his Muslim readers, as مسیح appears regularly in the Qur'ān (e.g., at 3:45) to describe Jesus.

33. See, for instance, the recent e-book translation into Persian of I. P. Petrushevskiǐ's *Islam in Iran* (Albany: State University of New York Press, 1985), translated by Karīm Keshāvarz (Los Angeles: Ketab Corporation, 2014), which frequently renders "God" in the context of Iranian Islam as خداوند (*Khudāvand*); see, for instance, 279.

34. Ba'labakkī, *Kūkh al-'Amm Tūm*, 266.

35. Jazanī, *Kulbah-e 'Amū Tum*, 496–97.

36. I designate Stowe's chapter 44 as the end of her narrative proper, as the *Cabin's* last chapter (chapter 45, "Concluding Remarks") breaks from fiction and speaks from the perspective of the historical "writer" (Stowe) herself. Furthermore, Middle Eastern translators regularly avoid including chapter 45 in their versions, dissuaded perhaps by this chapter's historical, colonial, and Christian concerns.

37. See, for example, three discrete occurrences of this term in the Qur'ān in a single *sura* alone at 39:2, 39:11, and 39:94.

38. The final paragraph of Jazanī's Persian *Kulbah-e 'Amū Tum* recalls Ba'labakkī's own Arabic conclusion by entirely removing all mention of "Christian[ity]," enjoining readers instead to have "faith" (ایمان).

39. In addition to its regular occurrence in the Qur'ān (e.g., 6:68, 69, 90; 7:2), ذکری (*dhikrā*) is also of importance because it occasionally signifies the Muslim scripture itself, with the Qur'ān self-identifying as a "reminder."

Debra J. Rosenthal

Staging *Uncle Tom's Cabin* in Tehran

When Hurricane Katrina hit New Orleans in late August 2005, it became one of the five deadliest hurricanes in the history of the United States and resulted in the country's costliest natural disaster in terms of property damage, not to mention human lives. While political response to the hurricane stalled and largely failed the people hit hardest, aesthetic response to the disaster has been continuous, impassioned, and highly critical of the U.S. government's multiple failures and of preexisting structural inequities in American society. The decade following Katrina produced many American literary works informed by the devastation: Douglas Brinkley's *The Great Deluge* (2009), Dave Egger's *Zeitoun* (2009), Dan Baum's *Nine Lives* (2009), Josh Neufeld's *AD: New Orleans After the Deluge* (2009), Mat Johnson and Simon Gane's *Dark Rain* (2010), and Jesmyn Ward's *Salvage the Bones* (2011). Photographer Jane Fulton Alt documented the storm flood's destruction in her book *Look and Leave* (2009). Filmmakers also interpreted the brutality of the hurricane and its human costs, in films such as Spike Lee's *When the Levees Broke* (2006) and *If God Is Willing and the Creek Don't Rise* (2010), Tia Lessin and Carl Deal's *Trouble the Water* (2008), PBS's *Fats Domino: Walkin' Back to New Orleans* (2008), and Werner Herzog's *Bad Lieutenant: Port of Call New Orleans* (2009). Innumerable visual, musical, and conceptual artists also have used their talents to retell and respond to Katrina and its aftermath.[1]

The wake of the hurricane's floodwaters reaches beyond the coasts of the United States: artists abroad also claim interpretive rights to the tragedy. When renowned Iranian playwright, director, and puppeteer Behrooz

Gharibpour watched televised images of Katrina's devastation of New Or-
leans from his home in Tehran, he felt called to make a theatrical and activist
response to what he rightly saw as the disproportionate misfortunes that fell
on black Americans. As an artist from a culture far different from the one in
which Katrina occurred, Gharibpour connected the catastrophic natural di-
saster to a classic American novel that thematizes slavery, *Uncle Tom's Cabin*.
He adapted Munīr Jazanī's 1956 Farsi translation of the novel into a script
and then staged the play at the Bahman Cultural Arts Center in Tehran in
2008. Since Gharibpour's theatrical production of *Uncle Tom's Cabin* was
motivated by Hurricane Katrina, it addresses issues of social inequity made
visible as the winds hit and the waters rose.[2] The present essay is based on a
DVD recording of one of these performances.[3]

Given the historical political antagonism between Iran and the United
States, one might wonder what Iranian officials think of fiction produced
by the West, as well as whether the literary output of liberal democracies
would be welcome in an Islamic state that still has a very active and promi-
nent censor. Most important for the concerns of this essay is that Ali Hos-
seini Khamenei, the second and current Supreme Leader of Iran and a Shia
cleric, advocates reading *Uncle Tom's Cabin*. He recommended the novel
to high-level state managers in 2002 because it details the reality of U.S.
history: "Isn't this the government that massacred the original native in-
habitants of the land of America? That wiped out the American Indians?
Wasn't it this system and its agents who seized millions of Africans from
their houses and carried them off into slavery and kidnapped their young
sons and daughters to become slaves and inflicted on them for long years
the most severe tragedies? Today, one of the most tragic works of art is
Uncle Tom's Cabin. . . . This book still lives after almost 200 years."[4] Khame-
nei, an official spokesman of Iranian governmental approval, highly recom-
mends both Stowe's novel and Victor Hugo's *Les Miserables* for their ability
to support negative interpretations of American and French history. Many
U.S. news sites quote Khamenei as saying, "In my opinion, Victor Hugo's
Les Miserables is the best novel that has ever been written in history. I have
not read all the novels written throughout history, no doubt, but I have read
many. [. . .] *Les Miserables* is a miracle in the world of novel writing. I have
said over and over again, go read *Les Miserables* at once. This *Les Miserables*
is a book of sociology, a book of history, a book of criticism, a divine book, a
book of love and feeling." Since Khamenei believes that novels allow him to
understand what life in the West is really like, he recommends that Iranians

turn toward the United States and "read the novels of some authors with leftist tendencies, such as Howard Fast," and that they read "the famous book *The Grapes of Wrath*, written by John Steinbeck, [...] and see what it says about the situation of the left and how the capitalists of the so-called center of democracy treated them."[5] In other words, Khamenei believes that Fast and Steinbeck usefully expose the ill treatment of civilians at the hands of American capitalists.

My discussion of this recent Tehran performance of *Uncle Tom's Cabin* will argue that although Iranian government officials emphasize an anti-American interpretation of the novel, playwright and director Behrooz Gharibpour manages to avoid supporting the regime's anti-Americanism, by stressing Stowe's universal themes of suffering and injustice. The Iranian production could be said to perpetuate anti-American propaganda, but it does so only by dramatizing Stowe's own criticism of certain aspects of American culture, such as flesh mongering, the separation of families, religious hypocrisy, and alcoholic depravity. The play demonstrates the "fundamental importance of translation studies as a shaping force in literary history,"[6] since it does not limit itself to anti-Americanism; rather, the heart of the show agitates against all forms of discrimination and disenfranchisement.

As an example of a Middle Eastern translation of canonical American literature, Gharibpour's *Uncle Tom's Cabin* performs many levels of interpretation: the translation from English into Farsi, the translation of a novel into a play,[7] and the translation of an antebellum American context into a contemporary Iranian milieu.[8] Intergeneric transpositions can be very vexing to evaluate; they are susceptible to charges of unfaithfulness or disloyalty to the original text and generic form. A comparison of this nineteenth-century novel by an American Christian woman and this twenty-first-century play by an Iranian Muslim man reveals much about cultural and literary adaptations. This essay is concerned with textual transmission and, in the words of Bassnett and Damrosch, the ways "texts move across cultures" and "the transformations those texts undergo in the process of movement."[9] Artists have always had to maintain a tricky equilibrium when elucidating or commenting on personal hardship. How can art contribute to understanding, dialogue, and social transformation without aestheticizing suffering? How can art represent tragedy without co-opting someone else's heartbreak or reaping benefits from another's pain? Such a balance can be especially complicated to pull off when addressing problems in a different country.[10]

IRANIAN SCHOOL EDUCATION AND WESTERN LITERATURE

The official Iranian state censor that proscribes theatrical events also enforces a strict educational map for its young citizens. According to a report of the Science Applications International Corporation (SAIC), *Iranian Textbooks: Content and Context*, "The textbooks of the Islamic Republic of Iran have changed since 1979. There is a movement to make the textbooks compatible with the post-Revolution political system, which is controlled by Islamic clerics. Through textbooks, Iran hopes to transform school children into devout Muslim citizens with little regard for the world beyond Iran. The children of Iran are not learning as much as they could be about international standards of human rights as envisioned by the Universal Declaration of Human Rights and the United Nations conventions on civil, political, social and economic rights."[11] The Center for Monitoring the Impact of Peace (CMIP), a nonprofit organization that examines textbooks and school curricula particularly in the Middle East, also surveyed numerous Iranian textbooks and concluded that "a massive effort is made to portray the West, with America at its head, as the incarnation of evil, and thus make it the object of the school students' hatred as a prerequisite for their spiritual mobilization for the global war with it." Schoolbooks also accuse "the Great Satan" (as the United States is called) of mistreating African Americans "while falsely using the issue of human rights against other governments—Iran, for example."[12] This constant demonization of the West is often referred to as "Westoxication."[13] Evidently, even in university classes today, "spies, some self-appointed and others professional, sit in on lectures and in classrooms, making sure that nothing is said that violates the official line."[14]

According to Iranian scholars Shamshiri and Zekavat, the Iranian world literature syllabus "is slim," and "its inclusion follows a systematic procedure in line with State ideological and doctrinal principles." A short extract of *Uncle Tom's Cabin* is included in Persian textbooks so that young students will have an exposure to the novel as an example of world literature. Shamshiri and Zekavat's study of literature anthologies used in Iranian high schools points out that most literary extracts are not accompanied by explanatory contextual information, because the "default pre-supposition" of the Iranian education ministry is that "a text could be understood apart from the (broad) context in which it was produced."[15] As a very rare exception, however, one textbook anthology's extract of *Uncle Tom's Cabin*

includes background information. According to Shamshiri and Zekavat, "The short note introducing this book insists on the dark side of antebellum American history. Although this knowledge is necessary to understand *Uncle Tom*, background information is needed elsewhere where it is never offered. And this might lead one to think that this is a deliberate attempt to sketch a dark picture of the Iranian regime's alleged enemy." The researchers of the study reveal that the decision to have the textbooks for high schools include explanatory cultural information about Stowe's novel is due to "ideological doctrines rather than informative illustration."[16] In Iran, they conclude, "globalization and cultural negotiation are (deliberately) mistaken for cultural war (and manipulated for political ends)."[17]

Since the only productions about American culture that Iranian censors allow on stage are works that fault U.S. culture and politics, it is safe to say that there can be no theatrical productions in Iran that "serve as promotion or advertisement for American culture." For example, Arthur Miller's *Death of a Salesman* passes the Iranian censors because it criticizes capitalism. Gharibpour states, "From the point of view of our cultural officials, these works serve to show how the U.S. is no paradise, and that it suffers from poverty, conflict, and opposition. So they [the Iranian censorship ministers] approve of such works going on stage to show that Americans themselves are critical of their country and by doing so, advance their own [Iranian officials'] political agenda."[18]

Khamenei's interpretation of the ideological basis behind *Uncle Tom's Cabin* might differ profoundly from that of a Western reader, and it is fascinating that Stowe's work does indeed still "live" (as Khamenei says) in surprising ways almost two centuries later. If Iranians themselves wanted to follow their Supreme Leader's recommendation, *Uncle Tom's Cabin* is available in a translation from the 1950s by Mohammad Ali Khalili, Monir Mehran, and Mohsen Soleimani. According to scholar Behnman Mirzababazadeh Fomeshi, an abridged version of the novel was created by Mostafa Jamshidi, and a 1909 film version starring Julia Swayne Gordon and Ralph Ince was dubbed into Farsi. According to Gharibpour, the 1956 translation was made by Munīr Jazanī, who did not have much experience translating but felt so moved by the novel that she undertook the task.[19] Scholars living and writing in Iran publish on the novel, as evidenced by the work of Ghasemi and Fomeshi. Thus, according to Fomeshi, Stowe's novel "is a popular work in Iran, thanks to the Islamic anti-American policy makers."[20]

BEHROOZ GHARIBPOUR

Born in 1950, Behrooz Gharibpour is a playwright and the managing director of the Iranian Artists Forum. Gharibpour was living and studying in Italy when the Iranian Revolution of 1979 overthrew the Shah of Iran, Mohammed Reza Shah Pahlavi, and installed in his place the Ayatollah Khomeini. According to the biography on his website, Gharibpour felt compelled to return home from Europe in the aftermath of the revolution.[21] Around the same time, writer and professor Azar Nafisi, well known for her memoir *Reading Lolita in Tehran*, similarly returned from the United States to Tehran. However, she was soon fired from her teaching position at the University of Tehran for refusing to wear the veil (she eventually left Tehran in 1997). A prolific writer, producer, and advocate for the theater, Gharibpour is the founder of the Children's Theater in Tehran, the Bahman Cultural Center, the Iranian Artists Forum, and the Marionette Opera House. He has staged, among other productions, the *Rostam and Sohrab Puppet Opera*, *2342 Bad Days*, and the *Qajar-Style Puppet Show*. Many of his plays have appeared at international theater festivals.[22] Although Iranian-themed productions remain Gharibpour's specialty, he also adapted *Macbeth* as a puppet show and Victor Hugo's *Les Miserables* for the Iranian stage.[23] Tehran has a vital theater scene, with over forty active performance halls, including the largest theater in the Middle East.[24]

According to Gharibpour, *Uncle Tom's Cabin* is one of the oldest American novels to have been translated into Farsi. Iranians of his generation studied the American Civil War and Abraham Lincoln as well. Gharibpour humorously points out that neighboring Afghans would watch American films dubbed into Farsi, which "led many Afghans to believe that Americans actually spoke Farsi. So there was a market for dubbed American films in Tajikistan and Afghanistan. Khaled Hosseini, the author of *The Kite Runner*, mentions that he used to think John Wayne spoke Farsi." Gharibpour speculates that through the popularity of dubbed Farsi films, *Uncle Tom's Cabin* has made its way even further east. Gharibpour muses that "Eastern civilizations, whether because of our legends and mythology or folklore, have always been battling oppression and people have been drawn to such stories. Afghans and Tajiks are no exception to this rule, so *Uncle Tom's Cabin* must certainly be available in these countries too."[25] In other words, because *Uncle Tom's Cabin* addresses the plight of

the downtrodden and oppressed, especially at the hands of capitalists, the novel has found a vast appreciative audience way beyond the bounds of the United States.[26]

Gharibpour first encountered the novel in his late teens and then saw a translated German movie version. He felt that the character of Tom was not very attractive to Iranians, because Tom "concedes to every trouble and hardship." According to Gharibpour, "Iranians are very much influenced by mythological and hero-stories and so such a story and character like Uncle Tom is bound to fail in Iran." A friend in the United States sent Gharibpour a script of a dramatic version. Gharibpour attempted a literal translation but realized that it did not have enough of a dramatic impact for a theatrical hit. He understood that the novel had an enormous impact on the American Civil War, but since Iranians had limited experience with blacks or with slavery, the story might not seem relevant to them.

Stowe's novel continued to haunt Gharibpour, and he eventually devoted his artistry to bringing Uncle Tom's Cabin to a large stage venue. Because of the age difference in his actors, there were varying levels of familiarity with Stowe's work: "The professional actors [. . .] by virtue of their age were expected to have seen the film and have read the book, and then there were also younger students of cinema and theater who were cast who might have been less familiar with it. More or less all of them knew of Uncle Tom's Cabin, but of course in all my works, I try to assign a reading list comprised of the novel, my script, as well as my notes, opinions, and research on the piece, and Uncle Tom's Cabin was no exception." According to University of Tehran professor and award-winning playwright Naghmeh Samini, the story line is better known among the older generation, especially among those with left-leaning politics before the Iranian Revolution; the novel does not resonate among young people, since the Iranian government favors it as anti-American propaganda.[27]

A longtime advocate of theater for both its aesthetic and political expression, Gharibpour is committed to expanding the stage beyond intellectual circles in order to include the general public. His belief that intellectuals might be apathetic toward his productions of Les Miserables and Uncle Tom's Cabin parallels some current aesthetics in the United States that cast Stowe as sentimental and middlebrow. A play based on Hemingway's A Farewell to Arms was considered more intellectual and thus was favored more by the upper classes. Yet Les Miserables was very well received and ran for more than seven months. Some resisted a staging of Hugo's novel, ac-

cording to Gharibpour, because he crafted it not long after Iran's eight-year-long war with Iraq. Many worried that war exhaustion would drive away audiences. This fear of desensitization led the playwright and director "to put all my energy into the war scenes to make them as real as possible, and so the scenes with the street battles were able to leave an amazing mark on the audience. I was very happy when I would see a member of the audience weeping. It was similar with *Uncle Tom's Cabin*: the general public, who are usually less judgmental and less likely to filter their sentiments, would often react with tears to the scenes where the slaves were flogged, or when they saw Uncle Tom or his family in misery."[28] Gharibpour believes that moving the audience to visible emotion is a forceful way to guide and measure their investment in the play's story and message.

IRANIAN "CO-OWNERSHIP" OF *UNCLE TOM'S CABIN*

Behrooz Gharibpour's Tehran staging of *Uncle Tom's Cabin* certainly loosens up Stowe's novel and renews its life in a new context. Caryl Emerson discusses Bakhtin's distinction between "canonization" and "re-accentuation": the first merits circumspection because it "hardens literary images in place and prevents free growth," and "we should welcome" the second because it "loosens up literary images and guarantees them a long life by embedding them in new contexts."[29] Bakhtin refers to such generic boundary crossings as transpositions or intergeneric shifts. According to Emerson, Bakhtin theorizes that one existing method of translation aims to "eliminate all traces of cultural space or time elapsed between the original and his [the translator's] version of it." However, Bakhtin finds more value in a less ossified form of translation, one that is more of a "free imitation" and that "we value precisely because we are asked to be conscious of co-ownership."[30]

I find the term *co-ownership* useful here because Gharibpour has become a co-author of *Uncle Tom's Cabin* by repurposing and adapting the story line to a Persian context. The adaptation of the novel is a fascinating entity of its own that differs from the original; Stowe and Gharibpour have become co-authors of a new text that resonates both with antebellum American themes and twenty-first-century Iranians. Emerson continues her argument about co-ownership or co-authorship by claiming that "transposing a theme might in fact be the most vigorous and autonomous commentary possible on another's work of art. It is the one category of 'translation' which does not hide co-authorship, but rather emphasizes it. . . . Both sides of the

boundary must be kept simultaneously in view: two languages, two media, two genres, and two voices."[31] Thus, reading Gharibpour through Emerson, the Persian stage version and Stowe's original novel converse across centuries, national boundaries, languages, and genres to co-author a new aesthetic experience. If we are familiar with Stowe's novel, we can keep both sides of the boundaries in view when watching Gharibpour's play.

Some argue that an original version may hold a privileged status in the view of the reader or audience. If we know the adapted work, there will be constant oscillation between it and the new adaptation we are experiencing. Yet some read or view the original only after seeing the adaptation, which challenges notions of the authority of priority; such readers or viewers therefore would not experience the adaptation as an adaptation but would instead feel the oscillation in reverse.[32] For U.S. readers who know Stowe's novel, viewing Gharibpour's staged version is a fascinating palimpsest where we identify elements of the original novel but constantly are dazzled as we view the adaptation as an autonomous work. For Western viewers, *Uncle Tom's Cabin* becomes denaturalized (an American story in Iran) and then renaturalized (an Iranian story about an American story). While there are innumerable points of entry in a discussion of Gharibpour's theatrical adaptation of Stowe's novel, I want to draw attention to six: his stage setting, the representation of drinking alcohol, women's dress, a church scene, the famous scene between Tom and Eva, and the ending.

THE STAGING OF GHARIBPOUR'S *UNCLE TOM'S CABIN*

Gharibpour's gorgeous stage setting is designed to evoke the antebellum American South. The theater stage does not have a curtain but is encircled by railroad tracks and bales of cotton, to keep slavery's commercial and capitalistic underpinnings in the audience's mind. At various times throughout the performance, actors appear silently picking cotton in the background. For Tehran audience members unfamiliar with the United States and its various regions, the cotton bales, railroad tracks, Southern costumes, and some architectural details work together to create a sense of the antebellum South.

Gharibpour scripted several scenes of heavy drinking and drunken revelry in his play, knowing that his audience would be comprised of non-drinking Muslims. Official Iranian state censors approved of these scripted scenes of depraved drinking, because such moments demonstrate the ills

of alcohol and reinforce Islam's disapproval of drink. According to Gharib-pour, "The censorship authorities actually have no problem with drinking being associated with a person turning into an evil and bloodthirsty individual! They do, however, find it problematic if the person drinks and becomes kind and positively affected; then they would probably censor it. Having said this, I think the novel, too, implies such a negative association [between alcohol and morality]."[33] In one tavern scene in the play, a young slave girl entertains the white slave owners with what can be termed a racialized "pickaninny" dance. One slave dealer wears a red wig to mark him as distinctly white. The girl receives fruit as a reward for amusing the men, and the slave traders seal their market transaction with a drink. To convince Legree to treat Tom well, Cassie serves Legree many drinks and acts sexually interested in him. Stage directions in Gharibpour's play read, "Cassie is wearing clean clothes and a lot of makeup and is moving flirtatiously in front of Legree, who is drunk with the drinks that Cassie serves him."[34] In another tavern scene, bottles of alcohol are prominently displayed, and barrels line the front of a bar. Festive dancing occurs, as if drink inspires goodwill, but the scene quickly changes to that of a slave auction. The effect is that the jollity of drinking closely elides into the horrors of flesh mongering, and Iranian state censors approved of such a depraved scene of American history. American temperance drama of the 1840s similarly used staged scenes of inebriation to advocate for sobriety and a temperate lifestyle.[35]

Gharibpour faced an interesting challenge: in some scenes, the female actors need to represent sexually "available" slave women, yet law and custom dictate that actresses must conform to modest Muslim dress codes. To finesse this problem of modest dress when needing to suggest immodesty, Gharibpour crafted the play so that most scenes with women take place outdoors. When indoors, Muslim women tend to relax their dress code, and female characters in scenes staged in private interior settings would be allowed to dress less modestly. Outdoor scenes provide an excuse for the actors to dress modestly in accordance with state and religious law and thereby avoid offending the audience. Although Talajooy argues that women rarely "appear on stage to resist on-stage and off-stage control" in post-revolutionary Iranian theater,[36] Gharibpour claims that women have the right to speak out as powerful orators. Thus they speak their minds in his play.

Although no part of Stowe's *Uncle Tom's Cabin* occurs inside a religious institution, Gharibpour felt that staging a scene inside one would lend

authority to his vision. In one scene in particular, a large cross faces the audience, and the actors sit in pews with their backs to the theatergoers, as if the actors have commandeered the front rows. The effect is that both audience and actors all find themselves, as Muslims, attending worship together in front of a large cross. Gharibpour argues, "I think I'm simply dramatizing a theme that Stowe is alluding to in her book. I simply try to make these points more explicit and to give them a more dramatic flair. She clearly raises this issue of multiple interpretations that can be made from the Bible or any sacred text, but I thought that it would be much more dramatic if this were presented in the context of an actual church, with priests debating the issue. I added the church scene so that I could contrast the differences between various interpretations of the Bible and make them even more visible."[37]

Gharibpour's translation of Stowe's Protestant Christianity to his Muslim audience makes heavy use of Catholic symbols to signify Christianity in general. For example, George crosses himself before fleeing, even though Stowe does not suggest that George is Catholic. In his recasting of Stowe's scenes in a slave market and a hotel and her scene where Eliza is being sold, Gharibpour tries to convey how people interpret religion and sacred texts for self-serving purposes. In his scripted scene, a priest "strongly and fanatically argues that the Bible endorses slavery, whereas in fact he is only voicing the opinion of a particular class and sector in society. I similarly see a parallel between him and people in our own society who view Islam in one way which contrasts with how I view it." According to Gharibpour, some critics complained that his play was tantamount to advertising for Christianity. He maintains that such critics only hold a fanatical view; they are incapable of seeing nuance. As an example, Gharibpour points to the scene where he has Uncle Tom carry his own cross (fig. 22): "In a Muslim country like ours, the purpose of such a scene is to convey a metaphorical and dramatic meaning rather than a religious one. I was trying to say that this is a 'heavy burden' that Uncle Tom has to carry. It is 'suffering without end' that Uncle Tom or the deprived and the poor or any other group whose rights have been violated has to carry."[38] Gharibpour's plays clearly passed through the filters of the censorship ministry, so any pro-Christian meaning likely evaded government officials.

Theatergoers can also see a profound influence of Iranian folk artistry in Gharibpour's adaptation. In one scene, Gharibpour makes use of traditional shadow puppets: the famous scene between Tom and Eva dazzles

Fig. 22. Tom carrying the cross in Behrooz Gharibpour's play *Uncle Tom's Cabin*, Bahman Cultural Arts Center, 2008. (Reproduced with permission of Behrooz Gharibpour.)

as the characters morph into shadow puppets on stage while they discuss good and evil, a theme long established in folk entertainment. This interpretation of the scene between Tom and Eva clearly draws on Iranian traditional marionette theater—so important to Persian culture—and thus elevates the scene to an almost legendary, transcendent level.[39] Puppets have inhered as important to Iranian tradition for centuries. For example, the eleventh-century poet Omar Khayam and the twelfth-century poet Nezami Ganjavi both make use of images of puppets to explore themes of fate and divinity.[40] In an essay, Massoudi outlines several historical periods and puppeteer practitioners. He concludes, "This brief literature survey has shown that puppetry has been part of Persian culture for a millennium and that puppetry . . . was performed from the Safavid period, through the Qajar era, and up to the Iranian present. The earliest references tell us little of the actual content but do show the philosophical importance of puppetry in Iran."[41] Gharibpour included a puppet scene in his staging of a play about disenfranchisement for several reasons: "I hold the deep conviction that the discovery of puppetry has had as much of a transformative effect as the discovery of the wheel, and has been at least as effective in helping to reduce the distances and the communicational rifts between us. This is perhaps because even a deeply philosophical puppet play has the ability to awaken an element of childhood in the audiences' consciousness, with which they are emancipated from the illusions of age and time, and discover a fantastical world where objects made of wood and other inanimate materials come to life."[42]

Understanding the shadow puppet scene in Gharibpour's production is

Fig. 23. The devil
threatens Eva in
Gharibpour's *Uncle
Tom's Cabin*, Bahman
Cultural Arts Center,
2008. (Reproduced
with permission of
Behrooz Gharibpour.)

challenging for a Western viewer who does not speak Farsi. Stage directions
read,

> *In a corner of the backyard in Master St. Clare's house. Washed sheets are
> hanging on a clothesline and have made that place appropriate for per-
> forming a shadow play. Evangeline, with cardboard wings, is behind this
> curtain and her angelic shadow is seen. The other actor of this play is Uncle
> Tom. Black children of different ages and the rest of the slaves observe the
> play.*

While this play-within-a-play is captivatingly beautiful and lyrical, the
scene makes use of devil and angel images that cannot be understood with-
out a familiarity with Iranian folk culture. It appears that Tom turns into a
satanic figure (see fig. 23)—it can be uncomfortable for a North American
viewer to see the black-as-devil metaphor concretized. The Tom-as-devil
shadow figure even says, "I am the Devil and I made it so that the Whites
enjoy the suffering and death of their kind, the tormenting of Blacks . . .
cruelty . . . cruelty . . . I tell them to have cruelty as much as they can."[43]
But Gharibpour intended for the devil image to represent the monster of
slavery; an Iranian audience would understand that Tom himself is not de-
monized but that he mutates into a messenger of the evil of enslavement.

The transformative powers of the shadow puppet tradition that morphs
Eva and Tom into symbolic figures also transforms St. Clare: he is so moved
by seeing Eva as a vision of an angel that he decides to liberate his slaves.
After she becomes Eva again, St. Clare takes Eva's hand, returns with her

behind the curtain, and says, "Oh, little angel, Master St. Clare can also be an angel, and can be a devilish slave. Anyone can be one of these two things. God has created us to be either like himself, kind and fair and loving, or like the Devil, cruel and bloodthirsty and ruthless. I have learned from my little angel. . . . Next week I will give all the slaves their freedom papers."[44] The spiritual conversion of St. Clare thus seems perfectly dramatized by tapping into the rich Persian tradition of shadow puppetry's ability to reveal human truths and longings.

One challenge in an intercultural adaptation is the cultural assumptions or baggage that might get inferred in the process of translation. A traditional story frequently dramatized in Iranian puppet shows is *Shah Salim*, the main character of which is Mobarak, Shah Salim's black slave. According to Massoudi, "there are two theories about historical roots of Mobarak: one lineage traces him to African origin, and the second sees him as a royal jester. . . . Because of Mobarak's black skin, some argue he comes from the era of the slave trade when some rich families purchased Africans. . . . Mobarak, like these black slaves, uses incorrect words and marred grammar."[45] I wondered whether Iranian audiences of Gharibpour's adaptation of *Uncle Tom's Cabin* would recall the black slave Mobarak when they saw the devilish Tom in the shadow puppet scene. Since I do not have any familiarity with indigenous puppet theater, I must rely on other experts. Behnam Fomeshi corrected my linking of Tom in Gharibpour's puppet scene to Mobarak: "In Iranian society, a few theatergoers may know that Mobarak is a black African servant. For Iranian audiences he is not repressed, a slave, or an African. As far as I understand this issue, while watching a theatrical production of *Uncle Tom's Cabin*, Iranian theatergoers would not think of Mobarak. A repressed African slave (Uncle Tom) never reminds Iranians of a bold servant who criticizes the rotten traditions of the Iranian society and pokes fun at those in power (such as Mobarak does)."[46] Gharibpour's shadow puppet scene featuring Tom and Eva thus draws from antiquity and resonates deeply with an Iranian audience, but it does not connect Tom to a famous black African servant from the traditional Iranian repertoire of marionette stories.[47]

THE PLAY'S FIERY END

At the end of Gharibpour's play, Tom carries a large wooden cross, which a Western viewer would see as clearly linking Tom to a Christ figure and

Fig. 24. Mrs. Shelby collapses at the cross in Gharibpour's *Uncle Tom's Cabin*, Bahman Cultural Arts Center, 2008. (Reproduced with permission of Behrooz Gharibpour.)

Fig. 25. Tom preaching in Gharibpour's *Uncle Tom's Cabin*, Bahman Cultural Arts Center, 2008. (Reproduced with permission of Behrooz Gharibpour.)

suggesting that Tom dies while suffering for the sins of society (see figs. 24 and 25). By titling chapter 40 "The Martyr," Stowe intended her readers to consider Tom in a salvific light. I am interested in this idea of martyrdom and what the image of a cross-bearing Tom might mean to a Shia Muslim. As explained above, Gharibpour means to metaphorically signal Tom's unbearable suffering. Shia Islam teaches that martyrdom is for believers who die for their religion. Tom is probably not a martyr in a Shia sense, but his martyr-like suffering due to discrimination would affect the humanity of a Tehran theatergoer. Such a misunderstanding of martyrdom might have occurred when Shakespeare scholar Stephen Greenblatt was invited to give a talk in Tehran; he perceived Iran to be a culture that celebrates and glorifies martyrdom. During his visit, he saw photographs of martyrs "along the

avenues, in traffic circles, on the sides of buildings, on the walls around the buildings, on overpasses and pedestrian bridges, everywhere. On the light poles, the martyrs' images were generally in twos, and the pairings, which may have been accidental, were sometimes striking: a teenager next to a hardened veteran, a raw recruit next to a beribboned high-ranking officer, a bearded fighter next to a sweet-faced young woman."[48]

Greenblatt's perception of omnipresent messages of martyrdom is perhaps validated by the conclusions of a nongovernmental organization's study of Iranian textbooks: "The Social Teachings textbook for the fifth grade of primary school indicates that, 'Martyrdom is the highest degree of sacrifice. . . .' The Persian Language and Literature textbook for the fifth grade of primary school also praises martyrdom and urges children to welcome it."[49] The Persian textbook for language and literature for the first year of high school explains, "The literature of resistance is the literature that calls for resistance, shows the oppressors, marks the popular heroes and martyrs."[50] Thus it could be easy for a Westerner who views Gharibpour's transposition to think that there could be an overlap between Christian and Shia views of Tom's sacrificial death. Gharibpour points out that since Muslims do not support jihad, martyrdom, the Taliban, or Daesh, only a fanatical branch might support this interpretation. Shiraz scholar Fomeshi writes,

> I, myself, may consider Tom's death martyrdom because he died for his beliefs. But, an Iranian audience, in general, doesn't think so. For those Muslims you are talking about martyrdom belongs to just some narrow religious contexts. For instance Iranians consider those killed in Karbala, or Iran-Iraq war, to be martyrs. In the latter case those killed are closely associated (by the government) to the Karbala story in order to be considered martyrs. And in all those cases religion plays an important role (by religion I mean Shia Islam). Therefore, to them Uncle Tom is not a martyr because he has nothing to do with Shia beliefs.[51]

Interestingly, Gharibpour has the slave Cassie kill Simon Legree by shooting him with a gun. Cassie's verbal anger in Stowe's original novel translates to lethal violent action in this play, a move that American playwright Robert Alexander similarly makes in his play *I Ain't Yo' Uncle: The New Jack Revisionist Uncle Tom's Cabin.*[52] Gharibpour chose to make the play's ending mesmeric, fiery, trancelike, hypnotic, and insurrectionary. The play ends with an impressive staging that simulates an inferno wreaking revenge

on the depraved slave-owning system. The ending seems to suggest an uprising, an insurrection, or violence, as slaves run around the stage setting numerous cotton bales on fire. The flames and the rhythmic swaying of a flag bearing the word "Freedom" effuse anger and violence.[53]

Of course, Stowe's final chapter of *Uncle Tom's Cabin* avoids such a scene of violence, though she ends her novel with a forceful fire-and-brimstone sermon. The last page of her novel reads, "But who may abide the day of his appearing? 'for that day shall burn as an oven.' [. . .] Not by combining together, to protect injustice and cruelty, and making a common capital of sin, is this Union to be saved,—but by repentance, justice and mercy; for, not surer is the eternal law by which the millstone sinks in the ocean, than that stronger law, by which injustice and cruelty shall bring on nations the wrath of Almighty God!" (456). Gharibpour's incendiary ending thus concretizes Stowe's intense passionate hatred of slavery and discrimination and brings home for Iranians the heated passion of Stowe's wrathful message. Gharibpour avers, "Stowe actually threw a small fire in the cotton storage that was America. . . . It is true that Stowe's language may have been mild and gentle but I think it's fair to say it started a war. Or at least she did have this deep conviction that such a world is not a humane world and that it must be burnt down."[54] The actors on Gharibpour's stage literally throw fire onto the onstage cotton bales, and the set is aflame with righteous anger and a call for justice.

UNCLE TOM'S CABIN, TRANSLATION, AND SOCIAL JUSTICE

Caryl Emerson asks, "On what grounds does a work enter a 'tradition,' and why are certain themes so resonant and so often reworked?"[55] Gharibpour might answer that his dramatic staging of Stowe's novel, inspired by a U.S. natural disaster, resonates with Iranian social issues of discrimination. His play demonstrates that oppressive patterns with long historical antecedents can be successfully translated from one culture to another. His *Uncle Tom's Cabin* can be seen as an interpretation that does not address the specific plight of African Americans or even of slavery in general, because Iran has a very small African population in the south of the country and a limited history of slavery among the aristocracy.[56] According to Gharibpour, while some racism against darker Iranians persists, "'skin color' and 'slavery' do not have the same cultural or historical significance for an Iranian as they

do for an American."[57] His actors' skin tones vary, reflecting the typical range of Iranian complexions; social status is conveyed in the production by costume, not casting or makeup, with the exception of the actor who darkens his face to play Uncle Tom.

According to Iranian scholar Behnam Fomeshi, "Of course there is/has been violation of human rights in Iran. But, slavery is not one of those. 'Slavery' as practiced in Iran was too different from that of [the] U.S. There used to be masters and servants in Iran, and servants were definitely considered 'human.'"[58] In the early 1800s, both black and white slaves were traded in Iran, and anti-slavery legislation was ratified in 1929. Rather than issues of slavery, Gharibpour's play investigates larger concerns of disenfranchisement. Gharibpour asserts that he "zoomed in on the material within the novel that was relevant to the Iranian audience and sparked interest as well as questions in their minds."[59] For example, his introductory materials to the script open with an invocation for freedom: "Rise and unshackle the chains! What dreams man develops in his head!" The introduction reflects his interest in the worldwide problem of slavery and oppression, by discussing the Roman slave Spartacus; Lincoln's efforts at emancipation; the 1951 novel *Spartacus* by Howard Fast; Gabriel Garcia Marquez's novella addressing human trafficking, *The Incredible and Sad Tale of Innocent Erendira and Her Heartless Grandmother*; and Frank Darabont's film featuring a black Christ figure, *The Green Mile*.[60]

In Gharibpour's view, "One of the fundamental teachings of Islam is to ban racial discrimination and to view all people in the same light. This is perhaps because Islam has its roots in Arabic and more-or-less dark-skinned regions." To this end, Gharibpour shares a common concern with Stowe: to highlight the plight of the dispossessed and to "direct the emotions and thoughts of my audience." Gharibpour maintains, "If Stowe had been in Iran she would have become aware of a different kind of discrimination and would have likely written a different novel altogether. As an Iranian I was concerned more with this notion of discrimination rather than the issues of color and race per se."[61]

"In all of my works," Gharibpour explains, "I have been sensitive to oppression and the struggle against it, to violation of others' rights, to greed for power, or to any other means of violating the human conscience. So what is obvious in my works is that I stand side by side with Mrs. Stowe and express my stance against violations of others' rights in whatever form. I've tried to use these emotional elements to force my audience to think

and to take a humanistic stance towards whatever race or color. I think—
and I say this with confidence and modesty—that the Uncle Tom's Cabin
I have written is characterized by a tangible respect for human rights, as
well as a more palpable emotional impact on the audience."[62] Gharibpour's
Iranian staged version is proof of the continued life of Uncle Tom's Cabin.
According to Caryl Emerson, "derived texts should be taken seriously, not
as threats or distortions of an original but as proof of the continued life
of literary images."[63] Thus the ability of Iranians to make such profound
meaning through this adaptation, despite the obvious ease with which the
play could be used as a simple vehicle for anti-Americanism, demonstrates
how powerfully Stowe's political novel was grounded in enduring observa-
tions of humanity's capacity for resilience and creative transformation in
moments of extreme personal suffering. Gharibpour's twenty-first-century
staged version of Stowe's nineteenth-century novel extends and amplifies
Stowe's vision of justice across centuries, genres, continents, and languages.

Notes

I am indebted to Nevin Mayer at John Carroll University's Grasselli Library for his
extraordinary research help and to Denise Kohn, Jon Miller, Robert Nowatzki, Wesley
Raabe, and Adam Sonstegard for invaluable suggestions for revisions. I am grateful to
Roshi Ahmadian for her excellent translations of Gharibpour's script from Farsi. This
essay was supported by a generous Summer Research Fellowship from John Carroll
University.

1. Hurricane Katrina brought attention to entrenched racism in the region, gov-
ernment corruption, and the failure of leaders to attend to the neediest. See Spike Lee's
2006 documentary film When the Levees Broke: A Requiem in Four Acts (Brooklyn,
NY: 40 Acres and a Mule Filmworks). For details on musical responses to Katrina,
see Phil Dyess-Nugent, Marcus Gilmer, Will Harris, Jason Heller, Keith Phipps, and
Scott Tobias, "After the Deluge: 29 Remarkable Works Inspired by Hurricane Katrina,"
AV Club, 22 August 2011, http://www.avclub.com/article/after-the-deluge-29-remark
able-works-inspired-by-h-60684 (accessed 7 January 2017). For scholarly articles on
the "cultural visualization" of Katrina, see "The Cultural Visualization of Hurricane
Katrina," ed. Nicola Mann and Victoria Pass, special issue, Invisible Culture 16 (Spring
2011), https://www.rochester.edu/in_visible_culture/Issue_16/contents.html (ac-
cessed 7 January 2017).

2. In a not-quite-similar case, the Hollywood movie The Curious Case of Benjamin
Button, directed by David Fincher (Hollywood: Paramount, 2008), transposes the Bal-
timore setting of F. Scott Fitzgerald's story to New Orleans, so that Katrina becomes a
frame. While the Fitzgerald original obviously never had any hurricane connection, the
movie's incorporation of the storm places it in the genre of artistic responses to Katrina.

3. My analysis is based on a DVD recording, shared by Behrooz Gharibpour, of a live performance of the 2008 staging of his script of *Uncle Tom's Cabin*.

4. Akbar Ganji, "Who Is Ali Khamenei? The Worldview of Iran's Supreme Leader," *Foreign Affairs*, October 2013, 24–48.

5. Margaret Eby, "Ayatollah Ali Khamenei Loves Victor Hugo," *New York Daily News*, 23 August 2013, http://www.nydailynews.com/blogs/pageviews/ayatollah-ali-khamenei-loves-victor-hugo-blog-entry-1.1640940 (accessed 7 January 2017).

6. Susan Bassnett and David Damrosch, "Introduction: Translation Studies Meets World Literature," *Journal of World Literature* 1 (2016): 295–98.

7. Of course, *Uncle Tom's Cabin* has appeared in dramatic form in English since 1852.

8. Although I do not know the extent to which *Uncle Tom's Cabin* is a topic of scholarly interest in Iran, at least two scholars from Shiraz University in Iran have published on the novel. See Parvin Ghasemi and Behnam Mirzababazadeh Formeshi, "Defusing the Controversy over *Uncle Tom's Cabin*: A New Historical Approach," *CLA Journal* 55.4 (June 2012): 335–51.

9. Bassnett and Damrosch, 295.

10. On a personal note, my family and I were living in Oxford, England, when Hurricane Katrina hit; thus we watched images of the devastation through the eyes of the English. We felt so helpless and found it difficult, if not impossible, to answer their questions about social injustice in the United States.

11. SAIC, *Iranian Textbooks: Content and Context* (Maclean, VA: SAIC, 2007), 2, http://fas.org/irp/dni/osc/irantext.pdf (accessed 7 January 2017).

12. CMIP, *The Attitude to "the Other" and to Peace in Iranian School Books and Teachers' Guides* (CMIP, 2006), 305, http://www.impact-se.org/docs/reports/Iran/Iran2006.pdf (accessed 25 May 2015).

13. CMIP, 306.

14. Stephen Greenblatt, "Shakespeare in Tehran," *New York Review of Books*, 2 April 2015, http://www.nybooks.com/articles/2015/04/02/shakespeare-in-tehran/ (accessed 7 January 2017).

15. Babak Shamshiri and Massih Zekavat, "World Literature in Iranian Persian Literature Textbooks," *Asian Journal of Education and e-Learning* 2.1 (February 2014): 24.

16. Ibid., 26.

17. Ibid., 27.

18. Behrooz Gharibpour, personal e-mail, 4 October 2013.

19. Ibid.

20. Behnam Mirzababazadeh Fomeshi, personal e-mail, 17 March 2015.

21. Behrooz Gharibpour, "Biography," http://behrouzgharibpour.com/contacts.aspx. This information was confirmed by Behrooz Gharibpour via personal e-mail on 30 December 2016.

22. Some of this information is derived from the International Campaign for Human Rights newsletter of 25 July 2011 ("Raising Voices," pt. 2, http://www.iranhumanrights.org/2011/07/raising-voices-part2-3/ [accessed 7 January 2017]), which greatly contradicts biographical information found on Gharibpour's personal website.

23. Gharibpour's publications are not translated into English. When Iranian scholars cite Gharibpour's scholarship, they cite, *Entering the World of Marionettes and Puppet*

Plays (Tehran: Intellectual Promotion Centre for Children and Adolescents Publications, 1981) and *Ostad Kheime Shab Bazi Miamoozad* [Master teaches *Kheimeh Shab Bazi*] (Tehran: Intellectual Promotion Centre for Children and Adolescents Publications, 1990).

24. Maryam Ala Amjadi, "The Modernity of a Live Tradition: Theater in Iran," *Tehran Times* 11388, 7 March 2012.

25. Gharibpour, personal e-mail, 4 October 2013.

26. Gharibpour is not the only Iranian playwright interested in dramatizing U.S. tragedy: Mohammad Rahmanian (b. 1962) wrote the play *Cho's Manifest* (2009) about the Virginia Tech massacre. Several other plays by Rahmanian address non-Iranian subjects. He set his *A Play for You* (1994) during a coup in Bolivia. His play *Rooster* (2000) addresses the plight of an Afghan family during the Taliban reign. He takes up the topic of censorship under Josef Stalin's Russia in *The Swan Song of Chekhov* (2004), and he explores the world of English football in his 2005 play *Fans*.

27. Naghmeh Samini, personal e-mail, 21 August 2015.

28. Gharibpour, personal e-mail, 4 October 2013. Some also resisted Gharibpour's staging of *Les Miserables* because the Tehran municipality invited him to turn a large unused slaughterhouse into the first and largest cultural center in Iran in the process. Since the space was located in the south of the city, where the more religiously conservative live, Gharibpour was criticized for attempting to introduce Western values to the devout.

29. Caryl Emerson, "Bakhtin and Intergeneric Shift: The Case of Boris Godunov," *Studies in Twentieth and Twenty-First Century Literature* 9.1 (1984): 145.

30. Ibid., 146.

31. Ibid., 147.

32. See Linda Hutcheon, *A Theory of Adaptation* (New York: Routledge, 2006), xv.

33. Gharibpour, personal e-mail, 4 October 2013.

34. Behrooz Gharibpour, "Uncle Tom's Cabin," trans. Roshi Ahmadian (unpublished script), 36; manuscript in the author's possession.

35. Amy Hughes, *Spectacles of Reform: Theater and Activism in Nineteenth-Century America* (Ann Arbor: University of Michigan Press, 2012), 46–85; John Frick, *Theatre, Culture, and Temperance Reform in Nineteenth-Century America* (New York: Cambridge University Press, 2003).

36. Saeed Talajooy, "Indigenous Performing Traditions in Post-Revolutionary Iranian Theater," *Iranian Studies* 44.4 (July 2011): 512.

37. Gharibpour, personal e-mail, 4 October 2013.

38. Ibid.

39. Jane Tompkins discusses how this scene between Eva and Tom in Stowe's novel reaches a transcendent level: "The scene I have been describing is a node within a network of allusion in which every character and event in the novel has a place. The narrative's rhetorical strength derives in part from the impression it gives of taking every kind of detail in the world into account, from the preparation of breakfast to the orders of the angels, and investing those details with a purpose and a meaning which are both immediately apprehensible and finally significant. The novel reaches out into the reader's world and colonizes it for its own eschatology: that is, it not only incorporates the homely particulars of 'Life among the Lowly' into its universal scheme, but it gives

them a power and a centrality in that scheme, thereby turning the socio-political order upside down" ("Sentimental Power: *Uncle Tom's Cabin* and the Politics of Literary History," in *Sensational Designs: The Cultural Work of American Fiction, 1790–1860* [New York: Oxford University Press, 1985], 139).

40. See Shiva Massoudi, "*Kheimeh Shab Bazi*: Iranian Traditional Marionette Theater," *Asian Theater Journal* 26.2 (Fall 2009) 262; Willem Floor, *History of the Theater in Iran* (Washington, DC: Mage, 2005), 63.

41. Massoudi, 264.

42. Union Internationale de la Marionnette (UNIMA), "International Message from Behrooz Gharibpour for the World Puppetry Day 2015," https://unimadeutschland. wordpress.com/2015/09/11/international-message-from-behrooz-gharibpour-for-the-world-puppetry-day-2015/ (accessed 7 January 2017).

43. Behrooz Gharibpour, *Uncle Tom's Cabin*, trans. Roshi Ahmadian, 21.

44. Ibid., 22.

45. Massoudi, 271.

46. Behnam Mirzababazadeh Fomeshi, personal e-mail, 20 March 2015.

47. For information on Iranian blackface (which, again, would not inform Gharibpour's staging of *Uncle Tom's Cabin* but is fascinating in its own right), see Talajooy, 505–9.

48. Greenblatt, 18.

49. SAIC, 6.

50. SAIC, 8–9.

51. Behnam Mirzababazadeh Fomeshi, personal e-mail, 22 March 2015.

52. For an analysis of the performativity of Cassy's verbal violence, see my essay "'I've Only to Say the Word': *Uncle Tom's Cabin* and Performative Speech," *Legacy* 27.2 (2010): 237–56, reprinted as a chapter in my book *Performatively Speaking: Speech and Action in Antebellum American Literature* (Charlottesville: University of Virginia Press, 2015).

53. According to Gharibpour, most Tehran theatergoers would know enough English to read the word "Freedom" on the flag (personal e-mail, 4 October 2013).

54. Gharibpour, personal e-mail, 4 October 2013.

55. Emerson, 159.

56. For information on Africans, slavery, and Iran, see Beeta Baghoolizadeh, "The Afro-Iranian Community: Beyond Haji Firuz Blackface, the Slave Trade, and Bandari Music," *Ajam Media Collective*, 20 June 2012, http://ajammc.com/2012/06/20/the-afro-iranian-community-beyond-haji-firuz-blackface-slavery-bandari-music/; Behnaz A. Mirzai, *Emancipation and Its Legacy in Iran: An Overview*, Cultural Interactions Created by the Slave Trade in the Arab-Muslim World (Paris: UNESCO, 2008) http://www. unesco.org/new/fileadmin/MULTIMEDIA/HQ/CLT/dialogue/pdf/Emancipation%20 Legacy%20Iran.pdf; Niambi Cacchioli, *Fugitive Slaves, Asylum, and Manumission in Iran, 1851–1913*, Cultural Interactions Created by the Slave Trade in the Arab-Muslim World (Paris: UNESCO, 2008), http://www.unesco.org/new/fileadmin/MULTIMEDIA/ HQ/CLT/dialogue/pdf/Disputed%20Freedom.pdf (all sites accessed 7 January 2017).

57. According to Baghoolizadeh in "The Afro-Iranian Community," "The neglect of Afro-Iranians by most Iranians stems from a number of factors, most of which stem from the Aryan myth. The Aryan myth effectively whitewashed Iran's history, leading many to believe that true Iranians are only light-skinned and that Iran never engaged in

slavery. Beyond this, the lack of Afro-Iranian presence in media further reinforces any preconceived notions that exist about Africans in Iran: that they simply do not exist. . . . Regardless of the reasons for the neglect, it is important to acknowledge the presence and history of the Afro-Iranian communities, not only for their sake, but with the intention of better confronting racist narratives, like the Aryan myth, that exclude so much of Iran's population."

58. Fomeshi, personal e-mail, 20 March 2015.
59. Gharibpour, personal e-mail, 4 October 2013.
60. Behrooz Gharibpour, *Uncle Tom's Cabin*, trans. Roshi Ahmadian, 3–5.
61. Gharibpour, personal e-mail, 4 October 2013.
62. Ibid.
63. Emerson, 160.

Contributors

César Braga-Pinto is Associate Professor of Brazilian, Lusophone, African, and Comparative Literature at Northwestern University. He is the author of *As promessas da história: Discursos proféticos e assimilação no Brasil colonial, 1500–1800* [Promises of history: Prophetic discourses and assimilation in colonial Brazil, 1500–1800] (2003), coeditor of *À procura de saúde: Crônicas de um doente / In Search of Health: Chronicles of a Sick Man* (2016), and author of *A violência das letras: Amizade e inimizade na literatura Brasileira, 1888–1940* [The violence of letters: Friendship and enmity in Brazilian literature, 1888–1940] (2017). Among his most recent articles are "Othello's Pathologies: Reading Adolfo Caminha with Lombroso" (*Comparative Literature*, 2014), "Journalists, Capoeiras, and Duels in Nineteenth-Century Rio de Janeiro" (*Hispanic American Historical Review*, 2014), and "The Honor of the Abolitionist and the Shamefulness of Slavery: Raul Pompeia, Luiz Gama, and Joaquim Nabuco" (*Luso-Brazilian Review*, 2014).

Kahlil Chaar-Pérez is an independent scholar and translator whose work addresses Caribbean and U.S. Latino aesthetics and politics from the nineteenth century to the present. After finishing his PhD in the Spanish and Portuguese Languages and Literatures Department at New York University, he was a College Fellow at Harvard University and a Postdoctoral Fellow at the University of Pittsburgh. He occasionally writes for the blog of the Society for U.S. Intellectual History.

Tracy C. Davis is Barber Professor of Performing Arts and Professor of Theatre and English at Northwestern University. She is the general editor of the six-volume *Cultural History of Theatre* (forthcoming) and the editor of *The Broadview Anthology of Nineteenth-Century British Performance* (2012). Her current research focuses on mid-Victorian liberals active in anti-colonial, anti-racist, and anti-genocidal critiques. She is a series editor for Cambridge University Press (Cambridge Studies in Theatre and Performance Theory) and Palgrave (Transnational Theatre Histories).

Marcy J. Dinius is Associate Professor of English at DePaul University. Her book *The Camera and the Press: American Visual and Print Culture in the Age of the Daguerreotype* was published by the University of Pennsylvania Press in 2012. She is at work on two book-length projects: one on the broad influence of David Walker's *Appeal* and another on the print and visual culture of radical abolition. She received her PhD in English from Northwestern University and has been awarded fellowships by the National Endowment for the Humanities, the Library of Congress, the Library Company of Philadelphia, and the University of Pennsylvania.

Jeffrey Einboden is a Professor in the English Department at Northern Illinois University. His books include *Nineteenth-Century U.S. Literature in Middle Eastern Languages* (2013), *Islam and Romanticism: Muslim Currents from Goethe to Emerson* (2014), and, most recently, *The Islamic Lineage of American Literary Culture* (2016).

Katarzyna Jakubiak is Associate Professor of English at Millersville University of Pennsylvania. Her research interests focus on the intersections between African diaspora literature and translation and on the reception of African diaspora literature in Poland in the twentieth century, especially during the Cold War period. Her recent publications include "The Black Body in Translation: Polish Productions of Lorraine Hansberry's *A Raisin in the Sun* in the 1960s" (*Theatre Journal*, 2011) and "Teaching *Dutchman* from an International Perspective," in *Approaches to Teaching Baraka's "Dutchman"* (forthcoming, edited by Gerald Early and Matthew Calihman). She has also translated works by African American authors into Polish.

Stefka Mihaylova is Assistant Professor of Theatre Studies at the University of Washington in Seattle, where she teaches the history and theory of twentieth- and twenty-first-century Western performance. She is currently

completing a book manuscript that explores how representations of race and gender shifted on American and British stages in the 1990s as artists began revising the concepts of radical performance inherited from the 1960s. Her articles have appeared in *Theatre Survey*, *NTQ*, and book collections.

Heike Paul is Chair of North American Studies at the Friedrich-Alexander-University Erlangen-Nuremberg. Among her recent publications are *The Myths That Made America: An Introduction to American Studies* (2014), the coedited volume *Critical Regionalism* (2016), and essays on contemporary American literature and public feeling. She is director of the Bavarian America Academy, Munich. Her current research engages with phenomena of cultural mobility, comparative reeducation studies, and dimensions of tacit knowledge. She is working on a monograph on the writings of Stewart O'Nan and a study of civil sentimentalism.

Debra J. Rosenthal, Professor and Chair of the English Department at John Carroll University, is the author of *Performatively Speaking: Speech and Action in Antebellum American Literature* (2015) and *Race Mixture in Nineteenth-Century U.S. and Latin American Fictions* (2004). She is the editor of *The Routledge Literary Sourcebook on Harriet Beecher Stowe's "Uncle Tom's Cabin"*. With David S. Reynolds, she edited *The Serpent in the Cup: Temperance in American Literature* (1997), and with Monika Kaup, she edited *Mixing Race, Mixing Culture: Inter-American Literary Dialogues* (2002). Rosenthal has published many journal articles and was a Visiting Fellow at St. Catherine's College at Oxford University.

Emily Sahakian is Assistant Professor of Theatre and French at the University of Georgia. In 2011, she received a dual PhD from Northwestern University and the École des hautes études en sciences sociales. Her first book, *Staging Creolization: Women's Theater and Performance from the French Caribbean* (2017), explores the plays of a pioneering generation of late twentieth-century female playwrights from Martinique and Guadeloupe and reconstructs these plays' international production and reception histories, in the Caribbean, in France, and in English translation in the United States. With Andrew Daily at the University of Memphis, she is currently preparing a critical edition and translation of *Histoire de nègre*, a Martinican community-based play created collaboratively under Édouard Glissant's direction.

Lisa Surwillo is Associate Professor of Iberian and Latin American Cultures at Stanford University, where she teaches courses on Iberian literature and transatlantic studies, with an emphasis on the nineteenth-century. Her research addresses the questions of property, empire, race, and personhood as they are manifested by literary works, especially dramatic literature, dealing with colonial slavery, abolition, and Spanish citizenship. She is the author of *The Stages of Property: Copyrighting Theatre in Spain* (2007), an analysis of the development of copyright and authorship in nineteenth-century Spain and the impact of intellectual property on theater, and *Monsters by Trade* (2014), a study of slave traders in Spanish literature and the role of these colonial mediators in the development of modern Spain.

Ioana Szeman is a Reader in Drama, Theatre, and Performance Studies at the University of Roehampton, London. Her book *Staging Citizenship: Roma, Performance, and Belonging in EU Romania*, based on long-term ethnographic fieldwork, is forthcoming from Berghahn. She is currently researching the relationship between theater and diplomacy during the Cold War, with a focus on international tours of Romanian theaters. Her articles have appeared in books and various journals, including *Theatre Research International, New Theatre Quarterly, TDR*, and *Performance Research*; she is a member of the *Feminist Review* editorial collective.

meLê yamomo is Assistant Professor of Theatre, Performance, and Sound Studies at the University of Amsterdam. meLê was a fellow at the "Interweaving Performance Cultures" Research Center (Berlin) and a postdoctoral researcher at the Deutsche Forschungsgemeinschaft (DFG) Kosseleck Project "Global Theatre Histories." He is a recipient of the "Veni Innovation Grant" by the Dutch Organization for Scientific Research (NWO) for his project "Sonic Entanglements: Listening to Modernities in Southeast Asian Sound Recordings." He completed a PhD in Theatre Studies and Musicology from the Ludwig-Maximilians-Universität Munich. meLê is also a theatre director and composer.

Index

ʿAbbās, Iḥsān, 346

abolitionism, 1–4, 9–10, 51, 170, 205, 216, 266, 324; anti-colonization stance, 47, 48–49, 61; in Brazil, 228, 229–39, 246; in Canada, 33–34, 38, 41–42, 47, 51; in Cuba, 145, 150; in Moldavia, 165–66, 167, 169–70, 174, 184–85, 188; transnational, 49–53

Abranches, Aristides de Sousa, *A mãe dos escravos*, 227–28, 251n6, 252n13

Achim, Viorel, 189n10

African colonization issue. *See* American Colonization Society; Liberia

African translations, initial absence of, 65–66, 70

Aguilar, Filomeno, Jr., 276

Ahmed, Sara, 211

Aiken, George, 287

Aldridge, Ira, 230, 253n24, 286, 309n22

Alecsandri, Vasile, 166, 175, 181

Alexander, Robert, *I Ain't Yo' Uncle: The New Jack Revisionist Uncle Tom's Cabin*, 381

"Amazing Grace," 151–52, 297, 311n68

American and Foreign Anti-Slavery Society (AFASS), 2, 67

American Colonization Society (ACS), 46, 48, 57n66, 60, 61, 66–67, 69, 70–71, 75n4

"America" signifier, 18

Amherstberg, Canada West 40, 44, 47–48, 51

Ammons, Elizabeth, 75n5

Anderson, Benedict, 262, 273, 274

anti-slavery movement and societies, 2, 42, 44, 48, 49, 55n35

Antonico (Antonio de Sousa Correa), 234

Arabic translations of novel, 345, 363n10. *See also* Baʿlabakkī, Munīr

Asachi, Gheorghe, 165; *Mirtil și Chloe*, 174–75; *Țiganii*, 166, 167, 168–69, 173, 174, 175–87, 191n64

Assing, Ottilie, 216–17

Ayeh, Yonis, 24

Ayguals de Izco, Wenceslao, *La chosa de Tom*, 15, 118, 120–21, 131, 134, 137n21

Bacon, Leonard W., 67

Baghoolizadeh, Beeta, 387n57

Bailey, Gamaliel, 2

Bakhtin, Mikhail, 373

Baʿlabakkī, Munīr, 345, 363n9; *Kūkh al-ʿAmm Tūm*, 345, 346, 349–55, 358, 361–62, 363n8

Baldwin, James, 211, 284, 288

Baraka, Amiri, 284, 288

Barbier, Paul-Jules, 88

Barclay, Arthur, 73

Baucom, Ian, 139–40
Beauplan, Arthur de, *Élisa*, 82–83, 85, 89–91, 94–95, 98, 100, 101, 106–8
Beecher, Lyman, 61
Belloc, Louise, 86, 114n112
Belting, Hans, 263–64
Benhabib, Seyla, 16
Berlant, Lauren, 20–21, 140, 142
Bernardin de St. Pierre, Jacques-Henri, 166, 174, 175
Betancourt Cisneros, Gaspar, 150
Bibb, Henry, 42, 47; and Malinda, 54n16
Biliżanka, Maria, 285
Blackburn, Ben, 45
blackface: in film, 8, 237–39; in minstrelsy, 8, 16, 22, 25n9, 52, 154, 235, 239, 275, 286–87, 305. *See also* Brazil; France; Poland; Romanian principalities
Blyden, Edward W., 66, 71–72
Bober, Jerzy, 299–301
Botrel, Jean-François, 118
Brazil, 19, 225–50; abolitionism in, 228, 229–39, 246; blackface in, 225, 229–32, 234, 237, 241–50; carnival adaptations of novel in, 239–41, 255n73; censorship in, 227, 228; Dumanoir and Dennery's play in, 16, 83, 228, 232, 235; film adaptations in, 234, 237–39; racial categories in, 231; stage adaptations in, 227–36, 252n13; telenovela adaptation (*A cabana do Pai Tomás*) in, 225, 236, 241–50, 255n78, 256n80; translations in, 231, 237, 268
Brougham, (Lord) Henry Peter, 316, 337–38n4
Brown, George, 47
Brown, John, 305
Brown, William Wells, 218n26, 220n39
Buddhism, 21
Bulgaria: reception of novel in, 8, 315–17, 333, 338n11; pedagogical use of novel in, 315, 321–23, 333–37; racial terminology in, 318–19, 320, 324, 336; translations in, 17, 19, 314, 315–24, 330–32, 336, 337n1, 338n11, 340n36
Bunyan, John, 20, 69
Burnham, Michelle, 60–61, 62

Burton, Richard D., 113n74
Butler, Judith, 264, 334

Cable, George Washington, 202–3
Caetano, João, 230, 232, 252n22
Canada, 33–53; abolitionism in, 33–34, 38, 41–42, 47, 51; biblical imagery about, 35, 38–39; émigrés in, 41–48, 52, 55n27; map of, 37; stage adaptations in, 52; role in novel of, 2, 13, 14, 33–34, 37–40, 43, 50–52, 57n79
Cardoso, Sérgio, 225, 236, 241–45, 255n78
Cassirer, Ernst, 262
Castilho, Celso, 229–30
Chalaye, Sylvie, 94, 96
Chaudhuri, Una, 9
Cheah, Pheng, 24
Child, Lydia Marie, 161n18
Chilly, Charles Marie de, 104–5
Chirot, Daniel, 173
Cima, Gay Gibson, 9
Civil War, 22, 344, 372
Clark, Margaret, 238
Clarke, Lewis Gerrard, 39, 41, 45
Clement of Ohrid, 317
Code Noir, 94
Codrescu, Theodor, *Coliba lui moşu Toma*, 7, 165, 166, 169–70, 171–72, 177–78
Cohen, Margaret, 12, 140, 324, 327
Cole, Catherine, 8
Compromise of 1850, 150
Concha, José de la, 134
Conway, Henry, 104
Cooper, James Fenimore, 193–94
Costa, Narciso, 233
Crimean War, 21–22, 173
Crummell, Alexander, 69–70
Cuba: antislavery fiction in, 121, 143, 144, 146–47, 161n20; counterpublic in, 144, 161n21; Orihuela's translation in, 7, 15, 140–43, 151–59; racial categories in, 7, 154–56, 161n15; slavery in, 116–17, 121–25, 128, 130–34, 139, 142–48, 150; U.S. relations with, 117, 122–24, 132, 141, 143–44, 148–50, 162nn32–33
Curran, John Philpot, 40–41

Dallas and Musgrave Dramatic Company, 260–61

Dānishvar, Sīmīn, 346

Debret, Jean Baptiste, 229

Dekker, Eduard Douwes (Multatuli), 273–74, 275

Delianus (pseud.), 267, 269–70, 279nn45–46

Delany, Martin, 64

Del Monte, Domingo, and circle, 121, 130, 137n41, 144–46, 147–48, 157

Dever, Carolyn, 12

Douglass, Frederick: anti-colonization stance, 2, 49–50, 59, 62, 64; German translation of, 216–17; *The Heroic Slave*, 34–35, 49–50; response to novel, 51–52, 57n70, 64–65, 218n26

Drescher, Seymour, 22

Drew, John, 45

Ducis, Jean François, 230, 232, 252nn22–23

Dumanoir, Philippe: with Adolphe Dennery, *La case de l'oncle Tom*, 9, 16, 82–85, 87, 89–92, 96, 98–108, 228, 232, 235, 240, 286–87; with Auguste Anicet-Bourgeois, *Le docteur noir*, 88, 98

Dumas, Alexandre, 118, 119, 135n8

Dutch East Indies, 15, 258, 259–60, 267–68

Dutch translations, 15, 259, 276n3

Dydacki, Franciszek, 284

Emelyanov, B., 327

Emerson, Caryl, 373–74, 382, 384

empathy, 10, 12, 21, 108, 142, 325–26

Enchev, Milan, 333

England: British editions of novel, 1, 4, 316, 337n4; slavery opposition in, 125; stage adaptations in, 16–17, 261

Everett, Edward, 123, 131

Fast, Howard, 368, 383

Fedorowicz, Eugeniusz, 293, 295–96

Ferreira, Procópio, 233

Fiedler, Leslie, 192

Filipov, Vladimir, 314–15, 332–33, 337n4

Fillmore, Millard, 123, 124

Fischer, Sibylle, 145, 147

Flaubert, Gustave, 86, 87, 327

Fluck, Winfried, 193, 200

Fomeshi, Behnam Mirzababazadeh, 370, 379, 381, 383

Foote, Andrew H., 47

Foucault, Michel, 334

France: blackface in, 97–98, 102; censorship in, 89, 97, 100, 109; critical reception of novel in, 86–87; popularity of novel in, 81–85, 89; race categories in, 6–7, 97, 101; role in novel of, 13, 50–51, 95; slaveholding history of, 93–94, 95–96, 99, 112n55, 125; stage adaptations in, 9, 15, 16–17, 81–86, 87–110; translations in, 15, 16, 19, 81, 87, 91, 95, 166, 170

Frank, Bill, 73

Frederickson, George, 153

Free-Soil Movement, 2

Fugitive Slave Act, 3, 9, 17, 33, 38, 41, 49, 204, 330; in *La case de l'oncle Tom*, 108–9

Garland, Judy, 239

Garraway, Doris, 96

Garrison, William Lloyd, 2

Germany: censorship in, 199; promotional use of novel in, 206–16; reception of novel in, 17, 23–24, 192–217; *Sklavengeschichten* (slaves stories) in, 193, 195–96, 216; stage adaptations in, 23, 192; translations in, 8, 19, 192, 284, 308n11

Gharibpour, Behrooz, 370–73, 385n23; *Kolbeye Amou Tom*, 18, 23, 366–68, 372–84

Ghasemi, Parvin, 370

Gheorghe, Nicolae, 189n10

Gillman, Susan, 160n5

Gilman, Sander, 195

Girardin, Émile de, 172

Gómez de la Avellaneda, Gertrudis, 121, 143, 161n18

Gorky, Maksim, 324–29, 332, 333

Gossett, Thomas, 193

Gouges, Olympe de, 111n34

Govedarov, Ivan G., *Chichovata Tomova koliba*, 320–21, 323, 339n25, 339n28

Greenberg, Betty, 318

Greenblatt, Stephen, 380–81
Grigoraş, Nicolae, 189n10
Groneman, Isaäc, 278n37
Gutzkow, Karl, 195
Guyon, Emilie, 98, 101
Gypsies. *See* Roma people

Hackländer, Friedrich Wilhelm, *Europäisches Sklavenleben*, 18–19, 193, 196–201
Hainey, Betty Jean, 239
Haiti, 47, 93, 158–59; revolution in, 6, 124, 127, 145
Hancock, Ian, 185, 190n59
Hansberry, Lorraine, 284, 288
Hartman, Saidiya V., 264–65
Hawthorne, Nathaniel, 345–46
Helbig, Adriana, 182–83
Henríquez Ureña, Max, 161n18
Henson, Josiah, 35, 37–38, 41, 45, 50, 52, 53n12, 216, 217
Hildreth, Richard, 98, 204
hooks, bell, 180, 183
Hosseini, Khaled, 371
Howard, June, 161n11
Hughes, Langston, 284
Hugo, Victor, 367, 371, 372–73
humanism, 82, 85, 104, 108, 225
Hunter, John, 46
Hurricane Katrina, artistic responses to, 366–67, 384–85nn1–2

Ikonomov, Teodosii, 338n16
India, 269
Iran: censorship in, 369–70, 374–75; pedagogical use of novel in, 369–70; political interpretations of novel in, 22, 367–68, 370, 371–72; puppetry in, 377–79; slavery in, 382–83; stage adaptations in, 18, 345, 367–68, 372–84; translations in, 345, 367, 370, 371
Islam, 343, 346, 351–54, 361, 380–81, 383
Italy, 20
Ivanov, Ivan, 324

Jacobson, Matthew, 205
Jamshidi, Mostafa, 370

Jarrett, Henry, and Harry Palmer, 287
Jaszcz (Jan Alfred Szczepański), 301
Jazanī, Munīr, *Kulbah-e ʿAmū Tum*, 345, 346, 347–48, 355, 356–59, 361–62, 365n32; Gharibpour's adaptation of, 367, 370
Jazz Singer, The (film), 8, 237
Johnston, Stephen, 52
Johnson, William, 45–46
Jolson, Al, 8, 248

Kadish, Doris, 86, 95
Kamenova, Anna, 314, 315, 326–27, 330–32, 334, 337
Kamenova, Denitsa, 336
Kapuscinski, Ryszard, 312n99
Karcher, Carolyn L., 161n18
Kaszycki, Lucjan, 286, 293, 302
Keen, Suzanne, 335
Khamenei, Ali, 367–68, 370
King, William, 45
King and I, The (Rodgers and Hammerstein), 20–21
Kirkland, Elias E., 45
Koester, Nancy, 344, 355
Kogălniceanu, Mihail, 165–66, 169–70, 174, 182, 183, 184–85
Kolodny, Annette, 199
Kościuszko, Tadeusz, 306
Kozak, Andrzej, 285, 300
Kropotkin, Pyotr, 268
Kudliński, Tadeusz, 299–300, 302
Kujawińska Courtney, Krystyna, 286
Kuliczkowska, Krystyna, 290–91
Kutzinski, Vera, 147

Lamartine, Alphonse de, 88
Lane, Jill, 154
Lang, Andrew, 278n37
Lemaître, Frédérick, 98
Leszczyński, Adam, 290
Lhamon, W. T., 25n9
Leonowens, Anna, 21
Lesser, Jeffrey, 266
Lewald, Fanny, 199, 220n50
liberalism, 19–20
Liberia, 59–73; emigration to, 2, 3, 11, 13,

14, 46–47, 48–49, 70–73, 145; founding
of, 75n4; responses to novel in, 65–72;
role in novel of, 7, 50–52, 57n76, 59–65,
67, 157, 344
Liberty Party, 2
Lincoln, Abraham, 145, 371, 383
Lobo, Fernando, 240, 241
London, Mark, and Tom Taylor, 261
Lott, Eric, 301–2, 305
Lowance, Mason, et al., 116
Lucas, Edith, 81, 86, 89, 109
Lugenbeel, J. W., 69
Luis-Brown, David, 148, 150
Lumumba, Patrice, 289–90, 304, 306,
310n38, 310n40
Luna, Ángel Maria de, and Rafael Leo-
poldo Palomino, *Haley*, 117–18, 122,
125–34

Machanette, Achille, 102
MacLean, Grace Edith, 192, 193
Madden, Richard, 125
Maggi, Andrea, 231
Malay states, 262
Manickam, Sandra Khor, 262
Manifest Destiny, 117, 123, 149
Manzano, Juan Francisco, 144
Marcos, Plínio, 243–44
Marie of Romania, 278n37
Marx, Karl, 4, 329–30
Massoudi, Shiva, 377, 379
Mastodon Colored Minstrels, 260, 277n8
Mavrov, D., and G. Palashev, *Chicho To-
movata koliba*, 321–24, 327, 330, 339n28
May, Samuel Joseph, 48
McCormick, John, 87, 88
McKittrick, Katherine, 33
McLuhan, Marshall, 263
media theory, 262–66, 271–72, 277n27
Meer, Sarah, 81, 85, 288, 301–2, 305
melodrama, 10, 12, 27n36; French, 87, 96–
97, 102; social, 88
Melville, Herman, 345–46
Metzger, Rainer, 24
Meyer, Hildegard, 194
Millo, Matei, 174, 175; *Baba Hârca*, 166,
175–76

miscegenation, 1, 6, 96, 97, 146; as incest,
147
Möhrmann, Renate, 199
Moldavia. *See* Romanian principalities
Moraes, Conchita de, 237
Morgan, Jo-Ann, 259
Moriah, Kristin, 24
Morrison, Toni, 215
mulattos, 5–7, 96, 99, 101, 147, 154, 157,
229, 239
Müller, Salomé, 202–4, 205, 206,
219–20nn38–39
Multatuli. *See* Dekker, Eduard Douwes
Murray, Hilton Alves, 225–26, 241, 248–
50
Mutev, Dimitar, *Chicheva Tomova koliba*,
316–20, 324, 337n4

Nabuco, Joaquim, 228
Nafisi, Azar, 371
Nahuÿs, Alphonse Johan Bernard Horst-
mar, 274
Napoleon III, 89, 93, 100, 109
Narvaez, Darcia, 335–36
Nascimento, Abdias do, 236
National Era, 1, 2, 72
Neale, J. M., 20
"négrophile" drama, 88
Negruzzi, Costache, 175
Nelson, Robert, 45, 46
Netherlands, stage adaptations in the, 267
"nigger" term, 7, 155–56
Nightingale, Florence, 21
Northrup, Solomon, 52
Norwid, Cyprian, 305–6
Nowakowski, Zygmunt, 282, 283, 284–85,
306–7
Nyanseor, Siahyonkron, 72–73

Obama, Barack, 23, 336
Oișteanu, Andrei, 167
Oliveira, Benjamin de, 234–35
Oliveira, Eduardo de, 246, 250
Oliveira, João Rodrigues Santiago de,
226–27, 250n2
Olivier, Laurence, 242, 243
O'Loughlin, Jim, 259

O'Neill, Eugene, 236
Onkel Toms Hütte (beer gardens and
 leisure sites), 207–10, 213–16
Onkel Toms Hütte (1965 film), 242, 256n83
Orihuela, Andrés Avelino de, 143, 149–50;
 La cabaña del Tío Tom, 7, 15, 140–43,
 150–59
Osterhammel, Jürgen, 266, 279n43
O'Sullivan, John O., 149
Othello: blackface tradition in, 242, 243,
 252n22; popularity in Brazil of, 230–31,
 232

Pao, Angela, 97
paternalism, 16, 85–86, 95–97, 101, 103,
 104, 106–7, 110, 113n75
Patrocínio, José do, 228, 234, 252n13
Pavlov, Ivan, 329, 334
Pease, Donald E., 13–14, 168
Peixoto, Luís, 235
Pena, Martins, 230
Pérez Galdós, Benito, 134
Persian translations. See Iran
Pezuela, Juan de la, 132
Philippines, 258, 259, 274, 277n3
Phillips, Tom, 210
Pierce, Franklin, 123, 124
Pilatte, Léon, La case de l'oncle Tom, 166,
 170, 171–72, 177–78
Pimentel, Frederico, 247–48
Plácido (Gabriel de la Concepción
 Valdés), 142
Poland: blackface in, 286–88; censorship
 in, 283, 292, 305; communist ideology
 and Uncle Tom's Cabin in, 283, 285; men-
 tion in novel of, 282, 306–7; stage adap-
 tations in, 17–18, 283–307; translations
 in, 7, 17, 19, 282, 284, 287, 290–92, 300
Polk, James K., 148
Pollard, Harry, 238, 287
Poor Paddy's Cabin (anon.), 19
Pop, Dimitrie, Bordeiul unchiului Tom, 7,
 165, 166, 170, 171–72, 177–78
Popivanov, Ivan, 325, 326, 328–30
Portugal, 16, 227
postcards. See Onkel Toms Hütte (beer
 gardens and leisure sites)

Power, A. L., 42–43
Pramoedya Ananta Toer, 273
Pratt, Mary Louise, 18
Proudfoot, Ian, 262
Przybylski, Wacław, and Ignacy Iwicki,
 284
Purvis, Robert, 51

quadroons, 5–7, 88, 101, 120, 154, 177–78,
 319

Rahmanian, Mohammad, 386n26
Ray, Mona, 238
Read, W. H., 269
reception theory, 14
Reynolds, David S., 12–13
Reynolds, Larry J., 159
Richards, Jason, 156
Riis, Thomas, 270
Riley, Isaac and family, 46
Riordan, Kevin, 9
Risley, Richard, 260
Rizal, José, 274–75
Robbins, Bruce, 142
Robeson, Paul, 284
Rodrigues, Nelson, 243–44
Roediger, David, 304
Romanian principalities: abolitionism in,
 165–66, 167, 169–70, 174, 184–85, 188;
 blackface in, 174, 175; censorship in,
 165–66, 169, 170, 175, 187; stage adapta-
 tions in, 166; translations in, 7, 15, 16,
 165–66, 169–72, 174, 177–78
Roma people (Țigani), 165–88, 188n2,
 188n10, 190n59
Ross, Alexander M., 54n17
Rossi, Ernesto, 230–31, 232
Röttger, Kati, 271–72
Roysen, David, 246, 247–48
Russia: censorship in, 282, 305; influence
 in Bulgaria, 324; slavery in, 10, 21, 268;
 translations in, 17, 19, 309n16
Ruy, Evaldo, 240, 241

Saco, José Antonio, 144, 145, 149, 157
Saint-Rémy, Joseph, 87
Samini, Naghmeh, 372

Sanches, Caetano Salazar, 251n4
Sand, George, 86–87, 119
San Luis, Luis José Sartorius, Count of, 132
Santos, Anscendina, 235–36
Sarrani, Abeer Abdulaziz al-, 363n10, 363n16, 363n19, 364n24
Scherzer, Karl, and Moritz Wagner, 202
Schmidt-Nowara, Christopher, 116
Schwartz, Roberto, 251n11
Schweikher, Marie, 217
sentimentalism, 10–12, 19, 20, 22–23, 87, 128, 140, 142–43, 161n11, 315, 318, 324–30, 333
serfdom, 10, 21, 165, 188n3, 268
Sewell, Anna, *Black Beauty* as "the *Uncle Tom's Cabin* of the horse world," 269
Shadd, Mary Ann, 42, 43, 55n35
Shamshiri, Babak, and Massih Zekavat, 369–70
Sharenkov, Victor, 333
Shaw, Lisa, 235
Shih, Shu-Mei, 24
Siegert, Bernhard, 262, 263, 278nn27–28
Siemann, Wolfram, 199
Sienkiewicz, Henryk, 287, 320
Singapore, 21, 259, 260–61, 262, 270, 272
Silva, Maximo, 233
slavery. *See* abolitionism; anti-slavery movement and societies; mulattos; quadroons; Underground Railroad; *and specific laws and countries*
slavery tropes and analogies, 4, 19, 22, 23, 200–201, 220n41, 289–90, 314–15, 333; animals, 269–70; in Asia, 266–68, 271; in Bulgaria, 318; in England, 4, 218n26; in Germany, 194, 195–98, 200–201, 204–6, 220n50; paternalism, 92, 95–96; in the Philippines, 274–75; in Poland, 288, 305–7, 313n103; in Romanian principalities, 165–66, 167; white slavery, 202–5, 206, 220n39
Śliwiak, Tadeusz, 286, 288–89, 293, 302, 305
Słomczyńska, Lidia, 288–89, 291–95, 297–99, 301–2, 307
Slovenia, 13

Snead, Patrick, 46
social(ist)–realist aesthetics, 10–11, 285, 315, 324–30, 333, 335, 340n42
Somerset v. Stewart, 40–41, 50
Soulé, Pierre, 122
Sousa Dantas, Manuel Pinto de, 228
Southeast Asia, 7, 19, 258–76; epistemology of race in, 262–65; literacy rates in, 272, 280n66; sonic images in, 270–71. *See also* Dutch East Indies; Singapore
Souza, Ruth de, 236, 244
Soviet Union. *See* Russia
Spain: censorship in, 119–21, 129, 131; popularity of novel in, 118–21; slave policies of, 17, 116, 121–34; stage adaptations in, 16, 83, 117, 122; translations in, 15, 117, 118–21, 134, 135n12
Spillers, Hortense S., 140
Stampf'l, Stanisław, 291
Stawiński, Julian: article by, 285, 309n16; Polish translation (*Chata wuja Toma*) by, 284, 290–91, 292, 297, 305
Stoler, Ann Laura, 178
Stowe, Harriet Beecher: Christian commitment, 344, 346; Civil War and, 344, 382; evolving position on colonization, 66–67; father's influence on, 61, 332; "woman writer" status in Germany, 194, 199, 205–6. *See also Uncle Tom's Cabin*
Sturdza, Mihail, 175
Suárez y Romero, Anselmo, 121, 143
Sue, Eugène, 118, 119, 135n8
Șuțu, Nicolae, 175
Sweden, 19
Sweeney, Fionnghuala, 50

Talajooy, Saeed, 375
Tanco y Bosmeniel, Félix, 143, 144, 146–48, 163n50
Tartar translation, 343–44
Taylor, Diana, 16, 264
Temple, Shirley, 239
Texier, Edmond Auguste, and de Leon de Wailly, *Oncle Tom*, 82–84, 85–86, 89–91, 94–95, 96, 98–99, 103–4, 106–8
Thailand, 20

Theobalt, Gerold, *Onkel Toms Hütte Reloaded*, 23
Thompson, George, 48–49, 56n66
Toledo, Caio Pompeu de, 247
Tomich, Dale, 116
Tompkins, Jane, 74n1, 151, 193, 286n39
Tom shows, 52, 261, 275, 286
"Tom" slur, 23, 73
Topsy and Eva (1927 film), 238
translation theory and practice, 19, 94, 348, 373–74, 379; Bakhtin on, 373; Venuti on, 5, 14, 25n12, 151, 319
transnationalism, 13–14, 15, 23, 93, 235, 290; newspapers and, 258–59, 272
Trouillot, Michel-Rolph, 93
Turkish translations, 345, 362n7
Tuwim, Irena, *Chata wuja Toma*, 284, 290–91, 292, 297, 305
Tuwim, Julian, 238

Uncle Tom's Cabin: authorial address in, 2, 365n36, 382; Christianity (Protestantism) in, 3, 12, 19–20, 22, 27n34, 85, 107, 139–41, 151–52, 159, 170, 171, 283, 290, 291–94, 300, 317, 320, 321–22, 330–32, 350–51, 355–61, 376, 382; circus version of, 260; communist propaganda use of, 283, 285, 307n3, 323, 330, 336–37; as conversion text, 20, 344, 346, 355–56, 361; dialect in, 154, 236, 288, 347–48; early reactions to, 1–3; education in, 95; epigraphs in, 151; expatriation solution in, 2, 23, 145, 344 (*see also* Canada; Liberia); historical authenticity of, 4, 11, 217; hymns and church music in, 151–52, 270, 293–94, 297–98, 311n55; intellectual property in, 132; as juvenile literature, 19, 23, 282, 284–85; *A Key to "Uncle Tom's Cabin,"* 35, 216; minstrel influences in, 288, 301; pastoralism in, 210–11; point of view in, 2; Poland reference in, 282, 306–7; preface to French translation, 170; Quakers in, 331–32; romantic racialism in, 5–12, 15, 25n9, 52, 141, 152–54, 157, 159; sales of, 1; sentimentalism in, 10, 19, 20, 22–23, 25n9, 52, 87, 140, 142, 159, 199, 200, 274, 318, 326–27, 328, 334; serialization of, 1, 2, 21, 72; skin tones in, 63, 98–99, 153, 156, 157, 200, 204, 322, 333, 336; U.S. stage adaptations of, 8, 88, 104, 111n33, 287, 381; "whiteness" in, 6, 98–99, 102, 153, 156–57, 198, 204. *See also individual countries*

—CHARACTERS: Adolph, 5, 90, 95, 102, 104, 112n51, 156–57, 301–2; Alfred St. Clare, 6, 158; Arthur Shelby, 37–39, 125, 155, 347–48; Augustine St. Clare, 4, 6, 11, 12, 13, 22, 39, 91, 95, 98, 99, 156, 158–59, 218n26, 268, 282, 283, 290, 306–7, 321, 334, 378–79; Bird (Mrs.), 326, 330; Cassy, 6, 23, 51, 59, 61, 89, 167, 179, 182, 295, 296, 348–50, 375, 381; Chloe, 23, 151, 154–55, 196, 291, 319; Dodo, 6; Eliza Harris, 2, 5, 9, 10, 38–39, 43, 59, 82–84, 88–91, 98–104, 106–8, 120, 125–39, 153–54, 157, 168, 176, 204, 292, 318, 325–26, 332–33; Emily de Thoux, 51, 59, 61, 95; Emily Shelby, 171, 380; Emmeline, 6, 23, 89, 167, 349; Eva St. Clare, 8, 12, 16–17, 19–20, 27n34, 91, 98, 129, 159, 273, 294–95, 334–35, 376–79; George Harris, 2, 3, 5, 6, 8, 11, 13, 14, 16–17, 23, 38–39, 43, 50–51, 59, 60–63, 65, 67, 82, 88, 95, 99–100, 106, 107, 125–31, 132, 153, 157–58, 168, 176, 290, 332–33, 352–54; George Shelby, 3, 10, 11, 95, 103, 106, 268, 286, 291, 297–98, 309n17, 357–60; Haley (Samuel), 10, 90–91, 94, 99–101, 103, 106, 107–8, 125–29, 134, 155, 314, 347–48; Harry Harris, 9, 10, 39, 43, 98, 106–7, 120, 125, 127; John Bird, 9, 17, 83, 85, 90–92, 99, 101–2, 103–9, 125, 230, 233, 330–31; John Van Trompe, 9, 17, 322; Lucy, 6, 90, 181; Mammy, 5; Marie St. Clare, 12, 20, 27n33; Ophelia, 4, 11, 12, 51, 67, 95, 254n54, 321; Phineas Fletcher, 91; Quimbo, 108, 291, 295, 297, 331, 355–56; Rachel Halliday, 91; Sambo, 156, 291, 295, 297, 331, 355–57; Simeon Halliday, 352–53; Simon Legree, 3, 6, 10, 20, 38, 73, 147, 152, 167, 269, 286, 314, 325, 331; Smyth (Mrs.), 43; Susan, 6; Tom, 2, 3, 6, 10, 11, 12, 16–17, 23, 35, 37–

39, 52, 73, 83–84, 88, 91, 94–95, 100, 103, 106–7, 119, 128–29, 147, 152–53, 170, 200, 204, 210, 268–69, 289, 290–99, 326, 331, 332, 350–51, 355–61, 373, 376–81; Tom Loker, 90, 99, 104, 107, 126, 127, 129, 332; Topsy, 2, 8, 13, 16–17, 61, 67–68, 103–4, 107, 233, 235, 236, 238–41, 254n54, 287, 301–2, 303, 325; Wilson (Senator), 8, 125–26, 127, 129–30

Uncle Tom's Cabin (1909 film), 370

Uncle Tom's Cabin (1910 film), 237–38, 255n63

Uncle Tom's Cabin (1914 film), 8, 261

Uncle Tom's Cabin (1918 film), 238

Uncle Tom's Cabin (1927 film), 237, 238, 278n38, 287

Underground Railroad, 9, 35, 55n30; map of, 36

Urechia, V. A., *Măriuca's Cabin*, 166, 167, 172, 176

Vasques, Francisco Correia, 231–32

Vazov, Ivan, 339n31

Venuti, Lawrence, 5, 14, 25n12, 151, 319

Vogl, Joseph, 262–63, 265–66, 271, 277n27

Voice of the Fugitive (broadsheet), 42, 47, 52, 55n32

Walker, David, 59

Walker, William, 148

Wall, David C., 6

Wallachia. *See* Romanian principalities

Walter, Krista, 50

Ward, Samuel Ringgold, 46

Warner, Michael, 161n21

Washington, Augustus, 61–64, 66, 69, 70–71, 73

Washington, Madison, 49–50

Webb, Frank, 216

Whittier, John Greenleaf, 2

Willes, Rev. T., 45

Williams, Raymond, 211

Wilson, Carol and Calvin D., 202

Wilson, Hiram, 50

Wilson, Ivy, 50

Wood, Alfred T., 68

Wright, Richard, 284

Ząbek, Maciej, 304

Zorilla, José, *Don Juan Tenorio*, 126

Zwemer, Samuel Marinus, 343–44, 346, 362